somethingtofoodabout

**exploring creativity
with innovative chefs**

Questlove
with
Ben Greenman

Photography
Kyoko Hamada

Design
Jeanette Abbink
Art Direction
Alexis Rosenzweig

somethingtofoodabout

Clarkson Potter/Publishers
New York

Dedication

For Richard Nichols

You asked, "What's the meaning of a meal?"

I answered, knowing I'll never fully satisfy
your curiosity.

Contents

Foreword

Whoever called James Brown "the hardest working man in show business" could not have anticipated Ahmir "Questlove" Thompson. Bandleader, percussionist, musician, producer, founder of and drummer for the Grammy Award–winning band the Roots, constantly working DJ, writer, and teacher, he makes even the Godfather of Soul look as if he might, in retrospect, have been underemployed.

His circle of friends—and the people he's worked with—is a list so eclectic as to defy logic or credulity: Elvis Costello, Jay Z, Common, D'Angelo, Erykah Badu, Amy Winehouse, Iggy Pop, Bootsy Collins, Bernie Worrell, Hank Williams Jr. . . .

Basically, all cool reverts to him. He's the actual Most Interesting Man Alive. In fact, chances are that if you are doing something/anything interesting, sooner or later, you will find yourself working with Questlove. It is, apparently, a physical law of the universe.

He doesn't sleep. He travels constantly. He is a compulsive Instagrammer. And it is from a look at his enticing account that yet another side of the man emerges: photos of a beaming Mr. Thompson in Tokyo, standing alongside Jiro Ono, or frying chicken with David Chang. A story in pictures unfolds which suggests that, in addition to being able to authoritatively discuss the backstory to every classic recording in the history of music, he has also a deep and penetrating knowledge of great food, and the people who make great food, around the world.

It's sort of sickening, really. How many things can one human being be good at?

The term *foodie* is inadequate to describe Questlove's relationship with the international subculture of chefs. He would be better described as a fully made member of the chef mafia.

This book offers some evidence of his reach, the depth of his interest—and his extraordinary good taste.

From New York City to his hometown of Philadelphia to Portland, New Orleans, and beyond, he takes us on a personal journey, exploring, through discussions with some of the most innovative personalities in the world of food, the creative process.

In ten conversations with ten wildly diverse, intensely focused chefs on the cutting edge of gastronomy—and through a delicious mix of essays, photos, and more—Questlove explores their personal history, motivation, inspiration, and the ways that food can intersect with the other creative arts.

Food can be magic.

It is magic. And yet it's not. It comes from somewhere—and from someplace and someone. Always. Food tells a story. Usually a very personal one.

Questlove gets to the heart of the matter. And so, here he is, getting to it.

Anthony Bourdain
New York City

"What is food for thought? Why does food for thought make you hungry? And hungrier, the more you eat? How is an idea translated into food? Are ideas something you can taste? I had endless questions about food, about cooking, about the science of cooking, about restaurants, about chefs. I had time to go in search of the answers. That's where I've been. Here's what I brought back from my journey . . ."

This book is about food in America, but it isn't really about food, and it doesn't start in America.

A few years ago, I went to Japan for my birthday. While I was there, I ate at Sukiyabashi Jiro. I had seen the documentary *Jiro Dreams of Sushi,* which is an inspirational biography of the famous sushi chef Jiro Ono, his quest for perfect sushi. I watched this film on repeat for months in awe of Jiro's commitment to his craft. He inspired me. And at the same time, I could relate to him, or at least to the questions he was asking himself. What does that mean, to perfect sushi? Does perfect sushi even exist? I know the feeling, at least when it comes to music: you can go through a first take of a song, and a second take, and a fiftieth, and sometimes you feel like you have hit the sweet spot, and sometimes you feel like you're moving further away. Is this drive for perfection necessary for creative people, or is it just something that happens to creative people whether it's necessary or not? All I knew for sure was that Jiro was still dreaming of sushi, and I wanted to be in his dream if he would be in mine.

And so I went, into the Chuo ward, into the Ginza district, onto 4-chome street, and finally into the basement of the Tsukamoto Sogyo Building, a nondescript glass-and-steel office tower topped by the gaudy neon signs that are so common in downtown Tokyo. I am an obsessive documenter, and during my meal—which included a brief audience with Jiro himself—I started taking pictures and posting them to Instagram. It's good that I did because while the food was impeccably prepared with flavors

and textures I couldn't have imagined, and it was also a sensory heaven in other ways, too: how it looked, in shape and color, how it smelled, how Jiro and his staff composed the meal like a piece of classical music.

If you've never been to Sukiyabashi Jiro, then you've never been to any place like Sukiyabashi Jiro. One of the dishes uses an octopus that has been massaged for hours. How many hours is enough when it comes to octopus massage? Only Jiro knows, and he feels that he needs to know more to be sure. That's the spirit of the place, and the longer I sat there, soaking it in, the more I started to understand it. Is his obsession a kind of freedom, or a kind of imprisonment, or both?

The octopus was massaged for hours.

I am notorious for long-winded posts on Instagram, but something about Jiro got me really writing. I was excited and excitable, and something about the intensity of the place left me a little raw (no pun intended). Here's one of the comments I posted:

> *I was like Popeye to spinach. 'Member*
> *when Michael Jackson tried that tonic*
> *in the "Say Say Say" video and it made him*
> *dance? You don't? Google it. I didn't dance,*
> *but damn if I wasn't in my head doing*
> *T.A.M.I. Show James Brown splits singing*
> *"Night Train" (Sting fans feel me . . . yes*
> *even my referenced references have*
> *footnote references).*

To me, at that moment, food was more than food: it was words, and it was the memory of music, and it was the memory of old television shows, because really it was ideas married to the senses. That's what those things are, too—they are my basis, in fact, for understanding how ideas could be married to senses, and where they would go for their honeymoon after.

My Instagram blew up. People couldn't get enough of my comments about my food, even though they could no more taste it than I could jump through the screen and taste what they were eating—meatloaf in Miami, or pho in Phoenix. I know they were eating

those things because when I got home from Japan, I walked back up the electronic trail, looked at the Instagram accounts and the blogs of the people who followed and reposted and commented on my Jiro pictures and writings. The world of food, of thinking about food in a nonprofessional, nonscholarly, but endlessly enthusiastic way, was larger than I thought. And the same way that endless enthusiasm had spurred me, at Jiro, to new heights, these people all over the Internet were writing and thinking about food with depth and intelligence and humor. They were going to restaurants in their hometowns and they were Jiro-ing them. They were making me dream and making me fans of these other chefs.

That experience planted the seed for this book. In my normal life, I travel all over. When I'm in other American cities, I stop to eat. I try to eat in places that move me as much as Sukiyabashi Jiro did. They don't have the same history or the same philosophy. They don't use the same ingredients. But there are restaurants in every city where the chefs are devoted to innovative, intense, idiosyncratically brilliant food. They prepare it, cook it, and present it as if it's artwork, which it is. Not every restaurant is necessarily a place for innovation and vision, but those that are do what Jiro did: they put you in their dream.

As a musician, I have spent two decades traveling all around the country and the world, touring. When I was first on the road, I ate wherever was convenient. That's a common behavior among musicians.

But at some point, I realized that my interest in food was something more involved and textured, and I started to ask the runners to recommend places— not necessarily the best in that businessman-in-town way, but spots I had to try. I started to invite friends of mine to these restaurants, as sharing the excitement, the privilege, the experience of dining in a restaurant—whether it's a date at White Castle on Valentine's Day or a marathon sushi meal in Tokyo—sharing in the experience with people is what food, culture, music, and art is all about. When I am in other cities, I now make it a priority to visit

innovative restaurants, and to think about what I'm seeing there. How is the food prepared? How is it served? Who is the chef? What are the ideas that circulate in the process?

I'm fascinated by chefs, people who have decided to devote their lives to food—to making it, but also to thinking about what it means to the broader culture. How does it make us who we are? How much is it a product of, or a producer of other parts of our culture? Or is it both, which means that it's almost unimaginably complex? That fascination led directly to this book: a series of conversations with some of America's most innovative chefs. I wanted to talk to them about their training, their ideas, their relationship to creativity and to change, and their hopes (and fears) for the future. I spoke to chefs about every aspect of their business. What is a restaurant? How can a chef ensure that a visit to their restaurant is something special? What is their philosophy of food? How do they make that philosophy work? What have they learned over the years? What have they unlearned? Where do new ideas come from? How do old ideas change? I wanted to speak to them, interview them, take their ideas and pick their brains before I took photos and picked their plates clean. When you get chefs talking about food in the right way, amazing things start happening. And they start wanting to talk about more than food, too. They wanted to design futuristic kitchen appliances and give me their B-side dishes. They wanted to cross over into their other enthusiasms: some of them have a deep well of information about music, some about movies, some about books, some about fashion, some about architecture, some about technology. I wanted to talk to them about whatever they wanted to talk about. I wanted to be in their conversation if they wanted to be in mine.

One question that came up over and over again was diversity. It came up as a question because there were no satisfying answers. The sad fact is that there's not much diversity in the world of fine dining, or in what we know to be fine dining. I noticed it first as a diner.

Sometimes I would visit restaurants and see pretty quickly that I was the only black person in the room. Those moments made it clear that I had been invited because of my celebrity, or because I could foot the bill. It wasn't that I would have been disqualified because of my color, at least not in any overt way. But it was clear from almost any restaurant that diversity wasn't a priority. Here, I'm talking not only about the people in dining rooms, but the people in kitchens. There aren't large numbers of black or Hispanic chefs in charge of the country's best restaurants. The same low-representation problem affects female chefs as well. The further I got into this book, the more I wanted to make sure that I handled the issue. But I wanted to handle it in a specific way. I knew from fairly early on that I didn't want to artificially inflate the numbers of minority and female chefs I was talking to. That would have been a kind of tokenism, a gesture that would have sidestepped the problem. Instead, I wanted to talk to chefs and ask them, whenever possible, why they thought that the food world was so white and male dominated. Their answers were interesting, opinions coming from different parts of the country. Donald Link, in New Orleans, pointed to the fact that few young black men (or women) seem to work in restaurant jobs, wondering if the reason was related to the historical stigma associated with kitchen work in the African-American community. Daniel Patterson, in San Francisco, saw minority representation in the fine-dining kitchen—along with related problems regarding the eating habits of inner-city Americans—as a stubborn problem, but one that couldn't be solved in food conferences or on Op-Ed pages. It was one of the driving forces behind his decision to create Loco'l, an affordable, real-food fast-food chain that would open its franchises in poor American neighborhoods. After I spoke to Donald, Daniel, and the rest, I started to read around on the topic. One of the best pieces I found was "Coding and Decoding Dinner," an essay in the *Oxford American* by the Washington, D.C.–based food writer Todd Kliman. Kliman's piece, which ran in May 2015, is about how restaurants are often

careful not to become "black" establishments—and, specifically, how they are reluctant to cross the "60-40 line," where more than 40 percent of diners are black. Many of the people Kliman interviewed wouldn't go on the record. I didn't have that problem. No one that I talked to shied away from the question. Most discussed it forthrightly, with a mix of frustration, optimism, clarity, and confusion. And yet, I still feel a little tug of responsibility that I wasn't able to present a more diverse food world. But that's just not the case right now. Or rather, it's not yet the case. Though I have to acknowledge reality, I'm optimistic for change.

What the facts do bear out is that all of the chefs in this book are artists facing forward. This book, hopefully, both looks at things from their point of view and faces them directly. This is not your typical food book. It's more about the ideas behind the food. Think of it as a tour through different food studios. It's getting inside the minds of the artists. It's the creative process of these chefs illustrated through photography: both in still lifes and action shots taken by a photographer whose work I greatly admire, Kyoko Hamada, and through my own Instagram. I'm a documentarian of all things, and this is no exception. It's food I've eaten, chefs I want to understand, it's somethingtofoodabout.

Questlove
New York City

"There is a history of food, but it's also the most ephemeral of the performing arts, because you can't record it."

Nathan Myhrvold
Seattle

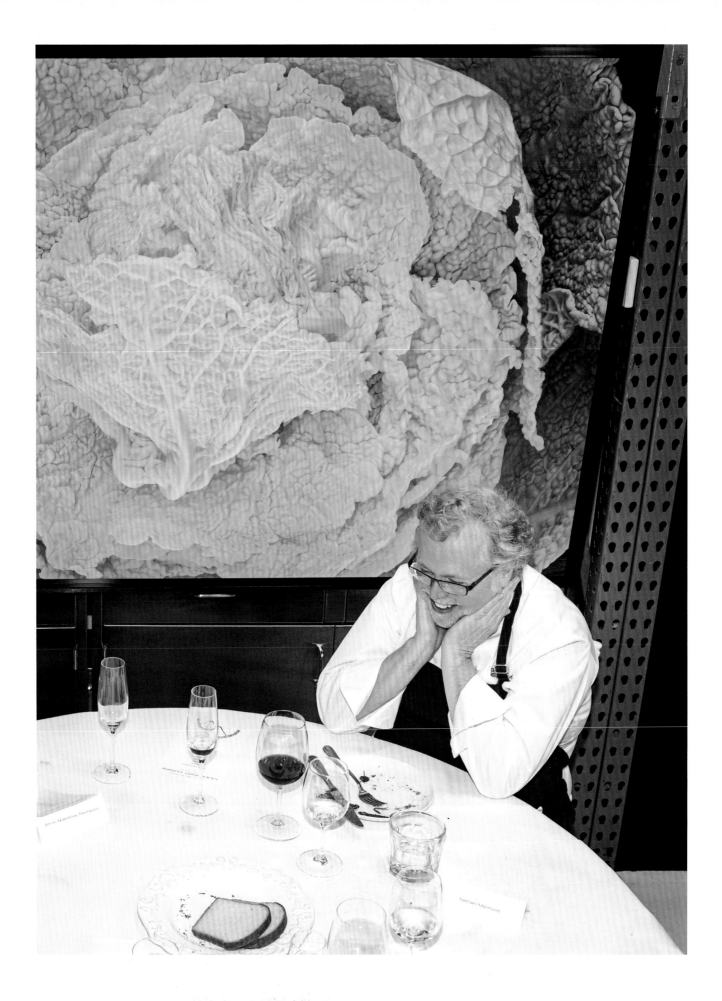

I'm super-analytical, maybe to a fault. When I talk about music, I love hearing stories about how it was made, popping the hood and figuring out how things work. Other musicians say they don't even think of me as a musician as much as a journalist who makes music, and I don't disagree.

Sometimes when people review Roots records, they question whether that analysis interferes with the artistry. For me, that analysis is the artistry. You take a song and take it apart and put it back together. That was one of my earliest bonding moments with the hip-hop producer J Dilla. He had a drum machine and he was remaking all his favorite beats, whether they were from DJ Premier or from Pete Rock. Dilla was a mad scientist but an artist.

These issues were on my mind when I started my journey into food and innovation, and they're what pointed my mind toward another mad scientist, Nathan Myhrvold. Nathan worked for Microsoft, where he was instrumental in helping to secure dozens of patents, and he continued on his own, trying to invent elegant and practical solutions to some of the world's most stubborn problems—hunger, poverty, disease.

Nathan also loves food. Over the years, he has investigated food as a hobbyist and a fan, and then, in recent years, as a professional. But he's a food professional like no one else I have ever met. He runs something called Modernist Cuisine, a massive food-related publishing and research project. It started when he was hearing all about sous vide cooking, which is a technique where food is sealed in plastic bags and then cooked in water or steam. Nathan was interested in the technique, but frustrated that what he was hearing wasn't specific. He wanted to know exactly how big the bags were in relation to the food, exactly how far it should be immersed in the water, exactly at what temperature it should be cooked, and exactly for how long. That led to a broad investigation of every kind of cooking, every kitchen tool, every food. It also led to a six-volume book that topped out at nearly 2,500 pages. The original book was priced stratospherically at $600, but it sold out instantly and became an indispensable reference for chefs everywhere. It also became the trigger for a Modernist Cuisine empire with a state-of-the-art lab in Seattle. Nathan continues to run his lab and comprehensively investigate every corner of the food world.

I planned a trip to Nathan's lab. I couldn't contain my excitement. I told everyone. I considered starting the book with a scene of my trip there. Then I decided that it would make more sense to end the book with the lab, in part because I wanted it to be the big finale and in part because I wanted to conduct lots of research and prepare myself. That preparation would be the book itself: having discussions with innovative people in the food world about their ideas. But I couldn't wait to talk to Nathan, literally. He was my first discussion.

I'm coming to your lab in a few months. I'm excited. I feel like there will be lots of machines I don't understand. Before I come, though, I wanted to ask you some of the main questions that I'm going through in this book, which is about innovation and food. What was the first restaurant you remember going to?

Well, I was born in Seattle but grew up in Santa Monica, California, and there was a Chinese restaurant there that we went to when I was a kid called Madame Wu's. I loved it. I thought it was so cool to have Chinese food.[1]

Did people in your house cook?

My mother cooked. She grew up in a farm in Minnesota, where she favored simple farm-stock cooking: meat and potatoes, chicken and potatoes. That wasn't trendy back then, but it was her mainstay. My mother actually did like ethnic food, so we had lots of that, and she liked going out and buying good cheeses. But you have to remember that American audiences were less adventurous then. There were always Chinese restaurants, say, but without the support of the mainstream population other cuisines couldn't really take hold. It would be interesting to find out when the first wave of sushi came to the United States, and or when more authentic Mexican and Thai hit. People have done projects to track where General Tso's chicken came from, or how fried fish moved from the Portuguese to the Japanese. And then there are those strange cuisines that are in the middle of nowhere: Benihana of Tokyo, a big American chain, is called Benihana of New York in Tokyo. So where is it actually located? And what does that mean about the food it serves?

Right. How do we decide which foods we claim as our own? Is it just a matter of where the ingredients come from, or where they came from originally? Is it where a dish is prepared? Food influences how we look at our culture. Where does that start?

There are even bigger questions, too. How do we decide what we call everyday cuisine? What's made into high delicacy? Is it about scarcity? Difficulty of preparation? For a while, I was into Southern barbecue. That's not universally accepted around the world. It's considered trailer park food. There's no intrinsic reason for that, of course. It's a very strange set of circumstances that made us take certain foods like bouillabaisse from Marseilles and elevate it while at the same time we take a hyper-regional food in the United States and diminish it.

I think about that all the time when I'm traveling. Certain places look like they're serving food that only belongs where it is. Other places look like they're serving food that could belong anywhere. Are there foods from other places that can't be successfully transported or translated, that just don't make sense out of their culture?

There are strange delicacies everywhere. I have never had a balut, the duck embryo that's served in the Philippines. I have had maggot cheese in Sardinia. They take a fresh cheese sort of like feta but not quite as salty and leave it out for flies to swarm and lay maggots. It's better than it sounds. Usually these weird foods are just things that people had to eat out of necessity. Take rotten shark in Iceland. This particular shark has a neurotoxin. It's strong enough to kill dogs. At some point these desperate fucking Vikings discovered that if you took the shark and buried it for six months the neurotoxin breaks down. After you unearth it, you hang it in an open-air shed for three months. There are all these chunks of sharks and the worst urinal smell—sharks don't have kidneys and don't eliminate urea the way we do by pissing it out. That means their flesh is permeated with ammonia. They eat that. I ate that.[2]

So that had to happen. I mean, I guess if you were the sharks you wouldn't see it that way, but from the human side, they needed to find a way to make that meat safe.

Huge amounts of food preparation happened because it's just what you had to do to make the thing palatable or to preserve. Sausage was a way to eat parts of an animal that you couldn't eat any other way, all of this tough sinewy stuff and all of this fat. Tons of things are about preserving: beef jerky, smoked meats, salted meats. Caviar is a way of salting and preserving fish eggs that would otherwise go to waste. On the other hand, it's hard to say that ice cream was created by necessity.

—— 1
This is what's known as "the undersell." Madame Wu's was famous. It was Chinese food for the stars. She had a Rolls-Royce with a personalized plate, MMEWU. Princess Grace went there. Mae West went there. Cary Grant went there. And so did Nathan Myhrvold.

—— 2
I thought that maybe this was something Nathan made up in a dream. It's not. It's called hákari. The shark it's made from is the Greenland shark, whose scientific name is *Somniosus microcephalus*, which means something like "tiny head sleeper shark." Look at how much science I am learning already.

So Ben and Jerry's is never a necessity, not even after a hard day? Some food is artistic expression, and some is social meaning. I like to think about this in musical terms, which might be inaccurate. But in music, people started making organized sound that articulated something inside themselves. But pretty quickly, it became a ritual: playing music at certain important times in society, then separating the audience from the performer, then preserving performances. Did the same thing happen with eating and dining?

We definitely have separated them as a way of encouraging high achievement but I don't see that as a bad thing necessarily. You mention music. Let's look at visual arts. Everybody's kids make little drawings in art class. There's a certain level in art that you see everywhere. But the world has also chosen to support people who have taken it to an extremely high degree, and that leads to a high-end art market that is very elitist and expensive. It gets shown in museums, which makes it available to the public, but elitism is part of the deal.

This year the Wu-Tang Clan made an album that no one could hear. Well, one person could hear it. It was a single pressing. They planned to auction it off to only one person, who would be the only person to ever listen to it. They claimed they got a five-million-dollar bid for it.[3] That made me wonder if there's something similar for food, an insane high end of the market.

There's a difference between art and craft, or artistic things and artisanal things. If you go to MoMA, that's art with a capital *A*. It's not people in a craft fair selling you macramé wall hangings, who would be considered artisans. But in food, the words get confused. One of the things that's quite amusing is that when quality foods started coming to the United States, that whole thing was associated with the concept of artisans: artisanal cheese, say, which was viewed as an alternative to industrial cheese. But even then there's a big distance from there to art. Art doesn't always make you comfortable. No one said to Damien Hirst,

"Hey, I'd really like to see a big shark in a thing full of formaldehyde." The food world has been wrestling with this for the last decades as chefs try new, weird things that don't necessarily please people immediately. Food is supposed to comfort us and then you put a foam on my plate: "What the fuck is this?"

The Modernist Cuisine cookbook project takes this creative expression and looks for the science underneath it. Some people have worried that this takes away from the mystery of great food.

When people say "What made you think you could bring science into the kitchen?" I say "Sorry. It was already there." Cooking is governed by physics and chemistry. In my mind, we're taking ignorance out of the kitchen. The idea that you would be better off not knowing how it works would be silly to me. Architecture is another great example. Lots of innovative architecture historically depends on technology. The Romans invented concrete and that's why we have the Pantheon. More recently, you couldn't have these droopy Gehry buildings without computer-aided design. And like food, architecture runs the gamut from art with a capital *A* to things that are very prosaic. Food is necessary—we need to eat or we're going to die—but that doesn't preclude the possibility of those high-end things.

What's also strange, though, is that in other arts those high-end things get collected. They get put in museums if they're paintings or they get put in textbooks if they're buildings. People study them. How does that work with food?

There is a history of food, but it's also the most ephemeral of the performing arts, because you can't record it.

But you can, in a way. There are cookbooks, including yours. If I open your book, aren't I looking at a record of the food?

Hopefully. But we are continually learning about the limits of old recipes. Part of the Modernist Cuisine project involves spending lots of time exploring historical recipes. Many professional cookbooks from the late nineteenth and twentieth centuries were made for apprentices. They have instructions that aren't tremendously helpful. To finish off a dish, they might say

3 ——
The album is called *The Wu— Once Upon a Time in Shaolin*. I haven't heard it, obviously. It's possible that by the time this book comes out, it will have leaked, or been revealed as a stunt, or that I'll have obtained a copy and worked it into DJ sets. For now, it illustrates my point.

"Cook until done." What the fuck does that mean? There's a shorthand that's useless for an average cook. Our books try to be more absolute. We want to democratize cooking techniques and make accurate versions of them available to everyone.

It would be great if you could record food. I mean, if you could just press a button during your meal and then play it back later. Imagine the difference between people making music before there were Edison cylinders and after there were Edison cylinders. All of a sudden, you have a real record.
If you could record at a molecular level, it would change everything. Someday that will happen. In the meantime, the best recipes are like sheet music rather than a record. What we try to do is to say maybe we should put notes down here. It's a funny thing that people consider this approach so scientific and artless. The same people don't think it's odd that there are piano tuners. The point of a piano tuner is to say that there is a middle C at 44Hz. Does that mean that there's no artistry in a great pianist?

Instructions, whether they are sheet music or recipes, don't always pan out. It depends who is making them. Inspiration matters also. Two people can play the same piece off a music stand and you'll get one masterpiece and one thing that sounds like a train wreck. The same thing must happen with food.
No question. That's one of the amazing things. To what degree does a recipe guarantee that you'll end up with a certain final product? There are great long-range historical examples. We've been doing a book about the history of bread. There was a recent archaeological discovery in Africa that gives us good evidence that humans were harvesting grain a hundred thousand years ago. Previously, we thought it was ten thousand years ago. At Modernist Cuisine, we've been wondering what was the first bread, and we're going to try to re-create it. Of course it'll be highly speculative and it probably won't be that good. It's fun to view as a treasure hunt.

It seems like you think that all chefs are scientists, in a way, that they are using the scientific method to conduct experiments all the time, but with food. I get into trouble with other musicians sometimes because I am always trying to figure out the corners of songs. What created that weird keyboard pattern? Is it true that you can get the drumstick to produce a certain sound if you put wax paper on the tip, or fur around the shoulder? I'm just making up random examples. I don't think I have ever drummed with fur around the shoulder.
That's one of the amazing things about cooking. People empirically figured things out. Lots of what they figured out is correct. Some of it isn't correct, and that's because people love to tell stories, even if we don't know what we're talking about. So in food we found that there were lots of myths guiding people's sense of food. For example, the idea that if you sear a steak you seal in the juices. It sounds so good. But the opposite turns out to be true.

Is there a limit to how useful knowledge is? Can we be too smart and knowledgeable for our own good? I feel this sometimes in music. Everyone knows something about hip-hop, and something about reggae, and something about heavy metal. Once everyone knows a little bit about everything, it's harder to bring new ideas into the mix.
We see the same thing in the food world. I think that's a theme I always emphasize. We love variety. Today, on earth, there's a higher variety available than ever before. How have we maximized variety? Partly it's come from importing other foods. We imported sushi to America and that was a hell of a discovery. But as time goes on, we're coming to the end of big imports like that. There aren't so many more things like sushi—deep, richly developed cuisines that people have worked their lives to perfect. On average, the world knows about all the world's foods, mostly, so going forward the only way we're going to get our fix for increasing variety is to invent it. The world is going to be more and more about invention and creating new foods.

How do food inventions spread? I know how media spreads, though that has changed since I've been doing this. It used to be that we would have to tour, and make sure that our records were stocked in stores across the country. Now, we just have to make sure that copies are uploaded to iTunes or even to Spotify.[4] Then people anywhere in the world can find them.

With music, that's clearly possible. A piece of classical music or jazz or hip-hop can move all around the world easily. But with food, there's no equivalent of the radio. You're dealing with physical limits. As a result, food stays in this funny place where the elite practitioners of the very highest forms remain really expensive. There's lots of manpower and there are lots of man-hours spent laboring over it and securing the finest ingredients. Because of that, maybe, people in the food industry can get disconnected from reality. You find a certain kind of chef who is super well-meaning but naive. They say things like "All those people in the inner city ought to have farm-to-table and home cooked meals" without also realizing that they are working two jobs and have single-parent families. We have huge dilemmas in our food system and there's a huge desire to have a single solution. "Let's all go to local organic sustainable home-cooked food!" But that can't solve everything. Part of the problem is that we have the food system we insisted on, and it's limited. The idea that the evil food companies made us do this is only partly true. People throughout America, not just corporate overlords, value low cost and efficiency. Plus there's the matter that people like to eat what they like to eat. There are deep-set cultural habits. The idea that we're all going to be vegans, that's not realistic. I don't mind anyone proselytizing, but let's look at what people really want.

Much of your life has been spent trying to understand and value ideas. You did it at Microsoft. You've done it since. One of your companies, Intellectual Ventures, buys up patents that you think might be worth something in the future. From all the years of doing that, what have you learned about where ideas come from? This isn't the cliché question that people ask writers and musicians, which is "Where do your ideas come from?" I may have been guilty of asking people that in this book, even. But I'm asking you something slightly different. Where do ideas come from, period?

In the case of Modernist Cuisine, the book, there were so many answers. Sometimes I was able to trace inspiration pretty directly. I might be having dinner somewhere in the world and notice something about a certain dish and an epiphany would hit. I would instantly email the team and they would get to researching it, or setting up an experiment. That's where my ideas come from. But it might also be a situation where we were following a particular line of inquiry over time—maybe we were interested in steaming broccoli, say. Because the idea had its own set of related ideas attached to it, we would then try it with every other vegetable. And then there are the out-of-left-field ideas, things that happen because you're bored, or because you misunderstand something simple and make it interestingly complicated, or vice versa. All of those are different paths, but the destination is the same: a new idea. When you have it, then you start to work with it.

Ideas can lead to new ideas endlessly. In the case of Modernist Cuisine, it almost did. You created a book that was 2,500 pages. How did you set limits for yourself?

We didn't set limits. Science did. In music, you can make lots of sounds. They may not sound good at all, but you can still make them. Your creative thought is limited only by the noises that all the instruments in the world can produce, and that's an extremely wide range. Your creative thought when it comes to cooking is moderated in a strong way by what's physically possible. You can have an idea of x but x may not be possible when it's subjected to chemistry and physics.

4 ——
Or Tidal. Or Beats. I used the two most obvious ones not because they're my favorites, but because they're most likely to still be around by the time the book comes out. If they are not, ask an older friend what they were. Or enjoy your new service, whatever it's called.

What's a brilliant idea that just didn't pan out scientifically?
We have tried to make hot ice cream a number of times. Or at least something that looks like ice cream. That hasn't worked yet. At another point we were talking about spherification—a liquid with a gel around it and that explodes in your mouth. We figured out how to make spheres and oblongs but we haven't been able to make cubes yet. Cubes want to turn into spheres, and if you really want rigid sides you also get sides that are too thick.

Recording changed music forever. What's the equivalent in food? What's the biggest technological revolution in the history of food?
Refrigeration was a huge deal. It allowed you to serve chilled and cold foods and to store food without curing it. Otherwise, if you really go back historically, you're looking at the discovery of the New World by Europeans. They brought back chocolate and tomatoes and corn. That was a gigantic change, maybe the single biggest change in ingredients, when all these domestic plants got brought back to the Old World. I don't know if you'll see that kind of thing again. The melting-pot process by which ingredients spread throughout the world has been greatly accelerated. Now you can see a bottle of soy sauce in any restaurant in the world.

Does the spread have negative effects, too? Airplanes changed the world by making it smaller, but they also allowed diseases to move all around the planet. In that last scene of *Rise of the Planet of the Apes*, they show the pilot infected with that anti-human virus walking through an airport, and then there's a map illustrating the outbreak. By the time of the *Dawn of the Planet of the Apes*, much of humanity has been wiped out.[5] So what about the spread of things that harm food—bacteria, blights, those kinds of things?
Phylloxera is a good example. It's a parasite that kills grapevines. Starting in the nineteenth century it started killing grapevines in Europe. To solve that they had to bring roots from elsewhere. The Native American root is resistant. Today there's an amazing situation, which is that all the European vines are planted with rootstock that's American—you take the root and graft on whatever else you want. Usually problems come a different way. There are cases where people became overreliant on

a single crop. The potato famine in Ireland, for example. Ireland was one hundred percent dependent on that food. They had put all their eggs in one basket, except that the eggs were potatoes, and when there was a crop failure there was starvation and a mass exodus. These days, there are fewer food-dependent migration patterns. There's an Indian economist named Amartya Sen who won the Nobel Prize for his research on famines. Early famines happened because local crops failed. But when food started to circulate around the world, which happened from the nineteenth century onward, all famine was political in the sense that there was adequate food supply denied to people by political circumstances—a war, or the group in charge wanted to kill people, or bureaucratic incompetence intervened. If that was true then, it's so much more so now. Today there's no reason for a person to starve to death. When you've got problems of malnutrition it's usually because there's a political thing.

I also wanted to talk to you about technology and preservation. Because storage space is getting cheaper, you can store all the music in the world in one place, in theory. How good are we getting at preserving our foods? I know there are these amazing underground vaults that keep copies of all the seeds in the world. Do we need those libraries?
Selective breeding is how we got all of our domestic plants. People chose the best-tasting apples. In recent years modern agriculture has tended to focus almost exclusively on cost or cost-related issues. So you have an old taste-breeding practice and a new cost-breeding practice. They are at odds. As we move away from great taste, it would be a shame to lose that. The other thing is that in addition to flavor difference, varieties of fruits and vegetables have different drought or disease resistance. We don't know when we might need those things. Most of the bananas on earth are Cavendish bananas. There's some blight that's affecting the Cavendish strain and we may need to breed new bananas, or bring back old ones. So you can never say you're done.

—— 5
I know that neither movie is a documentary. I am just using them as examples to try to keep up with Nathan. He knows lots of science.

(left) A dinosaur face-off

(right) Petrified dinosaur poop

(left) Light-up Periodic Table coasters with can of Diet Coke (Nathan's favorite)

(right) SousVide circulator by PolyScience; red radish cross section

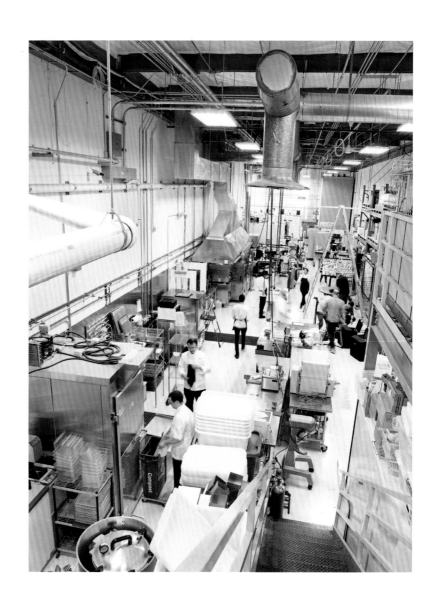

(left) Bag of fresh green peas
on top of centrifuge

(right) Modernist Cuisine Lab,
as seen from above

(below) Questlove laser-cut wafers on slate

(right) Whiteboard explanation of rye levain bread (aka Farmer's Bread), intimidating mathematical-equation clock, dinosaur toys

Pasta
vs
Bread:

Rye berry → Rye flour → Rye levain

230g H₂O → Rye levain rotelli

750g H₂O → Rye levain bread (Farmer's bread)

"You have to understand the ground rules so that you can decide when to break them."

———

Daniel Humm
New York

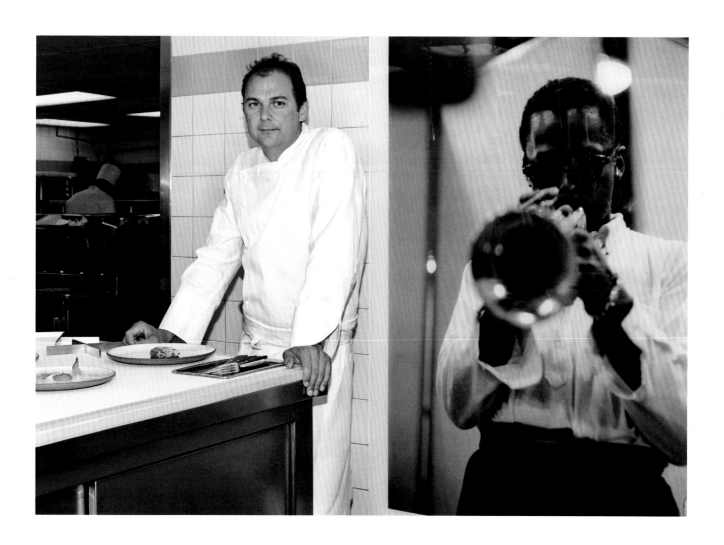

It's hard to eat in the city where you live. In some ways it's the easiest thing in the world. You can go to the refrigerator. You can walk down to the corner bodega. But it's harder than you think to *dine* in the city where you eat. How do you balance convenience with traditional quality with upstart novelty? It's like trying to pick a record to play when your mood isn't quite made up: do you reach for Janet Jackson, or Brian Wilson, or Flying Lotus, or Alabama Shakes?

One thing you try to reach for, always, is quality. When I met Daniel Humm, the chef at Eleven Madison Park and the restaurant's co-owner (along with Will Guidara), the restaurant's reputation preceded it. I knew that it was one of the city's great establishments. He's gotten every award and accolade you can get: three Michelin stars, four-star reviews from the *New York Times* (twice), ranked as the fifth-best restaurant in the world. I had an idea in my head that it would be the textbook version of a great restaurant: superb food, but maybe a stuffy atmosphere.

As it turns out, it's nothing close to that. It's great, of course, but from the first time I went there, it was also a place for me to learn about innovation. It wasn't innovation in the same way as Nathan Myhrvold. There wasn't any mad-scientist riffing. There weren't deep dives into obscure corners of food history. But Daniel also cares about challenging himself, creating new ideas, and—maybe most of all—about thinking about the relationship between the restaurant's reputation, its incredible physical space, and his need to be playful and exploratory. A lot of that thinking is about applying his ideas about innovation directly to the dining experience beyond the food, and the restaurant has been known to serve courses that involve card tricks at the table, or to give guests personalized gifts based on what the staff learn about them during the meal. Daniel has a deep and lasting interest in Miles Davis. It guides his restaurant in ways that I'll let him explain. At first that seemed strange, but as I went, it started to make more sense. Miles was someone else whose career was filled with moments of risk and reinvention, and who had to learn how to navigate the jazz academy and also his own need for change.

You were born in Zurich, Switzerland—we recorded part of *The Roots Come Alive* there.[1] **Many chefs in this book trained in Europe, but only a few were born and raised there. What was the first restaurant you remember going to?**

I was lucky because my dad is an architect, and he met people who were prominent in other fields. He brought me around to some of these meals that he had. The first one, I think, was at Frédy Girardet. It's a restaurant outside of Lausanne, in Crissier, run by Frédy Girardet himself.[2] We had a dinner in the kitchen. I was probably eight years old. I was so impressed by all the chefs, maybe thirty of them in white uniforms and toques.

Were you more impressed by the ceremony or by the food? I remember going to concerts with my parents—concerts they were playing in—and both were factors. I loved the music but also the spectacle of it: there were lights and there were special clothes and there was a sense of serving something to the audience.

Oh, it was both. I remember he made me spaghetti with lobster, which was great. But that was only part of it. I had never seen anything like it. From that point on I knew I wanted to be a chef. Actually, maybe there's an even earlier one. I remember going to a restaurant when I was seven or so. At the beginning of the meal they had endive and the leaves were in a glass sticking up and next to it there was a container with a sauce, like a little thicker than salad dressing. It was just a shock to me that you would take the leaf and dip it in the sauce and eat it. That was the first time I realized different things could be done in that way. It was the most simple thing, but it was vivid to me. It was cool. Food was interactive.

Let's go back to your childhood. (Not in the therapy sense.) I'm always recounting memories associated with my childhood that have shaped me as a musician. I'm curious how a chef's upbringing impacts who they, too, become as an artist and a chef. Who in your house cooked when you were growing up?

My mom was always at home, and cooking was a big part of what she did. She bought all the ingredients from the surrounding farms. She baked her own bread. She would buy a chicken. We didn't always eat lots of meat but she would

buy it for the weekend, for the big meal on Sunday, and that meant that earlier in the week we would have dishes that used the rest of the animal in interesting ways. For example, on Friday she would buy the chickens and that night we would eat the livers in the dish and then on the weekend the chicken. With other meats we would eat the cheaper cuts and then on the weekend the roast beef.

So that's an early lesson in sustainable eating, in a way. Those formative experiences with food, I think, mean more to us than we know. The way we get food is wired directly into the most fundamental parts of the brain. I remember my grandmother making certain kinds of food and offering it to the poorer families in the neighborhood. It's connected to ideas of generosity and sharing.

Those early memories are learning without really realizing that it's learning. I remember when I got a little bit older. Sometimes I would spend the night at a friend's house, and that's when I saw the difference most clearly. Once, my mom brought in a salad. It was raining outside, and the leaves were covered in dirt, and I had to wash them ten times. I got frustrated. Why am I washing these things over and over again? I asked her. When I am at other people's houses, I said, they buy these salads in the store already washed. Why can't we? But when I tasted it, the salad my mom brought in was so succulent and sweet. Her thinking started making sense.

I had something similar. Other people had music in their houses, but they didn't Have Music in the same way, where it was part of the daily grain. I was a showbiz kid.

When I create food today, there's a trace of that still. It's important that it all makes sense, that the feeling makes sense. Sometimes I see young chefs putting things together, but they don't have the context, and when you eat the dish they have prepared, you feel it doesn't make sense at all.

Throughout this book, I'm thinking about chefs' creativity, and how their innovation with and commitment to food is similar (or in some cases dissimilar) to the way I feel about music. In your case, you make it easy. Two words: *Miles Davis.*

Yes. Miles Davis is very much part of my restaurant.

— 1

This was our big live album in 1999, and I think four songs were from Switzerland—one from the Montreux Jazz Festival, and three from the Palais X-Tra, this massive nightclub in Zurich. If you're keeping score at home, the songs from Zurich were "The Next Movement," "The Ultimate," and "Don't See Us." I don't remember what we ate the night we played there.

— 2

Girardet was a legend. Many people considered his restaurant the best in the world in the seventies and eighties. And research has taught me that he was different from other famous chefs in that he spent much of his time in the kitchen actually supervising cooking. It gave him maybe a slightly lower profile but maybe better results.

He liked cooking.[3]

It started ten years ago, when we were reviewed by the *New York Observer*. They gave us a good review but the critic wrote "I wish this place would have a little more Miles Davis." I thought it was a cool thing to say. I had never read anything like that before, and wasn't sure exactly what she meant. So I set out to do a little research, to read as much as we could about Miles and even more than that—we even talked to people who played with Miles. We put together a list of eleven words and phrases that were most commonly used to describe him. They were words like *forward-moving, endless reinvention, collaborative, light, cool, innovative*. And when we looked at this list of words we had a wow moment. All those words were concepts, and every concept is an idea. This list of Miles Davis words is where we want to go. From then on, this list of words has always been with us when we make important decisions.

What word is most important?

Cool. Ten years ago, when we started our restaurant, we were not cool. We weren't the kind of place you wanted to go hang out. There was a certain stuffiness. We knew that we wanted to create a restaurant for the next generation. And then there are the words about continuing to be creative: *endless reinvention, innovative, forward-moving*. Miles created a new genre almost with every album: he went from cool jazz to modal jazz to funk-jazz.

One of the things about Miles is that his newness always came within tradition. That's one of the reasons that people had such a strong reaction to his shifts and changes. No one thought he was coming in from left field. When he did *Bitches Brew* or *Jack Johnson*, he was doing it not as a newcomer, but as someone who had been there since the bebop years at Minton's and Monroe's. That meant that he deserved to be listened to, that he had to be considered an authority both on maintaining traditions and changing.

He knew how to play jazz better than anyone and that's why he was able to be so innovative. When he was breaking the rules he knew he was breaking the rules. I think for any great artist in anything—whether it's architecture, art, music, food—you have to understand the ground rules so that you can decide when to break them.

Now that you mention Miles, I'm thinking about jazz. A jazz artist, at least in the period before there were original compositions and free-form explorations, went out there and played the same songs night after night. They varied them slightly, but they had a repertoire. It was the ability to find subtle variations each night, without ever sacrificing the essence of the piece, that made them great jazz artists.

For a chef to be successful, there has to be consistency, even if you're creative. Consistency is really important. You have to cook at a high level every night. And then, of course, there are periods of major change. We have four times a year that we change the menu to something new. But the changes you see within the cycle of each menu are to make it better. It's more about improvement and refinement than it is about improvising. The last day we're cooking should be the best.

So a new menu is like a new album? That's a metaphor other chefs have used, particularly Dave Beran at Next. He talks more about the composition of it than the performance, though. But one of the things he pointed out—and this is true for Miles, too, and for the Roots—is that for every album, no matter how much you love it and believe in it as an innovative thing, there's also the moment where something replaces it, when something else becomes the new album, and that formerly new album is suddenly the old album. Creative success requires that kind of succession.

Exactly. That's the moment when there's a creative recharge. It's true that jazz musicians play the standard songbook, but the innovators also pushed forward. At some point, Miles wasn't playing the same old songs anymore. He had moved past that. In an interview, someone asked him why he didn't play them, and he had an interesting answer. He said that he loved them too much. I understand that attitude. While we're working on a menu, we come up with an amazing dish. And then when the season is over, when we change the menu, we stop. We move on. One of my favorite quotes is from Willem De Kooning: "I have to change to stay the same." Change has always been part of this restaurant, and of any restaurant. Whenever you make a

3 ——
I was making a joke here, sort of. I was talking about the great 1956 album *Cookin' with the Miles Davis Quintet*. It's the one with the Phil Hays drawing on the cover and the "the" jogged a little bit upward. Miles wasn't talking about actual cooking, of course. He was talking about hot playing. "That's what we did," Miles said when someone asked him about the title. "We came in and cooked." Anyway, I didn't go back and insist on my joke. And why go back and insist on a joke when you can just tell it later on, in a footnote?

change, it's hard to explain to your staff where you're headed. There's a great deal of trust. No one ever really understands the new direction until you have five dishes under your belt and you can then take a measure of it. But this place, where you're changing to stay the same, is exactly where we want to be.

This gets to another question, which is how food is remembered. When you close a menu down, it's gone forever.

I think that's why it's interesting for us. With music, performances are recorded. For chefs, the things that we create don't exist other than in people's memories. There are ways to remember them, of course, with the most important one being cookbooks. They are crucial to memorialize these dishes. Otherwise in thirty or forty years no one will remember.

But even cookbooks are only an approximation or a set of instructions. It's like releasing sheet music for a musical performance rather than a recording. Nathan Myhrvold made that analogy and it seems kind of brilliant.

It depends how you do a cookbook. In ours, we would never just give a recipe. That means nothing on its own. It doesn't do the dish justice. But I think if you have the recipe and the photograph, and we write about it and explain the circumstances around its creation, that is something. It's important that we not leave any secrets out. There used to be a time when people would hold out secrets. We can give it all to you. In fact, I like the idea of fully revealing everything about the dish, because then the whole world starts doing those recipes. It kind of puts pressure on us to change.

Do you mean that once the secrets of the performance are revealed, somehow, then some magic goes out of the result?

For us it's very much about techniques that we're learning and then using for a period of time. Then we see other people use it, and at that point, we can't use it in the same way anymore. Say there's a certain way that we're putting something on the plate. We do it for a while and then there's a point where you see people copying us. It's no less great, the way we're doing it, but we have to stop doing it. I always think of it in terms of staying ahead of the curve. It is like fashion to some degree. Styles come and go. You don't just have jeans. You have jeans that

are tight and then you have loose and then they become tight again. Things come and go in the food world. That's why I get lots of my creative inspiration from the past. I look at cookbooks from the 1960s or 1970s and try to guess how things are going to work, which techniques will come back into view and which ones will fall out of favor.

Today, Eleven Madison Park is run by you and Will Guidara. The restaurant existed before— Danny Meyer opened it in 1998—but you guys took over, changed it, and eventually bought it from him. What was your plan?

To make it into one of the greatest restaurants in the world. We had this beautiful room in this incredible building. It was supposed to become the tallest building in the world. You see the park from there. You see the Flatiron Building. It's an unbelievable space. So Will and I wondered how to make a restaurant that's worthy of that space? What we did was go around the world and look at the best restaurants. What flatware are they using? What plates? What's the best china available? How can we make a cheese cart with sixty of the world's best cheeses? We made every idea our own, but we were heavily influenced by the idea of quality. And it worked. We moved up and got three Michelin stars. We became one of the best restaurants in America. But as we got more confident, we started to feel like the whole thing didn't really feel right to us.

How so? The tone was off?

Back then, so much money was flowing. There was this crazy opulence. That's a temptation that leads to strange decisions. There's a burgundy glass that's like a huge flower. At the time, the thought was that everyone in a fine restaurant would like the thing. If you look at it today, it just seems ridiculous. Who wants to drink out of that? The more time passed, we decided that it wasn't about getting all of the best things and putting them in front of people. It became about something else, which was going through all the available choices, making decisions, and giving them to people. People don't really want sixty cheeses on the cart. They want one or two or three, but the best. We don't need ten different kinds of bread. Let's just take one and make it as good as we can.

So how do you do that? You scour the world for the absolute best baker?
No, that's another part of it. We don't scour the world. We started looking much more into our region. We found a guy in Queens who was a potter and said "Okay, we want him to make our plates." We got a glassblower from Brooklyn to blow our glasses. We have metalworkers to do our champagne buckets and our trays. We used local ingredients. It's kind of like the Arts and Crafts movement. People are going back to the handmade and the local.

Local food is one thing that comes up often in my conversation with chefs, food writers, and even friends who cook regularly. It's definitely a trend. But another thing is how chefs age. Many chefs say that as they get older, they return to a kind of simplicity. And it's not just because of cost. It's because they see food as part of their world rather than an opportunity to make high art.
Early on you want to prove yourself. You want to show five techniques in one dish. When you're young, you have to do that, in some ways, to get recognized. I was the youngest chef in Europe to ever receive a Michelin star. I was twenty-four. The only reason that was possible is that I was showing everything I learned. But when I look at the food today it wasn't confident.

What's one outdated technique from back then? Is it like musicians hearing albums they made in the eighties and wincing at the drum sound, which was full of gated reverb?
I think we used foams too often. It was because the food world was going away from the heavy and thick French sauces. Suddenly, you were able to do these froths. Today there are still moments when we use it. It was so groundbreaking. Today, we still use foams, but much more sparingly. It's not the beginning of that trend. The energy is gone from it.

I gotta bring it back to Miles. He was very influenced by the composer and music theorist Karlheinz Stockhausen, of course, who thought about how time passes in music, and how it's controlled by repetition and tempo.[4]
That's true even for each meal. Think about how long courses last. It's not just what's on the plate but also the type of experience people want. Maybe forty years ago, we were at the absolute height of very long meals—everything was small

bites, and the experience was very long, twenty or thirty courses. When we did that ten years ago, it was considered innovative. We were one of the very few in the world who would have these meals. Now everyone is doing it. Little restaurants in Brooklyn have three-hour tasting menus. So now it's time to go back to something else, to manage time differently.

Are younger people today more educated about food? Younger music fans are. Because of the Internet, because of apps, they have access to so much music. I feel like nowadays, I talk to young people and the same kids that were turning me on to what CDs to buy fifteen years ago are telling me what food spots to go to.
It's really a special time to have a restaurant and be a chef. When you look into a dining room, you have these hipsters from Brooklyn alongside people from the Upper East Side. People are aware of food and they really know about it as culture. We're definitely very fortunate.

What about the way that technology has changed the dining experience review? I always think about how direct feedback like Yelp would affect me in how I do musical performances. If people complained about the line to get in, or that the beer was $15, or the band played ten minutes short, there's a danger that I'd try to appease everyone.
I don't know if other chefs agree with me, but I love reading TripAdvisor. I feel they are very honest reviews. They are anonymous and they are the experiences of people who are just people. I don't cook just for people who know food. I cook for everyone. I want everyone to enjoy this food. I want it to be delicious whether or not you are a professional. I'm not against the democracy of these reviews. But there are other problems with technology.

Like what?
It rushes people more quickly toward thinking it's their moment to create. It took us a long time to arrive at a restaurant where we have no menu, where you sit down and it's an experience. We would have never just opened and said "Here's a four-hour meal and you're going to eat what

4 —
Check out "Structure and Experiential Time," an essay he published in 1958 about Anton Webern. Maybe you'll understand it fully right away. If not, chew on ideas like this: "If we realize, at the end of a piece of music . . . that we have 'lost all sense of time,' then we have in fact been experiencing time most strongly."

we have." Over time, by paying attention, we felt our guests saying we want you to do it for us. The problem now is that you go to these little restaurants, and there's a chef who is twenty-four, and he's staging one of these big meals. They don't have the skills but they do these meals and it's treacherous.

Do you go to restaurants where young chefs are putting on these virtuosic displays?
I can't do that. I love these experiences when they are well thought out. I think it's the highest form of art, like the best Broadway show. If everything is really right it's unbelievable. But when it's more about the chef establishing ego then it's not the place I want to go.

It's a cliché of music that the record business is about both art and money. There are records, and then there's the business of records. With food, this might be even more true. The cost of entry into the restaurant world, especially at the high level, is high. And then you have to run it as well as you can. In some cases, you have to operate as a restaurateur as well as you cook as a chef.
Right. This is that "collaboration" keyword that also came from the Miles Davis master list. Almost ten years ago, when I started as the chef at Eleven Madison Park, I set the menu. Here are the recipes. This is how I want them to be served. That's how we operated. Maintaining that kind of control is what I learned from chefs before. But when we put the Miles Davis list together and saw the word, I knew that we had to change. We have 150 employees from all over the world, so what makes me think that I know everything? We shifted the process. We started having a group of eight chefs who are part of a team, and they help create the food. And then there are strategic meetings with our entire staff where we encourage everyone to be creative and to contribute. When we listen to what people say at those meetings, the ideas are unbelievable.

I have thought sometimes that the ideal thing to do for food would be to Warhol it—to bring together all these creative people and pair some of them off and set some limits and see what emerged. A Factory for food, but not the Cheesecake Factory.
To be like an editor? That's sort of how I feel these days, that I'm more like an editor.

And you've even said co-editor, right? You have spoken often about your relationship with Will. Will has, too—in one interview, he said that the two of you refuse to leave the restaurant angry. That's something I know well from the Roots, from my partnership with Tarik, or with Rich Nichols. Ideas happen between people, in small groups of people, no matter how much the outside world likes to pretend that there's one creative person shining out like a beacon.
This restaurant wouldn't exist without that partnership. We are two of the most passionate people and we feel so strongly about everything, though we don't always see things the same way. The necessary skill, then, is trust. He has to trust that the kitchen is doing the best things they can and the fastest they can and I have to trust that it gets delivered to diners in the best way. But within that trust, there's plenty of challenge. If he feels something could be done better, he will say it. Or I will say it to him. It's never a dull moment.

That's what the Roots can feel like at times— it's such second nature to turn to one side and say something, and expect a response back. It's not always a polite response, but who wants politeness in that way? It's always a committed response. It's like someone you've been to war with.
I feel lucky because we have grown to a certain comfort level. But there was a critical time where we barely made it. We weren't known. We operated this really expensive restaurant. We had a hundred people on payroll and all these incredibly costly ingredients. That was just really tough. Then the *New York Times* reviewed us, and it was a big moment. They gave us four stars and everything changed. Now we have three Michelin stars and we're number four in the world. We're always full and we can charge what we need to charge. That momentum enables us to do what we want, which isn't the case at many restaurants. I have a team of three people who only work creatively. They are totally separate from daily operations.[5]

— 5
I'm starting to like looking up food reviews almost as much as I liked reading record reviews. There's something kind of thrilling about it—here I am, talking to all these chefs further on down the road of their career, and then I'm returning to the site of the triumph or sometimes the defeat that helped shape them. This review was in 2009, by Frank Bruni, and it starts with a few paragraphs of thinking about the way that excellence doesn't appear or disappear, but instead sticks around. Great restaurants like Jean-Georges or Per Se, he says, don't change much. They have a certain magic but no sense of discovery. And then he moves to Eleven Madison Park: "That's why my visits to Eleven Madison Park over the last five years have, in arc and aggregate, given me such particular joy. I watched a distinguished restaurant get better, even though it already seemed popular enough to survive just the way it was. Then I watched an improved, excellent restaurant, which I elevated to three stars from two in early 2007, make yet another unnecessary advance."

Other chefs have talked about the pursuit of the ultimate ingredient. Is that a kind of mythological idea? Are you always looking for the perfect fish or the perfect mushroom or the perfect chicken?
In a way, yes. I want the food to be so simple that it's almost shockingly simple. It has to come from multiple techniques per plate to two, but executed with the best ingredients to the point where people go a little slack-jawed. But this is the hardest thing to do because you need ingredients of unbelievable quality. When people take that first bite, that shock of being so simple needs to go away and be replaced by something that's so delicious. But there's no room for error, absolutely none. You have to justify the price point. You have to justify the simple presentation.

Eleven Madison will change, as you say. But the overall food world will change, too. What do you think will be the biggest difference between the food world now and the food world in a decade?
I think there will be a widening of the gap. At the high end, restaurants are going to become more expensive. People who eat at places like that are going to have to be willing to pay more for meat and for seafood. And the lower end will expand, too, because it's cheap. At the same time, I think vegetables will come to play a

bigger role. There just aren't enough resources to keep going at this rate that we're going. Whatever the changes, I really hope that food can become much healthier without becoming more expensive. There are chains like Chipotle who do a good job at turning this conversation. And they are big enough to affect how things are grown and raised.

I think about that with the biggest pop labels and pop artists. Like when Taylor Swift took a stand against Spotify. Whether you agree with her or disagree with her, she's a huge brand who can actually move the needle when it comes to changing how things are done. With many other artists, they're speaking to a smaller population of people who are already seeing things their way.
There's no way around it. What we do as chefs touches less than a percent of the population. And so we have to think about everything else. That's where the change is going to come from. Can you really change the world with a fine-dining restaurant? No way. What we have is kind of like this protected fantasyland: the time we have to acquire ingredients, the fact that we can buy the very best. From within those limits, I hope that I can somehow change other parts of the world, but I'm aware that those limits exist. As I look toward the future in my own career, I think about what lies beyond the world of fine dining. Chefs often think about that: how we can use our passion and our expertise to make a broader difference. I don't think one should be without the other, and I think I'll always be connected to fine dining in some way, but I certainly want to contribute in other ways to the world of food.

(left) Sketches of Miles:
a Miles Davis drawing,
a gift to Daniel from Will

(right) A page from Daniel's
sketchbook, menu planning

(following spread)
Daniel's grandfather's
watch, tuna bone

➤ Colrabi

▱ sweet potato puree

⬤ glazed Musarov Fig

◢ wilted spinach

(previous spread) Oscar of
the Waldorf with celery root

(left) "Bon Appétit,"
Paul Bocuse, 2013

(above) Pig bladder; carrot
(before becoming tartare)
from Paffenroth Gardens
in New York's Hudson Valley

(above) Chefs making
the tomatoes nice

(right) Make It Nice

(following spread)
Butchered sunflower,
ready for braising with
green tomato and
sunflower sprouts

(pages 52–53)
Muscovy duck, cherries,
apricot, strawberries

Daniel Humm

Eleven Madison Park

1 **Cheddar**
Savory Black-and-White
Cookie with Apple

2 **Tuna**
Marinated with Cucumber

3 **Eggplant**
Slow Cooked with
Shelling Beans and Mint

4 **Squid**
Poached with Peppers
and Artichoke

5 **Tomato**
Salad with Basil and
Red Onion

6 **Caviar**
Benedict with Egg, Corn,
and Ham

7 **Foie Gras**
Marinated with Peaches
and Ginger

8 **Lobster**
Boil with Clams, Shrimp,
and Beans

9 **Sunflower**
Braised with Green Tomato
and Sunflower Sprouts

10 **Duck**
Roasted with Lavender,
Honey, Apricots, and Fennel

11 **Farmer's Cheese**
Sundae with Honey, Cherry,
Sorrel, and Oats

12 **Whey**
Sorbet with Caramelized
Milk and Yogurt

13 **Berry**
Cheesecake with White
Currant Sorbet and
Raspberry Vinegar

14 **Chocolate**
"Name That Milk"
Pretzel with Sea Salt

14 —

12 —

9 —

2 —

5 —

7 —

6 —

14 —

1 —

8 —

10 —

3 —

11 —

13 —

4 —

Six of one, half dozen of another: (from right to left) Danielle Snyder, Lela Rose, Janina Gavankar, Questlove, Jodi Snyder, Wangechi Mutu

"I think becoming obsessed over control, especially in the restaurant world, is insane."

Michael Solomonov
Philadelphia

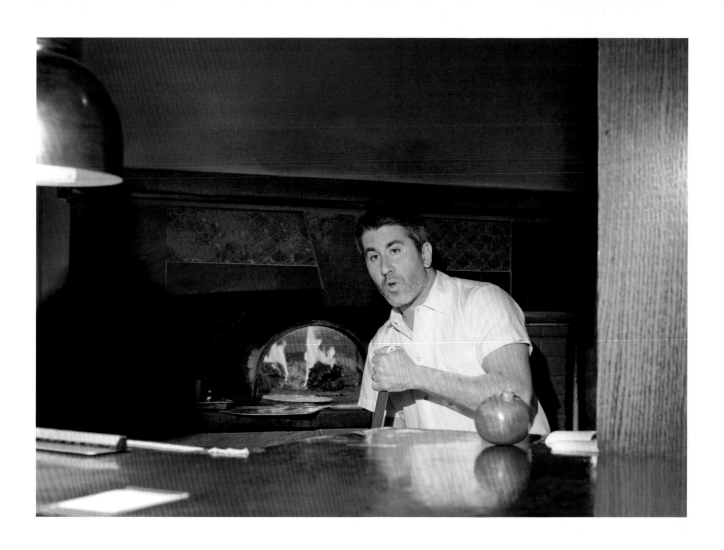

Now that I live in New York, I tell people that Philly is my second home, but really it's my first home. I was born there. I was raised there. I went to school there. My father was also from there, and he headed up a vocal group in the fifties, Lee Andrew and the Hearts, that was at the center of the city's doo-wop scene. Any job I have that brings me back to Philly puts me in a better mood. And so, that's where I went right after New York, and even though it was a cloudy day when I got to talking to Michael Solomonov, the skies felt brighter. The city seemed like it was in good spirits, maybe because the Eagles were making lots of moves. (That mattered to me, but not the way it once did. I hadn't been right with the team for years, ever since I got pulled over and the policeman said I looked like one of the Eagles. I went to strange places in my brain: Don Henley, Glenn Frey. It was one of those nights.)

Daniel Humm, who I spoke to in New York, was born in Switzerland, and used the long history of fine Continental dining as a foundation for his experiments at Eleven Madison Park. Michael Solomonov is the product of another culture combination. Michael was born in Israel but raised in Pittsburgh. Throughout his childhood, he bounced between the two cultures, which gave him a kind of productive whiplash. He didn't see either one as the only answer, and he didn't see the combination as complete unless and until it absorbed elements of both. The restaurants he ended up starting, cooking at, or both, do amazing things with this bicultural perspective. They remake Israeli food for America, and remake America's idea of Israel in the process. One thing I also learned from Michael was that inspiration can originate in cultural affinity but also in profound personal trauma. His younger brother was killed during his time in the Israeli army, and Michael's maturity as a chef and restaurateur was shaped by this experience. He wanted to do amazing things with Israeli food to honor his brother, but also to think hard about the different risks and rewards associated with cultural identity. What does it mean to be part of a culture? How far will you go in that direction? Does it preserve and protect you or expose and jeopardize you?

Philadelphia is a perfect place to explore those questions of culture and change. The city has gone through it all. Before I was born, my neighborhood was kind of the cultural epicenter of West Philadelphia. It was integrated and diverse. Then white flight happened and most of the people who ran restaurants went to the city. At that point, mostly what we had was soul food: Big George's, Broadway, those kinds of places. In the seventies, whenever there were music luminaries, they'd go there. Teddy Pendergrass, the Philly International people. There were some high-end places, too, like Pagano's, where I discovered my obsession with chicken Parmesan, but it wasn't the most diverse.

Now flash-forward to Michael's current life as a restaurateur. He runs Zahav, which serves traditional Israeli food remade for the modern world. He has Percy Street Barbecue, which serves what it says it serves. He has Dizengoff, a hummusiya (that's an Israeli place that serves hummus, if the name didn't tip you off). He has Abe Fisher, which reimagines foods popular in Jewish culture around the world. And then there's Federal Donuts, which strips it all down to donuts and fried chicken. Whew. That's five restaurants. You could work up an appetite just listing them all. (Maybe that's Michael's plan.) The range of restaurants he has is a microcosm of what's happened to Philadelphia as it's reclaimed its own multifaceted identity. And so I went from New York to Philly, from Humm to hummus, to talk to Michael.

This book is about innovation and the creative impulse in food. So I wanted to ask you this: if you weren't working in the food world, but you were still a creative artist, what would you be?
It's a complicated question, because the answer has changed over the years. If you had asked me when I just started out, I would have said photography. That was what I thought my career was going to be. I liked looking at things and gaining some kind of perspective on them. Now, after cooking for years, I'd say musician.

I endorse that choice. Every time I eat at Zahav, I love the music you play. It's what I would pick. What makes you think about music when you're cooking?
As a cook, there's something personal and primal about the physical act of putting food together. Now that I'm a parent, I see it every day. I see how important it is as a form of sustenance for kids, but also a source of pleasure. That's what I think of when I think of music. I guess I mean live music, mostly—a musician in front of a crowd playing something pleasing and with immediate impact. Music happens pretty quick, maybe a few notes, maybe a repeated riff, and then it's gone. That's what food can be like.

That's something that occurs to me all the time when I'm playing versus when I'm DJing. When I'm a DJ, even though my performance, my set, doesn't usually last, I'm using sounds that have been preserved and recorded. They're on vinyl, or more recently in a computer file. But they're somewhere. When I'm drumming with the Roots, whether it's our show or we're backing up another act, it happens and then it unhappens.[1]
I also think of the way a chef works in a restaurant, and how that's really like being part of a larger band. You have to choreograph and take cues from one another. There's a delicate harmony between the kitchen and the front of the house. You're working in concert.

And yet, before a chef or a musician plays as part of a larger project, there's that first spark of interest in making things. I'm trying to ask this next question to every chef, since I think all the time about the restaurants I went to growing up, and how they shaped how I think about food. What's the first restaurant you remember going to?
The first restaurant I remember going to is probably a Wendy's in Pittsburgh, where I grew up. I was all about the Jr. Bacon Cheeseburger,[2] plain. I would get two of those. A little later on, I remember going to ethnic places in Israel, so I had a sense that there were different kinds of food fairly early on—that people were making choices about what to serve and how to serve it.

How does a future cook figure out that food can mean something more than just a Jr. Bacon Cheeseburger on a plate? I'm not saying that there's anything the matter with a bacon cheeseburger, senior or junior. It's a fine family, the Bacon Cheeseburgers. I just wonder how you made that jump. I grew up with a dad who was already a professional musician, so I knew that there was a connection between the things I heard on the radio, no matter how artificial or plastic, and the process of making what people might consider art.
Well, both of my parents were very good cooks. My mom would do lots of stuff in the house, for the family, and had a pretty eclectic range. And my dad was also good, if a little Neanderthalic. Is that a word? He would make giant caveman omelets or lamb chops for a hundred people. It was like he was feeding a tribe. And then the subway.

The subway? What do you mean? He had some kind of snack bar on the subway platform?
No, no. Subway: the restaurant chain. My dad opened Subways in Israel, back in the late eighties and nineties, before the second intifada. I worked there when I was a teenager. Fast food in Israel is strange—maybe not quite as strange as in India, but you're still dealing with dietary restrictions. The Subway King over there, the regional executive in charge of setting rules for franchisees, deemed that all the restaurants had to be kosher. So that does strange things to the sandwiches. It takes something that's not so great in the first place and hamstrings it further.

—— 1
Concerts can be preserved, of course, but I was talking about the kind that aren't, which are purely ephemeral except for in the mind of the listener. It's sort of hard to imagine that now because everyone has recording devices, but think of all the performances that no one heard except the people who were there.

—— 2
One of my favorite abbreviations comes from the Wendy's website, where they call the Jr. Bacon Cheeseburger the "JBC," which sounds like a professional organization. I'm not sure why I was on the Wendy's website. Research?

**Did that teach you about creative limits?
I mean, when you work with narrow rules,
sometimes that inspires you. Like when it's
2 a.m. and you have only eggs, pickles, milk,
Brussels sprouts in your fridge and some
canned goods in your pantry but you still
have to make something delicious happen.
Musicians do that all the time: you have to
make a song at this tempo, or this length,
or with only these instruments.**

Maybe way back in the corners of my mind that
taught me something about how to salvage
inspiration from restrictions, but I don't think
that was part of my experience at the time. That
wasn't a creative time. It wasn't even primarily
food-related, really. It was more about watching
my dad work his ass off, and knowing that
I wasn't quite living up to his work ethic. I was
a very young teenager. I started working when
I was fourteen, which meant that I needed to get
a special work permit. I was a shitty employee.
He told me that had I not been his son he
would have fired me. But watching him build
his business from nothing into something was
cool. That stuck with me.

**I worked in a fast-food place once. I lasted
about four months. What I remember mostly
is that it was the year that Public Enemy's _It
Takes a Nation of Millions to Hold Us Back_
came out. It was a Tuesday in May and on the
way to work, I was listening to the cassette.[3]
It had an immediate effect on me. I was
feeling different. I was walking and thinking
differently. It was like I was filled with power.
I was a fry cook and they didn't let me listen
to music, but I kept sneaking into the freezer
and listening to the record. I told my manager
that I was going on lunch break and I left and
I never went back.**

There's one food-related memory I have of that
time. We would get these frozen logs of bread
dough that we would bake out in the customer
area. That was part of the Subway setup, the fact
that there's always fresh bread, and the impact
was pretty great. You're getting the illusion
of freshness. That idea was ahead of its time,
I think—not to push all the kitchen business
entirely into the back, but to take an aspect of
it and aggressively make it part of the dining
experience. I don't know about the rest of it.
We'd also get frozen logs of cookie dough, and
we'd stuff pot into them and bake them. The
store would stink something awful.

**Let's talk about Israel. If there's been one main
idea in your restaurant career, it's been to bring
Israeli cuisine to America.**

As I said, I grew up participating in both cultures.
But there's something even more important. My
brother David was in the Israeli army, and he
died in 2003. At the time, I was cooking at Vetri,
an Italian place here in Philadelphia. In the wake
of David's death, obviously, everything changed.
Food was a way to identify with Israel, and to
identify with him. It happened organically.
I was working at an Italian restaurant and had
cooked French. The first shot I had to write my
own menu, Israeli food just sort of happened. As
I went on, though, I found that I was interested
not just in the food, but in the eating.

**Well, food without eating is just sculpture.
I'm trying to do a Goethe move that coins a
phrase that ends up in the company of this
famous quote: "Music is liquid architecture;
architecture is frozen music." I'm not sure that
I have succeeded.**

Food in Israel is very much about how it's
distributed through society, and what that
means about the people who are eating it. I
remember clearly the moment that I realized
there was something different about food in
Israel. On the Sabbath, no matter how religious
you are, everyone sits down together to eat.
It's not a "Kumbaya" moment. It's not Jewish
observance in any formal sense. It's cultural
and there's a spiritual dimension also. It breaks
all generational stereotypes. Everybody goes
to somebody else's house and eats. Because
there are so many different cultures that make
up Israeli culture, you're eating things that
have been brought from many different places.
We don't get that here in the States as much
as we should. We have many options, but
they're all compartmentalized and segregated.
I would never go to a friend's house with
their grandparent and their kids and another
random friend.

**I'm just scanning your menu now: duck hearts,
Yemenite beef stew, your twist on konafi,
which is a phyllo dough dessert. You stuff it
with mascarpone cheese and put kumquat
syrup over it. Your idea of Israeli food might
surprise people.**

It surprised me. Before I went to Israel, I had
a certain idea of what their food was. It wasn't
what a typical outsider would think: falafel and

3 ——
Research can help you or
it can hurt you. In this case
research has revealed that
it was a Tuesday in June. So
why do I have such a vivid
memory of May? *Coming to
America,* the Eddie Murphy
movie, came out the same
week as the album, if you
believe the facts, but in my
mind they're separated by
about a month. I guess my
mind is playing tricks on me.
That, by the way, came out in
July of 1991. I'm sure of it.

hummus. My idea of Israel wasn't necessarily Middle Eastern. My grandmother was from Bulgaria but before that Spain: my heritage was Sephardic and then Balkan, so I had different food in mind, whether savory pastries or schnitzel. That's where I started, and as I spent more time learning about the culture, I picked up on Moroccan influences, or Egyptian, or Yemeni.

Okay. Let's play a game. You get to start a city.
I do?

Yes.[4] You get to invent one and design it however you want. How would food work in that city, and how would it be different from cities you see in modern-day America?
Everyone being able to shop in the same place is huge. I love the idea of communal ovens. There are lots of places in the world where people go to bake their bread. I think it's quite spiritual. People would eat less meat if they saw it being slaughtered. They would also throw out less. Shopping for food is pretty obvious. Do it collectively.

Funny you should say that, because the idea of doing things collectively clashes with another main idea in your life, which is that you're the central creative person with this vision that guides a restaurant. There's that same tension in bands: everyone plays, and everyone is necessary, but who is the bandleader? Does that desire to see food as a communal experience conflict with the control that you want, or even need, as a chef?
I think becoming obsessed over control, especially in the restaurant world, is insane. You have very little control over what's happening, especially over the customers. People can order what they want. What they get is something different. You can send a dish out to a table with an idea. How that idea is received is something different.

So would your utopia give diners in restaurants more control?
In my utopia, oddly, there are no restaurants. Or maybe there would be but they would be based on an honor system. Maybe there would be no money.

I'm coming to your utopia. I'm making a reservation.
There would be no reservations either.

How do you think of new dishes? Does it start with the menu? I have this fantasy that a menu is like a DJ's set list, that you write out all the songs—ingredients—and then organize them for maximum impact.
There's something intellectual and conceptual about a menu and then there's something visceral. I have a hard time sitting down and writing a menu on a piece of paper, like I'm writing a report. Usually I start and stop, or start and stall. What I need is some kind of aha! moment, and that rarely comes when I'm in front of that piece of paper. Usually what triggers it is taking a walk or reading a book or going to a concert.

And that's when the idea happens?
There's this dish that I have done: sweetbreads wrapped with chicken skin and seared and served with a little bit of tahini sauce and sumac. That came to me in an odd way. I was at a concert at the Kimmel Center listening to classical music. That's me, classical music: I was wearing a top hat. Anyway, during the performance, my mind drifted, for some reason, to sweetbreads. I hadn't been thinking about them but something about the music put them in my mind. I started thinking about their relationship to Chicken McNuggets. That's why people like sweetbreads, right? They taste like chicken nuggets and they can get caramelized quickly.

I experienced that just the other day, the strange ideas we have when we're in audiences. It's a Zen state. I recently posted a thing on Instagram about using Red Vines as straws at the movies. It's not a world-changing idea, and yet it is.[5]
Right. So there I was, listening to music, and the piece was still going and my mind was still wandering. What's the best part of chicken? That's easy: the skin. So maybe wrap the sweetbreads with the skin. But would they hold? There's a chemical used in cooking called transglutaminase, or meat glue. It's a protein binder. So why not adhere the skin to the sweetbread after putting the sweetbreads in chicken fat? You'd end up with a dish that

——— 4
He doesn't.

——— 5
Mentioning food brands on social media is a strange phenomenon in modern entertainment life. Sometimes I'll mention foods I like, crackers or cereal, and cases of them will just show up. In one case, I mentioned a type of cracker—I won't say which one, but it's a popular cracker that's been around for a while. They had a new flavor I loved. I said so and a bunch of boxes showed up, which was nice. Weirdly, they came with an adult-size onesie decorated with the logo of the cracker. I was not sure what to do with that. I am still not sure. https://insta-gram.com/p/zf9AeXwaw2.

tastes like barbecue chicken that you have at a beach, and you could add sauce to make it sour or lemony. My attention returned to the concert, but the whole idea had unfurled in my mind.

How do you know if a diner is getting the right things from a dish? I can watch a crowd, or hear applause ebb and flow. I can experiment on-site. You have to just send it out there and see what happens.
Right, and as a chef, most people don't tell you if your dish sucks. There's not a whole lot of booing in restaurants. So you serve it to people and literally watch them eat it. You tell your servers to pay attention to reactions. You see if plates come back full or empty. Sometimes I wish there was something more concrete.

So much of creativity is trying new things. What's an example of an idea that didn't work?
There's a dish I made at Marigold Kitchen, which used to be the Marigold Tea Room until Steve Cook took it over. It was a soup, a coconut and lobster bisque. My idea was to take a coconut panna cotta with poached meat and roe, set with gelatin. I thought it would be almost like an ice cube. You would pour the hot soup tableside and the panna cotta would melt and then everyone would think it was the best in the world. But something else happened: everyone got lukewarm soup. When they talk about trial and error in innovation, there's a reason they include the error part.

About three years ago I went through this evolution in my DJ life. For a while, I was always using my DJ sets to introduce crowds to new music. It was educational for them and I didn't like including music that I didn't like. Songs that weren't part of my palate didn't make it onto the set. Is it the same with chefs? Will you make dishes with foods you hate?
I have a healthy fear of mayonnaise. I don't know if there's a word for it. *Mayonnaiseophobia*?[6] That doesn't mean that it's completely forbidden in food. I have exceptions: if it's aioli and it's French fries, if it's on a BLT and there's not an excessive amount. But I think this is left over from Subway, when I would have to mix up the tuna fish wearing rubber gloves up to my elbows, hung over. Even talking about it I'm sweating a little.

Musicians practice their whole lives to make playing second nature. Most musicians, I should say. Every once in a while you meet the kind of player who keeps challenging himself not in the sense that he is trying to make the most beautiful song on the guitar that he already knows how to play, but in the sense that he's learning the rebab or bouzouki. Are you continually trying to pick up new tricks and techniques?**
I think I have passed that point, in a strange way. I think I'm trying to refine my technique, which sometimes means forgetting tricks. The older I get the less fussy I get. I tend to oversimplify, in part because I find that people respond to simple combinations and simple presentations, and in part because I become too cynical—too invested in a way, too guarded in a way—if a preparation is too complicated. Chefs can sometimes be very smart people, but overintellectualizing things can get a little ridiculous when we're talking about the most subjective art form in the world. And at the end of the day, I hate saying this and I hate hearing this, but I also believe it: it's just food. Our primary purpose is to feed people.

We've talked about inventing a dish. Now let's talk about inventing a restaurant. How do you take various ideas and put them together into a package? Is it like a concept album? That's a little bit of an inside joke: as the Roots got older, people started to say that we were making concept albums.[7] I think what they meant was that the album tried to collect a somewhat unified series of thoughts. Our manager Richard Nichols, who passed away last year, used to joke that he didn't know the alternative. Is a restaurant a concept album?
It's as useful and as pointless a way of talking about it as it is for albums: it's true in a sense, but so what? Zahav came out of a question from my business partner, who was curious why there aren't any Israeli restaurants here, especially ones that showcase vegetables. We opened a barbecue restaurant because nobody was really doing that and we grew up eating Jewish brisket and the economy sucked and we figured we'd have an inexpensive and easy food to make. Both those things are false, as it turned out, and we underestimated how weird people are about their barbecue. It took a long time for us to figure out how to execute it. We opened

6 ——
There is no specific word for the fear of mayonnaise. It's classed as one example of a fear of food, or cibophobia. I am going to pretend that I knew this before I looked it up on the Internet. This footnote is the only place I will ever admit that I didn't already possess this knowledge.

7 ——
They said it about *undun*: "a concept album following the troubled life of Redford Stevens." They said it about *. . . And Then You Shoot Your Cousin*: "a concept album about characters from society's fringe."

Federal Donuts because five of us were sitting around thinking about the size of the places we had opened, and we suddenly felt we needed something smaller. We did that on a whim and it's arguably the most successful place we have.

But a restaurant isn't just food. It's how the spot looks and how the menu is printed and the clothes people wear. We experience the full brunt of that in every record. And it's the music. For you, I mean, not just for us. You have lots of hip-hop playing in your restaurants, and primarily tracks from the late eighties and early nineties. Is that a philosophical choice? What do you want people to think about when they hear it?
It's mostly for me to help set a tone, but I want customers to pick up that energy. It's okay that when you come here, you're not wearing a suit. It's okay to relax. This is the kind of place where we want you to be bobbing your head.

Bobbing your head while eating konafi. I can dig it. When you start making things, whether it's music or food, so much of the energy comes from wanting to make your mark. You want people to know you have ideas. As you get older, certain ideas become more important to you. Certain ideas become less important. You're trying to hold on to whatever reputation you've built, and risk just enough to get new fans while not losing a majority of the old ones. I know the rhythm we have in the Roots: one album we're jazzy hip-hop, then there's a move toward a kind of gangster feel, then there's neo-soul and explicit social consciousness. How do you balance new ideas with protecting what you've already achieved?
My thinking on that has evolved greatly. I have kids now and I didn't have kids before. That's a major change that forces ideas to do a kind of double duty—on the one hand, I want my kids to see what it's like to be creative, though also ideas have to work more often than not because I want my family to be secure. It's very different than it used to be, when I was a young, work-addicted, narcissistic chef. As an older, more experienced chef, I have to be careful about innovation—or, at least, careful about letting innovation run wild and take you heedlessly past all the other requirements of a good restaurant. Innovation isn't just about putting your ideas first. I think about when I was starting Zahav. The birth of this restaurant that was so dear to me, that

represented a certain memory of my brother, coincided exactly with the economic crash in 2008. Add that to the fact that I was just getting through a period of drug addiction—at the time the restaurant opened, I was fifty days clean and sober. Had I only listened to myself, had I created and executed the restaurant plan only inside my own head, I would have failed. I would have relapsed, the restaurant would have crashed, and whatever memory I was trying to honor would instead have been destroyed. But I was smart enough, or helpless enough, to listen to others. I had so many people in my corner, and I needed all of them.

I was talking to someone recently and they asked me what I would invent to make my life as a musician easier. I don't remember what I answered, but it wasn't a good answer. So I am passing that question on to you. What would you invent to make a chef's life easier?
One of the things that makes Zahav stand out is that we cook all our meat and fish over charcoal. It's really rudimentary but also the best way to cook. The flavor is amazing and in this era of innovation it brings people back to flavor. It's a fucking pain in the ass. Stoking charcoal. It has to breathe, it has to burn, and then you have to remove the old embers or the ash. There's no way to rotate the charcoal. There's no conveyor charcoal. You have to get in there with a metal ice scoop in the middle of service and pick out ash. So I think I would invent a conveyor system with a fan and a bunch of robots.

You've been doing this for a decade or so. What do you think will be the biggest change in the coming decade in how food is grown, prepared, and served?
I think people are getting really good about produce in strange places. Agricultural things like urban farming in urban environments, like old factories and hydroponics. I think we're going to have lots of ecological limitations. I think we have a huge issue: fish that are getting farmed out. Meat is reliant on things like wheat and corn. Land is disappearing. And the population is only increasing. That's a problem. The only way for us to continue is to get creative. I think there's a larger divide between the upper and lower classes and the middle class, and that's going to really create options.

Do you think genetically modified food is the devil?

I think that there's a huge demand for food, all over the world. I understand mass production and commercial growing. On the one hand it can only be bad in the long term. When you start genetically modifying food there are health implications. The problem is that when you're living in a Third World country it doesn't matter. You just need to feed your children. As a chef I do not like it. We're going to pay tenfold. On the other hand, who the fuck am I to judge other people for that kind of thing? It's all economics and supply and demand.

But restaurants have to grapple with larger green issues, right? When you're making something that requires lots of energy to create—not in the kitchen, but before it even gets there—and something that produces lots of waste, do you have to be aware of those kinds of pressures?

There are some obvious ways to do it, like recycling. But really, when you think about it, sustainability happens in so many different ways. As a small business owner, I need to keep people employed, and the best way to do that is to be a successful restaurant group and provide a pleasing work environment. The other questions are as much about economics as they are about anything else. I know of restaurants who buy only fancy organic products, because they believe that's the way to save the environment. I don't know about that. Say there's a place in California with the best organic butter. Am I alienating better butter producers here in Pennsylvania? Am I burning fuel to go get it? And in the end, the most important thing is that I make the best choices for my cooking: that I end up cooking the most delicious food at the most reasonable price point. We don't want a smaller target market. We don't want only the people who make more than $200,000 a year. That kind of exclusivity makes your restaurant irrelevant, fast.

8 ——
It's in so many movies, from *Silent Running* to *2001: A Space Odyssey*. My favorite example is from *The Fifth Element*, where Milla Jovovich's character puts some pills into a little oven and they grow into a whole chicken.

This is sort of what I was saying before about absorbing pop music into my DJ sets. I can't DJ with only DJ ears. I have to start to recognize that the average listener has different preferences and maybe different needs. Do chefs eat differently from regular people?

It's not just chefs. Americans do. We're dealing with a small, relatively privileged slice of the world. There are countries that don't have enough water, or no education. Our generation likes to grapple with these privileged questions, like whether or not you immunize your kids. The food world can feel indulgent, definitely. I've benefited from people's interest in food, from the rise of food in pop culture. I'd be a fool to criticize that. Whatever it is that draws people has allowed me to do what I want to do. On the other hand, cost has gone up, resources are more expensive, and there's more competition.

Musicians have that, too. You're always spurring someone else on, measuring someone else's ideas. But there's also the sense that there are maybe limited audience resources. People can only hear so much. So you want to compete for the best ideas but also not forget that you're in a kind of marketplace.

Right. That's when you start to see this increasing critical culture, too. Chefs, and maybe some diners, get upset about how critical people are when they think about food. But that's proof of how interested they are.

The future's a strange place. I mean in movies. And it's especially strange with food. When they do meals in sci-fi, it's often that cliché: the nutrition pill.[8] Unless it's *Soylent Green*, in which case it's people. What do those sci-fi portrayals get right and wrong?

I remember reading a short story in high school, before I was even into food. The narrator was a high school girl and she went with her father to go to a nature preserve where you could fish and eat the fish that you caught. All their other food came to them in the form of bricks, and the fish pond was like a nostalgic part of society, like Colonial Williamsburg. The major issue, especially if things get catastrophic, is that the way that you preserve culture is around food. How do you recover your culture? How do you continue to be human? How relevant is anything else if there's no adherence to food culture?

Are there innovators or forward-looking thinkers in Philly that you want to throw some credit toward?

The Workshop School in West Philadelphia is the coolest thing in the world. Simon Hauger, the principal there, hooked me up with the students, who are these incredibly smart kids who are, among other things, competing for the X Prize, which is the automotive contest where people try to build vehicles that get the most miles per gallon. The Workshop School recycles all of our oil from Federal Donuts. They came in something like second in the whole world.

We've talked about creation. When I was a kid, I would write my own record reviews, and I kept doing that when the Roots became more famous. I would imagine what *Rolling Stone* would say about our album: how many stars, what people might object to, what would go over their heads. But back then, there were two or three main critical authorities and then lots of people talking in the schoolyard. Now, everyone's a critic, and the location of critical authority has shifted. It's everywhere and nowhere. This is especially true about the food world.

Over the years I have accepted that this is the way people get information and make comments. We give plenty of opportunity in our restaurants for people to make complaints. And many of them are warranted: we make plenty of mistakes. What bothers me about the Internet is that it doesn't give us a chance to address those errors then and there. Bad reviews are what they are. They're unavoidable. You might just not connect with a diner. As a chef or a restaurateur, you just have to deal with them. But people are less comfortable with voicing complaints directly. They don't like confronting. It would be so much easier. I don't mind bad reviews online. We just don't want that contract to be misunderstood. We want to provide the diner with a good, memorable experience. I want that diner to come to me if it's not happening.

There's a social contract.

Right. The unspoken promise is that you'll leave here happy. It means very little to us to comp a dish or send out more food. We are happy to do that when there are hurt feelings, and someone vanishes, and they pop up later to complain.

Do you see yourself doing this forever, or will you switch back and be a photographer?

I think I'm in this for the long run. I just know how it makes me feel, and I have seen how it makes others feel. I learned that early on, in an amazing way. Around the time I fell in love with cooking, I was working in a place in Israel along with another line cook. Conditions were brutal—sixteen-hour days, making three bucks an hour, and suffering the khamsin, which is this hot wind that comes roaring in from the desert. The hood didn't work in the restaurant, so there was no ventilation. One day, the cook I was working with sliced his finger open. Not just a little cut, either: blood was spurting. I told him to leave. He didn't leave. Instead, he put a pan on the stove, got it super hot, and cauterized his thumb. He threw the bloody pan out and cooked for six hours. I was appalled by what he did and impressed, and curious. He didn't have a big dramatic explanation. It was simple. "I really like cooking," he said. It was so intense and so insane. It was badass. That hooked me and I have never gotten unhooked.

(previous spread)
Israeli spices

(left) Duck hearts,
pomegranate juice
(no, of course it's not
blood), grill skewer

(right) Duck hearts
swimming in a marinade
of parsley, onion, garlic,
baharat, and canola oil;
pomegranate juice

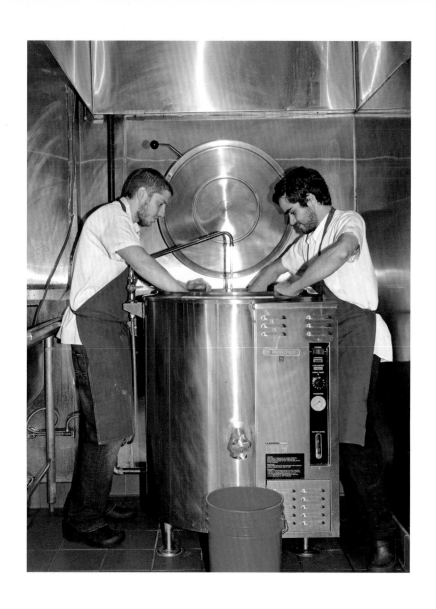

(left) Raw lamb shoulder

(right) An electric kettle as
tall as the chefs working it.
To hear them tell it, it cooks
chickpeas for hummus
like a dream.

(above) Lamb shoulder
with pomegranate

(right) Lamb shoulder
with pomegranate, eaten

(above) Pomegranate spatter

(right) Michael makes the
case for the traditional family
dinner, and then makes the
food for it, too

"Don't show 'em what you got, at least not right away."

Ludo Lefebvre
Los Angeles

When you grow up on the East Coast, the West Coast is a mystery that you try to simplify. At first, what I knew about Los Angeles food was one word: *Roscoe's.* Or maybe it was six words: *Roscoe's House of Chicken and Waffles.* I always knew about Roscoe's via the magazines I read. In a feature about the Gap Band, Charlie Wilson talked about Roscoe's, as did Natalie Cole. Or else it was on TV. When I watched *Soul Train* and the SOS Band was on, Don Cornelius had his moment of chitchat. "Y'all are from Atlanta," he said. "How y'all like it out here in sunny L.A.?" Someone, maybe T. C., said, "We're having a good time. We especially love going to Roscoe's Chicken and Waffles." Redd Foxx would call them out onstage. It became part of his act. As time went on, the legend only increased. Maya Rudolph, whose mother was the singer Minnie Riperton, has a great story about Stevie Wonder kind of stalking her family as he was about to present her mom with the final mix of "Lovin' You." Stevie stopped by Roscoe's first and then parked outside the house and called her from his mobile phone. Stevie had a car phone in 1975. "I've got a bucket of chicken out here," he said. "Come out and listen to the song." The very first time I went to Roscoe's there was right after D'Angelo's Voodoo tour. He and I had the same trainer, Mark Jenkins, who was also working with Angie Martinez, Mary J. Blige, and LL Cool J. I decided I was going to have a cheat day and head over to Roscoe's to eat. I caught LL there as well. We agreed not to say anything. The place was great, but to be honest I was the tiniest bit disappointed. It had been built up so much in myth that the reality left something to be desired.

I bring up Roscoe's because I think of myself as a connoisseur of fried chicken, as does my friend Ludo Lefebvre. Since the early part of the decade, he has built up a group of restaurants, including LudoBird in the Staples Center, serving fried chicken and biscuits and more, and that's where many tourists first encounter him. Others encountered him on television, where he had a show that involved traveling across the United States, cooking in other restaurants' kitchens. Others still have found him at his flagship restaurant, Trois Mec, on North Highland Avenue. When I first went there to eat, I thought someone was punking me. I was in Los Angeles, doing a show, and afterwards I headed over to this restaurant that I had heard so much about. I didn't expect unimaginable levels of glamour. But I did expect a certain look from the outside of the place. And then I turned from Melrose onto Highland and . . . well, to say that it was nondescript is an understatement. It's a place in a strip mall, surrounded by media companies that seem like they haven't been there for long or won't be there for much longer. It looked like a pizza joint. I squinted at the cabdriver. Had he gotten something wrong? He checked the address and I double-checked it.

It looked like a pizza joint, as it turned out, because it had been a pizza joint, a Raffallo's Pizza, the kind of place where the most inventive thing on the menu was the jalapeño pizza. That set my expectations at a modest level. But everything Ludo made, from buckwheat popcorn to chicken wings to carrots (and the dishes have changed each time I've been there), snuck up on me in the best way. This paralleled, in some ways, my experience with Ludo, who believes in a slow build—lots of training, lots of refinement, all before you're allowed to have your own ideas. This is one of the recurrent themes in the book, and Ludo was among the first to articulate it.

Let's start by talking about training. You've spoken to me before about how you had a long apprenticeship as a chef, and how most people should have this same long period where they have to execute other people's ideas rather than think of their own.

When I was training, for those years, I was not able to do my own creative work. I think I was too young. I was learning my job, and I was not ready at fourteen years of age, or twenty, to have what I would think of as my own ideas.

When I speak to students and they ask how to make it as a professional musician, I tell them to practice. I know it sounds like a cliché, but if I didn't say it, it would be a mistake. I remember the years of continuous practice, starting from when I was very young—being in the basement just listening to songs on my headphones and playing them back. And I practice to this day. That gets you your muscle memory. That gets you your foundation. Without that, nothing really happens. You have to do work to get you to the great ideas.

I was a head chef at L'Orangerie when I was twenty-five.[1] At that time, I was in charge, in a way, but I was still focused mainly on perfecting techniques. I learned the process through a one-star rating, through a two-star rating. It probably wasn't until I turned thirty or so that I had enough technique to begin to create my own dishes. And it's not just about food knowledge. It's the whole process. When I was coming up, you had no choice but to work in a restaurant, which meant getting abused, which meant succeeding or failing in real time and real space. It wasn't in a cookbook. Now people say they are chefs at twenty, and I guess that some of them are, but not in the way I remember.

Right. Don't show 'em what you've got, at least not right away. You need time to cook. I don't mean time to cook. I mean time to be cooked until you're finished, to figure out whether what you love is a hobby or a career—and, if it's a career, what kind of career it is. When I was graduating high school, my dad wanted me to be a music director for an established act. He would have been happy if I had called him

from the road, where I was working for Anita Baker or Al Jarreau, and told him how their show went, and where we were headed for the next show. It never occurred to him—and for a while, it didn't even occur to me—that I might be the established act.

Exactly. There are many levels and not everyone can or should reach the level of being at the top of an idea. You want to make good food and please people. You want to have interesting ideas. But at the same time, you have to keep your job. When you are working in a kitchen, and it has a reputation, and there's someone with a reputation in charge, you don't move up automatically or think that you're stepping to the front of the kitchen. There are lots of people waiting for a job. The promotion isn't yours just because you want it to be. Now I feel like all the young chefs learn from books, and then they quickly put out their own cookbooks where they talk about their own ideas and their own creativity. That's not the path for everyone. Some of them should slow the process down and just cook and get better at it.

What was the first major idea about food that you can remember changing your life?

I would say when I worked with Alain Passard at L'Arpège.[2] He was the third chef I studied with, but probably the most influential. I was still young and ready to learn from him. He was all about cooking with simplicity, about learning how to cook with the fire and the flame. It was amazing to work with him. There might be a whole prime rib that he cooked for eight hours slowly on the grill. Everything was cooked whole. I would learn by watching his cooking. It's about the flame. It's about the fire. We need that for cooking, obviously, but it has so much more to it. There are subtle things to know about it. Mr. Passard opened my mind about what is cooking. The sizzling. All this poetry and message. Cooking with my ear. All this new language, new vocabulary I never learned before in the kitchen. That's what he taught me, and it has always stayed with me.

[1] That's one of Los Angeles's premier haute cuisine French places, which was opened by Gerard and Virginie Ferry back in 1978 and closed in 2006 when the Ferrys sold it to Nobu Matsuhisa and Robert De Niro. While I was reading about the restaurant's history, I found an article about a woman who wanted to take her business partner to dinner. The restaurant gave her a white menu without prices, because she was a lady. She sued for $250 in damages based on the idea that they were discriminating against her. That seems like a small suit intended just to make a point. But that's all a little off-topic. The restaurant was a flagship of L.A.'s high-end dining scene. Ludo was there from 1996 to 2002. He succeeded Gilles Epié.

[2] Passard, who was born in 1956, has run L'Arpège since 1986. It used to be called L'Archestrate, but he renamed it for the arpeggio.

Most artists have those moments—not the same ones about fire and flame, but that epiphany that turns their head. I remember when the Roots were in England. Rich Nichols, who was our manager, took me to a club to see this famous DJ named Aba Shanti-I. Aba Shanti-I did things differently from any DJ I had seen up to that point. He used one turntable, which seemed like he was limiting himself, but that just meant that he could concentrate more on sculpting sound. He had an amazing technique, which was to turn down all the levels, lull the crowd, and turn them back up, one by one, to create a frenzy. It opened my mind.

That was what happened with Mr. Passard. The more I worked with him, the more I started to understand how his cooking—and not just his cooking, but any real cooking—was so different from other methods of preparing food. You can make food any number of ways. You can rush something out to a plate. You can get something into a sous vide bag. But that's not cooking the way I learned to think about it.

So that made you feel like you wanted to give people that same experience?
Not at that time. I started early, as a teenager, and in my twenties, I was still a punk in the kitchen. That's not right, really. I was a very good boy in the kitchen. I liked the discipline. But when I think back, it's a little sad because I was not into cooking like now. I still wanted to go out and have fun in my life. I wasn't completely devoted.

Everyone starts as an apprentice. Well, maybe not everyone. There's Athena. But most people don't spring fully grown from a god's head. And so there's always that moment when people move from being apprentices to being artists in their own right. Where did your first spark of inspiration come from? Other chefs have said from books, from movies, from dreams.
It was simple, in a sense. I realized early on that the goal of the chef, at least for me, was to go hunting every day for the best ingredients. That is where you find your inspiration. Whether it's vegetables, meat, or spice, I am always looking for something new, a new kind of food. The food has the innovation in it. When you find a food that's truly new to you, then creativity comes. Even these days, seventy percent of my time is spent finding ingredients that will excite me. That's the language of cooking. When I find a good ingredient, I work on technique and presentation. What makes sense to turn this ingredient into a dish?

What's the ingredient that's obsessing you now?
These days I am heavily into meat and vegetables. I have a wood grill at the restaurant so I use that often—most of the time I just cook everything on the grill, not just the meat but the vegetables. What I like to do is brine the vegetable and then cook it exactly the way we cook meat. It's like treating it with extra respect. All the technique that is usually spent on meat is transferred to the vegetable.

How much is what you make an extension of yourself versus an application of creative principles? When I do DJ sets, people ask me if I am just playing songs I like. I usually say "Yes, of course," but I think it's probably more complicated than I make it out to be. My own preferences matter, but I'm looking at them as part of something larger. How does food work for you in that way? Do you only cook what you like to eat?
I cook food I like to eat, definitely. That's one way to make sure it comes from the heart. But it can come from the heart in different ways. When I was a younger chef, I cooked for ego. Many young chefs do. I cooked more for myself than for the customer. I wanted to surprise people, to play with techniques, to impress. I was thirty years old and I was working for my star. Now that I'm more successful, I am settling into Trois Mec with a different idea. Now I am cooking for people.

When I was young, I was a huge music fan, which also meant that I was a huge reader of music criticism. Now that I'm an artist, I have a more complicated relationship with critics. A good review will get me geeked out. A bad review will get me depressed. That hasn't changed. But I understand more about what happens behind the scenes, about the politics that are at play, about the way that the critic, too, is playing out the same string of ego. Do you care about critics?
Of course I care. Restaurants need critics to be successful. A critic can change your life. If the New York Times comes and gives your restaurant stars, or takes stars away, they can make you or

destroy you. As I get older, I would say that I rely less on what critics say to me—or rather, I would like to say that. I am more comfortable. I am less stressed about critics. I am stronger with my technique. But I still want critics to recognize what I am doing. When I was young, it was that much more difficult.

How you feel about the *New York Times*'s stars is how I feel about *Rolling Stone*'s stars or Pitchfork's decimal-point rating system. It's not easy to forget bad reviews or get past them. I know which of our records were over 80 on Metacritic and which ones were in the mid to low 70s. What's your worst experience with a critic?
It's an especially bad one, and an especially good one, because it's very connected to this idea of innovation. In 2004, I went to Bastide on Melrose Place here in Los Angeles. There had been a chef before me who was fired. I took the job. When I arrived, the owner asked me if I could totally change the style of the restaurant. Before it was a bistro, with very good classic French food. The owner approached me and saw that I was developing my own style. "I want you to try something different here," he said. "I want you to do not crazy food but not boring food. I want more powerful and challenging flavors. I want dishes that are more interesting than just beef bourguignon." I was only thirty, and I was thrilled. It was my time to shine. The *LA Times*, which had loved the restaurant when it opened, came three months after I took over. We were all excited to see what would happen. They destroyed me. They didn't like the mushroom soup. They didn't like the popcorn chicken. The reviewer wrote that after the meal, one of her friends called her to ask her if the meal had been a bad dream. Even worse, it was like I had torn down this temple: it was Bastide, the best restaurant in the city. Before, the restaurant was four stars. They put me down at one star. So that was the cost of innovation. I tried to change the menu. I got killed. It was terrible. I cried a little bit. I'm a human. I'm not ashamed to say that.[3]

Because you had put yourself out there and been pushed back?
And because the attacks were so aggressive. Someone else called me the Freddy Krueger of cooking. The *LA Times* review had a quote from me from when I got there where I said "I'm an artist" that somehow made the situation worse. But it was every kind of lesson. For starters, the owner loved my food, thank God. I rededicated myself to the vision and fought back in the kitchen. It took me two years to recover my reputation. But also I think that the review was so bad that I think most diners didn't believe it. It attracted them so they could find out for themselves. In that way, it was good. If I had gotten a mediocre review, just two stars, I would have been pushed into the dark. This way I was in the light, even though it was in a negative way.

Right. It's better to get a reaction that's black or white than one that's an indistinct shade of gray. What was it they didn't like?
I think it was me. In that way, I think it was honest. My food cost fifty percent more than the food that was there before. I was spending so much in the kitchen in pursuit of my vision. None of the reviews said the food was overcooked or undercooked or of poor quality. They just didn't like the style. Think of painters. Maybe you're not going to like the style of Basquiat. But not everyone was on the same page. The critic who hated the restaurant was S. Irene Virbila, but then another critic from the same paper, Jonathan Gold, came to the place and said that it was a revolution in cooking in Los Angeles, something truly new.

It's hard to figure it out when things are so subjective. When our tastes develop and we're confident in them, we start to think that there's a certain amount of truth, that something is either good or bad. But I'm not sure there ever really is. You spoke before about cooking out of ego as a young chef. Is there a risk of too much experimentation?
Definitely there is. Sometimes chefs complicate too much. Sometimes they put too much thought on the plate. In a way, I think, to be creative is easy. You can put five flavors down. But to use two or three definitely and make an amazing dish is very difficult.

—— 3
I went and checked on the original review, just to make sure that Ludo wasn't exaggerating. The first thing that the critic ate, like he says, was mushroom soup with licorice and coffee essence. After she commends the way it looks ("the presentation is breathtakingly elegant"), she tastes it. Man, that's some rough going: "It is tongue-numbingly bitter, its intensity punishing, the gastronomic equivalent of body piercing. First the licorice kicks in, then—whomp!— lashes of coffee essence so vicious my tongue wants to curl up and hide somewhere. I feel as if I've been mugged. And that feeling doesn't let up for much of the rest of the meal." You don't really want to compare a meal with a mugging, do you? And she takes special care to say that the restaurant is potentially great, with great resources, a great owner, a great kitchen, and that it was recently given four stars. "Not a thing has changed," she writes, "except the chef."

That's a music production idea. Less production can be better. When you simplify like that, though, does it keep you from being ambitious?

In what way?

Do you stop looking for interesting things? That's one thing I remember from being a kid. People would be raving about a new pop single that was on the radio, and they would love it for its melody or the main guitar riff. I would hear other things, things in the corners of the mix, strange ways that the instruments were being tweaked or turned.

I don't think so. These days, I'm obsessed with vegetables because I'm in California, and it's the best state for that. I use lots of produce in my dishes and I would say eighty percent of it is from California. But I don't stop looking for interesting things. I just look closer to home. For the rest, well, most of the fish comes from the East Coast or from France. Meat comes from different places: the lamb might be from California, but the chicken is from Pennsylvania. It is like music, maybe, in that it's all about listening. To find what I need is really just about listening to what's going on. When I find a new rancher or a farmer, I talk to them about everything: where the animal comes from, how they feed them, how they kill them.

So you become a kind of student of farming?

Or a teacher. When you go to the farmers' market, you talk with your farmer and ask them for things. Can you do this? Can you do that? One guy, I asked him if he could grow a pepper from France. I hadn't ever been able to find it here and I wanted to. Or I might be talking with the fish guys and start pushing them a little more on the fish's age. I like smaller fish, less than ten or fifteen pounds, otherwise the meat is not firm enough. The truth is that if I don't have a good relationship with a fish man or a farmer, then I'm nothing. I'm not a magician.

I remember reading a quote by Clark Terry about searching for trumpet mouthpieces. It's a very long quote, and pretty technical, but the gist of it was that the size and thickness of the mouthpiece mattered for the sound produced. It seems obvious, but then you have all this thought behind it, all this technical knowledge. Without that small piece of metal, fashioned the way it was, some of the greatest art we've ever heard wouldn't have happened.[4]

That's true, and it happens. The other week I went to the market, and the farmer gave me an amazing mango. He couldn't stop saying how wonderful it was, and he was right. I was playing with it in the restaurant, and I loved it. Last week, I called the night before I was going to the market and I asked him if he could bring me a case of those mangos. "I only have five," he said. You have no idea how disappointed I was. I got excited and then the thing just wasn't there for me.

So you just deflate in those moments? Sometimes people would say that those are the most creative moments, because then you have to rethink everything on the spot, and that's when all your training comes into play.

The part of this job that is the most stressful for me is in the morning when I receive all my ingredients. When something doesn't come in right, or doesn't come in at all, it's a nightmare. You have to change the menu. You have to adjust. It's not fun. I buy my fish from the East Coast, and the other day I didn't get it as scheduled at three in the afternoon. I knew something was wrong. I called the guy. "Oh, shit, chef," he said. "I forgot to send it to you." The stress was unbelievable.

Musicians' lives are full of stories of resourcefulness. In George Clinton's memoir, there's a scene in there where his band doesn't have their sound equipment. It went missing. So the other bands on the bill help build a sound wall. They found a way to do it.

This is what we were saying before about innovation. Ideas come out of those situations. When there were chefs at court in the 1600s, the wild game that the kings wanted to eat was very strong and a little unpleasant in taste. It had an overpowering flavor. What they did was invent heavy sauces and poured them over the meat to mask its taste.

4 —
I don't know if the Clark Terry quote will excite people the way it excites me, but I love reading about specific tools of the trade. Here's what he says: "We were going through a thing here in New York, where most of the brass players had discovered that in the orchestra, all of the French horn mouthpieces were V-shaped—straight down and flat rimmed. You never saw a French horn mouthpiece with a bowl or cup—they all go straight down. So we came to the conclusion that this was far more conducive to what we were after than any other configuration: it's good for longevity; it's good for intonation; it's good for range; it's good for sound. So we decided to get into that, and Giardinelli fixed a couple of them up like mine, with a flat rim and a V-shape; and it's comparable to somewhere between a #3 or a #5 Bach mouthpiece." *JazzTimes*, October 2000, http://jazztimes.com/articles/20281-clark-terry-terence-blanchard-ron-miles-doc-cheatham-brass-fantasy.

If you weren't getting the best ingredients, would people even know? Would I know a good onion from a bad one? Would I know how a certain kind of fish is truly supposed to taste? In other arts, you have to wonder about that, too, all the time. What if a painter can't get the right brush and thinks that the trees, as painted, don't look right? Will someone in a gallery or a museum stop in front of it and isolate that problem, or will they just accept what they're seeing as the natural result of the creative process? I'm not talking about tricking people. I'm talking about how ideas move.

So much is training. I can tell. A good tomato in the market is amazing. The strange thing with food is that vegetables and meat of worse quality are so plentiful that people get accustomed to them. Those bad foods help to form people's taste and their sense of what is desirable. In those cases, even if you end up giving them a good tomato, they probably won't like it. It will seem strange and unfamiliar to them. It's sad, but maybe not so sad. It's what human beings do to survive in their environment. It's not the diners' fault. But it does definitely affect the way I have to cook. I'm in Los Angeles, in a state with so much produce, but if I am suddenly in Middle America, I'm dealing with places where they don't know the kinds of vegetables I'm using. Who is this crazy French chef? What is he cooking?

You're a chef who actually invented a kind of restaurant. In 2007 or so, you were responsible for the pop-up-restaurant craze. I would go so far as to say if it weren't for you, the idea that a chef could "pop up" anywhere, without a brick and mortar, and serve their food would not have happened. How did that happen?
It happened by accident. I was looking to open my own restaurant after Bastide, and finding a location was very difficult. It's like finding the perfect ingredient, but it's the biggest ingredient—you need to make sure that it's the right place, not just the right part of town but the right part of the street, right size, right light, and so on, and also that you can outfit it right. It wasn't happening. I was doing nothing for three or four months. I was doing nothing and going

nuts. In the meantime, I have a friend who owns bakeries. He wanted me to help him with his menus. His bakery, Breadbar, was in a perfect location on 3rd and Robertson, and the place only served breakfast and lunch. That gave me an idea. I said why don't you let me do a special event for three months. I'll open up a dinner service. I'll change the whole menu. I'll change the look. I'll hire my own people. And that's what happened. I divided his refrigerator into two spaces, brought in my own stuff and my own staff. It was like opening my own restaurant, but it cost no money. It was an amazing concept. Then after that lots of places asked me to come to their location and do the same concept. As it went, I learned about different neighborhoods, and I adapted. I might be in Santa Monica next to the water, and that meant more fish. Or I would be downtown in a Japanese art gallery, which meant a different menu and ambience.

And then you hit the road. That's musician talk. You went out on tour.
I had a television show.[5] That was an American education and also a cooking education. It was like a music group going to tour, but even more it was like an artist going on a traveling exhibition and doing a special painting in each place. What I made changed depending on where I was. We had to reinvent. When I was in Santa Fe I was cooking my French food with Santa Fe style. It made me rethink everything to the point of simplicity.

What do you mean? It sounds more complicated rather than more simple.
In that pop-up setting, you are very limited in execution. You get four burners and an oven. In most restaurants where I had worked, the kitchen was like a three-star Michelin restaurant. I might have twelve cooks under me. Now, suddenly, there are two cooks.

Oh, right. I get that exactly. It's like the first time I heard J Dilla's idea of how drums should sound and realized that everything else was so overdone and overproduced that it was killing the spirit. It was getting in between the people and the music. It was interfering with the essence of recorded rhythm.
When I went back to normal restaurants, I kept that efficiency and simplicity. All my life I was

— 5
Ludo has been a judge on various shows, like *The Taste* and *Hell's Kitchen,* but the show he's talking about was called *Ludo Bites America,* and it ran on the Sundance Channel back in 2011. He went from place to place establishing pop-up restaurants. Generally, he went to smaller cities, to Mobile and Omaha and Redondo Beach. *Redondo* can mean *round table.* Ironically, the tables at Trois Mec aren't round.

working in these places where ingredients and staff were never an issue. Then I went from a white jacket to a kind of straitjacket. I had no choice but to do things more efficiently, more simply, and more cheaply. It went from a $195 menu to a $35 menu. You don't have sole so you use skate. But you take these new resources and you apply to them the best technique possible. The other kind of benefit was that I was reaching lots of people I had never cooked for before. I was feeling so good. When you took away all of those fancy effects, it was me. I had my freedom. I was working for myself. I was so happy.

You saw different kinds of faces? I think about that all the time with concerts. As we've grown, as we've traveled, as we've selected different kinds of events—the Roots Picnic, the Super Bowl, European festivals—the crowd changes. Being a chef is a universal thing. It's not just to cook for a certain type of people. I was so happy to give to people a dish that cost $15. It changed my idea of everything. I realized you can eat an amazing sandwich and love it as much as a beautiful Dover sole. It made me not take myself too seriously. I still care about ingredients at the highest level but my idea of the highest level is different than it used to be. I was behind the wall in the kitchen and I came out into freedom.

6 —
The bonus dish at Trois Mec is the sixth course. You have the option to pay extra for the sixth course when you arrive. I make note of this because like many restaurants nowadays, Trois Mec sells tickets and you pay for those tickets in advance. Incidentally, it's even harder to get into Trois Mec than it is to get into the Roots Picnic. So don't be callin' me for the guest list (you know who you are).

And it seems like the goal is still to please people and send them off with a great experience. Once when I was at Trois Mec, you had a "bonus dish" that seemed strange on paper but was only one of the best things I have ever eaten.[6] It catapulted me back to a childhood memory: there was this buttery, truffle grilled cheese on white bread served with campfire ice cream. Grilled cheese and ice cream are two staples in most people's childhood and here you took that nostalgia and elevated it in such a way. That dish gets me back to Trois Mec every time I'm in L.A., even though it's no longer on the menu. What are things that you don't like in restaurants? There are creative problems, of course: bad ideas or good ideas done badly. But really it's poor hospitality that gets to me the most. I don't like when I go to the restaurant and I wait a long time for the waiter to come and take my order or I wait too long for a bottle of wine. You need to make sure your guests have the best time and feel the best they can. They are the most important people in the restaurant. That's what impresses me the most in a restaurant. Say hi to people. Say bye-bye. Of course it's about the food but we have lots of competition for where people choose to eat when they're not eating at home, and the way you distinguish yourself is hospitality. Sometimes the restaurant has an attitude. I'm French, so I have seen that often.

The snotty French waiter isn't a cliché?
Ooh la la. I just came back from Paris. It was terrible. You don't need to be American to be treated badly.

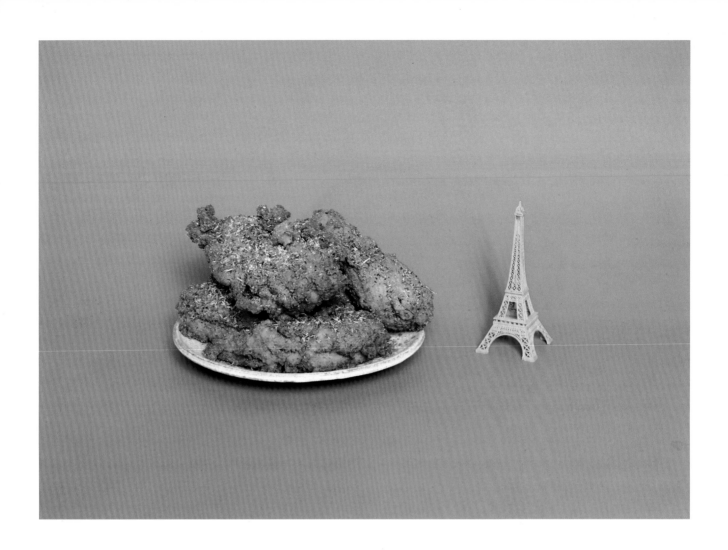

(above) LudoBird;
La Tour Eiffel

87

(above) Spot prawn on
copper pot

(right) Radish on soapbox

(following spread) Chef's
hand on striped bass

(left) The Trois Mec arsenal

(above) Colleen De Lee,
a home baker discovered by
Ludo. All baguettes for
the restaurant are made in
her apartment in L.A.

(left) Carrot BBQ, orange
curry, yogurt, avocado

(above) Potato pulp,
brown butter, bonito,
onion soubise, salers

(right) Spot prawn,
Japanese sweet potato,
purple daikon, fennel
fronds, watermelon
radish, flowers, mint

(right) Carolina Gold rice pudding, brown butter, egg yolk

(below) Smoked eel, white chocolate mashed potato

(opposite) Truffle grilled cheese, buttermilk maple, campfire ice cream

(following spread) Don't be fooled by the Raffallo's Pizza sign. Inside is Trois Mec; Petit Trois is next door.

COCKTAILS FRENCH FOOD

PETIT TROIS

OPEN 7 DAYS A WEEK

718 PETIT TROIS 718

A

PETIT TROIS
Bar à la Carte

PRIVATE
PROPERTY
UNAUTHORIZED OR IMPROPERLY
PARKED VEHICLES WILL BE
TOWED AWAY AT VEHICLE OWNERS
EXPENSE : ENFORCED 24 HOURS
LAMC 80.71-4 CVC 22658 LAPD (877) 275-5273
MELROSE TOW
(323) 465-6555
ALSO CALL FOR
24 HOUR ROAD SERVICE

"When an idea is a success, you close it down."

Dave Beran
Chicago

Chicago is the hidden metropolis for me. I mean, I know it's not a secret, but sometimes I feel like I'm keeping it a secret from myself. I spend most of my time in New York, and plenty of time in Los Angeles, but every time I end up in Chicago I feel like I should go there more. The city has so much culture and architecture. The streets are laid out perfectly. I hear it had something to do with a cow kicking over a lantern. It also has a fast-growing food scene. Chicago even took the James Beard Awards out of New York City. If you can one-up New York, you gotta have some of the best chefs to back it up.

And Chicago backs it up with Dave Beran at Next, which is one of the first restaurants that comes to mind when I think of innovation and cooking. That doesn't make me a genius. If anything, it makes them geniuses. Since Next opened in 2011, they have tried something unprecedented. Every three months, they change their face entirely. One season, it's a steakhouse. The next season (all puns intended), it's a Chinese restaurant. Not a trace of the former identity remains. Except in the kitchen, of course, where it's the same people making the transition from one style to the next (again, all puns intended, and possibly unavoidable). How could you not include Next in the book? You couldn't. That may be a double negative. I'm not positive.

This kind of versatility is impressive, but what's more impressive is that Dave Beran and his crew never stop trying new things in other ways, too. Eating there is an adventure. When I was in town one time, I went to Next, and Dave came out of the kitchen. At first I thought he was playing a joke on me. He said something in French and I thought I heard the word *garbage,* or at least a phrase that implied that I was getting leftovers. The plate had eggshells, fish eyes, and part of a skeleton. All in all it was the parts you don't eat, unless you're Oscar the Grouch. He put it on the table and said *"Bon appétit"* and then sat down to watch me. If he hadn't been watching, I wouldn't have eaten it. Not only did I manage to put it in my mouth, but it was one of the best things I ever had. The tastes and textures were perfect. Another time, Dave brought me a tossed salad. "Here's a banana split," he said. I gave him a look. "Just close your eyes and eat," he said. I did and damn if it wasn't a banana split. The lettuce was the sweetest lettuce I could have imagined and the tomatoes were strawberries somehow and the radishes had a chocolatey aftertaste.

What I learned those two times, I have learned again every other time I have gone—Next is amazing, and not because it's so foreign to me. It's amazing because I understand it. Being a chef is like being any kind of artist in that much of what you do is about manipulating and managing expectations. Think back to that plate of eggshells, eyes, and bones. Visually, it was horrific. Seeing it didn't just lower my expectations. It killed them. But eating it was a big bounce back up.

That kind of thing—managing expectations, counterprogramming a calculated discomfort—happens all the time in music, specifically in DJ culture. Recently I was in Boston. I was in the DJ booth, trying to assess the crowd. It was more of a black crowd than anything else, and I thought that maybe I would test them by playing Neil Diamond's "Sweet Caroline." It's a Red Sox fan song, but I wasn't sure if it would work on them the same way as on a white frat crowd. So how could I get to "Sweet Caroline" without anyone knowing it? I waited until later in the evening, when drinks were flowing freely. Then I moved into a section of the set that kicked off with "Rock and Roll Part 2" and went on to Kanye's "Black Skinhead." That's lots of energy, lots of exhilaration. Then I brought the whole room back in time with the *Sesame Street* theme—not Stevie Wonder's "1-2-3 Sesame Street," but the main theme, the one by Joe Raposo. That got the room ready for "Sweet Caroline," or as ready as it would ever be. I played it. For thirty seconds, they stopped and looked at me like they might rush the booth and flip over the turntable. I had a moment of uncertainty. They didn't expect it at all. They weren't pleased at first. But then they caught the taste of the song and started to sing. No one ever passes up the opportunity to sing.

I want to talk with you about innovation, because your restaurant is all about ongoing innovation—its promise, its problems, and so on. But let's go back to childhood for a minute. What's the first restaurant you remember going to?

Bonanza, which was in Marquette, Michigan. I went there when I was four years old, probably. It was one of those buffets.[1]

The all-you-can-eat kind?

That's the only kind I would have considered. I went back repeatedly. The whole reward of eating mystery buffet food is that you get to end up at the ice cream bar. That's the "exciting" part, though it's all exciting. I was mostly interested in holding out my plate so that people could spoon something onto it for me. Other than that, there are lots of kitchens in my childhood. My father teaches hotel restaurant management. He was a professor at Syracuse for twenty-five years. So when I was a kid, I spent lots of time where my father worked.

It's interesting to talk to chefs whose parents worked in and around food, because I'm a musician whose parents were in music. It really shaped how I thought of things from early on—I considered it both an art and a profession. Was that your sense?

Working in the food industry was never my intent. It was never something that intrigued me. I grew up playing hockey all the time, and spending time in those kitchens was, apart from hockey, the only time I got to spend with my dad.

Chefs I befriended over the years all innovate in different ways, through mixing styles of cuisine or changing the way restaurants deal with diners. In your case, the innovation is right there at the surface, because your restaurant, Next, is designed as a series of restaurants—it exists as one kind of restaurant for three months, and then becomes another kind. It suggests tons of questions about innovation—so many, in fact, that I don't know where to start. I'll start at the beginning. Who thought of Next?

Well, I was at Alinea, which was Grant Achatz's first restaurant.[2] Then Grant got really sick with Stage IV tongue cancer, and Nick Kokonas, his business partner, started to come in more often. We would offer Nick food, and he would always say no. One day he said yes for some reason,

and we made him something simple like duck with morel mushrooms. He loved it. He was eating, speaking idly, and he wondered aloud why we didn't just open a bistro and make food like that. Chef said, "No, no. It's boring. Just because it's good doesn't mean that it's a good idea." Nick stopped in again, and the same thing happened—Chef made him something simple like pasta, and he went on and on about how delicious it was, and wondered aloud why we just didn't serve pasta. He went away, thought it over, and came back with an idea. What if we did it all in one restaurant and just kept changing the concept? This was back in 2007.

So that was his brainstorm? To have a restaurant that wasn't really a restaurant? It's like the CD changer of dining.

Not just that. At the same time, Nick had an idea about how we might change reservations and booking. We had about forty tables in Alinea, and every time we had a no-show, we would lose our profit for the day. That was our revenue. So he thought it would be interesting to sell tickets for the dining room in advance. Plus, Alinea had just been named the sixth-best restaurant in the world.

Sixth-best restaurant among how many? I know about year-end lists for movies and albums, but what are the restaurant rankings you pay attention to?

Restaurant magazine in London does an annual Top 50. That's regarded as the industry gold standard. They say that it's the fifty best, but really it's the most relevant, and once you get into the two dozen or so, they're mostly interchangeable. We got up as high as sixth in the world.

What does it matter? Is it just for ego? It's not like diners in Chicago come in, look around, and say "Baby, let's leave and head across the street to the fifth-best place in the world."

The ranking mattered to a place like Alinea. Our clientele was maybe forty percent international, and beyond that lots of tourists. Only about ten percent of our clientele was local. So many people flew in for the meal. That kind of rank ensures that you'll be full. We had

—— 1

I went and looked up the Bonanza restaurant that Dave mentioned, only to find that it shut down at the beginning of 2014. "Mitch Lazeren, owner of the Bonanza location on US-41, released a statement on Friday, confirming that Bonanza in Marquette will be closing its doors. When will the last day be? Mitch says the doors will close for the final time on Sunday, January 26. He cited wage increases, rising food costs, increased taxes, and a changing economy as reasons for the closure. 'This was a business decision, not something that I took off the fly,' said Mitch. Bonanza currently has 42 employees, three of which have been working there for 34 years." Rest in peace, Bonanza. I'm not going to tell Dave that it's closed. I don't know if he knows or not, but I don't think it's my place to say. http://www.uppermichi-gansource.com/news/story.aspx?id=998548.

—— 2

Grant Achatz, Dave's boss and partner, trained at the Culinary Institute of America and then went to work for Thomas Keller at The French Laundry. He then moved to Chicago and started to work at Trio in Evanston, where he eventually was only one of thirteen American restaurants to get a fifth star from Mobil. These restaurant ratings services and their stars are almost as confusing as trying to compare the Source and their microphones with *Rolling Stone* stars or a Pitchfork score.

some Wednesdays when we only did twenty-two people. A good ranking pushes you up to the point where you're always full. That gives you freedom as a restaurateur and a certain amount of comfort.

So here you are, and your partners come along with this out-of-left-field idea, to make a restaurant that changes as it goes. Were you thrown? Were you enthusiastic? I mean why not just stop at six?
I would say reluctant more than enthusiastic. It was pitched to me as a dream project, like it could be anything I wanted. The first menu idea that came up was Paris 1906. In the time leading up to it, I started researching. I went to France and ate at a bunch of bistros. It was really disheartening. It wasn't bad, but it wasn't anything special. I came back determined not to do it. I'm not leaving Alinea to do bistro food. But Grant and Nick and I started talking about French food more generally. Why cook it at all? What are the stories behind it? As we started researching more, building in more of a narrative, we started to fall in love with the idea. Other big chefs, from Alain Ducasse on down, would always talk about Auguste Escoffier.[3] But no one brought his food into focus. People were inspired by him, but no one actually cooked his food. We wanted to make Escoffier himself known to diners. The menu we designed was based on Escoffier's famous cookbook *Le Guide Culinaire*—more than based on it, it drew from the cookbook. Everything we made came from there.

So it's like this was your solo album. Your chance to express your own ideas. Do you think of yourself as a kind of writer? You're writing about a past era by presenting a menu?
Writing is part of it, no question. We have to make a menu that explains itself. But the art form that I have the strongest association with is probably music. That can sound cliché, but when we talk about menu composition, we refer to albums. When you look at a menu, at how it's structured, you can either think of it as a collection of greatest hits or a series of dishes that tell a story. With Next we always want to tell a story. I think specifically about Radiohead

albums. Any one of their songs is good, but taken all together they do even more. A great song is greater because of what precedes it and what follows it. That first menu told the story of how French fine dining was born, and how certain dishes functioned in that story, whether suprêmes de poussin or pressed duck or scalloped potatoes, gratin de pommes de terre à la dauphinoise.

So writing a menu is like making a record. Do you also think about liner notes, and album art? Music is only one of the things that's on there, but I was one of those kids who fell inside the world of the rest of it, whether it was the soft-core wet-T-shirt photos on Ohio Players albums or the Pedro Bell illustrations and freaky liner notes on Funkadelic's *Cosmic Slop* or Mati Klarwein's paintings for Miles Davis's *Bitches Brew*.
Absolutely. We're thinking about those things, or their restaurant equivalents, from the beginning. The identity of each version of Next, whether that first menu or the Thai menu that followed or the more conceptual menu that came after that, which we called Childhood, is not only food or service style but the total package. We start with menu structure—a name, a word, an idea—and from there it builds out. What's the feeling behind it? How do we want to reinforce the emotion? Do we want to walk up and say "Hello" to you or "Welcome"? Do we want to start you with a glass of water or a cocktail? It's only then that you pull out the microscope and look at individual dishes. And it gets even more intricate than that, because you're scheduling a menu the way you would schedule a release date for an album or a movie. Say it's fall. Well, that means that in a few months it's winter. What are the subtleties and nuances behind the change in season? Maybe all of a sudden ayu isn't available but trout or halibut or turbot is. Or maybe in the summer white asparagus goes away. How do you deal with those foods being there or being gone?

You say that the restaurant is creating menus that are like albums, but you're also talking about a stage set, and an audience. That makes it almost like a play or at least a concert.
Well, the menu is very musical, but the restaurant as a whole is theatrical. We try not to say that in those exact words because people take it the wrong way. It can sound gimmicky, like a theme restaurant. But if you were to walk

3 —
Georges Auguste Escoffier (1846–1935), chef, restaurateur, and dean of modern French cooking. He had a thing for inventing foods in honor of the Australian opera singer Nellie Melba—not only Peach Melba and Melba Toast, but also Melba Sauce, which has raspberries and red currant, and Melba Garniture, which is chicken, truffles, and mushrooms stuffed into tomatoes with velouté sauce. Velouté sauce? I looked that up, too. It's one of Escoffier's five "mother sauces," sort of like the Old Testament of sauces. It's a light stock and a blond roux. The other sauces are tomato, béchamel, hollandaise, and espagnole. Now I have said everything I have learned about sauces.

into the restaurant between menus and see the basic space you would just see dark wood tables, blank walls, and a neutral space. It's similar to a stage. It's nothing, but when you add one chair then suddenly it takes on a personality.

Musicians have fingerprints. I mean that there are certain things that immediately tip you off to the fact that you're listening to a certain musician or band. Do you think about those when you're trying to create a new cuisine, or re-create a cuisine that exists elsewhere?
We call those bullet points. We did the elBulli menu back in 2012. It was based on Ferran Adrià's legendary restaurant in Catalonia. When we did our elBulli menu, we didn't transform ourselves into a replica. We couldn't. For starters we're not on the water, which is a minor point but not a minor point. We had to find something in the essence of the place. So we took a rose, and suspended it over every table. That both reminded people of the restaurant—they put a rose on every table—and performed a kind of memorial, since elBulli had closed the previous summer. And there was a third dimension, too, more practical than emotional—our tables were too small to have a centerpiece. But the rose was the bullet point that communicated everything we wanted to about elBulli.

What if you were humming along on French or Thai or elBulli and you suddenly decided that you didn't have a good handle on it? You might not be equally good at each kind of food, right?
I'm sure there are variations as we've gone. Critics and diners have responded differently to different menus. But we have a number of phases. They're probably the same ones you would have before you open any restaurant. We're just doing it three times a year. First we work it out on paper as best as we can. We try to get as close as possible. Then, before we release a menu to the public, we serve it to our staff multiple times. We vary who acts as the server and who acts as the diner. And then there are a couple of days of meals for friends and family. I have chefs locally who will tell me straight-out if something sucks. Over the course of five to fifteen test runs, you learn that the concept is at least eighty percent complete, which is enough to put it in front of the public.

Going back to the theater metaphor, you have rehearsals and then dress rehearsals before you open. And you even have tickets. Does that change the way you think of it? Is it even really a restaurant anymore?
At the end of the day it is still a restaurant: there's legitimate cooking and hard work. It just so happens that each time we rethink what we're doing, it's not just about coping with the fact that it's late August so it's the height of tomato season, or that it's fall so squash is coming in. We are looking around at the best ingredients but also trying to find a cuisine that works in all those other ways, too.

A devotion to innovation can be liberating but it can also create problems when those innovations succeed. I have become friends with Dominique Ansel, and he has talked about how the Cronut is a mixed blessing. It's great to establish that you're capable of inspiration, and you want to keep giving it to people if people keep wanting it, but creatively you also want to make new things. Personally, I couldn't believe he didn't just give up and sell the damn thing to Dunkin' Donuts and everyone else for zillions[4] but the guy is devoted to keep reinventing.
At Alinea, we had a running joke. There was a dish called Hot Potato/Cold Potato, and it had cold potato soup in a wax bowl, and then a pin poking through the side of the bowl and holding a hot potato. You would withdraw the pin and the hot would fall into the cold. It was a sensation for people. It was interactive and innovative and amazing-looking. We would always joke that you only get one Hot Potato. You only get one glorious aha! moment where you come up with that thing. It's amazing when it happens. You want to show it off to everyone. On the flip side, though, that can put a halt to your progress. When you have that hit, you don't want to stop doing it. At Next, the curse is that you can't have that Hot Potato. You can't have something that lasts a year or two. You have to let go of that dish because you have to let go of that whole style. But that's also a gift. At other places, when an idea is a success, you dig in and do that same thing for years. Here, when it's a success, you close it down.

——— 4
Dominique told me the actual number he was offered, but I have been sworn to secrecy. And for the record, you can't help but give it up to the guy for not selling out.

So I'll never eat the Hot Potato?
There will be other aha! moments.

When innovation is built into the foundation of the restaurant, does that become a kind of typecasting itself? I don't mean to do a jujitsu move, but I wonder if there are people who don't like changing. There are chefs who settle in comfortably to one way of cooking and try to perfect it over many years. That doesn't make them better or worse. It just means that they have a certain personality and a certain approach. Are there people who are great at executing but not good at innovating?
There are people who come to work at Next and last one menu, maybe two. The pace of change, the energy of each new idea, is so overwhelming. Even for me, over the course of our first few menus, I didn't know how to wrap my head around the fact that we had to close our doors and reopen with something different. Now I get that timeline. I get that rhythm. Four weeks into a new menu, I'm looking at a dish and already envisioning the change. And there are other people who understand that rhythm right off the bat, who know how to attach themselves strongly to an idea and detach in time to commit to the next idea.

How do you manage these different kinds of people? When you think about a producer like a Phil Spector, he would get his idea for an album and then just start to call in dozens of studio musicians until he got the exact sounds he wanted. There's a huge amount of effort, but the possibility for bruised feelings.
I had two main interests as a kid. The first was art. I loved all kinds of art, and my stepmom used to drive me all around Syracuse so I could photograph graffiti. I also played sports. Those were the two things I loved, and they helped to define my approach to situations. As it turned out, art plus sports is the perfect balance for dealing with a kitchen. If you have ever worked at a restaurant, you know that it's almost a physical sport. You're trying to keep two steps ahead and not get run over. It's the same with hockey. And there's a way in which my approach in the kitchen is like being a coach on a team. Some staff members respond to more vocal treatment, to yelling and aggression. Others need to be pulled aside and talked to quietly. They need a friend. Championship teams are about the dynamics. Even if the best chef in the world is in someone else's restaurant, you can have the best kitchen in the world.

This is the theory behind bands. On his own, Mick Jagger isn't the best singer. On his own, Keith Richards is a great guitarist, but maybe limited when you compare him to Segovia or Joe Satriani. Charlie Watts would be a decent jazz drummer in a decent jazz combo. Ron Wood kicked around from band to band, backing singers like Rod Stewart. Each of them was a pretty good chef on his own. But together: Ladies and gentlemen, the Rolling Stones. It's true for the Dirty Projectors. It's true for Public Enemy. It's true for the Roots.
When we opened, I got twelve hundred résumés. I called back three hundred. Eighty showed up. I picked twelve. And even in that process, I saw that there were certain people who were great cooks but couldn't work in our system. Traditionally if you look at kitchens you have swing cooks who float between stations. They handle all the plating so the chefs de partie can stay on their stations. We designed our kitchen in three main sections, so that when two sections are busy, the third is doing nothing. And then we eliminated the position of swing chef. That helped reduce a team of sixteen down to a team of twelve, and it meant that no one was consistently swinging from station to station. Everyone needs to learn everything. The kitchen is designed differently because the restaurant operates differently.

So who is your ideal Next employee? The most versatile cook? Are you looking for the guy who can play any instrument? Are you trying to hire Prince?
I'm trying to hire the most ambitious cook. I don't want the best meat person. I might not have a grill in this menu. I saw Arcade Fire in concert, and at various points in the concert people start trading instruments. The music still worked even when instruments passed from hand to hand. It's kind of like that in our kitchen. The guy who is doing pastry for our next menu is doing butcher for this menu. If the cooks aren't willing to switch like that, then

they wouldn't work here. If you want to stay in pastry, go to Per Se in their pastry department. There's nothing wrong with that. It's just not what we do.

I thought of another example that's similar. It's sort of like how the Roots work on *The Tonight Show*. We have had to learn to play with every kind of musician. One night the musical guest might be a soul singer, and that we can handle. We did a record with Betty Wright and Al Green. But we have to learn every style. Sometimes that involves research, even. Do you have periods where you have to research? And are there different kinds of research depending on the different menus?
In the summer of 2013, we did a vegan menu. I went vegan for a while, tried to eat that way, but it occurred to me that the goal wasn't only to make vegans happy, but to make non-vegans happy with a vegan menu. I grew up in Syracuse. I love Buffalo wings. I started to think analytically about it. Why do I like them? Is it the chicken? The flavor? The crunch? The sauce? As it turns out, it's not really the chicken at all. It's the ceremony, the way you get the crunch and the vinegar, the smell. It's everything except the chicken. It was such a challenge to look around, not to find a substitute for egg and cream but to find a food that would do what they do if they never existed.

You're up to your twelfth menu. You've done steakhouse. You've done traditional Japanese *kaiseki*. You've done tapas. And yet, they're all Next. How would someone coming to eat be able to tell that you're the same place, that it's not just the same name and location hosting a series of different places?
Despite all the change at Next, all the different menus, at the end of the day it's grounded in that philosophy that we're going to uphold certain standards and craft an experience that people can find themselves in. We're all trying to achieve this common goal. No matter what menu we do, no matter what we produce in the kitchen, we're trying to connect people to a place they've never been or a place they've been and that they miss. We're trying to transport people. That's part of the overall idea.

What about actual travel as a kind of transport?
Travel is a huge part of our idea. The more I have cooked, the more I have spent time at Next, the more that has become foregrounded. We use travel to spark reinvention. It's a major part of what we do. We went to Paris for the Bistro menu. We went to elBulli in Spain. We've been to London and to Tokyo. When we come back, we want to be able to bring diners there. And there are so many other places, too. I really want to go to Vietnam and try real genuine Vietnamese cuisine.

This project you're in requires you to cast a wide net and pull back ideas and cuisines from all over the world. Are there any foods you hate?
At the restaurant, all the cooks make fun of me because there are lots of foods I don't like. I don't like celery. I hate bell peppers, never mind whether they're green, yellow, or red.

It's funny. I guess I expect chefs to have broad taste, but the truth is probably that they get into the profession because they're especially sensitive to foods. Musicians are the same way. I remember when I was a kid, running downstairs, slipping, and sliding into a radiator just as Curtis Mayfield was playing "Freddie's Dead" on *Soul Train*. To this day, I feel phantom pain where that burn used to be. And D'Angelo has a similar experience with Marvin Gaye's version of "I Heard It Through the Grapevine," which is a pretty neutral song for me. It absolutely terrifies him. Do you hate these foods because of childhood trauma? Is it texture?
I don't think it's childhood or trauma or some long-buried celery beating. I just don't like the flavor. It got to the point where a cook would put too much celery in a veal stock and I would pick it up and say "There's celery in this." With that said, there are plenty of dishes we've made where those foods have been in play. In our Modern Chinese menu, we had a monkfish with celery, white asparagus, and chrysanthemum, and it worked perfectly. I didn't block it. I didn't throw a fit.

When you're planning your next Next menu, can you actually tell what's next in the food world? That's the most confusing question I've ever asked, I think, so let me rephrase it. You're trying both to reflect trends and also trying to ride those trends out until they're over. Does working at Next help you forecast trends in dining?

We've seen so many come and go, both for us and for all the other restaurants in our community. There was a trend a few years ago where we saw the whole chalkboard restaurant scenario. Then there was a period where fine dining is overly casual, where the staff wears aprons and sneakers—but bespoke, hipster aprons and sneakers. I think in a few years there's going to be a resurgence of major over-the-top opulent dining, the kind of thing where you have hundred-thousand-dollar chandeliers. I don't know how long it'll last, though. People love those kinds of extreme styles because they're different from what came before. The exciting thing about Next is that before you have a chance to kill an idea, the idea kills itself.

Do you ever go backwards in time and try to revive an old idea? Is the next Next thing something from the past?

That's happening right now. The current menu, Trio, is based off of the first kitchen Grant Achatz ran, Trio, which was up in Evanston.[5] We have the black truffle explosion, which is a single ravioli containing liquid black truffle. We have short ribs that taste like root beer.

Very subversive.

That's what one of the reviews said: subversive, playful, intense. These were the courses I learned when I first worked with Grant. Back then there were fourteen or fifteen people and we couldn't handle it. Now it's easy. We're more relaxed.

It's like the full-album concert, where a band plays its way completely through an old album. The Roots are asked every year to perform *Do You Want More?!!!??!* in its entirety. Would you ever do that at Next?

I don't think we'd go back to an old menu exactly. But there are some ideas we've had that are close. In 2012, we did an autumn *kaiseki,* which was a Japanese tasting menu. The format for that kind of menu is highly seasonal and rigid. No course can remind you of another time of year. I would love to revisit *kaiseki* but try it in a different season. Or take Paris Bistro. We always said we'd never do another French menu, but at the start of 2015, we put in a Bistro menu. It's close to what we had, but with an important difference—it's Paris in 1911 rather than in 1906. For many years I wouldn't have been okay with that, but I think I'm fine with it now, partly because much of the ego is gone. We have won enough awards. Now I just want to have fun and cook really delicious French food. Plus there are certain dishes that didn't work with the 1906 menu. People wanted duck pressed tableside. They even said that they would pay $500 for it. It didn't fit before, but this time around, we're going to put it on and see what happens. Bring on the duck.

5 ——
Trio was open from 1994 until 2006, and many chefs started out there: not just Grant, but people like Rick Tramonto, Gale Gand, and Shawn McClain.

(from right to left from top)
Service ware for "The Hunt," "Kaiseki," "Chicago Steak," "Chinese: Modern," "Tapas," "Paris: 1906"

(above) *Star Trek* plate and
fork wrapped in plastic

(right) Chamber of Secrets:
archives wrapped in plastic

Dave Beran

(left) White chocolate—olive
oil candy bar hidden in olive
branch

(above) This picture frightens
me, but it shouldn't: it's
jamón ibérico and a porrón
filled with red wine

(following spead) A giant
sheet of cod skin for cod
chips. This is the stage where
it is dried, before puffing.

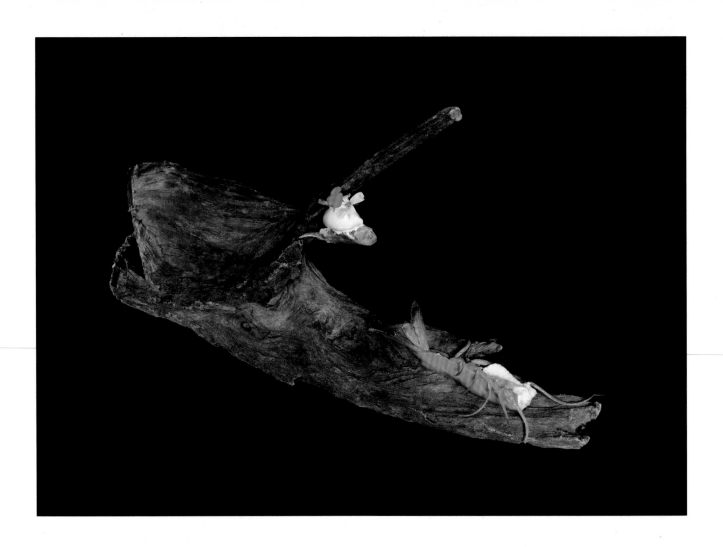

(previous spread)
Massaging the octopus.
And yes, I know that it
sounds like a euphemism.

(above) Gambas con fresas
y habas—or, if you'd prefer
the English, shrimp on a
log with strawberries and
bean sorbet

(right) Still life with charred
grapefruit, bean, potato,
orange, purple cauliflower,
and cognac

"When you eat meat the way you should, it's a very mindful process."

Jesse Griffiths
Austin

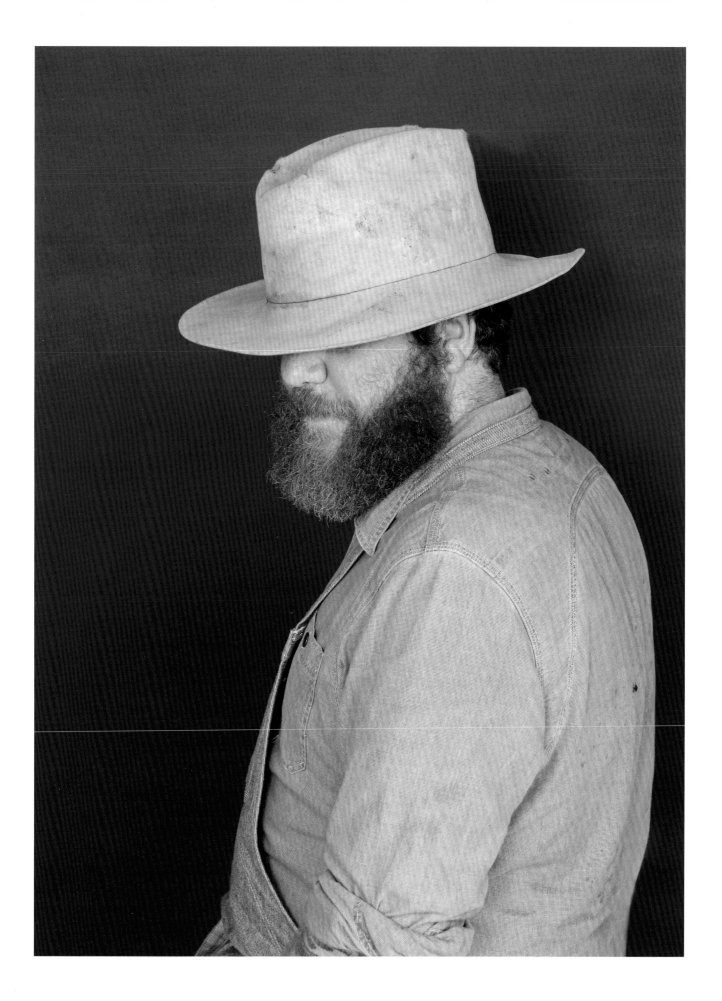

When the Roots first started at *The Tonight Show,* back before it was even *The Tonight Show,* I didn't know all the bands, or even all the kinds of bands. There was a certain indie vein that went over my head—Brooklyn bands, mostly, who wrote these shambling songs with angular guitar. I saw one, and then a second one, and I thought I had seen them all. Then one night we had Dirty Projectors[1] on. They were setting up before sound check, and I saw a guitar leaning up against an amp, and I flashed forward to the kind of song I was sure I would hear. As it turns out, I was completely wrong. They shattered my expectations. There was a sophisticated songwriting style. There were touches of prog. There was intricate and beautiful singing. But even opening myself up to the singularity of Dirty Projectors was a strange process, because as much as they stood out as a brilliantly idiosyncratic band, they didn't completely shatter my idea of the indie rock genre either.

I bring this up because there's a TripAdvisor headline I saw online that sounds like the best indie-rock song never made. "I Felt At Home the Moment I Stepped Out of the Car." It's a review for a resort in Thailand, but it's also how I felt when I arrived in Austin. Austin is my second-favorite city in the world behind Portland. I go through this exercise often; if I had to leave the tristate area and live elsewhere in the world, those would be the top two places. They're ahead of Tokyo. They're ahead of San Francisco. They're ahead of London. That's because they are singular (doublar?) examples of a certain genre of city. It's something about the culture, which is in turn about specific kinds of places: record stores, movie houses, and restaurants. The three things I love most. Few do it so perfectly.

In this constellation of perfect-city experiences, food is one of the brightest stars. But Austin was a hard nut for me to crack in that respect. For me, for a long time, Texas was strictly down-home barbecue. That was fine with me. I have lots of country back there in my family, before my people came up to Philly. My father was from Goldsboro, North Carolina. My mother's family was from Mobile, Alabama. There are distinctive barbecue cultures in all those places, and there's a powerful one in Austin, too. And I'm not just talking about the canonical ones like Stubb's and Franklin Barbecue. I remember going to this gas station that also sold barbecue, Sam's BBQ. It was a hood spot, in a way, but it was also nothing like a hood spot. They had a great tagline on their door, "Sam's BBQ: you don't need no teeths to eat my beef."

The more time I have spent in Austin, the more I have learned that even though there's plenty of that back-porch Southern culture, there are also countless other kinds of restaurants that were brought into existence by countless other kinds of food thinkers. Dai Due is a perfect example. They have meat—so much meat—but it would be wrong to call them barbecue. They're nothing close. They're a perfect embodiment of a local culture—as their founder, Jesse Griffiths, said, hunting is a part of Texas reality in a way it's not part of the reality elsewhere in the country. Liberal ideas of diet (vegan chic) and environmentalism (how to use animals and plants in sustainable ways) have a different look down there. Jesse loves to think about those things, and I loved hearing him think about them. Plus, you could dine out on Dai Due's ideas for almost as long as you could their food. It's where I first ate crickets. Yes, crickets.

— 1
Dirty Projectors also have a food connection. Once I was hooked on them, I would hang out with Dave Long-streth and his bandmates all the time, and we would go for sushi in New York and trade on-the-road restaurant secrets. Musicians know things once they've been on the road for a while. In fact, at one point, Dave was talking about how Dirty Projectors should release a book of restaurant recom-mendations. I guess I beat them to it.

For many chefs, I start by asking them about their childhood, how they came to food, what their evolution was. With you, I want to get right to the meat of the issue, literally. Your restaurant is very much about meat, and very much about hunting. This is an emotional issue for many people. Is that something that you have to contend with when people come to eat at Dai Due?

I'm very pro-hunting. I hunt often. Do I fully support the hunting community? No way. I find lots of it to be disgusting. But there are lots of good things happening between the hunting community and the food community. I've said this before, but hunting is like gardening. When you bring in the touchy subject of guns and violence, you introduce a dimension of cruelty that isn't really there—or at least it's not there in the simplistic way that people want it to be. People think it's cruel to shoot a deer but they don't hesitate to eat a chicken that has never seen the light of day. I have discussions with hunting opponents. They like to personify animals so much, fine. Imagine it's you. Would you rather wait in a warehouse for your entire life and then wait in line to be killed or would you rather be conducting your life in your natural habitat, without restriction, and then be killed quickly? Everything's got to die, at least everything in the wild, and being shot is one of the most humane ways to die in the wild. Every other way is a natural way, and it's brutal. It might involve coyotes. I don't get real preachy about hunting. I do it and it's part of how my family eats. But I think more people are coming around to it. Our culture is becoming more intelligent.

It seems like hunting would be an easier sell in Texas. That's the outsider view, at least. Or is that a stereotype?

No. It's true. It's ingrained in our culture here even in places like liberal Austin. Here, you could have a dead deer in the back of a pickup and it's not going to get lots of shit from people. But when you talk to New Yorkers or San Franciscans, it's not perceived the same way. It might just be the fact that hunting requires guns. More people don't have the same kinds of problems with fishing. But hunting is seen as a conservative white male activity, which doesn't make sense. Historically it can fall to anyone.

Ironically, I come from a family big on hunting. My father was an entertainer, so he traveled all the time, but his brothers, who lived in and around Philadelphia, were super big on hunting. I don't know where they would go in Pennsylvania, but they would go for rabbit or squirrel or possum. I had lots of that fresh-cooked meat, night-of meat in my childhood. My uncle Rosie, my father's second-oldest brother, was a policeman during the week and then Thursday and Friday he would go hunting. He sometimes brought back venison. So from very early, four or five, I remember him pulling the dead rabbit out, and Grandma making some of the best rabbit stew.

That's the thing about eating game. It's sustainable. We're eating a resource that is provided for us by nature. There are lots of deer out there. We should be eating them.[2]

Are there other things we should be eating?

Well, here in Texas we should be eating feral hogs. We should eat them all day, every day, until they're gone. They are highly destructive and breed like rabbits. Luckily, they're also delicious. There are two million of them in our state, and if we don't kill eighty percent every year they're just going to continue to grow and overrun everything.[3] I also like to serve lots of rabbit. They have a light ecological imprint. Both of those animals make more sense than, say, cows, which aren't any threat and require so much more water and land.

Introducing a new kind of meat, especially an unfamiliar one, seems difficult. It's hard enough to get people to try new vegetables.

I believe in normalizing everything. When we have a new meat in the restaurant, at first we'll put it in a context that diners are familiar with. Like we'll make a comfort food, a meatloaf with venison, or else a sausage or hot dog. We never sell a hot dog made with beef and pork—it's rabbit or deer or hog. That strategy disarms them. It's a presentation of the meat that's not confrontational at all. And it works on us, too. At some point, we stop thinking of it in terms of deer tongue being introduced at a mainstream restaurant. We're just using the animal in as many ways as we can. As it turns out, venison and feral hog outsell everything else.

— 2
I don't know what the rules were when my uncles were hunting, but these days, Pennsylvania permits one antlerless deer killed by bow and arrow with each required antlerless archery-hunting license, and there are two seasons, one in late September, and one in late November. There's also a porcupine-hunting season, which runs from September 1 to March 31, which carries daily limits of three porcupines and season limits of ten. Crows can be taken from the Fourth of July all the way until April 5, with no limits. I'm a sucker for lists of regulations. They're fascinating. Who makes policies? When do those policies change? How do we know that they're rational? Rabbits are restricted to four daily. Take that, Elmer Fudd.

— 3
Jesse was not exaggerating. I found an article called "A Plague of Pigs in Texas," from *Smithsonian* magazine, January 2011. At that point, they were causing $400 million in damage annually. The account of what they do—"They tear up recreational areas, occasionally even terrorizing tourists in state and national parks, and squeeze out other wildlife"— was so disconcerting that I started imagining recipes immediately.

I live in New York City, which is a media capital, and part of what that means is that people lose touch with how things are made. Very few people can make furniture. Very few people can fix cars. And very few people think very much about where their food comes from. That's by design. The biggest companies in the world want to keep people as alienated as possible so they can continue to conceal the process. And people are complicit in that. What they should be doing, I think, is witnessing the process and then making adjustments.

There's a vogue of vegetarianism because it's seen as healthier—it keeps you thin, it doesn't waste the lives of animals. But that's not really true, is it? I remember how early in the Roots' life, we were sort of exiled to Europe, and we were all eating vegetarian because one of the members of the band was vegetarian. It's like in *Pulp Fiction,* when Samuel Jackson says that he's pretty much a vegetarian because his girlfriend is. But we ate bread and potatoes and it wasn't healthy at all. Plus, we were hungry all the time. More than hungry: hangry. It wasn't until a girl explained to me the importance of protein that I started to come around to another idea of vegetarianism. There's nothing wrong with being a vegetarian. You're just not using a resource. If you find an educated person who has made the choice of laying off meat, that's fine. But I find someone who can't even have a discussion far more displeasing. They're just eating to meet their own needs. When you eat meat the way you should, it's a very mindful process. As a hunter there's no way that I can ever eat anything and not, for a split second at least, think about it when it was alive. When you reflect like that, hopefully you are able to think about an animal that lived in a forest or a nice pasture rather than in a warehouse.

That's a specific form of training, though. Musicians sometimes say that about songs: they don't hear the melody or the rhythm but rather they hear the work that went into making the final piece of art. But what if people don't come around and think about things that way?

Maybe they will understand at some basic level that they're getting the kind of energy out of the food that we put into it, that the producers did. Maybe their hamburger is really good and they don't even know why. I don't want to be the best restaurant in the world. I want to be the place people in our neighborhood come to eat dinner. That's what excites me, a busy dinner service. The other night we were slamming busy and loud, and a guy came in and read a book while he ate by himself. That's exactly what I wanted. That's what he wanted to do and it's his neighborhood. It's not about being the hot new place. He didn't really care. He wanted to have dinner and read a book. He is my ideal diner.

Let's go back. I ask this of every chef I meet: what was the first restaurant you remember going to?

Probably the Red Carpet Inn, which was near where I was born in Denton, Texas. They served all-you-can-eat catfish, and there was a basket of bread with burgundy napkins that hit the table immediately. The dinner rolls were on top and they had cinnamon rolls on the bottom. When you're a kid there's no way you can actually wait.[4]

Away from the Red Carpet Inn, back at home, what was food like?

My mom did one hundred percent of the cooking. She tried her best. She was a working mom. We ate very simply. We ate TV dinners, fish sticks, pot pies. I wonder sometimes if that boring eating put me in a frame of mind where I had to make food more exciting, but maybe I always wanted it to be exciting. How do you separate nature and nurture? I loved food. I loved it no matter what it was, even if it was Jack in the Box. But I also feel like I defaulted into food service. I was born into a hardworking family, and when I started working at sixteen the first job I got was in a restaurant. It wasn't by design, but I never did anything else, and my desire to be more involved in the creative aspects of food grew and grew.

4 ——
Enough chefs were mentioning all-you-can-eat restaurants that I figured I should know a little more about the history of the idea. When did it start? It seems like medieval kings probably had all they could eat, no questions asked. But it turns out that the modern version comes from Vegas. I guess I shouldn't have been surprised. Most people think it started in the late fifties, at the El Rancho Vegas. A casino publicist named Herbert McDonald started serving cold cuts at the bar, and people who were gambling late came by and ate. It grew from there, both in Vegas and everywhere else.

Sounds like a normal American upbringing— chain restaurants, packaged entrées from the supermarket. Where does the first spark of chef thinking come from?

I remember cooking a crappie, which is a kind of fish. Me and a friend cleaned it and I fried it with bacon and potatoes. That was really exciting for me. When I look back at things like that, or the fact that I ate oysters since I was seven, probably tells me that I was destined for food. I liked the self-sufficiency of it as much as the creativity.

Oysters when you were seven? Are you a brave eater generally, or are there certain foods you hate?

I don't care for popcorn. I hate the texture and the odor of buttery popcorn. I find that really off-putting. Also the odor of smoked cheese.

That's crazy, I have never met anyone who didn't like popcorn, especially movie theater popcorn. It's one of my favorite foods. It really should be its own food group. I have always wanted to create toppings and different kinds of flavored butters for movie theater popcorn. Would you ever include popcorn on a menu in your restaurant?

If my pastry chef said, I want to try something with popcorn, I would try it. I mean, I am able to try it. I understand the perspective that it's generally popular and I know that other people might enjoy it. But smoked cheese would probably fall under the Do Not Cook rule.

As I have become more immersed in food culture, it is clear that the culinary world draws inspiration from other art forms. What other art form is most connected to it in your opinion?

For me, music would be the closest. I like to play a game where I like to compare musicians to restaurants or eateries. For example, if Cheesecake Factory was a musician, who would it be? It would be Florida Georgia Line. I think there are lots of parallels to be drawn, not just in the creative achievement, but in the makeup of the audience, in the balance between risk and reward, in the work ethic. But I think that food is like music, generally, in the sense that it is transient. After it goes, it goes.

Isn't that where cookbooks come in? They preserve the past, right? I've talked about this with other chefs, and decided that it's more like sheet music than a record album. It's come up more than once. Is that a good analogy?

Older cookbooks, especially, came from a time before cooking was so ego-driven and so they were written from a much more real place, a much more sincere place. When you read Julia Child or Patience Gray or Elizabeth David, you are reading a narrative that's more about food.[5] There was a more down-to-earth perspective back then. Now, with the Internet, everything is so quick and things are so flashy and people look at things for the wrong reasons instead of seeing cooking for what it is, which is that it's our job. I miss the days when it was seen more as a trade rather than an iconic position in the world where people valued your opinion on politics.

When you were training, how did you balance learning the craft with developing your own creativity?

I think that what was formative for me was going to Europe for the first time and seeing not only centuries of exposure to food and ingredients, but also the way the profession grew and developed rules and conventions for training. In a way, it's unfortunate, because people there work really hard and love food and they don't really get the recognition people do here. The way they cook is totally different. People treat ingredients with way more respect. It's not really about you, no matter who you are. It's about rounding up the right ingredients and treating the cultural heritage with respect. That was really appealing to me. When I came back to the States, I started to see these restaurant trends that were put forth as marketing bullet points, like only using ingredients that were available locally. That's not a new concept. It's the oldest concept in the world. It's funny to me. People get press as if they developed it because we're in a culture of ego. It's what kind of drives our collective consciousness.

—— 5

Julia Child, you know. Gray and David were British food writers who published in the 1960s, 1970s, and 1980s. Gray traveled around, settled in the boot of Italy, and swore off all modern conveniences like telephones or televisions. While she was there in Italy, she wrote about the simplicity of peasant food in a book called *Honey from a Weed,* which sounds like a hip-hop album title. David completed several ambitious studies of cooking styles, books like *Mediterranean Food, Spices, Salt and Aromatics in the English Kitchen,* and *English Bread and Yeast Cookery* (not good hip-hop album titles at all). One of the most interesting footnotes to her career was her collaboration with the artist John Minton, who did her early book covers and illustrations. Minton started to feel like his work, which was figurative, was out of step with the growing trend of abstract painting, and he fell into depression and alcoholism. In 1957 he killed himself by overdosing on sleeping pills. It's not a happy part of the story, but it's sort of a fascinating comment on what happens when an artist can't or won't innovate, and sees ideas moving too quickly away from him.

When you have food ideas, where do they originate? Michael Solomonov says that ideas often come to him when he's far away from the kitchen, that his subconscious will start solving a food problem while he's watching a movie or an opera. How about you?

I'm hardly ever far away from the kitchen. Some of my ideas are the result of being inspired by what's in front of me, and some of them come from fatigue. I don't mean physical fatigue, though that's a factor, too. I mean fatigue with ingredients. Maybe I'll get tired of okra and just in time something else will come in and I'll remember a way to use it. Sometimes, I guess, it comes from reading just before I go to sleep at night. I dream things sometimes, or at least I wake up with ideas.

It's interesting that you say that you're rarely elsewhere. I have gone through phases in my life where I eat, breathe, and sleep music, and then phases where other projects that seemed like sidelines come to the forefront. Occasionally, there are even times when I think I'm balancing my life with friends and family and relationships. I haven't quite figured out the vacation thing yet. The only time I asked my management to take time off was when I went on a pilgrimage to Tokyo to eat at Jiro's, and even then, I still got in a few DJ gigs, so for me it's never full vacation mode. Do you think you need more time away?

It's hard to say. With a more consuming food life, I have more of a stage for ideas. Since we're doing breakfast, lunch, and dinner, any idea can come to fruition immediately. It doesn't have to simmer. That spurs lots of creativity. Today, for example, I have pecans and crickets. We roasted both of them with chilies we dried and sugar and salt and just made a little bowl that we can serve tonight.

I like to separate out the different stages of the creative process. There's a brainstorming process, where I get all of the ideas out in front of me. But then there's a period when I might go through eighty songs to get the eight that work, and that work well together.

It's similar with food, too. But you have to keep moving forward along both tracks. Sometimes you just make something to make it—you try it because it seems like it might work. And other times there's a set of ideas in place and you're introducing a new idea alongside them. Then you need to be mindful of what's already there: the choices you've made, the response you've gotten, the ingredients and what their limits are. I want to know where each ingredient is coming from and who's growing it, along with the processes and practices they use to make it available, how fair was its production, and so forth. When it gets to me, my job is to prepare it in the way that makes it taste exactly right, and also to make money off of that so our business can stay open.

I've been surprised by how much chefs have talked about the business side of their restaurants. I just assumed most chefs are consumed with the creative process and didn't want to be bogged down with paying bills, pricing menus, juggling the numbers.

You have to be. It's really a fun game to me. When I get a bunch of carrots, I don't see just the carrots but I see the tops and the peels too. That can go into a stock. Then I can roast the rest. I like to think of things with a frontier mentality. Use everything. Waste nothing. That's the only way that we can keep our doors open. My family was very frugal. I inherited that trait. I don't see it as negative, especially when you're running a restaurant like this. We want to create a value for our customer and hopefully have a successful business.

That's interesting, because it shifts the ground a little bit under the issue of sustainability. Lots of people talk about it as if it's a moral or ethical issue, as if it's a matter of how we treat the world and its bounty. With you, it sounds like it's a business issue.

It's completely about money. I don't want to be super-rich, but I want to succeed. And I want to succeed with certain terms. For me, the point is to support our community and to support businesses that do things on an ethical basis. Food is a resource, and if you approach it as being a resource, then you have solved part of the problem. Because of that, we only serve food that you can find locally. There's nothing wrong with salmon, but we don't have to think about salmon. It's other people's food. We don't have it here. If we thought the same way about energy, we could solve lots of other problems. There might not be as many wars.

You seem to have a simple philosophy: please your diners, make sense of the food you're serving. Earlier on, you sketched out a picture of your ideal diner, and it wasn't someone craving novelty or risk. It was a guy who came by and read a book while he ate. How do you experiment in the kitchen? Eating at your restaurant for me was all about risk and experiment. I ate crickets on a salad! Or maybe that's simple to you.
When I was young, I took more chances. Now the innovation is being brave enough to stick to the things that are classic or to return to the things that have been a success in the past. Sometimes I am in a phase where I want to experiment a bit more, and it doesn't always feel right. It can feel insincere at times, and then I'll pull back from it. For the most part, our food is laughably simple. If we do what we do best, I feel better and the staff finds it easier. You want to shout to be heard when you're young and now I just want to have a conversation.

As a chef, do you explore the fanciest and showiest places? Do you go for a fifteen-course meal to try and find inspiration? I have a hard time with certain kinds of music. It's not that I don't respect the creativity of the people who make it, but I can't digest it. I have an intolerance for it.
I can't really do the fancy thing. I can't eat like that anymore. I just want tacos or mussels or fried fish or wine or cheese. My tastes are super simple. I see it and I respect it and sometimes it's perfect but for me it's hardly ever fun anymore. I'd rather take that money and spend it on quesadillas. I do respect it and I see why people are excited by it and want to go that route.

You aren't that active on social media; many chefs are these days. What do you see is the effect of the Internet on the worlds of food and cooking?
I see it as being very negative. I miss the conversation with humans. When people leave here and they had a wonderful experience, they may wave goodbye or say thank you. That's great. But if they had a bad experience they go to their car and write a horrible Yelp review.[6] That's a shame. Their experience would have been better if they had come to us. Not only do

they harm themselves, but they hurt us. The anonymous online potshot is like a drone strike. You can sit in a military base in Colorado and kill someone in Afghanistan. I don't find the cultural shift to be very pleasing.

It's not easy to read bad reviews. There used to be a screening process, where a manager would only bring certain critics to your attention. Now, it's all right there in the open. Everyone can get in front of you.
When you read negative comments, you feel hurt. You start to doubt that dish or that server or the design of the restaurant. But that makes no sense. So many other people had it, and they seemed pleased. Doubt isn't a great thing in this business.

Let's talk about the future of food. What are the main challenges people are going to face?
I hope we treat our resources with more respect. They are so meaningful and we can do so much harm and so much good with simple choices. I hope that things along the lines of what we do become more widespread. And that people no longer see it as a novelty but an everyday reality. I know that I would like to see restaurants like ours pop up regularly, simple little neighborhood restaurants that use what they have and buy simple food. I'm very hopeful because I think that as a society we fuck things up pretty good until it's bad and then we turn it around. I hope we'll pull it out at the last minute.

—— 6
Just to clarify, Jesse and his restaurant don't get horrible reviews. The worst I could find was this: "It may be your cup of tea but it wasn't mine." That doesn't even make your ears warm.

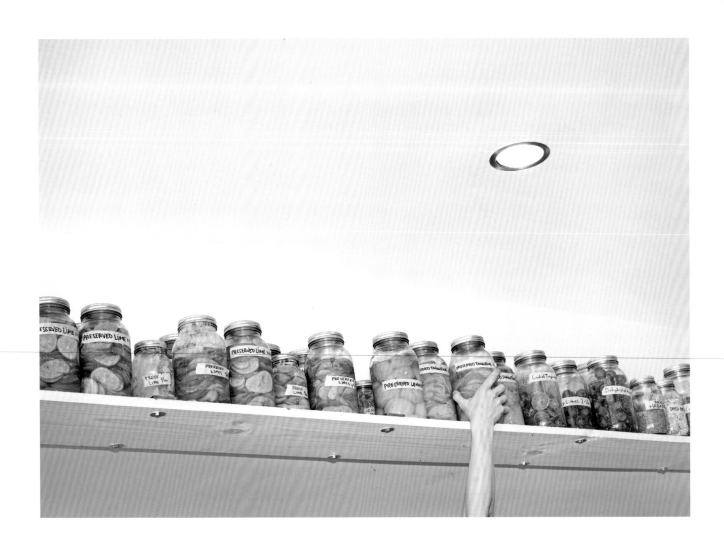

(above) Preserves and
pickles on a shelf

(opposite) Deer leg, Texas tile

(following spread)
Julia Poplawsky butchering
a deer. It only took twelve
hours.

(left) The Breakfast Table.
Is this how chefs and their
people eat? I'm usually
finished after a bowl of
Cap'n Crunch.

(above) A Vinyl Sandwich:
booths surrounding
record player

"Over time I started to realize that it was okay to embrace my roots."

Donald Link
New Orleans

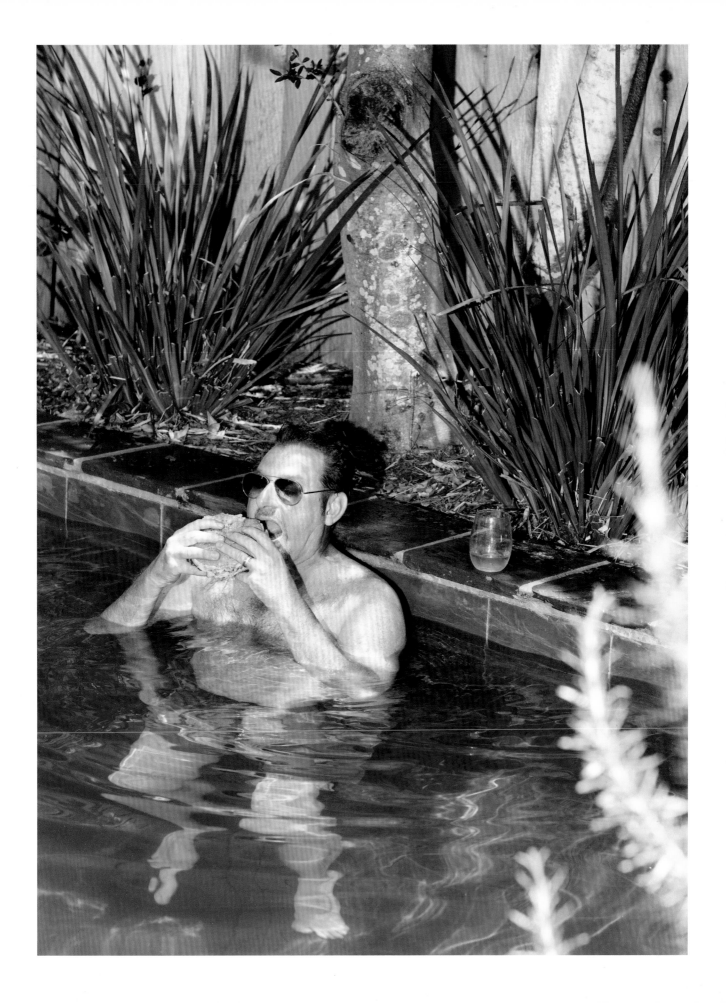

For years, I thought of New Orleans as a music city first—more than that, as America's first city of music. In 2005, the Roots were playing a gig, and we struck up a relationship with a local band called the To Be Continued Brass Band. They were teenagers from Carver High. Rich and I talked about it and decided that the city had a rich enough music history that we should move there and record our next record. We had the idea of doing something like a domestic Graceland, where we would mix musicology and cultural exploration. A few months later, Hurricane Katrina came along and ended that dream.

While we were there, though, my sense of the city changed. Going in, I knew that my knowledge of the city's culture beyond music was pretty narrow. Whenever anyone comes to Philly, the first thing I do is keep them from going to the Top Five typical cheesesteak spots—the Geno's and the Pat's, etc. I'm always looking for that person in each city, the guide who will steer me away from the predictable. And so, when we were in New Orleans, I made some new friends who introduced me to the true local spots. That's a kind of tricky process, because you start a game of oneupsmanship. If you go to a great hole in the wall, the food snobs will try to outdo you and come up with an even more secret one. That year, I tried local cooking in ways I hadn't before. I went into deep swamp food, meats like alligator, crocodile, frogs.

New Orleans is a great example of what I have started to learn, and what I saw very clearly at Jiro's: food is much more than taste. A real experience has to be immersive in all five senses. It has to smell awesome. It has to feel awesome. It has to have a distinctive look. Donald Link is an expert at paying homage to his culture while also building away from it. He picked up a thread that Dave Beran and others spun out—how does a creative professional know when to double down on success and when to cut loose and start something new? I have eaten at his places, from Herbsaint to Butcher to Cochon, and I have eaten with him, and every experience is a master class in how regional cuisines can survive and change, or change to survive.

Deep South food has one scary dimension, which is that you can only go back so many years before you bump into something dark in history. It's not Cochon's responsibility, and I feel it more in other places than in Louisiana, but it's really a factor. I was in Mobile, Alabama, recently, and there was a diner there that had a big plate-glass window in front. It was about to be dusk. There were these great old trees outside, and as the sun went down, the trees started to look haunting and threatening. I asked my tour manager how old the trees were and the answer came back: hundreds of years old. So these are the trees that my forefathers hanged from? I felt like they were going to come to life and chase me. It was too authentic. I didn't tell Donald Link that story before I spoke to him. I guess he knows it now, if he's reading this.

Some people in this book are transplants, in the sense they're cooking far from where they grew up. Ludo Lefebvre comes from France to open a restaurant in Los Angeles, or Ryan Roadhouse goes from Iowa to Canada to Tulsa, Oklahoma, to Denver to Portland. You're more or less back where you started in Louisiana. What was the first restaurant you remember going to?

Well, I was born in Bossier City, Louisiana, on an air force base. I grew up in Sulphur, Louisiana, which is named for the sulfur mines, and then spent a few years abroad when my dad was in the military. We came back to the States when I was six or seven, I went to college in Baton Rouge, at LSU, and then I settled in New Orleans. That was about twenty years ago. This is a long way of saying that I ate in Louisiana my whole life. And most of our eating was in people's homes. There weren't that many restaurants around. If we did go to a restaurant, it was probably a Chinese restaurant. That's all we had: a Chinese restaurant and McDonald's and cooking at home.

So who did the cooking? I remember my grandmother making us her version of down-home cuisine. Sometimes she would cook up what my dad's brothers would bring in from hunting. Sometimes she would make food to stockpile in the refrigerator.

Both sets of my grandparents cooked, though it wasn't equally distributed. My dad's dad didn't cook shit. In that family, it was my grandmother, and she might make a pork roast or a gumbo. But on my mom's side, there were ten kids who lived in-state, and my grandfather on that side cooked everything. He hunted and fished and he would have eight things on the stove: collard greens and creamed corn and rabbit and dumplings. They were these huge spreads.

Right now, when you talk, I'm picturing a huge Louisiana meal. I'm including all the things that you mentioned, the collard greens and creamed corn, but I'm including other things, too, things that probably make it much more like a movie cliché. When most people mention Philly food, they're not thinking much past cheesesteaks. Louisiana must have food clichés, and they're probably connected to cultural clichés in general. Even with new, more sophisticated shows like *True Detective* or *Treme*, there's always a *Big Easy*-type stereotype lurking in the background where people can't stop talking about beignets and jambalaya and po'boys and gumbo.

I don't think Louisiana is ever represented that well. I thought *True Detective* was a great show in terms of the cinematography and the screenwriting, but it didn't get points for cultural accuracy. Louisiana's a tough place to describe to outsiders. Most people's idea of our food comes from Paul Prudhomme in the eighties. Back then, he was everywhere, and so people got the idea that Louisiana food was Cajun food—and more specifically than that, a version of Cajun food that was really Paul's interpretation. But what does that mean? If you go back a little bit in history, Cajun is a blend of the cultures of the French, the Caribbean, and the Spanish. And so you start with things like Puerto Rican rice casseroles, then the Caribbean French come along and add roux, and others added okra, and gradually the cuisine became what it is today. When I grew up, it was never called Cajun. It was just food to us.

There's a comedian who has that joke for Chinese food, that in China they just call it food.[1]

As a kid, I never really thought about food in this formal professional way, where I would track influences and map cuisines. Now I can see the whole thing a little more clearly. That's what gave me the original idea for Cochon. I spent lots of time in culinary school doing fine-dining French. It wasn't that I had forgotten my heritage, only that there wasn't so much call for it. When I moved back to New Orleans in 2000, everyone kept asking me where to get good Cajun and there really wasn't a place. I decided to open Cochon to connect it to my upbringing.

— 1
I have a vague memory of hearing this in a stand-up special or seeing it in a movie, but it's proving very difficult to source that joke. It's all over message boards and seems to be part of the overall comic mind.

The idea of upbringing is brought up all the time in the book. I grew up surrounded by music, not just as a consumer but also as the son of musicians, and I got the idea early that music was something that required hard work but yielded amazing results. Did you feel that as a Louisianan, you somehow had access to a more evolved sense of eating? There must be places where food isn't really woven into the fabric of everyday life.

I went to debate camp in California at fifteen, and I'll never forget that first meal in the cafeteria. I was just shocked: This is what y'all eat? I may have even said it out loud. Even our school lunches were good when I was a kid—we had homemade rolls and greens and smothered hamburgers with onions and gravy. That was one of my early recognitions that there was a food culture at home, though that didn't point me toward the food business.

What did?

It's a winding path, probably like everyone. In high school, I had some rough times, and I cooked and washed dishes in burger joints. Then in the early nineties, in my early twenties, I moved to San Francisco with this girl I met at LSU and got a job at a place called Spaghetti Western. At first I was doing breakfast, but they asked me if I could add some Louisiana food. It was pretty basic stuff: dirty rice, some gumbo. I moved on to a Caribbean restaurant in the Upper Haight that was owned by a Cuban guy, and I remember how exciting that food was. It had a bigger flavor profile, bigger seasonings. Then I went on to a place called the Flying Saucer, where I worked with a guy named Albert Tordjman. He was half-Moroccan, half-French, and all crazy. There's an urban legend about a chef who stabs a knife into the table of the food critic and tells him to get the fuck out of his place. Well, Albert was the guy who really did that. I had just started culinary school out there, and all the instructors said that nobody could work with Albert. Anyone who can make it through one night with him, they said, can make it through anything. That was enough for me. I showed up at his door, and it's a good thing I did. In addition to being crazy, he was a genius. People who said he was the best chef in California weren't exaggerating. If anything, they were underselling. He's deceased now.

2 —

Again, I can't source this quote. Richard Pryor? This is part of a larger comedian intellectual-property issue: jokes just make the rounds and people claim them.

That's not the first story I have heard about an extreme personality in a kitchen. The restaurant business seems to work on people that way. Some comedian says that about cocaine: whatever your personality is, it just intensifies it. If you're a jerk, you become that much more of a jerk.[2]

It wasn't great behavior, but it showed me that the restaurant business is so much about passion. A guy came up to me one night, not even Albert, and shook me and screamed at me and said "You gotta be a fucking gladiator!" Albert was a gladiator. He was passionate to a fault. His cooking techniques were obsessively perfect. He wouldn't let us use a potato peeler. We had to do it with a knife. And when you cut vegetables, there was no hacking away at them. You had to do perfect dice. He would watch everything. He was meticulous and unyielding. And even though it was only a thirty-five-seat restaurant, it felt like we were doing a thousand covers a night. That's where I really found this deep love and appreciation for techniques and skills and seasoning—and, obviously, shutting the fuck up and keeping your head down and staying out of the line of fire.

That's the very definition of an apprenticeship, and it's something I have also heard from lots of chefs. You're not ready until you're ready. Dale Talde told me a story of working at a restaurant, I won't say which, and having a spoon thrown at him so hard it hit a pot next to him and dented it. Those things seem like violence, but they're also measures of commitment. So how did that travel with you back from California?

When I made my way back to New Orleans, I didn't want to be known as a Cajun chef. There was a bit of backlash in me in terms of not blackening catfish. I had an attitude that it just wasn't what I did. I opened Herbsaint at the very end of 2000, and that whole first year, I fought against anything that seemed like local color and tried to go traditional Continental instead. I remember making a foie gras terrine that was very French-based. Over time, I loosened up a bit and started to realize that it was okay to embrace my roots. I had a skill, which was that I had this built-in experience with boudin and gumbos. I could make them with soul and character. I stopped resisting. I realized that I didn't have to exactly re-create the dishes of my childhood, but that they were an amazing

foundation. I returned to Southern cooking with some of the ideas from California—big flavors and brightness and local ingredients. But that took changing what was around here.

What do you mean?
It took changing attitudes, for starters. At one point, I opened a second branch of Cochon in Lafayette, in Cajun country, and that didn't work out well. People out there had an even more specific and conservative idea of what the cuisine is and what it's not. They accepted only the most traditional dishes: gumbo, jambalaya, etouffee.

I had those battles with my father all the time, where his idea of music clashed with new things that were happening and he was stubborn about moving off his spot. I remember when he first saw Prince on TV. "Is that boy in his diapers?" he said. Another time, we were in a van and the Police were playing— it was that song where Andy Summers is screaming.[3] **My father didn't like that and he said so to the guy who was playing it. "Turn that devil shit off in front of my son," he said. And hip-hop, well, he didn't think much of it. I think in** Mo' Meta Blues **my description of his description is "a bunch of nonmusical nutgrabbing."**
Right. And I don't think that with most of these customers, their resistance to my food was hugely considered. It was simply that their moms cooked it a certain way, and so that's the only way, and everything else is crap. For me, I like different gumbos. I love that there are so many versions and variations and experiments. When I'm out, I always order it to see what that particular restaurant is doing. Take something like catfish courtbouillion. It's still a fairly conservative dish: fish cooked in white wine, tomatoes, bones in. But there are discrepancies in how it should be made. I had a guy once who came up to me in Lafayette. "I want to see how you make that," he said. I started to show him and he stopped me. "No, no," he said. "What you gotta do is get the seasoning in a can."

So how do you start connecting to simplicity without resorting to seasoning in a can? It's like a form of innovation that looks backwards instead of forward. It's like the opposite of Back to the Future. **It's more like** The Wiz—**or, as other people insist on calling it,** The Wizard of Oz.[4] **You need to teach people that they had the power to go home all along.**
The first thing you have to do is to realize that ingredients matter. Let's take pork. When I first got back to New Orleans and started calling purveyors for pork, what I got was this bland dry cheek and chemical laden pork shoulder. It was fucking nasty. We found our own farmer and made a deal to start raising a certain breed. We did lots of research on what kind of hogs would produce the best fat and meat without sacrificing the amount of meat. Now we sustain that farmer. We buy eight two-hundred-and-fifty-pound hogs a week. The same thing is true with produce. I'd go to markets and wonder why we're only getting these bell peppers when chiles grow like weeds. In fact, they're one of the only things that will grow around here. I had been to Spain and had these amazing chile peppers. I got a catalog and found a farmer and said "Hey, let's try these." In traditional Creole, or Cajun, the spices are really just these mediocre chiles in a shitty dry form. We get these amazing chiles, and then dry them and I keep them in a Ziploc bag.

Are you always receiving transmissions on the food frequency? Can you go to a country without thinking about the way they're eating? I ask, obviously, because I can't really go places without thinking about the local music culture.
Well, I've been fortunate enough to travel extensively, and I always pick up something new. I've been to France, to Italy, to Uruguay, to Peru, to Puerto Rico. I pick up ideas or rather bits of ideas. It's not like if I go to Mexico I'm going to come back and suddenly start cooking Mexican. But I had this ceviche in Mexico that I loved. I don't generally like Peruvian ceviches. They're too acidic and sharp. This Mexican one had a nice balance. It had spices that were not too extreme in terms of heat level but had great flavors that worked well together. That kind of thing is perfect for Creole cooking. Creole cooking is just waiting for it.

—— 3
It's "Mother," and he even says the word screaming as he screams: "The telephone is screaming." It's on Synchronicity, which was the first rock record I bought on my own, without my sister's help, so it has a special place in my heart.

—— 4
I just learned that The Wiz will return to TV as one of those live-action network musicals, like The Sound of Music or Peter Pan. It will already have aired by the time this book comes out, but let me just say for the record that I'm not sure how I feel about a Wiz without Michael Jackson.

When you have a discipline in any of the arts, music or food, there's so much training that goes into it before you're equipped to have your own ideas. You might have glimmerings before then, but not fully formed ideas. I do remember the period where I started to move from re-creating other people's beats to thinking that maybe the things I was playing were my own. Do you remember when you first felt that moment of invention?
It was probably at Elite Cafe in San Francisco in 1997 or 1998. I was serving this eighties version of bad Cajun food from a steam table. I went in and asked if they wanted to get rid of it and do some exciting Cajun. The owner called me to talk it through. I was very clear with him that my plan was to throw everything away and write a new menu. He agreed. I started inventing—in other words, finding these routes to arriving at the food I wanted. For example, at that time I couldn't find good sausage, so I started making my own. I began to combine French dishes like duck confit with traditional Louisiana staples like dirty rice. It got so popular that the general manager was concerned that I had set up something that nobody else would be able to follow if I left. To me, at the time, that was funny. I was twenty-seven and I didn't give a shit. You're telling me it's too good? That's not my problem.

When you talk about American culture, you're talking at least partly about race. Sometimes the issue is right there on top, and sometimes you have to peel away layers to get to it. What's the history of black food and black chefs in New Orleans as it relates to the broader community?
That's a tricky and complicated question. Think of the music of New Orleans. It came through Africa and the Caribbean, with black creators and black messengers. Lots of the food arrived along the same route, of course. It was Spanish and French food bouncing in and out of these New World locations. They weren't eating Creole food because it didn't exist yet. And the slaves created their own food because of what they had to cook with: different ingredients, different tools. But their food didn't get written about very much. Lafcadio Hearn was eloquent about Creole culture when he wrote about it in the nineteenth century, but he limited his sense of things to white colonists. So lots of black cooks and black food got written out of the process.

Does that process continue to this day in some ways? As I was researching for this book, and thinking about how race plays a role in music, in food, in the visual arts, I noticed that despite the fact that the food world includes so many kinds of dishes, so many influences, most chefs are still white men. Why is that?
It's something that's impossible not to think about. I have taken field trips to Baltimore and to Washington, D.C., and they have some of the same issues as New Orleans. When you look at large urban African-American communities, there's a lack of food and a lack of access, and it's hard not to feel like it's part of a bigger systemic problem with education and opportunity. When I was growing up in Louisiana, most people in black communities still cooked, especially in rural areas. Everyone was a home cook. That happened without it becoming a profession or an industry, really. I think the same is true with music. If you go to the Mississippi Delta, there are these musicians there that are just phenomenal, like nothing you've ever heard, and maybe they're making forty bucks a night. You just can't believe how good they are and they're in this Podunk fucking town, how skilled and advanced, but it doesn't necessarily translate to being able to make a living. And then in urban areas, there's not even that level of skill.

This is part of the much larger crisis in urban black communities. There probably isn't cooking because that depends on some kind of stability. Tariq and I both went to CAPA, this performing arts school in Philadelphia, and we've tried to keep a hand in sponsoring students and raising scholarship money and making sure that kids who show talent have at least a chance of turning it into something more permanent.
The terrible parts of this system seem to grow. There's poor education and too much violence and drugs. Households are busted up. Not quite forty percent of black males in New Orleans finish high school. There's not opportunity, and because of that, young people in those communities aren't looking for jobs in the same way. At my restaurants, for example, we don't get many black applicants. That makes the problem even harder to attack. It backs up the problem to a more basic level. You can't even

have discussions about black-owned restaurants, or black chefs, until you have black cooks. And getting black cooks means getting black workers in your kitchens, and that's going to take some basic job training: how to look for a job. When you go into the Quarter, you see black cooks there, but they're older. I want to restart some of that among younger people.

You also hear about all the problems with urban diets. Other chefs have talked about that, too—how there's not really a problem with food scarcity in poor neighborhoods. There's a problem with a surplus of the wrong kinds of foods; foods that are cheap, but not nutritional.

When I was in Baltimore, I went to a market to shop. I got ten dollars to buy food for four people. I can do that all day long. But the woman in front of me had the same budget, and she was spending it all on donuts and soda. That's an urban poverty issue that has consequences for food culture.[5] I try to deal with it by staying focused on local issues. We get offered all kinds of opportunities to participate in national charities. People from out of town are calling all the time to ask us to join up with this nutrition program or that local sourcing program. We've had to give up all of that to focus on just one thing, which is the problem of urban communities here in New Orleans. We have a job-training program called Liberty's Kitchen. I tell kids that if you want to come hang out in the restaurant, let me know. If you want to take an apprenticeship and show up and work, we can work on that, too. There's ways we can be directly involved, and not just by raising money.

This is a heavy issue. I feel like I'm Charlie Rose. Let's talk about lighter stuff for a little while. What's your favorite guilty-pleasure food?

I'm pretty fond of chicken wings, or, for that matter, any kind of fried chicken. Fried rice and fried chicken seem to be my greatest weaknesses.

Are there any foods that you hate?

Anything that's badly prepared. But I have a problem with bell peppers. And cranberries. I don't get it. I don't see the appeal at all. Maybe it's the tartness. And I'm not a huge fan of pineapple in hot food.

For me, it's beets. I've had so many horrible experiences with them. And then I ate at this vegan spot in Philly called Vedge and had no idea I was eating beets. The chef came out to explain the dish and I was stunned. "Beets?" I said. What's a food you want to eat in its native environment?

Vietnam is the number one place I want to go. It's just so fresh and vibrant and interesting. It's more like what we think of as street food, with incredibly inventive spices and herbs. Many cooks here go and eat Vietnamese food whenever they get the chance.

If you could invent one thing to make your life in the kitchen easier, what would it be?

A line cook. Everybody wants to be a chef these days. I want some actual cooks.

Many of the chefs in this book are at the same point creatively that I'm at: early middle age, I guess you'd call it. And one of the things I keep hearing is that as chefs get older they cook more simply. They set aside the impulse they had early in their careers to make a stand, or make a show.

Without a doubt, that's true for me. When you eat the food of some young chefs, it's like reading a fucking novel. What are you trying to accomplish? It's too ego-driven. These days, if I cook fish, I want to taste the fish. You shouldn't be serving it if it's not beautiful. So why put so much shit on the plate? And if you try for simplicity, that also helps you avoid cliché. We opened Cochon eight or nine years ago, and in that span we've seen the growth of lots of Southern food, but it has become so trite. Everything has bourbon or pecan or molasses. Everything has glaze. Do you need those same techniques piled on top of everything?

It's like the EPCOT problem. When you go there, there are all these international plazas that boil down countries to a few ideas: schnitzel in Austrialand, or tulip soup in Hollandland. Those are bad examples, but you know what I mean.

Pêche is a good illustration of this. We went to Uruguay, and I fell in love with this simple cooking there. It was brilliant. You have great meat and you have fire. After four bottles of wine I wrote out a two-page menu of my vision, based on that. Then I was talking to my partners

—— 5

A few weeks after this interview, in April 2015, Baltimore was in crisis as a result of other urban poverty issues: police brutality, entrenched gangs, underclass frustration, and more. I thought of Donald's point when I read the eloquent remarks of John Angelos, whose family owns the Baltimore Orioles. He wished for peaceful protests and hoped that unrest would not interfere with baseball games, but he said he was much more concerned with something else: "The past four-decade period during which an American political elite have shipped middle-class and working-class jobs away from Baltimore and cities and towns around the U.S. to third-world dictatorships like China and others, plunged tens of millions of good, hard-working Americans into economic devastation, and then followed that action around the nation by diminishing every American's civil rights protections in order to control an unfairly impoverished population living under an ever-declining standard of living." It's a messy sentence, but it's a messy situation.

and we decided we should go to San Sebastian, where they do the same thing but with seafood. We wanted to change the way people think of Gulf Coast seafood. The result was this Spanish South American style of roast meats and cooking over fire. How do you make it a New Orleans restaurant? Well, it is one, by default, because it's here. You don't need po'boys.

But do people clamor for them? Is the tourist jones still so strong that they want the cartoon version of New Orleans? You'd think that diners in general would be better informed because of the Internet—not that their taste would be better, necessarily, but that they would have a better sense of the tastes that are available to them.
The more people eat out around the world, the more they learn about international foods and world cuisines, the more sophisticated their palates become. You do see more and more people come to New Orleans looking for something special or distinctive. There was a time in the beginning of Cochon when everyone wanted fish blackened. That doesn't happen as much anymore.

Do you like the Internet in general for its effect on restaurants?
No. I hate it. Especially when it comes to the ways that it lets people weigh in critically. I don't know if you've seen that YouTube series "Real Actors Read Yelp Reviews." They're just ridiculous. There are some legitimate concerns. But honestly, the validity of the negative experiences that people have are maybe .02 percent. The most common thing you see is people getting pissed off because they were made to wait. What they don't tell you is that they had an eight o'clock reservation on a busy night and they show up at 7:40 or so and got seated at 8:08. Or someone else claims that they got food poisoning and there's no accounting for why the two hundred other people who ate at that same restaurant that same night were fine.

Other chefs have said that they read the reviews, sift through them, and find things that they can learn from.
I can't say I learn anything from Yelp. We look once every six months, and I get angry and say, what a bunch of morons. There's never anything

good in there. I'm in the restaurant all the time. I see how it works. I have a system of managers and chefs that are trained to look out for exactly the kinds of things that people on Yelp are claiming to have noticed. And they're good at their jobs. Managers can walk around and look at expressions, at the visual cues people give.

Michael Solomonov was talking about the Internet's criticism culture and said that for him the biggest problem is that it takes away the face-to-face component of desires, demands, and disappointments. It's one thing, he says, to go and talk to the chef and say that you were unhappy with your meal. It's another one to scurry home and carp about it.
In the restaurant, that's absolutely true. Feedback, especially negative feedback, is one of the most important things. People come up after meals all the time and say they loved everything. I'm glad to hear that but I'm more interested in what people didn't like. I mean, I know our food is good but at the same time I want to understand why some people didn't have a good experience so that we can turn that around. If someone orders pork belly and complains about it being too fatty, we'll give you something else. In the end, our only goal is to please diners. Still, I use the Internet all the time. I look up other restaurants. I look at menus and research different ingredients. I get images for plates and presentations. It's incredibly useful if I'm traveling: not to read reviews, but to get a list of new places in a city.

We're asking chefs not only to be innovators, but also futurists. Where do you see the food world going in the next decade?
I think you'll see food really become more intertwined with other culture, to the point where there might not be cuisines in the traditional sense. When I look back ten years, or twenty, food was very specific. There was Mexican or French or Chinese. If you wanted to bring one to the other, it took some doing. Now the food blends more and more. You almost cannot locate or recognize the actual source of a dish. It all melds together.

How about the future of ingredients? Will there be fewer and fewer good ingredients? Many chefs have said that fish, for instance, are in shorter and shorter supply.
We're lucky here, because we're on the water and have lots of connections. The Gulf is a pretty well-maintained fishery. But worldwide, I do think that farm fish will come into play. With other meats, like pork, there has been lots of movement. When we started making bacon, it sucked, so we got a relationship with one pig farm, and we sustain them. Our business alone accounts for about $7,000 a week. And there are lots of local farms that profit from those kinds of arrangements. We have a girl on staff who does nothing but work with farmers. She'll go and say this is how much we'll buy, this is our usage, this is how it's spaced out. The result might be fifteen cases of arugula every week, or ten pounds of squash, and we can start directing them as to what to plant and when. But the truth is that this is only a sliver of the larger picture. We're not going back to Wendell Berry's utopia of small farms. The best that can happen is that this kind of behavior from restaurants will pressure the bigger producers to behave more responsibly and make better food. You're not going to feed millions and millions of people with small community farms. I would like to tell everyone to buy chicken from local farmers, but that's not economically realistic. You're only going to make a big-picture difference when the major agricultural industry starts to shift, when labeling is more honest, when politicians get past rhetoric.

Do they ever? Plus, there's the matter that bespoke eating isn't for everyone. Think of audio equipment. I might know that a certain audio system sounds good, but the truth of the matter is that most people are going to be listening to music on their computer speakers, or through earbuds.
You can't be a stickler and say that there are only two choices—either locally produced organics or starvation. And while you can tell kids to eat healthy all day long, imagine a single mother in the middle of the country with no access to ingredients. Most urban farmers' markets are for yuppies, for hobby cooks. There are exceptions.

When I was in San Francisco, I would go to the market, and it was large and cheap—there were lots of Asian foods that were being used by real people. You could cook for twenty people for five bucks or less. Some Latino communities are the same way. There's a way to stretch food and eat better, and it's not necessarily this utopian yuppie idea of local and organic.

Maybe the answer is in bringing food back into the home. I've been asking people about their earliest meals, both in restaurants and at home, and every time I ask I think about my own answer. Much of the cooking was done by my grandmother. She used to make us bacon, or prepare what my uncles caught when they went hunting. She did it all for cheap. Those are the same kinds of dishes you might see now in a restaurant as part of a $500 meal.
We went to Belize and ate in these shacks in Mayan villages. One of the places was an Indian restaurant, and that was one of the best meals I've ever had. It was nothing fancy at all—a hacked-up chicken with chiles and curry—but it was out of this world, and cheap as hell. There is a way to cook well with no money. You say you think of your grandmother. I think about my grandfather, who I mentioned at the beginning of our conversation. It's almost the same thing. He's up there laughing, seeing what restaurants now charge for ham hocks and collard greens. That food was born out of poverty. Now it's haute cuisine. It's ironic.

(above) May the Farce Be with You: in a butcher shop far, far away

(right) My tools of the trade are a turntable and records. Here are a chef's tools.

(following spread) A Rare Delicacy: black-eyed peas over cookbook

(opposite) Okra on Pink
(raw okra)

(above) In-house cured
meats at Cochon Butcher

(following spread)
Caught red-handed

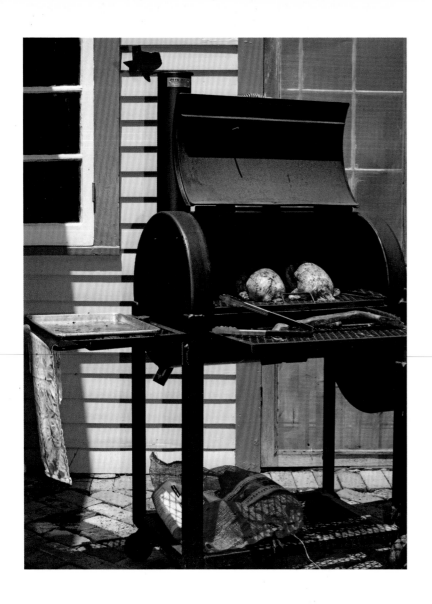

(above) Donald's famous
backyard smoked chicken

(right) Gulf shrimp in
Donald's kitchen sink

(left) Let's Invite Them Over: the neighbors drop by for dirty rice, shrimp and corn stew, black-eyed peas, rabbit and dumplings, smoked chicken, chicken in island style

(below) Gumbo in family gumbo bowl

"For me, food is art. I have a brush in my hand and this brush is a knife."

Dominique Crenn
San Francisco

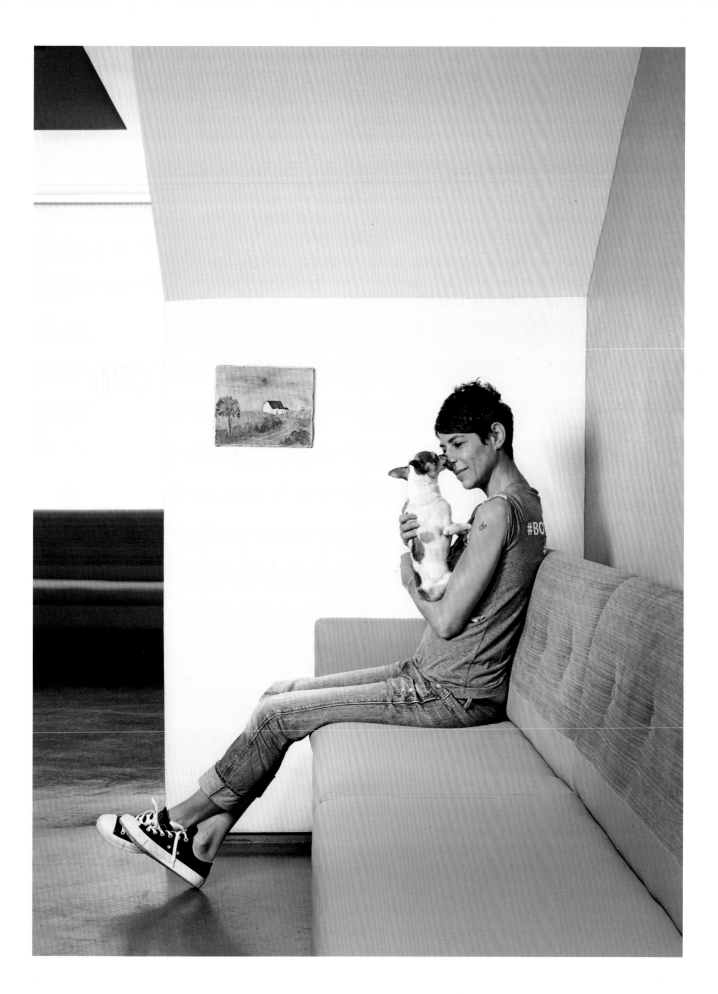

The first time I went to San Francisco was as a touring musician. The Roots started going there in the early nineties. And pretty quickly, it became a home away from home, because of the food. But it wasn't the city's food in general. It was one specific restaurant. There were these two sisters who befriended the band—I think they knew the product manager at our label—and they ran a Thai restaurant with their mother called Thanya & Salee's in Potrero Hill. It was the best Thai food I'd ever had, and the only restaurant I knew or cared about. I never ate anywhere else. It was for emotional reasons, too—my parents had recently split up, and I felt like I needed a more solid family structure. Thanya & Salee's gave me that. It felt like Thanksgiving every time we went there. Around 2006, at a time when many small businesses were suffering, they closed their doors.

I mentioned Thanya & Salee's because it was so emotional for me, and Dominique Crenn believes in the same emotional connection to food. Her menus aren't just straightforward descriptions of the dishes, but rather poems that she writes. When I first saw an Atelier Crenn menu, I noticed a subtitle, "Poetic Culinaria." She's not kidding. The menu is made up of lines of verse, formatted down the page: "Where the broad ocean leans against the Spanish land," or "The setting of orange sun," or "Taking a sip of autumn." The language is impressionistic and evocative, not ingredients and techniques. It's like she's

writing lyrics, and not necessarily about food but about life in general. It turns out that they're connected to certain memories, and those memories are connected to certain sensations, and that guides her in the dishes that she makes. I was talking to my editor about this, and he pointed out that this is sort of a further evolution of how menus have always worked, before dish names became lists of ingredients. Something like Peach Melba doesn't mean anything—you don't know what it is unless you know what it is. But Dominique has a specific, personal version of this naming practice, one that she connects intimately to her ideas about cooking. And she does it to great effect: she's one of only two women in the country with two Michelin stars. She knows what she's doing. And so, I should let her get on with the business of explaining it.

I'll start with the boilerplate.[1] **In this book, there are some questions I'm asking every chef. Like this one: What's the first restaurant you remember going to?**

That was a long time ago. I grew up in France. Both of my parents loved food. My father's best friend was Albert Coquil, who was a famous French food critic. They took me with them to restaurants. The one I have a vivid memory of, I was maybe eight years old, so it's probably not the first restaurant. But it was the first time I had a tasting menu. It took place in a restaurant in Brittany, in Cannes. I don't remember the name but it was a Michelin one-star restaurant. What I recall about it was the dance, the way that people were moving with each other, the way that we were being served, the sequence of the food. I thought I was watching a show or some kind of symphony with bodies. I told my mom that I was very taken by it.

You're jumping ahead. With that answer, you've already anticipated a good number of the questions I wanted to ask you later: questions about what art form you think of while you're cooking, about how you came to be interested in food as something more than simple sustenance. We'll get back to them later. But I wanted to go back to this idea of your family being very interested in food. My family was a musical family, professionally speaking, and I apprenticed at home. Then later, I went to a performing arts high school. How did you balance that early exposure to food with a sense of your own creativity?

I didn't go to school to learn how to cook. I wanted to be a chef but I didn't like the strictures of the schooling process. Instead, I went to school to study business and economics. Later on, when I came to San Francisco and realized that I wanted to work professionally as a chef, there was a long period where I was aware that I had to learn the basics. In some cases, it was relearning: I felt that I learned lots of them with my mother and my grandmother. I was very observant on many levels when my mother cooked at home, and when I went with my dad and his friend, I hung out and watched everything. But there was still the matter of those basics, of simply learning how to translate ideas into cooking. But I think that my lack of formal training meant that I was a little more geared to the understanding of people

I worked for, understanding how the way they were cooking reflected their personalities. I saw cooking as a version of who they were, and that's still how I cook. My cooking is about the way I am.

So you think you have always had a special relationship with food?

Yes, and for a specific reason. I was adopted when I was eighteen months old. Though I was born in France, I didn't know what else was in my blood. My parents were classic French in their upbringing, and when my mother took me to the market with her, she noticed that I would touch and smell ingredients that she might not have otherwise used. I would grab them and take them home and try to figure out what those particular ingredients were bringing to me, what stories they were telling me. I gravitated toward Middle Eastern foods, toward things that had maybe a little bit of Asian ingredients. The spices that attracted me were things like coriander and cilantro, cumin and ginger. They are foods that at that time in France would have been called exotic. I felt a connection with them. I felt that there were stories behind them that were somehow part of me.

It almost sounds like you were trying to reach back into your own past, before you were adopted, through the food. They say that the smelling parts of the brain are the closest to the memory parts of the brain.[2] **Were you actually time-traveling by picking certain ingredients?**

There was something about them, definitely. Maybe it was the smell of me with my birth mother or birth father.

I know people who have similar reactions to music. It seems like it's hardwired into them, like that tile is part of a mosaic that's been mostly destroyed.

People often say that food is the core of a society, the core of the human race. But it's also the core of individuals. It's with us from the very beginning, and anything that has to do with food can reconnect you to a story.

— 1

I used to think that was a cooking term. Doesn't it seem like one? Boil? Plate? Turns out it's actually a newspaper term—syndicates would send certain articles out to newspapers on metal plates.

— 2

I spoke to a scientist once at a party who told me that humans might be the only animals who associate smells with certain moments in their life, rather than with certain behaviors (foods, poisons, dangers). When I went to confirm that, I started to read more about the olfactory bulb but I got distracted thinking about west-central North Carolina, where Stevie Wonder was driving between tour stops in August 1973. He wasn't driving, obviously. He was being driven. He was in the passenger seat of a rental car. A flatbed truck hit them. He sustained serious injuries, including losing his sense of smell. And then I started thinking about *The Cosby Show* episode where Stevie's car hits Theo and Denise and then the whole family is invited to the studio. That's a seminal moment for many hip-hop artists, because it was the first time we ever saw a sampler.

Being so intent on finding the meaning in food from such a young age: that can't be the case with everyone. Lots of chefs in this book have grappled with a version of this question. They know that food is necessary for survival, and they wonder if it's always right to make more of it than that.

But food isn't just about feeding people because it's a necessity. My parents, when we weren't going out, ate at home, and it was pretty casual, but it was also about celebrating where the food was coming from. Both of them came from French farming families, and they learned about the soil and respecting where things came from. When we went to restaurants, I learned to look at the stories behind food, at the meaning, and that led to looking at food more like a form of art. For me, food is art. I have a brush in my hand and this brush is a knife. I just want to create emotion and memories. I hope it's good, of course, but making something with meaning is the most important thing.

Did you always have that approach, or has it changed over the years?

It has changed, but by evolution rather than in a drastic way. Ten years ago, I was in a place where I was trying to fit in with other people's ideas about cooking and I was struggling with that. Often people were telling me that my own ideas, this idea that food was something deeply emotional and personal, was too risky. I didn't understand the word *risk*. What I wanted was different. Now, what I cook is really me. It's really about me. I get to express myself fully. In my restaurant, in my cooking, I want to start a dialogue with my guests. But that's different from what I was asked to do before. My evolution has been finding your voice.

That's something you hear in music, too. People survive in the industry by doing what's asked of them, but those successful choices aren't necessarily related to the ideas that are important to them. I guess it's the case in any commercial art form—illustration, architecture. Any creative act that has the possibility of making people money also has that kind of compromise. What were the dishes that you were making that didn't matter to you?

There were lots of those. Short ribs. Pasta. Pizza. Burgers. I'm like, what the hell? I was working with ingredients that the guests wanted but they didn't have any real meaning to me. Even though it was boring, I tried to reflect on it. I tried to think of why diners wanted those things. America is about instant gratification. There's not a tremendous amount of education around food. The national food culture is very young. And there are ideas of independence. So what happens is that people think they have to feed themselves, and they don't really care where it comes from. I was struggling with that. I don't think that was always the culture. Earlier in the twentieth century, America used to be a farmland, and there was pride in the way they grew food. Industrialization came after the war, in the fifties, and people lost connection with food. These things all have reasons, but we have a responsibility to think about them.

When you invent something for your restaurant, when you add something to the menu, where do your ideas come from? Some chefs have told me that they get their ideas from experimenting in the kitchen. Other people tell me that they have to go far away from the kitchen and clear their heads so that they can allow themselves moments of inspiration and innovation.

My process is different than many restaurants'. My menu is a poem, literally a poem, and every line is a reflection on memories and moods that I have experienced. As a result, I never get inspiration in my kitchen or the market. I always get it through traveling, visiting a museum, going to the theater. I listen to lots of music. I love classical music, and maybe a classical piece that I'm learning gives me ideas for structure. Or it could be a conversation with someone that I meet on the street or at the café. Each part of the menu embraces a time in my life, a moment that I feel. With that you kind of create dishes, and with that you use things that connect.

That seems abstract. It's probably not, but it seems like it. Can you give me a specific example of how one menu came about?
I can give you one from a time two years ago. It was during spring. At the time I was taking care of a little girl called Hannah. She had leukemia and she passed away. My menu, which was the spring menu, was very much reflective of the emotion that I felt being with her and hanging out with her. She was also a poet. It was one of the most emotional menus I wrote in my life. That's how I get ideas. It's not that I look at a mushroom and think it's beautiful, though that can happen, too.

This is a very artist-centric way of looking at food. Which makes sense, you've got that artistic sensibility. I just wonder about the other half of the process, which is how people eat the food you've cooked. Do you think about the ideas and emotions that they are bringing to the dishes?
There's a dish that I created called Grain and Seeds. It's a dish with grain and seed, basically.[3] That dish reminded me of growing up on the farm, looking at my uncle and my grandmother, and also when I was a baby and my mom used to make cereals for me. In that way, this dish came from my own emotions. But then I had diners who came from other places, from Russia, from China. They made their own connections to the dish, not from the way I had defined it in my mind but because it reminded them of some other experience. Presenting emotions through food gives other people an opportunity to find their own emotions there.

That's a good working definition of art—you put your emotions into some form and then ask other people to see if they see their emotions reflected there.
I grew up in a family where my dad was very much into art. He was a politician but also a painter. What was interesting was that he used to say to me "Come here, Dom, and look at this painting." I would go over there and look. "What do you feel when you look at it?" he would say. As a child, I asked him what he thought it meant, or what he thought it was trying to do. "No," he would say. "I can't tell you. You have to really understand on your own." The more I looked,

the more I started to feel things. Even when I brought those things back to him, he didn't say if they were right or wrong. He was clear that he had a different experience. "When you're looking at art," he said, "you can't expect other people who are also looking to feel the same way. But you want to make sure that a piece of art evokes something inside of them."

This is one of my problems with cookbooks. I keep trying to think of an equivalent of music, and the closest I've been able to get is sheet music. There's no magic in sheet music. It's a way of recording something that might have been a great emotional and artistic experience. Don't cookbooks have the same limits?
I find them quite one-dimensional. They are a tool for understanding a recipe, but that's not the kind of thing I'm attracted to. The cookbooks that interest me let me feel the people that are behind them. I don't want to feel only one dimension. So you want to sense risk. You want to sense pain. You want to sense beauty. I wrote a cookbook. What I wanted to do is, through the cookbook, let people get to know me and see what I have inside of me. I try to give my diners the same treatment. When people come to the restaurant, I say hello to everyone and it's not just shaking their hand. I ask questions that have nothing to do with food. I ask about where they are from and maybe about their histories. I get a bit inside of who they are, a little bit about them.

When you first came to San Francisco, what was your impression of the place?
My English was so poor at the time that I spent lots of time just looking around, and I really connected with the surroundings of the city. There's lots of land. It's very European in a way: lots of French and Italian people. It's a region where they made wine. There was land for farming. There's a sense of eating local, too. Obviously Alice Waters started it in the early 1970s, this idea of helping farmers, but it's very entrenched here now. I love it here. I wouldn't ever want to live any other place.

—— 3
This undersells it. It has various plant seeds, including buckwheat, quinoa, sunflower, flaxseed, pumpkin, and coriander. It also has fish "seeds," including smoked trout roe, smoked sturgeon roe, shaved house-cured bottarga, and smoked bonito dashi.

But you have, right? What was that like?
I lived in Indonesia, in Jakarta. I went to cook in a hotel. They had resources there. Unfortunately, they don't have education to foster that. In the hotel, I used to wake at four in the morning to greet a truck of farmers bringing chickens. But the chickens weren't taken care of, not at all. They were in a 90-degree truck.[4] The quality was not good, not the quality of the product or the process. They didn't have the necessary education to do the best things for their food.

It's an interesting idea, building the infrastructure so that local culture can be preserved. But it's true, that without good habits, societies can disappear.
I was in Colombia a few months ago, at a conference. The second day I was there, I was talking to some people, and I got angry. "I just got here yesterday," I said, "and people took me to restaurants. But they took me to restaurants that served American food." Why would they do that? I didn't want that. I wanted to taste the food there. There's a famous chef in Colombia named Leonor Espinosa. She's interested in making sure that local food is raised to the top. I wanted everyone else there to understand that. The soul of a country starts with what's produced there. Countries need to embrace and foster that. If a place doesn't have its own cuisine, it doesn't have anything.

Globalization is a big enemy of that. You go to some cities and it's all the same chain stores you see in everyone's downtowns. And then there are other countries with incredible cultural traditions, their local spots are truly local, whether in music or film or food. Are there any food trips that you want to take that you haven't taken yet?
I want to go to Japan. My dad introduced me to Japanese culture at a young age and I was pretty fascinated by their way of thinking and doing things. I knew that it was one of the cultures I wanted to investigate. It's probably going to change my life.

You have to pick a time when you want it changed.
I want my life changed every day.

That's sort of how this book started, in Japan. I went to Jiro Sushi, and it was amazing. I always knew that food was art, in theory, but that was one of the first times that I understood it so deeply, that I saw this tradition that went back hundreds of years.
I think I am going to try to go this year or next.

As someone who is active on social media, I have asked many of my chef friends where they put the Internet on a scale and many have said that it's both angel and devil, in the sense that it brings them to the attention of so many more people, but also allows those people to talk to them without actually talking to them in person, it's one step removed from the person experiencing the craft and speaking to the creator.
When I look online and find someone who writes something that is especially nasty, it makes me sad, not for the people who are affected by what they're writing, but for them. There is no sense of reflection in those kinds of comments and no sense that they're part of a dialogue. I want nothing more than for someone to give me feedback about my restaurant. They don't have to agree. I don't want everybody to love my cooking and my heart. But it has to be thoughtful. There has to be an argument that makes sense. When you go out and trash a restaurant, who are you?

What I find sometimes is that all the voices on my Twitter feed and on my Facebook page can interfere with and short-circuit my own process. If I am trying something new in a song, even if I have doubts, I don't necessarily want to hear about all its shortcomings from strangers. How do you know when a food experiment has failed? Do you abandon it or go back and retool it?
It's important for us to do things that don't work. When you try them and they don't seem to be panning out, you make a note of it. Then maybe

you revisit them right away or put them in a drawer and you can go back to that later. "Remember when we did that?" It was an interesting idea but it was not the result we wanted to achieve. Going back, trying again, helps you to achieve and to better yourself. It's life: you need to learn and make mistakes. What we like to call mistakes, at least in a creative process, are not things we shouldn't have done. They are things we should have done to make sure we keep going forward in our lives.

You give such considered, thoughtful answers that I'm going to try to change things up with some quick questions. Are there any foods that you hate?
Hate is a big word. I think that I don't personally like food when it's covered with lots of layers of different things. If a chef says to himself, I have to put bacon over barbecue sauce over kimchee, because that's somehow interesting, I don't like that. I feel that's a form of laziness. I want the food to know about all its ingredients. And there is one thing I hate, I think. I do not like food that has been processed to such a great extent, like fast food at Burger King or McDonald's. It's not that I have never tried it. I have tried it and I don't like it. I didn't like the ingredients that they use in that.

I've spoken to April Bloomfield about this many times. You're a female chef in a profession where there are few of them—too few. What are the reasons for that, and what are some ways that those numbers can be evened out?
The history of the industry has been male-dominated for a long time. I think that the media fosters that. It's not just about chefs, not on an individual basis. It's the whole food industry, and all related industries. Men tend to get more attention. It's a cycle. What we're doing, and what we need to keep doing, as chefs and women, is to push for change. Strangely, I don't think it's as much of a problem inside the industry. I am close to other chefs, male and female both. When we're in the kitchen, we're just cooking. We look at each other as people that are skilled rather than people who represent their gender. But there are broader societal issues. Think about it. What are females in the society? We breed. We are the women of the house. It's hard when a woman who is working in an industry like the restaurant business wants to start a family. We need to see things differently. We need to grow up a bit. But our society is only part of the overall world. There are other places, other religions. It's a large issue.

If you could invent one device that would make your life in the kitchen easier, what would it be?
I don't think I would invent anything material. I think it would be probably a skill, though I don't know if what I'm about to describe is a skill. People need to have respect and understanding for diversity.

I agree completely. If we weren't right in the middle of a speed round, I would want to marinate on that a bit, but we are. So: in an average week, what makes you the angriest?
I get angriest when communication fails. If I order something or talk to farmers and they don't come in like we discussed. I get frustrated. I wish they had given me that information so I could have been proactive. If I come to work at ten and my fish guy says that he can't get me the live fish that he promised, and he hasn't given me any opportunity to adjust, I get angry. If I hear in time, it's less of a problem. It's all about communication.

What do you think food preparation and service will look like in ten years? In fifty?
We live in a world where environmental problems like global warming are very scary things. People need to be conscious and aware. We need to rethink the way we're doing things. The meat industry is overproducing, and there are consequences. Look at what they're doing in South America, all the deforestation.[5] If you take those trees down, you're killing the planet. If we kill the planet, how are we going to feed people? Technological advances don't help us connect more fundamentally with nature. The population in the world is growing faster than ever, and there's not very much awareness of the problems that will bring. I can get angry about the way people don't think.

—5
I'm reluctant to introduce a serious footnote in this book. Footnotes are places I go to look things up and riff on pop culture. But deforestation is pretty fascinating. Countries need to strip forests down to use their land agriculturally, because people are so poor. But even though there are short-term benefits to converting land for agricultural use, it'll wipe out the forests—projections for rain forests is that they'll be gone in a century—and that'll leave people in a worse spot than where they started.

(below) Comme des Garçons
sneakers, cleaver at home

(right) Dominique's glasses,
Mossant's hats

(left) A Gallic scene, or Yé-yé on the half shell: Françoise Hardy gets some spins

(below) The Sea: an interpretation of the ocean. (I got a little literature lesson about Raymond de Thomas de Saint-Laurent, the sea, and the psyche. It left me hungry for more.)

(following spread) *Guimauve* (French for marshmallow), white powdered sugar on blue cafeteria tray

EXOPAT **MATFER** MADE IN FRANCE E 08

EXOPAT **MATFER** MADE IN FRANCE G 08

(opposite) See salt? I do. And it's sea salt, too: sel de mer and butter.

(above) French omelet/snail/snail caviar

(following spread) Dominique in her thinking-and-writing spot: a beach with a perfect view of the Golden Gate Bridge

"While we're being chefs we might as well rethink institutional cooking: hospitals, prisons, schools."

Daniel Patterson
San Francisco

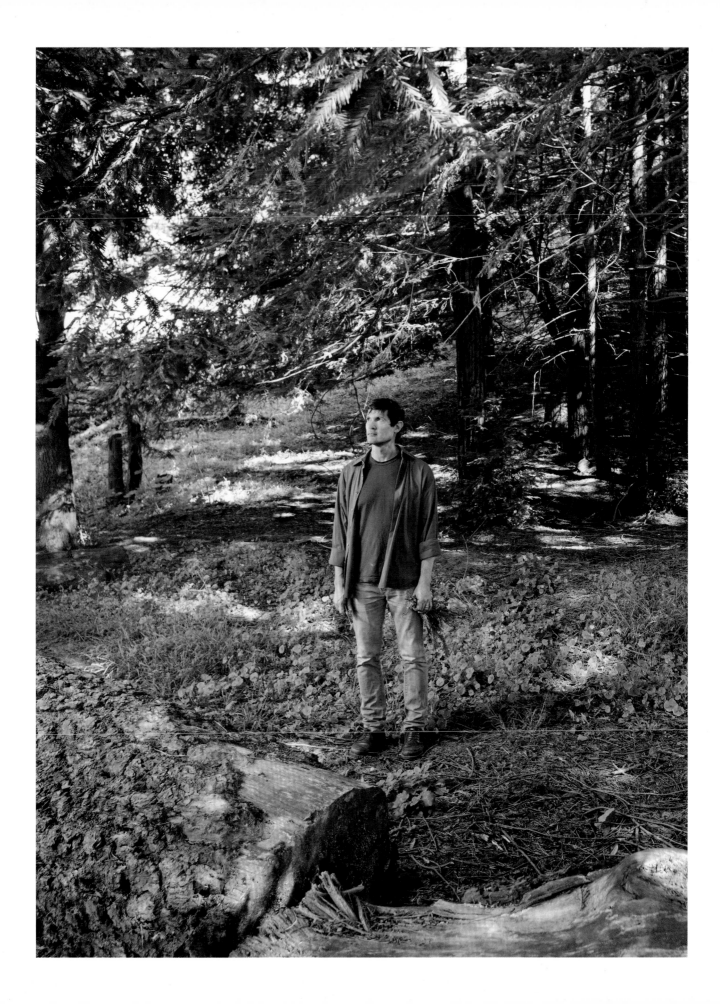

I was making my way back up to Seattle, to Modernist Cuisine. My adventure in Nathan's kitchen awaited me. But I was making my way slowly—I stayed in San Francisco for a little while, for good reasons. I stayed because of what I had learned (and was learning) about Northern California. The area is a special place for food, mainly because it has some of the best produce in the world. When I have spoken to chefs about the city and the region, that's one of the first things they say. They said it so often that I thought it was just one of those things that people say.

But speaking to Daniel Patterson made me see things in a different light. In 2006, when Daniel opened Coi, he wasn't exactly creating the idea of an intimate, locally sourced restaurant from whole cloth. Alice Waters had done something similar a generation before. But he was in the right place at the right time again. Coi was located at that sweet spot where the Generation X expectations of dining (a casual experience that did away with some of the pomp and circumstance of older version of fine dining) shaded into some of the concerns of millennials (quality of the ingredients, where they came from, what processes brought them to the table). Daniel wasn't formally trained, which I found interesting—that was an ongoing theme throughout my discussions with chefs, whether a creative profession like cooking could be taught in schools—and he is also a writer, which is relatively rare for chefs.

When I talked to Daniel, though, he was at a crossroads. His career as a high-end (and highly rewarded) chef was going very well. But he noticed that fine dining only really affected a tiny sliver of people. How could you not notice? Daniel found himself wondering about the role of food in the broader culture. And he didn't just wonder. He set about addressing this directly, as a thinker, as a writer, and finally as a restaurateur—in the first months of 2015, he was getting ready to open a restaurant named Loco'l, a high-quality fast-food establishment he created in collaboration with Roy Choi, the chef of the Kogi BBQ trucks, and as a result the man who launched both the Korean taco and the first wave of chef-based food trucks. Daniel was eager to discuss Loco'l, and how it would both build on the food he developed at Coi and also step aggressively away from it (how does a big-time chef downshift into the land of the 99-cent hamburger?). He also wanted to talk about travel, and poetry, and parenting, and everything. The result was a conversation like San Francisco's streets—steep inclines, sharp curves, nice things to look at, and sometimes hard work.

As we speak, you're starting a new restaurant. And not even a new restaurant: a new kind of restaurant, this fast-food place called Loco'l with Roy Choi. Why was that so important at this point in your career?

Over the years, I have been thinking more and more about how actual people eat. I'm not talking about the one percent of people who participate in fine-dining restaurants. I'm talking about the majority of people in this country. Where do they get their food? What does it mean to them? What are the factors, culturally and economically, that let them go into restaurants? The answer is sort of obvious, which is that most people eat fast food. You can see it in the numbers. So why not have a fast-food restaurant that keeps certain things about fast food—the fact that it's inclusive, that anyone can go there, and the fact that it's cheap—but reimagines it with a totally different kind of food? Quality food. Good ingredients. Real cooking.

So what was the process?

Well, I have a charity foundation that was teaching kids to cook. What it wasn't doing was teaching them how to eat. I was at a food conference and saw Roy give a speech. He was talking about hunger, and not in the traditional sense: people are malnourished but still overweight. We started to talk and we had this idea. More than that, we had a certainty that we had to do it.

I've mentioned this to you before, but the costs are real. There's a hip-hop artist whose limbs were amputated because of obesity and diabetes, and this kind of fast-food diet was a real contributor. It was how he ate since he was a kid. Let's go back and talk about your foundation. How did you eat when you were young?

My parents split up when I was pretty young, and the main cook would be whichever house we were at. It was very different depending on where I was. My mother had a garden. She used to make her own yogurt. When she cooked she did dishes out of Julia Child. My father, I remember, made lots of pork chops, with the shake and the bake. It's what one might call bachelor food. When we went out, it was with my grandparents, and it was a special occasion. I would sit next to my grandfather. He would have Manhattans and I would get the cherries. He also taught me how to make a mashed potato.

You take your baked potato and kind of score it and mash in the sour cream then the butter at the end.

Shake 'n Bake anything is just good. Did you have an appreciation for food early on? Did you not think about it so much? Some chefs were obsessed with food from the start, while others drifted into it as refugees from some other creative profession.

I think questions about how you get into food and why you love food are hard to parse. It's usually people who have a specific kind of palate, a sensitivity to smells and tastes. Also, I spent lots of time at my grandparents', watching my grandmother, who was an amazing cook. And then, a little later on, I spent some time in France. It was a culture that valued not only food but what happened around food—spending time at the table, having conversations. Food is not the most important thing in the dining process. It's how we share an experience with other human beings. It's how we feed our family. It's how we build a relationship with our friends.

Michael Solomonov talked about visiting Israel and discovering the same thing, that food was more than just sustenance there, that it was a basic part of the social makeup of the country. So does that mean that food was mainly about participating rather than creating?

I remember helping. I remember shaping cookies and cutting things that went into other things. I remember shucking corn. When I started working in kitchens, around the time I was fourteen, food was a big mystery to me. I would help unpack a sauce from a big container to a small one, and I would wonder how they made all that sauce for the huge container. Being in kitchens was about understanding and learning. It always seemed like magic.

Is that an apprenticeship? That period of just figuring out how things operate, what heat does to food, what knives do to food, that seems to go on for years.

Cooking is an apprenticeship that never ends. I was learning then and I'm learning now. Whether I'm in my own kitchen, talking to one of my cooks, or in someone else's kitchen, I'm

always finding things to learn. And, of course, it's also about making mistakes. I've made so many mistakes, but I'm always finding new ones to make. It's a process that doesn't really stop. There's just no way to accurately predict what's going to happen with food. I mean, you can predict in a narrow sense, but when you widen it a bit, you're dealing with combinations and personal tastes and lots of unpredictability. Does that count as a mistake? Here's an example: Say I'm starting a menu with six new dishes. Maybe four of them feel like they're working right off the bat, one needs work, and one is in limbo. It's in limbo because even though when I designed it, I was sure that it was going to be a home run, a huge hit, when I put it together it just isn't happening. After all these years, that kind of thing still occurs. I'm ready to go with something, and it's nothing.

I feel like as I get older two things happen creatively, and they seem contradictory. On the one hand, I've seen it all before, so nothing throws me. On the other hand, I have a greater expectation for myself that I should be able to avoid certain errors.
When I was younger, everything was much more traumatic. If I put out one dish that was wrong out of three or four hundred, I would think about that for weeks, obsessively. Partly the issue is that damaged people get into cooking. For me, the job fit very well with my own craziness. Examples are so frequent and so normal that it's hard to pick one. This summer I did this dish of beets and blackberries. It looked good on paper. I tried it a little and I was satisfied. But when I put it on the menu, I just had this violent internal reaction. I can't even describe it. It was like my entire body was revolting against me. The dinner service that night was excruciating. Every time someone ordered it, I was out of my mind. If you as a customer had this dish, you would probably think it was perfectly fine. There was nothing wrong with it. But there wasn't everything right with it.

That's a great way to put it, that there wasn't everything right with it. I might steal it for something. Maybe a T-shirt. As the artist—or craftsman—you see things that no one else sees, and they eat at you.
Once you get to a high level of cooking, there's this complete inability to accommodate anything being even a little bit off. I kept beating myself up over that dish: fuck, why didn't you try it more?

Over decades, that perfectionism becomes hardwired. There's perfect and there's failure and there nothing in between. This is a liability of creative work. Other jobs don't have that. People don't go home thinking they have ruined someone's entire day because of this one tiny mistake. As a result, they don't ruin their own day. I've been able to tamp that down over time, a little bit. I don't freak out the same way. I'm forty-six now. My kids are four and six. I still work fifteen hours a day. The importance of the creative work has never left. It's still central to my work and who I am. But it's like being a scientist and running the same experiment over and over and over. There's an applied knowledge that gives me trust in myself. It's not that my anxiety has gone down, but that my confidence has gone up.

People's creative ideas come from different places: dreams, books. Where do your ideas come from?
I have no specific ritual. I feel like different people are wired differently. Brains are wired. I have to have a 102-degree fever not to be thinking about cooking or writing or music. So my brain is always churning things. It's not possible not to have new ideas. In terms of my restaurant, this is built into the identity of the place. We're not a typical luxury restaurant. We built our identity on transforming things that are more common. That part of the concept is the most exciting part: locating different facets to otherwise familiar ideas. I know how to find ingredients and pay lots of money for them. I think that's a great way of cooking. But for me personally I want to find something new.

That idea of taking something familiar and changing it slightly comes up over and over again. Do you think of it as a form of serious parody? Some of the chefs in the book talk about their creativity in that sense, or talk about themselves as tinkerers: trying to imitating something else, noticing where and how they fail, and discovering something about their own creativity in the process. There are good examples of this in music, too.[1]
It's the opposite for me. I have a horror of re-creation. I can't imitate. I mean, I can, but what really starts me creatively is how an idea changes in my mind. When I see an idea, I might

1 ——
There was a pause then, as I tried to think of a good example and failed. Later on, I thought of one, not just a good one, but a great one—it was one of my first bonding moments with J Dilla. Hip-hop producers have drum machines, and one of the rites of passage is that they start remaking all their favorite beats. When I met Dilla, he pulled all these files out and one folder was DJ Premier beats and one was Pete Rock beats. He was imitating them not just to imitate but to figure out how he could understand all the ground that Pete Rock covered and then go further. Weirdly, he was very secretive about the Pete Rock files. Because of the ego situation people could easily think that he was trying to one-up Pete Rock rather than using him as inspiration. And so they were never allowed to see the light of day. Mos Def accidentally took one and made my favorite beat of all time, the "Little Brother" beat from the *Black Star* album.

see things in it that are completely different from how the things are presented. I wrote a cookbook. It's kind of a strange cookbook. Each recipe has an essay. The recipe is written in long form, in paragraphs, rather than as a list of instructions. At one point, I talk about a dish I did called oysters under glass, and how that came to be is a good illustration of this principle. There's pheasant under glass, of course. A friend of mine went to a restaurant and had it. It wasn't even me. But I was thinking about it, and for some reason over time it changed shape in my mind. The glass became a sheet of clear gelatin and the pheasant turned into oysters.

That might not be that different a process. Creative minds, in imitating, change. That might be the definition. Maybe it's a question of what you think of as imitating. When you were talking about oysters under glass, I was thinking of it in terms of hearing about someone's trip somewhere. Your friend told you about this dish, and you imagined it a certain way, because you weren't there. The other way it can happen is that you take the trip yourself. You go to a restaurant in a different place and have a dish, and because you're out of your normal place, it is a completely different idea. How important is travel to cooking?
Travel affects cooking the way it affects anything—it takes me out of what I know, out of the traditional patterns, and forces me to see how culture is expressed through food. I talk to people. I see new rituals, new ingredients. Sometimes you see different things. I was in Bogotá. They eat mazamorra, or peto, which is a sort of soft corn paste. That excited me. I wanted to try it in some form. I have had so many experiences in going to visit a place and tasting a food that I thought I knew. Maybe it's a dish, maybe it's an ingredient: duck confit in France, or going to Italy and finding the chicories—they're the radicchios that everyone grows in California, but seeing them there, how they're used, is really a revelatory experience. Food can move from place to place. You can put anything in a box and send it. But it loses its context, emotional meaning, and significance when it's taken away from where it is.

And the same must be true about cooking here in San Francisco.
Definitely. The air smells a certain way. The food tastes a certain way. There are ingredients that are distinctively local: cypress or angelica root or something like that. There are certain tastes that feel like San Francisco the way that beignets are in New Orleans. But cooking is so much part of the broader culture that it's hard to separate it out.

One of the things I keep coming back to is the question of how creative food people see themselves as artists. Over the years, I have spoken to chefs who think that what they're doing is a form of theater, or a form of architecture, or a form of painting. To you, what art form is the most similar?
I don't really think of cooking as an art form. I think of it as a craft. I think that what we do is more like building furniture or building a masonry wall. If you do it well, if you spend time learning, you can eventually do something that's artistic as well as functional. But there's still a distinction. To me, art is something that's removed from our basic sustenance, whereas food is something that's linked to it. If I had to pick one, I would probably say music. It's tactile in terms of pressure and speed of movement. There's interaction with other people. So much of what's done isn't in your mind.

Some chefs in this book went to chef school. Others, like you, are self-taught. Is schooling important?[2]
I don't think there's any right way. Some people go to school and it benefits them. I started working and learned as I went along. Maybe I would have learned faster if someone had taught me more directly. Maybe I would have learned things that I had to unlearn. It's hard to say.

Many chefs, as they get older, focus less on the athleticism of cooking, for lack of a better word—less pyrotechnics—and more on values and virtues. You're in your early forties. How has it changed?
When I was a young cook I was very driven by the idea of working at this high level. Chefs are pretty fucked up, and your sense of self-esteem is pretty bound up in that. As I have gotten older—I have kids now—I care less for personal

—— 2
The most concise version of this question came a few years ago, when I was co-hosting the 5 Under 35 Awards for the National Book Foundation. The awardees were up on the stage with the co-host, Ben Greenman, who was my co-writer on *Mo' Meta Blues*. Ben was taking questions from the audience. One guy stood up and asked "MFA or NYC?" I didn't know what he meant at first. It turned out that he was asking if it's better to learn in an institution or in the world.

achievement. I realize I have done everything I want to as a cook instead of maybe taking care of the people around me. Now I'm more focused on the diners, on giving the people who work for me a better job. And then beyond that I am thinking about the people who don't work there and don't come in to eat. It's a big world, and maybe I have gotten to the point where I have learned enough that I can contribute. It's important to be humble but realistic. I'm one person but I am one person who knows lots of other people.

You've gotten very good press: favorable coverage for the most part, good reviews. How much do critics matter?

I've been to some places around the world where they literally have no critics—bigger cities where there's no culture of criticism. Some of the chefs there have told me, "You know, we'd actually like someone to come in and tell us what they think." And I think there's a balance to listening to what every third person thinks about what they're eating and giving some credence to people who have studied food their whole life, who both understand the cultural context historically and know the immediate context of people who are doing the same thing around the world. But the fact is that every chef has to listen. When a customer walks through our door, in a way, they perform the function of a critic. If they're happy, good. If they're unhappy, something needs to change. Maybe they ended up in the wrong restaurant, and that's the reason, but maybe we're not doing our job well enough.

A number of chefs have said that they don't mind the idea of feedback, but that they don't like the way technology allows diners not to engage directly. Instead, they run back to their house and tap-tap-tap their complaints.

Cooking for another person is one of the most human things we can do. There's no amount of technology that changes that. If I take all this time and effort and emotion and I put it into the food I give to you, that experience is so primal that technology can't take away from that. To

the extent that people engage with the people who are cooking their food and bringing it to them, it makes their experience richer and it makes the restaurant better. But I also think technology has evolved in ways that help us do our jobs better. There's social media. People think that's distracting and I agree. But we could use social media better to be more organized, to communicate better amongst chefs and between suppliers. When technology helps with the logistics, we can use our time to focus more on those human things.

If you streamline those processes, you are giving yourself more time to cook. You're also giving yourself more time to think. In your case, that results in writing. You write about food. Has it given you another dimension to your enjoyment? Is there one thing that food writers get wrong?

As a kid I wanted to be a writer. I ended up being a cook. Those are two horribly paying jobs, and I traded one for the other. Since I started writing again ten or twelve years ago, I've gotten a tremendous amount of insight and empathy around how hard it is to do something meaningful and express what's important about it. There are lots of voices out there writing about food, more and more by the minute, but there aren't so many that are really good at it.

Food is one of those areas where there's lots of crossover. Some musicians write about music, but not a huge number. Some filmmakers write about making films, but not a huge number. Writers write about writing, obviously. And chefs write about food—making it, eating it, situating it in culture. What are the best food books?

That's a really good question with a sad answer, which is that I don't have lots of time to read. I wish I had a comprehensive sense of what's out there, but instead I have to pick the things that really get to me. One writer I love is Paula Wolfert. She's incredibly passionate. Take a book like *World of Food*, for example. She traveled everywhere and got down all these recipes. She made it to lots of places before they were ever popular and summarized the culture so perfectly. When I look at those books I'm kind of reminded of the fact that these things didn't just naturally exist in our consciousness. Someone went and found them.

Nathan Myhrvold talks about that, too, that all these international cuisines that we take for granted actually had to come here. Books help document that process. Do you want the people who work with you to read up on those kinds of things? How do you balance the intellectual and emotional dimensions of the profession? [3]

First and foremost, the culture of cooks is an emotional one. You have to really love cooking for other people. There are values of generosity that are primary. To me, intellectual values are very important, too, but they're secondary. I think of my restaurant. We're in this time where even in a kitchen environment, you might find lots of college-educated people, and that's great. But I wouldn't recommend books in the kitchen. I would recommend staying focused on who raised the animals, who grew the vegetables. Last week one of my cooks said he couldn't find Seamus Heaney's *Field Work*. That cracked me up. It was strange to hear it mentioned. He's one of my favorite poets. That book is very important to me. It has one of the all-time-great food poems: "Oysters." But I looked at him a little weird, because I think of the kitchen as a place for food, for making it. I'm not saying there shouldn't be reading around food. When there's curiosity, it should be encouraged. But there's a danger of imposing your own values on a culture that's broad-based in terms of people's backgrounds. You want to make your cooks feel comfortable the same way you want them to make your guests feel comfortable.

You bring up intellectual diversity, or educational diversity. Why is there not more racial diversity in the food world?

That's a dynamite question. I completely agree with you, and while I have lots of answers, I also have no answers. Food isn't monocultural at all. But the high-end food business is fairly monocultural. And if you look at that community it's very skewed toward white males. One of the reasons I live in Oakland, one of the reasons I love the city, is that I don't want my kids to live in a place that's so monocultural. So how can we make the profession more reflective of the reality of cooking? I think that business is a big deal. Raising money is an issue, of course. Ease and acceptance within that world of money is definitely a huge part of it. And then any organization is going to reflect to some degree the people who run it. It's a self-perpetuating

cycle. I've heard lots about these issues in conferences, but the fact is that it's the same people over and over and over discussing them, which is part of the problem. It may also be why the overall situation isn't getting better.

That's true in lots of industries. It's why people who talk about the half century since the Voting Rights Act, or other civil rights gains, are right to be happy that they occurred but wrong to think that those gains automatically translate into broader gains. Time has a way of closing ranks.

Those kinds of obstacles, prejudices, leak into every aspect of people's lives: how landlords rent, how people get jobs, how people look at you on the street. Because they're so embedded, it's hard to imagine how you might eradicate them entirely. To tackle it at that level, from my perspective as someone who runs restaurants, is impossible. But there are day-to-day decisions that add up. In our kitchen, white people are in the minority. Our general manager is half African-American, half Jewish. My company is over fifty percent women. I have a woman who has worked for me for three years. She's going to start her own restaurant. We're helping her do that, financially. I don't have to do that, but if you actually give a shit, do something, even if it's a tiny pickax on a mountain.

That relates to broader issues about food and culture: not just diversity in kitchen hires, but the Two Americas idea, where it's clear that different communities actually eat differently—and that doesn't even begin to look at the ways that poor people around the world eat.

We've come out of this really important time, or maybe we're in it still, where there's lots of talk around what problems we have here in the Untied States: scarcity of resources, growing wealth inequality. All of these things are issues, and because we're such a big player in the world, some of those problems have been exported. What I'd like to see is to move into a time of action where we start to do something about these problems. Personally, for me, I'm working with Roy Choi on Loco'l. Our basic premise is how to give people real food at fast-food prices. These kinds of places are where most of our country eats. We need to remake that idea.

——— 3
Whenever people talk about reading for motivation and some overall sense of the world, they like to mention Phil Jackson, who used to give his players books. Maybe he'd give Kobe a novel or Shaq a book of philosophy. Players liked to joke that they never read the books. I think of Phil Jackson but I also think of the Roots, and specifically about Richard Nichols, our manager, who passed away in 2014. Rich read widely and he liked to apply lessons in what he read to what we were doing. He might read a book on assembly lines and the auto industry to help himself understand how disco worked as product, and then he'd send us an article or a book so we understood it through that prism also. Everything had ideas underneath, like a rudder.

So the idea wouldn't be to turn up your nose at that kind of food, but get in there and change it?
Look at the institutional cooking, at hospitals, prisons, and schools. My son is starting kindergarten, and it's ridiculous to see what public schools feel like is good to feed children. How do you think they're going to grow up with proper brain function and physical well-being when you are feeding them garbage? There are lots of high-level conversations about organics and sustainables and locals, but I think the real thing is that people need to eat real food. And that has to happen by opening new places that have those ideas in mind. Op-Ed pieces in the *New York Times* are very important. It's valuable to take these problems, deconstruct them, and make people aware of them. Those people make laws and run companies. But lots of the people affected by those problems are in areas where they don't read the *New York Times*. I think there's a false idea that you can make people come to you and hear your solutions. It doesn't work like that. We need to find people where they are, understand how they live, and give them solutions they can afford that actually relate to their lives. Most of our country is being fed by corporations. Why can't chefs do that? We need to not wait on politicians to do something.

When you say "we," that sounds like there's a bunch of chefs that get together in a Holiday Inn meeting room somewhere in the middle of the country and plan strategy. Where's the exact middle of the country? Nebraska? [4]
Twenty years ago, chefs didn't talk very much. There wasn't a means of communication and there wasn't a culture of sharing. There was a sense of secrecy, of guarding things jealously. Now there's a certain fluidity in the way chefs communicate. People who work for me go to another kitchen and then come back and share. That can translate into cooperation in solving problems. Partly we're a community because we suffer similarly. Restaurants, especially high-end restaurants, are the worst business in the world. If you do everything perfectly you're rewarded with a tiny profit. You're like the canary in the coal mine. If there's any disruption of anything around you, the first thing that happens is that people don't go out to eat in places like yours. On the other hand, there's a role that chefs are starting to have where maybe we can influence habits.

This takes us right back to Loco'l.
Exactly. If you think about all the forms of public eating, fast food is the only place where everyone feels they belong. It's totally inclusionary. Sure, the food in those places is terrible, but anyone can walk in, no matter income or style of dress, and feel comfortable. At Loco'l, we're going to keep the good things, the idea of including everyone, and get rid of the bad ones. We're thinking about it for real, though. We know that if we make a burger bun, it can't be too high or too round, because then people can't drive with one hand and hold it with the other hand. And when we make chicken nuggets, we're sure to make them look like traditional nuggets, even if we're then using the best ingredients and the best processes to make them. We're keeping everything under six bucks, and plenty of menu items will be a dollar. But again, it's not just about the food. It's about redirecting the culture, about creating an alternative, about creating jobs, about creating a way out of the dead end that's there now.

4 ———
Turns out that the exact middle of the country is right near Lebanon, Kansas. It also turns out that there's another way to measure the center of the country, which is to imagine that all the people weigh the same, and then find the center of the country by people-population. That place is right near Hartville, Missouri. But measuring that way seems a little crazy.

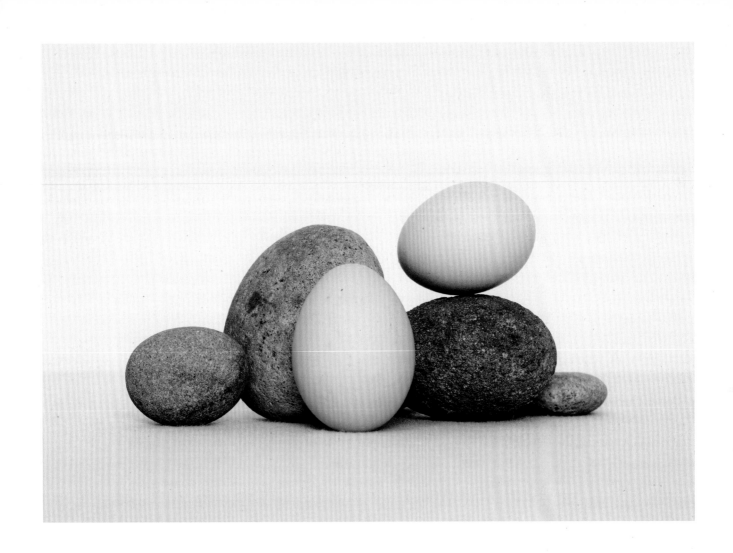

(above) What came first,
the rock or the egg?

(right) Daniel's pets
wondering and wandering
on his dining room table.
Eventually they may end
up on a menu. Life can
be cruel.

(following spread)
Foraging in the backyard

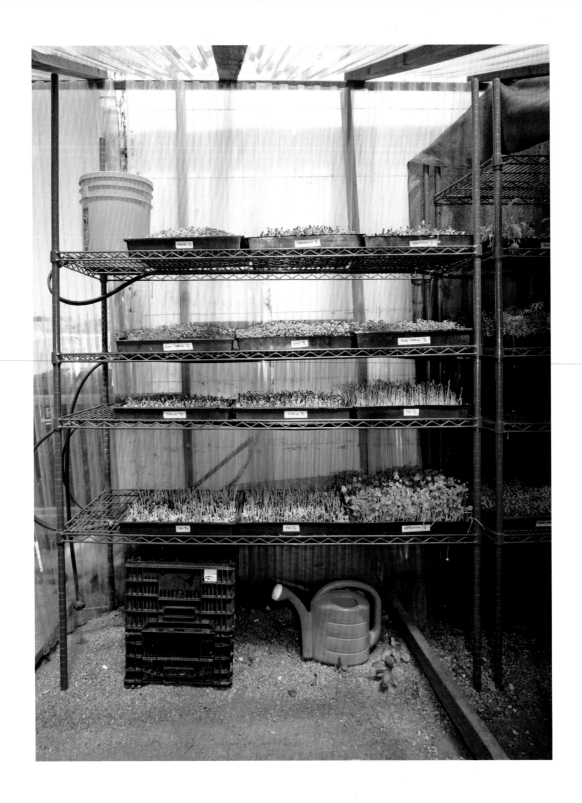

(left) Vertical farming

(below) Where do vinegars age? It's not a joke, though it sounds like the setup to one. They age in the basement.

(left) Butter Culture

(above) Follow the notes
on the wall

(above) Fall Rose: beet,
turnip, apple, walnut

(right) Crushed
Tofu-Vegetable Stew

"In some cuisines, what you're looking at, at the highest level, is a competent reproduction."

Ryan Roadhouse
Portland

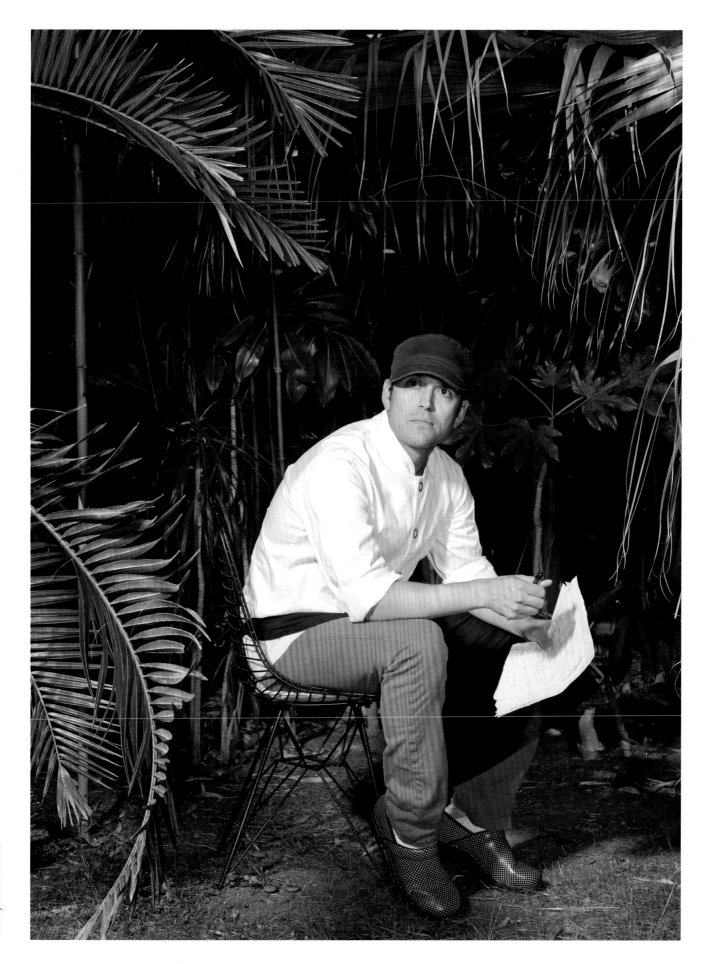

Portland is my number one city in the world. Some of the reasons are clear and maybe even superficial. Nike is there, and I'm a sneakerhead. They also have the best record stores ever, which was something I learned early on in our touring career. When you first start to travel, you are at the mercy of the runner—the person who picks you up from the hotel and brings you to sound check. Our runner was a huge music fan, and he introduced me to all these specialty record stores that are unknown to almost everyone, unless you happen to be a Japanese businessman who wants to buy rare 12-inch singles, mark them up, and sell them back to American collectors in Tokyo.

This collector's mentality, the sense that everything can be bespoke and valuable, that you can combine a hippie sensibility with a cosmopolitan sophistication, isn't for everyone. It's a highly specific tuning—that's clear from the way that it has been parodied on *Portlandia*. To me, though, it's undeniably compelling. It makes me think of when I was young and my mother made me shop for clothes in thrift stores. I resented it at the time, but I'll be grateful for it my whole life. It forced me to have a personal sense of style, to appreciate the paths that led away from the beaten path. Portland doesn't seem to have a tremendous number of natives, but the people who go there are all a certain type. I think I might be that type, too.

Portland's appeal is especially clear when it comes to food. Portland is the capital of food trucks. It's the first place that I ever saw a PB&J food truck. The city is also great for inspiring its chefs to move into uncharted waters. My conversation with Ryan Roadhouse was supposed to be about Nodoguro—the supper-club/idea curating series where he and his wife create menus based on strange content prompts. But as we spoke, it ranged far and wide, through the cities he lived and worked, through the hinterlands of pop culture, but it kept returning to the same fundamental ideas, ideas that had come up explicitly in my conversation with Dave Beran in Chicago and implicitly in many other conversations: How do you design your life as a chef so that you can consistently innovate? Can high-end cuisine also be pop culture?

Portland has always seemed like it's filled with people who go there from elsewhere to make music or cook food or do other things that get made fun of on *Portlandia*. Most people who are there aren't really from there. Will you disprove this theory?

No. I was born in Illinois, in Sterling. It's outside Chicago. My dad was Canadian, but my mom's family was from Illinois. As I grew up, my family moved around. I went to high school in Canada, in Saskatchewan, and then lots of places after that.

In the Midwest, what was the first restaurant you remember going to? I'm talking about right at the beginning, when you were a little kid and tagging along with the rest of your family.

The first one I remember must have been in Iowa, a pizza place. I would have been three or four years old and I remember getting cheese pizza and extra sauce on the side.

That's a pretty sophisticated order for a little kid. You liked the extra sauce or the idea of getting extra sauce?

Probably both. One of my least favorite foods is peel-and-eat shrimp, because it used to be my favorite food. When I was a little older, eight or so, I went to one of those places where they were having all you can eat. I ate my body weight in shrimp. I don't think I have ever been that sick. I don't know if I caught a bad one or if it was gluttony.

Apart from pizza and shrimp, what did you think about food at that point? Or, rather, did you think about it as something more than a set of calories that was going to end up in your stomach?

Food was very important. My grandfather, my father's father, had been an oil executive. The company he worked for went under, so he spent his middle years unemployed. At that point, I was sometimes living only with my grandparents. I was born to young parents and before my parents were more settled, I was raised by my grandparents and by the television. Mr. Rogers taught me how to tie my shoe and how to whistle. My grandfather's big thing during the day, especially when he was between jobs, was getting dinner ready, not just cooking but finding a bottle of wine, setting the table.

At one point, I tried to eat the butter off the table and he was very displeased with me. Food was very important to me, and he was the formative figure. That time with him got me started with cooking. One of the first things I made was these baked ham and cheese sandwiches. Either he encouraged me toward that recipe or I figured it out myself, but they were a lunch staple, one of my favorite things. In first grade, when we had to do writing assignments, I wrote about how to make those sandwiches. And there was a second dish I cooked, too, a pasta carbonara, that I patterned after my grandfather's recipe—cook noodles with a little butter, crack an egg, whip it with some bacon, and you're ready to go. When I got older, I took care of my brothers. After school, it was just the three of us at home, and it was fun to figure out what we were going to eat. Maybe I'd make that carbonara. Maybe I'd make Buffalo wings. Just not shrimp.

You got a head start. My family was in the business. I love music, and I loved it then, so it was generally rewarding to be immersed in that. But there were times that I felt like maybe I was overdoing it. Or walking back and forth in a narrow corridor.

Well, after that I lost touch with food for a while. Largely, that was because of the direction I got pushed in by my parents. They were still thinking mainly about my schooling. I was still very interested in eating, but cooking fell to the wayside in favor of sports and academics. At one point I remember finding a cookbook. It was one of those cookbooks that you just find in people's houses: red and white cover, nothing special, maybe Betty Crocker. I looked at something in there and decided to make it for breakfast the next morning. Before I knew it, I was cooking out of that cookbook regularly. It was a refuge from everything else in my life, all the stresses. I would do it in the morning before my girlfriend woke up. It was me time, the only time like that in the day.

But then you started working in kitchens, and I assume that you had to mostly do what you were told. Was it strange to take a step back and not be able to have your own ideas?
A little. I went through phases where I worked for endless hours underneath a chef with way more experience than I had. Often in those times, I wasn't allowed any creativity whatsoever. But I got a chef position at a very young age, which allowed me to do anything I wanted. Weirdly, at that same point, I realized that I didn't have enough craft to do the things I wanted to do. That's when I found people who served as true mature mentors. When I was working with them, it was a step back, a little bit, to a point where I came to feel that creativity didn't matter as much.

It didn't matter how? Because you were more focused on learning? Because you felt like it was more about giving food to diners?
It's largely because of the kind of cuisine I was cooking. I have only worked in Japanese restaurants. How I ended up there is one of those weird mixes of planning and chance. I loved sushi as a kid. I moved down to Tulsa, Oklahoma, to live with my mom, who had just gotten divorced. At that point, I really needed a job. I went to this local Japanese restaurant I had eaten in. I loved the food and I wanted to work there. The problem was that I was a bit too young to really cook. I begged and begged and they hired me and put me in the kitchen. A few years after that, I moved to Denver. I took my résumé around and found work at a Japanese-Hawaiian-fusion place. They were opening a second unit, and I ended up opening that location. I was very young, still, maybe twenty-one, and suddenly I was in charge of a restaurant. It was kind of a corporate setup— the place had long hours, seven days a week. I worked in kitchen-menu management for about two years and then left and went back to the earlier place as a more experienced person.

1 ——
This is an understatement. At one point, it was the second-most-expensive place in America, behind Masa in New York. A study in 2013 showed that the average bill there was $1,111, which is pricey unless it's in binary, in which case it's only $15.

You have a very detailed professional biography, and it's fascinating to me, because you learn different lessons all along the way. I have been asking chefs what art form they feel closest to, whether it's music or sculpture. Has your opinion on that changed over the years, as you've gone from restaurant to restaurant?
I remember one specific moment during the time I was in Los Angeles, I worked in a restaurant named Urasawa, which is on Rodeo Drive in Beverly Hills. It was a Michelin two-star place, very small, with a ridiculous price point.[1] Urasawa helped me understand more about creativity and the beautiful plate. But it also helped me see how theatrical a restaurant really is. When you walk into Urasawa, everything is staged. You have costumes. You have lighting. But again, the type of theater is different in Japanese cooking. The highest level of achievement is perfect reproduction. If that's the highest form of your craft, it's devoid of creativity. So there were unanswered questions about presentation and cost and formula. From there, a headhunter in Jackson Hole, Wyoming, found me working at a place that had a name but no real concept, and they were looking for a chef to come in and take on the place. It looked like a good place to experiment with my ideas and cut loose. Part of that was size. In Denver, I had started to look at my own ideas, but the size of the place worked against me. It was so big—more than two hundred seats—that we could develop the cuisine, but most of the people coming in would want pretty basic fare. Jackson Hole was smaller. There were fewer people, and so I learned that if I wanted people to come back I should change the menu often. We changed it twice a week, which emphasized creativity and dish development. It also meant more risk. Some of the dishes would go out with minimal testing. There was more off-the-cuff cooking.

Japanese dining is the exact opposite. It's all about formality and rigidity. Have you been to Japan and seen how things are done there?
Only once. The chef I worked for in Denver sent me there to motivate me. He had an apartment there. He had a restaurant for me to land in and an intense internship set up for me that let me hit the ground running. The restaurant was not what

I expected at all. It was one of my great surprises. I was blown away by this guy's cooking. It was so disjointed, so not-classic, so filled with these oddball ingredients like avocados and corn. It shattered what I thought of as traditional cuisine. Have you ever seen that movie *Jiro Dreams of Sushi*?

Not only did I see it, but it obsessed me. So much so that I insisted on taking a pilgrimage to Japan, to eat at his restaurant. And since then I've done it twice. In a way, that restaurant sparked this book. It helped me to understand chefs as creative artists with their own rules and traditions and challenges and obsession. Right. So that kind of tension between training and innovation is everywhere in that movie. What's a sushi master's version of creativity? Pressing the rice different on one side compared to how your father did it. There's a pressure to conform. But I also saw from this chef who I worked with that conformity could be avoided. In the end, I liked the structure of Japanese cooking. I think I personally work well within limitations. It's something I have always done. There are certain things about dishes based on tradition. And that's carried through to Nodoguro. My current setup seats only thirteen people. I am cooking on a household electric stovetop. I work with a farmer. I like to set major limitations for myself and try to work within that format.

After living and working in so many places, how did you end up in Portland, my favorite city? There's a place in Portland called Bamboo Sushi. They do sustainable seafood and sushi. The owner was very clever and savvy, and he wanted to expand his concept across the nation. That meant altering the concept slightly for other places: what worked in Portland might not work exactly the same way in San Francisco or Seattle, based partly on what fish were available and partly on other local factors. I was in Denver, and I applied for the San Francisco job. They got back to me and said, come to Portland. The personality here is a version of what you see when the city is parodied. There are lots of people here who do handcraft of one kind or another. That extends to the food world. The Portland model, for better or worse, is, say, a company of a few guys who go out and forage and then bring ingredients to the restaurant.

They have a little answering service, a tiny list of what they're getting, and in the afternoon they bring you a little box of these foraged ingredients. The fact that these guys can sustain themselves is amazing. In other cities, those same kinds of people have to make their money doing big bulk orders to New York and forage on the side. But in Portland there are lots of people doing these things more because they enjoy it.

So you cook at your pop-up Nodoguro. And you do what you call "atmosphere curation" with the help of your wife. What is that? I've never heard that term before, but I like it. It started as a result of necessity. When I did my first pop-up, I wanted to base it on flowers—on the language of flowers, how flowers contribute to cuisine. My wife, Lena, was watching as I prepared the menu, and she had the idea to put a little stamp of a dandelion or cherry blossoms on the menu. She also helped with the table decorations, which were little wood stumps along with glasses with dandelions planted in them. That helped to refine the experience. It made it a more complete idea. That pop-up went well. But when it came time for the next one, I realized that we had set the bar high. There were about forty people who came to the first one, and I needed all of them to come back, and to bring new people also. That meant making sure that the next idea was as creatively productive. For the second one, Lena did a little research as we were figuring out the concept, and she had the idea to do fireflies. It was a seasonally themed idea. At the time, she was only really thinking of it in terms of decor, but I started seeing how it could guide the menu, too. Then someone else got involved, which led to a little painting. I began to see how people could experience change not only through food, but through the new feel of the space.

There are other restaurants that do versions of that same thing, obviously, like Next in Chicago. But because you're running a smaller operation, you can make more sharp turns, or immerse yourself more completely. At some point, both of those things started to happen.

Right. I was reading Haruki Murakami's novels, and I started to notice that there were all these food items mentioned. And I wasn't the only one who was noticing. There was a weird online subculture that was springing up around the way that food worked in his fiction. There were blogs. There were two cookbooks in Japan. So I used Murakami as a starting point, and worked with the food elements in his fiction to make my menu. It was based on elements right out of these books, though we applied certain transformation to them. For example, in *Hear the Wind Sing*, there's a character who stacks up pancakes and pours Coca-Cola over them.[2] That seemed like a great starting point. That idea became our dessert, though not literally. We had a woman we were working with, a tea master, who was making a snack for us. She was a huge Murakami fan. She had gone to see him speak and he had told the crowd that his favorite food was canned peaches. We picked fresh peaches, blanched them, skinned them, and poached them in red syrup. Then we broke down all the flavors in Coca-Cola and ended up making this flat syrup that tasted like Coca-Cola, and serving it over a buttermilk ice cream that was slightly carbonated. So that act of translation from the novels brought us through to fizzing ice cream, syrup, peaches, on a Japanese rice sundae. That started to be when more people came in.

That's like writing a novel, or at least translating one. It would be like looking at a painting of people at the symphony, and trying to re-create the music that they're listening to.
It was an exciting way of making productive limitations. I tried to make food to my style but with all these additional twists as laid out in other people's artwork. The next one we did after that was Studio Ghibli, which was based on snapshots from all the movies.[3] For that menu, we ended up serving nine courses—things like chiashu with turnip, miso, and walnut, which we took from a scene in *Spirited Away*, or acorns, figs, and honey, which was related to *My Neighbor Totoro*. The total meal was $85, a low price point, at least compared to the other places I had seen. Then we did *Twin Peaks*, which was quite cool: our take on a Waldorf salad, or pie, or a traditional diner sandwich, or a damn fine cup of coffee.[4]

Not only did you do your *Twin Peaks* menu, but you got to serve it to David Lynch himself. What was that like?
You ask like you weren't there.

Oh, yeah. I was there. To me it was surreal, but I was just eating with him. How was it to actually make food for him in that context? It's almost like you're doing a remake of his show, but with food as the medium.
It was super-weird, but it wasn't as weird as I imagined it might be. We did the dinner in Los Angeles. We got out there, and the event was still a little bit in flux: equipment, scheduling, prep, everything. As a chef, I was worried about the actual cooking conditions—we were doing it in a bungalow at the Chateau Marmont, and I needed to figure out if the kitchen there really worked. The next day, we stopped off in the restaurant to have a cup of coffee, and the waiter asked us where we were staying. We told him Bungalow 3. "How did you sleep?" he said. We explained that we weren't actually sleeping there, that we were doing a food event. "Oh," he said. "That's the bungalow that John Belushi died in, so some of the staff feel like it's haunted." That made the whole thing even weirder: a *Twin Peaks* dinner for David Lynch in a haunted bungalow. And then the prep turned out to be pretty difficult. It was a hot L.A. day. There were gels we had to set. The refrigerator was heating up on us. And the whole time there were photographers circling us.

2 ——
That's Murakami's first novel, which I haven't read. I know someone who does something similar to what Ryan does—he tracks all the Western music in Murakami's fiction. That means lots of jazz and classical. In *Hear The Wind Sing,* he also mentioned the *Mickey Mouse Club* theme, Brook Benton's "Rainy Night in Georgia," the Beach Boys' "California Girls," and two songs by Elvis, "Return to Sender" and "Good Luck Charm."

3 ——
Ghibli was the studio founded by Hayao Miyazaki, who people call the Disney of Japan. They shut down in 2014 after Miyazaki's retirement, after making twenty movies. I think my favorite is *Totoro,* partly because of the soot sprites.

4 ——
As I'm writing this, David Lynch keeps leaving and rejoining the *Twin Peaks* reboot on Showtime. He was in, then he was out, and now he seems to be back in. I hope he stays in, and then we can see what foods his characters eat this time around, and then Ryan can put them on yet another Nodoguro menu. Maybe Lynch can eat that one too.

And then you had to serve the actual dinner. That's when I came in.

Yeah. That's when I met David, too. There was something about his work that I felt turned out to be true of him as well. There are these moments of horror and surrealism, but there is also a very accessible and approachable quality. I was worried he might pull a diva move where he only had a half hour, but he was super-nice and polite and happy to be there. But that's when it hit me. *Twin Peaks* was his. He might look at the dinner I made and say, "What the hell? This has nothing to do with *Twin Peaks*."

But you explained how you worked. You connected the dots for him as far as it went: his work to yours.

I tried to give a little background for each dish. The first course was Cod in the Dashi Percolator, which is flash-fried black cod, dashi with vaporized sake, mustard greens, crispy parsnip. That comes from a scene in the show where Agent Cooper and Sheriff Harry S. Truman—Kyle MacLachlan and Michael Ontkean—are drinking coffee. All of a sudden, Jack Nance runs out and says, "Fellas, don't drink that coffee—there was a fish in my percolator." For me, that suggested something about what to put around fish. We put this scalding hot dashi broth around the cod. I explained the connection. I watched David Lynch's expression. He seemed really thrilled. But what really made the evening is that he cut in. "Can I tell you a story of where that scene came from?" he said. Apparently he used to go to a café in Virginia. He was friends with two other guys, one of whom was part of the family that owned the café. The three of them would hang out and drink coffee. One day the third guy came in. He ordered coffee, took a gulp and spit it out. "What's the matter?" David Lynch and the other guy calmed him down. But he kept saying it was terrible. Finally, they investigated. In the kitchen, in the coffee percolator, there was a bar of Lava soap.

That was the amazing thing to me. You have this one incident, a real event, that gets translated and retranslated into different people's artwork. Did that change the way you thought of this overall process for extracting menus from other people's artwork?

It reminded me that it's a strange process, but also one that I'm growing comfortable with. For example, for a long time I have wanted to do a menu based on the work of the band Neutral Milk Hotel: re-create the sense of their music, lyrics, and album art. There's a surreal component but also a kind of safety or lushness. At first it seemed intimidating, like there were so many ways to get it wrong. Now I see it a little more clearly. That's been on the calendar for a while, but we're doing it as a collaboration with a ceramicist who is making actual dishes. It's a matter of coordinating with her schedule.

Do you feel like introducing all these new and strange elements is exciting for Japanese cuisine, or does it stretch it so much that it's a kind of betrayal?

Like I said, I had seen a chef who was really out there and experimental. And there's a personal part of it, too, an issue I have always dealt with, which is working in Japanese restaurants as a non-Japanese person. There's an idea that you're going to be better at that kind of cooking if you're Japanese. I remember situations where guests didn't want me to prepare their food, especially if it was an open counter. They wanted a Japanese person making their sushi. So maybe deep down I felt like I was bringing something new and novel to it just by being me.

Making art that's not what people expect is part of the fun. The Roots do a version of it at *The Tonight Show*. There are bands that get booked as musical guests on the show that seem like a weird fit for us, but that combination is what makes it interesting.

As I have headed down this path of cooking out from these cultural reference points, that relationship has become clearer. I realize that I only have formal training in Japanese food, and so I'll always be rooted in that. All these dishes at Nodoguro, no matter how strange they may seem, are broadly based on Japanese ideas. At the core all the food is Japanese but sometimes inspired by non-Japanese ideas.

Dave Beran at Next in Chicago was telling me that one of the liberating things is putting an old idea away. They do that there because they change over the whole place. At a traditional restaurant, if you do a dish people love, you're kind of stuck with it. But when change is built into the DNA of the place, you change along with it.

That's one of the great things. When we do themes and then set them aside, they're gone. We clean the slate and start over again. For us, there's an added dimension, which is that our very idea will have to change. I can't rent out the old café space attached to the grocery store forever. And so, as we find a new space, the idea behind it will have to change, too. And then there's the fact that I'm changing as a chef. At some point, you want to show off your techniques. But as you go, you realize that when it comes down to it, the experience of dining is sort of simple. You want to cook stuff and you want people to enjoy it. You want food to be delicious. You never want that obscured by technique. This relates back to Japanese cuisine, too. In classical Japanese cooking, there are all these weird ingredients, things that North Americans might think of as *Fear Factor* food: sea cucumbers and fermented guts. Making use of them in the right way is all craft. For me, I'm more about pure enjoyment.

Nathan Myhrvold talks about how America discovers food, and he's very interested in the way that cuisines come to us: we get sushi, we get Thai, we get Vietnamese. Then eventually it's all here, like it seemingly is now, at least in New York, and the new ideas are less about bringing things in and more about combining them. Are we getting to the point where all cuisines are fusion?
Yeah, I think we are, but I think it's great. Once again, look at Jiro. The filmmakers found this one guy, this super-unique individual who makes the best sushi in the world. But he's a very singular person. So is that authenticity? Is he embodying a tradition, or changing it? Those are all open questions. It's great for more people to go to Japan in their minds or via screen and come back here and see what's authentic, and how many versions of authenticity there are.

I'm always thinking up tools in music or in life that could make things easier. If you could invent one device that would make your life in the kitchen easier, what would it be?
There was a thing in the *DuckTales* cartoon when I was little. You could hit it and time would stop.[5] We do ten to twelve courses for people throughout the week. So the best tool I can imagine is a time-stopper. That's been one of the greatest challenges, doing these menus as a one-man show for this many courses. When people come in, they don't want to sit there for five hours to have dinner.

You mentioned *DuckTales*! You're pulling out a deep cut there. Millennials will have no idea what you are taking about. Other chefs have talked about pace, too. Nathan Myhrvold likes to keep things moving alone. He wants every course to be five minutes or less. People don't like to sit for as long as they used to. What else is changing in food culture? What are the main challenges people are going to face in ten years?
In the sushi world, one of the biggest changes has been the supply of bluefin tuna. In the nineteenth century, it was considered a cheap fish. Then it started to gain in value. In the late sixties, there were competitions to catch the fish. People caught all they could and in the end very little of it got used. In fact, it only started to be an issue because JAL airlines brought it back to Japan from the East Coast. It was a way of filling up returning planes. And now it's nearly extinct. I haven't touched one in five years. So you devise substitutes. You realize that there are lots of things that you would have never used that now are more central for use. For me, I use more local fish. I go to the guy down the lane and ask him what's coming from the coast. The seafood changes have been very cool. They let me blow up the toolkit and expand my mind.

5 —
It's a magic watch that Gyro invents in the episode "Time Teasers." Obviously. I'm just kidding about how obvious it was. I don't know the show that well. It's not even that it's much past my time. I just never crossed paths with it profitably. But there's a similar device in John D. MacDonald's *The Girl, the Gold Watch & Everything*. I don't know if I read the book version, which is from the early sixties, but I remember the TV movie, which starred Robert Hays. He could press the stem on the watch and everything around him turned red and he could do what he wanted: sneak into people's houses, take off people's clothes, switch the cat food and the dog food. That came out the same year he starred in *Airplane!* The TV movie was in June. *Airplane!* was in July. A few months later, Prince released *Dirty Mind*. What a year.

(right) Ryan's Tools:
shark skin grater, grater, tweezers, spatula, pan handle, cooking chopsticks, old carbon steel knife worn down into box cutter

(following spread)
Lotus root and green onion

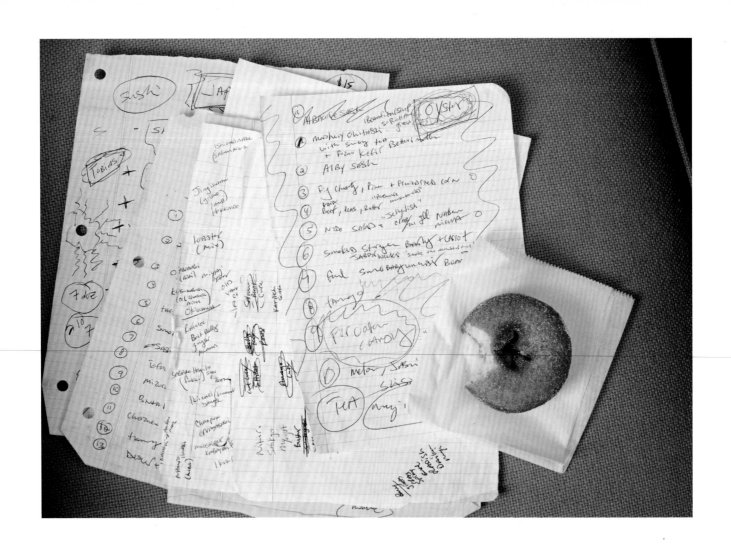

(previous spread)
Usually with coffee you
get a bear claw—this
time, it's a crab claw

(left) Sometimes the key to
an entire meal is a donut

(below) Laura Palmer's File:
the menu for Nodoguro's
Twin Peaks meal

FEDERAL BUREAU OF INVESTIGATION

Dale Cooper
Special Agent

Nodoguro "Twin Peaks"

Cod in the Dashi Percolator

Sesame pressed Trout Sashimi

Coffee Cup Custard with Blacktrumpet and Corn

Turnip Waldorf Salad and Miso

Smoked Cheese Pig

Seared Duck, Huckleberry and Real Potatoes

Uni Porridge with Coffee

Omelet

Soba and Donuts

Roasted Tea

Nodoguro "Twin Peaks" Menu

1 Cod in the
 Dashi Percolator

2 Sesame Pressed
 Trout Sashimi

3 Coffee Cup Custard
 with Black Trumpet
 and Corn

4 Turnip Waldorf Salad
 and Miso

5 Smoked Cheese Pig

6 Seared Duck,
 Huckleberry, and
 Real Potatoes

7 Uni Porridge with
 Coffee

8 Omelet

9 Soba and Donuts

10 Roasted Tea

10 —

4 —

8 —

7 —

1 —

9 —

2 —

5 —

3 —

6 —

Photos by Misha Gravenor

David Lynch comes to dinner
at Chateau Marmont's Bun-
galow 3, West Hollywood, CA

The Meal
Modernist Cuisine

Modernist Cuisine

12 —

1 —

3 —

10 —

8 —

9 —

2 —

11 —

7 —

5 —

4 —

6 —

13 —

The first person I saw when I arrived at the Modernist Cuisine lab in Seattle was Mr. Potato Head. (I know he's not exactly a person.) When I got to the lab on a rainy Seattle day—it was the first rainy day in a while, the staff said, though I wasn't sure whether or not to believe them—I was beside myself. The building held all the subjects in school that I was bad in: chemistry, biology, physics. The worst part was the trophy case off to the side with Einsteins of all shapes and sizes—paper dolls, action figures, statues. It was the most intimidating case I had ever seen. But at least there was a Mr. Potato Head there. Imagine my dismay when I got up closer and saw that even he was an Einstein, with a mustache and everything. *Et tu,* Mr. Potato Head?

Nathan Myhrvold came out to meet me and tour me through the lab. He was wearing a lab coat and the way he talked about things, always enthusiastic, was extremely Wonka-ish. I briefly imagined him putting on a top hat and a cane and singing "Imagination." We went past a machine designed specifically to track the way that bread rises with sonic pings that take measurements many times a second. Nathan showed me cameras that took heat-map images of foods as they cooled. He pointed out a special laser that cut patterns into or onto food. We paused in front of a 3-D printer that his team used to fashion strange-shaped dishes and platters. I asked him about making a special bowl that kept the milk and the cereal separate, and he said that was a definite possibility. He took out another dish, which looked like a futuristic car or a personal space plane. "What do you think this is for?" he said. I guessed an egg, and he shook his head. "You'll see later," he said.

Toward the end, he showed me the dinosaur tail. It was on the far side of the room, in its own corner. Nathan had a hypothesis that certain dinosaurs whipped their tails, Indiana Jones–style (or, if you prefer, Willow Smith). Right there, in his lab, he built a one-quarter-scale tail, down to the smallest vertebrae, and he was experimenting with it to see if the whip movement made sense. He said that he was going to present his findings at a dinosaur conference later in the year, so I don't think I'm giving anything away. By the time this book comes out, the world will already have seen the tail whipping around. Other parts of the lab were so interesting that I can't talk about them, or even show pictures of them. When a man who designed a dinosaur tail tells you that certain things are top secret, you listen.

After our tour through the lab, we sat down to eat. Over the years, the Modernist Kitchen has hosted in-lab meals for luminaries in various walks of life: Thomas Keller, David Chang, Martha Stewart, Bill Gates, Paul Allen, Dominique Crenn, and Ferran Adrià, among others. I may have been the first musician to sit down. I hope I'm not the last.

The meal was lunch, and it was thirteen courses. Thirteen is sometimes considered an unlucky number, but that's superstition, and this was science. And art. It was lots of both. What follows is a tour through the meal of a lifetime, with the dishes named exactly as they were named on the menu. Because I'm kind of a cinephile, I've structured it as a director's cut, with Nathan providing commentary for each dish. And because I'm a compulsive annotator and connection-creator, I had to create my own playlist to accompany the meal, a song to pair with each dish.

Photo by Questlove

1. PRESSURE-COOKED BASIL COCKTAIL

The first dish was served in an oversize spoon. Before we tasted it, Nathan put a jar filled with a bright green liquid on the table.

"This is a cocktail. In fact, this is the first cocktail you've ever had that has zero water in it. It's olive oil, a few drops of vinegar, and what's in this jar, which is what happens when you pressure-cook basil in pure alcohol. You get this really intense basil flavor, which goes well with olive oil. At elBulli, Ferran Adrià often began his dinners with a cocktail, but it wasn't a mixed drink. It was something weird and out of the ordinary, so when he came here, we came up with this idea."

I wasn't sure what he meant by "zero water" until I thought about it. All drinks have water: there's water in vodka, water in gin. But there was no water here, just basil flavor in pure alcohol. We drank the cocktail in one gulp, like he said. It was smooth. It was surprisingly light. It was, for once, easy being green.

Song Pairing: "No Water" by Bob Marley and the Wailers. When Nathan said that the dish had no water, that's all I could think about.

2. CHICKEN WING

The next dish arrived. It was a small rectangular plate with a single chicken wing on it.

"When we did *Modernist Cuisine at Home,* our second book, we wanted to have some dishes that weren't fancy-pants, that you couldn't only get at high-end restaurants. We had a chapter on Super Bowl snacks, including these wings. We use a supermarket starch for the outside called Wondra, which is pre-gelatinized and makes the chicken wings super crispy even when you dip them in sauce. I love these wings, but I love all kinds of food. Over this last weekend I went with a friend of mine to go trout fishing in Central Pennsylvania. One night we cooked. The other nights we went to this local tavern in this town. They had a sign that said 'Famous for Our Fries,' and that was their big thing, piles of French fries smothered in melted cheese and bacon bits. The only rule I have is that I generally don't eat in chain places because almost always if you look around the shopping center there's some local weird thing. I'd much rather take a shot at that."

I'll give it to Nathan on this one. The chicken wing was among the best I've ever had. It wasn't Buffalo style: the sauce was a little more sweet-and-sour than plain old hot. Still, no matter how amazing the wing tasted, if you opened your eyes and looked down at it, it was just your basic chicken wing. Daniel Patterson came to mind, the way he described making quality fast food but still keeping the familiar look of fast food.

Song Pairing: "Rapper's Delight" by the Sugarhill Gang. I remember when the song first hit the radio. I spent the weekend memorizing the lyrics and became an instant celebrity at school. Wonder Mike's entire bad food experience had me in stitches. The macaroni was soggy, the peas were mushy, and the chicken tasted like wood. We've come a long way.

3. PEA BUTTER

The next dish was a pea paste, so smooth and creamy that it almost seems insulting to call it "paste." Which is maybe why Nathan called it "butter." The pea butter was served like a tiny taco: a small green shell with two creamy dollops. "That's some good shit, huh?" Nathan said. Everyone nodded. Then he went to a washing machine, except it wasn't a washing machine, and what he took out wasn't clothes but a big circular metal piece.

"Peas are funny. If you can serve them within an hour or two of picking, they're great. Otherwise, they degrade, unless they're frozen while they're still sweet. Freezing vegetables does strange things to their texture, but if you're grinding them up, it doesn't matter. We grind peas into goo. Then we put that goo into a centrifuge, where it spins at insane speeds, experiencing a force thirty thousand times normal gravity. It separates into two substances and then this thin layer between them. There's pea broth on the top. You'll see that in a future dish. There's pea starch on the bottom that doesn't taste like much. It's basically green sawdust. The thin layer between them, we keep. We call it pea butter, but there's no fat. We love this dish in part because it's such a surprise. People aren't used to peas being a central focus of a dish. And Francisco, our chef here, came up with a cool way to do the pods. They are made from bagel dough that has pea in it so it's green. It's thinly sliced, and then we fold it over and stick ball bearings in it and crisp it up. Then we squirt in the pea butter."

Before I ate, I made sure that the ball bearings had been taken out. Nathan kept talking about the pea butter: the peas themselves were cheap enough, but that tiny layer between the broth and the starch was only four percent. That made me think about Jesse Griffiths, and how his experiments were limited by economics. "When I get a bunch of carrots, I don't see just the carrots but I see the tops and the peels, too," he said. "Use everything. Waste nothing. That's the only way that we can keep our doors open."

Song Pairing: "Pass the Peas" by the JB's. This song was recorded when I was just a few months old, and it's one of the foundational funk instrumentals. Jabo Starks is on drums.

4. PEA STEW

A bowl with the most beautifully colored vegetables arrived, and then little vessels with green broth followed.

"Pistou is the name of a condiment in Provence, so this dish, pea stew, is a play on words. We take the broth from the centrifuged peas and pour it over the vegetables. There's also ricotta cheese that we make ourselves. One of the things I love about this dish is that some people get the idea that there's a disconnect between farm-to-table cooking that's all about ingredients and fancy cooking that's all about technique. And look, sometimes it's great to have ingredients cooked simply. But sometimes it's not simple. Wine is not simple. Cheese is not simple. This dish and the dish before use a centrifuge. But the result is to celebrate a simple taste, which is the peas. It's not about detracting from the ingredient with technique. It's about making it better. I don't think there's a contradiction and I think it's a hell of a dish."

As I finished the dish, which was in fact a hell of a dish, Nathan pointed out that the centrifuge rotor had to be x-rayed annually so it wouldn't crack, spin out of control, and level the lab. He then went on to detail a series of science-related injuries he had suffered over the years, including having his eyebrows burned off.

Song Pairing: "More Peas" by the JB's. The original "Pass the Peas" ran single-length, under four minutes. The extended sequel stretches out over thirteen minutes.

5. CARROT SOUP

A tiny dish with two tiny pretzels was brought out to the table. I reached for one instinctively, but the pretzels weren't the dish. They were props. The dish was an orange-brown soup. "Do you know why pretzels are brown and shiny? The way you make pretzels is that you make a solution of lye, and you get it really hot, and before you make the pretzels, you dunk them in this hot solution. That's because the reactions that make food brown occur at a lower temperature in an alkaline environment. By making it more alkaline, you make the browning easy. I had known about this pretzel process for years, and I thought it must also work with other things. So we pressure-cook carrots with butter and baking soda. Baking soda is alkaline, so it makes the carrot caramelized and brown. The actual soup has nothing else. Like the cocktail, there's no water. It's only carrots, butter, and salt, along with the baking soda. The noodles in there are made of young coconut."

I have never been a huge fan of carrot soup, but this soup sold me. I asked Nathan and he explained that browning wasn't just about color, but about flavor also. It intensifies what's there already. It's a chemical reaction. It was one of the first things Nathan said to me: "When people say 'What made you think you could bring science into the kitchen?' I say 'Sorry. It was already there.'"

Song Pairing: "Pretzel Logic" by Steely Dan. The older I get, the smarter these lyrics seem: they're Steely Dan's version of the American South, complete with nostalgia and a nightmarish minstrelsy scenario. American culture can't get away from questions of race because the question of race is sort of what created American culture. It's like what I was saying about that diner in Alabama. To get from here to there and back again you have to make lots of twists and turns, but so does a pretzel.

6. BINCHOTAN

Toast was placed in the center of the table. Each of us was given a small jet-black log. Nathan had two, one on the plate in front of him and one on a plate off to the side. He picked up the small log from the side plate and banged it against the table. Was that what we were eating? My teeth were already hurting. "Binchotan is a Japanese charcoal. It's super hard, hard as a rock. It's made of a special wood prepared a special way, like everything in Japan. It's used in little hibachis. We decided to serve you some. Take one of these brioche points and spread the super-hard charcoal on your toast."

The charcoal spread easily. My teeth were saved. I was amazed. Maybe I was super strong from the carrots. Nathan was giggling. He explained that it was a liver mousse molded to look exactly like charcoal. They colored the outside with lampblack. When I spoke to Ludo in Los Angeles, he said that the real secret for him lay in finding ingredients. "I'm not a magician," he said. But for other chefs, there is an element of sleight of hand.

Song Pairing: "Chum" by Earl Sweatshirt. The more Nathan talked about how hard the binchotan was, the more I got this song stuck in my head, especially the lyric "Feeling as hard as Vince Carter's knee cartilage is." It's not an appetizing image, maybe, but that was part of the trick of this dish.

7. VONGOLE

Pasta plates approached the table. Nathan waved away someone behind me.
"Keep that offstage for a moment."

We were on a stage? We ate the pasta, which tasted sort of like spaghetti with clams. Nathan signaled a staff member to approach, and a plate appeared bearing what looked like a living sausage, or maybe a fingerless hand: it was about a foot and a half long and thick. I tried to remember if it was something I had seen on *The Addams Family*. Nathan asked if we knew what it was. Someone said "Geoduck."
"That's right. This is the world's nastiest-looking clam. It's native to the Northwest."

It was dead, right? I didn't need to ask. Of course it was dead. I asked just to make sure.
"No, it's alive."

Are you serious? I slid my chair back a bit.
"I'm completely serious. We did a dinner where some guy, being a wiseass, grabbed it and squeezed it, causing it to squirt water all over the other guy. So this is what we do to the geoduck. First we have to skin it. We apply a blowtorch up and down, and then you cut along the outside and peel it. The skin is super thin. When removed, that layer looks exactly like a condom. Then we split the rest down the center, flatten it out, put it in a sous vide bag, gently pound it to make it thin, and then slice it to make it into noodles. Then we make the sauce out of another part of the geoduck. We thought of this because we had a recipe in our first book that was spaghetti alle vongole, spaghetti with clams. Then we realized we could make the noodles out of clam. As you'll notice, several times today we've served you food that isn't quite what it seems. We do that for the same reason that a punch line of a joke is surprising and that's what makes it funny, or for the same reason there's suspense in other art forms."

The clam spurted. Water shot out of the top, which we were told is called the siphon.
"See. I told you. This is what we call a happy ending."

Song Pairing: "Pachuco Cadaver" by Captain Beefheart: it's like it perfectly describes the course. "A squid eating dough in a polyethylene bag is fast and bulbous, got me?"

8. QUAIL EGG

After the geoduck, the next course was small and sedate—just a tiny egg in the middle of a tiny nest, and a spoon alongside it.
"Here's a quail egg and we're going to teach you how to eat it. You take it and shake it out onto your spoon. Now *bon appétit*."

I stalled for a second. I wasn't sure about a raw egg. But I was a guest in someone else's house. Down the hatch. It tasted differently than I thought it would. It was almost tropical. Nathan was cackling.
"Exactly! It's not an egg at all. Lots of chefs have a mock egg dish. Sometimes they'll do a mock fried egg, sometimes a mock hard-boiled. But I had never seen a mock raw egg, so we made one. The yolk is mango and passion fruit. The white is lemongrass consommé. We make the yolk a little sac and give the white this jellied consistency, and then serve it in a real quail eggshell. Usually there's someone at the table who's terrified of eating a raw egg. They are reluctant. After the other people at the table have eaten it, there's a strange effect. The people who ate it are already reacting—their main taste is relief and surprise. If there's a holdout, everyone else starts telling them to eat it, that it'll be okay. Peer pressure sets in. We call this dish 'quail egg' on the menu, just that simple description, because surprise is part of what we're doing."

Back when I spoke to Daniel Humm, he talked to me about one of his formative experiences: being served a salad where you dipped the leaves in dressing rather than just having them dressed for you. He was amazed, he said, that dining wasn't just about passively receiving what was given to you: "It was cool," he said. "Food was interactive."

Song Pairing: "Egg Man" by the Beastie Boys. As they say, "The egg / a symbol of life."

9. POLENTA

The twin shocks of the geoduck and the quail egg still had me back on my heels. The next dish didn't seem like it had anything shocking in it. It was called polenta, and that's exactly what it looked like: a yellow meal with a red sauce on top of it.

"There are two basic types of corn. There's field corn, which is what you use to make cornmeal or polenta. Then, on the other side of the spectrum, there's sweet corn. This dish combines both. We juice the corn and let it separate. We use the centrifuge, but you could just put it in your refrigerator to achieve the same end. We pour off the clear part of the juice and use that to cook the polenta. Then we take the husks like you'd use to wrap a tamale and pressure-cook them into oil. On top of the polenta, you have salted ricotta and also a red marinara sauce. It's not tomato. But tomatoes are a red berry, even though we don't think of them in that way. They're an acidic red berry. These are strawberries, a different acidic red berry, and they're used to make a marinara, too."

The polenta was fantastically sweet, as was the marinara. I was nine courses in and beginning to get lost in it all.

Song Pairing: "Revolution 9" by the Beatles. We're up to course number 9, and it's getting dizzying and kaleidoscopic. Plus, the colors of this dish are a little trippy.

10. ROAST CHICKEN

Nathan told us to look toward the oven in the back of the room, because in three minutes, when it opened, it would be dramatic. In three minutes, it opened, and the chefs took out roast chickens. So far, it was nice, but maybe not dramatic. He took one and tapped the skin with a knife. A shatter-pattern, like a spiderweb, spread across the skin, which was crispier than any chicken skin I had ever seen.

"With roast chicken, you want to have the skin crispy and the meat moist. But that's a fundamental contradiction. If I make the skin crispy I'll overcook the breast meat. So how do you solve that? Some people brine the bird. The salt in the brine pries open the protein molecules and makes them take more water. The problem is that there's protein in the skin, too, and when you brine the skin, it gets rubbery. So we solve it by brining the bird but not the skin. We use syringes for that. Then we hang the chicken upside-down in the fridge. It's there for three days. We want the brine to penetrate through the whole meat. We also stick our hand there and separate the skin from the chicken. When the whole brining process is done, we roast the chicken for four and a half hours at 145 degrees, a very low temperature. They sit. Then we put it in at 575 degrees for three minutes to crisp up the skin."

I have owned a restaurant that served chicken, and I have thought about chicken skin more than I ever thought I would. The problems Nathan described were real, I thought. I ate Nathan's delicious chicken with a renewed appreciation for science.

Song Pairing: It's hard to decide between "Funky Chicken (Part 1)" by Willie Henderson and the Soul Explosions and Rufus Thomas's "Do the Funky Chicken," so I went with the Jackson 5's "How Funky Is Your Chicken." It's also a sign of respect for Nathan and his chefs: "I don't mind givin' in to the baddest man."

11. RYE LEVAIN NOODLES

Little bowls with brown-gray noodles appeared. The noodles had little black seeds on them. They looked pretty subdued, like a small pasta version of a chocolate-chip cookie. I half expected the Cookie Crisp wizard to leap out of the bowl.

"These are rye sourdough noodles. We're making rye sourdough bread for the bread book, and Francisco came up with the idea to make pasta from it. This dish really goes with the next dish, pastrami; this is pastrami and rye where the rye comes first. The black things on top are nigella seeds. They're the most traditional thing to put on Jewish rye. They weren't as available in the U.S. originally, so we got used to doing it with caraway seeds. The nigella adds a little flavor, a little texture, and a look. The sauce is a sauerkraut *beurre blanc*."

The noodles were excellent, but restrained. They hung back from the showy effects of the other dishes. I told Nathan about how there's a similar principle at work in DJ sets—I set people up with pauses or intentional dips before I ramp up again for the big finish. You want to hook people psychologically. When Ryan Roadhouse started his Nodoguro pop-up, he had a great idea. But how would he move it forward? How would he be sure that it was a point on a graph and not the entire graph? "There were about forty people who came to the first one," he said. "I needed all of them to come back, and to bring new people also." The way the chefs in this book learned to do it was through managing and manipulating expectations.

Song Pairing: "In the Air Tonight" by Phil Collins. The first minute of that song is nothing special, and I love watching the dance floor clear. Right when the thunderous drum part comes in, I switch over to the song I really intended, and it drives people crazy. These noodles worked the same way.

12. PASTRAMI

The most substantial dish in the meal, and the sequel (prequel?) to the rye noodles, came to the table. It was what I guess I'd describe as a brick of pastrami. The aroma preceded it: it smelled like meat that had gotten the highest possible levels of care and attention.

"This is our pastrami, our most time-consuming recipe. It takes a week. We brine it for four days, cook it for three days sous vide, then smoke it for six hours before we serve it. On top there's wasabi, but real wasabi. Much of the wasabi you get in restaurants is ordinary horseradish dyed green and mixed with dry mustard. Real wasabi is in the horseradish family, but the taste is more subtle."

"Time-consuming" is an understatement. Dominique Crenn had told me that she was frustrated with the way that American culture tended toward instant gratification, and how that sometimes interfered with creativity. This was the other end of the spectrum from that. The wasabi discussion led to a long digression about sushi, which led to Nathan and me comparing Jiro experiences. Before Nathan went, he did lots of research, unsurprisingly, on sushi-eating etiquette. Most Americans eat it with the rice on the bottom, which blocks the taste of the fish. Some Japanese diners opt for fish-down eating, which puts the fish in contact with the tongue. And then there's a compromise solution, where the sushi is held sideways and both rice and fish make contact with the tongue. That's what Nathan chose. When he ate there, he shared a table service with a prominent Japanese heart surgeon. I started to tell him that the Jiro discussion brought the book full circle—that's where my food journey had started, back in the Chuo ward, in the Ginza district, on 4-chome street, in the basement of the Tsukamoto Sogyo Building—but then dessert came and brought his meal full circle.

Song Pairing: "Hot Pastrami" by the Ronettes, though it's often attributed to the Crystals. It's a novelty, with the dish's name shouted out, along with other food items (mashed potatoes), various exhortations (yeah, baby one more time), and finally Phil Spector's name. It's probably the only song about pastrami.

13. PISTACHIO GELATO

The strange dish Nathan had shown us at the 3-D printer, the one that looked like a futuristic car or a personal space plane, reappeared in porcelain form with an egg-shaped scoop of something nestled into what I'd call the cockpit.

"So here is the dish, quite literally. It's cast directly from the mold we showed you before, the one that had wings on the side and then that little recess on top. It's a special porcelain that comes from Australia, and there was a whole deal in getting it. This dish doesn't show off the porcelain in its coolest form—it's semi-translucent, super white, super-fine grain. By the time I made this, I was kind of getting into porcelain, too. This is vegan ice cream. Pistachio is a mild flavor. When you add cream and egg yolks, you wind up getting green ice cream, not really pistachio ice cream. We grind up the pistachio nuts, separate out the oil, and homogenize it with water to make a pistachio cream. We use a rotor/stator homogenizer, a device where the blade, or rotor, is very close to the outside plate, or stator. You would use it if you're collecting a DNA sample and trying to extract DNA. In this case, it squishes all the liquid into a tiny little space and does a much better job of homogenizing. The result is that you have a cream that's never been through an udder. Actually, if you want to be technical about it, this is sorbet, because it has no dairy products in it. That's amaretto underneath it. Because our meals are long, we don't serve very much. So how do you serve a single scoop in a way that celebrates it? Like this. At the moment, this dish is only for this dish. I'm trying to think of other ways we might use it. I had the idea to do a future ice cream where you use the other parts of the dish for a sauce."

Whatever a rotor/stator homogenizer is, it makes excellent ice cream.

Song Pairing: "Paid in Full" by Eric B. & Rakim. There's a lyric in there about food. It's about fish. But it's also about a dish: "A nice big plate of fish, which is my favorite dish." And it's in a song that's about making good on your ideas and being rewarded for them. And now, at the conclusion of the meal, we're all (paid in) full.

Thirteen courses, thirteen surprises, thirteen satisfactions. There are lots of songs about thirteens: Organized Konfusion did one, as did Brownside. Chuck Berry did—"Thirteen Question Method." There's that Danzig song that Johnny Cash covered. I was too full and satisfied to think of any more.

What I was thinking of, strangely, was the ice cream. I had started the book determined to find out more about creativity in food—about each chef's creative process, about the balance between innovation and tradition, about the importance of a personal connection. The pistachio ice cream, served in the bowl that Nathan had made based on his own 3-D printed design, was in some ways a perfect illustration of that. It couldn't have been simpler. It didn't even have cream. And yet, it couldn't have been more sophisticated, given how much cutting-edge science went into it, how much trial and error, how much precision. The result was something beautiful: an amazing dish served on an amazing dish. Everyone at the table recognized that it meant something, even if it meant something different to each person. Dominique's definition of her food came to my mind: "Presenting emotions through food," she said, "gives other people an opportunity to find their own emotions there."

The table was cleared. We stayed and talked. The conversation drifted into other issues: the importance of making food that reflects the local culture, the role of sustainability, the pros and cons of formal training, the failure of the food industry to improve diversity. Nathan mentioned an event he had held for twenty-five female chefs, including Dominique, and someone wondered when we'd reach the point when it wasn't necessary to hold a special event to round up a bunch of female chefs, or chefs of color, or female chefs of color. The food world has to expand because food is so central to the rest of the world.

We got ready to leave through the rainy Seattle afternoon. The whole thing was the closest I have come to a Wonka experience. I turned to Wonka himself and asked him about the possibility of a three-course meal in a single stick of chewing gum. I had to. Would future Violet Beauregardes enjoy tomato soup, roast beef, blueberry pie and ice cream? They would have to work out the kinks, especially when it comes to the blueberry pie. I can't tell you what he said, but the answer was in the "other part of the lab."

It felt like the book's journey was ending. But in reality, it was just beginning. If there was one thing I had learned, it was that any single course is only part of a larger meal, and any meal is only part of a larger menu, and any menu is only part of a larger creative cycle that goes from conception to execution to reaction before starting over with a new conception. I knew it would take me a while to digest it all—not the food, but all the questions orbiting around it.

And so, we were done with the book.

Acknowledgments

When the meal's over, what's left? When the plates are taken away, what remains?

This project began as an exploration of food, but it ended as an exploration of creativity. Working with chefs, and trying to figure out how they do the things they do, helped me to see how my own creative process works. Creativity never stops. Throughout this project, chefs talked about the particular nature of food-based creativity. This is the particular nature: it goes away fast. When the meal's chewed, when it's swallowed, no real evidence remains. So how can an artist prove that he or she has made something? This book is really about the term of a creative project, that it extends beyond the work itself in both directions. Creativity starts before the product and ends long after the product has gone: after it's been consumed, viewed, experienced. And that's because a true creative product, no matter what part of its life cycle it's in, keeps humming with curiosity, still asking questions. It takes a form, but then it helps the people who encounter it to form a take. It spurs people to ask questions of their own. That, to me, is the definition of art: inquiry made interesting. The question mark at the beginning of my name isn't just for show. It's for tell, too.

Creative ideas are intersections. They are two beams of light that cross to make a brighter beam of light—or three beams of light, or four, or more. And because of that, creativity is a group effort. The idea may be yours, but you exist within a matrix of others. Your ability to see what they contribute to the way an idea develops isn't part of the skill. It is the skill.

These principles guide chefs and their food. They also guide musicians and their books. I'd like to extend a huge thank you to the team that helped a vision become a reality: Ben Greenman, Alexis Rosenzweig, Marc Gerald, Kyoko Hamada, Jeanette Abbink, Reed Barrow, Beth Lesko, Misha Gravenor, Colin Strohm, Julian Horn, Erin McDowell, Ashley Ricart, Kevin Rogers, Whitney Martin, Ramsey Alderson, Augusta Sagnelli, Daniel Dorsa, Naomi McColloch, and Sara Mark.

I would also like to extend respect and admiration to Francis Lam and the entire team at Clarkson Potter for thinking outside the box. Books like this only happen in partnership with the right book people.

Chefs are the head of the creative operation, and the chefs in this book were quick to remind me that nothing in their restaurants is possible without a supportive staff. From back of house to front of house, everyone is a neuron in the same brain.

Many neurons came together in the making of this book: At Modernist Cuisine: Fransisco Migoya, Melissa Lukach, Sara Mark, Stephanie Swane, and Scott Heimendinger (and everyone at the lab who let me geek out for a day); at Eleven Madison Park: Amy Livingston and Kristen Turkel; at Zahav: Felica D'Ambrosio and Amy Henderson; at Trois Mec: Doug Rankin and Kristen Lefebvre; the teams at NEXT and Dai Due; the entire staff at Atelier Crenn; at Coi: Alexandra Foote and the gracious staff; at Nodoguro: Elena Roadhouse and Colin Yoshimoto: and the staff at the Chateau Marmont.

And now the chefs themselves, the people who transform food into a physical and sensual reality, who make ideas matter, who make me think about food in the same way I think about music or art. These chefs took me into their worlds and I am forever appreciative of being let in. Thank you to Nathan Myhrvold, Daniel Humm, Michael Solomonov, Ludo Lefebvre, Dave Beran, Jesse Griffiths, Donald Link, Dominique Crenn, Daniel Patterson, and Ryan Roadhouse. When I began this book, I knew that the creative process behind food would illuminate and refine my own creative process But I didn't know how much. From every tiny remark about appetizer ingredients to every knock-down, drag-out conversation about the evolution of the process of dining in public, those men and women helped me think new and surprising thoughts about the things I made.

Food is creative and intellectual, but food memories are personal. I wanted to also throw some light toward people who I think about when I think about food: friends, family, close-to-hearters. To my aunts and uncles, for the Sunday dinners after church. To my cousins, who I'd fight with trying to claim the cereal prize at Grandma's. To my Grandma, who ended my two-year-running vegetarian childhood with bacon. To my Uncle June, who taught me the world's best egg omelet consists of milk, cheese, turkey and a dab of vanilla extract. To Ms. Riley,

238

who fed the block every summer with those half sandwiches and hugs (quarter waters to the rest of y'all). To John C, who would occasionally be down with sharing his sandwiches when I spent my lunch money on records in school. To Mama Angelina's on Locust, less for the food and more for the idea (new at the time) of attracting customers with video games—it got me into a lot of trouble as a kid. To my morning school breakfast spots: Harris', Gus', and Jack Myers (I miss the 25¢ Tastykake Oatmeal Bars), Pete's & Jerry's (who knew cheddar, butter, and jelly on a raisin bagel was a great idea?). To my sister Donn, who made the best Jiffy Pop for my 1 a.m. viewing of *Soul Train* and who took me to my first sushi restaurant. To my Dad, whose antidote to me spilling Mom's burning hot food on my lap would be to sacrifice himself and spill some on his own lap, too, so he could catch up to me running 300 mph out the door—that was hilarious to me at 10. To my Mom, for always making me feel like each spot we went to was some ritzy high-class place, even if it was Roy Rogers. To Tariq, for teaching me that the best dates could be had for 10 bucks at Wawa (4 rolls for $1.25, a half pound of honey turkey for $2.75, a quarter pound of pepper cheese for $2.15, a half gallon of punch/lemonade/tea for 99¢, all the napkins/mustard/plastic utensils for free, and split a Butterscotch Krimpets with what was left)—and that, if the girl was worth it, you could trek all the way to Yeadon for the dollar theater with free popcorn. To my Roots cohorts past and present—I'll never forget London '94, when we only had 40 quid and no electricity in our loft and still made a miracle with fish, chips, cheese, and red sauce. To the Black Lily movement, all the artists/musicians/poets/ part-time singers/mcs/hangers-on/observers/ staff/organizers/babysitters who were lured to the jam sessions by Terry's cooking. To the Tastytreats Crew of 2002–2012, for spreading good music and good Tastykakes throughout Philadelphia. To Nance, for forgiving me eventually for embracing hard-shell tacos when it was a slap in the face of authenticity. To Saana Hamri, the world's BEST tea maker. To my Quest Loves Food partners and collaborators, for making a lifestyle and dream turn into magic. To Jimmy Fallon, for providing a place for all the chefs I dreamed about meeting. To Lorne Michaels, for being easily sold with a bag of popcorn. To everyone in 6b, for being there for the occasional treats (sorry about the failed "double down" experiment—I almost sent 30 of y'all to the hospital). To my personal "Cheers," En Brasserie—thanks for everything guys, Love "Norm." To Steven Starr, major gratitude! To My Blue Ribbon Gods: Thank Ye! To my salt-tasting, lemon-sucking, vanilla-coconut-loving, avocado-stealing, bread-snacking, goat-cheese-advocating food segregationalist assistant Zarah: Chipotle is NOT a place one needs to eat four times a day! To Steve, who blames me for his having The Sugars. To Maddie, who swears nothing is better than her mom's cookin'. To Christine Farrier, for literally banning me from certain restaurants without her permission. To Elita Bradley, all my undying thanks and love for your talent. To William, my partner in culinary crime. To Ardenia, for making everything with love. To Sascha, for all the enlightenment and caviar. To my beer tutor Daria, here's a toast. To Alexis Rosenzweig, for carrying the heaviest torch to the end. To Shawn Gee, for taking us further than we ever thought we'd go. To everyone I shared a meal and broke bread with— if we had a meal together, that really means something significant.

Lastly but not leastly, no Philadelphian with a book about food should fail to acknowledge the true culinary masters of his city. So here are the top cheesesteak providers (look, everyone has an opinion; I'm name dropping my faves—not *yours*): Gennaro's, Ishkabibble's, Cosmi's, Tony Luke's, Philly's Finest Sambonis (food truck—catch 'em if you can), Max's Steaks, Pagano's Steaks, Barclay Prime (I know it's real 1% of me to brag about the $100 Cheesesteak . . . but it's really *that good*), Chubby's, and George's Pizza. And then the best hoagie joints: Ricci's Hoagies, Melino's Hoagies, Dalessandro's, Wawa (hey, if it's 2 a.m. after clubbing, you are allowed to consider Wawa a spot for authentic Philly hoagies). And special mention to Bottom of the Sea, home of the "Lapdance." Everyone that grew up around the way has at least one or two hood "fish sammich" spots they still frequent. I'm thinking about putting clothes on now and running over before they close at 2, and I'm hours away from home. My trainer hates you all, but I never let a health nut get in the way of our ongoing affair. Thank you for representing my city well, and for making it easy every time I had to make a list for a band or an ex-girlfriend's parents or a food blogger.

My love to you all.

Library of Congress Cataloging-in-Publication
Data is available

ISBN 978-0-553-459425
eBook ISBN 978-0-553-459432

Printed in China

Design by Rational Beauty:
Jeanette Abbink, Mike Abbink
Design intern: Yerang Choi

Photography by Kyoko Hamada
Art direction by Alexis Rosenzweig

Cover art by Reed Barrow
Cover art food styling by Erin McDowell
Food styling by Beth Lesko

Photo retouching by Colin Strohm
Photography assistants: Julian Horn, Kevin
Rogers, Whitney Martin, Ramsey Alderson,
Augusta Sagnelli, Daniel Dorsa, Naomi
McColloch, Sara Mark

Typeset in Lyon, designed by Kai Bernau from
Commerical Type Foundry, and Akkurat,
designed by Laurenz Brunner from Lineto

10 9 8 7 6 5 4 3 2 1

First Edition

The Rules of Summation

$\sum_{i=1}^{n} x_i = x_1 + x_2 + \cdots + x_n$

$\sum_{i=1}^{n} a = na$

$\sum_{i=1}^{n} ax_i = a \sum_{i=1}^{n} x_i$

$\sum_{i=1}^{n} (x_i + y_i) = \sum_{i=1}^{n} x_i + \sum_{i=1}^{n} y_i$

$\sum_{i=1}^{n} (ax_i + by_i) = a \sum_{i=1}^{n} x_i + b \sum_{i=1}^{n} y_i$

$\sum_{i=1}^{n} (a + bx_i) = na + b \sum_{i=1}^{n} x_i$

$\bar{x} = \dfrac{\sum_{i=1}^{n} x_i}{n} = \dfrac{x_1 + x_2 + \cdots + x_n}{n}$.

$\sum_{i=1}^{n} (x_i - \bar{x}) = 0$

$\sum_{i=1}^{2} \sum_{j=1}^{3} f(x_i, y_j) = \sum_{i=1}^{2} [f(x_i, y_1) + f(x_i, y_2) + f(x_i, y_3)]$

$\qquad = f(x_1, y_1) + f(x_1, y_2) + f(x_1, y_3)$

$\qquad + f(x_2, y_1) + f(x_2, y_2) + f(x_2, y_3)$

Expected Values & Variances

- $E[X] = x_1 f(x_1) + x_2 f(x_2) + \cdots + x_n f(x_n)$

$\qquad = \sum_{i=1}^{n} x_i f(x_i) = \sum_x x f(x)$ (2.3.1)

- $E[g(X)] = \sum_x g(x) f(x)$ (2.3.2a)

- $E[g_1(X) + g_2(X)] = \sum_x [g_1(x) + g_2(x)] f(x)$

$\qquad = \sum_x g_1(x) f(x) + \sum_x g_2(x) f(x)$

$\qquad = E[g_1(X)] + E[g_2(X)]$ (2.3.2b)

- $E(c) = c$ (2.3.3a)

- $E[cX] = cE[X]$ (2.3.3b)

- $E[a + cX] = a + cE[X]$ (2.3.3c)

- $\mathrm{var}(X) = \sigma^2 = E[X - E(X)]^2 = E[X^2] - [E(X)]^2$ (2.3.4)

- $\mathrm{var}(a + cX) = E[(a + cX) - E(a + cX)]^2$

$\qquad = c^2 \mathrm{var}(X)$ (2.3.5)

Marginal and Conditional Distributions

- $f(x) = \sum_y f(x, y)$ for each value X can take

$f(y) = \sum_x f(x, y)$ for each value Y can take (2.4.1)

- $f(x|y) = P[X = x | Y = y] = \dfrac{f(x, y)}{f(y)}$ (2.4.2)

- If X and Y are independent random variables, then $f(x, y) = f(x) f(y)$ for each and every pair of values x and y. The converse is also true.

- If X and Y are independent random variables, then the conditional probability density function of X given that

$f(x|y) = \dfrac{f(x, y)}{f(y)} = \dfrac{f(x) f(y)}{f(y)} = f(x)$

for each and every pair of values x and y. The converse is also true.

Expectations, Variances & Covariances

- $\mathrm{cov}(X, Y) = E[(X - E[X])(Y - E[Y])]$ (2.5.1)

- $\mathrm{cov}(X, Y) = E[(X - E[X])(Y - E[Y])]$

$\qquad = \sum_x \sum_y [x - E(X)][y - E(Y)] f(x, y)$ (2.5.3)

- $\rho = \dfrac{\mathrm{cov}(X, Y)}{\sqrt{\mathrm{var}(X)\mathrm{var}(Y)}}$ (2.5.4)

- $E[c_1 X + c_2 Y] = c_1 E(X) + c_2 E(Y)$ (2.5.5)

- $E[X + Y] = E[X] + E[Y]$ (2.5.6)

- $\mathrm{var}[aX + bY + cZ] = a^2 \mathrm{var}[X] + b^2 \mathrm{var}[Y] + c^2 \mathrm{var}[Z]$

$\qquad + 2ab \, \mathrm{cov}[X, Y] + 2ac \, \mathrm{cov}[X, Z]$

$\qquad + 2bc \, \mathrm{cov}[Y, Z]$ (2.5.7)

- If X, Y, and Z are independent, or uncorrelated, random variables, then the covariance terms are zero and:

$\mathrm{var}[aX + bY + cZ] = a^2 \mathrm{var}[X] + b^2 \mathrm{var}[Y]$

$\qquad + c^2 \mathrm{var}[Z]$ (2.5.8)

Normal Probabilities

- If $X \sim N(\beta, \sigma^2)$, then $Z = \dfrac{X - \beta}{\sigma} \sim N(0, 1)$

- If $X \sim N(\beta, \sigma^2)$ and a is a constant, then

$$P[X \le a] = P\left[Z \le \dfrac{a - \beta}{\sigma}\right]$$ (2.6.2)

- If $X \sim N(\beta, \sigma^2)$ and a and b are constants, then

$$P[a \le X \le b] = P\left[\dfrac{a - \beta}{\sigma} \le Z \le \dfrac{b - \beta}{\sigma}\right]$$ (2.6.3)

Assumptions of the Simple Linear Regression Model

SR1 The value of y, for each value of x, is $y = \beta_1 + \beta_2 x + e$

SR2 The average value of the random error e is $E(e) = 0$ since we assume that $E(y) = \beta_1 + \beta_2 x$

SR3 The variance of the random error e is $\mathrm{var}(e) = \sigma^2 = \mathrm{var}(y)$

SR4 The covariance between any pair of random errors, e_i and e_j is $\mathrm{cov}(e_i, e_j) = \mathrm{cov}(y_i, y_j) = 0$

SR5 The variable x is not random and must take at least two different values

SR6 (optional) The values of e are normally distributed about their mean $e \sim N(0, \sigma^2)$

Least Squares Estimation

- If b_1 and b_2 are the least squares estimates, then

$\hat{y}_t = b_1 + b_2 x_t$ (3.3.1)

$\hat{e}_t = y_t - \hat{y}_t = y_t - b_1 - b_2 x_t$ (3.3.2)

Undergraduate
Econometrics

Undergraduate Econometrics

Second Edition

R. Carter Hill
Louisiana State University

William E. Griffiths
University of New England

George G. Judge
University of California at Berkeley

John Wiley & Sons, Inc.
New York • Chichester • Weinheim • Brisbane • Singapore • Toronto

Carter Hill dedicates this work to his wife, Melissa Waters

Bill Griffiths dedicates this work to his parents,
Noel and Evelyn Griffiths

George Judge dedicates this work to Heather Judge Price

ACQUISITIONS EDITORS	Susan Elbe/Mia Zamora
EDITORIAL ASSISTANT	Cynthia Snyder
MARKETING MANAGER	Ilse Wolfe
PRODUCTION SERVICES MANAGER	Jeanine Furino
PRODUCTION EDITOR	Sandra Russell
SENIOR DESIGNER	Dawn Stanley
ILLUSTRATION EDITOR	Sandra Rigby
PRODUCTION MANAGEMENT SERVICES	Ingrao Associates

This book was set 10/12 Times Roman by Automated Composition Service, Inc. and printed and bound by Hamilton Printing Company. The cover was printed by Phoenix Color Corporation.

This book is printed on acid-free paper. ∞

Copyright 2001, 1997 © John Wiley & Sons, Inc. All rights reserved.

Library of Congress Cataloging in Publication Data:

Undergraduate econometrics / R. Carter Hill, William E. Griffiths, George G. Judge.—2nd ed.
 p. cm.
 A multi-media instructional package, including Web sites, is available to supplement the text.
 Includes bibliographical references and index.
 ISBN 0-471-33184-8(cloth: alk. paper)
 1. Econometrics. I. Griffiths, William E. II. Judge, George G. III. Title.
HB139.H548 2000
330'.01'5195—dc21 00-042295

Printed in the United States of America

10 9 8 7 6 5 4 3 2

Preface

Undergraduate Econometrics is an elementary book, designed for a one-semester or one-quarter introduction to econometrics. It is directed toward undergraduates and first-year graduate students, majoring in economics, agricultural and resource economics, finance, accounting or marketing, and MBA's. It is assumed that students have taken courses in the principles of economics, and elementary statistics. Neither matrix algebra nor calculus is used, except for nonessential references to the tools of calculus in a few instances.

For graduate students, a brief explanation of our title is in order. Our book is designed for beginning students of econometrics. It is not strictly for undergraduate students. We chose the title *Undergraduate Econometrics* because it clearly differentiates this book from our other, more advanced, books, and from other introductory books. We would like to reassure our first-year graduate and MBA students that the tools developed in the book, and their level of application, are relevant for tackling many practical problems in today's world.

The second edition retains much of the structure of the first edition. In particular, the first eight chapters cover the core material on simple and multiple regression, and provide a foundation for the remainder of the book. Reorganization has been designed to make the book more user friendly, and to include some new topics. Noteworthy additions are sections or chapters on functional form (Chapter 6.3), specification testing (Chapter 8.6), random regressors and moment-based estimation (Chapter 13), and qualitative and limited dependent variable models (Chapter 18). The Durbin–Watson bounds test has been included. New and hopefully easier examples have been used to explain nonlinear least squares. Many more exercises, including some based on reported computer output, have been included throughout. Supplementary support has been provided for EViews as well SAS, SHAZAM, and EXCEL. In a one-semester course, most instructors will cover Chapters 1–12 as primary material, with a selection from the remaining chapters that depends on personal preference. Some likely variations are: (i) The material on method of moments estimation in Chapter 13 will be included by instructors who wish to provide a foundation on this material for later courses; (ii) Some instructors will prefer to omit Chapters 10.2–10.4 which contain a number of examples of nonlinear least squares estimation; (iii) and Instructors who ask their students to complete a term project will want to include Chapter 19. Thus, although we view Chapters 1–12 as the foundation chapters, there is considerable flexibility. The topics after Chapter 12 can be taught in any order with only minor discomfort.

Undergraduate Econometrics is designed to give students an understanding of why econometrics is necessary, and to provide for them a working ability with basic econometric tools such that:

(i) They can apply these tools to estimation, inference, and forecasting in the context of real world economic problems.

(ii) They understand how to process information from a sample of economic data.

(iii) They can read critically the results and conclusions from others who use basic econometric tools.

(iv) They have a foundation and understanding for further study of econometrics.

(v) They have an appreciation of the range of more advanced techniques that exist and that may be covered in later econometric courses.

The book is *not* an econometrics cookbook, nor is it in a theorem-proof format. It emphasizes motivation, understanding, and implementation. Motivation is achieved by introducing very simple economic models and asking economic questions that the student can answer. Understanding is aided by lucid description of techniques, clear interpretation, and appropriate applications. Learning is reinforced by doing, with worked examples in the text and exercises at the end of each chapter. More difficult material is marked appropriately. Relatively difficult exercises are marked with an asterisk (*). Nonessential algebraic material and some relatively advanced concepts are identified by a border in the margin and end (or begin) with Skippy the Kangaroo, as an indication they can be skipped without loss of continuity.

Extensive supplementary material is available to support both students and instructors. This material includes:

1. *Using EViews for Undergraduate Econometrics, 2nd Edition*, by Mark Reiman and Carter Hill (ISBN 0-471-41239-2). This book presents the EViews software commands required for the examples in *Undergraduate Econometrics* in a clear and concise way. It is useful not only for students and instructors who will be using this software as part of their econometrics course, but also for those who wish to learn how to use EViews.

2. *Using Excel for Undergraduate Econometrics, 2nd Edition*, by Karen Gutermuth and Carter Hill (ISBN 0-471-41237-6). This supplement explains how to use Excel to reproduce most of the examples given in *Undergraduate Econometrics*. Detailed instructions are provided explaining both the computations and clarifying the operations of Excel. Templates are developed for common tasks.

3. A web site (check http://www.wiley.com/college/hill/) that can be accessed by students and instructors. The following material is available from this site:
 - The table of contents for the book.
 - Data files (as text files) for all exercises and examples in the text.
 - An alphabetical listing of all data files, with the variables in each file, and where in the book they are used.
 - SAS files for the examples in the text and handouts for instructors using the SAS software.
 - SHAZAM files for the examples in the text and handouts for instructors using the SHAZAM software.
 - EViews workfiles for all the examples in the text.
 - Extra examples with answers.

- Errata for the book.
- Links to other useful sites.

4. A CD-Rom for instructors (ISBN 0-471-40934-0) that contains:
 - Solutions to all exercises.
 - Computing help (EViews, SAS, SHAZAM, and EXCEL) for exercises.
 - Extra examples, with solutions and computing help.
 - Files in Microsoft Word and *.pdf formats, from which instructors can make transparencies for classroom use.
 - Files containing text figures in electronic format.
 - Relevant files listed above under point 2.

5. A website for instructor access only, containing:
 - The instructor's CD-Rom.
 - Extra examples and solutions, as they become available.
 - Supplementary text material for topics in, and not in, the text. Included will be (i) foundation material on statistical inference, (ii) explanatory material on alternative functional forms, and the interpretation of parameters and elasticities when using different functional forms, and (iii) proofs for some of the results in Chapter 13 on random regressors and moment based estimation.

Several reviewers and colleagues have helped us improve the content of the book. In addition to those in the Preface to the First Edition, we would like to mention Ralph Beals, William Boal, Sugato Chakravarty, Jim Chalfant, Karen Gutermuth, Elia Kacapyr, Subal Kumbhakar, Nazma Lahf-Zaman, David Richardson, and Eric Solberg. We also gratefully acknowledge the word-processing skills of Sue Nano. Marissa Ryan from John Wiley and Sons has been particularly supportive and helpful.

R. Carter Hill
William E. Griffiths
George G. Judge

Contents

Chapter 8 Further Inference in the Multiple Regression Model 170

Chapter 9 Dummy (Binary) Variables 199

Chapter *1*

An Introduction to Econometrics

1.1 Why Study Econometrics?

The importance of econometrics extends far beyond the discipline of economics. Econometrics is a set of research tools also employed in the business disciplines of accounting, finance, marketing and management. It is also used by social scientists, specifically researchers in history, political science, and sociology. Econometrics plays an important role in such diverse fields as forestry, and in agricultural economics. This breadth of interest in econometrics arises in part because economics is the social science that is also the foundation of business analysis. Thus research methods employed by economists, which comprise the field of econometrics, are useful to a broad spectrum of individuals.

Econometrics plays a special role in the training of economists. As a student of economics, you are learning to "think like an economist." You are learning economic concepts such as opportunity cost, scarcity, and comparative advantage. You are working with economic models of supply and demand, macroeconomic behavior, and international trade. Through this training you will better understand the world in which we live; you will learn how markets work, and the way in which government policies affect the marketplace.

If economics is your major or minor field of study, you have a wide range of opportunities before you upon graduation. If you wish to enter the business world, your employer will want to know the answer to the question, "What can you do for me?" Students taking a traditional economics curriculum answer, "I can think like an economist." While we may think that such a response is powerful, it is not very specific, and may not be very satisfying to an employer who does not understand economics.

The problem is that a gap exists between what you have learned as an economics student and what economists actually do. Very few economists make their livings by studying economic theory alone, and those who do are usually employed by universities. Most economists, whether they work in the business world or for the government, or teach in universities, engage in economic analysis which is in part "empirical." By that, we mean that they use economic data to estimate economic relationships, test economic hypotheses, and predict economic outcomes.

Studying econometrics fills a gap between being "a student of economics" and being "a practicing economist." With the econometric skills you will learn in this course, including how to work with econometric software, you will be able to answer the employer's question by saying "I can predict the sales of your prod-

uct." "I can estimate the effect on your sales if your competition lowers its price by \$1 per unit." "I can test whether your new ad campaign is actually increasing your sales." These answers are music to an employer's ears, because they reflect your ability to think like an economist *and* to analyze economic data. Such pieces of information, as we discuss in the next section, are keys to good business decisions. Being able to provide your employer with useful information will make you a valuable employee, and increase your odds of getting a desirable job.

On the other hand, if you plan to continue your education by enrolling in graduate school, you will find that this introduction to econometrics is invaluable. If your goal is to earn a master's or Ph.D. degree in economics, finance, accounting, marketing, agricultural economics, sociology, political science, or forestry, you will encounter more econometrics in your future. The graduate courses tend to be quite technical and mathematical, and the forest often gets lost in studying the trees. By taking this introduction to econometrics you will gain an overview of what econometrics is about, and develop some "intuition" about how things work, before entering a technically oriented course.

1.2 What Is Econometrics?

At this point we need to describe the nature of econometrics. It all begins with a theory from your field of study, whether it is accounting, sociology or economics, about how important variables are related to one another. In economics we express our ideas about relationships between economic variables using the mathematical concept of a function. For example, to express a relationship between income i and consumption c, we may write

$$c = f(i)$$

which says that the level of consumption is *some* function, $f(i)$, of income.

The demand for an individual commodity, say the Honda Accord, might be expressed as

$$q^d = f(p, p^s, p^c, i)$$

which says that the quantity of Honda Accords demanded, q^d, is a function $f(p, p^s, p^c, i)$ of the price of Honda Accords p, the price of cars that are substitutes p^s, the price of items that are complements p^c, like gasoline, and the level of income i.

The supply of an agricultural commodity such as beef might be written as

$$q^s = f(p, p^c, p^f)$$

where q^s is the quantity supplied, p is the price of beef, p^c is the price of competitive products in production (e.g., the price of hogs), and p^f is the price of factors or inputs (e.g., the price of corn) used in the production process.

Each of the above equations is a general economic model that describes how we visualize the way in which economic variables are interrelated. Economic models of this type *guide our economic analysis*.

For most economic decision or choice problems, it is not enough to know that certain economic variables are interrelated, or even the direction of the relationship.

In addition, we must understand the magnitudes involved. That is, we must be able to say **how much** a change in one variable affects another.

> **Econometrics** is about how we can use theory and data from economics, business, and the social sciences, along with tools from statistics, to answer "how much" type questions.

1.2.1 SOME EXAMPLES

As a case in point, consider the problem faced by a central bank. In the United States, this is the Federal Reserve System, with Alan Greenspan as Chairman of the Federal Reserve Board (FRB). In a period when price increases are beginning to indicate an increase in the inflation rate, the FRB must make a decision about whether to dampen the rate of growth of the economy. It can do so by raising the interest rate it charges its member banks when they borrow money (the discount rate) or the rate on overnight loans between banks (the federal funds rate). Increasing these rates will increase the interest rates faced by would-be investors, who may be firms seeking funds for capital expansion or individuals who wish to buy consumer durables like automobiles and refrigerators. These increased rates facing consumers and businesses reduce the quantity of the durable goods demanded, which reduces aggregate demand and slows the rate of inflation. These relationships are suggested by economic theory.

The real question facing Alan Greenspan is "*How much* should we increase the discount rate to slow inflation, and yet maintain a stable and growing economy?" The answer will depend on the responsiveness of firms and individuals to increases in the interest rates and to the effects of reduced investment on Gross National Product. They key elasticities and multipliers are called **parameters**. The values of economic parameters are unknown and must be estimated using a sample of economic data when formulating economic policies.

Econometrics is about how to best estimate economic parameters given the data we have. "Good" econometrics is important, since errors in the estimates used by policy makers such as the FRB may lead to interest rate corrections that are too large or too small, which has consequences for all of us.

Every day decision makers face "how much" questions similar to those facing Alan Greenspan. Some examples might include:

- A city council ponders the question of how much violent crime will be reduced if an additional million dollars is spent putting uniformed police on the street.
- U.S. Presidential candidate Gore questions how many additional California voters will support him if he spends an additional million dollars in advertising in that state.
- The owner of a local Pizza Hut franchise must decide how much advertising space to purchase in the local newspaper, and thus must estimate the relationship between advertising and sales.
- Louisiana State University must estimate how much enrollment will fall if tuition is raised by $100 per semester, and thus whether its revenue from tuition will rise or fall.

- The CEO of Proctor & Gamble must estimate how much demand there will be in ten years for the detergent Tide, as she decides how much to invest in a new plant and equipment.

- A real estate developer must predict by how much population and income will increase to the south of Baton Rouge, Louisiana, over the next few years, and if it will be profitable to begin construction of a new strip mall.

- You must decide how much of your savings will go into a stock fund and how much into the money market. This requires you to make predictions of the level of economic activity, the rate of inflation, and interest rates over your planning horizon.

- A public transportation council in the San Francisco Bay area must evaluate how an increase in commuter train (BART) rates will affect the number of travelers by car, bus, and BART.

To answer these questions of "how much," decision makers rely on information provided by empirical economic research. In such research, an economist uses economic theory and reasoning to construct relationships between the variables in question. Data on these variables are collected and econometric methods are used to estimate the key underlying parameters and to make predictions. The decision makers in the above examples obtain their "estimates" and "predictions" in different ways. Alan Greenspan and the Federal Reserve Board have a large staff of economists to carry out econometric analyses. The CEO of Proctor & Gamble may hire econometric consultants to provide her with projections of sales. You may get advice about investing from a stock-broker, who in turn is provided with econometric projections made by economists working for the parent company. Whatever the source of your information about "how much" type questions, it is a good bet that there is an economist involved who is using econometric methods to analyze data that yield the answers.

In the next section, we show how to introduce parameters into an economic model, and how to convert an economic model into an econometric model.

1.3 **The Econometric Model**

What is an econometric model, and where does it come from? We will give you a general overview, and we may use terms that are unfamiliar to you. Be assured that before you are too far into this book all the terminology will be clearly defined. In an econometric model we must first realize that economic relations are not exact. Economic theory does not claim to be able to predict the specific behavior of any individual or firm, but rather it describes the *average* or *systematic* behavior of *many* individuals or firms. When studying car sales we recognize that the *actual* number of Hondas sold is the sum of this systematic part and a random and unpredictable component, *e*, which we will call a **random error**. Thus an **econometric model** representing the sales of Honda Accords is

$$q^d = f(p, p^s, p^c, i) + e$$

The random error *e* accounts for the many factors that affect sales that we have omitted from this simple model. This component also reflects the intrinsic uncertainty in economic activity.

To complete the specification of the econometric model, we must also say something about the form of the algebraic relationship among our economic variables. For example, in your first economics courses quantity demanded was depicted as a *linear* function of price. We extend that assumption to the other variables as well, making the systematic part of the demand relation

$$f(p, p^s, p^c, i) = \beta_1 + \beta_2 p + \beta_3 p^s + \beta_4 p^c + \beta_5 i$$

The corresponding econometric model is

$$q^d = \beta_1 + \beta_2 p + \beta_3 p^s + \beta_4 p^c + \beta_5 i + e$$

The functional form represents a hypothesis about the relationship between the variables. In a particular problem our interest centers on trying to determine a form that is compatible with economic theory and the data.

In every econometric model, whether it is a demand equation, a supply equation, or a production function, there is a systematic portion and an unobservable random component. The systematic portion is the part we obtain from economic theory, and an assumption about the functional form. The random component represents a "noise" component, which obscures our understanding of the relationship among variables, and which we represent using the random variable e.

1.4 How Do We Obtain Data?

Where does data come from? Economists and other social scientists work in the hazy world in which data on all variables are "observed" and not obtained from a controlled experiment. This makes the task of learning about economic parameters all the more difficult. Procedures for using such data to answer questions of economic importance are the subject matter of this book. In the following sections we make clear the characteristics of experimental and nonexperimental data.

1.4.1 EXPERIMENTAL DATA

One way to acquire information about the unknown parameters of economic relationships is to conduct or observe the outcome of an experiment. In an ideal world, from a researcher's point of view, an economic model would describe how we might design an experiment that could be used to obtain economic observations or sample information, that then could be used to provide insights about the unknown economic parameters. Repeating the experiment T times would create a sample of T sample observations.

Let's see if we can bring all this together using a picture that describes a "controlled" experiment. Suppose we are interested in trying to understand how the quantity of Honda Accord automobiles that consumers purchase is determined. The microeconomic theory of consumer behavior suggests that the quantity purchased (q^d) should depend on the price of Honda Accords (p), the price of substitutes [perhaps Nissan Maximas] (p^s), the price of complements (gasoline, for example) (p^c) and the level of income (i).

In an ideal world for research, controlled experiments could be conducted to investigate the relationship between these "explanatory" variables and the "dependent" variable q^d. In a controlled experiment the experimental design team (headed by Einstein in this ideal world) sets the levels of the explanatory variables, runs the experiment, and obtains one observation on the dependent variable. This process is depicted in Figure 1.1, where on the left-hand side Einstein operates a control panel that fixes the price p of Hondas, the price of the substitute p^s, the price of the complement p^c, and the level of income i of a population group. Once these controls are set, economic firms and individuals react to this information so as to maximize their well-being. The exact workings of the economic actors are hidden from us in a "black box" into which we can never really see. What we do observe, at the end, is the number of Honda Accords that are purchased. For example, suppose Einstein sets the price and income variables under his control as:

$$p = \text{price of Accords} = \$25,000$$
$$p^s = \text{price of Maximas} = \$25,000$$
$$p^c = \text{price of gasoline per gallon} = \$1.35$$
$$i = \text{income of individuals in sample} = \$42,000$$

At the end of a month we *observe* the number of Honda Accords sold at one dealership to be $q^d = 37$. In our ideal world Einstein can *repeat* the experiment, changing (or leaving unchanged) any of the price variables or income, and observing the number of Hondas sold. By repeating this process a number of times, a *sample* of economic data is created.

In every experiment there is an unobservable random error, or noise, that enters the observable outcome. Einstein sets the values of the primary explanatory variables

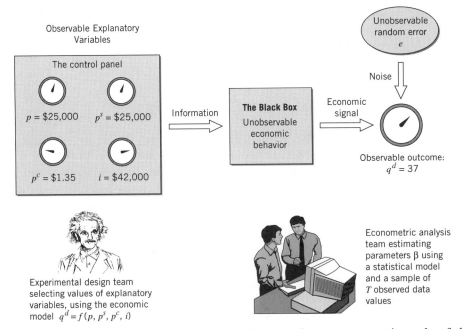

FIGURE *1.1* A controlled experiment generating data for an econometric study of the demand for Honda Accords.

that are indicated by economic reasoning, but it is clear that there are "other" substitute and complement goods whose prices are not controlled. There are unobservable factors dictating the level of consumer confidence and willingness to spend. There is the issue (crucial to car buyers Melissa Waters, Marge Judge, and others) of how this year's Accord model "looks" relative to the competition, and so on. These are "random" factors that are not controlled, but which affect the outcome we observe by blurring the picture or adding "noise" to the problem.

The experimental outcome we observe is the sum of a systematic component that depends on the controlled explanatory variables and this random noise. Consequently, the experimental outcome is random too. We **never know** what we will observe in any trial of the experiment, and thus the quantity of Accords sold, q^d, is **random**. Even if we carry out two experiments in a row with the same settings of the explanatory variables the outcomes will be different. If we collect a sample of T observations on q^d by repeating the experiment T times with different settings on the controls each time, and then if we collect another sample of T observations by repeating those same settings, the two samples will be different. Every sample of size T we collect will be different, and the differences are due to "sampling variability," which is evidence of the presence of the random error e.

For example, if we repeat the experiment a few times, we obtain observations such as those in Table 1.1. As prices and income vary, the monthly quantity sold also changes. But note that different quantities are sold in months 2 and 3 despite the fact that prices and income were constant. This is sampling variation.

Table 1.1 Monthly Sales of Honda Accords

month	q^d	p	p^s	p^c	i
1	37	25	25	1.35	42
2	28	23	25	1.35	32
3	30	23	25	1.35	32
4	35	20	25	1.35	35
5	40	25	27	1.35	42
6	46	25	30	1.35	52
7	52	25	32	1.35	55
8	55	25	25	1.40	60
9	60	25	25	1.45	70
10	65	25	25	1.55	100

Note: p, p^s and i are in $1000.

Given the observed data, we, the econometricians, wish to determine the relationship between each of the explanatory variables (p, p^c, p^s, i) and the dependent variable q^d using the sample of T observations on values of the explanatory variables and the observed quantities sold. Specifically, we want to estimate the effect (β) of a change in one explanatory variable on the expected quantity of Honda Accords sold. To do this we must combine economic theory, statistics, and computer science, the combination being *econometrics*. A fascinating part of econometrics is that if we obtained another sample of T observations using the same process our *estimates* would change, since the observed outcomes q^d would change. So, from just one sample of data, how are we to know the reliability of any estimate we obtain? The answer to this question is one of the important things that you will learn by reading this book.

In few cases can economists actually perform controlled experiments to obtain sample observations. Most economic data do not come from controlled experiments, and in this context we are like astronomers. When the experiments are *uncontrolled*, economists take the role of observers, and economic theory indicates the relevant variables to consider. By observing T values of each economic variable, a sample with T observations is created.

In Figure 1.1 we have tried to depict an "ideal" experimental situation. It shows us how economic data would be obtained for research purposes if we could arrange it. Of course, most of the time we have no control over the experiment being run. We do not have Einstein leading a design team, or anyone else, controlling the experiment.

1.4.2 NONEXPERIMENTAL DATA

Most economic data are collected for administrative rather than research purposes, often by government agencies. The data may be collected in a:

> *time series form*—data collected over discrete intervals of time—for example, the annual price of wheat in the United States from 1880 to 2000, or the daily price of General Electric stock from 1980 to 2000.

> *cross section form*—data collected over sample units in a particular time period—for example, income by counties in California during 1999, or high school graduation rates by state in 1999.

> *panel data form*—data that follow individual micro-units over time. Such data are increasingly available. For example, the U.S. Department of Education has several on-going surveys, in which the same students are tracked over time, from the time they are in the eighth grade until their midtwenties. These databases record not only student characteristics and performance, but also the socioeconomic characteristics of their families, their schools, and so on. Such data are rich sources of data for studies related to labor economics, economics of the household, health economics, and of course education.

The data may be collected at various levels of aggregation:

> *micro*—data collected on individual economic decision-making units such as individuals, households, or firms.

> *macro*—data resulting from a pooling or aggregating over individuals, households, or firms at the local, state, or national levels.

The data collected may also represent a flow or a stock:

> *flow*—outcome measures over a period of time, such as the consumption of gasoline during the last quarter of 1999.

> *stock*—outcome measured at a particular point in time, such as the quantity of crude oil held by Chevron in its U.S. storage tanks April 1, 1999 or the asset value of the Wells Fargo Bank on July 1, 1999.

The data collected may be quantitative or qualitative:

quantitative—outcomes such as prices or income that may be expressed as numbers or some transformation of them, such as real prices or per capita income.

qualitative—outcomes that are of an "either-or" situation. For example, a consumer either did or did not make a purchase of a particular good, or a person either is or is not married.

In Chapter 19 we list sources of economic data that are available in print, on the Internet, and on electronic media such as CD-ROMs.

1.5 Statistical Inference

The phrase **statistical inference** will appear often in this book. By this we mean we want to "infer" or learn something about the real world by analyzing a sample of data. The ways in which statistical inference are carried out include:

- Estimating economic parameters, such as elasticities, using econometric methods.
- Predicting economic outcomes, such as the enrollment in 2-year colleges in the United States for the next 10 years.
- Testing economic hypotheses, such as the question of whether newspaper advertising is better than store displays for increasing sales.

Econometrics includes all of these aspects of statistical inference, and as we proceed through this book you will learn how to properly estimate, predict, and test, given the characteristics of the data at hand.

1.6 A Research Format

Empirical economic research follows a pattern, and we will stress this orderly procedure throughout the book. The steps are:

1. It all starts with a problem or question. The idea may come after lengthy study of all that has been written on a particular topic. You will find that "inspiration is 99% perspiration." That means, after you dig at a topic long enough, a new and interesting question will occur to you. Alternatively, you may be led by your natural curiosity to an interesting question. Professor Hal Varian ("How to Build an Economic Model in Your Spare Time," *The American Economist*, 41(2), Fall 1997, pp. 3–10) suggests you look for ideas outside academic journals—in newspapers, magazines, etc. He relates a story about a research project that developed from his shopping for a new TV set.

2. Economic theory gives us a way of thinking about the problem: What economic variables are involved and what is the possible direction of the relationship(s)? Every research project, given the initial question, begins by building an economic model and listing the questions (hypotheses) of interest. More questions will occur during the research project, but it is good to list those that motivate you at the project's beginning.

3. The working economic model leads to an econometric model. We must choose a functional form and make some assumptions about the nature of the error term.

4. Sample data are obtained, and based on our initial assumptions, and our understanding of how the data were collected, a desirable method of econometric analysis is chosen.

5. Estimates of the unknown parameters are obtained with the help of a statistical software package, predictions are made and hypothesis tests are performed.

6. Model diagnostics are performed to check the validity of assumptions we've made. For example, were all of the right-hand-side explanatory variables relevant? Was the correct functional form used?

7. The economic consequences and the implications of the empirical results are analyzed and evaluated. What economic resource allocation and distribution results are implied, and what are their policy-choice implications? What remaining questions might be answered with further study or new and better data?

We will follow this path in the coming chapters. At the end of the work, a paper or report must be written, summarizing what you have found and the methods you used. Guidelines for writing economics papers are given in Chapter 19.

Chapter *2*

Some Basic Probability Concepts

Economic variables are by nature random. We do not know what their values will be until we observe them. Probability is one way of expressing uncertainty about economic events and outcomes. Consequently, in this chapter we review some fundamental concepts of probability theory that we will use throughout the book.

2.1 Experiments, Outcomes, and Random Variables

Where do data come from? A large amount of scientific data are obtained by experimentation. In contrast, economics is a social science, where much of the data do not come from a controlled experimental process. Such data are said to be *nonexperimental*. In this section we describe the nonexperimental process in economics.

2.1.1 Controlled Experiments—Experimental Data

If an agricultural economist wants to study the yield of a certain variety of seed corn, it seems natural to do an experiment in which the corn variety is planted on several plots of land of the same fertility and treated with identical amounts of fertilizer, pesticide, and so on, during the growing season. At the end of the growing season the yield can be measured in a variety of ways. We might measure the number of bushels per acre, the number of ears per stalk, or the moisture content of an ear of corn, just to name a few possibilities.

What we just described is a **controlled experiment,** similar to the one described in Figure 1.1 in Chapter 1. Controlled experiments are characterized by the fact that the conditions surrounding the experiment are under the control of the experimenter. One of the advantages of a controlled experiment is that *it is reproducible and can be repeated by independent researchers as a check on experimental procedures*. A second advantage of controlled experiments is that the experiment can be repeated under different settings for the control variables (the amount of fertilizer, pesticide, water) to see what effect that has on yield.

The experimental *outcome* is characterized by one or more measures of yield. Let X = bushels per plot and Y = number of ears per stalk. These measures are called **random variables.** Their distinguishing characteristic is that their values are not known until *after* the experiment is performed. After the experiment, when we

make the measurements, we obtain observed *values* of the random variables, like $x = 100$ bushels and $y = 15$ ears.

One interesting characteristic of outcomes from controlled experiments is that in repeated trials of the same experiment the actual values of the random variables will change from one trial to another. That is, if we planted corn on several identical plots, and grew it under "identical" conditions, the yield of corn from each plot would differ. The reason for the difference is that the conditions are not really *identical* from one trial of an experiment to another. There will be errors in measurement, some factors that are uncontrolled and, the truth is, every seed is a little different. This type of variation in experimental outcomes, which occurs naturally and uncontrollably, is called **sampling variation**; it is a fact of life in all experiments.

> A **random variable** is a variable whose value is unknown until it is observed. The *value* of a random variable results from an experiment; it is not perfectly predictable.

In this chapter random variables are indicated by uppercase letters, such as X or Y or Z, and the values that the random variables can take are represented by lower case letters, x or y or z. *After this chapter, we will not make this distinction and you will recognize the difference by the context.*

2.1.2 UNCONTROLLED EXPERIMENTS—NONEXPERIMENTAL DATA

Economic variables like gross national product (GNP), the prime interest rate, the unemployment rate, the price of ice cream, or the number of bottles of mineral water sold are random variables. We do not know what their values will be until we *observe* them. There is obviously a big difference between the process by which the values of these random variables are obtained and the controlled experimental process used in the previous section to obtain the number of bushels of corn. Socioeconomic random variables have values that are generated by an *uncontrolled* experiment carried out by society and not under the complete control of any one person or group. The values of the macroeconomic variables, such as GNP and the unemployment rate, are affected by changes in factors such as tax rates, government spending, and monetary policy. Even if we could control such factors, we still could not predict with certainty the values that the macroeconomic variables would take.

There are both public and private sources of economic data, and some of these are listed in Chapter 19. Although many data sources exist, for the most part (1) the data are "observed" and not the result of a controlled experiment, and (2) the data may have been collected for purposes other than economic analysis. Thus, the data might not contain observations on variables that a particular investigator wants, or, in the case of survey data, the variables might be based on questions that the investigator may have preferred to ask in a different way. As a result, *one of the challenges of economic research is to obtain data that are consistent with the theoretical variables in the economic model and that are useful in analyzing an economic problem.*

2.1.3 DISCRETE AND CONTINUOUS RANDOM VARIABLES

Random variables from controlled or uncontrolled experiments are either **discrete** or **continuous.**

> A **discrete random variable** can take only a finite number of values, that can be counted by using the positive integers.

Examples of discrete economic variables are the following:

- The number of children in a household: 0, 1, 2, ...
- The number of shopping trips an individual takes to a particular shopping mall per week: 0, 1, 2, ...

These economic variables take only a limited number of values, and it makes sense to *count* them in whole numbers. Discrete variables are also commonly used in economics to record qualitative, or nonnumerical, characteristics. In this role they are sometimes called **dummy variables**. For example, if we are studying individual behavior, we might want to record an individual's gender. One way to do this is to let the random variable, D, take the value 1 if the person is female and 0 if male. That is, the random variable is defined as

$$D = \begin{cases} 1 \text{ if person is female} \\ 0 \text{ if person is male} \end{cases}$$

Any qualitative characteristic that has two states (e.g., a yes-or-no, or buy-or-not-buy type of variable) can be characterized by a dummy variable like D. The actual *values* the dummy variable takes do not matter mathematically, but the choice of the values 0 and 1 is convenient for a variety of reasons.

In contrast to situations in which discrete random variables can be used, there are many times when it is not convenient to think of random variables as having a countable number of possible outcome values or states.

> A **continuous random variable** can take *any* real value (not just whole numbers) in an interval on the real number line.

An example is gross national product. For practical purposes, the GNP variable can take any value in the interval zero to infinity and, thus, is a continuous random variable. Admittedly, the GNP is measured in dollars and *can* be counted in whole dollars, but the value is so large that counting individual dollars serves no purpose. It is more convenient simply to assume that the number can be any real number larger than, or equal to, zero. Other examples of continuous random economic variables are all the usual macroeconomic variables, like money supply, interest rates, the federal deficit, and government spending; microeconomic examples are prices, household income, and expenditures on specific products.

2.2 The Probability Distribution of a Random Variable

The values of random variables are not known until an experiment is carried out, and all possible values are not equally likely. We can make **probability** statements about certain values occurring by specifying a **probability distribution** for the random variable. If event A is an outcome of an experiment, then the *probability of A*, which we write as $P(A)$, is the relative frequency with which event A occurs in *many* repeated trials of the experiment. For any event, $0 \leq P(A) \leq 1$, and the total probability of all possible events is one.

In this section we discuss how to make probability statements about discrete and continuous random variables using their probability distributions.

2.2.1 PROBABILITY DISTRIBUTIONS OF DISCRETE RANDOM VARIABLES

> When the values of a discrete random variable are listed with their chances of occurring, the resulting table of outcomes is called a **probability function** or a **probability density function.**

The probability density function spreads the total of 1 "unit" of probability over the set of possible values that a random variable can take. Consider a discrete random variable, X = the number of heads obtained in a single flip of a coin. The values that X can take are $x = 0,1$. If the coin is "fair" then the probability of a head occurring is .5. The probability density function, say $f(x)$, for the random variable X is

Coin Side	x	$f(x)$
tail	0	.5
head	1	.5

"The probability that X takes the value 1 is .5" means that the two values 0 and 1 have an equal chance of occurring and, if we flipped a fair coin *a very large number of times*, the value $x = 1$ would occur 50 percent of the time. We can denote this as $P[X = 1] = f(1) = 0.5$, where $P[X = 1]$ is the probability of the event that the random variable $X = 1$.

> For a discrete random variable X, the value of the probability density function $f(x)$ is the probability that the random variable X takes the value x, $f(x) = P(X = x)$. Therefore, $0 \leq f(x) \leq 1$ and, if X takes n values x_1, \ldots, x_n, then $f(x_1) + f(x_2) + \cdots + f(x_n) = 1$.

Sometimes, as the following example illustrates, the probability density function of a discrete random variable can be represented by a mathematical formula.

Example 2.1

Consider the discrete random variable that only takes two values, 1 and 0. The probability of a 1 occurring is p and the probability of a 0 occurring is $1 - p$. An example of this random variable is the number of heads (i.e., whether or not one occurs) on a coin toss with $p = 0.5$. Then, $P[X = x] = f(x) = p^x(1 - p)^{1 - x}$, for $x = 0,1$. ∎

2.2.2 THE PROBABILITY DENSITY FUNCTION OF A CONTINUOUS RANDOM VARIABLE

> For the continuous random variable Y the probability density function $f(y)$ can be represented by an **equation,** which can be described graphically by a curve. For continuous random variables the *area* under the probability density function corresponds to probability.

For example, the probability density function of a continuous random variable Y might be represented as in Figure 2.1. The total area under a probability density function is 1, and the probability that Y *takes* a value in the interval $[a, b]$, or $P[a \le Y \le b]$, is the area under the probability density function between the values $y = a$ and $y = b$. This is shown in Figure 2.1 by the shaded area.

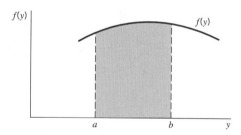

FIGURE **2.1** Probability as an area under a probability density function.

Since a continuous random variable takes an uncountably infinite number of values, the probability of any *one* occurring is zero. That is, $P[Y = a] = P[a \le Y \le a] = 0$.

In calculus, the *integral* of a function defines the area under it, and therefore

$$P[a \le Y \le b] = \int_{y=a}^{b} f(y)dy. \qquad (2.2.1)$$

You will not be asked to find integrals in this book, but if you continue to study econometrics, differential and integral calculus will be important.

Even if you cannot find the probability of an event involving a continuous random variable via integration of the probability density function, you may be able to use geometry to achieve the same objective.

Example 2.2

Pick a series of numbers, at random, between 0 and 1. This sounds easy, but it is not. Numerical analysts have spent years working on this problem and continue to work on it. The ability to create "random numbers" is essential for economists who "simulate" economic behavior to aid their study of economic models.

For a single pick, what does "at random" mean in this context? It might mean, on an intuitive level, that every value in the interval has an equal chance of being selected. Unfortunately, the [0, 1] interval contains an uncountably infinite number of values, and the probability of any one being selected is zero. A better definition of "at random" is that every interval of equal width has an equal probability of containing the chosen number. Thus the probability that the number is picked from the interval [.1, .3] is the same as the probability that it is picked from the interval [.7, .9] or from [.55555, .75555]; and the probability that the interval [.3, .6] contains the chosen number is the same as the probability that it is contained in [.15, .45].

A *uniform* random variable is a continuous random variable describing this kind of randomness. U is a uniform random variable on the interval $[a, b]$ if its probability density function is

$$f(u) = \begin{cases} 1/(b-a) & \text{if } a \leq u \leq b \\ 0 & \text{otherwise} \end{cases} \qquad (2.2.2)$$

The graph of this probability density function is given in Figure 2.2. Suppose the values of a and b are $a = 0$ and $b = 1$. Then function $f(u)$ is the horizontal line shown in the figure intersecting the vertical axis at height 1. The probability that the random variable U falls between the values 0.1 and 0.3, for example, is the area under the line representing $f(u)$ between the limits .1 and .3. The probability is given by the area of the shaded rectangle in Figure 2.2; $P[.1 \leq U \leq .3] = length \times width = (1 \times .2) = .2$. ∎

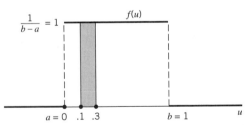

FIGURE **2.2** Probability density function of a uniform random variable.

2.3 Expected Values Involving a Single Random Variable

When working with random variables, it is convenient to summarize their probability characteristics using the concept of *mathematical expectation*. These expectations will make use of summation notation.

2.3.1 THE RULES OF SUMMATION

Throughout this book we will use *summation signs*, denoted by the Greek symbol Σ, to shorten algebraic expressions. The following rules apply to the summation operation.

1. If X takes n values x_1, \ldots, x_n then their sum is

$$\sum_{i=1}^{n} x_i = x_1 + x_2 + \cdots + x_n$$

2. If a is a constant, then

$$\sum_{i=1}^{n} a = na$$

3. If a is a constant then it can be pulled out in front of a summation

$$\sum_{i=1}^{n} ax_i = a \sum_{i=1}^{n} x_i$$

4. If X and Y are two variables, then

$$\sum_{i=1}^{n} (x_i + y_i) = \sum_{i=1}^{n} x_i + \sum_{i=1}^{n} y_i$$

5. If a and b are constants, then

$$\sum_{i=1}^{n} (a + bx_i) = na + b \sum_{i=1}^{n} x_i$$

6. If X and Y are two variables, then

$$\sum_{i=1}^{n} (ax_i + by_i) = a \sum_{i=1}^{n} x_i + b \sum_{i=1}^{n} y_i$$

7. The arithmetic mean (average) of n values of X is

$$\bar{x} = \frac{\sum_{i=1}^{n} x_i}{n} = \frac{x_1 + x_2 + \cdots + x_n}{n}$$

Also,

$$\sum_{i=1}^{n} (x_i - \bar{x}) = 0$$

8. We often use an abbreviated form of the summation notation. For example, if $f(x)$ is a function of the values of X,

$$\sum_{i=1}^{n} f(x_i) = f(x_1) + f(x_2) + \cdots + f(x_n)$$

$$= \sum_{i} f(x_i) \text{ ("Sum over all values of the index } i\text{")}$$

$$= \sum_{x} f(x) \text{ ("Sum over all possible values of } X\text{")}$$

9. Several summation signs can be used in one expression. Suppose the variable Y takes n values and X takes m values, and let $f(x, y) = x + y$. Then the *double summation* of this function is

$$\sum_{i=1}^{m} \sum_{j=1}^{n} f(x_i, y_j) = \sum_{i=1}^{m} \sum_{j=1}^{n} (x_i + y_j)$$

To evaluate such expressions, work from the innermost sum outward. First set $i = 1$ and sum over all values of j, and so on. To illustrate, let $m = 2$ and $n = 3$. Then

$$\sum_{i=1}^{2} \sum_{j=1}^{3} f(x_i, y_j) = \sum_{i=1}^{2} [f(x_i, y_1) + f(x_i, y_2) + f(x_i, y_3)]$$

$$= f(x_1, y_1) + f(x_1, y_2) + f(x_1, y_3)$$

$$+ f(x_2, y_1) + f(x_2, y_2) + f(x_2, y_3)$$

The *order* of summation does not matter, so

$$\sum_{i=1}^{m} \sum_{j=1}^{n} f(x_i, y_j) = \sum_{j=1}^{n} \sum_{i=1}^{m} f(x_i, y_j)$$

2.3.2 THE MEAN OF A RANDOM VARIABLE

An important characteristic of a random variable is its mathematical expectation or expected value, which is also called the ***mean* of the random variable.**

> The expected value, or **mean,** of a random variable X is the average value of the random variable in an infinite number of repetitions of the experiment (repeated samples); it is denoted $E[X]$.

As an example, let X be the number of heads occurring in the toss of a single, well-balanced coin. The values that X can take are $x = 0, 1$. If this experiment is repeated *a very large number of times*, the average value of X will be 0.5. Note that $E[X] = 0.5$ is *not* the value of X we expect to obtain on a single toss, since the value 0.5 cannot even occur. It is the *long-run average value we expect after making repeated trials of an experiment*.

Although $E[X]$ is easy to determine intuitively in the example of the coin toss, it will not always be so obvious. The mathematical representation of the expected value of a discrete random variable can be summarized as follows:

If X is a discrete random variable that can take the values x_1, x_2, \ldots, x_n with probability density values $f(x_1), f(x_2), \ldots, f(x_n)$, the expected value of X is

$$E[X] = x_1 f(x_1) + x_2 f(x_2) + \cdots + x_n f(x_n)$$

$$= \sum_{i=1}^{n} x_i f(x_i) = \sum_{x} x f(x) \qquad (2.3.1)$$

Equation (2.3.1) shows that for a discrete random variable, its mathematical expectation or *mean value* is a *weighted average of the values of the random variable*, with the weights being the probabilities attached to each value.

Example 2.3

Let us find the expected value of the discrete random variable X with probability density function given by $f(x) = p^x (1-p)^{1-x}$, for $x = 0,1$. Using (2.3.1) we write

$$E[X] = \sum_{x} x f(x) = 0f(0) + 1f(1) = 0(1-p) + 1(p) = p \qquad ■$$

To calculate the expected value of a *continuous* random variable Y, we once again "add up" all the values of the random variable weighted by the corresponding values of the probability density function $f(y)$. The only problem now is that we must add up an *infinite* number of weighted values. The way to actually do this is to use integration. Although we do not use integration, we will continually refer to the mean of continuous random variables, as in the following example.

Example 2.4

In Example 2.2 we considered the uniform random variable U. Suppose that the distribution parameters are $a = 0$ and $b = 1$, so that $f(u) = 1/(b-a) = 1$ for $0 \le u \le 1$. The expected value of U is $E[U] = .5$, which is the center of the probability density function $f(u)$ shown in Figure 2.2. *The mean of a random*

variable is always the "center" of its probability distribution. In general, the expected value of a uniform random variable is $E[U] = (a + b)/2$. Note that the parameters a and b that define the distribution of the uniform random variable are used to calculate the mean of the uniform random variable. ∎

2.3.3 EXPECTATION OF A FUNCTION OF A RANDOM VARIABLE

There are several useful rules for calculating expected values of functions of random variables.

1. If X is a discrete random variable and $g(X)$ is a function of it, then

$$E[g(X)] = \sum_x g(x)f(x) \qquad (2.3.2a)$$

 However, $E[g(X)] \neq g[E(X)]$ in general.

2. If X is a discrete random variable and $g(X) = g_1(X) + g_2(X)$, where $g_1(X)$ and $g_2(X)$ are functions of X, then

$$E[g(X)] = \sum_x [g_1(x) + g_2(x)]f(x)$$

$$= \sum_x g_1(x)f(x) + \sum_x g_2(x)f(x)$$

$$= E[g_1(x)] + E[g_2(x)] \qquad (2.3.2b)$$

The expected value of a sum of functions of random variables, or the expected value of a sum of random variables, is always the sum of the expected values.

The idea of how to determine the expected value of a function of a continuous random variable Y, say $g(y)$, is exactly the same as in the discrete case. The terms $g(y)$ must be weighted by $f(y)$ and then all those products summed. This operation is carried out via integration, but the interpretation of the result is the same.

Some properties of mathematical expectation work for both discrete and continuous random variables. For the discrete case, these results are shown using (2.3.2).

1. If c is a constant,

$$E[c] = c \qquad (2.3.3a)$$

2. If c is a constant and X is a random variable, then

$$E[cX] = cE[X] \qquad (2.3.3b)$$

3. If a and c are constants then

$$E[a + cX] = a + cE[X] \qquad (2.3.3c)$$

2.3.4 THE VARIANCE OF A RANDOM VARIABLE

We define the *variance* of a discrete or continuous random variable X, based on the rules in Section 2.3.3, as the expected value of $g(X) = [X - E(X)]^2$. Like the mean, the variance of a random variable is important in characterizing the scale of measurement and the spread of the probability distribution. We give it the symbol σ^2, or "sigma squared." Algebraically,

$$\text{var}(X) = \sigma^2 = E[g(X)] = E[X - E(X)]^2 = E[X^2] - [E(X)]^2 \qquad (2.3.4)$$

Examining $g(X) = [X - E(X)]^2$, we observe that the variance of a random variable is the *average* squared difference between the random variable X and its mean value $E[X]$. Thus, the variance of a random variable is the weighted average of the squared differences (or distances) between the *values* x of the random variable X and the mean (center of the probability density function) of the random variable. The larger the variance of a random variable, the greater the average squared distance between the values of the random variable and its mean, or the more "spread out" are the values of the random variable.

A useful property of variances is the following.

Let a and c be constants, and let $Z = a + cX$. Then Z is a random variable and its variance is

$$\text{var}(a + cX) = E[(a + cX) - E(a + cX)]^2 = c^2 \text{var}(X) \qquad (2.3.5)$$

This result says that if you:

1. Add a constant to a random variable it does not affect its variance, or dispersion. This fact follows, since adding a constant to a random variable *shifts* the location of its probability density function but leaves its shape, and dispersion, unaffected.
2. Multiply a random variable by a constant, the variance is multiplied by the square of the constant.

The square root of the variance of a random variable is called the **standard deviation;** it is denoted by σ. It, too, measures the spread or dispersion of a distribution, and it has the advantage of being in the same units of measure as the random variable.

2.4 Using Joint Probability Density Functions

Frequently we want to make probability statements about more than one random variable at a time. To answer probability questions involving two or more random

variables, we must know their *joint probability density function*. For the continuous random variables X and Y, we use $f(x, y)$ to represent their joint density function. A typical joint density function might look something like Figure 2.3.

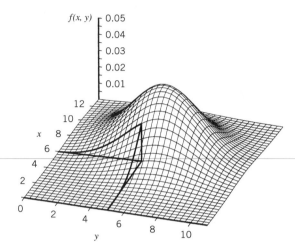

FIGURE **2.3** A joint probability density function.

This joint probability density function has the total probability of one unit as the total *volume* under its surface. The probability that the bivariate variable (X, Y) has $x \leq 6$ and $y \leq 5$, written $P[X \leq 6, Y \leq 5]$, corresponds to the *volume* under $f(x, y)$ above the rectangle (in the base of the figure) defining the event. If the joint probability density function were known, the probability of the event in question could be calculated by using integral calculus or numerical methods on a computer.

Example 2.5

As an example involving discrete random variables, suppose there is a *population* (not a sample) of 1,000 individuals whom we wish to categorize by their gender (male or female) and political affiliation (Democrat, Republican, or other). Suppose the population breakdown is given in Table 2.1. Given this population of 1,000 persons, consider the experiment of drawing an individual at random. Define two discrete random variables G (gender) and P (political affiliation) as

$$G = \begin{cases} 0 & \text{individual is male} \\ 1 & \text{individual is female} \end{cases}$$

$$P = \begin{cases} 0 & \text{individual is Democrat} \\ 1 & \text{individual is Republican} \\ 2 & \text{individual has other affiliation} \end{cases}$$

Table 2.1 **Population Breakdown by Gender and Political Affiliation**

	Male	Female	Political Totals
Democrat	200	270	470
Republican	300	100	400
Other	60	70	130
Gender totals	560	440	1000

Given that the experiment is random, then the *joint* probability distribution of G and P is obtained by dividing the entries of Table 2.1 by 1,000, to obtain the results shown in Table 2.2. Note that the joint probabilities $f(g,p)$ sum to 1.

Table 2.2 **Joint Probability Function $f(g, p)$ of G and P**

		G 0	G 1	$h(p)$
	0	.20	.27	.47
P	1	.30	.10	.40
	2	.06	.07	.13
	$f(g)$.56	.44	1.00

The joint probability density function is a function of the values g and p and can be used to compute the probabilities of joint events involving the random drawing of individuals from the population. Thus, the probability of drawing a female Republican is .10, or $f(1,1) = .10$. ∎

The idea of a joint probability density function extends to more than two random variables. For example, if X_1, X_2, \ldots, X_n are random variables, then their joint probability density function will be written $f(x_1, x_2, \ldots, x_n)$, and if it is known, it can be used to calculate probabilities involving X_1, X_2, \ldots, X_n.

2.4.1 MARGINAL PROBABILITY DENSITY FUNCTIONS

Given a joint probability density function, we can obtain the probability distributions of individual random variables.

If X and Y are two discrete random variables, then

$$f(x) = \sum_y f(x,y) \text{ for each value } X \text{ can take}$$

$$f(y) = \sum_x f(x,y) \text{ for each value } Y \text{ can take} \tag{2.4.1}$$

Note that the summations in (2.4.1) are over the *other* random variable, the one that we are eliminating from the joint probability density function. This operation is sometimes called "summing out" the unwanted variable in the table of joint probabilities. If the random variables are continuous the same idea works, with integrals replacing the summation sign.

Example 2.6

As an example we can obtain the probability distributions of G and P introduced in the previous section. From the totals in Table 2.1 we can see that the population contains 560 men and 440 women. Thus, the probability of randomly drawing a male is .56; it is .44 for a female. In Table 2.2 these values are given in the bottom margin in the row labeled $f(g)$, which is the probability density function of G alone, and is sometimes called the *marginal* distribution of G, since it is obtained from the joint distribution $f(g, p)$ and is found in the margin of the table. The probability of drawing a male $f(0)$ = .56 is found by summing down the first column of the joint probability Table 2.2, corresponding to $g = 0$, over *all* the values of P. Similarly, $f(1)$ = .44, the probability of randomly choosing a female from the population is found by summing the second column of the joint probability table over all values of P. ∎

2.4.2 CONDITIONAL PROBABILITY DENSITY FUNCTIONS

Often the chances of an event occurring are *conditional* on the occurrence of another event. For example, a weather forecaster on the morning news might say, "If the cold front reaches here today, then the chances of rain are 80 percent, but otherwise the chance of rain is low." The forecaster is giving the probability of rain *conditioned* by the event that the cold front arrives.

For discrete random variables X and Y, conditional probabilities can be calculated from the joint probability density function $f(x, y)$ and the marginal probability density function of the *conditioning* random variable. Specifically, the probability that the random variable X takes the value x *given* that $Y = y$, is written $P[X = x | Y = y]$. This conditional probability is given by the *conditional probability density function* $f(x|y)$:

$$f(x|y) = P[X = x | Y = y] = \frac{f(x, y)}{f(y)} \qquad (2.4.2)$$

Example 2.7

As an example, consider the population of individuals represented by Table 2.1. Suppose we wish to focus on female voters, and ask the question: What is the probability that a randomly selected woman (from this population) is a Republican? Thus, we are asking for the probability that the random variable $P = 1$ given (or conditional upon) that $G = 1$. From Table 2.1 we calculate that the probability of selecting a Republican, given that we sample *only* from the

female population, is 0.227 (=100/440). Similarly, the conditional probability of drawing a Democrat from the female population is 0.614, and the conditional probability of drawing an "other political affiliation" from the female population is 0.159.

The complete conditional distribution $f(p|1) = f(g = 1,p)/f(g = 1)$ is:

| p | $f(p|1)$ |
|---|---|
| 0 | $f(1,0)/f(1) = .27/.44 = .614$ |
| 1 | $f(1,1)/f(1) = .10/.44 = .227$ |
| 2 | $f(1,2)/f(1) = .07/.44 = .159$ |

Note that the sum of the conditional probabilities is 1. ■

For discrete random variables the conditional probability density function gives the probabilities of one event conditional on another. If the random variables are continuous, then the conditional probability density function is constructed in the same way but it yields an equation. The equation describes a curve that can be used to calculate probabilities as areas (or volumes) beneath it.

2.4.3 INDEPENDENT RANDOM VARIABLES

Making probability statements about more than one random variable is simplified if the random variables involved are unrelated, or *statistically independent* of one another. *Two random variables are statistically independent, or independently distributed, if knowing the value that one will take does not reveal anything about what value the other may take.* A simple example is what happens when two coins are tossed simultaneously. The fact that one coin lands "heads" reveals nothing about the outcome for the other coin. Thus, if the discrete random variable X is the number of heads showing on a toss of the first coin, and Y is the number of heads occurring on the second coin, then X and Y are independent random variables. An example of independent economic variables might be the expenditures on beef by two randomly chosen individuals. An example of dependent economic variables might be the inflation and unemployment rates.

When random variables are statistically independent, their *joint* probability density function factors into the product of their *individual* probability density functions, and vice versa.

> If X and Y are independent random variables, then
> $$f(x,y) = f(x)f(y) \tag{2.4.3}$$
> for each and every pair of values x and y. The converse is also true.

To consider more than two independent random variables, let X_1, \ldots, X_n be independent random variables with joint probability density function $f(x_1, \ldots, x_n)$ and individual probability density functions $f_1(x_1), f_2(x_2), \ldots, f_n(x_n)$.

> If X_1, \ldots, X_n are statistically independent, the joint probability density function can be factored and written as
>
> $$f(x_1, x_2, \ldots, x_n) = f_1(x_1) \cdot f_2(x_2) \cdots f_n(x_n) \qquad (2.4.4)$$

The idea of conditional probability provides a useful way to characterize the statistical independence of two random variables.

> If X and Y are independent random variables, then the conditional probability density function of X, given that $Y = y$, is
>
> $$f(x|y) = \frac{f(x, y)}{f(y)} = \frac{f(x)f(y)}{f(y)} = f(x) \qquad (2.4.5)$$
>
> for each and every pair of values x and y. The converse is also true.

Example 2.8

Continuing the voting-gender example, suppose that knowing the gender of an individual from a population tells us *nothing* about the probability that a randomly chosen individual is a Democrat, a Republican, or an Independent. That is, suppose that the conditional probability of a woman or man being Democrat, Republican, or Independent is the same as the unconditional, or marginal, probability; or

$$f(p|g) = h(p) \qquad \text{for } g = 0, 1$$

If the conditional probabilities of $P = 0, 1, 2$ given $g = 0, 1$ are all the same as the marginal (unconditional) probabilities for P, then knowing gender gives no information about political affiliation, and the two random variables are *statistically independent*. For the population in Table 2.1 this is *not* the case. ∎

2.5 The Expected Value of a Function of Several Random Variables: Covariance and Correlation

In economics we are *usually* interested in exploring relationships between economic variables. One question that is frequently asked is: How closely do two price variables move together? An answer to this important question is provided by the **covariance** and **correlation** between these two random variables. The covariance literally indicates the amount of covariation exhibited by the two random variables.

As with the mean and variance of single random variables, the covariance is a mathematical expectation.

> If X and Y are random variables, then their covariance is
>
> $$\text{cov}(X, Y) = E[(X - E[X])(Y - E[Y])] \tag{2.5.1}$$

This expectation is more complicated than the ones we have taken thus far because it involves two random variables. However, there are expressions analogous to (2.3.2) that we can use.

> If X and Y are discrete random variables, $f(x, y)$ is their joint probability density function, and $g(X, Y)$ is a function of them, then
>
> $$E[g(X, Y)] = \sum_x \sum_y g(x, y)f(x, y) \tag{2.5.2}$$

Let $g(X, Y) = (X - E[X])(Y - E[Y])$, then $\text{cov}(X, Y)$ can be obtained using (2.5.2).

> If X and Y are discrete random variables and $f(x, y)$ is their joint probability density function, then
>
> $$\text{cov}(X, Y) = E[(X - E[X])(Y - E[Y])]$$
> $$= \sum_x \sum_y [x - E(X)][y - E(Y)]f(x, y) \tag{2.5.3}$$

If X and Y are continuous random variables, then the definition of covariance is similar, with integrals replacing the summation signs.

The *sign* of the covariance between two random variables indicates whether their association is positive (direct) or negative (inverse). The covariance between X and Y is the expected, or average, value of the random product $[X - E(X)][Y - E(Y)]$. In Figure 2.4 are plotted typical pairs of randomly drawn values (x, y) of two continuous random variables, X and Y. In quadrant I the values (x, y) are greater than their means, $[E(X), E(Y)]$, and thus the product $[x - E(X)][y - E(Y)]$ is positive. In quadrant III the values of the random variables are both less than the mean values, and the product is also positive. In quadrants II and IV the product is negative. Because a greater proportion of values falls in quadrants I and III, *on the average*, the product is positive, and in this case $\text{cov}(X, Y) > 0$. If two random variables have positive covariance then they tend to be positively (or directly) related.

FIGURE **2.4** Data scatter of joint values of random variables with a positive covariance.

In Figure 2.5 the greater proportion of values (x, y) falls in quadrants II and IV, where $[x-E(X)]\,[\,y-E(Y)]$ is negative, and thus, on average, the product is negative and $cov(X, Y) < 0$. The values of two random variables with negative covariance tend to be negatively (or inversely) related. Zero covariance implies that there is neither positive nor negative association between pairs of values.

FIGURE **2.5** Data scatter of joint values of random variables with a negative covariance.

The magnitude of covariance is difficult to interpret because it depends on the units of measurement of the random variables. The meaning of *covariation* is revealed more clearly if we divide the covariance between X and Y by their respective standard deviations. The resulting ratio is defined as the correlation between the random variables X and Y and is often denoted by the Greek letter rho, ρ.

If X and Y are random variables then their *correlation* is

$$\rho = \frac{\mathrm{cov}(X, Y)}{\sqrt{\mathrm{var}(X)\mathrm{var}(Y)}} \qquad (2.5.4)$$

As with the covariance, the correlation ρ between two random variables measures the degree of *linear* association between them. However, unlike the covariance, the correlation must lie between -1 and 1. Thus, the correlation between X and Y is 1 or -1 if X is a perfect positive or negative linear function of Y. If there is no linear association between X and Y, then $\mathrm{cov}(X, Y) = 0$ and $\rho = 0$. For other values of correlation the magnitude of the absolute value $|\rho|$ indicates the "strength" of the association between the values of the random variables. The larger the absolute value $|\rho|$ the more nearly exact the linear association between the values. This is illustrated in Figure 2.6.

FIGURE **2.6** Data scatter from joint probability density functions: (*a*) $\rho = 0$; (*b*) $\rho = .3$; (*c*) $\rho = .7$; (*d*) $\rho = .95$.

FIGURE **2.6** (Continued)

A consequence of statistical independence is the following:

> If X and Y are *independent random variables* then the *covariance* and *correlation* between them are zero. The converse of this relationship is *not* true.

Independent random variables X and Y have zero covariance, indicating that there is *no linear association* between them. However, just because the covariance or correlation between two random variables is zero *does not* mean that they are necessarily independent. *Zero covariance means that there is no linear association between the random variables.* Even if X and Y have zero covariance, they might have a nonlinear association, like $X^2 + Y^2 = 1$.

2.5.1 THE MEAN OF A WEIGHTED SUM OF RANDOM VARIABLES

In (2.5.2) we presented the rule for finding the expected value of a function of two discrete random variables. Let the function $g(X, Y)$ be

$$g(X, Y) = aX + bY$$

where a and b are constants. This is called a *weighted* sum. Now use (2.5.2) to find the expectation

$$E[aX + bY] = aE(X) + bE(Y) \qquad (2.5.5)$$

This rule says that the expected value of a weighted sum of two random variables is the weighted sum of their expected values. This rule works for any number of random variables whether they are *discrete or continuous*.

Note that if $a = b = 1$, then the rule says that the expected value of the sum of a set of random variables is the sum of their expected values as shown in (2.5.6).

If X and Y are random variables, then $E[X + Y] = E[X] + E[Y]$ (2.5.6)

In fact, the rule can be extended to sums of *functions* of random variables. So, we can say, in general, *the expected value of any sum is the sum of the expected values.*

2.5.2 THE VARIANCE OF A WEIGHTED SUM OF RANDOM VARIABLES

The following rules of variance are useful. They can be established using (2.5.2) and its generalization to n random variables.

1. If X, Y, and Z are random variables and a, b, and c are constants, then

$$\text{var}[aX + bY + cZ] = a^2 \, \text{var}[X] + b^2 \, \text{var}[Y] + c^2 \, \text{var}[Z] + 2ab \, \text{cov}[X, Y]$$
$$+ 2ac \, \text{cov}[X, Z] + 2bc \, \text{cov}[Y, Z] \qquad (2.5.7)$$

2. If X, Y, and Z are independent, or uncorrelated, random variables, then the covariance terms are zero and

$$\text{var}[aX + bY + cZ] = a^2 \, \text{var}[X] + b^2 \, \text{var}[Y] + c^2 \, \text{var}[Z] \qquad (2.5.8)$$

3. If X, Y, and Z are independent, or uncorrelated, random variables, and if $a = b = c = 1$, then

$$\text{var}[X + Y + Z] = \text{var}[X] + \text{var}[Y] + \text{var}[Z] \qquad (2.5.9)$$

This important rule explains when the "variance of a sum is the sum of the variances." The random variables involved must be independent, or uncorrelated.

2.6 The Normal Distribution

In the previous sections we discussed random variables and their probability density functions in a general way. In real economic contexts some *specific* probability

density functions have been found to be very useful. The most important is the normal distribution.

If X is a normally distributed random variable with mean β and variance σ^2, symbolized as $X \sim N(\beta, \sigma^2)$, then its probability density function is expressed mathematically as:

$$f(x) = \frac{1}{\sqrt{2\pi\sigma^2}} \exp\left[\frac{-(x - \beta)^2}{2\sigma^2}\right], \qquad -\infty < x < \infty \qquad (2.6.1)$$

where $\exp[a]$ denotes the exponential function e^a. The mean β and variance σ^2 are the parameters of this distribution and they determine its location and dispersion. The range of the continuous normal random variable is minus infinity to plus infinity. Pictures of normal probability density functions are given in Figure 2.7 for various values of the mean and variance. The normal probability density function is a symmetric, bell-shaped curve centered at β, its mean value. Note from Figure 2.7 that normal distributions with the same mean β but different variances σ^2 are more or less spread out about the mean, depending on the magnitude of the variance. For example, the larger the variance, the more disperse and spread out the values. Distributions with the same variance but different means are identical in shape but located at different points along the x-axis.

Like all continuous random variables, probabilities involving normal random variables are found as areas under probability density functions. Unfortunately, these areas are not easy to calculate directly unless you have a computer program that will do the work. Alternatively, we can make use of the relation between a normal random variable and its "standardized" equivalent. A **standard normal random variable** is one that has a normal probability density function with mean 0 and variance 1. If $X \sim N(\beta, \sigma^2)$, then

$$Z = \frac{X - \beta}{\sigma} \sim N(0, 1)$$

Dividing by the standard deviation σ is appropriate, since it has the same units of measure as the random variable X. Since $Z = (X/\sigma) - (\beta/\sigma)$, it is easy to use the rules for mean and variance that we have derived to verify that the mean and variance of Z are 0 and 1, respectively.

The standard normal random variable is important for theoretical and practical reasons. Theoretically, the standard normal random variable is important because it is related to a number of other random variables that are central to the study of econometrics. Examples are the chi-square random variable and the t random variable, which are introduced in Chapter 5. The F random variable appears in Chapter 8. Practically, the relationship between the standard normal random variable Z and the normal random variable X is very useful, since any probability statement involving X can be recast as a probability statement involving Z; probabilities (areas under the probability density function) for Z are found in Table 1 at the back of this book. Computer programs have various functions that make calculating standard normal probabilities simple and accurate.

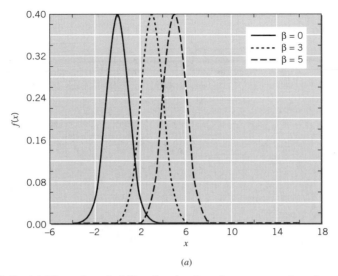

(a)

FIGURE 2.7 (a) Normal probability density functions: means β and variance 1.

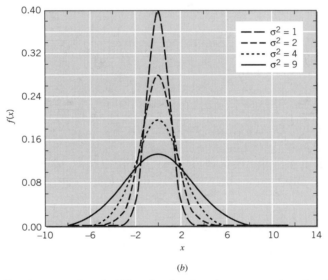

(b)

FIGURE 2.7 (b) Normal probability density functions: mean 0 and variances σ^2.

To calculate probabilities involving normal random variables, the following rules are useful:

If $X \sim N(\beta, \sigma^2)$ and a is a constant, then

$$P[X \geq a] = P\left[\frac{X - \beta}{\sigma} \geq \frac{a - \beta}{\sigma}\right] = P\left[Z \geq \frac{a - \beta}{\sigma}\right] \qquad (2.6.2)$$

and

If $X \sim N(\beta, \sigma^2)$ and a and b are constants, then

$$P[a \leq X \leq b] = P\left[\frac{a - \beta}{\sigma} \leq \frac{X - \beta}{\sigma} \leq \frac{b - \beta}{\sigma} \right]$$

$$= P\left[\frac{a - \beta}{\sigma} \leq Z \leq \frac{b - \beta}{\sigma} \right] \qquad (2.6.3)$$

REMARK: When using Table 1, and (2.6.2) and (2.6.3), to compute normal probabilities, remember that:

1. The standard normal probability density function is symmetric about zero.
2. The total amount of probability under the density function is 1.
3. Half the probability is on either side of zero.

For example, if $X \sim N(3, 9)$, then using Table 1,

$$P[4 \leq X \leq 6] = P[.33 \leq Z \leq 1] = .3413 - .1293 = .212$$

The standard normal probability density function is depicted in Figure 2.8. On it are marked the positions of one, two, and three standard deviations. From Table 1 we see that 68.2 percent of the probability of a standard normal random variable falls within one standard deviation, on either side, of the mean value (zero), 95.4 percent of the probability falls within two standard deviations, and 99.7 percent of the probability falls within three standard deviations.

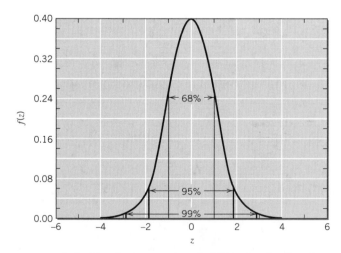

*FIGURE **2.8*** Standard normal probability density function.

An interesting and useful fact about the normal distribution is that a weighted sum of normal random variables has a normal distribution.

> If $X_1 \sim N(\beta_1, \sigma_1^2)$, $X_2 \sim N(\beta_2, \sigma_2^2)$, $X_3 \sim N(\beta_3, \sigma_3^2)$ and c_1, c_2, c_3 are constants, then
>
> $$Z = c_1X_1 + c_2X_2 + c_3X_3 \sim N[E(Z), \text{var}(Z)] \qquad (2.6.4)$$

This result extends to any number of random variables.

Equations (2.5.6) and (2.5.8) can be used to calculate the mean and variance of Z in the usual way. We will use this rule countless times in the remainder of this book.

2.7 **Learning Objectives**

> **REMARK:** *Learning Objectives* sections will appear at the end of each chapter. We urge you to think about, and possibly write out answers to these questions. If you are unsure about the questions or answers consult your instructor or TA. When examples are requested in *Learning Objectives* sections, you should think of examples <u>not</u> in the book.

Based on the material in this chapter you should be able to:

1. Explain the difference between a random variable and its values, and give an example.

2. Explain the difference between controlled and uncontrolled experiments, and the difference between experimental and nonexperimental data.

3. Explain the link between the sampling variation in experiments and the concept of a random variable.

4. Explain the difference between discrete and continuous random variables, and give examples of each.

5. State the characteristics of a probability function for a discrete random variable, and give an example.

6. Compute probabilities of events, given a discrete probability function.

7. Explain the meaning of the following statement: "The probability that the discrete random variable takes the value 2 is .3."

8. Explain how the probability density function of a continuous random variable is different from the probability function of a discrete random variable.

9. Show, geometrically, how to compute probabilities given a probability density function for a continuous random variable.

10. Write out, in long form, expressions using single and double summation signs. Use summation notation to represent a sum of terms.

11. Explain, intuitively, the concept of the mean, or expected value, of a random variable.

12. Use the definition of expected value for a discrete random variable, in (2.3.1)

and (2.3.2), to compute expectations, given a probability function $f(x)$ and a function $g(x)$.

13. Define the variance of a discrete random variable, and explain in what sense the values of a random variable are more spread out if the variance is larger.

14. Use a joint probability function (table) for two discrete random variables to compute probabilities of joint events, and to find the (marginal) probability function of each individual random variable.

15. Find the conditional probability function for one discrete random variable given the value of another and their joint probability function.

16. Give an intuitive explanation of statistical independence of two random variables, and state the conditions that must hold to prove statistical independence. Give examples of two independent random variables and two dependent random variables.

17. Define the covariance and correlation between two random variables, and compute these values given a joint probability function of two discrete random variables.

18. Find the mean and variance of a weighted sum of random variables.

19. Use Table 1 at the back of this book to compute probabilities involving normal random variables and weighted sums of normal random variables.

20. (Optional) Use computer software to compute probabilities involving normal random variables and weighted sums of normal random variables.

2.8 Exercises

2.1 Express each of the following sums in summation notation:
(a) $x_1 + x_2 + x_3 + x_4$
(b) $x_3 + x_4$
(c) $x_1 y_1 + x_2 y_2 + x_3 y_3 + x_4 y_4$
(d) $x_1 y_2 + x_2 y_3 + x_3 y_4 + x_4 y_5$
(e) $x_2 y_2^2 + x_3 y_3^2$
(f) $(x_1 - y_1) + (x_2 - y_2) + (x_3 - y_3)$

2.2 Write out each of the following sums and compute where possible:
(a) $\sum_{i=1}^{4} (a + b x_i)$
(b) $\sum_{i=1}^{3} i^2$
(c) $\sum_{x=0}^{3} (x^2 + 2x + 2)$
(d) $\sum_{x=2}^{4} f(x + 2)$
(e) $\sum_{x=0}^{2} f(x, y)$
(f) $\sum_{x=2}^{4} \sum_{y=1}^{2} (x + 2y)$

2.3 Based on long years of experience, an instructor in the principles of economics has determined that in her class the probability distribution of X, the number of students absent on Mondays, is as follows:

x	0	1	2	3	4	5	6	7
$f(x)$.005	.025	.310	.340	.220	.080	.019	.001

(a) Sketch a probability function of X.
(b) Find the probability that on a given Monday either 2, or 3, or 4 students will be absent.
(c) Find the probability that on a given Monday more than 3 students are absent.
(d) Compute the expected value of the random variable X. Interpret this expected value.
(e) Compute the variance and standard deviation of the random variable X.
(f) Compute the expected value and variance of $Y = 7X + 3$.

2.4 Let X be a continuous random variable with probability density function given by

$$f(x) = -.5x + 1, \qquad 0 \le x \le 2$$

(a) Graph the density function $f(x)$.
(b) Find the total area beneath $f(x)$ for $0 \le x \le 2$.
(c) Find $P(X \ge 1)$.
(d) Find $P(X \le .5)$.
(e) Find $P(X = 1.5)$.

2.5 Let X be a uniform random variable, which ranges between 10 and 20.
(a) Write down the probability density function for X and sketch it.
(b) Find the total area beneath the probability density function for $10 \le x \le 20$.
(c) Compute the probability that $17 \le X \le 19$.

2.6 In the fall of 1995 15,064,859 students were enrolled in institutions of higher education in the United States, divided among 4-year institutions, 2-year institutions, and less than 2-year institutions. The enrollment breakdown by gender was

	4-year	2-year	less than 2-year
Men	4,076,416	2,437,905	172,874
Women	4,755,790	3,310,086	311,788

Source: Digest of Educational Statistics 1997, Table 170.

In this population the probabilities (rounded) of enrolling in a type of higher education, by gender, are

	4-year	2-year	less than 2-year
Men	.27	.16	.01
Women	.32	.22	.02

(a) Verify the computed probabilities for 4-year schools.
(b) Consider the experiment of drawing an enrolled student at random from this population. Define the random variable $X = 0$ if a male is selected

and $X = 1$ if a female is selected. Define the random variable $Y = 1$ if a 4-year student is chosen, $Y = 2$ if a 2-year student is chosen, and $Y = 3$ if a less than 2-year student is chosen. What is the probability that a randomly drawn student is male $(X = 0)$? What is the probability that a randomly chosen student attends a 2-year college $(Y = 2)$?

(c) Obtain the marginal probability functions $f(x)$ and $g(y)$.

(d) Compute the conditional probability function for Y given that $X = 1$.

(e) Given that a randomly chosen student is male, what is the probability that he attends a 2-year college?

(f) Given that a randomly chosen student is male, what is the probability that he attends either a 2-year college or a 4-year college?

(g) Are gender and type of college institution attended statistically independent?

2.7　Suppose a certain mutual fund has an annual rate of return that is approximately normally distributed with mean (expected value) 10% and standard deviation 4%. Use Table 1 for parts (a)–(c).

(a) Find the probability that your 1-year return will be negative.

(b) Find the probability that your 1-year return will exceed 15%.

(c) If the mutual fund managers modify the composition of its portfolio, they can raise its mean annual return to 12%, but will also raise the standard deviation of returns to 5%. Answer parts (a) and (b) in light of these decisions. Would you advise the fund managers to make this portfolio change?

(d) Verify your computations in (a)–(c) using your computer software.

2.8　Let X and Y be two random variables, which may be discrete or continuous. Starting from equation (2.5.1), and using the properties of "expected values," show that their covariance can be expressed as $\text{cov}(X, Y) = E(XY) - \mu_X\mu_Y$, where $\mu_X = E(X)$ and $\mu_Y = E(Y)$.

2.9　Let Z be a standard normal random variable. Using Table 1, find

(a) $P(Z \leq 3)$

(b) $P(Z \leq 1)$

(c) $P(Z \leq -1)$

(d) $P(Z \leq -3)$

(e) $P(-1 \leq Z \leq 1)$

(f) $P(-3 \leq Z \leq 1)$

(g) Table 1 provides probabilities that Z falls between 0 and a given positive value, z. Computer software programs have functions that compute normal probabilities, but these functions generally provide the *cumulative probability* that Z is less than, or equal to, any given value z. That is, computer functions for normal probabilities generally return $P(Z \leq z)$. Use your computer software to compute the probabilities in (a)–(f).

2.10　Show that the results in (2.3.3) are true.

2.11　Show that (2.3.5) is true.

2.12　Let X be a continuous random variable whose probability density function is

$$f(x) = \begin{cases} 2x & 0 \leq x \leq 1 \\ 0 & otherwise \end{cases}$$

(a) Sketch the probability density function $f(x)$.

(b) Geometrically calculate the probability that X falls between 0 and $\frac{1}{2}$.

(c) Geometrically calculate the probability that X falls between $\frac{1}{4}$ and $\frac{3}{4}$.

2.13 Suppose X_1 and X_2 are independent continuous random variables, each of which has the probability density function $f(x)$ in Exercise 2.12. What is their *joint* probability density function $f(x_1, x_2)$?

2.14 The random variables gender (G) and political affiliation (P) have (hypothetical) joint probability density function $f(g, p)$ in Table 2.2.

(a) Are the random variables G and P independent? If not, why not?

(b) Find the complete conditional distribution $f(p|g = 0)$.

2.15 Let the discrete random variable X have probability density function

$$f(x) = p^x (1-p)^{1-x} \qquad \text{for } x = 0, 1$$

(a) Find the mean and variance of X.

(b) Let X_1, \ldots, X_n be independent discrete (0, 1) random variables, each with probability density function $f(x)$. The random variable $B = X_1 + X_2 + \cdots + X_n$ has a binomial distribution with parameters n and p. The values of B are $b = 0, \ldots, n$ and represent the number of "successes" (i.e., $X_i = 1$) in n independent trials of an experiment, each with probability p of success. Calculate the mean and variance of B.

(c) Let X_1, \ldots, X_n be independent discrete (0, 1) random variables with probability density functions $f(x)$. The random variable $B = X_1 + \cdots + X_n$ has a binomial distribution. The random variable $Y = B/n$ is the proportion of successes in n trials of an experiment. Find the mean and variance of Y.

2.16 The joint probability density function of two discrete random variables X and Y is given by the following table:

		Y		
		1	3	9
	2	$\frac{1}{8}$	$\frac{1}{24}$	$\frac{1}{12}$
X	4	$\frac{1}{4}$	$\frac{1}{4}$	0
	6	$\frac{1}{8}$	$\frac{1}{24}$	$\frac{1}{12}$

(a) Find the marginal probability density function of Y.

(b) Find the conditional probability density function of Y given that $X = 2$.

(c) Find the covariance of X and Y.

(d) Are X and Y independent?

2.17 A fair die is rolled two times. Let X_1 and X_2 denote the number of points showing on the first and second rolls, respectively. Let $U = X_1 + X_2$ and $V = X_1 - X_2$.

(a) Find the mean and variance of V.

(b) Find the covariance of U and V.

(c)*Show that U and V are not independent.

2.18* Let X_1 and X_2 be *independent* discrete random variables with joint probability density function $f(x_1, x_2)$. Show that

$$E[X_1 X_2] = E[X_1]E[X_2].$$

2.19 Show that var(X) can be expressed as $E[X^2] - [E(X)]^2$ using the properties of expected values.

2.20 Use equation 2.5.2 to show that equation 2.5.5 is true.

2.21 Use the properties of expectations and variances to show that if $X \sim N(\beta, \sigma^2)$ then

$$Z = \frac{X - \beta}{\sigma} = \frac{X}{\sigma} - \frac{\beta}{\sigma} \sim N(0, 1)$$

2.22 Let X_1, X_2, \ldots, X_n be independent random variables that all have the same probability distribution, with mean β and variance σ^2. Let

$$\overline{X} = \frac{1}{n} \sum_{i=1}^{n} X_i$$

(a) Prove that $E[\overline{X}] = \beta$
(b) Prove that var$(\overline{X}) = \sigma^2/n$

2.23 Consider the joint probability density function

$$f(x, y) = (0.6)^x (0.4)^{1-x} (0.3)^y (0.52)^{1-y} 2^{xy}$$

where the possible values for X and Y are $x = 0, 1$ and $y = 0, 1$. Find:
(a) $f(0,0), f(0,1), f(1,0), f(1,1)$
(b) The marginal density functions $f(x)$ and $f(y)$
(c) The conditional density function $f(y|x = 0)$
(d) $E(X)$ and $E(Y)$
(e) var(X) and var(Y)
(f) cov(X, Y) and the correlation between X and Y
(g) $E(X + Y)$ and var$(X + Y)$

2.24 Suppose that Y_1, Y_2, Y_3 is a sample of observations from a $N(\beta, \sigma^2)$ population but that $Y_1, Y_2,$ and Y_3 are *not* independent. In fact suppose

$$\text{cov}(Y_1, Y_2) = \text{cov}(Y_2, Y_3) = \text{cov}(Y_1, Y_3) = .5\sigma^2.$$

Let $\overline{Y} = (Y_1 + Y_2 + Y_3)/3$.
(a) Find $E(\overline{Y})$.
(b) Find var(\overline{y}).

2.25 The length of life (in years) of a personal computer is approximately normally distributed with mean 2.9 years and variance 1.96 years.
(a) What fraction of computers will fail in the first year?
(b) What fraction of computers will last 4 years or more?
(c) What fraction of computers will last at least 2 years?

(d) What fraction of computers will last more than 2.5 years but less than 4 years?

(e) If the manufacturer adopts a warranty policy in which only 5 percent of the computers have to be replaced, what will be the length of the warranty period?

2.26 Fifteen male economists are in a life raft with a maximum carrying capacity of 2,850 pounds. If the distribution of weights of male economists is normal with a mean of 178 pounds and with a standard deviation of 17 pounds, find

(a) the probability that all the economists weigh less than 189 pounds.

(b) the probability that the raft is overloaded, thus making some economists shark-bait.

(c) What is the maximum number of economists that should enter the raft if the probability of overloading [see part (b)] is not to exceed 0.001? (Can't you just see the economists bidding for the available positions?)

Chapter *3*

The Simple Linear Regression Model: Specification and Estimation

Economic theory suggests many relationships between economic variables. In microeconomics you considered demand and supply models in which the quantities demanded and supplied of a good depend on its price. You considered "production functions" and "total product curves" that explained the amount of a good produced as a function of the amount of an input, such as labor, that is used. In macroeconomics you specified "investment functions" to explain that the amount of aggregate investment in the economy depends on the interest rate and "consumption functions" that related aggregate consumption to the level of disposable income.

Each of these specifications involves a relationship among economic variables. In this chapter we consider how to use a sample of economic data to learn about such relationships. As economists, we are interested in questions such as: If one variable (e.g., price of a good) changes in a certain way, *by how much* will another variable (e.g., quantity demanded or supplied) change? Also, given that we know the value of one variable, can we *forecast* or *predict* the corresponding value of another? We will answer these questions in this chapter by using a **regression model.** Like all models the regression model is based on assumptions. In this chapter we hope to be very clear about these assumptions, as they are the conditions under which the analysis in subsequent chapters is appropriate.

3.1 An Economic Model

In order to develop the ideas of regression models we are going to use a simple, but important, economic example. Suppose that we are interested in studying the relationship between household income and expenditure on food. Consider the "experiment" of randomly selecting households from a particular population. The population might consist of households within a particular city, state, province, or country. For now, suppose that we are only interested in households with a household income of $480 per week, or $24,960 per year. In this experiment we randomly select a number of households from this population and interview them. The characteristic that we are interested in is the household's weekly expenditures on food, so we ask the question, "How much did your household spend on food last week?" Weekly food expenditure, which

we denote as *y*, is a *random variable* because the value is unknown to us until a household is selected and the question is asked and answered.

> **REMARK:** In Chapter 2 we distinguished random variables from their values by using uppercase (*Y*) letters for random variables and lowercase (*y*) letters for their values. We will not follow this practice any longer, as it leads to unacceptably complicated notation. We will use *y* to denote random variables as well as their values, and we will make the interpretation clear in the surrounding text.

The continuous random variable *y* has a *probability density function*, $f(y)$, that describes the probabilities of obtaining various food expenditure values. Clearly, the amount spent on food will vary from one household to another for a variety of reasons. Some households will be devoted to gourmet food, some will contain teenagers, some will contain senior citizens, some will be vegetarian. All of these factors and many others, including random, impulsive buying, will cause weekly expenditures on food to vary from one household to another, despite the fact that they all have the same income. The probability density function in this case describes how expenditures are "distributed" over the population, and it might look like one of those in Figure 3.1.

FIGURE **3.1a** Probability distribution $f(y|x = 480)$ of food expenditure *y* given income *x* = $480

FIGURE **3.1b** Probability distributions of food expenditures *y* given income *x* = $480 and *x* = $800

The probability distribution in Figure 3.1a is actually a conditional probability density function, since it is "conditional" upon household income. If *x* = weekly household income, then the conditional probability density function is $f(y|x = \$480)$. The *conditional mean*, or *expected value*, of *y* is $E(y|x = \$480) = \mu_{y|x}$ and is our population's average weekly food expenditure. The *conditional variance* of *y* is var($y|x = \$480) = \sigma^2$, which measures the dispersion of household expenditures *y* about their mean $\mu_{y|x}$. The parameters $\mu_{y|x}$ and σ^2, if they were known, would give us some valuable information about the population we are considering. If we knew these parameters, and if we knew that the conditional distribution $f(y|x = \$480)$ was *normal*, $N(\mu_{y|x}, \sigma^2)$, then we could calculate probabilities that *y* falls in specific intervals using properties of the normal distribution.

As economists, we are usually more interested in studying relationships *between* variables, in this case the relationship between *y* = weekly food expenditure and *x* = weekly household income. Economic theory tells us that expenditure on economic goods depends on income. But in your economics classes it was probably

not mentioned that expenditure is a *random variable*. Our problem is to use data to obtain information about this random variable.

An econometric analysis of the expenditure relationship can provide answers to some important questions, such as: If weekly income goes up by $20, how much will *average* weekly food expenditure rise? Or, could weekly food expenditures *fall* as income rises? How much would we predict the weekly expenditure on food to be for a household with an income of $800 per week? The answers to such questions provide valuable information for decision makers. For example, suppose that we are managers of a supermarket chain and are responsible for long-range planning. If economic forecasters are predicting that local income will increase over the next few years, then we must decide if and how much to expand our facilities to serve our customers. Or, if the chain has one supermarket in a high-income neighborhood and another in a low-income neighborhood, then forecasts of expenditure on food for different income levels give an indication of how large the supermarkets in those areas should be.

In order to investigate the relationship between expenditure and income, we must build an **economic model** and then an **econometric model** that forms the basis for a quantitative economic analysis. In our food expenditure example, economic theory suggests that *average* weekly household expenditure on food, represented by the conditional mean $E(y|x)$, depends on household income, x. If we consider households with different levels of income, we expect the average expenditure on food to change. In Figure 3.1b we show the probability density functions of food expenditure for two different levels of weekly income, $480 and $800. Each density function $f(y|x)$ shows that expenditures will be distributed about the mean value $\mu_{y|x}$, but the mean expenditure by households with higher income is larger than the mean expenditure by lower income households.

In most economics textbooks, consumption or expenditure functions relating consumption to income are depicted as *linear functions*, and we will begin by assuming the same thing. But *remember*, it is just an assumption. Our economic model of household food expenditure, depicted in Figure 3.2, is

$$E(y|x) = \mu_{y|x} = \beta_1 + \beta_2 x. \tag{3.1.1}$$

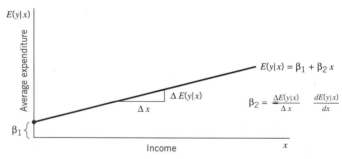

FIGURE *3.2* The economic model: a linear relationship between average expenditure on food and income.

The conditional mean $E(y|x)$ in (3.1.1) is called a **simple regression function.** It is called *simple* regression not because it is easy, but because there is only one economic variable on the right-hand side of the equation. The unknown **regression parameters** β_1 and β_2 are the intercept and slope of the regression function, respectively. In our food expenditure example, the intercept, β_1, represents the average

weekly household expenditure on food by a household with *no* income, $x = \$0$. The slope β_2 represents the change in $E(y|x)$ given a \$1 change in weekly income; it could be called the *marginal propensity to spend on food*. Algebraically,

$$\beta_2 = \frac{\Delta E(y|x)}{\Delta x} = \frac{dE(y|x)}{dx} \qquad (3.1.2)$$

where Δ denotes "change in" and $dE(y|x)/dx$ denotes the "derivative" of $E(y|x)$ with respect to x. We will not use derivatives to any great extent in this book, and if you are unfamiliar or rusty with the concept, you can think of d as a "stylized" version of Δ and go on. We will come back to the interpretation and uses of these parameters later in the chapter.

The economic model (3.1.1) summarizes what theory tells us about the relationship between household income (x) and average household expenditure on food, $E(y|x)$. The parameters of the model, β_1 and β_2, are quantities that help characterize economic behavior, and that serve as a basis for making economic decisions. In order to use data, we must now specify an *econometric model* that describes how the data on household income and expenditure are obtained, and that guides the econometric analysis.

3.2 **An Econometric Model**

The model $E(y|x) = \beta_1 + \beta_2 x$ that we specified in Section 3.1 describes economic behavior, but it is an abstraction from reality. If we take a random sample of households with weeky income $x = \$480$, we know the actual expenditure values will be scattered around the average or mean value $E(y|x = 480) = \beta_1 + \beta_2 (480)$, as shown in Figure 3.1. If we were to sample household expenditures at other levels of income, we would expect the sample values to be symmetrically scattered around their mean value $E(y|x) = \beta_1 + \beta_2 x$. In Figure 3.3 we arrange bell-shaped figures like Figure 3.1, depicting $f(y|x)$, along the regression line for *each* level of income.

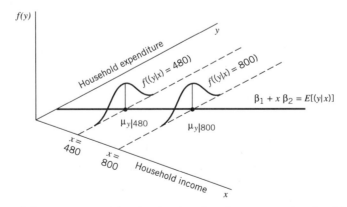

FIGURE *3.3* The probability density function for y at two levels of income.

This figure shows that at each level of income the *average* value of household expenditure is given by the regression function, $E(y|x) = \beta_1 + \beta_2 x$. It also shows that we assume *values* of household expenditure on food will be distributed around

These ideas, taken together, define our econometric model. They are a collection of assumptions that describe the data. To keep things uncluttered in this summary *and henceforth*, we will *not* use the "conditioning" notation $y|x$.

ASSUMPTIONS OF THE SIMPLE LINEAR REGRESSION MODEL—I

- The average value of y, for each value of x, is given by the *linear regression*

$$E(y) = \beta_1 + \beta_2 x$$

- For each value of x, the values of y are distributed about their mean value, following probability distributions that all have the same variance,

$$\text{var}(y) = \sigma^2$$

- The values of y are all *uncorrelated*, and have zero *covariance*, implying that there is no linear association among them.

$$\text{cov}(y_i, y_j) = 0$$

This assumption can be made stronger by assuming that the values of y are all *statistically independent*.

- The variable x is not random, and must take at least two different values.

- (*optional*) The values of y are *normally distributed* about their mean for each value of x,

$$y \sim N[(\beta_1 + \beta_2 x), \sigma^2]$$

3.2.1 INTRODUCING THE ERROR TERM

It is convenient for economists to describe the assumptions of the simple linear regression model in terms of y, which in general is called the *dependent* variable in the regression model. However, for statistical purposes it is also useful to characterize the assumptions another way.

The essence of regression analysis is that any observation on the dependent variable y can be decomposed into two parts: a systematic component and a random component. The systematic component of y is its mean $E(y)$, which itself is not random, since it is a mathematical expectation. The random component of y is the difference between y and its mean value $E(y)$. This is called a **random error term,** and it is defined as

$$e = y - E(y) = y - \beta_1 - \beta_2 x \tag{3.2.1}$$

If we rearrange (3.2.1) we obtain the simple linear regression model

$$y = \beta_1 + \beta_2 x + e \tag{3.2.2}$$

The dependent variable y is explained by a component that varies systematically with the *independent* variable x and by the random error term e.

Equation 3.2.1 shows that y and error term e differ only by the constant $E(y)$, and since y is random, so is the error term e. Given what we have already assumed

about y, the *properties* of the random error, e, can be derived directly from (3.2.1). Since y and e differ only by a constant, $\beta_1 + \beta_2 x$, the probability density functions for y and e are identical except for their location, as shown in Figure 3.4.

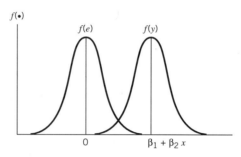

FIGURE **3.4** Probability density functions for e and y.

It is customary in econometrics to state the assumptions of the regression model in terms of the random error e. For future reference the assumptions are named SR1–SR6, "SR" denoting "simple regression."

ASSUMPTIONS OF THE SIMPLE LINEAR REGRESSION MODEL—II

SR1. The value of y, for each value of x, is

$$y = \beta_1 + \beta_2 x + e$$

SR2. The average value of the random error e is

$$E(e) = 0$$

since we assume that

$$E(y) = \beta_1 + \beta_2 x$$

SR3. The variance of the random error e is

$$\text{var}(e) = \sigma^2 = \text{var}(y)$$

since y and e differ only by a constant, which does not change the variance.

SR4. The covariance between any pair of random errors, e_i and e_j is

$$\text{cov}(e_i, e_j) = \text{cov}(y_i, y_j) = 0$$

If the values of y are *statistically independent*, then so are the random errors e, and vice versa.

SR5. The variable x is not random and must take at least two different values.

SR6. (*optional*) The values of e are *normally distributed* about their mean

$$e \sim N(0, \sigma^2)$$

if the values of y are normally distributed, and vice versa.

The random error e and the dependent variable y are both random variables, and the properties of one can be determined from the properties of the other. There is one interesting difference between these random variables, however, and that is that y is "observable" and e is "unobservable." If the regression parameters β_1 and β_2 were *known*, then for any value of y we could calculate $e = y - (\beta_1 + \beta_2 x)$. This is illustrated in Figure 3.5.

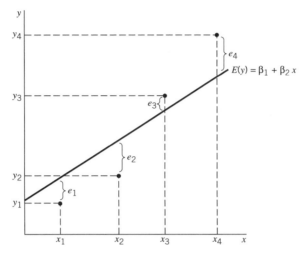

FIGURE **3.5** The relationship among y, e and the true regression line.

Knowing the regression function $E(y|x) = \beta_1 + \beta_2 x$, we could separate y into its fixed and random parts. Unfortunately, since β_1 and β_2 **are never known**, it is **impossible** to calculate e, and no bets on its true value can ever be collected.

It is useful to think about e in a slightly different way. The random error e represents all factors affecting y other than income. These factors cause individual observations y to differ from the mean value $E(y|x) = \beta_1 + \beta_2 x$. In the food expenditure example, what factors can result in a difference between expenditure y and its mean, $E(y|x)$?

1. We have included income as the only explanatory variable in this model. *Any **other** economic factors that affect expenditures on food* are "collected" in the error term. Naturally, in any economic model, we want to include all the important and relevant explanatory variables *in* the model, so the error term e is a "storage bin" for unobservable and/or unimportant factors affecting household expenditures on food. As such, it adds noise that masks the relationship between x and y, as shown in Figure 1.1.

2. The error term e captures any approximation error that arises, because the linear functional form we have assumed may be only an approximation to reality.

3. The error term captures any elements of random behavior that might be present in each individual. Knowledge of all variables that influence an individual's food expenditure *might not* be sufficient to perfectly predict expenditure. An unpredictable random behavioral component might also be contained in e.

3.3 Estimating the Parameters for the Expenditure Relationship

The economic and statistical models we developed in the previous section are the basis for using a sample of data to *estimate* the intercept and slope parameters, β_1 and β_2. Data on food expenditure from "last week" and weekly income from a random sample of forty households are given in Table 3.1. They are typical of those obtained by conducting a survey in a large city.

Table 3.1 Food Expenditure and Income Data

Observation t	Food Expenditure y_t	Weekly Income x_t	Observation t	Food Expenditure y_t	Weekly Income x_t
1	52.25	258.30	21	98.14	719.80
2	58.32	343.10	22	123.94	720.00
3	81.79	425.00	23	126.31	722.30
4	119.90	267.50	24	146.47	722.30
5	125.80	482.90	25	115.98	734.40
6	100.46	487.70	26	207.23	742.50
7	121.51	496.50	27	119.80	747.70
8	100.08	519.40	28	151.33	763.30
9	127.75	543.30	29	169.51	810.20
10	104.94	548.70	30	108.03	818.50
11	107.48	564.60	31	168.90	825.60
12	98.48	588.30	32	227.11	833.30
13	181.21	591.30	33	84.94	834.00
14	122.23	607.30	34	98.70	918.10
15	129.57	611.20	35	141.06	918.10
16	92.84	631.00	36	215.40	929.60
17	117.92	659.60	37	112.89	951.70
18	82.13	664.00	38	166.25	1014.00
19	182.28	704.20	39	115.43	1141.30
20	139.13	704.80	40	269.03	1154.60

We assume that the expenditure data in Table 3.1 are observed values of the random variable y_t, $t = 1, \ldots, 40$, that satisfy the assumptions SR1–SR5.

Given this theoretical model for explaining the sample observations on household food expenditure, the problem now is how to use our sample information y_t and x_t to estimate the unknown parameters β_1 and β_2 that represent the unknown intercept and slope coefficients for the food expenditure–income relationship. If we represent the 40 data points as (y_t, x_t), $t = 1, \ldots, 40$, and plot them, we obtain the **scatter diagram** in Figure 3.6.

Our problem is to estimate the location of the mean expenditure line $E[y] = \beta_1 + \beta_2 x$. We would expect this line to be somewhere in the middle of all the data points, since it represents *average behavior*. To estimate β_1 and β_2 we could simply draw a freehand line through the middle of the data and then measure the slope and intercept with a ruler. The problem with this method is that different people would draw different lines, and the lack of a formal criterion makes it difficult to assess the accuracy of the method. Another method is to draw a line from the smallest

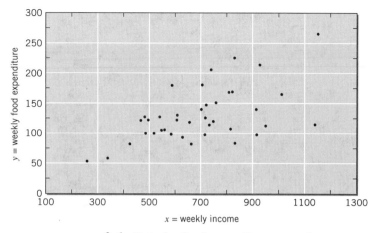

FIGURE **3.6** Data for food expenditure example.

income point to the largest income point. This approach does provide a formal rule. However, it might not be a very good rule, because it ignores information on the exact position of the remaining 38 observations. It would be better if we could devise a rule that uses all the information from all the data points.

3.3.1 THE LEAST SQUARES PRINCIPLE

To estimate β_1 and β_2 we want a rule, or formula, that tells us how to make use of the sample observations. Many rules are possible, but the one that we will use is based on the **least squares principle.** This principle asserts that to fit a line to the data values we should fit the line so that the sum of the squares of the vertical distances from each point to the line is as small as possible. The distances are squared to prevent large positive distances from being canceled by large negative distances. This rule is arbitrary, but very effective, and is simply one way to describe a line that passes through the middle of the data. The intercept and slope of this line, the line that best fits the data using the least squares principle, are b_1 and b_2, the least squares estimates of β_1 and β_2. The fitted line itself is then

$$\hat{y}_t = b_1 + b_2 x_t \tag{3.3.1}$$

The vertical distances from each point to the fitted line are the *least squares residuals*. They are given by

$$\hat{e}_t = y_t - \hat{y}_t = y_t - b_1 - b_2 x_t \tag{3.3.2}$$

These residuals are depicted in Figure 3.7a.

Now suppose we fit another line, *any other line*, to the data, say

$$\hat{y}_t^* = b_1^* + b_2^* x_t \tag{3.3.3}$$

where b_1^* and b_2^* are any other intercept and slope values. The residuals for this line, $\hat{e}_t^* = y_t - \hat{y}_t^*$, are shown in Figure 3.7b. The *least squares estimates b_1 and b_2* have the property that the sum of their squared residuals is *less than* the sum of

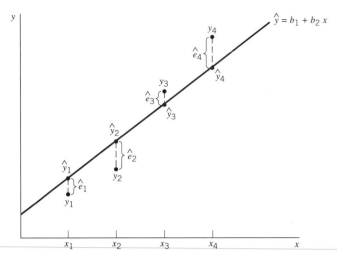

FIGURE 3.7a The relationship among y, \hat{e} and the fitted regression line.

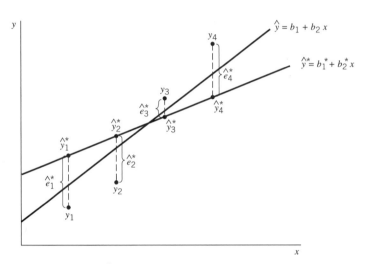

FIGURE 3.7b The residuals from another fitted line.

squared residuals for *any* other line,

$$\sum \hat{e}_t^2 = \sum (y_t - \hat{y}_t)^2 \leq \sum \hat{e}_t^{*2} = \sum (y_t - \hat{y}_t^*)^2$$

no matter how the other line might be drawn through the data. The *least squares principle* says that the estimates b_1 and b_2 of β_1 and β_2 are the ones to use, since the line using them as intercept and slope fits the data best.

Now the problem is to find b_1 and b_2 in a convenient way. Given the sample observations on y and x, we want to find values for the unknown parameters β_1 and β_2 that minimize the "sum of squares" function

$$S(\beta_1, \beta_2) = \sum_{t=1}^{T} (y_t - \beta_1 - \beta_2 x_t)^2 \tag{3.3.4}$$

> **REMARK:** Occasionally there will be algebraic material in this book that can be skipped on the first reading of a chapter, or that can be skipped if you are unfamiliar or uncomfortable with calculus. We will mark these sections with a dark bar in the left-hand margin and we will indicate their end by inserting a small portrait of "Skippy" the kangaroo. The first such section follows. In this section we use calculus to solve the minimization problem of finding the least squares estimates. You can "hop" down to Skippy if you are not comfortable with calculus.

Since the points (y_t, x_t) have been observed, the sum of squares function S is a function of the unknown parameters β_1 and β_2. This function, which is a quadratic in terms of the unknown parameters β_1 and β_2, is a "bowl-shaped surface" like the one depicted in Figure 3.8. For a two-dimensional illustration see Exercise 3.7.

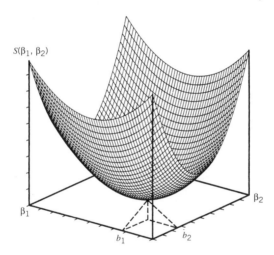

FIGURE **3.8** The sum of squares function and the minimizing values b_1 and b_2.

Given the data, our task is to find, out of all the possible values that β_1 and β_2 can take, the point (b_1, b_2) at which the sum of squares function S is a minimum. This minimization problem is a common one in calculus, and the minimizing point is at the "bottom of the bowl." Those of you familiar with calculus and "partial differentiation" can verify that the partial derivatives of S with respect to β_1 and β_2 are

$$\frac{\partial S}{\partial \beta_1} = 2T\beta_1 - 2\sum y_t + 2\sum x_t \beta_2$$

$$\frac{\partial S}{\partial \beta_2} = 2\sum x_t^2 \beta_2 - 2\sum x_t y_t + 2\sum x_t \beta_1 \tag{3.3.5}$$

These derivatives are equations of the slope of the bowl-like surface in the directions of the axes. Intuitively, the "bottom of the bowl" occurs where the slope of the bowl, in the direction of each axis, $\partial S/\partial \beta_1$ and $\partial S/\partial \beta_2$, is zero.

Algebraically, to obtain the point (b_1, b_2) we set (3.3.5) to zero, and replace β_1 and β_2 by b_1 and b_2, respectively, to obtain

$$2(\sum y_t - Tb_1 - \sum x_t b_2) = 0$$
$$2(\sum x_t y_t - \sum x_t b_1 - \sum x_t^2 b_2) = 0 \qquad (3.3.6)$$

Rearranging (3.3.6) leads to two equations usually known as the *normal equations*,

$$Tb_1 + \sum x_t b_2 = \sum y_t \qquad (3.3.7a)$$
$$\sum x_t b_1 + \sum x_t^2 b_2 = \sum x_t y_t \qquad (3.3.7b)$$

These two equations comprise a set of two linear equations in two unknowns b_1 and b_2. We can find the least squares estimates by solving these two linear equations for b_1 and b_2. To solve for b_2, multiply the first equation (3.3.7a) by $\sum x_t$; multiply the second (3.3.7b) by T; subtract the second equation from the first and then isolate b_2 on the left-hand side. To solve for b_1, divide both sides of (3.3.7a) by T.

The formulas for the least squares estimates of β_1 and β_2 are

$$b_2 = \frac{T \sum x_t y_t - \sum x_t \sum y_t}{T \sum x_t^2 - (\sum x_t)^2} \qquad (3.3.8a)$$

$$b_1 = \bar{y} - b_2 \bar{x} \qquad (3.3.8b)$$

where $\bar{y} = \sum y_t / T$ and $\bar{x} = \sum x_t / T$ are the sample means of the observations on y and x.

This formula for b_2 reveals why we had to assume that the values of x_t take at least two different values. If $x_t = 5$, for example, for all observations, then b_2 *does not exist*, since the numerator and denominator of (3.3.8a) are zero (see Exercise 3.10).

If we plug the sample values y_t and x_t into (3.3.8), then we obtain the least squares *estimates* of the intercept and slope parameters β_1 and β_2. It is interesting, however, and very important, that the formulas for b_1 and b_2 in equations 3.3.8 are *perfectly general*, and can be used *no matter what the sample values turn out to be*. This should ring a bell. When the formulas for b_1 and b_2 are taken to be rules that are used whatever the sample data turn out to be, then b_1 and b_2 are *random variables*. When actual sample values are substituted into the formulas, we obtain numbers that are the observed *values of random variables*. To distinguish these two cases we call the rules or general formulas for b_1 and b_2 the **least squares estimators.** We call the numbers obtained when the formulas are used with a particular sample **least squares estimates.**

- Least squares *estimators* are general formulas and are *random variables*.
- Least squares *estimates* are numbers that are the observed *values of random variables*.

The distinction between *estimators* and *estimates* is a fundamental concept that is essential to understand *everything* in the rest of this book. Keep this distinction in mind. This is going to take some concentration, since from now on we do not make any notation difference between these random variables and their values.

3.3.2 ESTIMATES FOR THE FOOD EXPENDITURE FUNCTION

We have used the least squares principle to derive (3.3.8), which can be used to obtain the least squares estimates for the intercept and slope parameters β_1 and β_2. To illustrate the use of these formulas, we will use them to calculate the values of b_1 and b_2 for the household expenditure data given in Table 3.1. From (3.3.8a) we have

$$b_2 = \frac{T \sum x_t y_t - \sum x_t \sum y_t}{T \sum x_t^2 - (\sum x_t)^2} = \frac{(40)(3834936.497) - (27920)(5212.520)}{(40)(21020623.02) - (27920)^2}$$

$$= 0.1283 \tag{3.3.9a}$$

and from (3.3.8b)

$$b_1 = \bar{y} - b_2\bar{x} = 130.313 - (0.1282886)(698.0) = 40.7676 \tag{3.3.9b}$$

A convenient way to report the values for b_1 and b_2 is to write out the *estimated* or *fitted* regression line:

$$\hat{y}_t = 40.7676 + 0.1283x_t \tag{3.3.10}$$

This line is graphed in Figure 3.9. The line's slope is 0.1283 and its intercept, where it crosses the vertical axis, is 40.7676. The least squares fitted line passes through the middle of the data in a very precise way, since one of the characteristics of the fitted line based on the least squares parameter estimates is that it passes through the point defined by the sample means, $(\bar{x}, \bar{y}) = (698.00, 130.31)$. See Exercise 3.3.

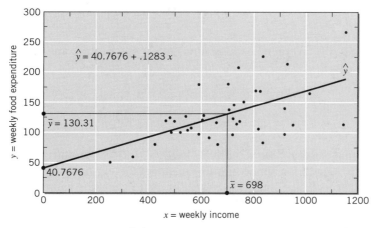

FIGURE *3.9* The fitted regression line.

3.3.3 INTERPRETING THE ESTIMATES

Once obtained, the least squares estimates are interpreted in the context of the economic model under consideration. The value $b_2 = 0.1283$ is an estimate of β_2, the amount by which weekly expenditure on food increases when weekly income increases by \$1. Thus, we estimate that if income goes up by \$100, weekly expenditure on food will increase by approximately \$12.83. A supermarket chain with information on likely changes in the income and the number of households in an area could estimate that it is likely to sell \$12.83 more per household per week for every \$100 increase in income. This is a very valuable piece of information for long-run planning.

Strictly speaking, the intercept estimate $b_1 = 40.7676$ is an estimate of the weekly amount spent on food for a family with zero income. In most economic models we must be very careful when interpreting the estimated intercept. The problem is that we usually do not have any data points near $x = 0$, which is certainly true for the food expenditure data shown in Figure 3.9. If we have no observations in the region where income is zero, then our estimated relationship may not be a good approximation to reality in that region. So, although our estimated model suggests that a household with zero income will spend \$40.7676 per week on food, it might be risky to take this estimate literally. You should consider this issue in each economic model that you estimate.

3.3.3a. Elasticities

The income elasticity of demand is a useful way to characterize the responsiveness of consumer expenditure to changes in income. From microeconomic principles, the elasticity of any variable y with respect to another variable x is

$$\eta = \frac{\text{percentage change in } y}{\text{percentage change in } x} = \frac{\Delta y/y}{\Delta x/x} = \frac{\Delta y}{\Delta x} \cdot \frac{x}{y} \qquad (3.3.11)$$

In the linear economic model given by (3.1.1) we have shown that

$$\beta_2 = \frac{\Delta E(y)}{\Delta x} \qquad (3.3.12)$$

so the elasticity of "average" expenditure with respect to income is

$$\eta = \frac{\Delta E(y)/E(y)}{\Delta x/x} = \frac{\Delta E(y)}{\Delta x} \cdot \frac{x}{E(y)} = \beta_2 \cdot \frac{x}{E(y)} \qquad (3.3.13)$$

To estimate this elasticity we replace β_2 by $b_2 = 0.1283$. We must also replace "x" and "$E(y)$" by something, since in a linear model the elasticity is different on each point upon the regression line. One possibility is to choose a value of x and replace $E(y)$ by its fitted value $\hat{y}_t = 40.7676 + 0.1283x_t$. Another frequently used alternative is to report the elasticity at the "point of the means" $(\bar{x}, \bar{y}) = (698.00, 130.31)$ since that is a representative point on the regression line.

If we calculate the income elasticity at the point of the means, we obtain

$$\hat{\eta} = b_2 \cdot \frac{\overline{x}}{\overline{y}} = 0.1283 \times \frac{698.00}{130.31} = 0.687 \qquad (3.3.14)$$

This *estimated* income elasticity takes its usual interpretation. We estimate that a 1% change in weekly household income will lead, on average, to approximately a 0.7% increase in weekly household expenditure on food when $(x, y) = (\overline{x}, \overline{y}) = (698.00, 130.313)$. Since the estimated income elasticity is less than one, we would classify food as a "necessity" rather than a "luxury," which is consistent with what we would expect for an "average" household.

3.3.3b. Prediction
Finally, the estimated equation can be used for prediction or forecasting purposes. Suppose that we wanted to predict weekly food expenditure for a household with a weekly income of $750. This prediction is carried out by substituting $x = 750$ into our estimated equation to obtain

$$\hat{y}_t = 40.7676 + 0.1283x_t = 40.7676 + 0.1283(750) = \$136.98 \qquad (3.3.15)$$

We *predict* that a household with a weekly income of $750 will spend $136.98 per week on food.

3.3.3c. Examining Computer Output
Many different software packages can compute least squares estimates. In this book we have chosen SAS, EViews, SHAZAM, and Excel to illustrate computations, but there are many other fine software packages which do the job. Every software package's regression output looks different, and uses different terminology to describe the output. Despite these differences, the various outputs provide the same basic information, which you should be able to locate and interpret. The matter is complicated somewhat by the fact that the packages also report various numbers whose meaning you may not know. For example, using the food expenditure data, the EViews output is shown in Figure 3.10 and SAS output is shown in Figure 3.11.

```
Dependent Variable: FOODEXP
Method: Least Squares
Sample: 1 40
Included Observations: 40
```

Variable	Coefficient	Std. Error	t-Statistic	Prob.
C	40.76756	22.13865	1.841465	0.0734
INCOME	0.128289	0.030539	4.200777	0.0002

R-squared	0.317118	Mean dependent var	130.3130
Adjusted R-squared	0.299148	S.D. dependent var	45.15857
S.E. of regression	37.80536	Akaike info criterion	10.15149
Sum squared resid	54311.33	Schwarz criterion	10.23593
Log likelihood	-201.0297	F-statistic	17.64653
Durbin-Watson stat	2.370373	Prob(F-statistic)	0.000155

FIGURE 3.10 EViews regression output.

In the EViews output the parameter estimates are in the "Coefficient" column, with names "C," for constant term (the estimate b_1) and "INCOME" (the estimate b_2). The estimates that we report in the text are rounded to 4 significant digits.

The SAS output is

```
Dependent Variable: FOODEXP

                        Analysis of Variance

                    Sum of          Mean
    Source     DF   Squares         Square       F Value   Prob>F
    Model      1    25221.22299     25221.22299  17.647    0.0002
    Error      38   54311.33145     1429.24556
    C Total    39   79532.55444

           Root MSE      37.80536    R-square    0.3171
           Dep Mean     130.31300    Adj r-sq    0.2991
           C.V.          29.01120

                       Parameter Estimates

                     Parameter    Standard     T for H0:
    Variable    DF    Estimate      Error      Parameter=0    Prob > |T|

    INTERCEP    1     40.767566    22.13865442    1.841          0.0734
    INCOME      1      0.12829      0.03053925    4.201          0.0002
```

FIGURE 3.11 SAS regression output.

In the SAS output the parameter estimates are in the "Parameter Estimate" column, with names "INTERCEP," (the estimate b_1) and "INCOME" (the estimate b_2). Despite the different formats for the output, the parameter estimates are the same, except for SAS reporting an additional significant digit for b_1.

We leave discussion of the rest of the output until later chapters. By the end of this course you will know how to interpret the remainder of the information.

3.3.4 OTHER ECONOMIC MODELS

We have used the household expenditure on food versus income relationship as an example to introduce the ideas of simple regression. The simple regression model can be applied to estimate the parameters of many other economic relationships. Examples include a demand relationship involving price and quantity data for a particular commodity; a production function reflecting the relationship involving the output of a product and the input of a factor; an aggregate consumption function relating aggregate consumption to income; an aggregate investment function representing the level of investment and the rate of interest; a supply function involving data on quantity supplied and the product price; and an environmental relation between gasoline consumption and air quality in San Francisco.

The simple linear regression model is much more flexible than it looks at first glance, because the variables y and x can be *transformations*, involving logarithms, squares, cubes, or reciprocals of the basic economic variables. Thus, the simple linear regression model can be used for *nonlinear relationships between variables*. This somewhat weird terminology results from the fact that the term *linear* in "linear regression" actually means that the *parameters* are not transformed in any way. The

model is *linear* in the parameters, and expressions like $\ln(\beta_2)$ are not permitted. To get a feel for a nonlinear model that uses variable transformations, but is linear in the parameters, try Exercise 3.6. Also, we treat this topic more fully in Chapter 6.3. There we discuss details of different functional forms that can be created through various variable transformations.

A word of warning: If y and x are transformed in some way, then the economic interpretation of the parameters can change. A popular transformation in economics is the natural logarithm. Economic models like $\ln(y) = \beta_1 + \beta_2 \ln(x)$ are common. A nice feature of this model, if the assumptions of the regression model hold, is that the parameter β_2 is the elasticity of y with respect to x. This fact is used in Exercise 3.6. The proof relies on calculus; if you are not comfortable with calculus, skip the marked text.

The derivative of $\ln(y)$ with respect to x is

$$\frac{d[\ln(y)]}{dx} = \frac{1}{y} \cdot \frac{dy}{dx}$$

The derivative of $\beta_1 + \beta_2 \ln(x)$ with respect to x is

$$\frac{d[\beta_1 + \beta_2 \ln(x)]}{dx} = \frac{1}{x} \cdot \beta_2$$

Setting these two pieces equal to one another, and solving for β_2 gives

$$\beta_2 = \frac{dy}{dx} \cdot \frac{x}{y} = \eta \tag{3.3.16}$$

Look back at (3.3.11). There we defined the elasticity of y with respect to x. It is defined in terms of finite changes, Δy and Δx, and is actually an *arc* elasticity. If we replace Δy and Δx by dy and dx, the *point* elasticity is defined. Equation (3.3.16) shows that in an economic model in which $\ln(y)$ and $\ln(x)$ are linearly related, the parameter β_2 is the point elasticity of y with respect to x.

In subsequent chapters we take a very close look at the least squares principle and why and when it is an effective rule to use. Each economic model, and its associated statistical model, must be carefully scrutinized to confirm that the assumptions of the regression model are valid. If they are not valid, then the least squares procedure may *not* be very effective. Checking the assumptions is sometimes a difficult task since economics is not an exact science and because economic data are *not* obtained by a controlled laboratory experiment. Economic data are usually "messy." This is one way "econometrics" differs from "statistics."

3.4 Learning Objectives

Based on the material in this chapter you should be able to:

1. Explain the difference between an estimator and an estimate, and give an example.

2. Explain the difference between an economic and an econometric model, and give an example.

3. Explain the difference between the dependent variable and the independent variable in a simple regression model.

4. Discuss the interpretation of the slope and intercept parameters of the simple regression model.

5. Explain the decomposition of an observable variable y into its systematic and random components, show this decomposition graphically, and discuss the relationship between the systematic component of y and an economic model.

6. Explain the role of the random error e in the simple regression model. In the context of an example, explain what factors cause e to exist.

7. Explain the meaning of the assumption $E(e) = 0$ in an intuitive way.

8. Explain the meaning of the assumption $\text{var}(e) = \sigma^2$ in an intuitive way.

9. Explain why, in the simple regression model, the independent variable x_t must take at least two different values.

10. Explain the meaning of the assumption $\text{cov}(e_i, e_j) = 0$, and how this assumption is different than assuming that e_i and e_j are statistically independent.

11. Explain why, in the food expenditure example, it might be reasonable to assume that the random errors are normally distributed.

12. Explain how the least squares principle is used to fit a line through a scatter plot of data.

13. Use the formulas for the least squares estimates, given data on y and x, to compute estimates of the intercept and slope in the simple linear regression model.

14. Define the least squares residual and the least squares fitted value of the dependent variable and show them on a graph.

15. Define the elasticity of y with respect to x and explain its computation in the simple linear regression model when y and x are not transformed in any way.

16. Explain how the elasticity of y with respect to x is computed in the simple linear regression model in which both y and x are transformed by taking the natural logarithm.

17. Explain how to predict the value of y given any value of x, given the fitted regression model.

18. Identify the least squares parameter estimates in computer output.

19. Explain what the word "simple" means, in the context of the simple linear regression model.

20. Explain the difference between a "linear model" and a "nonlinear model," and give an example.

3.5 Exercises

3.1 Let y = household food expenditure and x = household income. Determine which of the following are linear regression models and which are nonlinear regression models.

(a) $y = \beta_1 + \beta_2 x^2 + e$

(b) $y = \beta_1 x^{\beta_2} + e$

(c) $y = \exp(\beta_1 + \beta_2 x + e)$

(d) $y = \exp(\beta_1 + \beta_2 x) + e$

(e) $\log(y) = \beta_1 + \beta_2 x + e$

(f) $y = \beta_1 x^{\beta_2} \exp(e)$

3.2 Consider the following five observations on $y_t = \{5, 2, 3, 2, -2\}$ and $x_t = \{3, 2, 1, -1, 0\}$. Do this exercise by hand.

(a) Find $\sum_{t=1}^{5} x_t^2$, $\sum_{t=1}^{5} x_t y_t$, $\sum_{t=1}^{5} x_t$, $\sum_{t=1}^{5} y_t$, \bar{x}, \bar{y}

(b) Find b_1 and b_2.

(c) On a graph, plot the data points and sketch the fitted regression line, $\hat{y}_t = b_1 + b_2 x_t$.

(d) Give an interpretation of b_1 and b_2.

(e) On the sketch in part (c), locate the point of the means, (\bar{x}, \bar{y}). Does your fitted line pass through that point? If not, go back to the drawing board, literally.

3.3* Algebraically show that the fitted least squares line $\hat{y}_t = b_1 + b_2 x_t$ passes through the point of the means, (\bar{x}, \bar{y}).

3.4* Algebraically show that the average value of \hat{y}_t equals the sample average of y. That is, show that $\bar{\hat{y}} = \bar{y}$, where $\bar{\hat{y}} = \sum \hat{y}_t / T$.

3.5 Consider the problem of estimating a production function that expresses the relationship between the level of output of a commodity and the level of input of a factor of production. Assume that you have the production data given in Table 3.2.

Table 3.2 **A Sample of Observations on Poultry Feed Inputs and Meat Outputs**

Input x	Output y
1	0.58
2	1.10
3	1.20
4	1.30
5	1.95
6	2.55
7	2.60
8	2.90
9	3.45
10	3.50
11	3.60
12	4.10
13	4.35
14	4.40
15	4.50

(a) Assume that the data can be described by the simple linear regression model $y = \beta_1 + \beta_2 x + e$ and that all the assumptions hold. Use the least squares principle to estimate b_1 and b_2 (use the computer!).

(b) Give an economic interpretation to the estimated parameters.

(c) Use the results of part (a) to plot the estimated production function.

(d) If the cost of feed input is 6 cents per pound, derive the total cost and marginal cost functions.

(e)* Show how to use the total cost function (which relates total cost to output) to obtain estimates of the parameters of the production function connecting feed inputs and poultry meat outputs.

3.6 Assume that Moscow Makkers, a new hamburger outlet in Moscow, is unsure of its pricing policy. Each week the store changes the hamburger price slightly, using various specials. The quantities sold and their corresponding prices are as shown in Table 3.3 Suppose that the demand equation that relates quantity sold (q_t) to price (p_t) is $\ln(q_t) = \beta_1 + \beta_2 \ln(p_t) + e_t$. Note that this equation can be written in the more familiar form $y_t = \beta_1 + \beta_2 x_t + e_t$ by defining $y_t = \ln(q_t)$ and $x_t = \ln(p_t)$.

Table 3.3 **Quantity and Price Data**

Week	Number Sold (q_t)	Price (p_t)
1	892	1.23
2	1012	1.15
3	1060	1.10
4	987	1.20
5	680	1.35
6	739	1.25
7	809	1.28
8	1275	0.99
9	946	1.22
10	874	1.25
11	720	1.30
12	1096	1.05

(a) Using your computer software package, find $y_t = \ln(q_t)$ and $x_t = \ln(p_t)$, for $t = 1, 2, \ldots, 12$ and plot them on a graph. "ln" denotes the "natural" logarithm.

(b) Assume that the assumptions of the simple regression model hold for the transformed values y and x. Find least squares estimates b_1 and b_2 of β_1 and β_2.

(c) Give an economic interpretation to b_2. (Hint: See (3.3.16) and the discussion surrounding it.)

(d) Should the Makkers increase or decrease price if they want to increase total receipts?

3.7* Suppose that in a simple linear regression model we know that the intercept β_1 is equal to zero, that is, $\beta_1 = 0$.

(a) Algebraically, what does the sum of squares function become?

(b) Find a formula for estimating β_2 by using the least squares principle. This requires the use of calculus.

(c) Use a geometric instead of a calculus approach. Taking the production

model in Exercise 3.5 as an example, and the data in Table 3.2, use your software package to plot the sum of squares function from part (a). What is the minimizing value? Is this a least squares estimate?

(d) Repeat this exercise assuming that $\beta_2 = 0$, but that β_1 is not zero.

3.8 An interesting and useful economic concept is the "learning curve." The idea is related to a phenomenon that occurs in assembly line production, such as in the automobile industry, or any time a task is performed repeatedly. Workers learn from experience and become more efficient in performing their task. This means it takes less time and labor costs to produce the final product. This idea forms the basis for an economic model relating cost per unit at time t (u_t) to the *cumulative* production of a good up to, but not including, time t (q_t). The relationship between the variables is often taken to be

$$u_t = u_1 q_t^a$$

where u_t equals the unit cost of production for the first unit produced, and a equals the elasticity of unit costs with respect to cumulative production (which we expect to be negative). This nonlinear relationship between the variables is transformed to a linear one by taking logarithms of both sides:

$$\ln(u_t) = \ln(u_1) + a \ln(q_t) = \beta_1 + \beta_2 \ln(q_t)$$

We have "renamed" $\ln(u_1)$ and a so that the model looks more familiar. Ernst Berndt is the author of an excellent book, more advanced than this one, entitled *The Practice of Econometrics: Classic and Contemporary* (Addison and Wesley, 1991). On page 85 of that book Berndt gives the example of learning in the production of a product called titanium dioxide, which is used as a thickener in paint. He provides data on production and unit costs from the DuPont Corporation for the years 1955 to 1970. The data are given in Table 3.4, and in the file *learn.dat*.

Table 3.4 **Learning Curve Data**

Year	Real Cost	Cumulative Production
1955	24.96350	1127.00
1956	25.49296	1239.00
1957	25.27027	1363.00
1958	25.44460	1479.00
1959	25.03401	1580.00
1960	24.73404	1705.00
1961	23.12746	1839.00
1962	21.71053	1988.00
1963	21.49410	2156.00
1964	21.24352	2333.00
1965	20.15113	2511.00
1966	20.14652	2700.00
1967	20.35928	2892.00
1968	18.59649	3078.00
1969	16.72316	3280.00
1970	16.41631	3488.00

(a) Use your computer software to plot a graph of u against q, and $\ln(u)$ against $\ln(q)$.

(b) Obtain the least squares estimates b_1 and b_2 of β_1 and β_2 and give their economic interpretation. Do these numbers make sense?

3.9 The capital asset pricing model (CAPM) is an important model in the field of finance. It explains variations in the rate of return on a security as a function of the rate of return on a portfolio consisting of all publicly traded stocks, which is called the *market* portfolio. Generally, the rate of return on any investment is measured relative to its opportunity cost, which is the return on a risk-free asset. The resulting difference is called the *risk premium*, since it is the reward or punishment for making a risky investment. The CAPM says that the risk premium on security j is *proportional* to the risk premium on the market portfolio. That is

$$r_j - r_f = \beta_j(r_m - r_f)$$

where r_j and r_f are the returns to security j and the risk-free rate, respectively, r_m is the return on the market portfolio, and β_j is the j'th security's *beta* value. A stock's *beta* is important to investors because it reveals the stock's volatility. It measures the sensitivity of security j's return to variation in the whole stock market. As such, values of *beta* less than one indicate that the stock is "defensive," since its variation is less than the market's. A *beta* greater than one indicates an "aggressive stock." Investors usually want an estimate of a stock's beta before purchasing it. The CAPM model shown above is the "economic model" in this case. The "econometric model" is obtained by including an intercept in the model (even though theory says it should be zero) and an error term,

$$r_j - r_f = \alpha_j + \beta_j(r_m - r_f) + e$$

(a) Explain why this econometric model is a simple regression model like those discussed in this chapter.

(b) Ernst Berndt (1991, p. 42) provides data on the monthly returns of Mobil Oil (MOBIL) for the 10-year period January 1978 to December 1987. In addition, he gives the returns on the market portfolio, MARKET, and the return on a risk-free asset, 30-day U.S. Treasury bills (RKFREE). These data are contained in the file *capm.dat* provided by your instructor. The three columns of numbers in this file are MOBIL, MARKET, and RKFREE, respectively. Use these 120 observations to estimate Mobil Oil's *beta*. What do you conclude about the stock of Mobil Oil?

(c) Finance theory says that the intercept parameter α_j should be zero. Does this seem correct, given your estimates?

(d) Estimate the model under the assumption that $\alpha_j = 0$. (Hint: See Exercise 3.7). Does the estimate of the stock's *beta* change much?

3.10 Show that the numerator and denominator of (3.3.8a) are zero if all the values $x_t = c$, $t = 1, \dots, T$, where c is any constant, like $c = 5$. Consequently, if x_t does not take *at least* two values, then the least squares estimate b_2 cannot be calculated.

3.11 Graph the following observations of x and y on graph paper.

x	1	2	3	4	5	6
y	4	6	7	7	9	11

(a) Using a ruler, draw a line that fits through the data. Measure the slope and intercept of the line you have drawn.
(b) Use the formulas (3.3.8a) and (3.3.8b) to compute, using only a hand calculator, the least squares estimates of the slope and the intercept. Plot this line on your graph.
(c) Obtain the sample means of $\bar{y} = \sum y_t/T$ and $\bar{x} = \sum x_t/T$. Obtain the predicted value of y for $x = \bar{x}$ and plot it on your graph. What do you observe about this predicted value.
(d) Using the least squares estimates from (b), compute the least squares residuals \hat{e}_t. Find their sum.
(e) Plot the least squares residuals against x. Do you observe any pattern?

3.12 We have defined the simple linear regression model to be $y = \beta_1 + \beta_2 x + e$. Suppose however that we knew, for a fact, that $\beta_1 = 0$.
(a) What does the linear regression model look like, algebraically, if $\beta_1 = 0$?
(b) What does the linear regression model look like, graphically, if $\beta_1 = 0$?
(c) Are the formulas for the least squares estimates in (3.3.8) appropriate if we know $\beta_1 = 0$?
(d) If $\beta_1 = 0$ the least squares "sum of squares" function (3.3.4) becomes $S(\beta_2) = \sum_{t=1}^{T} (y_t - \beta_2 x_t)^2$. Using the data,

x	1	2	3	4	5	6
y	4	6	7	7	9	11

plot the value of the sum of squares function for enough values of β_2 for you to locate the approximate minimum. What is the significance of the value of β_2 that minimizes $S(\beta_2)$? [Hint: your computations will be simplified if you algebraically reduce $S(\beta_2) = \sum_{t=1}^{T} (y_t - \beta_2 x_t)^2$ by squaring the term in parentheses and carrying the summation operator through.]
(e)*Using calculus, find the formula for the least squares estimate of β_2 in this model. Use it to compute b_2 and compare this value to the value you obtained geometrically.
(f) Use your computer software to estimate the simple regression model assuming that $\beta_1 = 0$.
(g) Using the estimates obtained in (f), plot the fitted (estimated) regression function. On the graph locate the point (\bar{x}, \bar{y}). What do you observe?
(h) Using the estimates obtained in (f), obtain the least squares residuals, $\hat{e}_t = y - b_2 x_t$. Find their sum.

3.13 We have defined the simple linear regression model to be $y = \beta_1 + \beta_2 x + e$. Suppose however that we knew, for a fact, that $\beta_2 = 0$.
(a) What does the linear regression model look like, algebraically, if $\beta_2 = 0$?

(b) What does the linear regression model look like, graphically, if $\beta_2 = 0$?

(c) If $\beta_2 = 0$, what kind of a relationship is there between y and x?

(d) Are the formulas for the least squares estimates in (3.3.8) appropriate if we know $\beta_2 = 0$?

(e) If $\beta_2 = 0$ the least squares "sum of squares" function (3.3.4) becomes $S(\beta_1) = \sum_{t=1}^{T} (y_t - \beta_1)^2$. Using the data,

x	1	2	3	4	5	6
y	4	6	7	7	9	11

plot the value of the sum of squares function for enough values of β_1 for you to locate the approximate minimum. What is the significance of the value of β_1 that minimizes $S(\beta_1)$? [Hint: your computations will be simplified if you algebraically reduce $S(\beta_1) = \sum_{t=1}^{T} (y_t - \beta_1)^2$ by squaring the term in parentheses and carrying the summation operator through.]

(f)*Using calculus, find the formula for the least squares estimate of β_1 in this model. Use it to compute b_1 and compare this value to the value you obtained geometrically. Have you seen the formula for b_1 anywhere else? What is it?

3.14 A small business hires a consultant to predict the value of weekly sales of their product if their weekly advertising is increased to $600 per week. The consultant takes a record of how much the firm spent on advertising per week and the corresponding weekly sales over the past 6 months. The consultant writes in his report, "Over the past 6 months the average weekly expenditure on advertising has been $450 and average weekly sales have been $7500. Based on the results of a simple linear regression, I predict sales will be $8500 if $600 per week is spent on advertising."

(a) What is the estimated simple regression used by the consultant to make this prediction?

(b) Sketch a graph of the estimated regression line. Locate the average weekly values on the graph.

3.15 A soda vendor at Louisiana State University football games observes that the warmer the temperature at game time the more sodas she sells. Based on 32 home games covering 5 years, she estimates the relationship between soda sales and temperature to be $\hat{y} = -240 + 6x$, where y = the number of sodas she sells and x = degrees Fahrenheit.

(a) Interpret the estimated slope and intercept. Do the estimates make sense? Why or why not?

(b) On a day when the temperature at game time is forecast to be 80 degrees, how many sodas does she predict she will sell.

(c) Below what temperature does she predict she will sell no sodas?

(d) Sketch a graph of the estimated regression line.

3.16 In the file *br-1.dat* are 213 observations on the selling prices ($y = price$) and the sizes of houses ($x = sqft$) in a subdivision in Baton Rouge from the year 1985. The selling prices y are measured in $ and the house sizes x are measured in square feet.

(a) Compute the summary statistics. What are the mean house prices and size in the selected subdivision? What are the minima and maxima?

(b) Plot house price against house size and comment.

(c) Use your computer software to estimate the simple regression in which price is the dependent variable and house size is the independent variable. Interpret the estimated coefficients.

(d) Plot the least squares residuals against *sqft*.

(e) Predict the price of a house with 2000 square feet of living space.

3.17 One would suspect that new home construction depends on mortgage interest rates. If interest rates are high, fewer people will be able to afford to borrow the funds necessary to finance the purchase of a new home. Builders are aware of this fact, and thus when mortgage interest rates are high, they will be less inclined to build new homes. While this is intuitively reasonable, let us ask the question "If mortgage interest rates go up by 1%, how much does home construction fall?"

(a) Go to the web site **http://www.economagic.com.** Find the monthly series
 • 30 Year Conventional Mortgage Interest Rates
 • United States: Single Family Housing Starts (in thousands)

Save these two series into an EXCEL spreadsheet or a text file.

(b) Explain the meaning of each of these series.

(c) Plot each of the series against time for the period January 1972 to the present.

(d) Plot the series against each other, with y = housing starts and x = the 30-year conventional mortgage rate.

(e) Estimate the simple regression relating y = housing starts to x = the 30-year conventional mortgage rate and interpret the results.

Properties of the Least Squares Estimators

The simple linear regression model that we developed in Chapter 3 is an econometric model that is useful for studying the relationship between economic variables. The example we are using as a basis for discussion relates weekly household expenditure on food to weekly household income. In this example we wish to estimate how changes in income affect expenditure on food. The econometric model summarizes what economic theory says about the relationship, namely, that expenditure on food is a linear function of income; it also makes explicit the fact that when data are collected by sampling, then the household food expenditure data are *random*. At any given level of income, x, the actual expenditures we observe will be scattered about $E(y|x)$, the average or *expected value* of expenditure for that income. We repeat assumptions SR1–SR6 for easy reference in this chapter.

ASSUMPTIONS OF THE SIMPLE LINEAR REGRESSION MODEL

SR1. $y_t = \beta_1 + \beta_2 x_t + e_t$

SR2. $E(e_t) = 0 \Leftrightarrow E(y_t) = \beta_1 + \beta_2 x_t$

SR3. $\text{var}(e_t) = \sigma^2 = \text{var}(y_t)$

SR4. $\text{cov}(e_i, e_j) = \text{cov}(y_i, y_j) = 0$

SR5. x_t is not random and must take at least two different values.

SR6. $e_t \sim N(0, \sigma^2) \Leftrightarrow y_t \sim N[(\beta_1 + \beta_2 x_t), \sigma^2]$ *(optional)*

4.1 The Least Squares Estimators as Random Variables

In Chapter 3 we obtained just one sample of data consisting of observations on income and expenditure for forty households. Using these data we obtained the *least squares estimates* $b_1 = 40.7676$ and $b_2 = .1283$ of the unknown intercept and slope parameters, β_1 and β_2, respectively. There are, of course, many other households that could have been chosen. Other samples of forty households would yield *different* values for household food expenditure, y_t, $t = 1, \ldots, 40$, even if we carefully selected households with the same incomes as in the initial sample. These samples would lead to different estimates b_1 and b_2 of the model parameters. Household food expenditures, y_t, $t = 1, \ldots, 40$ are random variables, because their values are

not known until the sample is collected. Consequently, when viewed as an estimation procedure, b_1 and b_2 are also random variables, since their values depend on the random variable y whose values are not known until the sample is collected.

To repeat an important passage from Chapter 3, when the formulas for b_1 and b_2, given in equations 3.3.8, are taken to be rules that are used whatever the sample data turn out to be, then b_1 and b_2 are *random variables*. In this context we call b_1 and b_2 the *least squares estimators*. When actual sample values, numbers, are substituted into the formulas, we obtain numbers that are *values of random variables*. In this context, we call b_1 and b_2 the *least squares estimates*.

REMARK: In this chapter, based on assumptions SR1–SR6, we investigate the statistical properties of the least squares *estimators*, which are procedures for obtaining estimates of the unknown parameters β_1 and β_2 in the simple linear regression model. In this context b_1 and b_2 are random variables. The properties of the least squares estimation procedures we establish in this chapter do not depend on any particular sample of data, and they can be established "pre-data," that is, *prior* to any data collection or analysis.

After the data are collected, the least squares estimates are calculated numbers, such as $b_2 = .1283$, from the previous chapter. In "post-data" analysis, nonrandom quantities such as this have *no statistical properties*. Their reliability and usefulness are assessed in terms of the properties of the procedures by which they were obtained.

We can investigate the properties of the random estimators b_1 and b_2 and deal with the following important questions:

1. If the least squares estimators b_1 and b_2 are random variables, then what are their means, variances, covariances, and probability distributions?
2. The least squares principle is only *one* way of using the data to obtain estimates of β_1 and β_2. How do the least squares estimators compare with other rules that might be used, and how can we compare alternative estimators? For example, is there another estimator that has a higher probability of producing an estimate that is close to β_2?

These are two of the questions that we will investigate in Chapter 4.

4.2 The Sampling Properties of the Least Squares Estimators

The least squares estimators b_1 and b_2 are random variables and they have probability distributions that we can study prior to the collection of any data. The characteristics of their probability density functions are of great interest to us. If the probability density functions are known, then they can be used to make probability statements about b_1 and b_2. The means (expected values) and variances of random variables provide information about the location and spread of their probability distributions (see Chapter 2.3). The means and variances of b_1 and b_2 provide information about the range of values that b_1 and b_2 are likely to take. Knowing this

range is important, because our objective is to obtain estimates that are *close* to the true parameter values. In this section we determine the means and variances of the least squares estimators b_1 and b_2. Since b_1 and b_2 are random variables, they may have a covariance, and this we will determine as well. These "pre-data" characteristics of b_1 and b_2 are called **sampling properties,** because the randomness of the estimators is brought on by sampling from a population.

4.2.1 THE EXPECTED VALUES OF b_1 AND b_2

Given the statistical model described by the assumptions SR1–SR5, the least squares estimators are good ones, as we will see in this chapter. The least squares *estimator* b_2 of the slope parameter β_2, based on a sample of T observations, is

$$b_2 = \frac{T \sum x_t y_t - \sum x_t \sum y_t}{T \sum x_t^2 - (\sum x_t)^2} \qquad (3.3.8a)$$

The least squares *estimator* b_1 of the intercept parameter β_1 is

$$b_1 = \bar{y} - b_2 \bar{x} \qquad (3.3.8b)$$

where $\bar{y} = \sum y_t / T$ and $\bar{x} = \sum x_t / T$ are the sample means of the observations on y and x, respectively.

In this section we will determine the expected value of b_2. We also give the expected value of b_1, but we will not derive it. We begin by rewriting the formula in (3.3.8a) into the following one that is more convenient for theoretical purposes:

$$b_2 = \beta_2 + \sum w_t e_t \qquad (4.2.1)$$

where w_t is a constant (nonrandom) given by

$$w_t = \frac{x_t - \bar{x}}{\sum (x_t - \bar{x})^2} \qquad (4.2.2)$$

Equation (4.2.1) is very easy to use, but *not* so easy to obtain. After we present and discuss the expected value of b_2, we will look at how (4.2.1) is obtained.

Since w_t is a constant, depending only on the values of x_t, we can find the expected value of b_2 using the fact that the *expected value of a sum is the sum of the expected values* (see Chapter 2.5.1):

$$
\begin{aligned}
E(b_2) &= E(\beta_2 + \sum w_T e_T) = E(\beta_2 + w_1 e_1 + w_2 e_2 + \cdots + w_T e_T) \\
&= E(\beta_2) + E(w_1 e_1) + E(w_2 e_2) + \cdots + E(w_T e_T) \\
&= E(\beta_2) + \sum E(w_t e_t) = \beta_2 + \sum w_t E(e_t) = \beta_2
\end{aligned} \qquad (4.2.3)
$$

since $E(e_t) = 0$. When the expected value of any estimator of a parameter equals the true parameter value, then that estimator is *unbiased*. Since $E(b_2) = \beta_2$, the least squares estimator b_2 is an unbiased estimator of β_2. The intuitive meaning

of unbiasedness comes from the repeated sampling itnerpretation of mathematical expectation. (See Chapter 2.3.2.) If many samples of size T are collected, and the formula (3.3.8a) for b_2 is used to estimate β_2, then the average value of the estimates b_2 obtained from all those samples will be β_2, *if the statistical model assumptions are correct.*

However, if the assumptions we have made are *not correct*, then the least squares estimator may not be unbiased. In (4.2.3) note in particular the role of the assumptions SR1 and SR2. The assumption that $E(e_t) = 0$, for each and every t, makes $\sum w_t E(e_t) = 0$ and $E(b_2) = \beta_2$. If $E(e_t) \neq 0$, then $E(b_2) \neq \beta_2$. Recall that e_t contains, among other things, factors affecting y_t that are *omitted* from the economic model. If we have omitted anything that is important, then we would expect that $E(e_t) \neq 0$ and $E(b_2) \neq \beta_2$. Thus, having an econometric model that is correctly specified, in the sense that it includes all relevant explanatory variables, is a must in order for the least squares estimators to be unbiased.

The unbiasedness of the estimator b_2 is an important sampling property. When sampling repeatedly from a population, the least squares estimator is "correct," on average, and this is one desirable property of an estimator. This statistical property by itself does not mean that b_2 is a good estimator of β_2, but it is part of the story. The unbiasedness property depends on having *many* samples of data from the same population. The fact that b_2 is unbiased does not imply *anything* about what might happen in just *one* sample. An individual estimate (number) b_2 may be near to, or far from β_2. Since β_2 is *never* known, we will never know, given one sample, whether our estimate is "close" to β_2 or not. Thus, the estimate $b_2 = .1283$, from the previous chapter, may be close to β_2 or not. The least squares estimator b_1 of β_1 is also an *unbiased* estimator, and $E(b_1) = \beta_1$.

4.2.1a. The Repeated Sampling Context

To illustrate unbiased estimation in a slightly different way, we present in Table 4.1 least squares estimates of the food expenditure model from 10 random samples of size $T = 40$ from the same population. Note the variability of the least squares parameter estimates from sample to sample. This *sampling variation* is due to the simple fact that we obtained 40 *different* households in each sample, and their weekly food expenditure varies randomly.

Table 4.1 **Least Squares Estimates from 10 Random Samples of Size $T = 40$**

n	b_1	b_2
1	51.1314	0.1442
2	61.2045	0.1286
3	40.7882	0.1417
4	80.1396	0.0886
5	31.0110	0.1669
6	54.3099	0.1086
7	69.6749	0.1003
8	71.1541	0.1009
9	18.8290	0.1758
10	36.1433	0.1626

The property of unbiasedness is about the *average* values of b_1 and b_2 if *many* samples of the same size are drawn from the same population. The average value of b_1 in these 10 samples is $\bar{b}_1 = 51.43859$. The average value of b_2 is $\bar{b}_2 = 0.13182$. If we took the averages of estimates from many samples, these averages would approach the true parameter values β_1 and β_2. Unbiasedness does not say that an estimate from any one sample is close to the true parameter value, and thus we can not say that an *estimate* is unbiased. We can say that the least squares estimation procedure (or the least squares estimator) is unbiased.

4.2.1b. Derivation of Equation (4.2.1)

In this section we show that (4.2.1) is correct. You may skip to Section 4.2.2 for now if you choose. We **highly** recommend, however, that you work through this algebra at some point. It will enhance your understanding of the remainder of this chapter, as well as much of the remainder of the book.

The first step in the conversion of the formula for b_2 into (4.2.1) is to use some tricks involving summation signs. The first useful fact is that

$$\sum (x_t - \bar{x})^2 = \sum x_t^2 - 2\bar{x} \sum x_t + T\bar{x}^2 = \sum x_t^2 - 2\bar{x}\left(T \frac{1}{T} \sum x_t\right) + T\bar{x}^2$$

$$= \sum x_t^2 - 2T\bar{x}^2 + T\bar{x}^2 = \sum x_t^2 - T\bar{x}^2 \tag{4.2.4a}$$

Should you ever have to calculate $\sum(x_t - \bar{x})^2$, using the shortcut formula $\sum(x_t - \bar{x})^2 = \sum x_t^2 - T\bar{x}^2$ is much easier. Then, starting from (4.2.4a),

$$\sum (x_t - \bar{x})^2 = \sum x_t^2 - T\bar{x}^2 = \sum x_t^2 - \bar{x} \sum x_t = \sum x_t^2 - \frac{(\sum x_t)^2}{T} \tag{4.2.4b}$$

To obtain this result we have used the fact that $\bar{x} = \sum x_t/T$, so $\sum x_t = T\bar{x}$.

The second useful fact is similar to the first, and it is

$$\sum (x_t - \bar{x})(y_t - \bar{y}) = \sum x_t y_t - T\bar{x}\bar{y} = \sum x_t y_t - \frac{\sum x_t \sum y_t}{T} \tag{4.2.5}$$

This result is proven in a similar manner.

If the numerator and denominator of b_2 in (3.3.8a) are divided by T, then using (4.2.4) and (4.2.5) we can rewrite b_2 in *deviation from the mean form* as

$$b_2 = \frac{\sum (x_t - \bar{x})(y_t - \bar{y})}{\sum (x_t - \bar{x})^2} \tag{4.2.6}$$

This formula for b_2 is one that you should remember, as we will use it time and time again in the next few chapters. Its primary advantage is its theoretical usefulness. For example, it clearly shows that if assumption 5 is violated and $x_t = 5$ for every observation, then $b_2 = 0/0$ and is mathematically undefined.

In order to derive (4.2.1) we make a further simplification using another property of sums. The sum of any variable about its average is zero, that is,

$$\sum (x_t - \bar{x}) = 0 \tag{4.2.7}$$

Then, the formula for b_2 becomes

$$b_2 = \frac{\sum (x_t - \bar{x})(y_t - \bar{y})}{\sum (x_t - \bar{x})^2} = \frac{\sum (x_t - \bar{x})y_t - \bar{y} \sum (x_t - \bar{x})}{\sum (x_t - \bar{x})^2}$$

$$= \frac{\sum (x_t - \bar{x})y_t}{\sum (x_t - \bar{x})^2} = \sum \left[\frac{(x_t - \bar{x})}{\sum (x_t - \bar{x})^2} \right] y_t = \sum w_t y_t \qquad (4.2.8)$$

where w_t is the constant given in (4.2.2).

Finally, to obtain (4.2.1) replace y_t by $y_t = \beta_1 + \beta_2 x_t + e_t$ and simplify:

$$b_2 = \sum w_t y_t = \sum w_t(\beta_1 + \beta_2 x_t + e_t) = \beta_1 \sum w_t + \beta_2 \sum w_t x_t + \sum w_t e_t \quad (4.2.9a)$$

We use two more summation tricks, which we prove below (4.2.9b), to simplify (4.2.9a). First, $\sum w_t = 0$, this eliminates the term $\beta_1 \sum w_t$. Secondly, $\sum w_t x_t = 1$, so $\beta_2 \sum w_t x_t = \beta_2$, and (4.2.9a) simplifies to (4.2.1), which is what we wanted to show.

$$b_2 = \beta_2 + \sum w_t e_t \qquad (4.2.9b)$$

The term $\sum w_t = 0$, because

$$\sum w_t = \sum \left[\frac{(x_t - \bar{x})}{\sum (x_t - \bar{x})^2} \right] = \frac{1}{\sum (x_t - \bar{x})^2} \sum (x_t - \bar{x}) = 0 \quad (\text{using } \sum (x_t - \bar{x}) = 0)$$

To show that $\sum w_t x_t = 1$ we again use $\sum (x_t - \bar{x}) = 0$. Another expression for $\sum (x_t - \bar{x})^2$ is

$$\sum (x_t - \bar{x})^2 = \sum (x_t - \bar{x})(x_t - \bar{x}) = \sum (x_t - \bar{x})x_t - \bar{x} \sum (x_t - \bar{x}) = \sum (x_t - \bar{x})x_t$$

Consequently,

$$\sum w_t x_t = \frac{\sum (x_t - \bar{x})x_t}{\sum (x_t - \bar{x})^2} = \frac{\sum (x_t - \bar{x})x_t}{\sum (x_t - \bar{x})x_t} = 1$$

4.2.2 THE VARIANCES AND COVARIANCE OF b_1 AND b_2

Given the expected values, or means, of b_1 and b_2, our interest now shifts to the precision of these estimators. To that end, we now obtain the variances and covariance of these random *estimators*. Before presenting the expressions for the variances and covariance, let us consider why they are important to know. The variance of the random variable b_2 is the average of the squared distances between the values of the random variable and its mean, which we now know is $E(b_2) = \beta_2$. The variance

(Chapter 2.3.4) of b_2 is defined as

$$\text{var}(b_2) = E[b_2 - E(b_2)]^2$$

It measures the spread of the probability distribution of b_2. In Figure 4.1 are graphs of two possible probability distributions of $b_2, f_1(b_2)$ and $f_2(b_2)$, that have the same mean value but different variances.

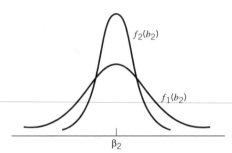

FIGURE **4.1** Two possible probability density functions for b_2.

The probability density function $f_2(b_2)$ has a smaller variance than the probability density function $f_1(b_2)$. Given a choice, we are interested in estimator precision and would *prefer* that b_2 have the probability distribution $f_2(b_2)$ rather than $f_1(b_2)$. With the distribution $f_2(b_2)$ the probability is more concentrated around the true parameter value β_2, giving, relative to $f_1(b_2)$, a *higher* probability of getting an estimate that is *close* to β_2. Remember, getting an estimate close to β_2 is our objective.

The variance of an estimator measures the *precision* of the estimator in the sense that it tells us how much the estimates produced by that estimator can vary from sample to sample as illustrated in Table 4.1. Consequently, we often refer to the *sampling variance* or **sampling precision** of an estimator. The lower the variance of an estimator, the greater the sampling precision of that estimator. One estimator is *more precise* than another estimator if its sampling variance is less than that of the other estimator.

We will now present and discuss the variances and covariance of b_1 and b_2. Then we will derive the variance of the least squares estimator b_2. *If the regression model assumptions SR1–SR5 are correct* (SR6 is not required), then the variances and covariance of b_1 and b_2 are:

$$\text{var}(b_1) = \sigma^2 \left[\frac{\sum x_t^2}{T \sum (x_t - \bar{x})^2} \right]$$

$$\text{var}(b_2) = \frac{\sigma^2}{\sum (x_t - \bar{x})^2}$$

$$\text{cov}(b_1, b_2) = \sigma^2 \left[\frac{-\bar{x}}{\sum (x_t - \bar{x})^2} \right] \tag{4.2.10}$$

At the beginning of this section we said that for unbiased estimators, smaller variances are better than larger variances. Let us consider the factors that affect the variances and covariance in (4.2.10).

1. The variance of the random error term, σ^2, appears in each of the expressions. It reflects, as we discussed in Chapter 3.2, the dispersion of the values y about their mean $E(y)$. The greater the variance σ^2, the greater is the dispersion, and the greater is the *uncertainty* about where the values of y fall relative to their mean $E(y)$. The information we have about β_1 and β_2 is less precise the larger is σ^2. We saw in Figure 3.3 that this variance is reflected in the spread of the probability distributions $f(y|x)$. The *larger* the variance term σ^2, the *greater* the uncertainty there is in the statistical model, and the *larger* the variances and covariance of the least squares estimators.

2. The sum of squares of the values of x about their sample mean, $\sum(x_t - \bar{x})^2$, appears in each of the variances and in the covariance. This expression measures how *spread out* about their mean are the sample values of the independent or explanatory variable x. The more they are spread out, the larger the sum of squares. The less they are spread out the smaller the sum of squares. The *larger* the sum of squares, $\sum(x_t - \bar{x})^2$, the *smaller* the variances of the least squares estimators and the more *precisely* we can estimate the unknown parameters. The intuition behind this is demonstrated in Figure 4.2.

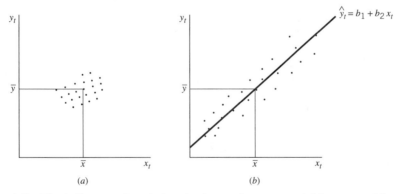

FIGURE **4.2** The influence of variation in the explanatory variable on precision of estimation (*a*) Low variation, low precision (*b*) High variation, high precision.

On the right, in panel (b), is a data scatter in which the values of x are widely spread out along the x-axis. In panel (a) the data are "bunched." Which data scatter would you prefer, given the task of fitting a line by hand? Pretty clearly, the data in panel (b) do a better job of determining where the least squares line must fall, because they are more spread out along the x-axis.

3. The larger the sample size T, the *smaller* the variances and covariance of the least squares estimators; it is better to have *more* sample data than less. The sample size T appears in each of the variances and covariance because each of the sums consists of T terms. Also, T appears explicitly in $\text{var}(b_1)$. The sum of squares term $\sum(x_t - \bar{x})^2$ gets larger and larger as T increases because each of the terms in the sum is positive or zero (being zero if x happens to equal its sample mean value for an observation). Consequently, as T gets

larger, both var(b_2) and cov(b_1, b_2) get smaller, since the sum of squares appears in their denominator. The sums in the numerator and denominator of var(b_1) both get larger as T gets larger and offset one another, leaving the T in the denominator as the dominant term, ensuring that var(b_1) also gets smaller as T gets larger.

4. The term $\sum x^2$ appears in var(b_1). The larger this term is, the larger the variance of the least squares estimator b_1. Why is this so? Recall that the intercept parameter β_1 is the expected value of y, given that $x = 0$. The farther our data are from $x = 0$ the more difficult it is to interpret β_1, as in the food expenditure example, and the more difficult it is to accurately estimate β_1. The term $\sum x^2$ measures the distance of the data from the origin, $x = 0$. If the values of x are near zero, then $\sum x^2$ will be small and this will reduce var(b_1). But if the values of x are large in magnitude, either positive or negative, the term $\sum x^2$ will be large and var(b_1) will be larger.

5. The sample mean of the x-values appears in cov(b_1, b_2). The covariance *increases* the larger in magnitude is the sample mean \bar{x}, and the covariance has the *sign* that is opposite that of \bar{x}. The reasoning here can be seen from Figure 4.2. In panel (b) the least squares fitted line must pass through the point of the means. Given a fitted line through the data, imagine the effect of increasing the estimated slope, b_2. Since the line must pass through the point of the means, the effect must be to *lower* the point where the line hits the vertical axis, implying a *reduced* intercept estimate b_1. Thus, when the sample mean is positive, as shown in Figure 4.2, there is a negative covariance between the least squares estimators of the slope and intercept.

The preceding lengthy discussion describes the characteristics of the model and data that affect the least squares variances and the covariance between them.

As an illustration, we will derive the variance of b_2. You may, if you choose, skip the marked text for the present. Once again, we urge you to work through this algebra at some point. Only by working through the algebra will you appreciate the important point that the variance formulas are correct only if assumptions SR3 and SR4 hold.

Deriving the variance of b_2: The starting point is (4.2.1).

$$\text{var}(b_2) = \text{var}(\beta_2 + \sum w_t e_t) = \text{var}(\sum w_t e_t) \quad \text{[since } \beta_2 \text{ is a constant]}$$

$$= \sum w_t^2 \text{var}(e_t) \quad \text{[using (2.5.8), since cov}(e_i, e_j) = 0]$$

$$= \sigma^2 \sum w_t^2 \quad \text{[using var}(e_t) = \sigma^2]$$

$$= \frac{\sigma^2}{\sum (x_t - \bar{x})^2} \tag{4.2.11}$$

The very last step uses the fact that

$$\sum w_t^2 = \sum \left[\frac{(x_t - \bar{x})^2}{\{\sum (x_t - \bar{x})^2\}^2} \right] = \frac{\sum (x_t - \bar{x})^2}{\{\sum (x_t - \bar{x})^2\}^2} = \frac{1}{\sum (x_t - \bar{x})^2} \tag{4.2.12}$$

Note carefully that the derivation of the variance expression for b_2 depends on assumptions SR3 and SR4. If cov(e_i, e_j) \neq 0 then we cannot drop out all these terms. See (2.5.7). If var(e_t) \neq σ^2 for all observations then σ^2 cannot be factored out of the summation. If either of these assumptions fails to hold then var(b_2) is *something else*, and is not given by (4.2.11). The same is true for the variance of b_1 and the covariance.

4.2.3 LINEAR ESTIMATORS

The least squares estimator b_2 is a weighted sum of the observation y_t, $b_2 = \sum w_t y_t$ [see (4.2.8)]. In mathematics weighted sums like this are called **linear combinations** of the y_t; consequently, statisticians call estimators like b_2, that are linear combinations of an observable random variable, **linear estimators.** Putting together what we know so far, we can describe b_2 as a *linear, unbiased estimator* of β_2, with a variance given in (4.2.10). Similarly, b_1 can be described as a *linear, unbiased estimator* of β_1, with a variance given in (4.2.10).

4.3 The Gauss–Markov Theorem

The one and only "theorem" that we will prove in this book is the Gauss-Markov Theorem. The theorem is about the estimators b_1 and b_2 of the unknown intercept and slope parameters, β_1 and β_2. The theorem and proof are about the least squares estimation *procedure*, and thus can be established prior to the collection of any data. We will first state and discuss this famous result, and then prove it.

> **GAUSS-MARKOV THEOREM:** Under the assumptions SR1–SR5 of the linear regression model, the estimators b_1 and b_2 have the *smallest variance of all linear and unbiased estimators* of β_1 and β_2. They are the **Best Linear Unbiased Estimators (BLUE)** of β_1 and β_2.

Let us clarify what the Gauss–Markov theorem does, and does not, say.

1. The estimators b_1 and b_2 are "best" when compared to *similar* estimators, those that are linear *and* unbiased. The theorem does *not* say that b_1 and b_2 are the best of all *possible* estimators.

2. The estimators b_1 and b_2 are best within their class because they have the minimum variance. This definition of "best" goes back to our discussion in Chapter 4.2.2. When comparing two linear and unbiased estimators, we *always* want to use the one with the smaller variance, since that estimation rule gives us the higher probability of obtaining an estimate that is close to the true parameter value.

3. In order for the Gauss–Markov theorem to hold, assumptions SR1–SR5 must be true. If any of these assumptions are *not* true, then b_1 and b_2 are *not* the best linear unbiased estimators of β_1 and β_2.

4. The Gauss–Markov theorem does *not* depend on the assumption of normality (assumption SR6).

5. In the simple linear regression model, if we want to use a linear and unbiased estimator, then we have to do no more searching. The estimators b_1 and b_2 are the ones to use. This explains why we are studying these estimators (we wouldn't have you study *bad* estimation rules, would we?) and why they are so widely used in research, not only in economics but in all the other social and physical sciences as well.

6. The Gauss–Markov theorem applies to the least squares estimators. It *does not* apply to the least squares *estimates* from a single sample.

Now the proof. On the *first* reading of the chapter you can skip the marked text.

Proof of the Gauss–Markov Theorem: We will prove the Gauss–Markov theorem for the least squares estimator b_2 of β_2. Our goal is to show that in the class of linear and unbiased estimators, the estimator b_2 has the smallest variance. Let $b_2^* = \sum k_t y_t$ (where the k_t are constants) be any other linear estimator of β_2. To make comparison to the least squares estimator b_2 easier, suppose that $k_t = w_t + c_t$, where c_t is another constant and w_t is given in (4.2.2). While this is tricky, it is legal, since for any k_t that someone might choose we can find c_t. Into this new estimator substitute y_t and simplify, using the properties of w_t, $\sum w_t = 0$ and $\sum w_t x_t = 1$.

$$b_2^* = \sum k_t y_t = \sum (w_t + c_t) y_t = \sum (w_t + c_t)(\beta_1 + \beta_2 x_t + e_t)$$
$$= \sum (w_t + c_t)\beta_1 + \sum (w_t + c_t)\beta_2 x_t + \sum (w_t + c_t)e_t$$
$$= \beta_1 \sum w_t + \beta_1 \sum c_t + \beta_2 \sum w_t x_t + \beta_2 \sum c_t x_t + \sum (w_t + c_t)e_t$$
$$= \beta_1 \sum c_t + \beta_2 + \beta_2 \sum c_t x_t + \sum (w_t + c_t)e_t \tag{4.3.1}$$

Take the mathematical expectation of the last line in (4.3.1), using the properties of expectation (see Chapter 2.5.1) and the assumption that $E(e_t) = 0$:

$$E(b_2^*) = \beta_1 \sum c_t + \beta_2 + \beta_2 \sum c_t x_t + \sum (w_t + c_t)E(e_t)$$
$$= \beta_1 \sum c_t + \beta_2 + \beta_2 \sum c_t x_t \tag{4.3.2}$$

In order for the linear estimator $b_2^* = \sum k_t y_t$ to be unbiased, it must be true that

$$\sum c_t = 0 \text{ and } \sum c_t x_t = 0 \tag{4.3.3}$$

These conditions must hold in order for $b_2^* = \sum k_t y_t$ to be in the class of *linear* and *unbiased* estimators. So we will assume the conditions (4.3.3) hold and use them to simplify expression (4.3.1):

$$b_2^* = \sum k_t y_t = \beta_2 + \sum (w_t + c_t)e_t \tag{4.3.4}$$

We can now find the variance of the linear, unbiased estimator b_2^* following the steps in (4.2.11) and using the additional fact that

$$\sum c_t w_t = \sum \left[\frac{c_t(x_t - \bar{x})}{\sum (x_t - \bar{x})^2} \right] = \frac{1}{\sum (x_t - \bar{x})^2} \sum c_t x_t - \frac{\bar{x}}{\sum (x_t - \bar{x})^2} \sum c_t = 0$$

Use the properties of variance to obtain:

$$\begin{aligned}
\text{var}(b_2^*) &= \text{var}(\beta_2 + \sum (w_t + c_t)e_t) = \sum (w_t + c_t)^2 \text{var}(e_t) \\
&= \sigma^2 \sum (w_t + c_t)^2 = \sigma^2 \sum w_t^2 + \sigma^2 \sum c_t^2 \\
&= \text{var}(b_2) + \sigma^2 \sum c_t^2 \\
&\geq \text{var}(b_2) \text{ since } \sum c_t^2 \geq 0
\end{aligned} \qquad (4.3.5)$$

The last line of (4.3.5) establishes that, for the family of linear and unbiased estimators b_2^*, each of the alternative estimators has variance that is greater than or equal to that of the least squares estimator b_2. The *only* time that $\text{var}(b_2^*) = \text{var}(b_2)$ is when all the $c_t = 0$, in which case $b_2^* = b_2$. Thus, *there is no other linear and unbiased estimator of* β_2 *that is better than* b_2, which proves the Gauss–Markov theorem.

4.4 **The Probability Distributions of the Least Squares Estimators**

The properties of the least squares estimators that we have developed so far do not depend in any way on the normality assumption SR6. If we additionally make this assumption, that the random errors e_t are normally distributed with mean 0 and variance σ^2, then the probability distributions of the least squares estimators are also normal. This conclusion is obtained in two steps. First, based on assumption SR1, if e_t is normal, then so is y_t. Second, the least squares estimators are linear estimators, of the form $b_2 = \sum w_t y_t$, and weighted sums of normal random variables, using (2.6.4), are normally distributed themselves. Consequently, *if* we make the normality assumption, assumption SR6 about the error term, then the least squares estimators are normally distributed.

$$b_1 \sim N\left(\beta_1, \frac{\sigma^2 \sum x_t^2}{T \sum (x_t - \bar{x})^2} \right)$$

$$b_2 \sim N\left(\beta_2, \frac{\sigma^2}{\sum (x_t - \bar{x})^2} \right) \qquad (4.4.1)$$

As you will see in Chapter 5, the normality of the least squares estimators is of great importance in many aspects of statistical inference. Note that this is another least squares estimator property that we can establish before the data are drawn, based on the model assumptions.

What if the errors are not normally distributed? Can we say anything about the probability distribution of the least squares estimators? The answer is, sometimes, yes.

> If assumptions SR1–SR5 hold, and if the sample size T is **sufficiently large,** then the least squares estimators have a distribution that approximates the normal distributions shown in (4.4.1).

The $64 question is "How large is sufficiently large?" The answer is, there is no specific number. The reason for this vague and unsatisfying answer is that "how large" depends on many factors, such as what the distributions of the random errors look like (are they smooth? symmetric? skewed?) and what the x_t values are like. In the simple regression model, some would say that $T = 30$ is sufficiently large. We, the authors of this book, are somewhat stodgy on this question, and would say that $T = 50$ would be a reasonable number. The bottom line is, however, that these are rules of thumb, and that the meaning of "sufficiently large" will change from problem to problem. Nevertheless, for better or worse, this *large sample*, or *asymptotic*, result is frequently invoked in regression analysis.

4.5 Estimating the Variance of the Error Term

The variance of the random error term, σ^2, is the one unknown parameter of the simple linear regression model that remains to be estimated. The variance of the random variable e_t (see Chapter 2.3.4) is

$$\text{var}(e_t) = \sigma^2 = E[e_t - E(e_t)]^2 = E(e_t^2) \qquad (4.5.1)$$

if the assumption $E(e_t) = 0$ is correct. Since the "expectation" is an average value we might consider estimating σ^2 as the average of the squared errors,

$$\hat{\sigma}^2 = \frac{\sum e_t^2}{T} \qquad (4.5.2)$$

The formula in (4.5.2) is unfortunately of no use, since the random errors e_t are *unobservable*! However, while the random errors themselves are unknown, we do have an analogue to them, namely, the least squares residuals. Recall that the random errors are

$$e_t = y_t - \beta_1 - \beta_2 x_t$$

and the least squares residuals are obtained by replacing the unknown parameters by their least squares estimators,

$$\hat{e}_t = y_t - b_1 - b_2 x_t$$

It seems reasonable to replace the random errors e_t in (4.5.2) by their analogues, the least squares residuals, to obtain

$$\hat{\sigma}^2 = \frac{\sum \hat{e}_t^2}{T} \tag{4.5.3}$$

Unfortunately, the estimator in (4.5.3) is a *biased* estimator of σ^2. Happily, there is a simple modification that produces an unbiased estimator, and that is

$$\hat{\sigma}^2 = \frac{\sum \hat{e}_t^2}{T - 2} \tag{4.5.4}$$

The "2" that is subtracted in the denominator is the number of *regression parameters* (β_1, β_2) in the model, and this subtraction makes the estimator $\hat{\sigma}^2$ unbiased, so that

$$E(\hat{\sigma}^2) = \sigma^2 \tag{4.5.5}$$

Consequently, before the data are obtained, we have an unbiased estimation procedure for the variance of the error term, σ^2, at our disposal.

4.5.1 ESTIMATING THE VARIANCES AND COVARIANCES OF THE LEAST SQUARES ESTIMATORS

Having an unbiased estimator of the error variance, we can *estimate* the variances of the least squares estimators b_1 and b_2, and the covariance between them. Replace the unknown error variance σ^2 in (4.2.10) by its estimator to obtain:

$$\hat{\text{var}}(b_1) = \hat{\sigma}^2 \left[\frac{\sum x_t^2}{T \sum (x_t - \bar{x})^2} \right], \qquad \text{se}(b_1) = \sqrt{\hat{\text{var}}(b_1)}$$

$$\hat{\text{var}}(b_2) = \frac{\hat{\sigma}^2}{\sum (x_t - \bar{x})^2}, \qquad \text{se}(b_2) = \sqrt{\hat{\text{var}}(b_2)}$$

$$\hat{\text{cov}}(b_1, b_2) = \hat{\sigma}^2 \left[\frac{-\bar{x}}{\sum (x_t - \bar{x})^2} \right] \tag{4.5.6}$$

The square roots of the estimated variances, $\text{se}(b_1)$ and $\text{se}(b_2)$, are the *standard errors* of b_1 and b_2.

4.5.2 THE ESTIMATED VARIANCES AND COVARIANCES FOR THE FOOD EXPENDITURE EXAMPLE

Let us apply the results of this section to the food expenditure example. The least squares estimates of the parameters in the food expenditure model are given in Chapter 3.3.2. In order to estimate the variances and covariance of the least squares

estimators, we must first compute the least squares residuals and calculate the estimate of the error variance in (4.6.4). In Table 4.2 are the least squares residuals for the first five households in Table 3.1.

Table 4.2 **Least Squares Residuals for Food Expenditure Data**

y	$\hat{y} = b_1 + b_2 x$	$\hat{e} = y - \hat{y}$
52.25	73.9045	−21.6545
58.32	84.7834	−26.4634
81.79	95.2902	−13.5002
119.90	100.7424	19.1576
125.80	102.7181	23.0819

Using the residuals for all $T = 40$ observations, we estimate the error variance to be

$$\hat{\sigma}^2 = \frac{\sum \hat{e}_t^2}{T - 2} = \frac{54311.3315}{38} = 1429.2456 \qquad \text{(R4.1)}$$

The estimated variances, covariances and corresponding standard errors are

$$\text{vâr}(b_1) = \hat{\sigma}^2 \left[\frac{\sum x_t^2}{T \sum (x_t - \bar{x})^2} \right] = 1429.2456 \left[\frac{21020623}{40(1532463)} \right] = 490.1200$$

$$\text{se}(b_1) = \sqrt{\text{vâr}(b_1)} = \sqrt{490.1200} = 22.1387$$

$$\text{vâr}(b_2) = \frac{\hat{\sigma}^2}{\sum (x_t - \bar{x})^2} = \frac{1429.2456}{1532463} = 0.0009326$$

$$\text{se}(b_2) = \sqrt{\text{vâr}(b_2)} = \sqrt{0.0009326} = 0.0305 \qquad \text{(R4.2)}$$

$$\text{côv}(b_1, b_2) = \hat{\sigma}^2 \left[\frac{-\bar{x}}{\sum (x_t - \bar{x})^2} \right] = 1429.2456 \left[\frac{-698}{1532463} \right] = -0.6510 \quad \text{(R4.3)}$$

In Chapter 5 these estimated variances and covariances are used extensively in the statistical inference procedures of interval estimation and hypothesis testing.

4.5.3 SAMPLE COMPUTER OUTPUT

It is standard for regression output to include the estimated error variance, $\hat{\sigma}^2$, or its square root, $\hat{\sigma}$, and the standard errors of b_1 and b_2. For example, in the

EViews output the column labeled "Std. Error" contains $se(b_1)$ and $se(b_2)$. The entry called "S.E. of regression" is the value of $\hat{\sigma}$. EViews also reports the sum of squared residuals, $\sum \hat{e}_t^2$, as "Sum squared resid." The sample mean $\bar{y} = \sum y_t/T$ is called "Mean dependent var."

Table 4.3 **EViews Regression Output**

```
Dependent Variable: FOODEXP
Method: Least Squares
Sample: 1 40
Included Observations: 40
```

Variable	Coefficient	Std. Error	t-Statistic	Prob.
C	40.76756	22.13865	1.841465	0.0734
INCOME	0.128289	0.030539	4.200777	0.0002

R-squared	0.317118	Mean dependent var	130.3130
Adjusted R-squared	0.299148	S.D. dependent var	45.15857
S.E. of regression	37.80536	Akaike info criterion	10.15149
Sum squared resid	54311.33	Schwarz criterion	10.23593
Log likelihood	-201.0297	F-statistic	17.64653
Durbin-Watson stat	2.370373	Prob(F-statistic)	0.000155

In SAS output the column labeled "Standard Error" contains $se(b_1)$ and $se(b_2)$. The entry called "Root MSE" is the value of $\hat{\sigma}$. The sample mean $\bar{y} = \sum y_t/T$ is called "Dep Mean." In the "Analysis of Variance" table, SAS reports the sum of squared residuals, $\sum \hat{e}_t^2$, in the column labeled "Sum of Squares" and the row labeled "Error." In the row "Error" the column "Mean Square" contains $\hat{\sigma}^2$.

Table 4.4 **SAS Regression Output**

```
Dependent Variable: FOODEXP
```

Analysis of Variance

Source	DF	Sum of Squares	Mean Square	F Value	Prob>F
Model	1	25221.22299	25221.22299	17.647	0.0002
Error	38	54311.33145	1429.24556		
C Total	39	79532.55444			

Root MSE	37.80536	R-square	0.3171	
Dep Mean	130.31300	Adj r-sq	0.2991	
C.V.	29.01120			

Parameter Estimates

Variable	DF	Parameter Estimate	Standard Error	T for H0: Parameter=0	Prob > \|T\|
INTERCEP	1	40.767566	22.13865442	1.841	0.0734
INCOME	1	0.12829	0.03053925	4.201	0.0002

SHAZAM users will see regression output clearly identifying the estimated error variance and coefficient standard errors.

Table 4.5 **SHAZAM Regression Output**

```
VARIANCE OF THE ESTIMATE-SIGMA**2 =   1429.2

VARIABLE         ESTIMATED        STANDARD
  NAME          COEFFICIENT        ERROR
X                  0.12829       0.3054E-01
CONSTANT          40.768           22.14
```

Each of these econometric software packages will print out the estimated coefficient variances and covariances in the form of an array, or matrix. This "coefficient covariance matrix" will appear something like it does in SAS.

Table 4.6 **SAS Estimated Covariance Array**

Covariance of Estimates		
COVB	INTERCEP	X
INTERCEP	490.12001955	-0.650986935
X	-0.650986935	0.000932646

In the covariance matrix the variances are contained on the diagonal, with $\hat{\text{var}}(b_1)$ = 490.1200 and $\hat{\text{var}}(b_2)$ = 0.0009326. The estimated covariances are $\hat{\text{cov}}(b_1, b_2)$ = $\hat{\text{cov}}(b_2, b_1)$ = −0.6510.

4.6 Learning Objectives

Based on the material in this chapter, you should be able to:

1. Explain why the least squares estimators are random variables, and why least squares estimates are not.
2. Explain the meaning of the statement "If regression model assumptions SR1–SR5 hold, then the least squares estimator b_2 is unbiased." In particular, what exactly does "unbiased" mean?
3. Explain why b_2 is biased if an important variable has been omitted from the model.
4. Explain the meaning of the phrase "sampling variability."
5. Explain how the factors, σ^2, $\sum(x_t-\bar{x})^2$, and T, affect the precision with which we can estimate the unknown parameter β_2.
6. Explain how the factors, σ^2, $\sum(x_t-\bar{x})^2$, T, and $\sum x_t^2$ affect the precision with which we can estimate the unknown parameter β_1.
7. Explain how the factors, σ^2, $\sum(x_t-\bar{x})^2$, T, and \bar{x} affect the covariance between b_1 and b_2.
8. Explain the term "linear estimator."
9. State and explain the Gauss-Markov theorem.
10. Explain the steps in the proof of the Gauss-Markov theorem (if it was given to you) and how the regression assumptions SR1–SR5 play their roles.

11. State the probability distributions of the least squares estimators if the errors are assumed to be normal. Explain what you can say if the errors are not normal.

12. Explain how to estimate the error variance σ^2 using the least squares residuals.

13. Explain how to estimate the variances and covariance of b_1 and b_2.

14. Define the term "standard errors."

4.7 Exercises

4.1 Since we usually have only one sample of data, why should we be interested in the sampling properties of an estimator?

4.2 If the random error e_t is distributed normally with mean zero and variance σ^2, i.e., $e_t \sim N(0, \sigma^2)$, how are b_2 and e_t/σ distributed?

4.3 Consider the simple linear regression model, $y_t = \beta_1 + \beta_2 x_t + e_t$, $t = 1, \ldots , T$, and assume that assumptions SR1–SR5 hold.
 (a) Find the expected value of the least squares residual, \hat{e}_t. Show your work.
 (b) If $\bar{y} = \sum y_t/T$, show that $E(\bar{y}) = \beta_1 + \beta_2\bar{x}$, where $\bar{x} = \sum x_t/T$. Clearly state any assumptions you are employing at each step of your answer.
 (c) Show that var$(\bar{y}) = \sigma^2/T$. Clearly state any assumptions you are employing at each step of your answer.
 (d) "If I am running a regression of y on x, it is better to have all the x values bunched up and close together, so that I have a better idea of where the least squares line goes." Is this statement true or false? Explain your answer.

4.4 You have the results of a simple linear regression based on state level data and the District of Columbia, $T = 51$ observations.
 (a) The estimated error variance is 2.04672. What is the sum of the squared least squares residuals?
 (b) The estimated variance of b_2 is 0.00098. What is the standard error of b_2. What is the value of $\sum(x_t - \bar{x})^2$?
 (c) Suppose the dependent variable y_t = the state's mean income (in thousands of \$) of males who are 18 years of age or older, and x_t = the percentage of males 18 years or older who are high school graduates. If $b_2 = .18$, interpret this result.
 (d) Suppose $\bar{x} = 69.139$ and $\bar{y} = 15.187$, what is the estimate of the intercept parameter?
 (e) Given the results in (b) and (d), what is $\sum x_t^2$?
 (f) For the State of Arkansas the value of $y_t = 12.274$ and the value of $x_t = 58.3$. Compute the least squares residual for Arkansas. [Hint: use the information in parts (c) and (d)].

4.5 Indicate whether each of the following statements about the simple regression model is true or false. If false, explain why.
 (a) If the sample means of x and y are zero, then the estimated y-intercept is zero.
 (b) The slope of the simple regression model indicates how the actual value of y changes as x changes.
 (c) The residuals from a least squares regression are all zero.
 (d) The sum of the residuals from a least squares regression is zero.

(e) The method of least squares minimizes the residuals.

(f) If the sample covariance between x and y is zero, then the slope of the least squares regression line is zero.

4.6 Using the data in Exercise 3.2, calculate the following terms *by hand:*

 (a) w_t given in (4.2.2)

 (b) b_2, using (4.2.8)

 (c) $\sum w_t$

 (d) $\sum w_t x_t$

 (e) \hat{e}_t

 (f) $\hat{\sigma}^2$

 (g) $\text{vâr}(b_2)$

4.7 Using the Moscow Makkers data in Table 3.3, Exercise 3.6, and your computer software:

 (a) Find the estimated variances and covariance of the least squares estimators.

 (b) Find $\hat{\sigma}^2$.

4.8 Using the learning curve data in Table 3.4, Exercise 3.8, which is in the file *learn.dat*, and your computer software:

 (a) Find the estimated variances and covariance of the least squares estimators

 (b) Find $\hat{\sigma}^2$.

4.9 Using the CAPM data discussed in Exercise 3.9, and located in the file *capm.dat*:

 (a) Find the estimated variances and covariance of the least squares estimators.

 (b) Find $\hat{\sigma}^2$.

4.10 Suppose that x_t is a constant c for all sample observations.

 (a) Compute the denominator of the formula for the least squares estimate of b_2 in equation (4.2.6).

 (b) Compare your answer here to your answer in Exercise 3.10.

 (c) Explain, intuitively, why least squares estimation fails in this case. [Hint: See the discussion following (4.2.10).]

4.11 Consider Exercise 3.5 and the data in Table 3.2. Use your computer software to:

 (a) Compute the least squares residuals \hat{e}_t.

 (b) Compute $\hat{\sigma}^2$.

 (c) Compute $\text{vâr}(b_2)$.

4.12 The gross income and tax paid by a cross-section of 30 companies in 1988 and 1989 is given in the file *tax.dat*.

 (a) Use these data to estimate the relationship

$$tax_t = \beta_1 + \beta_2 income_t + e_t$$

 for each of the years 1988 and 1989.

 (b) Give interpretations of the two estimates of β_2.

 (c) Find the average income for each year and predict the tax paid for each average income. Compare the average and marginal tax rates.

 (d)* Consider the estimate for β_2 for 1989 and the corresponding estimated variance. Pretend that the estimated variance is the same as the true vari-

ance var(b_2), and assume that b_2 is normally distributed. Find the probability that the sampling error $|b_2 - \beta_2|$ is (*i*) less than .04, and (*ii*) less than .01.

(e) Pool the observations from the two years of data and use the resulting 40 observations to estimate one tax–income relationship. Compare the estimates for β_1 and β_2, and the estimated variances with those from the separate equations. What implicit assumptions are you making when you pool the two sets of observations?

4.13* Show that the least squares estimator b_1 is the best linear unbiased estimator of β_1.

4.14* Professor E. Z. Stuff has decided that the least squares estimator is too much trouble. Noting that two points determine a line, Dr. Stuff chooses two points from a sample of size T and draws a line between them. The slope of this line he calls the EZ-estimator of β_2 in the simple regression model. Algebraically, if the two points are (y_1, x_1) and (y_2, x_2), the EZ-estimation rule is:

$$b_{EZ} = \frac{y_2 - y_1}{x_2 - x_1}$$

Assuming that all the assumptions of the simple regression model hold:
(a) Show that b_{EZ} is a "linear" estimator.
(b) Show that b_{EZ} is an unbiased estimator.
(c) Find the variance of b_{EZ}.
(d) Find the probability distribution of b_{EZ}.
(e) Convince Professor E. Z. Stuff that his estimator is not as good as the least squares estimator.

4.15* Suppose that you wish to estimate the slope of the regression model $y_t = \beta_1 + \beta_2 x_t + e_t$. The problem you have is threefold, however, because (1) you are stranded on a desert island and have no computer or calculator and (2) you have only 3 observations and (3) you do not remember the formulas for the least squares estimators and you do not have your formula sheet. So, in a burst of creativity you decide to do the following. Recalling that two points determine a line, you form an average of observations 2 and 3 as follows:

$$y^* = \frac{y_2 + y_3}{2}, \quad x^* = \frac{x_2 + x_3}{2}$$

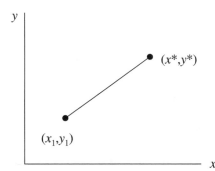

The slope of the line connecting the points is $b^* = (y^* - y_1)/(x^* - x_1)$. Suppose you decide to use this formula to estimate β_2.

(a) Show that the estimator of β_2 you have created is a "linear" estimator.

(b) Show that the estimator of β_2 you have created is "unbiased."

(c) Find the variance of the estimator of β_2 you have created.

(d) You have done well, you think, and created an estimator of β_2 that is just as good as the least squares estimator, right? Yes, no, or maybe, and explain.

4.16* Professor I. B. Smart considered the linear regression model $y_t = \beta_1 + \beta_2 x_t + e_t$. He wished to estimate the slope parameter β_2, but he was stranded on a desert island and did not have his computer and he didn't remember the least squares formula. So, he took the T observations and divided them into two groups, based on the magnitude of x_t, consisting of T_1 and T_2 observations each ($T = T_1 + T_2$). He calculated the means of the x and y values in each of the two groups:

$$\bar{x}_1 = \frac{\sum_{t=1}^{T_1} x_t}{T_1}, \quad \bar{x}_2 = \frac{\sum_{t=1}^{T_2} x_t}{T_2}, \quad \bar{y}_1 = \frac{\sum_{t=1}^{T_1} y_t}{T_1}, \quad \bar{y}_2 = \frac{\sum_{t=1}^{T_2} y_t}{T_2}$$

Then he plotted the points (\bar{x}_1, \bar{y}_1) and (\bar{x}_2, \bar{y}_2) on a graph:

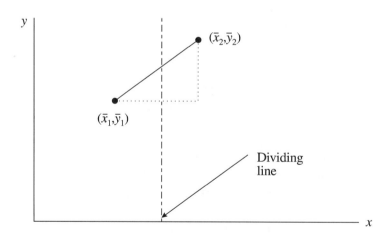

As an estimate of β_2 he used the slope of the line connecting the two means.

$$b_{\text{smart}} = \frac{\bar{y}_2 - \bar{y}_1}{\bar{x}_2 - \bar{x}_1}.$$

Assume that the assumptions of the linear regression model hold.

(a) What is a linear estimator? Show that Dr. Smart's estimator is a linear estimator of β_2.

(b) What is an unbiased estimator? Show that Dr. Smart's estimator is an unbiased estimator of β_2. (Hint: Substitute $y_t = \beta_1 + \beta_2 x_t + e_t$ into the formula and then work on that.)

(c) What is the variance of Dr. Smart's estimator of β_2? (Hint: Do not use the "definition of variance" you learned in Chapter 2. Using the expression you found in (b) after you substituted in for y_t, use the properties of variance and remember that x_t is not random.)

(d) If you had the choice of using Dr. Smart's estimator of β_2 or the least squares estimator of β_2, which would you choose and why? (Ignore computational ease as a reason.) You just need to explain your reason here. Do not prove anything.

(e) What is the difference between an *estimate* and an *estimator*?

4.17 You are given the following information about the data for a simple regression model:

$$\sum (x_t - \bar{x})(y_t - \bar{y}) = 655 \quad \sum (x_t - \bar{x})^2 = 1305 \quad \sum (y_t - \bar{y})^2 =?$$
$$\sum x_t = 475 \quad \sum y_t = 405 \quad T = 8$$

(a) What is the least squares estimate of the slope of the simple regression model? Interpret this estimate.

(b) What is the least squares estimate of the intercept? Interpret this estimate.

(c) Demonstrate, numerically, using the data for this problem, that the fitted regression line passes through the point of the mean (\bar{x}, \bar{y}).

4.18 Suppose you are estimating a simple linear regression model. If you multiply all the x_t values by 10, but not the y_t values, what happens to the parameter values β_1 and β_2? What happens to the least squares estimates b_1 and b_2? What happens to the variance of the error term?

4.19 Suppose you are estimating a simple linear regression model. If you multiply all the y_t values by 10, but not the x_t values, what happens to the parameter values β_1 and β_2? What happens to the least squares estimates b_1 and b_2? What happens to the variance of the error term?

Chapter *5*

Inference in the Simple Regression Model: Interval Estimation, Hypothesis Testing, and Prediction

In Chapter 4 we developed the properties of the least squares estimators under the following set of assumptions:

ASSUMPTIONS OF THE SIMPLE LINEAR REGRESSION MODEL

SR1. $y_t = \beta_1 + \beta_2 x_t + e_t$

SR2. $E(e_t) = 0 \Leftrightarrow E(y_t) = \beta_1 + \beta_2 x_t$

SR3. $\text{var}(e_t) = \sigma^2 = \text{var}(y_t)$

SR4. $\text{cov}(e_i, e_j) = \text{cov}(y_i, y_j) = 0$

SR5. x_t is not random, and must take at least two different values.

SR6. $e_t \sim N(0, \sigma^2) \Leftrightarrow y_t \sim N[(\beta_1 + \beta_2 x_t), \sigma^2]$ (*optional*)

If all these assumptions, including assumption SR6 of normality, are correct, then the least squares estimators b_1 and b_2 are normally distributed random variables and have, from Chapter 4.4, normal distributions with means and variances as follows:

$$b_1 \sim N\left(\beta_1, \frac{\sigma^2 \sum x_t^2}{T \sum (x_t - \bar{x})^2}\right)$$

$$b_2 \sim N\left(\beta_2, \frac{\sigma^2}{\sum (x_t - \bar{x})^2}\right)$$

From Chapter 4.5 we know that the unbiased estimator of the error variance is

$$\hat{\sigma}^2 = \frac{\sum \hat{e}_t^2}{T - 2}$$

By replacing the unknown parameter σ^2 with this estimator we can estimate the variances of the least squares estimators and their covariance.

In Chapter 4 you learned how to calculate *point* estimates of the regression parameters β_1 and β_2 using the best, linear unbiased estimation procedure. The estimates represent an *inference* about the regression function $E(y) = \beta_1 + \beta_2 x$ of the population from which the sample of data was drawn.

In this chapter we introduce the additional tools of statistical inference: **interval estimation, prediction, interval prediction**, and **hypothesis testing**. A prediction is a forecast of a future value of the dependent variable y, for any value of x. Interval estimation and prediction are procedures for creating ranges of values, sometimes called **confidence intervals**, in which the unknown parameters, or the value of y, are likely to be located. Hypothesis testing procedures are a means of comparing conjectures that we as economists might have about the regression parameters to the information about the parameters contained in a sample of data. Hypothesis tests allow us to say that the data are compatible, or are not compatible, with a particular conjecture, or hypothesis.

The procedures for interval estimation, prediction, and hypothesis testing, depend heavily on assumption SR6 of the simple linear regression model, and the resulting normality of the least squares estimators. If assumption SR6 is not made, then the sample size must be sufficiently large so that the least squares estimator's distributions are *approximately* normal, in which case the procedures we develop in this chapter are also approximate. In developing the procedures in this chapter we will be using the normal distribution, and distributions related to the normal, namely "Student's" t-distribution and the chi-square distribution.

5.1 Interval Estimation

In the following section we develop key results for the chi-square and t-distributions. You can skip to Chapter 5.1.2 on the first reading.

5.1.1 THE THEORY

A standard normal random variable that we will use to construct an interval estimator is based on the normal distribution of the least squares estimator. Consider, for example, the normal distribution of b_2 the least squares estimator of β_2, which we denote as

$$b_2 \sim N\left(\beta_2, \frac{\sigma^2}{\sum (x_t - \bar{x})^2}\right)$$

A standardized normal random variable is obtained from b_2 by subtracting its mean and dividing by its standard deviation:

$$Z = \frac{b_2 - \beta_2}{\sqrt{\operatorname{var}(b_2)}} \sim N(0, 1) \tag{5.1.1}$$

That is, the standardized random variable Z is normally distributed with mean 0 and variance 1.

5.1.1a The Chi-Square Distribution

Chi-square random variables arise when standard normal, $N(0,1)$, random variables are squared.

If Z_1, Z_2, \ldots, Z_m denote m *independent* $N(0,1)$ random variables, then

$$V = Z_1^2 + Z_2^2 + \cdots + Z_m^2 \sim \chi_{(m)}^2 \qquad (5.1.2)$$

The notation $V \sim \chi_{(m)}^2$ is read as: the random variable V has a **chi-square distribution** with m *degrees of freedom*. The **degrees of freedom** parameter m indicates the number of *independent* $N(0,1)$ random variables that are squared and summed to form V. The value of m determines the entire shape of the chi-square distribution, and its mean and variance.

$$E[V] = E[\chi_{(m)}^2] = m$$
$$\text{var}[V] = \text{var}[\chi_{(m)}^2] = 2m \qquad (5.1.3)$$

In Figure 5.1, graphs of the chi-square distribution for various degrees of freedom, m, are presented. Since V is formed by squaring and summing m standardized normal $[N(0,1)]$ random variables, the values of V must be nonnegative, $v \geq 0$, and the distribution has a long tail, or is *skewed*, to the right. As the degrees of freedom m gets larger, however, the distribution becomes more symmetric and "bell-shaped." In fact, as m gets large, the chi-square distribution converges to, and essentially becomes, a normal distribution.

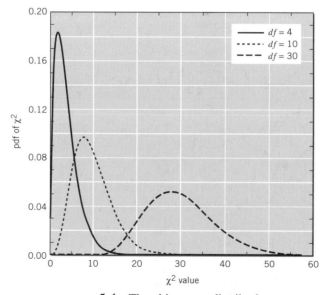

FIGURE *5.1* The chi-square distribution.

Computer programs have functions that calculate probabilities involving chi-square random variables, and their use will be discussed when needed.

5.1.1b The Probability Distribution of $\hat{\sigma}^2$

If assumption SR6 holds, then the random error term e_t has a normal distribution, $e_t \sim N(0, \sigma^2)$. We can standardize this random variable by dividing by its standard deviation so that $e_t/\sigma \sim N(0, 1)$. The square of a standard normal random variable is a chi-square random variable with one degree of freedom, so $(e_t/\sigma)^2 \sim \chi^2_{(1)}$. If all the random errors are independent then

$$\sum \left(\frac{e_t}{\sigma} \right)^2 = \left(\frac{e_1}{\sigma} \right)^2 + \left(\frac{e_2}{\sigma} \right)^2 + \cdots + \left(\frac{e_T}{\sigma} \right)^2 \sim \chi^2_{(T)} \qquad (5.1.4)$$

Since the true random errors are unobservable we replace them by their sample counterparts, the least squares residuals $\hat{e}_t = y_t - b_1 - b_2 x_t$ to obtain

$$V = \frac{\sum \hat{e}_t^2}{\sigma^2} = \frac{(T-2)\hat{\sigma}^2}{\sigma^2} \qquad (5.1.5)$$

The random variable V in (5.1.5) does not have a $\chi^2_{(T)}$ distribution because the least squares residuals are *not* independent random variables. All T residuals $\hat{e}_t = y_t - b_1 - b_2 x_t$ depend on the least squares estimators b_1 and b_2. It can be shown that only $T - 2$ of the least squares residuals are independent in the simple linear regression model. Consequently, the random variable in (5.1.5) has a chi-square distribution with $T - 2$ degrees of freedom. That is, when multiplied by the constant $(T-2)/\sigma^2$ the random variable $\hat{\sigma}^2$ has a *chi-square distribution with $T - 2$ degrees of freedom,*

$$V = \frac{(T-2)\hat{\sigma}^2}{\sigma^2} \sim \chi^2_{(T-2)} \qquad (5.1.6)$$

The chi-square random variable V is statistically independent of the least squares estimators b_1 and b_2. Consequently, V and the standard normal random variable Z in (5.1.1) are independent. Take our word on this. Now we define a *t*-random variable.

5.1.1c The *t*-Distribution

A "*t*" random variable (no uppercase) is formed by dividing a standard normal, $Z \sim N(0, 1)$, random variable by the square root of an *independent* chi-square random variable, $V \sim \chi^2_{(m)}$, that has been divided by its degrees of freedom, m.

If $Z \sim N(0, 1)$ and $V \sim \chi^2_{(m)}$, and if Z and V are independent, then

$$t = \frac{Z}{\sqrt{V/m}} \sim t_{(m)} \qquad (5.1.7)$$

The shape of the *t*-distribution is completely determined by the degrees of freedom parameter, m, and the distribution is symbolized by $t_{(m)}$.

Figure 5.2 shows a graph of the t-distribution with $m = 3$ degrees of freedom, relative to the $N(0,1)$. Note that the t-distribution is less "peaked," and more spread out than the $N(0,1)$. The t-distribution is symmetric, with mean $E[t_{(m)}] = 0$ and variance $\text{var}[t_{(m)}] = m/(m-2)$. As the degrees of freedom parameter $m \to \infty$, the $t_{(m)}$ distribution approaches the standard normal $N(0,1)$.

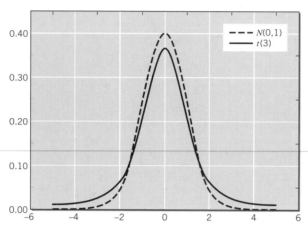

FIGURE 5.2 The standard normal and $t_{(3)}$ probability density functions.

Computer programs have functions that calculate probabilities involving t random variables, and we will introduce their use when needed. Since certain probabilities are widely used, Table 2 inside the front cover of this book contains percentiles of t-distributions.

5.1.1d A Key Result

Using the facts about t-random variables, we can obtain a very important result. From the two random variables V and Z we can form a t-random variable. Recall that a t-random variable is formed by dividing a standard normal random variable, $Z \sim N(0,1)$, by the square root of an *independent* chi-square random variable, $V \sim \chi^2_{(m)}$, that has been divided by its degrees of freedom, m. That is, from (5.1.7),

$$t = \frac{Z}{\sqrt{V/m}} \sim t_{(m)}$$

The t-distribution's shape is completely determined by the degrees of freedom parameter, m, and the distribution is symbolized by $t_{(m)}$. Using Z and V from (5.1.1) and (5.1.5), respectively, we have

$$t = \frac{Z}{\sqrt{V/(T-2)}} = \frac{\dfrac{b_2 - \beta_2}{\sqrt{\dfrac{\sigma^2}{\sum(x_t - \bar{x})^2}}}}{\sqrt{\dfrac{(T-2)\hat{\sigma}^2}{\sigma^2} \Big/ T - 2}} = \frac{b_2 - \beta_2}{\sqrt{\dfrac{\hat{\sigma}^2}{\sum(x_t - \bar{x})^2}}}$$

$$= \frac{b_2 - \beta_2}{\sqrt{\text{vâr}(b_2)}} = \frac{b_2 - \beta_2}{\text{se}(b_2)} \sim t_{(T-2)} \tag{5.1.8}$$

5.1.2 Obtaining Interval Estimates

If assumptions SR1–SR6 of the simple linear regression model hold, then

$$t = \frac{b_k - \beta_k}{se(b_k)} \sim t_{(T-2)}, \quad k = 1, 2 \tag{5.1.9}$$

The random variable t has a t-distribution with $(T - 2)$ degrees of freedom, which we denote by writing $t \sim t_{(T-2)}$. The random variable t in (5.1.9) will be the basis for interval estimation and hypothesis testing in the simple linear regression model. Equation 5.1.9, for $k = 2$, is

$$t = \frac{b_2 - \beta_2}{se(b_2)} \sim t_{(T-2)} \tag{5.1.10}$$

where

$$\hat{var}(b_2) = \frac{\hat{\sigma}^2}{\sum (x_t - \bar{x})^2} \quad \text{and} \quad se(b_2) = \sqrt{\hat{var}(b_2)}$$

Using Table 2 inside the front cover of the book we can find critical values t_c from a $t_{(m)}$ distribution such that

$$P(t \geq t_c) = P(t \leq t_c) = \frac{\alpha}{2}$$

where α is a probability value often taken to be $\alpha = .01$ or $\alpha = .05$. The values t_c and $-t_c$ are depicted in Figure 5.3.

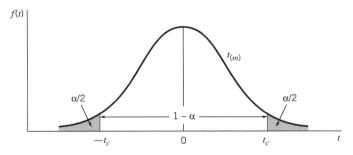

FIGURE **5.3** Critical values from a t-distribution.

Each of the shaded "tail" areas contains $\alpha/2$ of the probability, so that $1 - \alpha$ of the probability is contained in the center portion. Consequently, we can make the probability statement

$$P(-t_c \leq t \leq t_c) = 1 - \alpha \tag{5.1.11}$$

Now, we put all these pieces together to create a procedure for interval estimation.

Substitute t from (5.1.10) into (5.1.11) to obtain

$$P\left[-t_c \leq \frac{b_2 - \beta_2}{\text{se}(b_2)} \leq t_c\right] = 1 - \alpha \qquad (5.1.12)$$

Simplify this expression to obtain

$$P[b_2 - t_c \text{ se}(b_2) \leq \beta_2 \leq b_2 + t_c \text{ se}(b_2)] = 1 - \alpha \qquad (5.1.13)$$

In the interval endpoints, $b_2 - t_c \text{ se}(b_2)$ and $b_2 + t_c \text{ se}(b_2)$, both b_2 and $\text{se}(b_2)$ are random variables, since their values are not known until a sample of data is drawn. The random endpoints of the interval define an *interval estimator* of β_2. The probability statement in (5.1.13) says that the inverval $b_2 \pm t_c \text{ se}(b_2)$, with random endpoints, has probability $1 - \alpha$ of containing the true but unknown parameter β_2. This interval estimation procedure and its properties are established based on model assumptions SR1–SR6 and may be applied to any sample of data that we might obtain. When b_2 and $\text{se}(b_2)$ in (5.1.13) are *estimated values* (numbers), based on a sample of data, then $b_2 \pm t_c \text{ se}(b_2)$ is called a $(1 - \alpha) \times (100\%)$ *interval estimate* of β_2, or, equivalently, it is called a $(1 - \alpha) \times (100\%)$ *confidence interval*.

The interpretation of interval *estimators* and interval *estimates* requires a great deal of care. The properties of the *random interval estimator* are based on the notion of repeated sampling. If we were to select *many* random samples of size T, compute the least squares estimate b_2 and its standard error $\text{se}(b_2)$ *for each sample*, and then construct the interval estimate $b_2 \pm t_c \text{ se}(b_2)$ for each sample, then $(1 - \alpha) \times (100\%)$ of all the intervals constructed *would contain the true parameter* β_2. This we know before any data are actually collected.

Any *one* interval estimate, based on one sample of data, may or may not contain the true parameter β_2, and since β_2 is unknown, we will *never* know if it does or not. When confidence intervals are discussed, remember that our confidence is in the *procedure used to construct the interval estimate;* it is not in any one interval estimate calculated from a sample of data.

5.1.3 THE REPEATED SAMPLING CONTEXT

In Chapter 4.2.1a we illustrated the sampling properties of the least squares estimators by collecting 10 additional samples of size $T = 40$ from the same population that gave us the food expenditure data. In Table 4.1 we display the least squares estimates for these additional samples. In Table 5.1 we repeat these values, and we also report the estimates of σ^2 and the estimated standard errors from each sample. Note the sampling variation illustrated by these estimates.

Using the ten samples of data and the results in Table 5.1 the 95 percent confidence interval estimates for the parameters β_1 and β_2 are given in Table 5.2. Sampling variability causes the center of each of the interval estimates to change with the location of the least squares estimates, and it causes the widths of the intervals to change with the standard errors. If we ask the question, "How many of these intervals contain the true parameters, and which ones are they?" we must answer that we do not know, and we will never know. But since 95 percent of all interval estimates constructed this way contain the true parameter values, we would expect perhaps nine or ten of these intervals to contain the true but unknown parameters.

Table 5.1 **Least Squares Estimates from Ten Random Samples**

n	b_1	se(b_1)	b_2	se(b_2)	$\hat{\sigma}^2$
1	51.1314	27.4260	0.1442	0.0378	2193.4597
2	61.2045	24.9177	0.1286	0.0344	1810.5972
3	40.7882	17.6670	0.1417	0.0244	910.1835
4	80.1396	23.8146	0.0886	0.0329	1653.8324
5	31.0110	22.8126	0.1669	0.0315	1517.5837
6	54.3099	26.9317	0.1086	0.0372	2115.1085
7	69.6749	19.2903	0.1003	0.0266	1085.1312
8	71.1541	26.1807	0.1009	0.0361	1998.7880
9	18.8290	22.4234	0.1758	0.0309	1466.2541
10	36.1433	23.5531	0.1626	0.0325	1617.7087

Table 5.2 **Interval Estimates from Ten Random Samples**

n	$b_1 - t_c$se(b_1)	$b_1 + t_c$se(b_1)	$b_2 - t_c$se(b_2)	$b_2 + t_c$se(b_2)
1	−4.3897	106.6524	0.0676	0.2207
2	10.7612	111.6479	0.0590	0.1982
3	5.0233	76.5531	0.0923	0.1910
4	31.9294	128.3498	0.0221	0.1551
5	−15.1706	77.1926	0.1032	0.2306
6	−0.2105	108.8303	0.0334	0.1838
7	30.6237	108.7261	0.0464	0.1542
8	18.1541	124.1542	0.0278	0.1741
9	−26.5649	64.2229	0.1131	0.2384
10	−11.5374	83.8340	0.0968	0.2284

Note the difference between *point* estimation and *interval* estimation. We have used the least squares estimators to obtain, from a sample of data, point estimates that are "best guesses" of unknown parameters. The estimated variance vâr(b_k), for $k = 1$ or 2, and its square root $\sqrt{\text{vâr}(b_k)} = \text{se}(b_k)$, provide information about the *sampling variability* of the least squares estimator from one sample to another. Interval estimators combine point estimation with estimation of sampling variability to provide a range of values in which the unknown parameters might fall. Interval estimates are a convenient way to inform others about the estimated *location* of the unknown parameter and also provide information about the sampling variability of the least squares estimator, through se(b_k), and the "level of confidence" $1 - \alpha$. When the sampling variability of the least squares estimator is relatively small, then the interval estimates will be relatively narrow, implying that the least squares estimates are "reliable." On the other hand, if the least squares estimators suffer from large sampling variability, then the interval estimates will be wide, implying that the least squares estimates are "unreliable."

5.1.4 AN ILLUSTRATION

For the food expenditure data in Table 3.1, where $T = 40$ and the degrees of freedom are $T - 2 = 38$, if we let $\alpha = .05$, (5.1.13) becomes

$$P[b_2 - 2.024\mathrm{se}(b_2) \le \beta_2 \le b_2 + 2.024\mathrm{se}(b_2)] = .95 \qquad (5.1.14)$$

The critical value $t_c = 2.024$, which is appropriate for $\alpha = .05$ and 38 degrees of freedom, can be found in the t table at the front of the book. Alternatively, it can be computed exactly, as we have done, using an econometric software package.

To construct an interval estimate for β_2 we use the least squares estimate $b_2 = .1283$, which has the **standard error**

$$\mathrm{se}(b_2) = \sqrt{\hat{\mathrm{var}}(b_2)} = \sqrt{0.0009326} = 0.0305 \qquad (\mathrm{R5.1})$$

Substituting these values into (5.1.14) we obtain a "95 percent confidence interval estimate" for β_2:

$$b_2 \pm t_c\mathrm{se}(b_2) = .1283 \pm 2.024(.0305) = [.0666, .1900] \qquad (\mathrm{R5.2})$$

Is β_2 in the interval $[.0666, .1900]$? We do not know, and we will never know. What we *do* know is that when the procedure we used is applied to many random samples of data from the same population, then 95 percent of all the interval estimates constructed using this procedure will contain the true parameter. The interval estimation procedure "works" 95 percent of the time. All we can say about the interval estimate based on our one sample is that, given the reliability of the procedure, we would be "surprised" if β_2 was not in the interval $[.0666, .1900]$. Since this interval estimate contains no random quantities we *cannot* make probabilistic statements about it such as "There is a .95 probability that β_2 is in the interval $[.0666, .1900]$."

What is the usefulness of an interval estimate of β_2? When reporting regression results we always give a point estimate, such as $b_2 = .1283$. However, the point estimate alone gives no sense of its reliability. Interval estimates incorporate both the point estimate and the standard error of the estimate, which is a measure of the variability of the least squares estimator. If an interval estimate is wide (implying a large standard error), there is not much information in the sample about β_2. A narrow interval estimate suggests we have learned more about β_2.

What is "wide" and what is "narrow" depends on the problem at hand. For example, in our model $b_2 = .1283$ is an estimate of how much weekly food expenditure will rise given a \$1 increase in weekly income. A prudent supermarket CEO will consider values of β_2 around .1283 to allow for estimation error. The question is, which values? One answer is provided by the interval estimate $[.0666, .1900]$. While β_2 may or may not be in this interval, the CEO knows that the procedure used to obtain the interval estimate "works" 95% of the time. If varying β_2 within the interval has drastic outcome consequences, then the CEO may conclude that she has insufficient evidence upon which to make a decision, and order a new and larger sample of data.

5.2 Hypothesis Testing

Interval estimation, or the construction of confidence intervals, is a major technique for making statistical inferences from the data. Another tool of statistical inference is hypothesis testing. Many economic decision problems require some basis for

deciding whether or not a parameter is a specified value, or whether it is positive or negative. In the food expenditure example, it makes a good deal of difference for decision purposes whether or not $\beta_2 = 0$. If $\beta_2 = 0$, then income has no effect on the level of household expenditure on food, and there would be no need for supermarket managers to worry about income changes in the planning of new supermarkets.

Hypothesis testing procedures compare a conjecture we have about a population to the information contained in a sample of data. More specifically, the conjectures we test concern the unknown parameters of the economic model. Given an econometric model, **hypotheses** are formed about economic behavior. These hypotheses are then represented as conjectures about model parameters.

Hypothesis testing uses the information about a parameter that is contained in a sample of data, namely, its least squares point estimate and its standard error, to draw a conclusion about the conjecture, or hypothesis.

In each and every hypothesis test four ingredients must be present:

COMPONENTS OF HYPOTHESIS TESTS

1. A *null* hypothesis, H_0
2. An *alternative* hypothesis, H_1
3. A test *statistic*
4. A *rejection* region

We will discuss these components in terms of the food expenditure model, but our comments apply to other models and tests as well.

5.2.1 THE NULL HYPOTHESIS

The *null hypothesis,* which is denoted H_0 (*H-naught*), specifies a value for a parameter. The null hypothesis is stated $H_0 : \beta_2 = c$, where c is a constant, and is an important value in the context of a specific regression model. A null hypothesis is the belief we will maintain until we are convinced by the sample evidence that it is not true, in which case we *reject* the null hypothesis.

5.2.2 THE ALTERNATIVE HYPOTHESIS

Paired with every null hypothesis is a logical alternative hypothesis, H_1, that we will accept if the null hypothesis is rejected. The alternative hypothesis is flexible and depends to some extent on economic theory. For the null hypothesis $H_0 : \beta_2 = c$ three possible alternative hypotheses are:

- $H_1 : \beta_2 \neq c$. Rejecting the null hypothesis that $\beta_2 = c$ implies the conclusion that β_2 takes some other value greater than or less than c.
- $H_1 : \beta_2 > c$. Rejecting the null hypothesis that β_2 is c leads to the conclusion that it is greater than c. Using this alternative *completely* discounts the possibility that $\beta_2 < c$. It implies that these values are logically unacceptable alternatives to the null hypothesis. Inequality alternative hypotheses are widely used in economics, since economic theory frequently provides information about the

signs of relationships between variables. For example, in the food expenditure example we might well use the alternative $H_1 : \beta_2 > 0$, since economic theory strongly suggests that necessities like food are normal goods, and that food expenditure will rise if income increases.

- $H_1 : \beta_2 < c$. Following the previous discussion, use this alternative when there is no chance that $\beta_2 > c$.

5.2.3 THE TEST STATISTIC

The sample information about the null hypothesis is embodied in the sample value of a **test statistic.** Based on the value of a test statistic, which itself is a random variable, we decide either to reject the null hypothesis or not to reject it. A test statistic has a very special characteristic: its probability distribution must be *completely known when the null hypothesis is true*, and it must have some *other* distribution if the null hypothesis is not true.

As an example, consider in the food expenditure example the null hypothesis $H_0 : \beta_2 = c$ and the alternative $H_1 : \beta_2 \neq c$.

In (5.1.10) we established, under assumptions SR1–SR6 of the simple linear regression model, that

$$t = \frac{b_2 - \beta_2}{\text{se}(b_2)} \sim t_{(T-2)} \tag{5.2.1}$$

If the null hypothesis $H_0 : \beta_2 = c$ is *true*, then, by substitution, it must be true that

$$t = \frac{b_2 - c}{\text{se}(b_2)} \sim t_{(T-2)} \tag{5.2.2}$$

If the null hypothesis is *not true*, then the *t*-statistic in (5.2.2) does *not* have a *t*-distribution with $T-2$ degrees of freedom. You may skip the following explanation on the first reading.

To examine the distribution of the *t*-statistic in (5.2.2) when the null hypothesis is not true, suppose that the true $\beta_2 = 1$. Following the steps in (5.1.8), we would find that

$$t = \frac{b_2 - 1}{\text{se}(b_2)} \sim t_{(T-2)}$$

If $\beta_2 = 1$, and $c \neq 1$, then the test statistic in (5.2.2) does not have a *t*-distribution, since, in its formation, the numerator of (5.1.8) is *not* standard normal. It is not standard normal because the incorrect value $\beta_2 = c$ is subtracted from b_2.

If $\beta_2 = 1$ and we *incorrectly* hypothesize that $\beta_2 = c$, then the numerator of (5.1.8) that is used in forming (5.2.2) has the distribution

$$\frac{b_2 - c}{\sqrt{\text{var}(b_2)}} \sim N\left[\frac{1 - c}{\sqrt{\text{var}(b_2)}}, 1\right]$$

where

$$\text{var}(b_2) = \frac{\sigma^2}{\sum(x_t - \bar{x})^2}.$$

Since its mean is not zero, this distribution is *not* standard normal, as required in the formation of a t random variable.

5.2.4 THE REJECTION REGION

The **rejection region** is the range of values of the test statistic that leads to *rejection* of the null hypothesis. It is possible to construct a rejection region only if we have a test statistic whose distribution is known when the null hypothesis is true. In practice, the rejection region is a set of test statistic values that, *when the null hypothesis is true*, are unlikely and have *low probability* of occurring. If a sample value of the test statistic is obtained that falls in a region of low probability, then it is unlikely that the test statistic has the assumed distribution, and thus it is unlikely that the null hypothesis is true.

To illustrate let us continue to use the food expenditure example. *If* the null hypothesis $H_0 : \beta_2 = c$ is *true*, then the test statistic $t = (b_2 - c)/\text{se}(b_2) \sim t_{(T-2)}$. Thus, if the hypothesis is true, then the distribution of t is that shown in Figure 5.3. If the alternative hypothesis $H_1 : \beta_2 \neq c$ is true, then values of the test statistic t will tend to be unusually "large" or unusually "small." The terms *large* and *small* are determined by choosing a probability α, called *level of significance of the test*, which provides a meaning for "an unlikely event." The level of significance of the test α is frequently chosen to be .01, .05, or .10. The rejection region is determined by finding critical values t_c such that $P(t \geq t_c) = P(t \leq -t_c) = \alpha/2$. Thus, the rejection region consists of the two "tails" of the t-distribution.

When the null hypothesis is true, the probability of obtaining a sample value of the test statistic that falls in *either* tail area is "small," and, combined, is equal to α. Sample values of the test statistic that are in the tail areas are *incompatible with the null hypothesis* and are evidence against the null hypothesis being true. When testing the null hypothesis $H_0 : \beta_2 = c$ against the alternative $H_1 : \beta_2 \neq c$ we are led to the following rule:

> **REJECTION RULE FOR A TWO-TAILED TEST:** If the value of the test statistic falls in the rejection region, either tail of the t-distribution, then we reject the null hypothesis and accept the alternative.

On the other hand, if the null hypothesis $H_0 : \beta_2 = c$ is true, then the probability of obtaining a value of the test statistic t in the central *nonrejection* region, $P(-t_c \leq t \leq t_c) = 1 - \alpha$, is high. Sample values of the test statistic in the central nonrejection area are *compatible with the null hypothesis* and are not taken as evidence against the null hypothesis being true. Care must be taken here in interpreting the outcome of a statistical test, however, because one of the basic precepts of hypothesis testing is that finding a sample value of the test statistic in the nonrejection region *does not make the null hypothesis true!* Intuitively, if the true value of β_2 is near c, but not equal to it, then the value of the test statistic will still fall in the nonrejection region with high probability. In this case we would not reject the null hypothesis even though it is false. Consequently, when testing the null hypothesis $H_0 : \beta_2 = c$ against the alternative $H_1 : \beta_2 \neq c$ the rule is:

> If the value of the test statistic falls between the critical values $-t_c$ and t_c, in the nonrejection region, then we *do not reject* the null hypothesis.

Avoid saying that "we accept the null hypothesis." This statement implies that we are concluding that the null hypothesis is true, which is not the case at all, based on the preceding discussion. The weaker statements, "We do not reject the null hypothesis," or "We fail to reject the null hypothesis," do not send any misleading message.

The test decision rules are summarized in Figure 5.4.

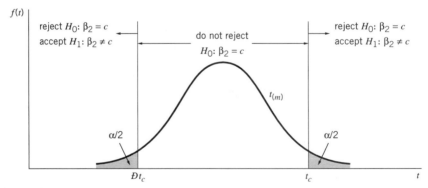

FIGURE **5.4** Rejection region for a test of $H_0 : \beta_2 = c$ against $H_1 : \beta_2 \neq c$.

5.2.5 THE FOOD EXPENDITURE EXAMPLE

Let us illustrate the hypothesis testing procedure by testing the null hypothesis that $\beta_2 = .10$ against the alternative that $\beta_2 \neq .10$, in the food expenditure model. That is, if income rises by \$100, do we expect food expenditures to rise by \$10, or not? We will carry through the test using, as you should, a standard testing format that summarizes the four test ingredients and the test outcome.

> **FORMAT FOR TESTING HYPOTHESES**
>
> 1. Determine the null and alternative hypotheses.
> 2. Specify the test statistic and its distribution if the null hypothesis is true.
> 3. Select α and determine the rejection region.
> 4. Calculate the sample value of the test statistic.
> 5. State your conclusion.

Apply these steps to our problem.

1. The null hypothesis is $H_0 : \beta_2 = .10$. The alternative hypothesis is $H_1 : \beta_2 \neq .10$.

2. Using (5.2.2), the test statistic $t = (b_2 - .10)/\text{se}(b_2) \sim t_{(T-2)}$ *if the null hypothesis is true.*

3. Let us select $\alpha = .05$. The critical value t_c is 2.024 for a t-distribution with $(T - 2) = 38$ degrees of freedom. Again, we note this value can be found in the t table at the front of the book or computed exactly by using a software package. Thus, we will reject the null hypothesis in favor of the alternative if $t \geq 2.024$ or $t \leq -2.024$, or, equivalently, if $|t| \geq 2.024$.

4. Using the data in Table 3.1, the least squares estimate of β_2 is $b_2 = .1283$, with standard error $\text{se}(b_2) = 0.0305$. The value of the test statistic is $t = (.1283 - .10)/.0305 = .93$. The computer-generated value, using more significant digits, is $t = .9263$.

5. Conclusion: Since $t = .9263 < t_c = 2.024$ we *do not reject* the null hypothesis. The sample information we have is *compatible* with the null hypothesis that $\beta_2 = .10$.

5.2.6 TYPE I AND TYPE II ERRORS

Whenever we reject, or do not reject, a null hypothesis, there is a chance that we might be making a mistake. This is unavoidable. In any hypothesis testing situation there are two ways that we can make a correct decision and two ways that we can make an incorrect decision. We make a correct decision if:

- The null hypothesis is *false* and we decide to *reject* it.
- The null hypothesis is *true* and we decide *not* to reject it.

Our decision is incorrect if:

- The null hypothesis is *true* and we decide to *reject* it (a Type I error).
- The null hypothesis is *false* and we decide *not* to reject it (a Type II error).

When we reject the null hypothesis we risk what is called a **Type I error.** The probability of a Type I error is α, the **level of significance** of the test. A value of the test statistic in the rejection region, the range of unlikely values for the test statistic where we reject the null hypothesis, occurs with probability α when the null hypothesis is true. Thus, the hypothesis testing procedure we use will *reject* a true hypothesis with probability α. The only good news here is that we control the probability of a Type I error by choosing the level of significance of the test.

If this type of decision error is a *costly* one, then we should choose the level of significance to be small, perhaps $\alpha = .01$ or $.05$.

We risk a **Type II error** when we do not reject the null hypothesis. Our testing procedure will lead us to *fail to reject* null hypotheses that are false with a certain probability. The magnitude of the probability of a Type II error is *not* under our control and *cannot* be computed, as it depends on the true but unknown value of the parameter in question. We know these facts about the probability of a Type II error:

- The probability of a Type II error varies inversely with the level of significance of the test, α, which is the probability of a Type I error. If you choose to make α smaller, the probability of a Type II error increases.

- The closer the true value of the parameter is to the hypothesized parameter value the larger is the probability of a Type II error. If in the null hypothesis we hypothesize that $\beta_2 = c$, and if the true (unknown) value of β_2 is *close* to c, then the probability of a Type II error is high. Intuitively, the test loses the *power* to discriminate between the true parameter value and the (false) hypothesized value if they are similar in magnitude.

- The larger the sample size T, the lower the probability of a Type II error, given a level of Type I error α.

- For most types of hypotheses that economists test there is no one best test that can be used in all situations. By "best" test we mean one that has the minimum Type II error for any given level of Type I error, α. However, the test based on the t-distribution that we have described is a very good test and it is without question the test used most frequently in the situation that we have described.

5.2.7 The p-Value of a Hypothesis Test

When reporting the outcome of statistical hypothesis tests it has become common practice to report the *p-value* of a test. In the context of the food expenditure example, when testing the null hypothesis $H_0 : \beta_2 = .10$ against the alternative hypothesis $H_1 : \beta_2 \neq .10$, we reject the null hypothesis when the absolute value of the t-statistic is greater than or equal to the critical value t_c that corresponds to the level of significance we have chosen. That is, we reject the null hypothesis when $|t| \geq t_c$. The p-value of a test is calculated by finding the probability that the t-distribution can take a value greater than or equal to the absolute value of the sample value of the test statistic.

Using a p-value, we can determine whether to reject a null hypothesis by comparing it to the level of significance α. The rule is:

> **REJECTION RULE FOR A HYPOTHESIS TEST:** When the *p-value* of a hypothesis test is *smaller* than the chosen value of α, then the test procedure leads to *rejection* of the null hypothesis.

Conversely, if p is greater than α, we do not reject the null hypothesis. This rule is very handy. If we have the p-value of a test, we can determine the outcome of the test by comparing the p-value to the chosen level of significance, α, *without* looking up or calculating the critical values ourselves.

In the food expenditure example, the p-value for the test of $H_2 : \beta_2 = .10$ against $H_1 : \beta_2 \neq .10$ is illustrated in Figure 5.5.

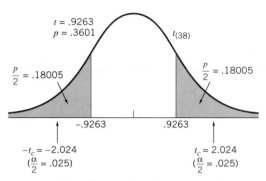

FIGURE **5.5** The p-value for a two-tailed test.

The p-value for this hypothesis test is $p = .3601$, which is the area in the tails of the $t_{(38)}$ distribution where $|t| \geq .9263$. In Figure 5.5 the p-value is depicted by the combined shaded tail areas. On the figure we have also marked the $\alpha = .05$ critical values $t_c = \pm 2.024$. The figure makes clear why the rule *reject H_0 if $p \leq \alpha$* gives the same result as the t-test. When $p \leq \alpha$, the value of the t-statistic must fall in the rejection region. When $p > \alpha$, the value of the test statistic falls in the non-rejection region. The fact that the portion of the p-value in the upper tail area is approximately .18 means that the critical value t_c marking off $\alpha/2 = .025$ must be to the right of $t = .9263$, and thus the t-test will not lead to rejection of the null hypothesis.

5.2.8 TESTS OF SIGNIFICANCE

In the food expenditure model one important null hypothesis is $H_0 : \beta_2 = 0$. This hypothesis explains the genesis of the term "null" hypothesis, since if it is true then income has no (a null) effect on food expenditure. Tests of these important null hypotheses, which state that the independent variable has no effect upon the dependent variable, are called **tests of significance.** The general alternative hypothesis is $H_1 : \beta_2 \neq 0$. Rejecting the null hypothesis that $\beta_2 = 0$ implies the conclusion that β_2 takes some other value, and it can be either positive or negative. Rejecting the null hypothesis implies that there is a "statistically significant" relationship between y and x.

5.2.8a A Significance Test in the Food Expenditure Model

Let us illustrate the hypothesis testing procedure by testing whether income has an effect (either positive or negative) on food expenditure. We will carry through the test using the five-point format on page 103.

1. The null hypothesis is $H_0 : \beta_2 = 0$. The alternative hypothesis is $H_1 : \beta_2 \neq 0$. If the null hypothesis is true, then there is no economic relationship between weekly household income and weekly household food expenditure, given our econometric model. If the alternative hypothesis is true, then there *is* a relationship between income and food expenditure.

2. The test statistic $t = b_2/\text{se}(b_2) \sim t_{(T-2)}$ *if the null hypothesis is true.*

3. Let us select $\alpha = .05$. The critical value t_c is 2.024 for a t-distribution with $(T - 2) = 38$ degrees of freedom. Thus we will reject the null hypothesis in favor of the alternative if $t \geq 2.024$ or $t \leq -2.024$, or, equivalently, if $|t| \geq 2.024$.

4. Using the data in Table 3.1, the least squares estimate of β_2 is $b_2 = .1283$, with

standard error $se(b_2) = 0.0305$. The value of the test statistic is $t = .1283/.0305 = 4.21$. The value of the t statistic reported by computer software, which carries out the computation with more significant digits, is $t = 4.20$.

5. Conclusion: Since $t = 4.20 > t_c = 2.024$ we *reject* the null hypothesis and accept the alternative, that there is a relationship between weekly income and weekly food expenditure. This test is called a "test of significance" since it is a test of whether b_2 is *significantly* (in the statistical sense that we have described) different from zero. Consequently the conclusion is stated as "The sample indicates a statistically significant relationship between weekly income and weekly food expenditure."

6. In the food expenditure example the p-value for the test of $H_0 : \beta_2 = 0$ against $H_1 : \beta_2 \neq 0$ is illustrated in Figure 5.6.

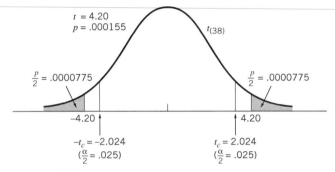

FIGURE **5.6** The p-value for a two-tailed significance test.

The p-value for this hypothesis test is $p = .000155$, which is the area in the tails of the $t_{(38)}$ distribution where $|t| \geq 4.20$. Since $p \leq \alpha$ we reject the null hypothesis that $\beta_2 = 0$ and accept the alternative that $\beta_2 \neq 0$, and thus that a "statistically significant" relationship exists between y and x.

In Figure 5.6 the p-value is depicted by the combined shaded tail areas. On the figure we have also marked the $\alpha = .05$ critical values $t_c = \pm 2.024$. The figure illustrates why the rule *reject H_0 if $p \leq \alpha$* gives the same result as the t-test. When $p \leq \alpha$, the value of the t-statistic must fall in the rejection region. The fact that the portion of the p-value in the upper tail area is approximately .00008 means that the critical value t_c marking off $\alpha/2 = .025$ must be to the left of $t = 4.20$, and thus the t-test will lead to rejection of the null hypothesis.

> **REMARK:** "Statistically significant" does not, however, necessarily imply "economically significant." For example, suppose the CEO of the supermarket chain plans a certain course of action *if $\beta_2 \neq 0$*. Furthermore suppose a large sample is collected from which we obtain the estimate $b_2 = .0001$ with $se(b_2) = .00001$, yielding the t-statistic $t = 10.0$. We would reject the null hypothesis that $\beta_2 = 0$ and accept the alternative that $\beta_2 \neq 0$. Here $b_2 = .0001$ is statistically different from zero. However, .0001 may not be "economically" different from 0, and the CEO may decide not to proceed with her plans. The message here is that one must not abandon one's intelligence when doing a statistical analysis by blindly reporting results unaccompanied by thought.

5.2.8b Reading Computer Output

The hypothesis that $\beta_2 = 0$ is so important when interpreting the results of a regression analysis that econometric software automatically reports the results of this test. The test statistic value, using the computer's calculation, is

$$t = \frac{b_2}{se(b_2)} = \frac{.1283}{.0305} = 4.20 \tag{R5.3}$$

In the EViews computer output shown in Figure 5.7, this value is the "coefficient" value divided by the standard error. The value of the t-statistic for the null hypothesis $H_0 : \beta_2 = 0$ is shown in the column labeled "**t-Statistic**." The p-value of this test, a two-tail p-value that EViews has rounded to .0002, is reported in the column labeled "**Prob.**" Other software packages may call these values by other names, but the results will always be shown in a similar table. The format of the table makes it easy to scan the regression output and observe if income has a statistically significant effect on food expenditure or not. Simply examine the p-value and compare it to the chosen value of α (the level of significance of the test). If $p \le \alpha$ we know immediately that we will reject the null hypothesis $H_0 : \beta_2 = 0$ in favor of the alternative $H_1 : \beta_2 \ne 0$. The results of testing $H_0 : \beta_1 = 0$ are also given by the software, but this test is not usually as economically relevant as the test for $\beta_2 = 0$.

```
Dependent Variable: FOODEXP
Method: Least Squares
Sample: 1 40
Included Observations: 40
```

Variable	Coefficient	Std. Error	t-Statistic	Prob.
C	40.76756	22.13865	1.841465	0.0734
INCOME	0.128289	0.030539	4.200777	0.0002

FIGURE 5.7 EViews regression output.

5.2.9 A RELATIONSHIP BETWEEN TWO-TAILED HYPOTHESIS TESTS AND INTERVAL ESTIMATION

There is an *algebraic* relationship between two-tailed hypothesis tests and confidence interval estimates. Suppose that we are testing the null hypothesis $H_0 : \beta_k = c$ against the alternative $H_1 : \beta_k \ne c$. If we *fail to reject* the null hypothesis at the α level of significance, then the value c will fall *within* a $(1 - \alpha) \times 100\%$ confidence interval estimate of β_k. Conversely, if we reject the null hypothesis, then c will fall *outside* the $(1 - \alpha) \times 100\%$ confidence interval estimate of β_k. This algebraic relationship is true because we fail to reject the null hypothesis when $-t_c \le t \le t_c$, or when

$$-t_c \le \frac{b_k - c}{se(b_k)} \le t_c$$

which, when rearranged, becomes

$$b_k - t_c se(b_k) \le c \le b_k + t_c se(b_k).$$

The endpoints of this interval are the same as the endpoints of a $(1 - \alpha) \times 100\%$ confidence interval estimate of β_k. Thus, for any value of c within the interval, we

do not reject $H_0 : \beta_k = c$ against the alternative $H_1 : \beta_k \neq c$. For any value of c outside the interval we reject $H_0 : \beta_k = c$ and accept the alternative $H_1 : \beta_k \neq c$.

This relationship can be handy if you are given only a confidence interval and want to determine what the outcome of a two-tailed test would be. However, you should note two things about this relationship between interval estimation and hypothesis testing:

1. The relationship is between confidence intervals and *two-tailed* tests. It does not apply to one-tailed tests.
2. A confidence interval is an *estimation* tool; that is, it is an interval *estimator*. A hypothesis test about one or more parameters is a completely separate form of inference, with the only connection being that the test statistic incorporates the least squares estimator. To test hypotheses you should carry out the steps outlined on page 103, and *should not* compute and report an interval estimate. *Keep hypothesis testing and parameter estimation separate at all times!*

5.2.10 ONE-TAILED TESTS

We have focused so far on testing hypotheses of the form $H_0 : \beta_k = c$ against the alternative $H_1 : \beta_k \neq c$. This kind of test is called a two-tailed test, since portions of the rejection region are found in both tails of the test statistic's distribution. One-tailed tests are used to test $H_0 : \beta_k = c$ against the alternative $H_1 : \beta_k > c$, or $H_1 : \beta_k < c$. The motivation for such alternatives was discussed in Section 5.2.2.

The logic of one-tailed tests is identical to that for the two-tailed tests that we have studied. The test statistic is the same, and is given by (5.2.2). What is different is the selection of the rejection region and the computation of the *p*-values. For example, to test $H_0 : \beta_k = c$ against the alternative $H_1 : \beta_k > c$ we select the rejection region to be values of the test statistic t that support the *alternative* hypothesis and that are *unlikely* if the null hypothesis is true. *Large* values of the t-statistic are unlikely if the null hypothesis is true. We define the rejection region to be values of t greater than a critical value t_c, from a t-distribution with $T - 2$ degrees of freedom, such that $P(t \geq t_c) = \alpha$, where α is the level of significance of the test and the probability of a Type I error. This critical value is depicted in Figure 5.8.

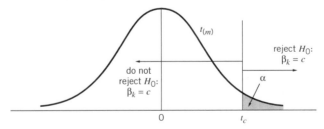

FIGURE 5.8 The rejection region for the one-tailed test of $H_0 : \beta_k = c$ against $H_1 : \beta_k > c$.

The decision rule for this one-tailed test is, "Reject $H_0 : \beta_k = c$ and accept the alternative $H_1 : \beta_k > c$ if $t \geq t_c$." If $t < t_c$ then we do not reject the null hypothesis.

Computation of the *p*-value is similarly confined to one tail of the distribution of the test statistic, though its interpretation is exactly as before. For testing $H_0 : \beta_k = c$ against the alternative $H_1 : \beta_k > c$, the *p*-value is computed by finding the probability

that the test statistic is greater than or equal to the computed sample value of the test statistic.

To illustrate these ideas, let us return to the food expenditure example and test $H_0 : \beta_2 = 0$ against the alternative $H_1 : \beta_2 > 0$. This is the relevant "test of significance" for this example, since economic theory rules out negative values of β_2. Following our standard testing format we have:

1. The null hypothesis is $H_0 : \beta_2 = 0$. The alternative hypothesis is $H_1 : \beta_2 > 0$. If the null hypothesis is true, then there is no economic relationship between weekly household income and weekly household food expenditure, given our economic and statistical model. If the alternative hypothesis is true, then there *is* a positive relationship between income and food expenditure.

2. The test statistic $t = b_2/\text{se}(b_2) \sim t_{(T-2)}$, *if the null hypothesis is true.*

3. For the level of significance $\alpha = .05$ the critical value t_c is 1.686 for a t-distribution with $T - 2 = 38$ degrees of freedom. Thus, we will reject the null hypothesis in favor of the alternative if $t \geq 1.686$.

4. Using the data in Table 3.1, the least squares estimate of β_2 is $b_2 = .1283$, with standard error $\text{se}(b_2) = 0.0305$. Exactly as in the two-tailed test, the value of the test statistic is $t = .1283/.0305 = 4.21$. The value of the t-statistic reported by computer software, which carries out the computation with more significant digits, is $t = 4.20$.

5. Conclusion: Since $t = 4.20 > t_c = 1.686$, we *reject* the null hypothesis and accept the alternative, that there is a positive relationship between weekly income and weekly food expenditure. The p-value for this test is $p(t \geq 4.20) = .000775$, which is far less than the level of significance $\alpha = .05$; thus, we also reject the null hypothesis on this basis. The p-value in the one-tailed test is exactly one-half the p-value in the two-tailed test. By forming an inequality alternative, we have added the information that negative values of β_2 are impossible. By adding this "extra" or "nonsample" information we have increased the ability, or power, of the test to discriminate between the null and alternative hypotheses.

5.2.11 A COMMENT ON STATING NULL AND ALTERNATIVE HYPOTHESES

We have noted in the previous sections that a statistical test procedure cannot prove the truth of a null hypothesis. When we fail to reject a null hypothesis, all the hypothesis test can establish is that the information in a sample of data is *compatible* with the null hypothesis. On the other hand, a statistical test can lead us to *reject* the null hypothesis, with only a small probability, α, of rejecting the null hypothesis when it is actually true. Thus, rejecting a null hypothesis is a stronger conclusion than failing to reject it.

Consequently, the null hypothesis is usually stated in such a way that if our theory is correct then we will reject the null hypothesis. For example, economic theory implies that there should be a positive relationship between income and food expenditure. When using a hypothesis test we would like to establish that there is statistical evidence, based on a sample of data, to support this theory. With this goal we set up the null hypothesis that there is *no* relation between the variables, $H_0 : \beta_2 = 0$. In the alternative hypothesis we put the conjecture that we would like to establish, $H_1 : \beta_2 > 0$.

Alternatively, suppose the conjecture that we would like to establish is that the marginal propensity to spend on food is greater than .10. To do so, we define the null hypothesis $H_0 : \beta_2 = .10$. In the alternative hypothesis we put the conjecture that we would like to establish, $H_1 : \beta_2 > .10$. You may view the null hypothesis to be too limited in this case, since it is feasible that $\beta_2 < .10$. The hypothesis testing procedure for testing the null hypothesis that $H_0 : \beta_2 \leq .10$ against the alternative hypothesis $H_1 : \beta_2 > .10$ is *exactly the same* as testing $H_0 : \beta_2 = .10$ against the alternative hypothesis $H_1 : \beta_2 > .10$. The test statistic, rejection region, and p-value are exactly the same. For a one-tailed test you can form the null hypothesis in either of these ways. What counts is that the alternative hypothesis is properly specified.

Finally, it is important to set up the null and alternative hypotheses *before* you carry out the regression analysis. Failing to do so can lead to errors in formulating the alternative hypothesis. Suppose that we wish to show that $\beta_2 > .10$ and the least squares estimate of β_2 is $b_2 = .05$. Does that mean we should set up the alternative $\beta_2 < .10$, to be consistent with the estimate? The answer is *no*. The alternative is formed to state the conjecture that we wish to establish, $\beta_2 > .10$.

5.3 The Least Squares Predictor

The ability to predict values of the dependent variable y is one of the objectives of linear regression analysis. Given the model and assumptions SR1–SR6, we want to predict for a given value of the explanatory variable x_0 the value of the dependent variable y_0, which is given by

$$y_0 = \beta_1 + \beta_2 x_0 + e_0 \qquad (5.3.1)$$

where e_0 is a random error. This random error has mean $E(e_0) = 0$ and variance $\mathrm{var}(e_0) = \sigma^2$. We also assume that it is uncorrelated with any of the sample observations, so that $\mathrm{cov}(e_0, e_t) = 0$.

In (5.3.1) we can replace the unknown parameters by their estimators, b_1 and b_2. Since y_0 is not known, the random error e_0 cannot be estimated, so we replace it by its expectation, zero. This produces the least squares predictor of y_0,

$$\hat{y}_0 = b_1 + b_2 x_0 \qquad (5.3.2)$$

graphed in Figure 5.9. This prediction is given by the point on the least squares fitted line where $x = x_0$.

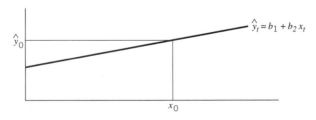

FIGURE **5.9** A point prediction.

How good a prediction procedure is this? Since the least squares estimators b_1 and b_2 are random variables, then so is $\hat{y}_0 = b_1 + b_2 x_0$. To evaluate the sampling prop-

erties of this predictor it is customary to examine the **forecast error**

$$f = \hat{y}_0 - y_0 = b_1 + b_2 x_0 - (\beta_1 + \beta_2 x_0 + e_0)$$
$$= (b_1 - \beta_1) + (b_2 - \beta_2)x_0 - e_0 \tag{5.3.3}$$

Using the properties of the least squares estimators and the assumptions about e_0, the expected value of f is

$$E(f) = E(\hat{y}_0 - y_0) = E(b_1 - \beta_1) + E(b_2 - \beta_2)x_0 - E(e_0)$$
$$= 0 + 0 - 0 = 0 \tag{5.3.4}$$

which means, on average, the forecast error is zero, and \hat{y}_0 is an *unbiased linear predictor* of y_0.

Using (5.3.3) for the forecast error, and what we know about the variances and covariances of the least squares estimators, it can be shown that the variance of the forecast error is

$$\text{var}(f) = \text{var}(\hat{y}_0 - y_0) = \sigma^2 \left[1 + \frac{1}{T} + \frac{(x_0 - \bar{x})^2}{\sum (x_t - \bar{x})^2} \right] \tag{5.3.5}$$

Notice that the further x_0 is from the sample mean \bar{x}, the more unreliable the forecast will be, in the sense that the variance of the forecast error is larger.

If the random errors are normally distributed, or if the sample size is large, then the forecast error f is normally distributed with mean zero and variance given by (5.3.5).

The forecast error variance is estimated by replacing σ^2 by its estimator to give

$$\hat{\text{var}}(f) = \hat{\sigma}^2 \left[1 + \frac{1}{T} + \frac{(x_0 - \bar{x})^2}{\sum (x_t - \bar{x})^2} \right] \tag{5.3.6}$$

The square root of this quantity is the *standard error of the forecast,*

$$\text{se}(f) = \sqrt{\hat{\text{var}}(f)} \tag{5.3.7}$$

We can use the predicted value \hat{y}_0 and the standard error of the forecast to compute a confidence interval, or a **prediction interval.** The marked steps can be skipped the first time through the material.

We can construct a standard normal random variable as

$$\frac{f}{\sqrt{\text{var}(f)}} \sim N(0, 1) \tag{5.3.8}$$

then by replacing var(f) in (5.3.8) by vâr(f), we obtain a t-statistic,

$$\frac{f}{\sqrt{\text{vâr}(f)}} = \frac{f}{\text{se}(f)} \sim t_{(T-2)} \tag{5.3.9}$$

Using these results we can construct a prediction interval for y_0 just as we constructed confidence intervals for the parameters β_k. If t_c is a critical value from the $t_{(T-2)}$ distribution such that $P(t \ge t_c) = \alpha/2$, then

$$P(-t_c \le t \le t_c) = 1 - \alpha \tag{5.3.10}$$

Substitute the t random variable from (5.3.9) into (5.3.10) to obtain

$$P\left[-t_c \le \frac{\hat{y}_0 - y_0}{\text{se}(f)} \le t_c\right] = 1 - \alpha$$

and simplify this expression to obtain

$$P[\hat{y}_0 - t_c\text{se}(f) \le y_0 \le \hat{y}_0 + t_c\text{se}(f)] = 1 - \alpha \tag{5.3.11}$$

A $(1 - \alpha) \times 100\%$ confidence interval, or prediction interval, for y_0 is

$$\hat{y}_0 \pm t_c\text{se}(f) \tag{5.3.12}$$

Equation (5.3.5) implies that the farther x_0 is from the sample mean \bar{x}, the larger the variance of the prediction error. The greater the variance, the less reliable the prediction. In other words, our predictions for values of x_0 close to the sample mean \bar{x} are more reliable than our predictions for values of x_0 far from the sample mean \bar{x}. This result is a reasonable one. We would not expect to predict very accurately for an x about which we have little sample information.

The relationship between point and interval predictions for different values of x_0 is illustrated in Figure 5.10. A point prediction is always given by the fitted least squares line, $\hat{y}_0 = b_1 + b_2x_0$. A prediction confidence interval takes the form of two

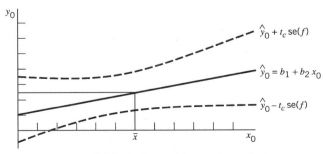

FIGURE 5.10 Point and interval prediction.

bands around the least squares line. Since the forecast variance increases the farther x_0 is from the sample mean of \bar{x}, the confidence bands increase in width as $|x_0 - \bar{x}|$ increases.

5.3.1 PREDICTION IN THE FOOD EXPENDITURE MODEL

In Chapter 3.3.3b we predicted the weekly expenditure on food for a household with $x_0 = \$750$ weekly income. The point prediction is

$$\hat{y}_0 = b_1 + b_2 x_0 = 40.7676 + .1283(750) = 136.98 \qquad \text{(R5.4)}$$

This means we predict that a household with \$750 weekly income will spend \$136.98 on food per week.

Using our estimate $\hat{\sigma}^2 = 1429.2456$, the estimated variance of the forecast error is

$$\hat{\text{var}}(f) = \hat{\sigma}^2 \left[1 + \frac{1}{T} + \frac{(x_0 - \bar{x})^2}{\sum (x_t - \bar{x})^2} \right]$$

$$= 1429.2456 \left[1 + \frac{1}{40} + \frac{(750 - 698)^2}{1532463} \right] = 1467.4986 \qquad \text{(R5.5)}$$

The standard error of the forecast is then

$$\text{se}(f) = \sqrt{\hat{\text{var}}(f)} = \sqrt{1467.4986} = 38.3079 \qquad \text{(R5.6)}$$

If we select $1 - \alpha = .95$, then $t_c = 2.024$ and the 95 percent confidence interval for y_0 is

$$\hat{y}_0 \pm t_c \text{se}(f) = 136.98 \pm 2.024(38.3079) \qquad \text{(R5.7)}$$

or [59.44 to 214.52]. Our prediction interval thus suggests that a household with \$750 weekly income will spend somewhere between \$59.44 and \$214.52 on food. Such a wide interval means that our point prediction, \$136.98, is not reliable. We might be able to improve it by measuring the effect that factors other than income might have. Extensions of the model that include other factors will begin in Chapter 7.

5.4 Learning Objectives

Based on the material in this chapter, you should be able to:

1. Discuss how "repeated sampling theory" relates to interval estimation and hypothesis testing.
2. Explain the statistical difference between an estimator and an estimate.
3. Explain why the least squares estimators b_1 and b_2 are considered random variables.
4. Explain under what conditions the least squares estimators b_1 and b_2 are normally distributed, or approximately normally distributed, random variables.

5. Explain why it is important for statistical inference that the least squares estimators b_1 and b_2 are normally distributed random variables.

6. Describe the differences between the standard normal and t-distributions, and what happens to the t-distribution as the sample size increases.

7. Explain the "level of confidence" of an interval estimator, and exactly what it means in a repeated sampling context, and give an example.

8. Explain the difference between an interval estimator and an interval estimate. Explain how to interpret an interval estimate.

9. Explain the terms null hypothesis, alternative hypothesis, and rejection region, giving an example and a sketch of the rejection region.

10. Explain the logic of a statistical test, including why it is important that a test statistic have a known probability distribution if the null hypothesis is true.

11. Explain the term p-value, how to use a p-value to determine the outcome of a hypothesis test, and provide a sketch showing a p-value.

12. Use your computer software to compute a p-value for a one- or a two-tailed test.

13. Explain the difference between one- and two-tailed tests, and how the choice depends on economic theory.

14. Explain, intuitively, how to choose the rejection region for a one-tailed test.

15. Explain Type I error, and illustrate it in a sketch.

16. Explain Type II error and how it is related to Type I error.

17. Define the level of significance of a test.

18. Explain what is meant by the phrase "statistically significant regression model."

19. Use regression output to carry out tests concerning the intercept and slope, and to construct interval estimates.

20. Explain the difference between economic and statistical significance.

21. Explain how to choose what goes in the null hypothesis, and what goes in the alternative hypothesis.

22. Explain how to use the simple linear regression model to predict the value of y for any value of x.

23. Define the forecast error.

24. Explain "unbiased prediction" and the conditions under which the least squares predictor is unbiased.

25. Explain, intuitively and also technically, why predictions for x values further from \bar{x} are less reliable.

26. Use your computer software to make point predictions of y for any value of x, and construct prediction intervals.

5.5 Exercises

5.1 Using the regression output for the food expenditure model in Figure 5.7:
 (a) Construct a 95% interval estimate for β_1 and interpret.
 (b) Test the null hypothesis that β_1 is zero, against the alternative that it is

not, at the 5% level of significance without using the reported *p*-value. What is your conclusion?

(c) Draw a sketch showing the *p*-value .0734 shown in Figure 5.7, the critical value from the *t*-distribution used in (b) and how the *p*-value could have been used to answer (b).

(d) Test the null hypothesis that β_1 is zero, against the alternative that it is positive, at the 5% level of significance. Draw a sketch of the rejection region and compute the *p*-value. What is your conclusion?

(e) Explain the differences and similarities between the "level of significance" and the "level of confidence."

(f) The results in (d) show that we are 95% confident that β_1 is positive. True or False? If false, explain.

5.2 The general manager of an engineering firm wants to know if a draftsman's experience influences the quality of his work. She selects 24 draftsmen at random and records their years of work experience and their quality rating (as assessed by their supervisors). Work experience (EXPER) is measured in years and quality rating (RATING) takes a value of 1 through 7, with 7 = excellent and 1 = poor. She estimates the following model:

$$\text{rating} = \beta_1 + \beta_2 \text{ experience} + error$$

The SAS output is

```
Parameter Estimates

                   Parameter    Standard    T for HO:
Variable    DF     Estimate     Error       Parameter=0    Prob > |T|

INTERCEP    1      3.203808     0.70910640   4.518          0.0002
EXPER       1      0.076118     0.04448964   1.711          0.1012
```

(a) Interpret the coefficient of EXPER.

(b) Construct a 95% confidence interval for β_2, the slope of the relationship between quality rating and experience. In what are you 95% confident?

(c) What is the *p*-value for the test of the null hypothesis that β_2 is zero against the alternative that it is not? Show, in a diagram, how the *p*-value is computed. If we choose the probability of a type I error to be $\alpha = .05$, do we reject the null hypothesis or not, just based on an inspection of the *p*-value?

(d) Predict the quality rating of a draftsman with 5 years of experience. Describe what statements or steps you would use to obtain a 95% prediction interval for quality rating with experience of 5 years, using your computer software.

5.3 Consider a model explaining the demand for food in the United States. Let *Q* be the total *real* expenditure on food, let *X* be the *real* total expenditure on all goods and services. To obtain these "real" variables we have divided the nominal quantities by a price index deflating all to a 1980 basis. Economic theory suggests that $Q = f(X)$. We consider the following econometric model:

$$\ln(Q) = \beta_1 + \beta_2 \ln(X) + e$$

Using data from 1965 to 1989 (25 annual observations) we estimate the model and obtain the following SAS output [LQ = ln(Q) and LX = ln(X)].

```
Dependent Variable: LQ

Parameter Estimates

                    Parameter     Standard     T for HO:
Variable     DF     Estimate        Error      Parameter=0    Prob > |T|

INTERCEP     1      7.590002      0.27774614     27.327         0.0001
LX           1      0.322397      0.01944875     16.577         0.0001
```

(a) State the economic interpretation of the estimated slope coefficient in the context of this problem.
(b) Test the null hypothesis that a 1% increase in real expenditure on all goods and services leads to a 0.25% increase in the real expenditure on food against the alternative that it does not. What do you conclude? Be sure to show all the proper steps in carrying out a hypothesis test. Use the .01 level of significance.
(c) Construct a 95% confidence interval estimate for β_2.
(d) What assumption about the error term in this model must hold in order for interval estimation and hypothesis testing to be valid. Why? What if the number of observations was 100 rather than 25?
(e) Suppose that in this model we have omitted an important variable, namely the real price of food, relative to all other goods. What are the consequences of this omission for (a)–(c)?

5.4 In an estimated regression, the reported t-statistic is -6.607 and the parameter estimate is -3782.196. What is the estimated variance of the least squares estimator for the parameter?

5.5 What would you conclude, at the 5% and the 1% levels of significance, about a two-tailed test of significance based on the following p-values?
(a) $p = .005$
(b) $p = 0.0108$

5.6 In an estimated simple regression model, based on 24 observations, the estimated slope parameter is .310 and the estimated standard error is .082.
(a) Test the hypothesis that the slope is zero, against the alternative that it is not, at the 1% level of significance.
(b) Test the hypothesis that the slope is zero, against the alternative that it is positive at the 1% level of significance.
(c) Test the hypothesis that the slope is zero against the alternative that it is negative at the 5% level of significance. Draw a sketch showing the rejection region.
(d) Test the hypothesis that the estimated slope is 0.5, against the alternative that it is not, at the 5% level of significance.
(e) Obtain a 99% interval estimate of the slope. Interpret.

5.7 Given the simple linear model $y_t = \beta_1 + \beta_2 x_t + e_t$, and the least squares estimators, we can estimate $E(y_t)$ for any value of $x = x_0$ as $\hat{E}(y_0) = b_1 + b_2 x_0$.
(a) Describe the difference between predicting y_0 and estimating $E(y_0)$.
(b) Find the expected value and variance of $\hat{E}(y_0) = b_1 + b_2 x_0$.

5.8 When discussing the unbiasedness of the least squares predictor we showed that $E(f) = E(\hat{y}_0 - y_0) = 0$, where f is the forecast error. Why did we define unbiasedness in this strange way? What is wrong with saying, as we have in other unbiasedness demonstrations, that $E(\hat{y}_0) = y_0$?

5.9 In the file *br-1.dat* are 213 observations on the selling prices ($y = price$) and the sizes of houses ($x = sqft$) in a subdivision in Baton Rouge from the year 1985. The selling prices y are measured in \$ and the house sizes x are measured in square feet.
 (a) Contruct a 95% interval estimate for the effect of an increase in house size of 1 square foot on expected price.
 (b) Test the hypothesis that there is no relationship between house size and price, against the alternative that the relationship is a positive one.
 (c) Test the hypothesis that the value of a square foot of housing space is \$50, against the alternative that it is not.
 (d) Compute point and interval predictions for the price of a house with 2000 square feet of living space.

5.10 Using the data in Exercise 3.2 (also used in Exercise 4.6), calculate *by hand*, showing your work, \hat{y}_0 and se(f) for $x_0 = 5$.

5.11 Using the data for the production function discussed in Exercise 3.5 and the linear regression model and an $\alpha = .05$ level:
 (a) Find interval estimates for β_1 and β_2 and interpret.
 (b) Test the hypothesis that $\beta_1 = 0$ against the alternative that it is positive and interpret.
 (c) Test the hypothesis that $\beta_2 = 0$ against the alternative that it is positive and interpret.
 (d) Test the hypothesis that the marginal product of the input is 0.35 against the alternative that it is not and interpret.
 (e) Compute and compare the estimated forecast error variance for input levels 8 and 16. Discuss the sampling theory interpretation of the variance of the forecast error.

5.12 Using the data for Moscow Makkers (see Exercise 3.6):
 (a) Test the null hypothesis that the elasticity of demand for hamburgers is equal to -1 against the alternative that it is not.
 (b) Construct point and interval predictions for the number of hamburgers that will be sold when the price is \$2.

5.13 A life insurance company wishes to examine the relationship between the amount of life insurance held by a family and family income. From a random sample of 20 households, the company collected the data in the file *insur.dat*. The data are in thousands of dollars.
 (a) Estimate a linear relationship between life insurance (y) and income (x).
 (b) Discuss the relationship you estimated in (a). In particular:
 (i) What is your estimate of the resulting change in the amount of life insurance when income increases by \$1,000?
 (ii) What is the standard error of the estimate in (i), and how do you use this standard error for interval estimation and hypothesis testing?
 (iii) One member of the management board claims that for every \$1,000 increase in income, the amount of life insurance held will go up by \$5,000. Choose an alternative hypothesis and explain your choice. Does your estimated relationship support this claim? Use a 5 percent significance level.

(iv) Write a short report summarizing your findings about the relationship between income and the amount of life insurance held.
 (c) Test the hypothesis that as income increases the amount of life insurance increases by the same amount. That is, test the hypothesis that the slope of the relationship is 1.
 (d) Predict the amount of life insurance held by a family with an income of $100,000.

5.14 Consider the learning curve data in Exercise 3.8.
 (a) Construct a 95% interval estimate for β_2 and interpret.
 (b) Test at the 5% level of significance whether there is no learning against the alternative that there is learning. Formulate the null and alternative hypotheses and discuss your reasoning. Explain your conclusion.
 (c) Construct a 95% prediction interval for the unit cost of production when cumulative production is $q_0 = 2000$.
 (d) Write a short report summarizing all your findings (here and in Exercise 3.8) concerning the learning curve in production of titanium dioxide.

5.15 Consider the capital asset pricing model (CAPM) in Exercise 3.9.
 (a) Test at the 5% level of significance the hypothesis that Mobil Oil's *beta* value is one against the alternative that it is less than one. What is the economic interpretation of a beta equal to one? Less than one?
 (b) Predict the risk premium for Mobil Oil if the risk premium of the market portfolio is 1%, and if it is 10%. Construct 95% interval estimates of Mobil's risk premium for the same two values of the market's risk premium.
 (c) Test the hypothesis that the intercept term in the CAPM model is zero, against the alternative that it is not. What do you conclude?
 (d) Estimate the model *without* including an intercept and repeat parts (a) and (b).
 (e) Write a short report summarizing what you know about Mobil Oil's stock and its relationship to the stock market as a whole.

5.16 Below is the SAS output of a least squares regression. The dependent variable MIM = mean income of males who are 18 years of age or older, in thousands of dollars. The explanatory variable PMHS = percent of males 18 or older who are high school graduates. The data consist of 51 observations on the 50 states plus the District of Columbia. Thus MIM and PMHS are "state averages." The regression output is

Parameter Estimates

Variable	DF	Parameter Estimate	Standard Error	T for H0: Parameter=0	Prob > \|T\|
INTERCEP	1	(a)	2.17380740	1.257	(b)
PMHS	1	0.180141	(c)	5.754	0.0001

Covariance of Estimates

COVB	INTERCEP	PMHS
INTERCEP	(d)	-0.067766273
PMHS	-0.067766273	0.0009801423

(a) Fill in the missing spaces (a)–(d) in the SAS output. Show your calculations.

(b) State the economic interpretation of the estimated slope. Is the sign of the coefficient what you would expect from economic theory?

(c) Construct a 99% confidence interval estimate of the slope of this relationship.

(d) Test the hypothesis that the slope of the relationship is 0.2, against the alternative that it is not. State in words the meaning of the null hypothesis in the context of this problem.

(e) For the state of Louisiana the values of the variables are MIM = 15.365 and PMHS = 61.3. Compute the least squares residual. Show your computations.

(f) Predict the value of MIM for a state with PMHS = 75.

5.17 The Catering company Thirst Quenchers has contracted to supply soda at the University of California (Golden Bears) football games. They suspect that the major factor influencing the quantity of soda consumed is the maximum temperature on the day of each game. The last three seasons have yielded the 18 observations on quantity of soda sold and maximum temperature (F) in the file *football.dat*.

(a) Estimate the linear equation that relates the quantity of soda sold to the maximum temperature.

(b) Is there evidence to suggest that increases in temperature increase the quantity of soda sold?

(c) Construct a prediction and a 95% prediction interval for the amount of soda sold when the maximum temperature is 70 degrees (F).

(d) At what temperature would you predict the quantity of sodas sold to be zero?

5.18 Gordon H. Hanson and Antonio Splimbergo ("Illegal Immigration, Border Enforcement, and Relative Wages: Evidence from Apprehensions at the U.S.–Mexico Border," *American Economic Review*, 89(5), December 1999, 1337–1357) investigate the effects of U.S. and Mexican wages, and the effect of border enforcement, on apprehensions of illegal immigrants at the U.S.–Mexico Border. They use monthly data from January 1968 to August 1996.

(a) Let A_t be the number of apprehensions by the U.S. Border Patrol of individuals attempting to enter the United States illegally in month t, and let E_t be the person hours spent by the U.S. Border Patrol policing U.S. borders in month t. Interpret the following estimated relationship and test the significance of the estimated slope.

$$\ln\left(\frac{A_t}{A_{t-1}}\right) = b_1 + 0.510\ln\left(\frac{E_t}{E_{t-1}}\right)$$

(s.e.) (0.126)

(note : intercept not reported)

(b) Let MW_t be the real Mexican hourly wage in the manufacturing sector in month t. Interpret the following estimated relationship and test the significance of the estimated slope.

$$\ln\left(\frac{A_t}{A_{t-1}}\right) = b_1 - 0.550\ln\left(\frac{MW_t}{MW_{t-1}}\right)$$

(s.e.) (0.169)

(note : intercept not reported)

5.19 Charles E. Swanson and Kenneth J. Kopecky ("Lifespan and Output," *Economic Inquiry*, 37(2), April 1999, 213–225) argue that increases in lifespan increase output per person-hour due to the willingness of individuals to opt for more pre-work learning, and that a longer lifespan increases an individual's willingness to adopt new technology. To examine the effect of lifespan on output they estimate the regression $G_i = \beta_1 + \beta_2 L_i + e_i$, where G_i is the annualized per capita growth of country i between 1960 and 1985, and L_i is life expectancy in 1960. Their estimation results are summarized in the following table (N = number of countries in a group):

Group	N	b_2	*t-value*
Africa	38	1.51	3.36
OECD	23	−0.033	−0.70
Latin America	22	0.012	0.34
Asia	17	0.113	2.51
All Countries	104	0.075	5.77

(a) State the interpretation of the estimated slopes in the table. Are the estimated signs what you would expect? If not, why not?
(b) Test the hypothesis that the slopes of these estimated equations are zero, against the alternative that they are positive, at the $\alpha = .05$ level of significance.
(c) Construct 95% interval estimates of the slopes for the Latin American and Asian country groups.

Chapter 6

The Simple Linear Regression Model: Reporting the Results and Choosing the Functional Form

In the last three chapters we considered the simple linear regression model $y_t = \beta_1 + \beta_2 x_t + e_t$ where the random error $e_t \sim N(0, \sigma^2)$. We developed procedures for estimating the unknown model parameters and for making statistical inferences in the form of point and interval estimates and hypothesis tests. To complete the analysis of the simple linear regression model, in this chapter we consider

- How to measure the variation in y_t explained by the model

- How to report the results of a regression analysis

- Some alternative functional forms that may be used to represent possible relationships between y_t and x_t

6.1 The Coefficient of Determination

Two major reasons for analyzing the model

$$y_t = \beta_1 + \beta_2 x_t + e_t \tag{6.1.1}$$

are to explain how the dependent variable (y_t) changes as the indepenent variable (x_t) changes, and to predict y_0 given an x_0. These two objectives come under the broad headings of estimation and prediction. Closely allied with the prediction problem is the desire to use x_t to explain as much of the variation in the dependent variable y_t as possible. In using the statistical model in (6.1.1) we introduce the "explanatory" variable x_t in hope that its variation will "explain" the variation in y_t.

To develop a measure of the variation in y_t that is explained by the model, we begin by separating y_t into its explainable and unexplainable components. We have

assumed that

$$y_t = E(y_t) + e_t \qquad (6.1.2)$$

where $E(y_t) = \beta_1 + \beta_2 x_t$ is the explainable, "systematic" component of y_t, and e_t is the random, unsystematic, unexplainable noise component of y_t. Although both of these parts are unobservable to us, we can estimate the unknown parameters β_1 and β_2 and, analogous to (6.1.2), decompose the value of y_t into

$$y_t = \hat{y}_t + \hat{e}_t \qquad (6.1.3)$$

where $\hat{y}_t = b_1 + b_2 x_t$ and $\hat{e}_t = y_t - \hat{y}_t$.

In Figure 6.1 the "point of the means" (\bar{x}, \bar{y}) is shown, with the least squares fitted line passing through it. This is a characteristic of the least squares fitted line whenever the regression model includes an intercept term. Subtract the sample mean \bar{y} from both sides of the equation to obtain

$$y_t - \bar{y} = (\hat{y}_t - \bar{y}) + \hat{e}_t \qquad (6.1.4)$$

As shown in Figure 6.1, the difference between y_t and its mean value \bar{y} consists of a part that is "explained" by the regression model, $\hat{y}_t - \bar{y}$, and a part that is unexplained, \hat{e}_t.

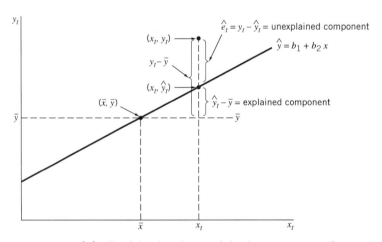

FIGURE **6.1** Explained and unexplained components of y_t.

The breakdown in (6.1.4) leads to a useful decomposition of the total variability in y, within an entire sample, into explained and unexplained parts. There are many ways to measure the "total variation" in a variable. One convenient way is to square the differences between y_t and its mean value \bar{y} and sum over the entire sample. If we square and sum both sides of (6.1.4) we obtain

$$
\begin{aligned}
\sum (y_t - \bar{y})^2 &= \sum [(\hat{y}_t - \bar{y}) + \hat{e}_t]^2 \\
&= \sum (\hat{y}_t - \bar{y})^2 + \sum \hat{e}_t^2 + 2 \sum (\hat{y}_t - \bar{y})\hat{e}_t \\
&= \sum (\hat{y}_t - \bar{y})^2 + \sum \hat{e}_t^2 \qquad (6.1.5)
\end{aligned}
$$

because, as you are asked to show in Exercise 6.5, the cross-product term $\sum(\hat{y}_t - \bar{y})\hat{e}_t = 0$ and drops out.

Equation (6.1.5) is a decomposition of the "total sample variation" in y into explained and unexplained components. Specifically, these "sums of squares" are:

1. $\sum(y_t - \bar{y})^2$ = total sum of squares = SST: a measure of *total variation* in y about its sample mean.

2. $\sum(\hat{y}_t - \bar{y})^2$ = explained sum of squares = SSR: that part of total variation in y about its sample mean that is explained by the regression.

3. $\sum\hat{e}_t^2$ = error sum of squares = SSE: that part of total variation in y about its mean that is not explained by the regression.

Thus, (6.1.5) becomes

$$SST = SSR + SSE \qquad (6.1.6)$$

This decomposition accompanies virtually every regression analysis. It is usually presented in what is called an **analysis of variance table** with general format of Table 6.1. This table provides a basis for summarizing the decomposition in (6.1.5). It gives SSR, the variation explained by x, SSE, the unexplained variation and SST, the total variation in y. The **degrees of freedom** (DF) for these sums of squares are:

1. $df = 1$ for SSR (the number of explanatory variables other than the intercept)

2. $df = T - 2$ for SSE (the number of observations minus the number of parameters in the model)

3. $df = T - 1$ for SST (the number of observations minus 1, which is the number of parameters in a model containing only β_1)

In the column labeled "Mean Square" are (*i*) the ratio of SSR to its degrees of freedom, $SSR/1$, and (*ii*) the ratio of SSE to its degrees of freedom, $SSE/(T-2) = \hat{\sigma}^2$. The "mean square error" is our unbiased estimate of the error variance, which we first developed in Chapter 4.5.

One widespread use of the information in the analysis of variance table is to define a measure of the *proportion of variation* in y explained by x within the regression model:

$$R^2 = \frac{SSR}{SST} = 1 - \frac{SSE}{SST} \qquad (6.1.7)$$

Table 6.1 **Analysis of Variance Table**

Source of Variation	DF	Sum of Squares	Mean Square
Explained	1	SSR	$SSR/1$
Unexplained	$T - 2$	SSE	$SSE/(T - 2)\ [= \hat{\sigma}^2]$
Total	$T - 1$	SST	

The measure R^2 is called the **coefficient of determination.** The closer R^2 is to 1, the better the job we have done in explaining the variation in y_t with $\hat{y}_t = b_1 + b_2 x_t$; and the greater is the predictive ability of our model over all the sample observations.

If $R^2 = 1$, then all the sample data fall exactly on the fitted least squares line, so $SSE = 0$, and the model fits the data "perfectly." If the sample data for y and x are uncorrelated and show no linear association, then the least squares fitted line is "horizontal," and identical to \bar{y}, so that $SSR = 0$ and $R^2 = 0$. When $0 < R^2 < 1$, it is interpreted as "the percentage of the variation in y about its mean that is explained by the regression model."

> **REMARK:** R^2 is a *descriptive* measure. By itself it does not measure the *quality* of the regression model; this point will be made in Section 6.1.1. It is *not* the objective of regression analysis to find the model with the highest R^2. Following a regression strategy focused solely on maximizing R^2 is not a good idea.

6.1.1 ANALYSIS OF VARIANCE TABLE AND R^2 FOR FOOD EXPENDITURE EXAMPLE

The analysis of variance table for the food expenditure example appears in Table 6.2. Make sure you can locate the values in this table on *your* computer output. From this table, we find that

$$SST = \sum (y_t - \bar{y})^2 = 79532 \tag{R6.1}$$

$$SSR = \sum (\hat{y}_t - \bar{y})^2 = 25221 \tag{R6.2}$$

$$SSE = \sum \hat{e}_t^2 = 54311 \tag{R6.3}$$

$$R^2 = \frac{SSR}{SST} = 1 - \frac{SSE}{SST} = 1 - \frac{54311}{79532} = 0.317 \tag{R6.4}$$

$$SSE/(T-2) = \hat{\sigma}^2 = 1429.2455 \tag{R6.5}$$

Your computer software may include other items in the analysis of variance table, such as an F-value. Disregard these items for now, as we will return to them in Chapter 8.

The value $R^2 = 0.317$ says that about 32 percent of the variation in food expenditure about its mean is explained by variations in income. Alternatively, we can say

Table 6.2 **Analysis of Variance Table for Food Expenditure Example**

Source	DF	Sum of Squares	Mean Square
Explained	1	25221.2229	25221.2229
Unexplained	38	54311.3314	1429.2455
Total	39	79532.5544	

that *the regression model* explains 32 percent of the variation in food expenditure about its mean, leaving 68 percent of the variation unexplained. Although this R^2 value sounds low, it is typical in regression studies using cross-sectional data, in which a sample of individuals, or other economic units, are observed at the same point in time. Studies using time-series data, in which one individual is observed over time, usually have much higher R^2 values. The lesson here is that the success of a model cannot be completely judged on the magnitude of its R^2. Even if this number is low, the estimated parameters may contain useful information. Attempting to summarize the entire worth of a model by this one number is an error that should be avoided.

6.1.2 CORRELATION ANALYSIS

In Chapter 2.5 we discussed the *covariance* and *correlation* between two random variables X and Y. The correlation coefficient ρ between X and Y is defined in (2.5.4) to be

$$\rho = \frac{\text{cov}(X, Y)}{\sqrt{\text{var}(X)\text{var}(Y)}} \tag{6.1.8}$$

In Chapter 2 we did not discuss *estimating* the correlation coefficient. We will do so now to develop a useful relationship between the sample correlation coefficient and R^2.

Given a sample of data pairs (x_t, y_t), $t = 1, \ldots, T$, the sample correlation coefficient is obtained by replacing the covariance and variances in (6.1.8) by their sample analogues:

$$r = \frac{\hat{\text{cov}}(X, Y)}{\sqrt{\hat{\text{var}}(X)\hat{\text{var}}(Y)}} \tag{6.1.9}$$

where

$$\hat{\text{cov}}(X, Y) = \sum_{t=1}^{T} (x_t - \bar{x})(y_t - \bar{y})/(T - 1) \tag{6.1.10a}$$

$$\hat{\text{var}}(X) = \sum_{t=1}^{T} (x_t - \bar{x})^2/(T - 1) \tag{6.1.10b}$$

The sample variance of Y is defined like $\hat{\text{var}}(X)$. So we can write the sample correlation coefficient r as

$$r = \frac{\sum_{t=1}^{T} (x_t - \bar{x})(y_t - \bar{y})}{\sqrt{\sum_{t=1}^{T} (x_t - \bar{x})^2 \sum_{t=1}^{T} (y_t - \bar{y})^2}} \tag{6.1.11}$$

The sample correlation coefficient r has a value between -1 and 1, and it measures the strength of the linear association between observed values of X and Y.

6.1.3 CORRELATION ANALYSIS AND R^2

There are two interesting relationships between R^2 and r in the simple linear regression model.

1. The first is that $r^2 = R^2$. That is, the square of the sample correlation coefficient between the sample data values x_t and y_t is algebraically equal to R^2, as you are invited to show in Exercise 6.8. Intuitively, this relationship makes sense: r^2 falls between 0 and 1 and measures the strength of the linear association between x and y. This interpretation is not far from that of R^2: the proportion of variation in y about its mean explained by x in the linear regression model.

2. It is an interesting fact that R^2 can also be computed as the square of the sample correlation coefficient between y_t and $\hat{y}_t = b_1 + b_2 x_t$. As such, it measures the linear association, or goodness of fit, between the sample data and their predicted values. Consequently, R^2 is sometimes called a measure of "goodness of fit."

6.2 Reporting Regression Results

As we have seen, regression analyses are carried out using computer software. Various software packages report information in different styles and using slightly different terminology. Some software packages will report more summary information than others. In fact, some regression software will report advanced information that you may not recognize. Skills that you must develop are the ability to read computer output, summarize the information that is presented, and correctly interpret the parts you want.

Furthermore, a report that includes information from a regression analysis usually will not include pages of computer output at the end for the reader to sort through. Instead, regression results are summarized within the text in a form that is convenient for the reader. One way to summarize the regression results is in the form of a "fitted" regression equation:

$$\hat{y}_t = 40.7676 + 0.1283x_t \qquad R^2 = 0.317$$
$$(22.1387)\ (0.0305) \qquad\quad \text{(s.e.)} \tag{R6.6}$$

The value $b_1 = 40.7676$ estimates the weekly food expenditure by a household with no income; $b_2 = 0.1283$ implies that given a \$1 increase in weekly income we expect expenditure on food to increase by about \$.13; or, in more reasonable units of measurement, if income increases by \$100 we expect food expenditure to rise by \$12.83. The $R^2 = 0.317$ says that about 32 percent of the variation in food expenditure about its mean is explained by variations in income. The numbers in parentheses underneath the estimated coefficients are the *standard errors* of the least squares estimates. Apart from critical values from the t-distribution, (R6.6)

contains all the information that is required to construct interval estimates for β_1 or β_2, or to test hypotheses about β_1 or β_2.

Another conventional way to report results is to replace the standard errors with the *t*-values, given in the computer output. These values arise when testing H_0: $\beta_1 = 0$ against H_1: $\beta_1 \neq 0$ and H_0: $\beta_2 = 0$ against H_1: $\beta_2 \neq 0$. Using these *t*-values we can report the regression results as

$$\hat{y}_t = 40.7676 + 0.1283x_t \qquad R^2 = 0.317$$
$$\quad\ (1.84) \quad\ (4.20) \qquad\quad (t) \qquad\qquad\qquad \text{(R6.7)}$$

When reporting the results this way, we recognize that the null hypothesis H_0: $\beta_2 = 0$ is an important one, since, if b_2 is not statistically significantly different from 0, then we cannot conclude that x influences y.

6.2.1 The Effects of Scaling the Data

Data we obtain are not always in a convenient form for presentation in a table or use in a regression analysis. When the *scale* of the data is not convenient, it can be altered without changing any of the real underlying relationships between variables. For example, suppose we are interested in the variable x = U.S. total personal income. In 1999 its value is x = \$93,491,400,000,000. That is, 93 trillion, 491.4 billion dollars. As written the number is very cumbersome. If we were to report such data in a table, it would take up too much space; if we were entering such data into the computer for analysis we would not like typing in all those digits. Thus, it is common practice to report and use data in convenient units of measurement. We might divide the variable x by 1 trillion and use instead the scaled variable $x^* = x/1,000,000,000,000 = \93.4914 trillion. This is a much more manageable number, but what, if any, are the effects of scaling the variables in a regression model?

Consider the food expenditure model. The food expenditure data, which we introduced first in Chapter 3, are measured in *dollars* of food expenditure and income per week. Consequently, as in the previous section, we interpret the least squares estimate $b_2 = 0.1283$, as the expected increase in food expenditure, in dollars, given a \$1 increase in weekly income. It may be more convenient to discuss increases in weekly income of \$100. Such a change in the units of measurement is called *scaling the data*. The choice of the scale is made by the investigator so as to make interpretation meaningful and convenient. The choice of the scale does not affect the measurement of the underlying relationship, but it does affect the interpretation of the coefficient estimates and some summary measures. Let us summarize the possibilities:

1. Changing the scale of x: Consider the estimated food expenditure equation

$$\hat{y}_t = 40.77 + 0.1283x_t$$

$$= 40.77 + (100 \times 0.1283)\left(\frac{x_t}{100}\right)$$

In the second line of this equation we have changed the units of measurement of income into hundreds of dollars by dividing x_t by 100. Also, to

keep intact the equality of the left- and right-hand sides, we have multiplied the coefficient 0.1283 by 100. In terms of income measured in hundreds of dollars, $x_t^* = x_t/100$, the equation becomes

$$\hat{y}_t = 40.77 + 12.83x_t^* \tag{R6.8}$$

The new coefficient says that a \$100.00 increase in income will increase food expenditure by \$12.83. Use your computer software to divide income by 100 and re-estimate the equation. Notice that the coefficient of income is, indeed, 100 times larger. Notice, also, that the only other change occurs in the standard error of the regression coefficient, which changes by the same multiplicative factor as the coefficient, so that their ratio, the t-statistic, is unaffected. All other regression statistics are unchanged.

2. Changing the scale of y: If we change the units of measurement of y, but not x, then all the coefficients must change in order for the equation to remain valid. For example, if food expenditure is measured in cents rather than dollars, we multiply y_t by 100 to get

$$100\hat{y}_t = (100 \times 40.77) + (100 \times 0.1283)x_t$$
$$\hat{y}_t^* = 4077 + 12.83x_t \tag{R6.9}$$

This model says that someone with zero income will spend 4077 cents per week on food, and that a \$1 per week increase in income will increase food expenditure by 12.83 cents. This process also scales the least squares residuals and the standard errors of the regression coefficients, but it will not affect t-statistics or R^2.

3. If the scale of y and the scale of x are changed by the same factor, then there will be no change in the reported regression results for b_2, but the estimated intercept and residuals will change; t-statistics and R^2 are unaffected. The interpretation of the parameters is made relative to the new units of measurement.

In Exercise 6.11 we allow you to explore the effects of rescaling the food expenditure data.

6.3 Choosing a Functional Form

In the household food expenditure function the dependent variable, household food expenditure, has been assumed to be a linear function of household income. That is, we represented the economic relationship as $E(y_t) = \beta_1 + \beta_2 x_t$, which implies that there is a linear, straight-line relationship between $E(y)$ and x. The econometric model that corresponds to this economic model is

$$y_t = \beta_1 + \beta_2 x_t + e_t \tag{6.3.1}$$

This brings us to our first of many "what if" questions about the model. What if the relationship between y_t and x_t is not linear? Fortunately, all we have done is

not lost. One of the important features of the simple linear regression model is that it is much more flexible than it appears at first glance.

> **REMARK:** The term *linear* in "simple linear regression model" means not a linear relationship between the variables, but a model in which the *parameters* enter in a linear way. That is, the model is "linear in the parameters," but it is not, necessarily, "linear in the *variables*."

By "linear in the parameters" we mean that the *parameters* are not multiplied together, divided, squared, cubed, and so on. The variables, however, can be *transformed* in any convenient way, *as long as the resulting model satisfies assumptions SR1–SR5 of the simple linear regression model.*

The motivation for this discussion is that economic theory does not always imply that there is a linear relationship between the variables. For example, in the food expenditure model we do *not* expect that as household income rises, food expenditures will continue to rise indefinitely at the same constant rate. Instead, as income rises we expect food expenditures to rise, but we expect such expenditures to increase at a decreasing rate. This phrase is used many times in economics classes. What it means graphically is that there is not a straight-line relationship between the two variables, and that it might look something like Figure 6.2. As we will see in the next section, by *transforming* the variables y and x we can represent many "nonlinear-in-the-variables" functions and still use the linear regression model.

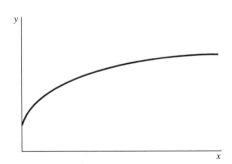

FIGURE 6.2 A nonlinear relationship between food expenditure and income.

Now comes the tricky part. In order to carry out a statistical analysis of a sample of data we must choose an algebraic form that is consistent with economic theory. If we believe that the relationship between $E(y)$ and x looks like Figure 6.2, then specifying a linear relationship between the variables may not produce a satisfactory approximation. In the following section we will present, in a rather straightforward way, some common functional forms, and then apply them.

6.3.1 SOME COMMONLY USED FUNCTIONAL FORMS

Choosing an algebraic form for the relationship means choosing *transformations* of the original variables. This is not an easy process, and it requires good analytic

geometry skills and some experience. It may not come to you easily. Nevertheless, these skills are an important part of an economist's tool kit. The variable transformations that we begin with are:

1. The natural logarithm: if x is a variable, then its natural logarithm is $\ln(x)$.
2. The reciprocal: if x is a variable, then its reciprocal is $1/x$.

Using just these two algebraic transformations, we can represent an amazing variety of "shapes." In Table 6.3 we provide six commonly used statistical models that employ the original variables, y and x, their logarithmic transformations, their reciprocal transformations, or some combination. In Figure 6.3 we illustrate the shapes that these models (without the random errors e_t) can take. Let us examine each of the functional forms in Table 6.3, the shapes they can take, and some economic implications of their use. In models that are *nonlinear in the variables*, great care must be taken when interpreting the parameter values. They are no longer simply the slope and intercept of a line, as they are in the context of a model written in terms of the original variables. If you are unclear about the interpretation of the slopes and elasticities in Table 6.3, or would like details of how they are derived, then visit our web site. There you will find supplementary material on interpreting and using functional forms, and derivations of the results in Table 6.3.

1. The model that is *linear in the variables* describes fitting a straight line to the original data, with slope β_2 and point elasticity $\beta_2 x_t/y_t$. The slope of the relationship is constant, but the elasticity changes at each point.
2. The reciprocal model takes shapes shown in Figure 6.3(a). As x increases, y approaches the intercept, its asymptote, from above or below depending on the sign of β_2. The slope of this curve changes, and flattens out, as x increases. The elasticity also changes at each point and is opposite in sign to β_2. In Figure 6.3(a), when $\beta_2 > 0$, the relationship between x and y is an inverse one and the elasticity is negative: a 1% increase in x leads to a reduction in y of $-\beta_2/(x_t y_t)$ percent.

Table 6.3 **Some Useful Functional Forms**

Type	Statistical Model	Slope	Elasticity
1. Linear	$y_t = \beta_1 + \beta_2 x_t + e_t$	β_2	$\beta_2 \dfrac{x_t}{y_t}$
2. Reciprocal	$y_t = \beta_1 + \beta_2 \dfrac{1}{x_t} + e_t$	$-\beta_2 \dfrac{1}{x_t^2}$	$-\beta_2 \dfrac{1}{x_t y_t}$
3. Log–Log	$\ln(y_t) = \beta_1 + \beta_2 \ln(x_t) + e_t$	$\beta_2 \dfrac{y_t}{x_t}$	β_2
4. Log–Linear (Exponential)	$\ln(y_t) = \beta_1 + \beta_2 x_t + e_t$	$\beta_2 y_t$	$\beta_2 x_t$
5. Linear–Log (Semi-log)	$y_t = \beta_1 + \beta_2 \ln(x_t) + e_t$	$\beta_2 \dfrac{1}{x_t}$	$\beta_2 \dfrac{1}{y_t}$
6. Log–Inverse	$\ln(y_t) = \beta_1 - \beta_2 \dfrac{1}{x_t} + e_t$	$\beta_2 \dfrac{y_t}{x_t^2}$	$\beta_2 \dfrac{1}{x_t}$

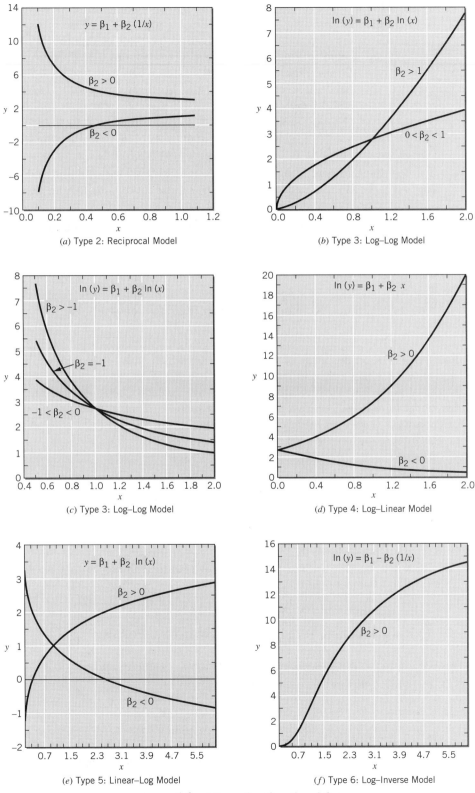

FIGURE 6.3 Alternative functional forms.

3. The log–log model is a very popular one. Its name comes from the fact that the logarithm appears on both sides of the equation. In order to use this model, all values of y and x must be positive. The shapes that this equation can take are shown in Figures 6.3(b) and 6.3(c). Figure 6.3(b) shows cases in which $\beta_2 > 0$, and Figure 6.3(c) shows cases when $\beta_2 < 0$. The slopes of these curves change at every point, but the *elasticity is constant and equal to* β_2. This **constant elasticity model** is very convenient for economists, since we like to talk about elasticities and are familiar with their meaning. *However,* ease of interpretation and convenience are *never* sufficient reasons for choosing a functional form. See the following remark.

4. The log–linear model ("log" on the left-hand-side of the equation and "linear" on the right) can take the shapes shown in Figure 6.3(d). Both its slope and elasticity change at each point and are the same sign as β_2.

5. The linear–log model has shapes shown in Figure 6.3(e). It is an increasing or decreasing function, depending on the sign of β_2.

6. The log–inverse model ("log" on the left-hand-side of the equation and a reciprocal on the right) has a shape shown in Figure 6.3(f). It has the characteristic that near the origin it increases at an increasing rate (convex) and then, after a point, increases at a decreasing rate (concave).

> **REMARK:** Given this array of models, some of which have similar shapes, what are some guidelines for choosing a functional form? We must certainly choose a functional form that is sufficiently flexible to "fit" the data. Choosing a satisfactory functional form helps preserve the model assumptions. That is, a major objective of choosing a functional form, or transforming the variables, is to create a model in which the error term has the following properties:
>
> 1. $E(e_t) = 0$
> 2. $\text{var}(e_t) = \sigma^2$
> 3. $\text{cov}(e_i, e_j) = 0$
> 4. $e_t \sim N(0, \sigma^2)$
>
> If these assumptions hold, then the least squares estimators have good statistical properties and we can use the procedures for statistical inference that we have developed in Chapters 4 and 5.

6.3.2 EXAMPLES USING ALTERNATIVE FUNCTIONAL FORMS

In this section we will examine an array of economic examples and possible choices for the functional form.

6.3.2a The Food Expenditure Model

Suppose that in the food expenditure model we wish to choose a functional form that is consistent with Figure 6.2. From the array of shapes in Figure 6.3 two possible choices that are similar in some aspects to Figure 6.2 are the reciprocal model and the linear–log model. These two functional forms are different ways of modeling the data and lead to estimates of the unknown parameters that have different economic interpretations.

The reciprocal model is

$$y_t = \beta_1 + \beta_2 \, \frac{1}{x_t} + e_t \tag{6.3.2}$$

For the food expenditure model, we might assume that $\beta_1 > 0$ and $\beta_2 < 0$. If this is the case, then as income increases, household consumption of food increases at a decreasing rate and reaches an upper bound β_1. This model is *linear in the parameters* but it is *nonlinear in the variables*. Even so, if the error term e_t satisfies our usual assumptions, then the unknown parameters can be estimated by least squares, and inferences can be made in the usual way.

Another property of the reciprocal model, ignoring the error term, is that when $x < -\beta_2/\beta_1$ the model predicts expenditure on food to be negative. This is unrealistic and implies that this functional form is inappropriate for small values of x.

When choosing a functional form, one practical guideline is to consider how the dependent variable changes with the independent variable. In the reciprocal model the slope of the relationship between y and x is

$$\frac{dy}{dx} = -\beta_2 \, \frac{1}{x_t^2}$$

If the parameter $\beta_2 < 0$, then there is a positive relationship between food expenditure and income, and, as income increases, this "marginal propensity to spend on food" diminishes, as economic theory predicts. Indeed, as x becomes very large the slope approaches zero, which says that as income increases the household expenditure on food stops increasing after some point.

For the food expenditure relationship, an alternative to the reciprocal model is the linear–log model

$$y_t = \beta_1 + \beta_2 \ln(x_t) + e_t \tag{6.3.3}$$

which is shown in Figure 6.3(e). For $\beta_2 > 0$ this function is increasing, but at a decreasing rate. As x increases the slope β_2/x_t decreases. Similarly, the greater the amount of food expenditure y, the smaller the elasticity, β_2/y_t. These results are consistent with the idea that at high incomes, and large food expenditures, the effect of an increase in income on food expenditure is small.

6.3.2b Some Other Economic Models and Functional Forms
In this section we *briefly* describe some common economic models and functional forms that are used when estimating them.

1. **Demand models:** statistical models of the relationship between quantity demanded (y^d) and price (x) are very frequently taken to be linear in the variables, creating a linear demand curve, as so often depicted in textbooks. Alternatively, the log–log form of the model, $\ln(y_t^d) = \beta_1 + \beta_2 \ln(x_t) + e_t$, is very convenient in this situation because of its "constant elasticity" property. Consider Figure 6.3(c), where several log–log models are shown for several values of $\beta_2 < 0$. They are negatively sloped, as is appropriate for demand curves, and the price elasticity of demand is the constant β_2.

2. **Supply models:** if y^s is the quantity supplied, then its relationship to price is often assumed to be linear, creating a linear supply curve. Alternatively, the log–log, constant elasticity form, $\ln(y_t^s) = \beta_1 + \beta_2 \ln(x_t) + e_t$, can be used. Economists are *very* interested in supply and demand, and we devote Chapter 14 in its entirety to these and similar *equilibrium* models.

3. **Production functions:** another basic economic relationship that can be investigated using the simple linear statistical model is a production function, or total product function, that relates the output of a good produced to the amount of a variable input, such as labor. One of the assumptions of production theory is that diminishing returns hold; the marginal-physical product of the variable input declines as more is used. To permit a decreasing marginal product, the relation between output (y) and input (x) is often modeled as a log–log model, with $\beta_2 < 1$. This relationship is shown in Figure 6.3(b). It has the property that the marginal product, which is the slope of the total product curve, is diminishing, as required.

4. **Cost functions:** a family of cost curves, which can be estimated using the simple linear regression model, is based on a "quadratic" total cost curve. Suppose that you wish to estimate the total cost (y) of producing output (x); then a potential model is given by

$$y_t = \beta_1 + \beta_2 x_t^2 + e_t \tag{6.3.4}$$

If we wish to estimate the average cost (y/x) of producing output x then we might divide both sides of (6.3.4) by x and use

$$(y_t/x_t) = \beta_1/x_t + \beta_2 x_t + e_t/x_t \tag{6.3.5}$$

which is consistent with the quadratic total cost curve.

5. **The Phillips curve:** one important relationship in the macro-literature is the Phillips curve that was suggested by A. W. Phillips in 1958. This important relationship conjectures a systematic relationship between changes in the wage rate and changes in the level of unemployment. If we let w_t be the wage rate in time t, then the percentage change in the wage rate is

$$\%\Delta w_t = \frac{w_t - w_{t-1}}{w_{t-1}} \tag{6.3.6}$$

If we assume that $\%\Delta w_t$ is proportional to the excess demand for labor d_t, we may write

$$\%\Delta w_t = \gamma d_t \tag{6.3.7}$$

where γ is an economic parameter. Since the unemployment rate u_t is inversely related to the excess demand for labor, we could write this using a reciprocal function as

$$d_t = \alpha + \eta \frac{1}{u_t} \tag{6.3.8}$$

where α and η are economic parameters. Given (6.3.7) we can substitute for d_t, and rearrange, to obtain

$$\%\Delta w_t = \gamma \left(\alpha + \eta \, \frac{1}{u_t} \right)$$

$$= \gamma\alpha + \gamma\eta \, \frac{1}{u_t}$$

This model is *nonlinear in the parameters* and *nonlinear in the variables*. However, if we represent $y_t = \%\Delta w_t$ and $x_t = 1/u_t$, and $\gamma\alpha = \beta_1$ and $\gamma\eta = \beta_2$, then the simple linear regression model $y_t = \beta_1 + \beta_2 x_t + e_t$ represents the relationship between the rate of change in the wage rate and the unemployment rate.

6.3.3 CHOOSING A FUNCTIONAL FORM: EMPIRICAL ISSUES

How does one choose the best transformation for y and x, and hence the best functional form for describing the relationship between y and x? Unfortunately, there are no hard and fast rules that will work for all situations. The best we can do is give examples and describe all the issues that are worth considering. So far, we have focused on theoretical issues, with questions like: Does a selected function possess the theoretical properties considered desirable in the economic relationship being examined? We also mentioned that we should choose a function such that the properties of the simple regression model hold. More will be said on these points as we move through the text. In this section we turn to some empirical issues related to choice of functional form.

Figure 6.4 describes a plot of average wheat yield (in tonnes per hectare) for the Greenough Shire in Western Australia, against time. The observations are for the period 1950–1997, and time is measured using the values 1,2, ... , 48. These data can be found in the fourth and fifth columns of the file *y1y4.dat*. Yield is in column 4, and time is in column 5. Notice in Figure 6.4 that wheat yield fluctuates quite a bit, but, overall, it tends to increase over time, and the increase is at an increasing rate, particularly towards the end of the time period. An increase in yield is expected because of technological improvements, such as the development of varieties of wheat which are higher yielding and more resistant to pests and diseases. Suppose that we are interested in measuring the effect of technological improvement on yield. Such a relationship would be of particular interest to organizations that distribute wheat research funds. Direct data on changes in technology are not available, but we can examine how wheat yield has changed over time as a consequence of changing technology.

Let y = yield and let x = time, measured from 1 to 48. One problem with the linear equation

$$y_t = \beta_1 + \beta_2 x_t + e_t \tag{6.3.9}$$

is that it implies that yield increases at the same constant rate β_2, when, from Figure 6.4, we expect this rate to be increasing. Let us examine the consequences of estimating (6.3.9). The least squares estimated equation is

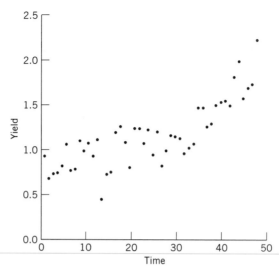

FIGURE **6.4** Scatter plot of wheat yield over time.

$$\hat{y}_t = 0.638 + 0.0210x_t \qquad R^2 = 0.649$$
$$(0.064)\ (0.0022) \qquad\quad (\text{s.e.})$$

(R6.10)

The predicted values from this regression (\hat{y}_t), along with the actual values for yield, are displayed in the upper part of Figure 6.5. The lower part of the graph displays the residuals, centered around zero. The values on the x-axis represent the years 1950–1997. Notice that there is a concentration of positive residuals at each end of the sample and a concentration of negative residuals in the middle. The bar chart in Figure 6.6 makes these concentrations even more apparent. They are caused by the inability of the straight line to capture the fact that yield is increasing at an increasing rate.

FIGURE **6.5** Predicted, actual and residual values from straight line.

FIGURE **6.6** Bar chart of residuals from straight line.

What alternative can we try? Two possibilities are x^2 and x^3. It turns out that x^3 provides the better fit, and so we consider instead the functional form

$$y_t = \beta_1 + \beta_2 x_t^3 + e_t \qquad (6.3.10)$$

The slope of this function is $dy_t/dx_t = 3\beta_2 x_t^2$. So, providing the estimate of β_2 turns out to be positive, the function will be increasing, and it will be increasing at the same rate as x_t^2 increases. Before estimating (6.3.10), note that the values of x_t^3 can get very large. This variable is a good candidate for scaling along the lines discussed in Section 6.2.3. We define $z_t^3 = x_t^3/1,000,000$. Then, the estimated version of (6.3.10) is

$$\hat{y}_t = 0.874 + 9.68 z_t^3 \qquad R^2 = 0.751$$
$$\quad\;\; (0.036)\;(0.824) \qquad\quad \text{(s.e.)} \qquad\qquad\qquad \text{(R6.11)}$$

The fitted, actual, and residual values from this equation appear in Figure 6.7. Notice how the predicted (fitted) values are now increasing at an increasing rate. Also, the predominance of positive residuals at the ends and negative residuals in the middle no longer exists. Furthermore, the R^2 value has increased from 0.649 to 0.751, indicating that the equation with x^3 fits the data better than the one with just x. Both these equations have the same dependent variable (y_t), and the same number of explanatory variables (only 1). In these circumstances the R^2 can be used legitimately to compare goodness-of-fit. If the dependent variables are different, say y_t and $\log(y_t)$, or the numbers of explanatory variables in each equation are different, a direct comparison using R^2 is not possible. This issue is considered further in Chapter 8.

What lessons have we learned from this example? First, a plot of the original dependent variable series y against the explanatory variable x is a useful starting point for deciding on a functional form. Secondly, examining a plot of the residuals is a useful device for uncovering inadequacies in any chosen functional form. Runs of positive and/or negative residuals can suggest an alternative. As we travel through the book, you will discover that patterns in the residuals can also mean many other specification inadequacies, such as omitted variables, heteroskedastic-

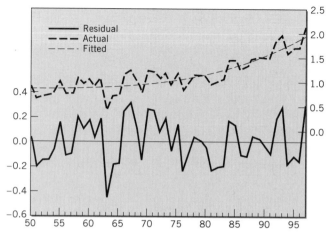

FIGURE **6.7** Fitted, actual and residual values from equation with cubic term.

ity, and autocorrelation. Thus, as you become more knowledgeable and experienced, you should be careful to consider other options. For example, wheat yield in Western Australia is heavily influenced by rainfall. Inclusion of a rainfall variable might be an option worth considering.

6.4 Are the Residuals Normally Distributed?

Recall that hypothesis tests and interval estimates for the coefficients relied on the assumption that the errors, and hence the dependent variable y, are normally distributed. Thus, when choosing a functional form, it is desirable to create a model in which the errors are normally distributed. Can the assumption of normally distributed errors be checked out? Most computer software will create a histogram of the residuals for this purpose, and also give statistics that can be used to formally test a null hypothesis that the residuals come from a normal distribution. The relevant EViews output for the food expenditure example appears in Figure 6.8.

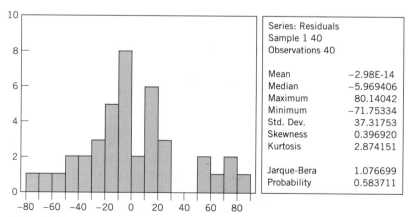

FIGURE **6.8** EViews output: Residuals histogram and summary statistics for food expenditure example.

What does this histogram tell us? First, notice that it is centered around zero, the mean of the least squares residuals. Second, it seems, on the whole, to represent an approximate normal distribution, but the low count in the cell on the right of zero, and the empty cells near 40, may make us wonder if a formal test would reject a hypothesis of normality. A convenient formal test is one that is attributable to Jarque and Bera and has been named after them.

The Jarque-Bera test for normality is based on two measures: skewness and kurtosis. In the present context, *skewness* refers to how symmetric the residuals are around zero. Perfectly symmetric residuals will have a skewness of zero. The skewness value for the food expenditure residuals is 0.397. *Kurtosis* refers to the "peakedness" of the distribution. For a normal distribution the kurtosis value is 3. From Figure 6.8, we see that the food expenditure residuals have a kurtosis of 2.87. So, the question we have to ask is whether 2.87 is sufficiently different from 3, and 0.397 sufficiently different from zero, to conclude the residuals are not normally distributed. The Jarque-Bera statistic is given by

$$JB = \frac{T}{6} \left(S^2 + \frac{(k-3)^2}{4} \right)$$

where S is skewness and k is kurtosis. Thus, large values of the skewness, and/or values of kurtosis quite different from 3, will lead to a big value of the Jarque-Bera statistic. When the residuals are normally distributed, the Jarque-Bera statistic has a chi-squared distribution with 2 degrees of freedom. Thus, we reject the hypothesis of normally distributed errors if a calculated value of the statistic exceeds a critical value selected from the chi-squared distribution with 2 degrees of freedom.

Applying these ideas to the food expenditure example, we have

$$JB = \frac{40}{6} \left(0.3969^2 + \frac{(2.874-3)^2}{4} \right) = 1.077 \qquad \text{(R6.12)}$$

The 5% critical value from a χ^2 distribution with 2 degrees of freedom is 5.99. Because $1.077 < 5.99$, there is insufficient evidence from the residuals to conclude that the normal distribution assumption is unreasonable. The same conclusion could have been reached by examining the *p*-value. The *p*-value appears in the EViews output described as "Probability." Thus, we also fail to reject the null hypothesis on the grounds that $0.584 > 0.05$.

6.5 Learning Objectives

Based on the material in this chapter, you should be able to:

1. Decompose the total sum of squares of the dependent variable y in a regression into its two components: the regression sum of squares and the error sum of squares.

2. Explain the meaning of *SST*, *SSR*, and *SSE*, and identify where these quantities appear in an Analysis of Variance Table.

3. Define and explain the meaning of the coefficient of determination. What other interpretation can you give to the coefficient of determination?

4. Report the results of a fitted regression equation in such a way that confidence intervals and hypothesis tests for the unknown coefficients can be constructed quickly and easily.

5. Explain the meaning of all the quantities that are typically reported in the results from a regression equation.

6. Describe how estimated coefficients and other quantities from a regression equation will change when the variables are scaled. Why would you want to scale the variables?

7. Explain the difference between a model which is linear in the variables and one which is linear in the parameters.

8. Appreciate the wide range of nonlinear functions that can be estimated using a model that is linear in the parameters.

9. Write down the equations for the following functional forms: (a) linear, (b) reciprocal, (c) log–log, (d) log–linear, (e) linear–log, and (f) log–inverse.

10. Know the difference between the slope of a functional form, and the elasticity from a functional form. Understand the different slopes and elasticities from the six functions listed in point 9.

11. Give some economic examples of the different functional forms.

12. How would you go about choosing a functional form?

13. How might you decide whether a functional form is adequate?

14. How do you test whether the equation "errors" are normally distributed?

6.6 Exercises

6.1 Suppose that a simple regression has quantities $\sum(y_t - \bar{y})^2 = 631.63$ and $\sum \hat{e}_t^2 = 182.85$. Find R^2.

6.2 Suppose that a simple regression has quantities $T = 20$, $\sum y_t^2 = 5930.94$, $\bar{y} = 16.035$, and $SSR = 666.72$. Find R^2.

6.3 Suppose that a simple regression has quantities $R^2 = 0.7911$, $SST = 552.36$ and $T = 20$. Find $\hat{\sigma}^2$.

6.4 Consider the following estimated regression equation:

$$\hat{y}_t = 5.83 + 0.869x_t \qquad R^2 = 0.756$$
$$\quad (1.23)\ (0.117) \qquad \text{(s.e.)}$$

Rewrite the estimated equation that would result if:
(a) all values of x_t were divided by 10 before estimation.
(b) all values of y_t were divided by 10 before estimation.
(c) all values of y_t and x_t were divided by 10 before estimation.

6.5* Show that, if an intercept is present in the regression model, then $\sum(\hat{y}_t - \bar{y})\hat{e}_t = 0$.

6.6 The Phillips curve that was introduced in Section 6.3 says that the rate of change of money wages is a function of the reciprocal of the unemployment

rate. Specifically, let

w_t = money wage rate in year t

u_t = unemployment rate in year t

$\%\Delta w_t = \dfrac{w_t - w_{t-1}}{w_{t-1}} \times 100$ = percentage rate of change in the wage rate

The Phillips curve is given by

$$\%\Delta w_t = \beta_1 + \beta_2 \, \frac{1}{u_t} + e_t$$

where it is hypothesized that $\beta_1 < 0$ and $\beta_2 > 0$. Using the 18 observations on aggregate data given in the file *phillips.dat:*
(a) Find least squares estimates for β_1 and β_2.
(b) Test whether there is a relationship between $\%\Delta w$ and $(1/u)$.
(c) Draw a graph of the estimated relationship with u on the horizontal axis and $\%\Delta w$ on the vertical axis.
(d) Find an estimate for the "natural rate of unemployment" (the natural rate of unemployment is the rate for which $\%\Delta w = 0$).
(e) Find estimates for $d(\%\Delta w)/du$ when $u = 1$ and when $u = 3$.
(f) When does a change in the unemployment rate have the greatest impact on the rate of change in wages? When does it have the smallest?
(g) What is the economic meaning of β_1 and what is suggested by its estimate b_1?
(h) Find 95 percent interval estimates for β_1 and β_2.

6.7* (a) Using the format suggested in Chapter 1.6, write up the research results for Exercise 6.6. Your write-up should include the economic model, the statistical model, the sample observations, the estimation methods, the empirical results, the statistical implications, and the economic implications.
(b) Locate the sources and develop the nominal wage change $\%\Delta w$ and unemployment rate u observations for the period 1974–1983 for the U.S. economy.
(c) Carry through an econometric analysis of the data obtained under (b).

6.8 Verify numerically using the food expenditure data that
(a) the square of the sample correlation coefficient between the predicted and actual y values is the coefficient of determination: $r^2 = R^2$.
(b) the square of the sample correlation coefficient between x and y is equal to the coefficient of determination in the simple linear regression model.
(c) Show algebraically that the result in (b) is true.

6.9 Reconsider the learning curve data in Exercise 3.8. Discuss the economic interpretation of the parameters of this model in light of the discussion in Chapter 6.3.

6.10 Use your computer software to graph the relationship between a variable $x > 0$ and its natural logarithm $\ln(x)$.

6.11 Consider the food expenditure data in Table 3.1.
(a) Using your computer software, create the variables $y_t^* = y_t/100$ and $x_t^* = x_t/100$.

(b) Estimate the following models and discuss the similarities and differences in these results:

(i) Regress y on x

(ii) Regress y on x^*

(iii) Regress y^* on x

(iv) Regress y^* on x^*

6.12 The first three columns in the file *y1y4.dat* contain observations on wheat yield in the Western Australian shires Northampton, Chapman Valley, and Mullewa, respectively. There are 48 annual observations for the years 1950–1997. For the Chapman Valley shire, consider these three equations:

$$y_t = \beta_1 + \beta_2 t + e_t$$
$$y_t = \alpha_1 + \alpha_2 \ln(t) + e_t$$
$$y_t = \gamma_1 + \gamma_2 t^2 + e_t$$

Estimate each of the three equations. Taking into consideration

(a) plots of the fitted equations,

(b) plots of the residuals, and

(c) values for R^2,

which equation do you think is preferable?

6.13 For the equation of your choice in Exercise 6.12, test whether the errors could be viewed as normally distributed.

6.14 For each of the three functions in Exercise 6.12,

(a) Find the predicted value for yield when $t = 49$.

(b) Find estimates of the slopes dy_t/dt at the point $t = 49$.

(c) Find estimates of the elasticities $(dy_t/dt)(t/y_t)$ at the point $t = 49$.

Comment on the estimates you obtained in parts (b) and (c). What is their significance?

6.15 The file *london.dat* is a cross section of 1519 households drawn from the 1980–1982 British Family Expenditure Surveys. Data have been selected to include only households with one or two children living in Greater London. Self-employed and retired households have been excluded. The data were used by:

Richard Blundell, Alan Duncan, and Krishna Pendakur, "Semiparametric Estimation and Consumer Demand," *Journal of Applied Econometrics*, Vol. 13, No. 5, 1998, pp. 435–462.

List of variables

$wfood$ = budget share for food expenditure

$wfuel$ = budget share for fuel expenditure

$wcloth$ = budget share for clothing expenditure

$walc$ = budget share for alcohol expenditure

$wtrans$ = budget share for transportation expenditure

$wother$ = budget share for other expenditures

$totexp$ = total household expenditure
(rounded to the nearest 10 UK pounds sterling)
$income$ = total net household income
(rounded to the nearest 10 UK pounds sterling)
age = age of household head
nk = number of children

The budget share of a commodity, say food, is defined as

$$wfood = \frac{\text{expenditure on food}}{\text{total expenditure}}$$

A functional form that has been popular for estimating expenditure functions for commodities is

$$wfood = \beta_1 + \beta_2 \ln(totexp) + e$$

(a) Estimate this function for households with one child and households with two children. Report and comment on the results. (You may find it more convenient to use the files *lon1.dat* and *lon2.dat* that contain the data for the one and two children households, with 594 and 925 observations, respectively.)
(b) It can be shown that the expenditure elasticity for food is given by

$$\eta = \frac{\beta_1 + \beta_2 [\ln(totexp) + 1]}{\beta_1 + \beta_2 \ln(totexp)}$$

Find estimates of this elasticity for one- and two-children households, evaluated at average total expenditure in each case. Do these estimates suggest food is a luxury or a necessity? (Are the elasticities greater than one or less than one?)
(c) Analyze the residuals from each estimated function. Does the functional form seem appropriate? Is it reasonable to assume the errors are normally distributed?

6.16* Prove the elasticity result given in Exercise 6.15(b).

6.17 Repeat Exercise 6.15 using fuel expenditure rather than food expenditure.

6.18 Repeat Exercise 6.15 using alcohol expenditure rather than food expenditure.

6.19 Does an increase in the concentration of arsenic in drinking water lead to an increase in the concentration of arsenic in toenails? These concentrations were measured in 15 wells and in toenail clippings from 15 corresponding people. The measurements in parts per million appear in the file *arsen.dat*. Let y = toenail concentration and x = water concentration.
(a) Plot the following observations:
 (i) y against x
 (ii) $\ln(y)$ against $\ln(x)$
 (iii) y against $\ln(x)$
 (iv) $\ln(y)$ against x
 Based on these plots, what functional form would you choose for relating y to x? Choose from those listed in part (a).

(b) Estimate the following equations:
 (i) $y_t = \beta_1 + \beta_2 x_t + e_t$
 (ii) $\ln(y_t) = \alpha_1 + \alpha_2 \ln(x_t) + e_t$
 (iii) $y_t = \gamma_1 + \gamma_2 \ln(x_t) + e_t$
 (iv) $\ln(y_t) = \theta_1 + \theta_2 x_t + e_t$
 Report the results. Does the level of arsenic in the water appear to influence the level of arsenic in the toenails?

(c) Plot the residuals for each of the above regressions against the relevant explanatory variable. Do these plots support your choice of function in part (a)?

6.20 You wish to investigate how dietary habits change with age. In the file *diet.dat* you have observations on the following variables for 314 individuals:

AGE: age in years.
FIBER: grams of fiber consumed per day.
CALORIES: number of calories consumed per day.
CHOL: cholesterol consumed in mg per day.
FAT: grams of fat consumed per day.

Estimate four equations with fiber, calories, cholesterol, and fat as the dependent variables and age as the explanatory variable. Report the results and explain what you have discovered. Do you think age is a good predictor for dietary intake?

6.21 The file *appli.dat* gives unit shipments of dishwashers, disposers, refrigerators, and washers in the United States from 1960 to 1985. This and other data are published currently in the Department of Commerce's Survey of Current Business. Also included in the file are durable goods expenditures and private residential investment in the United States. Specifically, the variables are:
1. YEAR: 1960 to 1985
2. DISH: Factory shipments of dishwashers (thousands)
3. DISP: Factory shipments of disposers (thousands)
4. FRIG: Factory shipments of refrigerators (thousands)
5. WASH: Factory shipments of washing machines (thousands)
6. DUR: Durable goods expenditures (billions of 1972 dollars)
7. RES: Private residential investment (billions of 1972 dollars)

 (a) Suppose that you wish to predict dishwasher shipments for 1986. Which variable is the best predictor, durable goods expenditure or private residential investment?
 (b) Given the 1986 data are DISH = 3915, DUR = 208.2 and RES = 67.2, would you change the conclusion you drew for part (a).
 (c) For each of the two regression equations, plot the residuals against time. What does the residual pattern suggest to you?

6.22 Repeat Exercise 6.21 using washing machines instead of dishwashers. For 1986, use WASH = 5320.

The Multiple Regression Model

The simple regression model, with one explanatory variable, is useful in a range of situations. However, most problems involve two or more explanatory variables that influence the dependent variable y. For example, in a demand equation the quantity demanded of a commodity depends on the price of that commodity, the prices of substitute and complementary goods, and income. Output in a production function will be a function of more than one input. Aggregate money demand will be a function of aggregate income and the interest rate. Investment will depend on the interest rate and changes in income.

When we turn an economic model with more than one explanatory variable into its corresponding econometric model, we refer to it as a **multiple regression model.** Most of the results we developed for the simple regression model in Chapters 3–6 can be extended naturally to this general case. There are slight changes in the interpretation of the β parameters, the degrees of freedom for the t-distribution will change, and we will need to modify the assumption concerning the characteristics of the explanatory (x) variables.

As an example for introducing and analyzing the multiple regression model, consider a model used to explain total revenue for a fast-food hamburger chain in the San Francisco Bay area. We begin with an outline of this model and the questions that we hope it will answer.

7.1 Model Specification and the Data

7.1.1 THE ECONOMIC MODEL

Each week the management of a Bay Area Rapid Food hamburger chain must decide how much money should be spent on advertising their products and what specials (lower prices) should be introduced for that week. Of particular interest to management is how total revenue changes as the level of advertising expenditure changes. Does an increase in advertising expenditure lead to an increase in total revenue? If so, is the increase in total revenue sufficient to justify the increased advertising expenditure? Management is also interested in pricing strategy. Will reducing prices lead to an increase or decrease in total revenue? If a reduction in price leads only to a small increase in the quantity sold, total revenue will fall (demand is price inelastic); a price reduction that leads to a large increase in quantity sold will produce

an increase in total revenue (demand is price elastic). This economic information is essential for effective management.

The first step is to set up an economic model in which total revenue depends on one or more explanatory variables. We initially hypothesize that total revenue, *tr*, is linearly related to price, *p*, and advertising expenditure, *a*. Thus, the economic model is

$$tr = \beta_1 + \beta_2 p + \beta_3 a \qquad (7.1.1)$$

where *tr* represents total revenue for a given week, *p* represents price in that week, and *a* is the level of advertising expenditure during that week. Both *tr* and *a* are measured in terms of thousands of dollars.

How we measure price is not so clear, however, since a hamburger outlet sells a number of products: burgers, fries, and shakes, and each product has its own price. What we need for the model in (7.1.1) is some kind of average price for all products, and information on how this average price changes from week to week. Let us assume that management has constructed a single weekly price series, *p*, measured in dollars and cents, that describes overall prices.

The remaining items in (7.1.1) are the unknown parameters β_1, β_2, and β_3 that describe the dependence of revenue (*tr*) on price (*p*) and advertising (*a*). In the multiple regression model the intercept parameter, β_1, is the value of the dependent variable when each of the independent, explanatory variables takes the value zero. In many cases this parameter has no clear economic interpretation, but it is almost always included in the regression model. It helps in the overall estimation of the model and in prediction.

The other parameters in the model measure the change in the value of the dependent variable given a unit change in an explanatory variable, *all other variables held constant*. For example, in (7.1.1),

> β_2 = the change in *tr* ($1000) when *p* is increased by one unit ($1), and *a* is held constant, or
>
> $$\beta_2 = \frac{\Delta tr}{\Delta p}_{(a\text{ held constant})} = \frac{\partial tr}{\partial p}$$

The symbol ∂ stands for "partial differentiation." Those of you familiar with calculus may have seen this operation. It means that, as the definition states, we calculate the change in one variable, *tr*, when the variable *p* changes, all other factors, *a*, held constant. We will occasionally use this symbol, but you will not be asked to evaluate such derivatives.

The sign of β_2 could be positive or negative. If an increase in price leads to an increase in revenue, then $\beta_2 > 0$, and the demand for the chain's products is price inelastic. Conversely, a price elastic demand exists if an increase in price leads to a decline in revenue, in which case $\beta_2 < 0$. Thus, knowledge of the *sign* of β_2 provides information on the price elasticity of demand. The *magnitude* of β_2 measures the amount of the change in revenue for a given price change.

The parameter β_3 describes the response of revenue to a change in the level of advertising expenditure. That is,

> β_3 = the change in tr ($1000) when a is increased by one unit ($1000), and p is held constant, or
>
> $$\beta_3 = \frac{\Delta tr}{\Delta a}_{(p\,\text{held constant})} = \frac{\partial tr}{\partial a}$$

We expect the sign of β_3 to be positive. That is, we expect that an increase in advertising expenditure, unless the ad is offensive, will lead to an increase in total revenue. Whether or not the increase in total revenue is sufficient to justify the added advertising expenditure, and the added cost of producing more hamburgers, is another question. With $\beta_3 < 1$, an increase of $1,000 in advertising expenditure will yield an increase in total revenue that is less than $1,000. For $\beta_3 > 1$, it will be greater. Thus, in terms of the chain's advertising policy, knowledge of β_3 is very important.

The next step along the road to learning about β_1, β_2, and β_3 is to convert the economic model into an econometric model.

7.1.2 THE ECONOMETRIC MODEL

The economic model in (7.1.1) describes the expected or average behavior of many individual franchises. As such, we should write it as $E(tr) = \beta_1 + \beta_2 p + \beta_3 a$, where $E(tr)$ is the "expected value" of total revenue. Writing it in this way recognises that weekly data for total revenue, price, and advertising for all franchises will not follow an exact linear relationship. Equation (7.1.1) describes not a line as in Chapters 3–6, but a *plane*. The plane intersects the vertical axis at β_1. The parameters β_2 and β_3 measure the slope of the plane in the directions of the "price axis" and the "advertising axis," respectively. Table 7.1 shows representative weekly observations on total revenue, price and advertising expenditure for a hamburger franchise. The complete set of 52 observations is contained in the file *table7-1.dat*. If we plot the data we obtain Figure 7.1. These data do not fall exactly on a plane, but instead

Table 7.1 **Weekly Observations on Revenue, Price, and Advertising Expenditure for the Hamburger Chain**

Week	Revenue (*tr*) $1,000 units	Price (*p*) $	Advertising (*a*) $1,000 units
1	123.1	1.92	12.4
2	124.3	2.15	9.9
3	89.3	1.67	2.4
4	141.3	1.68	13.8
5	112.8	1.75	3.5
48	120.1	1.94	9.3
49	107.4	2.37	8.3
50	128.6	2.10	15.4
51	124.6	2.29	9.2
52	127.2	2.36	10.2

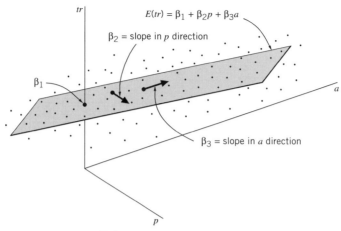

FIGURE **7.1** The multiple regression plane.

resemble a "cloud." To allow for a difference between observable total revenue and the expected value of total revenue we add a *random error term, e = tr − E(tr)*. This random error represents all the factors that cause weekly total revenue to differ from its expected value. These factors might include the weather, the behavior of competitors, a new surgeon general's report on the deadly effects of fat intake, and so on. Denoting the *t*'th weekly observation by the subscript *t*, we have

$$tr_t = E(tr_t) + e_t = \beta_1 + \beta_2 p_t + \beta_3 a_t + e_t \qquad (7.1.2)$$

The economic model in (7.1.1) describes the average, systematic relationship between the variables *tr*, *p*, and *a*. The expected value $E(tr)$ is the nonrandom, systematic component, to which we add the random error *e* to determine *tr*. Thus, *tr* is a random variable. We do not know what the value of weekly total revenue will be until we observe it.

The introduction of the error term, and assumptions about its probability distribution, turn the economic model into the *econometric* model in (7.1.2). The econometric model provides a more realistic description of the relationship between the variables, as well as a framework for developing and assessing estimators of the unknown parameters.

7.1.2a The General Model

Let's digress for a moment and summarize how the concepts developed so far relate to the general case. In a general multiple regression model, a dependent variable y_t is related to a number of *explanatory variables* $x_{t2}, x_{t3}, \ldots, x_{tK}$ through a linear equation that can be written as

$$y_t = \beta_1 + \beta_2 x_{t2} + \beta_3 x_{t3} + \cdots + \beta_K x_{tK} + e_t \qquad (7.1.3)$$

The coefficients $\beta_2, \beta_3, \ldots, \beta_K$ are unknown parameters. The parameter β_k measures the effect of a change in the variable x_{tk} upon the expected value of y_t, $E(y_t)$, all other variables held constant. The parameter β_1 is the intercept term. The "variable" to which β_1 is attached is $x_{t1} = 1$.

The equation for total revenue can be viewed as a special case of (7.1.3) where $K = 3$, $y_t = tr_t$, $x_{t1} = 1$, $x_{t2} = p_t$, and $x_{t3} = a_t$. Thus we rewrite (7.1.2) as

$$y_t = \beta_1 + \beta_2 x_{t2} + \beta_3 x_{t3} + e_t \qquad (7.1.4)$$

In this chapter we introduce point and interval estimation in terms of this model with $K = 3$. The results generally hold for models with more explanatory variables ($K > 3$).

7.1.2b The Assumptions of the Model

To make the econometric model in (7.1.4) complete, assumptions about the probability distribution of the random errors, e_t, need to be made. The assumptions that we introduce for e_t are similar to those introduced for the simple regression model in Chapter 3. They are

1. $E[e_t] = 0$. Each random error has a probability distribution with zero mean. Some errors will be positive, some will be negative; over a large number of observations they will average out to zero. With this assumption we assert that the average of all the omitted variables, and any other errors made when specifying the model, is zero. Thus, we are asserting that our model is, on average, correct.

2. $\text{var}(e_t) = \sigma^2$. Each random error has a probability distribution with variance σ^2. The variance σ^2 is an unknown parameter and it measures the uncertainty in the statistical model. It is the same for each observation, so that for no observations will the model uncertainty be more, or less, nor is it directly related to any economic variable. Errors with this property are said to be *homoskedastic*.

3. $\text{cov}(e_t, e_s) = 0$. The covariance between the two random errors corresponding to any two different observations is zero. The size of an error for one observation has no bearing on the likely size of an error for another observation. Thus, any pair of errors is uncorrelated.

4. We will sometimes further assume that the random errors e_t have normal probability distributions. That is, $e_t \sim N(0, \sigma^2)$.

Because each observation on the dependent variable y_t depends on the random error term e_t, each y_t is also a random variable. The statistical properties of y_t follow from those of e_t. These properties are

1. $E(y_t) = \beta_1 + \beta_2 x_{t2} + \beta_3 x_{t3}$. The expected (average) value of y_t depends on the values of the explanatory variables and the unknown parameters. This assumption is equivalent to $E(e_t) = 0$. It says that the average value of y_t changes for each observation and is given by the *regression function* $E(y_t) = \beta_1 + \beta_2 x_{t2} + \beta_3 x_{t3}$.

2. $\text{var}(y_t) = \text{var}(e_t) = \sigma^2$. The variance of the probability distribution of y_t does not change with each observation. Some observations on y_t are not more likely to be further from the regression function than others.

3. $\text{cov}(y_t, y_s) = \text{cov}(e_t, e_s) = 0$. Any two observations on the dependent variable are uncorrelated. For example, if one observation is above $E(y_t)$, a subsequent observation is not more or less likely to be above $E(y_t)$.

4. We sometimes will assume that the values of y_t are normally distributed about their mean. That is, $y_t \sim N[(\beta_1 + \beta_2 x_{t2} + \beta_3 x_{t3}), \sigma^2]$, which is equivalent to assuming that $e_t \sim N(0, \sigma^2)$.

In addition to the above assumptions about the error term (and hence, about the dependent variable), we make two assumptions about the explanatory variables. The first is that the explanatory variables are not random variables. Thus, we are assuming that the values of the explanatory variables are known to us prior to observing the values of the dependent variable. This assumption is realistic for our hamburger chain where a decision about prices and advertising is made each week and values for these variables are set accordingly. For cases in which this assumption is untenable, our analysis will be conditional upon the values of the explanatory variables in our sample, or, further assumptions must be made. These issues are taken up further in Chapter 13.

The second assumption is that any one of the explanatory variables is not an exact linear function of any of the others. This assumption is equivalent to assuming that no variable is redundant. As we will see, if this assumption is violated, a condition called *exact collinearity*, the least squares procedure fails.

To summarize then, let us construct a list of the assumptions for the general multiple regression model in (7.1.3), much as we have done in the earlier chapters, to which we can refer as needed:

ASSUMPTIONS OF THE MULTIPLE REGRESSION MODEL

MR1. $y_t = \beta_1 + \beta_2 x_{t2} + \cdots + \beta_K x_{tK} + e_t, \qquad t = 1, \ldots, T$

MR2. $E(y_t) = \beta_1 + \beta_2 x_{t2} + \cdots + \beta_K x_{tK} \Leftrightarrow E(e_t) = 0.$

MR3. $\text{var}(y_t) = \text{var}(e_t) = \sigma^2$

MR4. $\text{cov}(y_t, y_s) = \text{cov}(e_t, e_s) = 0$

MR5. The values of x_{tk} are not random and are not exact linear functions of the other explanatory variables.

MR6. $y_t \sim N[(\beta_1 + \beta_2 x_{t2} + \cdots + \beta_K x_{tK}), \sigma^2] \Leftrightarrow e_t \sim N(0, \sigma^2)$

7.2 Estimating the Parameters of the Multiple Regression Model

In this section we consider the problem of using the least squares principle to estimate the unknown parameters of the multiple regression model. We will discuss estimation in the context of the model in (7.1.4), which we repeat here for convenience.

$$y_t = \beta_1 + \beta_2 x_{t2} + \beta_3 x_{t3} + e_t \qquad (7.2.1)$$

This model is simpler than the full model, and yet all the results we present carry over to the general case with only minor modifications.

7.2.1 LEAST SQUARES ESTIMATION PROCEDURE

To find an estimator or rule for estimating the unknown parameters, we follow the least squares procedure that was first introduced in Chapter 3 for the simple regression model. With the least squares principle we minimize the sum of squared differences between the observed values of y_t and their expected values $E[y_t] = \beta_1 + x_{t2}\beta_2 + x_{t3}\beta_3$. Mathematically, we minimize the sum of squares function $S(\beta_1, \beta_2, \beta_3)$, which is a function of the unknown parameters, given the data,

$$S(\beta_1, \beta_2, \beta_3) = \sum_{t=1}^{T} (y_t - E[y_t])^2$$

$$= \sum_{t=1}^{T} (y_t - \beta_1 - \beta_2 x_{t2} - \beta_3 x_{t3})^2 \qquad (7.2.2)$$

Given the sample observations y_t, minimizing the sum of squares function is a straightforward exercise in calculus. The solutions are the least squares estimates b_1, b_2 and b_3. To give expressions for them, it is convenient to express each of the variables as deviations from their means. That is, let

$$y_t^* = y_t - \bar{y}, \quad x_{t2}^* = x_{t2} - \bar{x}_2, \quad x_{t3}^* = x_{t3} - \bar{x}_3$$

Then the least squares estimates b_1, b_2, and b_3 are:

$$b_1 = \bar{y} - b_2\bar{x}_2 - b_3\bar{x}_3$$

$$b_2 = \frac{(\sum y_t^* x_{t2}^*)(\sum x_{t3}^{*2}) - (\sum y_t^* x_{t3}^*)(\sum x_{t2}^* x_{t3}^*)}{(\sum x_{t2}^{*2})(\sum x_{t3}^{*2}) - (\sum x_{t2}^* x_{t3}^*)^2}$$

$$b_3 = \frac{(\sum y_t^* x_{t3}^*)(\sum x_{t2}^{*2}) - (\sum y_t^* x_{t2}^*)(\sum x_{t3}^* x_{t2}^*)}{(\sum x_{t2}^{*2})(\sum x_{t3}^{*2}) - (\sum x_{t2}^* x_{t3}^*)^2} \qquad (7.2.3)$$

These formulas can be used to obtain least squares estimates in the model (7.2.1), whatever the data values are. They are provided as an illustration and are not meant to be memorized. In practice we use computer software to calculate b_1, b_2, and b_3. Looked at as a general way to use sample data, the formulas in (7.2.3) are referred to as estimation rules or procedures and are called the *least squares estimators* of the unknown parameters. In general, since their values are not known until the data are observed and the estimates calculated, the *least squares estimators are random variables*. When applied to a specific sample of data, the rules produce the least squares estimates, which are numeric values.

7.2.2 LEAST SQUARES ESTIMATES USING HAMBURGER CHAIN DATA

Table 7.2 contains the output obtained when the EViews computer software is used to estimate β_1, β_2, and β_3 for the hamburger revenue equation. For the moment, we are

Table 7.2 EViews Output for Revenue Equation for Hamburger Chain

Variable	Coefficient	Std. Error	t-Statistic	Prob.
C	104.7855	6.482719	16.16382	0.0000
PRICE	-6.641930	3.191193	-2.081331	0.0427
ADVERT	2.984299	0.166936	17.87689	0.0000
R-squared	0.867085			
Adjusted R-squared	0.861660			
S.E. of regression	6.069611			
Sum squared resid.	1805.168			

concerned only with the least squares estimates, which, from the equation, are

$$b_1 = 104.79 \qquad b_2 = -6.642 \qquad b_3 = 2.984 \qquad (R7.1)$$

The various other entries on the output will be discussed as we move through the remainder of Chapter 7.

To interpret the coefficient estimates, note that the regression function that we are estimating is

$$E[y_t] = \beta_1 + \beta_2 x_{t2} + \beta_3 x_{t3} \qquad (7.2.4)$$

and the fitted regression line is

$$\hat{y}_t = b_1 + b_2 x_{t2} + b_3 x_{t3}$$
$$= 104.79 - 6.642 x_{t2} + 2.984 x_{t3} \qquad (R7.2)$$

so in terms of the original economic variables found in (7.1.1),

$$\hat{tr}_t = 104.79 - 6.642 p_t + 2.984 a_t \qquad (R7.3)$$

Based on these results, what can we say?

1. The negative coefficient of p_t suggests that demand is price elastic, and we estimate that an increase in price of $1 will lead to a fall in weekly revenue of $6,642. Or, stated positively, a reduction in price of $1 will lead to an increase in revenue of $6,642. If such is the case, a strategy of price reduction through the offering of specials would be successful in increasing total revenue.

2. The coefficient of advertising is positive, and we estimate that an increase in advertising expenditure of $1,000 will lead to an increase in total revenue of $2,984. We can use this information, along with the costs of producing the additional hamburgers, to determine whether an increase in advertising expenditures will increase profit.

3. The estimated intercept implies that if both price and advertising expenditure were zero the total revenue earned would be $104,790. This is obviously not correct. In this model, as in many others, the intercept is included in the

model for mathematical completeness and to improve the model's predictive ability.

The estimated equation can also be used for prediction. Suppose management is interested in predicting total revenue for a price of $2 and an advertising expenditure of $10,000. This prediction is given by

$$\hat{tr}_t = 104.785 - 6.6419(2) + 2.9843(10)$$
$$= 121.34 \tag{R7.4}$$

Thus, the predicted value of total revenue for the specified value of p and a is approximately $121,340.

REMARK: A word of caution is in order about interpreting regression results. The negative sign attached to price implies that reducing the price will increase total revenue. If taken literally, why should we not keep reducing the price to zero? Obviously that would not keep increasing total revenue. This makes the following important point: estimated regression models describe the relationship between the economic variables for values *similar* to those found in the sample data. Extrapolating the results to extreme values is generally not a good idea. In general, predicting the value of the dependent variable for values of the explanatory variables far from the sample values invites disaster. Refer to Figure 5.10 and the surrounding discussion.

7.2.3 ESTIMATION OF THE ERROR VARIANCE σ^2

There is one remaining parameter to estimate, the variance of the error term, σ^2. To develop an estimation procedure for σ^2 we use the least squares residuals, which represent the only sample information we have about the error term values. For this parameter we follow the same steps that were outlined in Chapter 4.5.

The least squares residuals for the model in (7.2.1) are

$$\hat{e}_t = y_t - \hat{y}_t = y_t - (b_1 + x_{t2}b_2 + x_{t3}b_3) \tag{7.2.5}$$

One estimator of σ^2, and the one we will use, is

$$\hat{\sigma}^2 = \frac{\sum \hat{e}_t^2}{T - K} \tag{7.2.6}$$

where K is the number of parameters being estimated in the multiple regression model. Note that in Chapter 4, where there was one explanatory variable and two coefficients, $K = 2$.

In the hamburger chain example we have $K = 3$. The estimate for our sample of data in Table 7.1 is

$$\hat{\sigma}^2 = \frac{\sum \hat{e}_t^2}{T - K} = \frac{1805.168}{52 - 3} = 36.84 \tag{R7.5}$$

Check Table 7.2. Notice that the sum of squared residuals in the table is 1805.168, which agrees with the value in (R7.5). However, EViews does not report the estimate $\hat{\sigma}^2$. Instead, it reports its square root $\hat{\sigma}$, which it calls *S.E. of regression* (short for standard error of regression). This value is $\hat{\sigma} = 6.0696$. One major purpose of obtaining the estimate in (R7.5) is to enable us to get an estimate of the unknown variances and covariances for the least squares estimators. Let us turn now to the properties of the least squares estimators.

7.3 Sampling Properties of the Least Squares Estimators

In a general context, the least squares estimators (b_1, b_2, b_3) in (7.2.3) are random variables; they take on different values in different samples and their values are unknown until a sample is collected and their values computed. The sampling properties of a least squares estimator tell us how the estimates vary from sample to sample. They provide a basis for assessing the reliability of the estimates. In Chapter 4 we found that the least squares estimator was unbiased and that there is no other linear unbiased estimator that has a smaller variance, if the model assumptions are correct. This result remains true for the *general* multiple regression model that we are considering in this chapter.

> **THE GAUSS–MARKOV THEOREM:** For the multiple regression model, if assumptions MR1–MR5 listed at the beginning of the chapter hold, then the least squares estimators are the Best Linear Unbiased Estimators (BLUE) of the parameters in a multiple regression model.

If we are able to assume that the errors are *normally distributed*, then y_t will also be a normally distributed random variable. The least squares estimators will also have normal probability distributions, since they are linear functions of y_t. If the errors are not normally distributed, then the least squares estimators are approximately normally distributed in large samples, in which $T - K$ is greater than, perhaps, 50. These facts are of great importance for the construction of interval estimates and the testing of hypotheses about the parameters of the regression model.

7.3.1 THE VARIANCES AND COVARIANCES OF THE LEAST SQUARES ESTIMATORS

The variances and covariances of the least squares estimators give us information about the reliability of the estimators b_1, b_2, b_3. Since the least squares estimators are unbiased, the smaller their variances the higher is the probability that they will produce estimates "near" the true parameter values. For $K = 3$ we can express the variances and covariances in an algebraic form that provides useful insights into the behavior of the least squares estimator. For example, we can show that:

$$\text{var}(b_2) = \frac{\sigma^2}{\sum_{t=1}^{T} (x_{t2} - \bar{x}_2)^2 (1 - r_{23}^2)} \tag{7.3.1}$$

where r_{23} is the sample correlation coefficient between the values of x_2 and x_3 (see Chapter 6.1.2). Its formula is given by

$$r_{23} = \frac{\sum (x_{t2} - \bar{x}_2)(x_{t3} - \bar{x}_3)}{\sqrt{\sum (x_{t2} - \bar{x}_2)^2 \sum (x_{t3} - \bar{x}_3)^2}} \qquad (7.3.2)$$

For the other variances there are formulas of a similar nature. It is important to understand the factors affecting the variance of b_2:

1. The larger the error variance σ^2 the larger is the variance of the least squares estimators. This is to be expected, since σ^2 measures the overall uncertainty in the model specification. If σ^2 is large, then data values may be widely spread about the regression function $E[y_t] = \beta_1 + \beta_2 x_{t2} + \beta_3 x_{t3}$ and there is less information in the data about the parameter values. If σ^2 is small, then data values are compactly spread about the regression function $E[y_t] = \beta_1 + \beta_2 x_{t2} + \beta_3 x_{t3}$ and there is more information about what the parameter values might be.

2. The larger is the sample size T, the smaller the variances of the least squares estimators. A larger value of T means a larger value of the summation $\sum (x_{t2} - \bar{x}_2)^2$. Since this term appears in the denominator of (7.3.1), when it is large, $\text{var}(b_2)$ is small. This outcome is also an intuitive one; more observations yield more precise parameter estimation.

3. The larger the variation in an explanatory variable around its mean [measured in this case by $\sum (x_{t2} - \bar{x}_2)^2$], the smaller the variance of the least squares estimator. In order to estimate β_2 precisely, we would like there to be a large amount of variation in x_{t2}. The intuition here is that, if the variation or change in x_2 is small, it is difficult to measure the effect of that change. This difficulty is reflected in a large variance for b_2.

4. The larger the correlation between x_2 and x_3, the larger the variance of b_2. Note that $1 - r_{23}^2$ appears in the denominator of (7.3.1). A value of $|r_{23}|$ close to 1 means $1 - r_{23}^2$ will be small, which in turn means $\text{var}(b_2)$ will be large. The reason for this fact is that variation in x_{t2} about its mean adds most to the precision of estimation when it is not connected to variation in the other explanatory variables. When the variation in one explanatory variable is connected to variation in another explanatory variable, it is difficult to disentangle their separate effects. In Chapter 8 we discuss "collinearity," which is the situation when the explanatory variables are correlated with one another. Collinearity leads to increased variances of the least squares estimators.

These factors affect the variances of the least squares estimators in larger models in the same way.

It is customary to arrange the estimated variances and covariances of the least squares estimators in an array, or matrix, with variances on the diagonal and covariances in the off-diagonal positions. For the $K = 3$ model the arrangement is

$$\text{cov}(b_1, b_2, b_3) = \begin{bmatrix} \text{var}(b_1) & \text{cov}(b_1, b_2) & \text{cov}(b_1, b_3) \\ \text{cov}(b_1, b_2) & \text{var}(b_2) & \text{cov}(b_2, b_3) \\ \text{cov}(b_1, b_3) & \text{cov}(b_2, b_3) & \text{var}(b_3) \end{bmatrix} \qquad (7.3.3)$$

Using the EViews software to compute this matrix for the hamburger chain equation yields the values in Table 7.3.

Table 7.3 **Covariance Matrix for Coefficient Estimates: EViews Output**

	C	PRICE	ADVERT
C	42.02565	−19.86312	−0.161109
PRICE	−19.86312	10.18371	−0.054021
ADVERT	−0.161109	−0.054021	0.027868

From this table we can conclude that

$$\hat{\text{var}}(b_1) = 42.026 \qquad \hat{\text{cov}}(b_1, b_2) = -19.863$$
$$\hat{\text{var}}(b_2) = 10.184 \qquad \hat{\text{cov}}(b_1, b_3) = -0.16111$$
$$\hat{\text{var}}(b_3) = 0.02787 \qquad \hat{\text{cov}}(b_2, b_3) = -0.05402 \qquad \text{(R7.6)}$$

These estimated variances can be used to say something about the range of the least squares estimates if we were to obtain other samples of 52 weeks of data for the burger franchise. For example, the standard error of b_2 is given by the square root of 10.184, or approximately $\text{se}(b_2) = 3.2$. We know that the least squares estimator is unbiased, so its mean value is $E(b_2) = \beta_2$. If b_2 is normally distributed, then based on statistical theory we expect 95 percent of the estimates b_2, obtained by applying the least squares estimator to other samples, to be within about two standard deviations of the mean β_2. Given our sample, $2 \times \text{se}(b_2) = 6.4$, so we estimate that 95 percent of the b_2 values would lie within 6.4 of β_2. It is in this sense that the estimated variance of b_2 tells us something about the reliability of the least squares estimates. If the difference between b_2 and β_2 can be large, b_2 is not reliable; if the difference between b_2 and β_2 is likely to be small, then b_2 is reliable. Whether a particular difference is "large" or "small" will depend on the context of the problem and the use to which the estimates are to be put. In later sections we use the estimated variances and covariances to test hypotheses about the parameters and to construct interval estimates.

7.3.2 THE PROPERTIES OF THE LEAST SQUARES ESTIMATORS ASSUMING NORMALLY DISTRIBUTED ERRORS

We have asserted that under assumptions MR1–MR5, listed at the end of Section 7.1.2b, for the multiple regression model,

$$y_t = \beta_1 + \beta_2 x_{t2} + \beta_3 x_{t3} + \cdots + \beta_K x_{tK} + e_t \qquad (7.3.4)$$

the least squares estimator b_k is the best linear unbiased estimator of the parameter β_k. If we add assumption MR6, that the random errors e_t have normal probability distributions, then the dependent variable y_t is normally distributed,

$$y_t \sim N[(\beta_1 + \beta_2 x_{t2} + \cdots + \beta_K x_{tK}), \sigma^2] \Leftrightarrow e_t \sim N(0, \sigma^2) \qquad (7.3.5)$$

Since the least squares estimators are linear functions of dependent variables, it

follows that the least squares estimators are normally distributed also,

$$b_k \sim N[\beta_k, \text{var}(b_k)] \tag{7.3.6}$$

That is, each b_k has a normal distribution with mean β_k and variance $\text{var}(b_k)$. By subtracting its mean and dividing by the square root of its variance, we can transform the normal random variable b_k into the **standard normal variable** z,

$$z = \frac{b_k - \beta_k}{\sqrt{\text{var}(b_k)}} \sim N(0, 1), \qquad \text{for } k = 1, 2, \cdots, K \tag{7.3.7}$$

that has mean zero and a variance of one. The variance of b_k depends on the unknown variance of the error term, σ^2, as illustrated in (7.3.1) for the $K = 3$ case. When we replace σ^2 by its estimator $\hat{\sigma}^2$, from (7.2.6), we obtain the estimated $\text{var}(b_k)$, which we denote as $\hat{\text{var}}(b_k)$. When $\text{var}(b_k)$ is replaced by $\hat{\text{var}}(b_k)$ in (7.3.7), we obtain a t random variable instead of the normal variable. That is,

$$t = \frac{b_k - \beta_k}{\sqrt{\hat{\text{var}}(b_k)}} \sim t_{(T-K)} \tag{7.3.8}$$

One difference between this result and that in Chapter 5 is the degrees of freedom of the t random variable. In Chapter 5, where there were two coefficients to be estimated, the number of degrees of freedom was $(T - 2)$. In this chapter there are K unknown coefficients in the general model and *the number of degrees of freedom for t-statistics is* $(T - K)$.

The square root of the variance estimator $\hat{\text{var}}(b_k)$ is called the standard error of b_k, which is written as

$$\text{se}(b_k) = \sqrt{\hat{\text{var}}(b_k)} \tag{7.3.9}$$

Consequently, we will usually express the t random variable as

$$t = \frac{b_k - \beta_k}{\text{se}(b_k)} \sim t_{(T-K)} \tag{7.3.10}$$

We now examine how the result in (7.3.10) can be used for interval estimation and hypothesis testing. The procedures are identical to those described in Chapter 5; only the degrees of freedom change.

7.4 Interval Estimation

Interval estimates of unknown parameters are based on the probability statement that

$$P\left(-t_c \leq \frac{b_k - \beta_k}{\text{se}(b_k)} \leq t_c\right) = 1 - \alpha \tag{7.4.1}$$

where t_c is the critical value for the t-distribution with $(T - K)$ degrees of freedom, such that $P(t \geq t_c) = \alpha/2$. Rearranging (7.4.1), we obtain

$$P[b_k - t_c \text{se}(b_k) \leq \beta_k \leq b_k + t_c \text{se}(b_k)] = 1 - \alpha \qquad (7.4.2)$$

The interval endpoints,

$$[b_k - t_c \text{se}(b_k), b_k + t_c \text{se}(b_k)] \qquad (7.4.3)$$

define a $100(1 - \alpha)\%$ confidence interval estimator of β_k. If this interval estimator is used in many samples from the population, then 95% of them will contain the true parameter β_k. This fact we can establish based on the model assumptions alone, before any data are collected. Thus, even before the data are collected, we have confidence in this *interval estimation procedure (estimator)* when it is used repeatedly.

Returning to the equation used to describe how the hamburger chain's revenue depends on price and advertising expenditure, we have

$$
\begin{aligned}
T &= 52 & K &= 3 \\
b_1 &= 104.79 & \text{se}(b_1) &= \sqrt{\text{vâr}(b_1)} = 6.483 \\
b_2 &= -6.642 & \text{se}(b_2) &= \sqrt{\text{vâr}(b_2)} = 3.191 \\
b_3 &= 2.984 & \text{se}(b_3) &= \sqrt{\text{vâr}(b_3)} = 0.1669
\end{aligned}
\qquad \text{(R7.7)}
$$

Note where the standard errors are located in the computer output in Table 7.2. We will use this information to construct interval estimates for

β_2 = the response of revenue to a price change

β_3 = the response of revenue to a change in advertising expenditure

To construct a 95% confidence interval for β_2, we make use of (7.4.3). The degrees of freedom are given by $(T - K) = (52 - 3) = 49$. The critical value $t_c = 2.01$ does not appear in the tabulated values for the t-distribution found in Table 2 at the front of the book. However, it can be approximated by interpolating between these values or by using statistical software.

A 95% confidence interval for β_2 based on our particular sample is obtained from (7.4.3) by replacing the formulas b_2 and $\text{se}(b_2)$ by their values $b_2 = -6.642$ and $\text{se}(b_2) = 3.191$. Thus, our 95% interval estimate for β_2 is given by $(-13.06, -0.23)$.

This interval estimate suggests that decreasing price by \$1 will lead to an increase in revenue somewhere between \$230 and \$13,060. This is a wide interval, and it is not very informative. Another way of describing this situation is to say that the point estimate of $b_2 = -6.642$ is not very reliable, as its standard error (which measures sampling variability) is relatively large.

In general, if an interval estimate is uninformative because it is too wide, there is nothing immediate that can be done. A wide confidence interval for the parameter β_2 arises because the estimated sampling variability of the least squares estimator b_2 is large. In the computation of a confidence interval, a large sampling variability is reflected by a large standard error. A narrower interval can only be obtained by reducing the variance of the estimator. Based on the variance expression in (7.3.1), one solution is to obtain more and better data, exhibiting more independent varia-

tion. This alternative is usually not open to economists, who do not use controlled experiments to obtain data. Alternatively, we might introduce some kind of non-sample information on the coefficients. The question of how to use both sample and nonsample information in the estimation process is taken up in Chapter 8.

Returning to the Bay Area Rapid Food example, we find the 95% interval estimate for β_3, the response of revenue to advertising, as (2.65, 3.32).

This interval is relatively narrow and informative. We estimate that an increase in advertising expenditure of $1000 leads to an increase in total revenue that is somewhere between $2,650 and $3,320.

7.5 Hypothesis Testing for a Single Coefficient

As well as being useful for interval estimation, the t-distribution result in (7.3.10) provides the foundation for testing hypotheses about individual coefficients. Hypotheses of the form H_0: $\beta_2 = c$ versus H_1: $\beta_2 \neq c$, where c is a specified constant, are called *two-tailed tests*. Hypotheses with inequalities, such as H_0: $\beta_2 \leq c$ versus H_1: $\beta_2 > c$ are called one-tailed tests. In this section we consider examples of each type of hypothesis. For a two-tailed test, we consider testing the significance of an individual coefficient; for one-tailed tests, some hypotheses of economic interest are considered.

7.5.1 TESTING THE SIGNIFACANCE OF A SINGLE COEFFICIENT

When we set up a multiple regression model, we do so because we believe all the $(K-1)$ explanatory variables influence the dependent variable y. If we are to confirm this belief, we need to examine whether or not it is supported by the data. That is, we need to ask whether the data provide any evidence to suggest that y is related to each of the explanatory variables. If a given explanatory variable, say x_k, has no bearing on y, then $\beta_k = 0$. Testing this null hypothesis is sometimes called a "test of significance" for the explanatory variable x_k. Thus, to find whether the data contain any evidence suggesting y is related to x_k we test the null hypothesis

$$H_0 : \beta_k = 0$$

against the alternative hypothesis

$$H_1 : \beta_k \neq 0$$

To carry out the test we use (7.3.10), which, if the null hypothesis is true, is

$$t = \frac{b_k}{\text{se}(b_k)} \sim t_{(T-K)}$$

For the alternative hypothesis "not equal to" we use a two-tailed test, introduced in Chapter 5.2, and reject H_0 if the computed t-value is greater than or equal to t_c (the critical value from the right side of the distribution), or less than or equal to $-t_c$ (the critical value from the left side of the distribution).

In the Bay Area Rapid Food example we test, following our standard testing format, whether revenue is related to price:

1. $H_0: \beta_2 = 0$
2. $H_1: \beta_2 \neq 0$
3. The test statistic, if the null hypothesis is true, is $t = b_2/\text{se}(b_2) \sim t_{(T-K)}$.
4. With 49 degrees of freedom and a 5 percent significance level, the critical values that lead to a probability of 0.025 in each tail of the distribution are $t_c = 2.01$ and $-t_c = -2.01$. Thus, we reject the null hypothesis if $t \geq 2.01$ or if $t \leq -2.01$. In shorthand notation, we reject the null hypothesis if $|t| \geq 2.01$.
5. The computed value of the t-statistic is

$$t = \frac{-6.642}{3.191} = -2.08 \tag{R7.8}$$

Since $-2.08 < -2.01$, we reject $H_0: \beta_2 = 0$ and conclude that there is evidence from the data to suggest revenue depends on price. The p-value in this case is given by $P[|t_{(49)}| > 2.08] = 2 \times 0.021 = 0.042$. Using this procedure we reject H_0 because $0.042 < 0.05$.

For testing whether revenue is related to advertising expenditure, we have

1. $H_0: \beta_3 = 0$
2. $H_1: \beta_3 \neq 0$
3. The test statistic, if the null hypothesis is true, is $t = b_3/\text{se}(b_3) \sim t_{(T-K)}$.
4. We reject the null hypothesis if $|t| \geq 2.01$.
5. The value of the test statistic is

$$t = \frac{2.984}{0.1669} = 17.88 \tag{R7.9}$$

Because $17.88 > t_c = 2.01$, the data support the conjecture that revenue is related to advertising expenditure. The p-value for $t = 17.88$ is 0.0000 or essentially zero; thus, we can also conclude that the null hypothesis is rejected because $0.0000 < 0.05$.

Returning to Table 7.2, we see that the t-values -2.08 and 17.88 are reported in the computer output along with their corresponding p-values. Thus, hypothesis tests of this kind are carried out routinely, and their outcomes can be read immediately from the computer printout.

7.5.2 ONE-TAILED HYPOTHESIS TESTING FOR A SINGLE COEFFICIENT

In Section 7.1 we noted that two important considerations for the management of the Bay Area Rapid Food hamburger chain were whether demand was price elastic or inelastic and whether the additional revenue from additional advertising expenditure would cover the costs of the advertising. We now are in a position to state these questions as testable hypotheses, and to ask whether the hypotheses are compatible with the data.

7.5.2a Testing for Elastic Demand

With respect to demand elasticity, we wish to know if:

- $\beta_2 \geq 0$: a decrease in price leads to a decrease in total revenue (demand is price inelastic)

- $\beta_2 < 0$: a decrease in price leads to an increase in total revenue (demand is price elastic)

If we are not prepared to accept that demand is elastic unless there is strong evidence from the data to support this claim, it is appropriate to take the assumption of an inelastic demand as our null hypothesis. Following our standard testing format, developed in Chapter 5.2, and the discussion of one-tailed tests in Chapter 5.2.10, we first state the null and alternative hypotheses:

1. H_0: $\beta_2 \geq 0$ (demand is unit elastic or inelastic)

2. H_1: $\beta_2 < 0$ (demand is elastic)

3. To create a test statistic we act as if the null hypothesis were the equality $\beta_2 = 0$. If this null hypothesis is true, then from (7.3.10) the t-statistic is $t = b_k/\text{se}(b_k) \sim t_{(T-K)}$. This result we know prior to the collection of any data. It is based only on the model assumptions.

4. The rejection region consists of values from the t-distribution that are unlikely to occur if the null hypothesis is true. If we define "unlikely" in terms of a 5% significance level, we answer this question by finding a critical value t_c such that $P[t_{(T-K)} \leq t_c] = 0.05$. Then, we reject H_0 if $t \leq t_c$. Given a sample of $T = 52$ data observations, the degrees of freedom are $T - K = 49$ and the t-critical value is $t_c = -1.68$.

5. The value of the test statistic is

$$t = \frac{b_2}{\text{se}(b_2)} = \frac{-6.642}{3.191} = -2.08 \tag{R7.10}$$

Since $t = -2.08 < t_c = -1.68$, we reject H_0: $\beta_2 \geq 0$ and conclude H_1: $\beta_2 < 0$ (demand is elastic) is more compatible with the data. The sample evidence supports the proposition that a reduction in price will bring about an increase in total revenue.

An alternative to comparing the computed value -2.08 to the critical value $t_c = -1.68$ is to compute the p-value that is given by $P[t_{(49)} < -2.08]$ and to reject H_0 if this p-value is less than 0.05. Using our computer software, we find that $P[t_{(49)} < -2.08] = 0.021$. Since $0.021 < 0.05$, the same conclusion is reached.

7.5.2b Testing Advertising Effectiveness

The other hypothesis of interest is whether an increase in advertising expenditure will bring an increase in total revenue that is sufficient to cover the increased cost of advertising. This will occur if $\beta_3 > 1$. Setting up the test, we have:

1. H_0: $\beta_3 \leq 1$

2. H_1: $\beta_3 > 1$

3. We compute a value for the t-statistic as if the null hypothesis were $\beta_3 = 1$. Using (7.3.10) we have, if the null hypothesis is true,

$$t = \frac{b_3 - 1}{se(b_3)} \sim t_{(T-K)}.$$

4. In this case, if the level of significance is $\alpha = .05$, we reject H_0 if $t \geq t_c = 1.68$.
5. The value of the test statistic is:

$$t = \frac{b_3 - \beta_3}{se(b_3)} = \frac{2.984 - 1}{0.1669} = 11.89 \qquad (R7.11)$$

Since 11.89 is much greater than 1.68, we do indeed reject H_0 and accept the alternative $\beta_3 > 1$ as more compatible with the data. Also, the p-value in this case is essentially zero (less than 10^{-12}). Thus, we have *statistical evidence* that an increase in advertising expenditure will be justified by the increase in revenue. Of course, to totally justify the increase in advertising expenditure, we also need to consider the cost of producing the extra hamburgers that have led to the increase in revenue.

Because both of the foregoing tests are one-sided tests, a critical value from just one side of the t-distribution is considered in each case. For testing β_2, the critical value of -1.68 from the left side of the distribution was considered; for β_3 the critical value of 1.68 from the right side of the distribution was considered. With two-tailed tests critical values from both sides of the t-distribution are used.

7.6 Measuring Goodness of Fit

In Chapter 6, for the simple regression model, we introduced R^2 as a measure of the proportion of variation in the dependent variable that is explained by variation in the explanatory variable. In the multiple regression model the same measure is relevant, and the same formulas are valid, but now we talk of the proportion of variation in the dependent variable explained by *all* the explanatory variables in the linear model. The coefficient of determination is

$$R^2 = \frac{SSR}{SST} = \frac{\sum(\hat{y}_t - \bar{y})^2}{\sum(y_t - \bar{y})^2}$$

$$= 1 - \frac{SSE}{SST} = 1 - \frac{\sum \hat{e}_t^2}{\sum(y_t - \bar{y})^2} \qquad (7.6.1)$$

where SSR is the variation in y "explained" by the model, SST is the total variation in y about its mean, and SSE is the sum of squared least squares residuals and is the portion of the variation in y that is not explained by the model. The values of these sums of squares appear in the analysis of variance (or ANOVA) table reported by regression software.

For the Bay Area Rapid Food example, the ANOVA table includes the information in Table 7.4.

Table 7.4 **Partial ANOVA Table**

Source	DF	Sum of Squares
Explained	2	11776.18
Unexplained	49	1805.168
Total	51	13581.35

Using these sums of squares, we have

$$R^2 = 1 - \frac{\sum \hat{e}_t^2}{\sum (y_t - \bar{y})^2} = 1 - \frac{1805.168}{13581.35} = 0.867 \qquad \text{(R7.12)}$$

The interpretation of R^2 is that 86.7% of the variation in total revenue is explained by the variation in price and by the variation in the level of advertising expenditure. It means that, *in our sample*, only 13.3% of the variation in revenue is left unexplained and is due to variation in the error term or to variation in other variables that implicitly form part of the error term.

As mentioned in Chapter 6.1, the coefficient of determination is also viewed as a measure of the predictive ability of the model over the sample period, or as a measure of how well the estimated regression fits the data. The value of R^2 is equal to the squared sample correlation coefficient between the \hat{y}_t and the y_t. Since the sample correlation measures the linear association between two variables, if the R^2 is high, that means there is a close association between the values of y_t and the values predicted by the model, \hat{y}_t. In this case, the model is said to "fit" the data well. If R^2 is low, there is not a close association between the values of y_t and the values predicted by the model, \hat{y}_t, and the model does not fit the data well.

One difficulty with R^2 is that it can be made large by adding more and more variables, even if the variables added have no economic justification. Algebraically it is a fact that as variables are added the sum of squared errors *SSE* goes down (it can remain unchanged, but this is rare) and thus, R^2 goes up. If the model contains $T-1$ variables, the $R^2 = 1$. The manipulation of a model just to obtain a high R^2 is not wise.

An alternative measure of goodness of fit, called the adjusted R^2, and often symbolized as \bar{R}^2, is usually reported by regression programs; it is computed as

$$\bar{R}^2 = 1 - \frac{SSE/(T-K)}{SST/(T-1)}$$

For the Bay Area data the value of this descriptive measure is $\bar{R}^2 = .8617$. This measure does not always go up when a variable is added, because of the degrees of freedom term $T-K$ in the numerator. As the number of variables K increases, *SSE* goes down, but so does $T-K$. The effect on \bar{R}^2 depends on the amount by which *SSE* falls. While solving one problem, this corrected measure of goodness of fit unfortunately introduces another one. It loses its interpretation; \bar{R}^2 is no longer the percent of variation explained. This modified \bar{R}^2 is sometimes used and misused as a device for selecting the appropriate set of explanatory variables. This practice should be avoided. Let's concentrate on the unadjusted R^2 and think of it as a descriptive device for telling us about the "fit" of the model; it tells us the proportion of variation in the dependent variable explained by the explanatory variables, and the predictive ability of the model over the sample period. Return to Table 7.2. Note where the values $R^2 = 0.867$ and $\bar{R}^2 = 0.862$ appear in the EViews output.

One final note is in order. The intercept parameter β_1 is the y-intercept of the regression "plane," as shown in Figure 7.1. If, for theoretical reasons, you are certain that the regression plane passes through the origin, then $\beta_1 = 0$ and can be omitted from the model. Although this is not a common practice, it does occur, and regression software includes an option that removes the intercept from the model. If the model does not contain an intercept parameter, then the measure R^2 given in (7.6.1) is no longer appropriate. The reason it is no longer appropriate is that, without an intercept term in the model,

$$\sum (y_t - \bar{y})^2 \neq \sum (\hat{y}_t - \bar{y})^2 + \sum \hat{e}_t^2$$

or $SST \neq SSR + SSE$. Under these circumstances it does not make sense to talk of the proportion of total variation that is explained by the regression. Thus, when your model does not contain a constant, it is better not to report an R^2, even if your computer output displays one.

7.7 Learning Objectives

Based on the material in this chapter, you should be able to:

1. Recognize a multiple regression model and be able to interpret the coefficients in that model.
2. Understand and explain the meanings of the assumptions for the multiple regression model.
3. Use your computer to find least squares estimates of the coefficients in a multiple regression model. Interpret those estimates.
4. Explain the meaning of the Gauss-Markov theorem.
5. Use your computer to obtain variance and covariance estimates, and standard errors, for the estimated coefficients in a multiple regression model.
6. Explain the circumstances under which coefficient variances (and standard errors) are likely to be relatively high, and relatively low.
7. Find interval estimates for single coefficients. Interpret the interval estimates.
8. Test hypotheses about single coefficients in a multiple regression model. In particular:
 (a) What is the difference between a one- and a two-tailed test?
 (b) How do you compute the p-value for a one-tailed test? For a two-tailed test?
 (c) What is meant by "testing the significance of a coefficient"?
 (d) What is the meaning of the t-values and p-values that appear in your computer output?
9. Compute and explain the meaning of R^2 in a multiple regression model.

7.8 Exercises

7.1* Consider the multiple regression model

$$y_t = x_{t1}\beta_1 + x_{t2}\beta_2 + x_{t3}\beta_3 + e_t$$

with the 9 observations on y_t, x_{t1}, x_{t2}, and x_{t3} given in Table 7.5. Use a hand calculator to answer the following questions:

Table 7.5 **Data for Exercise 7.1**

y_t	x_{t1}	x_{t2}	x_{t3}
1	1	0	1
2	1	1	−2
3	1	2	1
−1	1	−2	0
0	1	1	−1
−1	1	−2	−1
2	1	0	1
1	1	−1	1
2	1	1	0

(a) Calculate the observations in terms of deviations from their means. That is, find

$$x^*_{t2} = x_{t2} - \overline{x}_2 \qquad x^*_{t3} = x_{t3} - \overline{x}_3 \qquad y^*_t = y_t - \overline{y}$$

(b) Calculate $\sum y^*_t x^*_{t2}$, $\sum x^{*2}_{t2}$, $\sum y^*_t x^*_{t3}$, $\sum x^*_{t2} x^*_{t3}$, $\sum x^{*2}_{t3}$.
(c) Use (7.2.3) to find least squares estimates b_1, b_2, b_3.
(d) Find the least squares residuals \hat{e}_1, \hat{e}_2, ... , \hat{e}_9.
(e) Find the variance estimate $\hat{\sigma}^2$.
(f) Use (7.3.2) to find the sample correlation between x_2 and x_3.
(g) Find the standard error for b_2.
(h) Find *SSE*, *SST*, *SSR*, and R^2.

7.2 Use a computer to verify your answers to Exercise 7.1, parts (c), (e), (f), (g), and (h).

7.3 Use your answers to Exercise 7.1 or 7.2 to:
(a) Compute a 95% confidence interval for β_2.
(b) Test the hypothesis H_0: $\beta_2 = 1$ against the alternative that H_1: $\beta_2 \neq 1$.

7.4 Consider the following model that relates the proportion of a household's budget spent on alcohol *walc* to total expenditure *totexp*, age of the household head *age*, and the number of children in the household *nk*.

$$walc = \beta_1 + \beta_2 \ln(totexp) + \beta_3\, age + \beta_4\, nk + e$$

The data in the file *london.dat* were used to estimate this model. See Exercise 6.15 for more details about the data. Note that only households with one or two children are being considered. Thus, *nk* only takes the value 1 or 2. The EViews output from estimating this equation appears in Table 7.6.
(a) Fill in the following blank spaces that appear in this table.
 (i) The *t*-statistic for b_1.
 (ii) The standard error for b_2.
 (iii) The estimate b_3.
 (iv) R^2.
 (v) $\hat{\sigma}$.
(b) Interpret each of the estimates b_2, b_3, and b_4.

Table 7.6 **EViews Output for Exercise 7.4**

Dependent variable: WALC
Sample: 1 1519
Included observations: 1519

Variable	Coefficient	Std. Error	t-Statistic	Prob.
C	0.009052	0.019050		0.6347
LTOTEXP	0.027641		6.608620	0.0000
AGE		0.000208	−6.962389	0.0000
NK	−0.013282	0.003259	−4.074993	0.0000

R-squared		Mean dependent var.	0.060596
Adjusted R-squared	0.053047	S.D. dependent var.	0.063325
S.E. of regression			
Sum squared resid	5.752896		

(c) Compute a 95% interval estimate for β_3. What does this interval tell you?

(d) Test the hypothesis that the budget proportion for alcohol does not depend on the number of children in the household. Can you suggest a reason for the test outcome?

7.5 The data set used in Exercise 7.4 is used again. This time it is used to estimate how the proportion of the household budget spent on transportation *wtrans* depends on the log of total expenditure *ltotexp*, *age*, and number of children *nk*. The EViews output is reported in Table 7.7.

(a) Write out the estimated equation in the standard reporting format with standard errors in parentheses below the coefficient estimates.

(b) Interpret the estimates b_2, b_3 and b_4. Do you think the results make sense from an economic or logical point of view?

(c) Are there any variables that you might exclude from the equation? Why?

(d) What proportion of variation in the budget proportion allocated to transportation is explained by this equation.

(e) Predict the proportion of a budget that will be spent on transportation, for both one- and two-children households, when total expenditure and age are set at their sample means, which are 98.7 and 36, respectively.

Table 7.7 **EViews Output for Exercise 7.5**

Dependent Variable: WTRANS
Sample: 1 1519
Included observations: 1519

Variable	Coefficient	Std. Error	t-Statistic	Prob.
C	−0.031466	0.032186	−0.977630	0.3284
LTOTEXP	0.041383	0.007067	5.856081	0.0000
AGE	−5.80E-05	0.000351	−0.164993	0.8690
NK	−0.012965	0.005507	−2.354152	0.0187

R-squared	0.024723	Mean dependent var	0.132350
Adjusted R-squared	0.022791	S.D. dependent var	0.105322

7.6 (a) Use the data in the file *london.dat* (see Exercises 6.15, 7.4, and 7.5) to estimate budget share equations of the form

$$w = \beta_1 + \beta_2 \ln(totexp) + \beta_3 \ age + \beta_4 \ nk + e$$

for all budget shares (food, fuel, clothing, alcohol, transportation, and other) in the data set. Report and discuss your results. In your discussion comment on how total expenditure, age, and number of children influence the various budget proportions. Also comment on the significance of your coefficient estimates.

(b) Commodities are regarded as luxuries if $\beta_2 > 0$ and necessities if $\beta_2 < 0$. For each commodity group, test $H_0: \beta_2 \leq 0$ against $H_1: \beta_2 > 0$ and comment on the outcomes.

7.7 The file *cocaine.dat* contains 56 observations on variables related to sales of cocaine powder in northeastern California over the period 1984–1991. The data are a subset of those used in the study Caulkins, J. P. and R. Padman (1993), "Quantity Discounts and Quality Premia for Illicit Drugs," *Journal of the American Statistical Association*, 88, 748–757. The variables are

price = price per gram in dollars for a cocaine sale,

quant = number of grams of cocaine in a given sale,

qual = quality of the cocaine expressed as percentage purity,

trend = a time variable with 1984 = 1 up to 1991 = 8.

Consider the regression model

$$price = \beta_1 + \beta_2 \ quant + \beta_3 \ qual + \beta_4 \ trend + e$$

(a) What signs would you expect on the coefficients β_2, β_3, β_4?

(b) Use your computer software to estimate the equation. Report the results and interpret the coefficient estimates. Have the signs turned out as you expected?

(c) What proportion of variation in cocaine price is explained by variation in quantity, quality, and time?

(d) It is claimed that the greater the number of sales, the higher the risk of getting caught; and, thus, sellers are willing to accept a lower price if they can make sales in larger quantities. Set up H_0 and H_1 that would be appropriate to test this hypothesis. Carry out the hypothesis test.

(e) Test the hypothesis that the quality of cocaine has no influence on price against the alternative that a premium is paid for better quality cocaine.

(f) What is the average annual change in the cocaine price? Can you suggest why price might be changing in this direction?

7.8 This question is concerned with the value of houses in towns surrounding Boston. In uses the data of Harrison, D. and D. L. Rubinfeld (1978), "Hedonic Prices and the Demand for Clean Air," *Journal of Environmental Economics and Management*, 5, 81–102. EViews output appears in Table 7.8.

Table 7.8 **EViews Output for Exercise 7.8**

Dependent Variable: VALUE
Sample:1 506
Included Observations: 506

Variable	Coefficient	Std. Error	t-Statistic	Prob.
C	28.40666	5.365948	5.293875	0.0000
CRIME	−0.183449	0.036489	−5.027548	0.0000
NITOX	−22.81088	4.160741	−5.482407	0.0000
ROOMS	6.371512	0.392387	16.23784	0.0000
AGE	−0.047750	0.014102	−3.386085	0.0008
DIST	−1.335269	0.200147	−6.671448	0.0000
ACCESS	0.272282	0.072276	3.767250	0.0002
TAX	−0.012592	0.003770	−3.339939	0.0009
PTRATIO	−1.176787	0.139415	−8.440868	0.0000

The variables are defined as follows:

 VALUE = median value of owner-occupied homes in $1000's,
 CRIME = per capita crime rate,
 NITOX = nitric oxides concentration (parts per million),
 ROOMS = average number of rooms per dwelling,
 AGE = proportion of owner-occupied units built prior to 1940,
 DIST = weighted distances to five Boston employment centers,
 ACCESS = index of accessibility to radial highways,
 TAX = full-value property-tax rate per $10,000,
 PTRATIO = pupil-teacher ratio by town.

(a) Report briefly on how each of the variables influences the value of a home.
(b) Find 95% confidence intervals for the coefficients of CRIME and ACCESS.
(c) Test the hypothesis that increasing the number of rooms by one increases the value of a house by $7,000.
(d) Test as an alternative hypothesis H_1 that reducing the pupil–teacher ratio by 10 will increase the value of a house by more than $10,000.

7.9 Data on per capita consumption of beef, the price of beef, the price of lamb, the price of pork, and per capita disposable income for Australia, for the period 1949–1965, are given in the file *meat.dat*. All prices and income have been deflated, with 1953 as the base year. Consider the log–log demand curve

$$\ln(qb_t) = \beta_1 + \beta_2 \ln(pb_t) + \beta_3 \ln(pl_t) + \beta_4 \ln(pp_t) + \beta_5 \ln(in_t) + e_t$$

where
qb_t is per capita consumption of beef in year t (pounds),
pb_t is the price of beef in year t (pence per pound),
pl_t is the price of lamb in year t (pence per pound),

pp_t is the price of pork in year t (pence per pound), and
in_t is per capita disposable income in year t (Australian currency pounds).
(a) What signs do you expect on each of the coefficients?
(b) Estimate β_1, β_2, β_3, β_4, and β_5 using least squares. Interpret the results. Do they seem reasonable?
(c) Compute the estimated covariance matrix for the least squares estimator and the standard errors.
(d) Compute 95% interval estimates for each of the parameters.

7.10 Consider the following total cost function where y_t represents total cost for the t-th firm and x_t represents quantity of output.

$$y_t = \beta_1 + \beta_2 x_t + \beta_3 x_t^2 + \beta_4 x_t^3 + e_t$$

Data on a sample of 28 firms in the clothing industry are in the file *clothes.dat*.
(a) Write down the marginal cost function corresponding to the above total cost function. What sign would you expect for β_4?
(b) Write down the average cost function that corresponds to the above total cost function.
(c) Use the total cost function to find least squares estimates of β_1, β_2, β_3 and β_4. Graph the total, average and marginal cost functions implied by these estimates.
(d) Compute 95% interval estimates of the parameters.
(e) At what output price is it profitable for firms to produce? How many firms in the sample are producing unprofitable outputs?
(f) Find estimates of β_1, β_2, β_3 and β_4 by applying least squares to the average cost function you derived in (b). Are the standard errors of the estimates greater or less than those that were obtained in (c) when the total cost function was used? Is it possible to make any conjectures about which set of estimates might be "best?"

7.11 Consider the following aggregate production function for the U.S. manufacturing sector

$$Y_t = f(K_t, L_t, E_t, M_t)$$

where Y_t is gross output in time t, K_t is capital, L_t is labor, E_t is energy, and M_t is other intermediate materials. Twenty-five observations on these variables are given in index form in the file *manuf.dat*. Assume the statistical model $Y_t = \alpha K_t^{\beta_2} L_t^{\beta_3} E_t^{\beta_4} M_t^{\beta_5} \exp\{e_t\}$ where $e_t \sim N(0, \sigma^2)$.
(a) Estimate the unknown parameters of the production function, and find the corresponding standard errors.
(b) Discuss the economic and statistical implications of these results.

Chapter *8*

Further Inference in the Multiple Regression Model

Economists develop and evaluate theories about economic behavior. Hypothesis testing procedures are used to test their theories. In Chapter 7, we developed and applied t-tests of individual hypotheses. An important new development that we encounter in this chapter is using the F-distribution to simultaneously test a null hypothesis consisting of two or more hypotheses about the parameters in the multiple regression model.

The theories that economists develop also sometimes provide *nonsample* information that can be used along with the information in a sample of data to estimate the parameters of a regression model. A procedure that combines these two types of information is called **restricted least squares.** It can be a useful technique when the data are not information-rich, a condition called collinearity, and the theoretical information is good. The restricted least squares procedure also plays a useful practical role when testing hypotheses. In addition to these topics we discuss model specification for the multiple regression model and the construction of "prediction" intervals.

In this chapter we adopt assumptions MR1–MR6, including normality, listed on page 150. If the errors are not normal, then the results presented in this chapter will hold approximately if the sample is large.

In Chapter 7 we learned how to use t-tests to test hypotheses about single parameters in a multiple regression model. There are, however, many instances where tests involving more than one parameter are appropriate. For example, we might want to test whether a group of explanatory variables is relevant in a particular model. Should variables on socioeconomic background, along with variables describing education and experience, be used to explain a person's wage? Does the quantity demanded of a product depend on the prices of substitute goods or only on its own price? Other questions that lead to hypothesis tests involving more than one parameter are: Does a production function exhibit constant returns to scale? If all prices and income go up by the same proportion, will quantity demanded for a commodity remain unchanged?

What we discover in this chapter is that a single null hypothesis that may involve one or more parameters can be tested via a t-test or an F-test. Both are equivalent. A joint null hypothesis, that involves a set of hypotheses, is tested only via an F-test.

8.1 The *F*-Test

The F-test for a set of hypotheses is based on a comparison of the sum of squared errors from the original, unrestricted multiple regression model to the sum of

squared errors from a regression model in which the null hypothesis is assumed to be true. To illustrate what is meant by an unrestricted multiple regression model and a model that is restricted by the null hypothesis, consider the Bay Area Rapid Food hamburger chain example in which weekly total revenue of the chain (tr) is a function of a price index of all products sold (p) and weekly expenditure on advertising (a).

$$tr_t = \beta_1 + \beta_2 p_t + \beta_3 a_t + e_t \tag{8.1.1}$$

Suppose that we wish to test the hypothesis that changes in price have no effect on total revenue against the alternative that price does have an effect. The null and alternative hypotheses are: $H_0 : \beta_2 = 0$ and $H_1 : \beta_2 \neq 0$. The restricted model that assumes the null hypothesis is true is

$$tr_t = \beta_1 + \beta_3 a_t + e_t \tag{8.1.2}$$

Setting $\beta_2 = 0$ in the unrestricted model in (8.1.1) means that the price variable p_t does not appear in the restricted model in (8.1.2).

When a null hypothesis is assumed to be true, we place conditions, or constraints, on the values that the parameters can take, and the sum of squared errors increases. Thus, the sum of squared errors from (8.1.2) will be larger than that from (8.1.1). The idea of the *F*-test is that if these sums of squared errors are substantially different, then the assumption that the null hypothesis is true has significantly reduced the ability of the model to fit the data, and thus the data do not support the null hypothesis. If the null hypothesis is true, we expect that the data are compatible with the conditions placed on the parameters. Thus, we expect little change in the sum of squared errors when the null hypothesis is true.

We call the sum of squared errors in the model that assumes a null hypothesis to be true the *restricted sum of squared errors*, or SSE_R, where the subscript R indicates that the parameters have been restricted or constrained. To make a clear distinction between the restricted sum of squared errors and the sum of squared errors from the original, unrestricted model, we call the sum of squared errors from the original model the *unrestricted sum of squared errors*, or SSE_U. It is *always* true that $SSE_R - SSE_U \geq 0$. The null hypothesis can be made up of a single hypothesis or a set of hypotheses. Let J be the number of hypotheses. For example, for testing (8.1.2), $J = 1$. The general *F*-statistic is given by

$$F = \frac{(SSE_R - SSE_U)/J}{SSE_U/(T - K)} \tag{8.1.3}$$

If the null hypothesis is true, then the statistic F has what is called an *F*-distribution with J numerator degrees of freedom and $T - K$ denominator degrees of freedom. Some details about this distribution are given later in this section. *If the null hypothesis is not true*, then the difference between SSE_R and SSE_U becomes large, implying that the constraints placed on the model by the null hypothesis have a large effect on the ability of the model to fit the data. If the difference $SSE_R - SSE_U$ is large, the value of F tends to be *large*. Thus, we *reject* the null hypothesis if the value of the *F*-test statistic becomes too large. We make the judgment about what is too large by comparing the value of F to a critical value F_c, which leaves a probability α in the upper tail of the *F*-distribution with J and $T - K$ degrees of freedom.

The critical value for the F-distribution is depicted in Figure 8.1. Tables of critical values for $\alpha = .01$ and $\alpha = .05$ are provided at the end of the book.

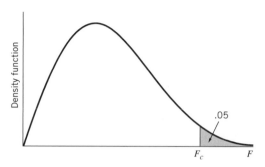

FIGURE *8.1* The probability density function of an F random variable.

For the unrestricted and restricted models in (8.1.1) and (8.1.2), respectively, we find

$$SSE_U = 1805.168 \qquad SSE_R = 1964.758 \qquad \text{(R8.1)}$$

By imposing the null hypothesis $H_0 : \beta_2 = 0$ on the model the sum of squared errors has increased from 1805.168 to 1964.758. There is a single hypothesis, so $J = 1$ and the F-test statistic is

$$F = \frac{(SSE_R - SSE_U)/J}{SSE_U/(T - K)} = \frac{(1964.758 - 1805.168)/1}{1805.168/(52 - 3)} = 4.332 \qquad \text{(R8.2)}$$

We compare this value to the critical value from an F-distribution with 1 and 49 degrees of freedom. The F critical values in Tables 3 and 4 at the end of the book are reported for only a limited number of degrees of freedom. However, the exact critical value for any number of degrees of freedom can be obtained using statistical software. For the $F_{(1,49)}$ distribution, the $\alpha = .05$ critical value is $F_c = 4.038$. Since $F = 4.332 \geq F_c$, we reject the null hypothesis and conclude that price does have a significant effect on total revenue. The p-value for this test is $p = P[F_{(1,49)} \geq 4.332] = .0427$, which is less than $\alpha = .05$; thus, we reject the null hypothesis on this basis as well. The p-value can also be obtained using statistical software. Check that you can locate it in the EViews output for the F-test that appears in Table 8.1. In this table $C(2)$ is β_2, the price coefficient. The chi-square test is a test that will not concern us at this time.

Table *8.1* **EViews Output for Testing Price Coefficient**

Null Hypothesis:	$C(2) = 0$		
F-statistic	4.331940	Probability	0.042651
Chi-square	4.331940	Probability	0.037404

You might recall that we used a *t*-test to test $H_0 : \beta_2 = 0$ against $H_1 : \beta_2 \neq 0$ in Chapter 7. Indeed, in Table 7.2 the *p*-value for this *t*-test is 0.0427, the same as the *p*-value for the *F*-test that we just considered. When testing one "equality" null hypothesis against a "not equal to" alternative hypothesis, either a *t*-test or an *F*-test can be used and the outcomes will be identical. The reason for this correspondence is an exact relationship between the *t*- and *F*-distributions. The square of a *t* random variable with *df* degrees of freedom is an *F* random variable with distribution $F_{(1,df)}$. When using a *t*-test for $H_0 : \beta_2 = 0$ against $H_1 : \beta_2 \neq 0$, we found that $t = -2.081$, $t_c = 2.01$, and $p = .0427$. The *F*-value that we have calculated is $F = 4.332 = t^2$ and $F_c = (t_c)^2$. Because of this exact relationship, the *p*-values for the two tests are identical, meaning that we will always reach the same conclusion whichever approach we take. There is no equivalence when using a one-tailed *t*-test since the *F*-test is not appropriate when the alternative is an inequality, ">" or "<".

We can summarize the elements of an *F*-test as follows:

1. The null hypothesis H_0 consists of one or more (*J*) equality hypotheses. The null hypothesis may *not* include any "greater than or equal to" or "less than or equal to" hypotheses.

2. The alternative hypothesis states that *one or more* of the equalities in the null hypothesis is not true. The alternative hypothesis may not include any "greater than" or "less than" options.

3. The test statistic is the *F*-statistic in (8.1.3).

4. If the null hypothesis is true, *F* has the *F*-distribution with *J* numerator degrees of freedom and $T - K$ denominator degrees of freedom. The null hypothesis is *rejected* if $F \geq F_c$, where F_c is the critical value that leaves $\alpha\%$ of the probability in the upper tail of the *F*-distribution.

5. When testing a single equality hypothesis it is perfectly correct to use either the *t*- or *F*-test procedure. They are equivalent. In practice, it is customary to test single hypotheses using a *t*-test. The *F*-test is usually reserved for joint hypotheses.

8.1.1 THE *F*-DISTRIBUTION: THEORY

An *F* random variable is formed by the ratio of two independent chi-square random variables that have been divided by their degrees of freedom.

If $V_1 \sim \chi^2_{(m_1)}$ and $V_2 \sim \chi^2_{(m_2)}$ and if V_1 and V_2 are independent, then

$$F = \frac{V_1/m_1}{V_2/m_2} \sim F_{(m_1, m_2)} \tag{8.1.4}$$

The **F-distribution** is said to have m_1 *numerator degrees of freedom* and m_2 *denominator degrees of freedom*. The values of m_1 and m_2 determine the shape of the dis-

tribution, which in general looks like Figure 8.1. The range of the random variable is $(0, \infty)$, and it has a long tail to the right.

When you take courses in econometric theory, you prove that

$$V_1 = \frac{SSE_R - SSE_U}{\sigma^2} \sim \chi^2_{(J)} \tag{8.1.5}$$

$$V_2 = \frac{SSE_U}{\sigma^2} \sim \chi^2_{(T-K)} \tag{8.1.6}$$

and that V_1 and V_2 are independent. The result for V_1 requires the relevant null hypothesis to be true; that for V_2 does not. Note that σ^2 cancels when we take the ratio of V_1 to V_2, yielding

$$F = \frac{V_1/J}{V_2/(T-K)} = \frac{(SSE_R - SSE_U)/J}{SSE_U/(T-K)} \tag{8.1.7}$$

The chi-square statistic given in the EViews output in Table 8.1 is equal to V_1 with σ^2 replaced by $\hat{\sigma}^2$. It is a large-sample approximation which you will learn more about in advanced courses.

8.2 Testing the Significance of a Model

An important application of the F-test is for what is called "testing the overall significance of a model." In Chapter 7 we tested whether the dependent variable y is related to a particular explanatory variable x_k using a t-test. In this section we extend this idea to a joint test of the relevance of *all* the included explanatory variables. Consider again the general multiple regression model with $(K-1)$ explanatory variables and K unknown coefficients

$$y_t = \beta_1 + x_{t2}\beta_2 + x_{t3}\beta_3 + \cdots + x_{tK}\beta_K + e_t \tag{8.2.1}$$

To examine whether we have a viable explanatory model, we set up the following null and alternative hypotheses

$$H_0 : \beta_2 = 0, \beta_3 = 0, \cdots, \beta_K = 0 \tag{8.2.2}$$
$$H_1 : \text{\textit{at least one} of the } \beta_k \text{ is nonzero}$$

The null hypothesis has $K - 1$ parts; it is called a joint hypothesis. It states as a conjecture that each and every one of the parameters β_k, other than the intercept parameter β_1, is zero. If this null hypothesis is true, none of the explanatory variables influence y, and thus our model is of little or no value. If the alternative hypothesis H_1 is true, then at least one of the parameters is not zero, and thus, one or more of the explanatory variables should be included in the model. The alternative hypothesis does not indicate, however, which variables those might be. Since we are testing whether or not we have a viable explanatory model, the test for (8.2.2) is sometimes referred to as a *test of the overall significance of the regression model*. Since the t-distribution can only be used to test a single null hypothesis, we use the

F-test for testing the hypotheses in (8.2.2). The unrestricted model is that given in (8.2.1). The restricted model, obtained assuming the null hypothesis is true, is

$$y_t = \beta_1 + e_t \tag{8.2.3}$$

The least squares estimator of β_1 in this restricted model is $b_1^* = \sum y_t/T = \bar{y}$, which is the sample mean of the observations on the dependent variable. The restricted sum of squared errors from the hypothesis (8.2.2) is

$$SSE_R = \sum(y_t - b_1^*)^2 = \sum(y_t - \bar{y})^2 = SST$$

In this one case, in which we are testing the null hypothesis that all the model parameters are zero *except the intercept*, the restricted sum of squared errors is the total sum of squares (SST) from the full unconstrained model. The unrestricted sum of squared errors is the sum of squared errors from the unconstrained model, or $SSE_U = SSE$. The number of hypotheses is $J = K - 1$. Thus, to test the overall significance of a model, the F-test statistic can be modified as

$$F = \frac{(SST - SSE)/(K-1)}{SSE/(T-K)} \tag{8.2.4}$$

The calculated value of this test statistic is compared to a critical value from the $F_{(K-1, T-K)}$ distribution. It is used to test the overall significance of a regression model. The outcome of the test is of fundamental importance when carrying out a regression analysis, and it is usually reported by computer software in the ANOVA table, since all the test ingredients, SST, SSE, K, and $T - K$ are summarized there.

To illustrate, we test the overall significance of the regression used to explain Bay Area Rapid Food's total revenue. We want to test whether the coefficients of price and of advertising expenditure are both zero, against the alternative that at least one of the coefficients is not zero. Thus, in the model

$$tr_t = \beta_1 + \beta_2 p_t + \beta_3 a_t + e_t$$

we want to test

$$H_0 : \beta_2 = 0, \beta_3 = 0$$

against the alternative

$$H_1 : \beta_2 \neq 0 \text{ or } \beta_3 \neq 0, \text{ or both are nonzero.}$$

The ingredients for this test, and the test statistic value itself, are reported in the analysis of variance table reported by most regression software. The SHAZAM version of this table for the Bay Area Rapid Food data appears in Table 8.2. From this table, we see that $SSE_R = SST = 13581$ and $SSE_U = SSE = 1805.2$. Also, the values of *mean square* are the ratios of the sums of squares values to the degrees of freedom, DF. In turn, the ratio of the mean squares is the F-value for the test of

Table 8.2 **ANOVA Table Obtained Using SHAZAM**

ANALYSIS OF VARIANCE–FROM MEAN

	SS	DF	MS	F
REGRESSION	11776.	2.	5888.1	159.828
ERROR	1805.2	49.	36.840	P-VALUE
TOTAL	13581.	51.	266.30	0.000

overall significance of the model. For the Bay Area hamburger data this calculation is

$$F = \frac{(SST - SSE)/(K - 1)}{SSE/(T - K)} = \frac{(13581 - 1805.2)/2}{1805.2/(52 - 3)}$$

$$= \frac{5888.1}{36.84} = 159.83 \tag{R8.3}$$

The 5% critical value for the F-statistic with $(2, 49)$ degrees of freedom is $F_c = 3.187$. Since $159.83 > 3.187$, we reject H_0 and conclude that the estimated relationship is a significant one. Instead of looking up the critical value, we could have made our conclusion based on the p-value, which is calculated by most software, and is reported in Table 8.2. Our sample of data suggests that price or advertising expenditure or both have an influence on total revenue. Note that this conclusion is consistent with conclusions reached using separate t-tests for testing the significance of price and the significance of advertising expenditure in Chapter 7.

8.2.1 THE RELATIONSHIP BETWEEN JOINT AND INDIVIDUAL TESTS

We conclude this section by asking the question: Why use the F-distribution to perform a simultaneous test of $H_0 : \beta_2 = 0$, $\beta_3 = 0$? Why not just use separate t-tests on each of the null hypotheses $H_0 : \beta_2 = 0$ and $H_0 : \beta_3 = 0$? The answer relates to the correlation between the least squares estimators. The F-test that tests both hypotheses simultaneously makes allowance for the fact that the least squares estimators b_2 and b_3 are correlated. It is a test for whether the *pair* of values $\beta_2 = 0$ and $\beta_3 = 0$ are consistent with the data. When separate t-tests are performed, the possibility that $\beta_2 = 0$ is not considered when testing $H_0 : \beta_3 = 0$, and vice versa. It is not a pair of values being tested with t-tests, but a conjecture about a single parameter at a time. Each t-test is treated in isolation from the other, no allowance is made for the correlation between b_2 and b_3. As a consequence, the joint F-test at a 5% significance level is not equivalent to separate t-tests that each use a 5% significance level. Conflicting results can occur. For example, it is possible for individual t-tests to fail to conclude that coefficients are significantly different from zero, while the F-test implies that the coefficients are *jointly* significant. This situation frequently arises when the data are collinear, as described in Section 8.7.

8.3 An Extended Model

We have hypothesized so far in this chapter that total revenue at the Bay Area Rapid Food franchise is explained by product price and advertising expenditures,

$$tr_t = \beta_1 + \beta_2 p_t + \beta_3 a_t + e_t \tag{8.3.1}$$

One aspect of this model that is worth questioning is whether the *linear* relationship between revenue, price, and advertising expenditure is a good approximation to reality. This linear model implies that increasing advertising expenditure will continue to increase total revenue at the same rate, irrespective of the existing level of revenue and advertising expenditure. That is, the coefficient β_3, that measures the response of $E(tr)$ to a change in a, is constant; it does not depend on a. However, as the level of advertising expenditure increases, we would expect diminishing returns to set in. That is, the increase in revenue that results from an advertising expenditure increase of \$1,000 is likely to decline as the total amount spent on advertising grows. One way of allowing for diminishing returns to advertising is to include the squared value of advertising, a^2, into the model as another explanatory variable, so

$$tr_t = \beta_1 + \beta_2 p_t + \beta_3 a_t + \beta_4 a_t^2 + e_t \tag{8.3.2}$$

Adding the term $\beta_4 a_t^2$ to our original specification yields a model in which the response of expected revenue to advertising depends on the level of advertising. The response of $E(tr)$ to a is

$$\frac{\Delta E(tr_t)}{\Delta a_t} \Big|_{(p \text{ held constant})} = \frac{\partial E(tr_t)}{\partial a_t} = \beta_3 + 2\beta_4 a_t \tag{8.3.3}$$

When a_t increases by one unit (\$1,000), and p_t is held constant, $E(tr_t)$ increases by $(\beta_3 + 2\beta_4 a_t) \times \$1,000$. To determine the anticipated signs for β_3 and β_4 we note that we would expect the response of revenue to advertising to be positive when $a_t = 0$. That is, we expect that $\beta_3 > 0$. Also, to achieve diminishing returns the response must decline as a_t increases. That is, we expect $\beta_4 < 0$.

Having proposed an extended model that might be more realistic, our next step is to estimate it. For estimation purposes, the squared value of advertising is "just another variable." That is, we can write (8.3.2) as

$$y_t = \beta_1 + \beta_2 x_{t2} + \beta_3 x_{t3} + \beta_4 x_{t4} + e_t \tag{8.3.4}$$

where

$$y_t = tr_t, \qquad x_{t2} = p_t, \qquad x_{t3} = a_t, \qquad x_{t4} = a_t^2$$

The least squares estimates, using the data in Table 7.1, are

$$\hat{tr}_t = 104.81 - 6.582 p_t + 2.948 a_t + 0.0017 a_t^2 \atop (6.58) \quad (3.459) \quad (0.786) \quad (0.0361) \text{ (s.e.)} \tag{R8.4}$$

What can we say about the addition of a_t^2 to the equation? The first thing to notice is that its coefficient is positive, not negative, as was expected. Second, its t-value for the hypothesis $H_0 : \beta_4 = 0$ is $t = 0.0017/0.0361 = 0.048$. This very low value indicates that b_4 is not significantly different from zero. If β_4 is zero, there are no diminishing returns to advertising, which is counter to our belief in the phenomenon of diminishing returns. Thus, we conclude that β_4 has been estimated imprecisely and its standard error is too large.

When economic parameters are estimated imprecisely, one solution is to obtain more and better data. Recall that the variances of the least squares estimators are reduced by increasing the number of sample observations. Consequently, another 26 weeks of data were collected. These data have been appended to the data in Table 7.1 and stored in a new file called *chap8-3.dat*. The ranges of p_t and a_t are wider in this data set, and greater variation in the explanatory variables leads to a reduction in the variances of the least squares estimators, and may help us achieve more precise least squares estimates. This fact, coupled with the fact that we now have a total of 78 observations, rather than 52, gives us a chance of obtaining a more precise estimate of β_4, and the other parameters as well. Using the new combined data set yields the following least squares estimated equation:

$$\hat{tr}_t = 110.46 - 10.198p_t + 3.361a_t - 0.0268a_t^2$$
$$\qquad\quad (3.74) \quad\ (1.582) \qquad (0.422) \qquad (0.0159)\ \text{(s.e.)} \qquad\qquad \text{(R8.5)}$$

A comparison of the standard errors in this equation with those in (R8.4) indicates that the inclusion of the additional 26 observations has greatly improved the precision of our estimates. In particular, the estimated coefficient of a_t^2 now has the expected sign. Its t-value of $t = -0.0268/0.0159 = -1.68$ implies that b_4 is significantly different from zero, using a one-tailed test and $\alpha = .05$. The 78 data points we have are compatible with the assumption of diminishing returns to advertising expenditures.

8.4 Testing Some Economic Hypotheses

Using the expanded model for Bay Area Rapid Food total revenue in (8.3.2) and the $T = 78$ observations in the file *chap8-3.dat*, we can test some interesting economic hypotheses and illustrate the use of t- and F-tests in economic analysis.

8.4.1 The Significance of Advertising

In the context of our expanded model

$$tr_t = \beta_1 + \beta_2 p_t + \beta_3 a_t + \beta_4 a_t^2 + e_t \qquad\qquad (8.4.1)$$

how would we test whether advertising has an effect on total revenue? If either β_3 or β_4 are not zero, then advertising has an effect on revenue. Based on one-tailed t-tests we can conclude that individually, β_3 and β_4, are not zero, and are of the correct sign. But the question we are now asking involves both β_3 and β_4, and thus a joint test is appropriate. The joint test will use the F-statistic in (8.1.3) to test $H_0 : \beta_3 = 0$, $\beta_4 = 0$. We will compare the unrestricted model in (8.4.1) to the

restricted model, which assumes the null hypothesis is true. The restricted model is

$$tr_t = \beta_1 + \beta_2 p_t + e_t \tag{8.4.2}$$

The elements of the test are:

1. The joint null hypothesis $H_0 : \beta_3 = 0$, $\beta_4 = 0$.
2. The alternative hypothesis $H_1 : \beta_3 \neq 0$, or $\beta_4 \neq 0$, or both are nonzero.
3. The test statistic is $F = [(SSE_R - SSE_U)/J]/[SSE_U/(T-K)]$ where $J = 2$, $T = 78$ and $K = 4$. $SSE_U = 2592.301$ is the sum of squared errors from (8.4.1). $SSE_R = 20907.331$ is the sum of squared errors from (8.4.2).
4. If the joint null hypothesis is true, then $F \sim F_{(J, T-K)}$. The critical value F_c comes from the $F_{(2, 74)}$ distribution, and for the $\alpha = .05$ level of significance it is 3.120.
5. The value of the F-statistic is $F = 261.41 > F_c$ and we reject the null hypothesis that both $\beta_3 = 0$ and $\beta_4 = 0$ and conclude that at least one of them is not zero, implying that advertising has a significant effect on total revenue.

8.4.2 THE OPTIMAL LEVEL OF ADVERTISING

Economic theory tells us that we should undertake all those actions for which the marginal benefit is greater than the marginal cost. This optimizing principle applies to the Bay Area Rapid Food franchise as it attempts to choose the optimal level of advertising expenditure. From (8.3.3), the marginal benefit from another unit of advertising is the increase in total revenue:

$$\frac{\Delta E(tr_t)}{\Delta a_t} \Big|_{(p\ \text{held constant})} = \beta_3 + 2\beta_4 a_t$$

The marginal cost of another unit of advertising is the cost of the advertising plus the cost of preparing additional products sold due to effective advertising. If we ignore the latter costs, advertising expenditures should be increased to the point where the marginal benefit of \$1 of advertising falls to \$1, or where

$$\beta_3 + 2\beta_4 a_t = 1$$

Using the least squares estimates for β_3 and β_4 in (R8.5) we can *estimate* the optimal level of advertising from

$$3.361 + 2(-.0268)\hat{a}_t = 1$$

Solving, we obtain $\hat{a}_t = 44.0485$, which implies that the optimal weekly advertising expenditure is \$44,048.50.

Suppose that the franchise management, based on experience in other cities, thinks that \$44,048.50 is too high, and that the optimal level of advertising is actually about \$40,000. We can test this conjecture using either a *t*- or *F*-test.

The null hypothesis we wish to test is $H_0 : \beta_3 + 2\beta_4(40) = 1$ against the alternative that $H_1 : \beta_3 + 2\beta_4(40) \neq 1$. The test statistic is

$$t = \frac{(b_3 + 80b_4) - 1}{se(b_3 + 80b_4)}$$

which has a $t_{(74)}$ distribution if the null hypothesis is true. The only tricky part of this test is calculating the denominator of the t-statistic. Using the properties of variance developed in Chapter 2.5.2,

$$\widehat{var}(b_3 + 80b_4) = \widehat{var}(b_3) + 80^2 \, \widehat{var}(b_4) + 2(80)\widehat{cov}(b_3, b_4) = .76366$$

where the estimated variances and covariance are provided by your statistical software. Then, the calculated value of the t-statistic is

$$t = \frac{1.221 - 1}{\sqrt{.76366}} = .252 \qquad \text{(R8.6)}$$

The critical value for this two-tailed test comes from the $t_{(74)}$ distribution. At the $\alpha = .05$ level of significance $t_c = 1.993$, and thus we cannot reject the null hypothesis that the optimal level of advertising is \$40,000 per week.

Alternatively, using an F-test, the test statistic is $F = [(SSE_R - SSE_U)/J]/[SSE_U/(T - K)]$ where $J = 1$, $T = 78$ and $K = 4$. $SSE_U = 2592.301$ is the sum of squared errors from the full, unrestricted model in (8.4.1). SSE_R is the sum of squared errors from the restricted model, in which it is assumed that the null hypothesis is true. The restricted model is

$$tr_t = \beta_1 + \beta_2 p_t + (1 - 80\beta_4)a_t + \beta_4 a_t^2 + e_t$$

Rearranging this equation by collecting terms, to put it in a form that is convenient for estimation, we have

$$(tr_t - a_t) = \beta_1 + \beta_2 p_t + \beta_4(a_t^2 - 80a_t) + e_t$$

Estimating this model by least squares yields the restricted sum of squared errors $SSE_R = 2594.533$. The calculated value of the F-statistic is

$$F = \frac{(2594.533 - 2592.301)/1}{2592.302/74}$$

$$= .0637 \qquad \text{(R8.7)}$$

The value $F = .0637$ is $t^2 = (.252)^2$, obeying the relationship between t- and F-random variables that we mentioned previously. The critical value F_c comes from the $F_{(1, 74)}$ distribution. For $\alpha = .05$ the critical value is $F_c = 3.970$.

> **REMARK:** While it is frequently convenient to compute an F-value by using the restricted and unrestricted sums of squares, it is often more convenient to use the power of modern statistical software. Most statistical software packages have TEST statements of some sort that automatically compute the F-value when provided the null hypotheses. You should check out the commands necessary to carry out such tests using your software.

8.4.3 THE OPTIMAL LEVEL OF ADVERTISING AND PRICE

Management believes that expected weekly total revenue will be $175,000 if advertising is set at $40,000 and price is set at $2. That is, in the context of our model,

$$E(tr_t) = \beta_1 + \beta_2 p_t + \beta_3 a_t + \beta_4 a_t^2$$
$$= \beta_1 + \beta_2(2) + \beta_3(40) + \beta_4(40)^2$$
$$= 175$$

Are this conjecture *and* the conjecture that optimal advertising is $40,000 compatible with the evidence contained in the sample of data? We formulate the two joint hypotheses

$$H_0 : \beta_3 + 2\beta_4(40) = 1, \qquad \beta_1 + 2\beta_2 + 40\beta_3 + 1600\beta_4 = 175$$

The alternative is that at least one of these hypotheses is not true. Because there are $J = 2$ hypotheses to test jointly, we will use an F-test. Constructing the restricted model will now require substituting both of these hypotheses into our extended model. This substitution is left as an exercise. The test statistic is $F = [(SSE_R - SSE_U)/J]/[SSE_U/(T - K)]$, where $J = 2$. The computed value of the F-statistic is $F = 1.75$. The critical value for the test comes from the $F_{(2, 74)}$ distribution and is $F_c = 3.120$. Since $F < F_c$, we do not reject the null hypothesis, and conclude that the sample data are compatible with the hypotheses that the optimal level of advertising is $40,000 per week and that if the price is $2 the total revenue will be, on average, $175,000 per week.

8.5 The Use of Nonsample Information

In many estimation and inference problems we have information over and above the information contained in the sample observations. This nonsample information may come from many places, such as economic principles or experience. When it is available, it seems intuitive that we should find a way to use it. If the nonsample information is correct, and if we combine it with the sample information, the precision with which we can estimate the parameters will be improved.

To illustrate how we might go about combining sample and nonsample information, consider a model designed to explain the demand for beer. From the theory of consumer choice in microeconomics, we know that the demand for a good will depend on the price of that good, on the prices of other goods, particularly substitutes and complements, and on income. In the case of beer, it is reasonable to

relate the quantity demanded (q) to the price of beer (p_B), the price of other liquor (p_L), the price of all other remaining goods and services (p_R), and income (m). We write this relationship as

$$q = f(p_B, p_L, p_R, m) \qquad (8.5.1)$$

Using *ln* to denote the natural logarithm, we assume the log–log functional form is appropriate for this demand relationship

$$\ln(q) = \beta_1 + \beta_2 \ln(p_B) + \beta_3 \ln(p_L) + \beta_4 \ln(p_R) + \beta_5 \ln(m) \qquad (8.5.2)$$

This model is a convenient one because it precludes infeasible negative prices, quantities, and income, and because the coefficients β_2, β_3, β_4, and β_5 are elasticities.

A relevant piece of nonsample information can be derived by noting that, if all prices and income go up by the same proportion, we would expect there to be no change in quantity demanded. For example, a doubling of all prices and income should not change the quantity of beer consumed. This assumption is that economic agents do not suffer from "money illusion." Let us impose this assumption on our demand model and see what happens. Having all prices and income change by the same proportion is equivalent to multiplying each price and income by a constant. Denoting this constant by λ, and multiplying each of the variables in (8.5.2) by λ, yields

$$\begin{aligned}
\ln(q) &= \beta_1 + \beta_2 \ln(\lambda p_B) + \beta_3 \ln(\lambda p_L) + \beta_4 \ln(\lambda p_R) + \beta_5 \ln(\lambda m) \\
&= \beta_1 + \beta_2 \ln(p_B) + \beta_3 \ln(p_L) + \beta_4 \ln(p_R) + \beta_5 \ln(m) \\
&\quad + (\beta_2 + \beta_3 + \beta_4 + \beta_5) \ln(\lambda)
\end{aligned} \qquad (8.5.3)$$

Comparing (8.5.2) with (8.5.3) shows that multiplying each price and income by λ will give a change in $\ln(q)$ equal to $(\beta_2 + \beta_3 + \beta_4 + \beta_5) \ln(\lambda)$. Thus, for there to be no change in $\ln(q)$ when all prices and income go up by the same proportion, it must be true that

$$\beta_2 + \beta_3 + \beta_4 + \beta_5 = 0 \qquad (8.5.4)$$

Thus, we can say something about how quantity demanded should not change when prices and income change by the same proportion, and this information can be written in terms of a specific restriction on the parameters of the demand model. We call such a restriction nonsample information. If we believe that this nonsample information makes sense, and hence that the parameter restriction in (8.5.4) holds, then it seems desirable to be able to obtain estimates that obey this restriction.

To obtain estimates that obey (8.5.4), begin with the multiple regression model

$$\ln(q_t) = \beta_1 + \beta_2 \ln(p_{Bt}) + \beta_3 \ln(p_{Lt}) + \beta_4 \ln(p_{Rt}) + \beta_5 \ln(m_t) + e_t \qquad (8.5.5)$$

and a sample of data consisting of thirty years of annual data on beer consumption collected from a randomly selected household. These data are contained in the file *table8-3.dat*, and a few observations are shown in Table 8.3.

Table 8.3 **Selected Observations on Price, Quantity and Income Data for Beer Demand Model**

q (liters)	p_B ($)	p_L ($)	p_R ($)	m ($)
81.7	1.78	6.95	1.11	25088
56.9	2.27	7.32	0.67	26561
64.1	2.21	6.96	0.83	25510
65.4	2.15	7.18	0.75	27158
64.1	2.26	7.46	1.06	27162
\vdots				

To introduce the nonsample information, we solve the parameter restriction $\beta_2 + \beta_3 + \beta_4 + \beta_5 = 0$ for one of the β_ks. It is not important mathematically which we solve for, but for reasons explained shortly we solve for β_4:

$$\beta_4 = -\beta_2 - \beta_3 - \beta_5 \tag{8.5.6}$$

Substituting this expression into the original model in (8.5.5) gives

$$\ln(q_t) = \beta_1 + \beta_2 \ln(p_{Bt}) + \beta_3 \ln(p_{Lt}) + (-\beta_2 - \beta_3 - \beta_5)\ln(p_{Rt}) + \beta_5 \ln(m_t) + e_t$$

$$= \beta_1 + \beta_2(\ln(p_{Bt}) - \ln(p_{Rt})) + \beta_3(\ln(p_{Lt}) - \ln(p_{Rt})) + \beta_5(\ln(m_t) - \ln(p_{Rt})) + e_t$$

$$= \beta_1 + \beta_2 \ln\left(\frac{p_{Bt}}{p_{Rt}}\right) + \beta_3 \ln\left(\frac{p_{Lt}}{p_{Rt}}\right) + \beta_5 \ln\left(\frac{m_t}{p_{Rt}}\right) + e_t \tag{8.5.7}$$

We have used the parameter restriction to eliminate the parameter β_4 and in so doing, and in using the properties of logarithms, we have constructed the new variables $\ln(p_{Bt}/p_{Rt})$, $\ln(p_{Lt}/p_{Rt})$, and $\ln(m_t/p_{Rt})$. The last line in (8.5.7) is our "restricted" model. To get least squares estimates that satisfy the parameter restriction, called "restricted least squares estimates," we apply the least squares estimation procedure directly to the restricted model in (8.5.7). The estimated equation is

$$\ln(\hat{q}_t) = -4.798 - 1.2994 \ln\left(\frac{p_{Bt}}{p_{Rt}}\right) + 0.1868 \ln\left(\frac{p_{Lt}}{p_{Rt}}\right) + 0.9458 \ln\left(\frac{m_t}{p_{Rt}}\right)$$

$$\quad (3.714) \quad (0.166) \qquad\qquad\quad (0.284) \qquad\qquad\quad (0.427) \tag{R8.8}$$

Let the restricted least squares estimates in (R8.8) be denoted as b_k^*. In (R8.8) we have estimates of β_1, β_2, β_3, and β_5. To obtain an estimate of β_4 we use the restriction (8.5.6)

$$b_4^* = -b_2^* - b_3^* - b_5^*$$
$$= -(-1.2994) - 0.1868 - 0.9458$$
$$= 0.1668$$

By using the restriction *within* the model, we have ensured that the estimates obey the constraint, so that $b_2^* + b_3^* + b_4^* + b_5^* = 0$.

> **REMARK:** While it is always possible to obtain restricted estimates by substituting the constraints into the model, it may become messy if there are a number of restrictions or if the restrictions involve several parameters. Most statistical software packages have RESTRICT statements of some sort that automatically compute the restricted least squares estimates when provided the constraints. You should check out the commands available in your software.

What are the properties of this "restricted" least squares estimation procedure? First, the restricted least squares estimator is biased, and $E(b_k^*) \neq \beta_k$, *unless* the constraints we impose are *exactly* true. This result makes an important point about econometrics. A *good economist* will obtain more reliable parameter estimates than a poor one, because a good economist will introduce better nonsample information. This is true at the time of model specification and later, when constraints might be applied to the model. *Good economic theory* is a very important ingredient in empirical research.

The second property of the restricted least squares estimator is that its variance is smaller than the variance of the least squares estimator, *whether the constraints imposed are true or not*. By combining nonsample information with the sample information, we reduce the variation in the estimation procedure caused by random sampling. The reduction in variance obtained by imposing restrictions on the parameters is not at odds with the Gauss-Markov Theorem. The Gauss-Markov result, that the least squares estimator is the best linear unbiased estimator, applies to linear and unbiased estimators that use data alone, with no constraints on the parameters. By incorporating the additional information with the data, we usually give up unbiasedness in return for reduced variances.

8.6 Model Specification

In what has been covered so far, we have generally taken the role of the model as given. Questions have been of the following type: Given a particular regression model, what is the best way to estimate its parameters? Given a particular model, how do we test hypotheses about the parameters of that model? How do we construct interval estimates for the parameters of a model? What are the properties of estimators in a given model? Given that all these questions require knowledge of the model, it is natural to ask where the model comes from. In any econometric investigation, choice of the model is one of the first steps. Thus, in this section we focus on the following questions: What are the important considerations when choosing a model? What are the consequences of choosing the wrong model? Are there ways of assessing whether a model is adequate?

Three essential features of model choice are (1) choice of functional form, (2) choice of explanatory variables (regressors) to be included in the model, and (3) whether the multiple regression model assumptions MR1–MR6, on page 150, hold. Later chapters in the book on heteroskedasticity, autocorrelation, and random regressors deal with violations of the assumptions. For choice of functional form and regressors, economic principles and logical reasoning play a prominent and vital role. We need to ask: What variables are likely to influence the dependent variable y? How is y likely to respond when these variables change? At a constant rate? At a decreasing rate? Is it reasonable to assume constant elasticities over the

whole range of the data? The answers to these questions have a bearing on regressor choice and choice of a suitable functional form. Alternative functional forms were considered in some detail in Chapter 6.3; further issues are addressed in Chapter 10. In the next section we consider the consequences of choosing the wrong set of regressors and some questions about regressor choice. In the section following, a test for misspecification is presented.

8.6.1 OMITTED AND IRRELEVANT VARIABLES

Even with sound economic principles and logic, it is possible that a chosen model may have important variables omitted or irrelevant variables included. To introduce the *omitted-variable* problem, suppose that, in a particular industry, the wage rate of employees W_t, depends on their experience E_t and their motivation M_t, such that we can write

$$W_t = \beta_1 + \beta_2 E_t + \beta_3 M_t + e_t \tag{8.6.1}$$

However, data on motivation are not available. So, instead, we estimate the model

$$W_t = \beta_1 + \beta_2 E_t + v_t \tag{8.6.2}$$

By estimating (8.6.2) we are imposing the restriction $\beta_3 = 0$ when it is not true. The implications of imposing an incorrect restriction were discussed in Section 8.5. The least squares estimator for β_1 and β_2 will generally be biased, although it will have lower variance. One occasion when it will not be biased is when the omitted variable (M_t) is uncorrelated with the included variables (E_t). Uncorrelated explanatory variables are rare, however. A proof of the omitted variable bias is given later in this section.

The possibility of omitted-variable bias means one should take care to include all important relevant variables. It also means that, if an estimated equation has coefficients with unexpected signs, or unrealistic magnitudes, a possible cause of these strange results is the omission of an important variable.

One method for assessing whether a variable or a group of variables should be included in an equation is to perform "significance tests." That is, t-tests for hypotheses such as $H_0 : \beta_3 = 0$ or F-tests for hypotheses such as $H_0 : \beta_3 = \beta_4 = 0$. However, it is important to remember that there are two possible reasons for a test outcome that does not reject a zero null hypothesis.

1. The corresponding variables have no influence on y and can be excluded from the model.

2. The corresponding variables are important ones for inclusion in the model, but the data are not sufficiently good to reject H_0. That is, the data are not sufficiently rich to prove that the variables are important. (Possible causes of poor data are discussed in Section 8.7.)

Because the "insignificance" of a coefficient can be caused by (1) or (2), you must be cautious about following rules that throw out variables with insignificant coefficients. You could be excluding an irrelevant variable, but you also could be inducing omitted-variable bias in the remaining coefficient estimates.

The consequences of omitting relevant variables may lead you to think that a good strategy is to include as many variables as possible in your model. However, doing so will not only complicate your model unnecessarily, it may inflate the variances of your estimates because of the presence of *irrelevant variables*. To see clearly what is meant by an irrelevant variable, suppose that the correct specification is

$$W_t = \beta_1 + \beta_2 E_t + \beta_3 M_t + e_t \tag{8.6.3}$$

but we estimate the model

$$W_t = \beta_1 + \beta_2 E_t + \beta_3 M_t + \beta_4 C_t + e_t$$

where C_t is the number of children of the tth employee, and where, in reality, $\beta_4 = 0$. Then, C_t is an irrelevant variable. Including it does *not* make the least squares estimator biased, but it does mean the variances of b_1, b_2, and b_3 will be greater than those obtained by estimating the correct model in (8.6.3). This result follows because, by the Gauss-Markov theorem, the least squares estimator of (8.6.3) is the minimum-variance linear unbiased estimator of β_1, β_2, and β_3. The inflation of the variances will not occur if C_t is uncorrelated with E_t and M_t. Note, however, that even though the number of children is unlikely to influence the wage rate, it could be correlated with experience.

The estimation consequences of omitted variables and irrelevant variables are something to keep in mind when assessing empirical results. They also point back to our original recommendation: Economic principles and logical rasoning are important considerations for variable choice.

8.6.1a Omitted Variable Bias: A Proof

Suppose we inadvertently omit a variable from the regression model. That is, suppose the true model is $y = \beta_1 + \beta_2 x + \beta_3 h + e$, but we estimate the model $y = \beta_1 + \beta_2 x + e$, omitting h from the model. Then we use the estimator

$$b_2^* = \frac{\sum (x_t - \bar{x})(y_t - \bar{y})}{\sum (x_t - \bar{x})^2} = \frac{\sum (x_t - \bar{x}) y_t}{\sum (x_t - \bar{x})^2}$$

$$= \beta_2 + \beta_3 \sum w_t h_t + \sum w_t e_t$$

where

$$w_t = \frac{x_t - \bar{x}}{\sum (x_t - \bar{x})^2}$$

So,

$$E(b_2^*) = \beta_2 + \beta_3 \sum w_t h_t \neq \beta_2$$

Taking a closer look, we find that

$$\sum w_t h_t = \frac{\sum (x_t - \bar{x}) h_t}{\sum (x_t - \bar{x})^2} = \frac{\sum (x_t - \bar{x})(h_t - \bar{h})}{\sum (x_t - \bar{x})^2}$$

$$= \frac{\sum (x_t - \bar{x})(h_t - \bar{h})/(T - 1)}{\sum (x_t - \bar{x})^2/(T - 1)} = \frac{\hat{\text{cov}}(x_t, h_t)}{\hat{\text{var}}(x_t)}$$

Consequently,

$$E(b_2^*) = \beta_2 + \beta_3 \frac{\hat{\text{cov}}(x_t, h_t)}{\hat{\text{var}}(x_t)} \neq \beta_2$$

Knowing the sign of β_3 and the sign of the covariance between x_t and h_t tells us the direction of the bias. Also, while omitting a variable from the regression usually biases the least squares estimator, if the sample covariance, or sample correlation, between x_t and the omitted variable h_t is zero, then the least squares estimator in the misspecified model is still unbiased.

8.6.2 TESTING FOR MODEL MISSPECIFICATION: THE RESET TEST

Testing for model misspecification is a way of asking: Is our model adequate, or can we improve on it? It could be misspecified if we have omitted important variables, included irrelevant ones, chosen a wrong functional form, or have a model that violates the assumptions of the multiple regression model. The RESET test (Regression Specification Error Test) is designed to detect omitted variables and incorrect functional form. It proceeds as follows.

Suppose that we have specified and estimated the regression model

$$y_t = \beta_1 + \beta_2 x_{t2} + \beta_3 x_{t3} + e_t \tag{8.6.4}$$

Let (b_1, b_2, b_3) be the least squares estimates and let

$$\hat{y}_t = b_1 + b_2 x_{t2} + b_3 x_{t3} \tag{8.6.5}$$

be the predicted values of the y_t. Consider the following two artificial models

$$y_t = \beta_1 + \beta_2 x_{t2} + \beta_3 x_{t3} + \gamma_1 \hat{y}_t^2 + e_t \tag{8.6.6}$$

$$y_t = \beta_1 + \beta_2 x_{t2} + \beta_3 x_{t3} + \gamma_1 \hat{y}_t^2 + \gamma_2 \hat{y}_t^3 + e_t \tag{8.6.7}$$

In (8.6.6) a test for misspecification is a test of $H_0 : \gamma_1 = 0$ against the alternative $H_1 : \gamma_1 \neq 0$. In (8.6.7), testing $H_0 : \gamma_1 = \gamma_2 = 0$ against $H_1 : \gamma_1 \neq 0$ or $\gamma_2 \neq 0$ is a test for misspecification. In the first case a t or an F-test can be used. An F-test is required for the second equation. Rejection of H_0 implies the original model is inadequate and can be improved. A failure to reject H_0 says the test has not been able to detect any misspecification.

The idea behind the test is a general one. Note that \hat{y}_t^2 and \hat{y}_t^3 will be polynomial functions of x_{t2} and x_{t3}. Thus, if the original model is not the correct functional form, the polynomial approximation that includes \hat{y}_t^2 and \hat{y}_t^3 may significantly improve the fit of the model and this fact will be detected through nonzero values of γ_1 and γ_2. Furthermore, if we have omitted variables, and these variables are correlated with x_{t2} and x_{t3}, then some of their effect may be picked up by including the terms \hat{y}_t^2 and/or \hat{y}_t^3. Overall, the general philosophy of the test is: If we can significantly improve the model by artificially including powers of the predictions of the model, then the original model must have been inadequate.

As an example of the test, consider the beer demand example used in Section 8.5 to illustrate the inclusion of nonsample information. The log–log model that we specified earlier is

$$\ln(q_t) = \beta_1 + \beta_2 \ln(p_{Bt}) + \beta_3 \ln(p_{Lt}) + \beta_4 \ln(p_{Rt}) + \beta_5 \ln(m_t) + e_t \qquad (8.6.8)$$

Estimating this model and then augmenting it with squares of the predictions, and squares and cubes of the predictions, yields the RESET test results in the top half of Table 8.4. The F-values are quite small, and their corresponding p-values of 0.93 and 0.70 are well above the conventional significance level of 0.05. There is no evidence from the RESET test to suggest the log–log model is inadequate.

Now, suppose that we had specified a linear model instead of a log–log model. That is, we estimated the model

$$q_t = \beta_1 + \beta_2 p_{Bt} + \beta_3 p_{Lt} + \beta_4 p_{Rt} + \beta_5 m_t + e_t \qquad (8.6.9)$$

Augmenting this model with the squares and then the squares and cubes of the predictions \hat{q}_t yields the RESET test results in the bottom half of Table 8.4. The p-values of 0.0066 and 0.0186 are below 0.05 suggesting the linear model is inadequate.

You should use your computer software to reproduce the results in Table 8.4. When doing so, note that we did not include the nonsample restriction on the coefficients that was utilized in Section 8.5. It was omitted to make comparison of the two functional forms easier. You should also be aware that, as a device for discriminating between alternative functional forms, the RESET test does not always produce such clear-cut results. For example, it is possible for both a linear model and a log–log model not to be rejected.

Table 8.4 **RESET Test Results for Beer Demand Example**

Ramsey RESET Test: LOGLOG Model			
F-statistic (1 term)	0.0075	Probability	0.9319
F-statistic (2 terms)	0.3581	Probability	0.7028
Ramsey RESET Test: LINEAR Model			
F-statistic (1 term)	8.8377	Probability	0.0066
F-statistic (2 terms)	4.7618	Probability	0.0186

8.7 Collinear Economic Variables

Most economic data that are used for estimating economic relationships are nonexperimental. Indeed, in most cases they are simply "collected" for administrative or other purposes. Consequently, the data are not the result of a planned experiment in which an experimental design is specified for the explanatory variables. In controlled experiments, such as discussed in Chapter 1, the right-hand-side variables in the statistical model can be assigned values in such a way that their individual effects can be identified and estimated with precision. When data are the result of an uncontrolled experiment, many of the economic variables may move together in systematic ways. Such variables are said to be **collinear,** and the problem is labeled **collinearity,** or **multicollinearity** when several variables are involved. In this case there is no guarantee that the data will be "rich in information," nor that it will be possible to isolate the economic relationship or parameters of interest.

As an example, consider the problem faced by Bay Area Rapid Food marketing executives when trying to estimate the increase in the total revenue attributable to advertising that appears in newspapers *and* the increase in total revenue attributable to coupon advertising. Suppose it has been common practice to coordinate these two advertising devices, so that at the same time advertising appears in the newspapers, there are flyers distributed containing coupons for price reductions on hamburgers. If variables measuring the expenditures on these two forms of advertising appear on the right-hand side of a total revenue equation like (7.1.2), then the data on these variables will show a systematic, positive relationship; intuitively, it will be difficult for such data to reveal the separate effects of the two types of ads. Because the two types of advertising expenditure move together, it may be difficult to sort out their separate effects on total revenue.

As a second example, consider a production relationship explaining output over time as a function of the amounts of various quantities of inputs employed. There are certain factors of production (inputs), such as labor and capital, that are used in *relatively fixed proportions.* As production increases, the amounts of two, or more, such inputs reflect proportionate increases. Proportionate relationships between variables are the very sort of systematic relationships that epitomize "collinearity." Any effort to measure the individual or separate effects (marginal products) of various mixes of inputs from such data will be difficult.

We should also note at this point that it is not just *relationships between variables* in a sample of data that make it difficult to isolate the separate effects of individual explanatory variables in an economic or statistical model. A related problem exists when the values of an explanatory variable do not vary or change much within the sample of data. When an explanatory variable exhibits little variation, then it is difficult to isolate its impact. In Chapter 7.3.1, we noted that the more variation in an explanatory variable, the more precisely its coefficient can be estimated. Lack of variation is the other side of the coin, and it leads to estimator imprecision. This problem also falls within the context of "collinearity."

8.7.1 THE CONSEQUENCES OF COLLINEARITY

The consequences of collinear relationships among explanatory variables in an econometric model may be summarized as follows:

1. Whenever there are one or more *exact* linear relationships among the explanatory variables, then *the condition of exact collinearity, or exact mul-*

ticollinearity, exists. In this case, the least squares estimator is not defined. We *cannot* obtain estimates of the β_k's using the least squares principle. This is indicated in (7.3.1). If there is an exact linear relationship between x_{t2} and x_{t3}, for example, then the correlation between them is $r_{23} = \pm 1$, and the variance of b_2 is undefined, since 0 appears in the denominator. The same is true of the covariance and the formulas for b_2 and b_3.

2. When *nearly* exact linear dependencies among the explanatory variables exist, some of the variances, standard errors, and covariances of the least squares estimators may be large. We have noted the effect on estimator variance of a high correlation between two explanatory variables in Chapter 7.3.1. Large standard errors for the least squares estimators imply high sampling variability, estimated coefficients that are unstable to small changes in the sample or model specification, interval estimates that are wide, and relatively imprecise information provided by the sample data about the unknown parameters.

3. When estimator standard errors are large, it is likely that the usual *t*-tests will lead to the conclusion that parameter estimates are not significantly different from zero. This outcome occurs despite possibly high R^2 or *F*-values indicating "significant" explanatory power of the model as a whole. The problem is that *collinear variables do not provide enough information to estimate their separate effects*, even though economic theory may indicate their importance in the relationship.

4. Estimates may be very sensitive to the addition or deletion of a few observations, or the deletion of an apparently insignificant variable.

5. Despite the difficulties in isolating the effects of individual variables from such a sample, accurate forecasts may still be possible if the nature of the collinear relationship remains the same within the new (future) sample observations. For example, in an aggregate production function where the inputs labor and capital are nearly collinear, accurate forecasts of output may be possible for a particular ratio of inputs but not for various mixes of inputs.

8.7.2 IDENTIFYING AND MITIGATING COLLINEARITY

One simple way to detect collinear relationships is to use sample correlation coefficients between pairs of explanatory variables. These sample correlations are descriptive measures of linear association. A commonly used rule of thumb is that a correlation coefficient between two explanatory variables greater than 0.8 or 0.9 in absolute value indicates a strong linear association and a potentially harmful collinear relationship. The problem with examining only pairwise correlations is that the collinearity relationships may involve more than two of the explanatory variables, which may or may not be detected by examining pairwise correlations.

 A second simple and effective procedure for identifying the presence of collinearity is to estimate so-called "auxiliary regressions." In these least squares regressions the left-hand-side variable is *one* of the explanatory variables, and the right-hand-side variables are all the remaining explanatory variables. For example, the auxiliary regression for x_{t2} is

$$x_{t2} = a_1 x_{t1} + a_3 x_{t3} + \cdots + a_K x_{tK} + error$$

If the R^2 from this artificial model is high, above .80, the implication is that a large portion of the variation in x_{t2} is explained by variation in the other explanatory variables. In Chapter 7.3.1 we made the point that it is variation in a variable that is *not* associated with any other explanatory variable that is valuable in improving the precision of the least squares estimator b_2. If the R^2 from the auxiliary regression is not high, then the variation in x_{t2} is not explained by the other explanatory variables, and the estimator b_2's precision is not affected by this problem.

The collinearity problem is that the data do not contain enough "information" about the individual effects of explanatory variables to permit us to estimate all the parameters of the statistical model precisely. Consequently, one solution is to obtain more information and include it in the analysis.

One form the new information can take is more, and better, sample data. Unfortunately, in economics, this is not always possible. Cross-sectional data are expensive to obtain, and, with time series data, one must wait for the data to appear. Alternatively, if new data are obtained via the same nonexperimental process as the original sample of data, then the new observations may suffer the same collinear relationships and provide little in the way of new, independent information. Under these circumstances the new data will help little to improve the precision of the least squares estimates.

We may add structure to the problem by introducing, as we did in Section 8.5, *nonsample* information in the form of restrictions on the parameters. This nonsample information may then be combined with the sample information to provide restricted least squares estimates. The good news is that using nonsample information in the form of linear constraints on the parameter values reduces estimator sampling variability. The bad news is that the resulting restricted estimator is *biased* unless the restrictions are *exactly* true. Thus, is it important to use good nonsample information, so that the reduced sampling variability is not bought at a price of large estimator biases.

8.8 Prediction

The prediction problem for a linear statistical model with one explanatory variable was covered in depth in Chapter 5. The results in that chapter extend naturally to the more general model that has more than one explanatory variable. Let us summarize these results.

Consider a linear statistical model with an intercept term and two explanatory variables x_2, x_3. That is

$$y_t = \beta_1 + x_{t2}\beta_2 + x_{t3}\beta_3 + e_t \qquad (8.8.1)$$

where the e_t are uncorrelated random variables with mean 0 and variance σ^2. Given a set of values for the explanatory variables, $(1 \; x_{02} \; x_{03})$ the prediction problem is to predict the value of the dependent variable y_0, which is given by

$$y_0 = \beta_1 + x_{02}\beta_2 + x_{03}\beta_3 + e_0 \qquad (8.8.2)$$

Note that in this prediction problem we are assuming that the parameter values determining y_0 are the same as those in (8.8.1) describing the original sample of data. Furthermore, the random error e_0 we assume to be uncorrelated with each of

the sample errors e_t and to have the same mean, 0, and variance, σ^2. Under these assumptions, the best linear unbiased predictor of y_0 is given by

$$\hat{y}_0 = b_1 + x_{02}b_2 + x_{03}b_3 \qquad (8.8.3)$$

where the b_k's are the least squares estimators. This predictor is unbiased in the sense that the average value of the forecast error is zero. That is, if $f = (y_0 - \hat{y}_0)$ is the forecast error, then $E(f) = 0$. The predictor is best in that for any other linear and unbiased predictor of y_0, the variance of the forecast error is larger than $\text{var}(f)$ = $\text{var}(y_0 - \hat{y}_0)$.

The variance of forecast error $\text{var}(y_0 - \hat{y}_0)$ contains two components. One component arises because b_1, b_2, b_3 are estimates of the true parameters. The other component occurs because e_0 is random. An expression for $\text{var}(y_0 - \hat{y}_0)$ is obtained by computing

$$
\begin{aligned}
\text{var}(f) &= \text{var}[(\beta_1 + \beta_2 x_{02} + \beta_3 x_{03} + e_0) - (b_1 + b_2 x_{02} + b_3 x_{03})] \\
&= \text{var}(e_0 - b_1 - b_2 x_{02} - b_3 x_{03}) \\
&= \text{var}(e_0) + \text{var}(b_1) + x_{02}^2 \, \text{var}(b_2) + x_{03}^2 \, \text{var}(b_3) + 2x_{02} \, \text{cov}(b_1, b_2) \\
&\quad + 2x_{03}\text{cov}(b_1, b_3) + 2x_{02}x_{03} \, \text{cov}(b_2, b_3).
\end{aligned}
\qquad (8.8.4)
$$

To obtain $\text{var}(f)$ we have used the facts that the unknown parameters and the values of the explanatory variables are constants, and that e_0 is uncorrelated with the sample data, and thus is uncorrelated with the least squares estimators b_k. Then $\text{var}(e_0) = \sigma^2$ and the remaining variances and covariances of the least squares estimators are obtained using the rule for calculating the variance of a weighted sum in (2.5.8). Each of these terms involves σ^2, which we replace with its estimator $\hat{\sigma}^2$ to obtain the estimated variance of the forecast error $\hat{\text{var}}(f)$. The square root of this quantity is the standard error of the forecast, $\text{se}(f) = \sqrt{\hat{\text{var}}(f)}$.

If the random errors e_t and e_0 are normally distributed, or if the sample is large, then

$$\frac{f}{\text{se}(f)} = \frac{y_0 - \hat{y}_0}{\sqrt{\hat{\text{var}}(y_0 - \hat{y}_0)}} \sim t_{(T-K)} \qquad (8.8.5)$$

Following the steps we have used many times, a $100(1 - \alpha)\%$ interval predictor for y_0 is $\hat{y}_0 \pm t_c \text{se}(f)$, where t_c is a critical value from the $t_{(T-K)}$ distribution.

Thus, we have shown that the methods for prediction in the model with $K = 3$ are straightforward extensions of the results from the simple linear regression model. If $K > 3$, the methods extend similarly.

8.9 Learning Objectives

Based on the material in this chapter, you should be able to:

1. Explain the concepts of restricted and unrestricted sums of squared errors and how they are used to test hypotheses.

2. Use the F-test to test a null hypothesis which is made up of a single hypothesis or a set of hypotheses.

3. Use your computer to perform an F-test.

4. Test the overall significance of a regression model, and identify the components of this test from your computer output.

5. Explain how to test a single hypothesis about a linear combination of more than one coefficient.

6. Use your computer software to obtain restricted least squares estimates.

7. Explain the properties of restricted least squares estimates.

8. Define an omitted variable. Define an irrelevant variable.

9. What are the consequences of an omitted variable? What are the consequences of an irrelevant variable?

10. Explain how the RESET test works.

11. Use your computer software to perform the RESET test on an estimated model.

12. Explain what is meant by collinear economic variables.

13. What are the consequences of exact collinearity? What are the consequences of strong, but not exact, collinearity?

14. What can you do to overcome collinearity?

15. Explain how to use a least squares estimated model for prediction and for assessment of the precision of the predictions.

8.10 Exercises

8.1 Using the combined data in the file *chap8-3.dat*:
(a) Obtain the results reported in equation (R8.5).
(b) Estimate the model in (8.4.2) and obtain from it the sum of squared errors used in the test of the significance of advertising.
(c) Use your software's "TEST" statement to carry out the tests described in Sections 8.4.1, 8.4.2 and 8.4.3.
(d) Obtain the restricted model for the test described in Section 8.4.3 and use it to calculate the restricted sum of squared errors, SSE_R.
(e) Obtain a 95% prediction interval for total revenue if $p = 2$ and $a = 20$.
(f) Is there any evidence of collinearity present in the data?
(g) Write a report summarizing all your findings.

8.2 In Exercise 7.11 the model

$$Y_t = \alpha K_t^{\beta_2} L_t^{\beta_3} E_t^{\beta_4} M_t^{\beta_5} \exp\{e_t\}$$

was estimated using the data in the file *manuf.dat*. Using the data and results from Exercise 7.11, test the following hypotheses
(a) $H_0 : \beta_2 = 0$ against $H_1 : \beta_2 \neq 0$
(b) $H_0 : \beta_2 = 0, \beta_3 = 0$ against $H_1 : \beta_2 \neq 0$ and/or $\beta_3 \neq 0$
(c) $H_0 : \beta_2 = 0, \beta_4 = 0$ against $H_1 : \beta_2 \neq 0$ and/or $\beta_4 \neq 0$
(d) $H_0 : \beta_2 = 0, \beta_3 = 0, \beta_4 = 0$ against $H_1 : \beta_2 \neq 0$ and/or $\beta_3 \neq 0$ and/or $\beta_4 \neq 0$
(e) $H_0 : \beta_2 + \beta_3 + \beta_4 + \beta_5 = 1$ against the alternative $H_1 : \beta_2 + \beta_3 + \beta_4 + \beta_5 \neq 1$
(f) Analyze the impact of collinearity on this model.

Table 8.5 **EViews Output for Exercise 8.3**

R-squared		Mean dependent var	16.97628
Adjusted R-squared		S.D. dependent var	13.45222
S.E. of regression	5.146058	F-statistic	
Sum squared resid	979.8306	Prob (F-statistic)	

8.3 A portion of the EViews output from using $T = 40$ observations to estimate the model

$$y_t = \beta_1 + \beta_2 x_t + \beta_3 z_t + e_t$$

appears in Table 8.5. Use this output to find
(a) R^2
(b) The value of the F-statistic for testing $H_0 : \beta_2 = \beta_3 = 0$. Do you reject or fail to reject H_0?

8.4 Consider again the model in Exercise 8.3. Suppose this model has been estimated after augmenting it with the squares and cubes of predictions \hat{y}_t^2 and \hat{y}_t^3. Partial EViews output from estimating the augmented regression appears in Table 8.6. Use RESET to test for misspecification.

Table 8.6 **EViews Output for Exercise 8.4**

R-squared	0.901306	Mean dependent var	16.97628
Adjusted R-squared	0.890026	S.D. dependent var	13.45222
S.E. of regression	4.461062	F-statistic	79.90759
Sum squared resid	696.5375	Prob (F-statistic)	0.000000

8.5 Consider the model

$$y_t = \beta_1 + x_{t2}\beta_2 + x_{t3}\beta_3 + e_t$$

and suppose that application of least squares to 20 observations on these variables yields the following results:

$$\begin{bmatrix} b_1 \\ b_2 \\ b_3 \end{bmatrix} = \begin{bmatrix} 0.96587 \\ 0.69914 \\ 1.7769 \end{bmatrix} \quad \hat{cov}\begin{bmatrix} b_1 \\ b_2 \\ b_3 \end{bmatrix} = \begin{bmatrix} 0.21812 & 0.019195 & -0.050301 \\ 0.019195 & 0.048526 & -0.031223 \\ -0.050301 & -0.031223 & 0.037120 \end{bmatrix}$$

$$\hat{\sigma}^2 = 2.5193 \qquad R^2 = 0.9466$$

(a) Find the total variation, unexplained variation, and explained variation for this model.
(b) Find 95% interval estimates for β_2 and β_3.
(c) Use a t-test to test the hypothesis $H_0 : \beta_2 \geq 1$ against the alternative $H_1 : \beta_2 < 1$.
(d) Use your answers in part (a) to test the joint hypothesis $H_0 : \beta_2 = 0$, $\beta_3 = 0$.

8.6 Consider Exercise 7.10 where the cubic cost function

$$y_t = \beta_1 + \beta_2 x_t + \beta_3 x_t^2 + \beta_4 x_t^3 + e_t$$

was estimated.
(a) Find 95% interval estimates for the parameters β_2, β_3, and β_4.
(b) Test whether the data suggest that a linear function will suffice.
(c) Test whether the data suggest that a quadratic function will suffice.
(d) What parameter restrictions imply a linear average cost function? Test these restrictions.
(e) Estimate a log–log cost function of the form $\ln(y_t) = \alpha_1 + \alpha_2 \ln(x_t) + e_t$. Does the RESET test suggest the log–log function is preferable to the cubic? Is the log–log cost function reasonable from an economic standpoint?

8.7 Suppose that, from a sample of 63 observations, the least squares estimates and the corresponding estimated covariance matrix are given by

$$\begin{bmatrix} b_1 \\ b_2 \\ b_3 \end{bmatrix} = \begin{bmatrix} 2 \\ 3 \\ -1 \end{bmatrix} \qquad \hat{cov} \begin{bmatrix} b_1 \\ b_2 \\ b_3 \end{bmatrix} = \begin{bmatrix} 3 & -2 & 1 \\ -2 & 4 & 0 \\ 1 & 0 & 3 \end{bmatrix}$$

Test each of the following hypotheses and state the conclusion:
(a) $\beta_2 = 0$
(b) $\beta_1 + 2\beta_2 = 5$
(c) $\beta_1 - \beta_2 + \beta_3 = 4$

8.8 Use the sample data for beer consumption in the file *table8-3.dat* to:
(a) Compute the coefficients of the demand relation using only sample information. Compare and contrast these results to the restricted coefficient results given in Section 8.5.
(b) Examine the presence of collinearity.
(c) Use (8.5.7) to construct a 95% prediction interval for q when $p_B = 3.00$, $p_L = 10$, $p_R = 2.00$ and $m = 50,000$. (Hint: construct the interval for $\ln(q)$ and then take antilogs.)
(d) Repeat part (c) using the unconstrained model from part (a).

8.9 Consider production functions of the form $Q = f(L, K)$ where Q is the output measure and L and K are labor and capital inputs, respectively. A popular functional form is the Cobb–Douglas equation

$$\ln(Q) = \beta_1 + \beta_2 \ln(L) + \beta_3 \ln(K) + e_t.$$

(a) Use the 33 observations in the file *cobb.dat* to estimate the Cobb–Douglas production function. Is there evidence of collinearity?
(b) Re-estimate the model with the restriction of constant returns to scale, i.e., $\beta_2 + \beta_3 = 1$, and comment on the results.

8.10 The RESET test suggests augmenting an existing model with the squares of the predictions \hat{y}_t^2 or their squares and cubes (\hat{y}_t^2, \hat{y}_t^3). What would happen if you augmented the model with the predictions themselves, \hat{y}_t?

8.11 The SHAZAM output in Table 8.7 relates to the two models

$$y_t = \beta_1 + \beta_2 x_t + \beta_3 w_t + e_t$$
$$y_t = \beta_1 + \beta_2 x_t + e_t$$

RESET tests have been applied to the second model. Discuss the following questions:
(a) Should w_t be included in the model?
(b) What can you say about omitted variable bias?
(c) What can you say about the existence of collinearity and its possible effect?

8.12 The file *toodyay.dat* contains 48 annual observations on a number of variables related to wheat yield in the Toodyay Shire of Western Australia, for the period of 1950–1997. Those variables are:

y = wheat yield in tonnes per hectare,
t = trend term to allow for technological change,
rg = rainfall at germination (May–June),
rd = rainfall at development state (July–August),
rf = rainfall at flowering (September–October).

The unit of measurement for rainfall is centimeters. A model that allows for the yield response to rainfall to be different for the three different periods is

$$y_t = \beta_1 + \beta_2 t + \beta_3 rg_t + \beta_4 rd_t + \beta_5 rf_t + e_t$$

(a) Estimate this model. Report the results and comment on the signs and significance of the estimated coefficients.

Table 8.7 SHAZAM Output for Exercise 8.11

CORRELATION MATRIX OF VARIABLES–35 OBSERVATIONS			
X	1.0000		
W	0.97491	1.0000	
	X	W	
\|_ols y x w			
VARIABLE NAME	ESTIMATED COEFFICIENT	STANDARD ERROR	T-RATIO 32 DF
X	−0.99845	1.235	−0.8085
W	0.49785	0.1174	4.240
CONSTANT	3.6356	2.763	1.316
\|_ols y x			
VARIABLE NAME	ESTIMATED COEFFICIENT	STANDARD ERROR	T-RATIO 33 DF
X	4.1072	0.3383	12.14
CONSTANT	−5.8382	2.000	−2.919
\|_diagnos / reset			
RAMSEY RESET SPECIFICATION TESTS USING POWERS OF YHAT			
RESET(2) =	17.982	– F WITH DF1 = 1	AND DF2 = 32
RESET(3) =	8.7234	– F WITH DF1 = 2	AND DF2 = 31

(b) Test the hypothesis that the response of yield to rainfall is the same irrespective of whether the rain falls during germination, development, or flowering.

(c) Estimate the model under the restriction that the three responses to rainfall are the same. Comment on the results.

8.13 The file *cars.dat* contains observations on the following variables for 392 cars:

$$mpg = \text{miles per gallon,}$$
$$cyl = \text{number of cylinders,}$$
$$eng = \text{engine displacement in cubic inches,}$$
$$hp = \text{horsepower,}$$
$$wgt = \text{vehicle weight in pounds.}$$

(a) Estimate the following equation:

$$mpg = \beta_1 + \beta_2 cyl + \beta_3 eng + \beta_4 hp + \beta_5 wgt + e$$

Report and comment on the results.

(b) Test the following hypotheses:
(i) $H_0 : \beta_2 = 0$,
(ii) $H_0 : \beta_3 = 0$,
(iii) $H_0 : \beta_2 = \beta_3 = 0$.
Are the test outcomes consistent with your intuition?

(c) Compute the correlations between all pairs of the explanatory variables, as well as R^2's for auxiliary regressions for each of the explanatory variables. Do these calculations help explain the test outcomes in part (b)?

8.14 In the paper B. H. Baltagi, J. M. Griffen, and S. R. Vadali (1998), "Excess Capacity: A Permanent Characteristic of U.S. Airlines," *Journal of Applied Econometrics*, 13, 645–657, the authors consider estimation of airline cost functions. Tables 8.8, 8.9, and 8.10 contain output obtained using their data to estimate a function of the form

$$\ln(VC) = \beta_1 + \beta_2 \ln(Y) + \beta_3 \ln(K) + \beta_4 \ln(PL) + \beta_5 \ln(PF) + \beta_6 \ln(PM)$$
$$+ \beta_7 \ln(STAGE) + e$$

where VC = variable cost; Y = output; K = capital stock; PL = price of labor; PF = price of fuel; PM = price of materials; and $STAGE$ = average flight length.

(a) Interpret the coefficients of *LY*, *LK*, and *LPF*.

(b) Do the estimated coefficients have the anticipated signs?

(c) Which coefficients are not significantly different from zero?

(d) Does the RESET test suggest the model is misspecified?

(e) Constant returns to scale exist if $\beta_2 + \beta_3 = 1$. Test this hypothesis.

(f) If all input prices increase by the same proportion, variable cost will increase by the same proportion if $\beta_4 + \beta_5 + \beta_6 = 1$. Test this hypothesis.

(g) The tests in parts (e) and (f) could also be carried out using t statistics. Explain how you would use the information in Tables 8.8 and 8.9 to compute these t statistics.

Table 8.8 Least Squares Output for Exercise 8.14

Dependent Variable: LVC
Sample: 1 268
Included observations: 268

Variable	Coefficient	Std. Error	t-Statistic	Prob.
C	7.528901	0.582172	12.93244	0.0000
LY	0.679157	0.053399	12.71856	0.0000
LK	0.350305	0.052879	6.624638	0.0000
LPL	0.275366	0.043807	6.285921	0.0000
LPF	0.321864	0.036098	8.916433	0.0000
LPM	−0.068318	0.100338	−0.680879	0.4966
LSTAGE	−0.194390	0.028577	−6.802349	0.0000

R-squared	0.989528	Mean dependent var	6.243818
Adjusted R-squared	0.989287	S.D. dependent var	1.135334
S.E. of regression	0.117512	F-statistic	4110.310
Sum squared resid	3.604139	Prob(F-statistic)	0.000000

Table 8.9 Covariance Matrix for Least Squares Estimates: Exercise 8.14

	C	LY	LK	LPL	LPF	LPM	LSTAGE
C	0.338924	0.007059	−0.005419	0.011217	0.017152	−0.056298	−0.004939
LY	0.007059	0.002851	−0.002753	−9.89E-05	0.000179	−0.000364	−0.001097
LK	−0.005419	−0.002753	0.002796	2.83E-05	−0.000110	0.000294	0.000887
LPL	0.011217	−9.89E-05	2.83E-05	0.001919	−8.60E-05	−0.002159	3.64E-05
LPF	0.017152	0.000179	−0.000110	−8.60E-05	0.001303	−0.002929	−0.000102
LPM	−0.056298	−0.000364	0.000294	−0.002159	−0.002929	0.010068	0.000104
LSTAGE	−0.004939	−0.001097	0.000887	3.64E-05	−0.000102	0.000104	0.000817

Table 8.10 Test Results for Exercise 8.14

Ramsey RESET Test:

F-statistic (1 term)	3.380323	Probability	0.067120
F-statistic (2 terms)	1.860108	Probability	0.157729

Wald Test:
Equation: COSTFN

Null Hypothesis: C(2) + C(3) = 1

F-statistic	6.104834	Probability	0.014121
Chi-square	6.104834	Probability	0.013481

Wald Test:
Equation: COSTFN

Null Hypothesis: C(4) + C(5) + C(6) = 1

F-statistic	75.43246	Probability	0.000000
Chi-square	75.43246	Probability	0.000000

Chapter 9

Dummy (Binary) Variables

9.1 Introduction

The multiple regression model is

$$y_t = \beta_1 + \beta_2 x_{t2} + \beta_3 x_{t3} + \cdots + \beta_K x_{tK} + e_t \tag{9.1.1}$$

The assumptions of the model are

ASSUMPTIONS OF THE MULTIPLE REGRESSION MODEL

MR1. $y_t = \beta_1 + \beta_2 x_{t2} + \cdots + \beta_K x_{tK} + e_t, \ t = 1, \ldots, T$

MR2. $E(y_t) = \beta_1 + \beta_2 x_{t2} + \cdots + \beta_K x_{tK} \Leftrightarrow E(e_t) = 0$

MR3. $\text{var}(y_t) = \text{var}(e_t) = \sigma^2$

MR4. $\text{cov}(y_t, y_s) = \text{cov}(e_t, e_s) = 0$

MR5. The values of x_{tk} are not random and are not exact linear functions of the other explanatory variables

MR6. $y_t \sim N(\beta_1 + \beta_2 x_{t2} + \cdots + \beta_K x_{tK}, \sigma^2) \Leftrightarrow e_t \sim N(0, \sigma^2)$

Assumption MR1 defines the statistical model that we assume is appropriate for *all* T of the observations in our sample. One part of the assertion is that the parameters of the model, β_k, are the same for each and every observation. Recall that

β_k = the change in $E(y_t)$ when x_{tk} is increased by one unit, and all

 other variables are held constant

$$= \frac{\Delta E(y_t)}{\Delta x_{tk}}_{\text{(other variables held constant)}} = \frac{\partial E(y_t)}{\partial x_{tk}}$$

That is, assumption 1 implies that for each of the observations $t = 1, \ldots, T$ the effect of a one-unit change in x_{tk} on $E(y_t)$ is exactly the same. If this assumption does not hold, and if the parameters are not the same for all the observations, then the meaning of the least squares estimates of the parameters in (9.1.1) is not clear.

In this chapter we extend the multiple regression model of Chapter 8 to situations in which the regression parameters are different for some of the observations in a sample. We use *dummy variables,* which are explanatory variables that take one of two values, usually 0 or 1. These simple variables are a very powerful tool for capturing qualitative characteristics of individuals, such as gender, race, and geographic region of residence. In general, we use dummy variables to describe any event that has only two possible outcomes. We explain how to use dummy variables to account for such features in our model. As a second tool for capturing parameter variation, we make use of **interaction variables**. These are variables formed by multiplying two or more explanatory variables together. When using either dummy variables or interaction variables, some changes in model interpretation are required. We will discuss each of these scenarios.

We explore the various ways, dummy variables can be included in a model and the different interpretations that they bring.

9.2 The Use of Intercept Dummy Variables

Dummy variables allow us to construct models in which some or all regression model parameters, including the intercept, change for some observations in the sample. In this section we examine the most common use of dummy variables, how to modify the regression model intercept parameter.

To make matters specific, let us consider an example from real estate economics. Buyers and sellers of homes, tax assessors, real estate appraisers, and mortgage bankers are interested in predicting the current market value of a house. A common way to predict the value of a house is to use a "hedonic" model, in which the price of the house is explained as a function of its characteristics, such as its size, location, number of bedrooms, age, etc.

For the present, let us assume that the size of the house, S, is the only relevant variable in determining house price, P. Specify the regression model as

$$P_t = \beta_1 + \beta_2 S_t + e_t \tag{9.2.1}$$

In this model β_2 is the value of an additional square foot of living area, and β_1 is the value of the land alone.

In real estate the three most important words are "location, location and location." How can we take into account the effect of a property being in a desirable neighborhood, such as one near a university, or near a golf course? Thought of this way, location is a "qualitative" characteristic of a house.

Dummy variables are used to account for qualitative factors in econometric models. They are often called *binary* or *dichotomous* variables as they take just two values, usually 1 or 0, to indicate the presence or absence of a characteristic. That is, a dummy variable D is

$$D = \begin{cases} 1 & \text{if characteristic is present} \\ 0 & \text{if characteristic is not present} \end{cases} \tag{9.2.2}$$

Thus, for the house price model, we can define a dummy variable, to account for a desirable neighborhood, as

$$D_t = \begin{cases} 1 & \text{if property is in the desirable neighborhood} \\ 0 & \text{if property is not in the desirable neighborhood} \end{cases} \qquad (9.2.3)$$

Adding this variable to the regression model, along with a new parameter δ, we obtain

$$P_t = \beta_1 + \delta D_t + \beta_2 S_t + e_t \qquad (9.2.4)$$

The effect of the inclusion of a dummy variable D_t into the regression model is best seen by examining the regression function, $E(P_t)$, in the two locations. If the model in (9.2.4) is correctly specified, then $E(e_t) = 0$ and

$$E(P_t) = \begin{cases} (\beta_1 + \delta) + \beta_2 S_t & \text{when } D_t = 1 \\ \beta_1 + \beta_2 S_t & \text{when } D_t = 0 \end{cases} \qquad (9.2.5)$$

In the desirable neighborhood, $D_t = 1$, and the intercept of the regression function is $(\beta_1 + \delta)$. In other areas the regression function intercept is simply β_1. This difference is depicted in Figure 9.1, assuming that $\delta > 0$.

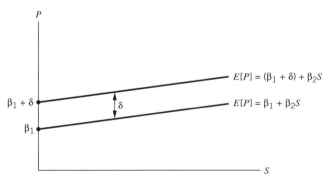

FIGURE *9.1* An intercept dummy variable.

Adding the dummy variable D_t to the regression model creates a *parallel shift* in the relationship by the amount δ. In the context of the house price model the interpretation of the parameter δ is that it is a "location premium," the difference in house price due to being located in the desirable neighborhood. A dummy variable like D_t that is incorporated into a regression model *to capture a shift in the intercept as the result of some qualitative factor* is called an **intercept dummy variable**. In the house price example we expect the price to be higher in a desirable location, and thus we anticipate that δ will be positive.

The least squares estimator's properties are not affected by the fact that one of the explanatory variables consists only of zeros and ones. D_t is treated as any other explanatory variable. We can construct an interval estimate for δ, or we can test the significance of its least squares estimate. Such a test is a statistical test of whether the neighborhood effect on house price is "statistically significant." If $\delta = 0$, then there is no location premium for the neighborhood in question.

9.3 Slope Dummy Variables

Instead of assuming that the effect of location on house price causes a change in the intercept of the hedonic regression equation in (9.2.1), let us assume that the change is in the slope of the relationship. We can allow for a change in a slope by including in the model an additional explanatory variable that is equal to the *product* of a dummy variable and a continuous variable. In our model the slope of the relationship is the value of an additional square foot of living area. If we assume this is one value for homes in the desirable neighborhood, and another value for homes in other neighborhoods, we can specify

$$P_t = \beta_1 + \beta_2 S_t + \gamma (S_t D_t) + e_t \qquad (9.3.1)$$

The new variable $(S_t D_t)$ is the product of house size and the dummy variable, and is called an **interaction variable,** as it captures the interaction effect of location and size on house price. Alternatively, it is called a **slope dummy variable,** because it allows for a change in the slope of the relationship. The interaction variable takes a value equal to size for houses in the desirable neighborhood when $D_t = 1$, and it is zero for homes in other neighborhoods. Despite its unusual nature, a slope dummy variable is treated just like any other explanatory variable in a regression model. Examining the regression function for the two different locations best illustrates the effect of the inclusion of the interaction variable into the economic model.

$$E(P_t) = \beta_1 + \beta_2 S_t + \gamma (S_t D_t) = \begin{cases} \beta_1 + (\beta_2 + \gamma)S_t & \text{when} & D_t = 1 \\ \beta_1 + \beta_2 S_t & \text{when} & D_t = 0 \end{cases} \qquad (9.3.2)$$

In the desirable neighborhood, the price per square foot of a home is $(\beta_2 + \gamma)$; it is β_2 in other locations. We would anticipate that γ, the difference in price per square foot in the two locations, is positive, if one neighborhood is more desirable than the other. This situation is depicted in Figure 9.2a.

Another way to see the effect of including an interaction variable is to use calculus. The partial derivative of expected house price with respect to size (measured in square feet), which gives the slope of the relation, is

$$\frac{\partial E(P_t)}{\partial S_t} = \begin{cases} \beta_2 + \gamma & \text{when } D_t = 1 \\ \beta_2 & \text{when } D_t = 0 \end{cases}$$

If the assumptions of the regression model hold for (9.3.1), then the least squares estimators have their usual good properties, as discussed in Chapter 7.3. A test of the hypothesis that the value of a square foot of living area is the same in the two locations is carried out by testing the null hypothesis $H_0 : \gamma = 0$ against the alternative $H_1 : \gamma \neq 0$. In this case, we might test $H_0 : \gamma = 0$ against $H_1 : \gamma > 0$, since we expect the effect to be positive.

If we assume that house location affects *both* the intercept and the slope, then both effects can be incorporated into a single model. The resulting regression model is

$$P_t = \beta_1 + \delta D_t + \beta_2 S_t + \gamma (S_t D_t) + e_t \qquad (9.3.3)$$

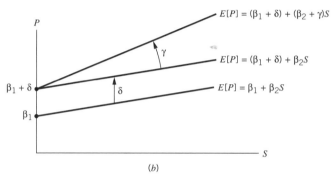

FIGURE *9.2* (*a*) A slope dummy variable. (*b*) A slope and intercept dummy variable.

In this case the regression functions for the house prices in the two locations are

$$E(P_t) = \begin{cases} (\beta_1 + \delta) + (\beta_2 + \gamma)S_t & \text{when } D_t = 1 \\ \beta_1 + \beta_2 S_t & \text{when } D_t = 0 \end{cases} \qquad (9.3.4)$$

In Figure 9.2*b* we depict the house price relations assuming that $\delta > 0$ and $\gamma > 0$.

9.4 An Example: The University Effect on House Prices

A real estate economist collects data on two similar neighborhoods, one bordering a large state university, and one that is a neighborhood about 3 miles from the university. She records 1000 observations, a few of which are shown in Table 9.1. (The complete data file is called *table9-1.dat*, which will be provided by your instructor, or which can be found at our web site.) House prices are given in \$; size (*SQFT*) is the number of square feet of living area. Also recorded are the house age (years); location (*UTOWN* = 1 for homes near the university, 0 otherwise); whether the house has a pool (*POOL* = 1 if a pool is present, 0 otherwise); and whether the house has a fireplace (*FPLACE* = 1 is a fireplace is present, 0 otherwise).

The economist specifies the regression equation as

$$PRICE_t = \beta_1 + \delta_1 UTOWN_t + \beta_2 SQFT_t + \gamma(SQFT_t \times UTOWN_t)$$
$$+ \beta_3 AGE_t + \delta_2 POOL_t + \delta_3 FPLACE_t + e_t \qquad (9.4.1)$$

Table 9.1 **Representative Real Estate Data Values**

Price	Sqft	Age	Utown	Pool	Fplace
205452	2346	6	0	0	1
185328	2003	5	0	0	1
248422	2777	6	0	0	0
154690	2017	1	0	0	0
221801	2645	0	0	0	1
199119	2156	6	0	0	1
272134	2991	9	0	0	1
250631	2798	0	0	0	1
197240	2480	0	0	1	0
235755	2750	0	0	0	0
287339	2367	28	1	1	0
255325	2130	0	1	1	1
301037	2987	6	1	0	1
264122	2484	4	1	0	1
253392	2053	1	1	0	0
257195	2284	4	1	0	0
338295	3000	11	1	0	1
263526	2399	6	1	0	0
300728	2874	9	1	0	0
220987	2093	2	1	0	1

We anticipate that all the coefficients in this model will be positive except β_3, which is an estimate of the effect of age, or depreciation, on house price. Using 481 houses not near the university ($UTOWN = 0$) and 519 houses near the university ($UTOWN = 1$), the estimated regression results are shown in Table 9.2. The model $R^2 = 0.8697$ and the overall-F statistic value is $F = 1104.213$, indicating that the model fits the data well. The variable $USQFT$ is the slope dummy, interaction, variable $SQFT \times UTOWN$. Based on one-tailed t-tests of significance, at the $\alpha = .05$ level, we reject the hypothesis that any of the parameters are zero, and accept the alternative that they are positive, except the coefficient on AGE, which we accept

Table 9.2 **House Price Equation Estimates**

Variable	DF	Parameter Estimate	Standard Error	T for H0: Parameter=0	Prob > \|T\|
INTERCEP	1	24500	6191.7214197	3.957	0.0001
UTOWN	1	27453	8422.5823569	3.259	0.0012
SQFT	1	76.121766	2.45176466	31.048	0.0001
USQFT	1	12.994049	3.32047753	3.913	0.0001
AGE	1	−190.086422	51.20460724	−3.712	0.0002
POOL	1	4377.163290	1196.6916441	3.658	0.0003
FPLACE	1	1649.175634	971.95681885	1.697	0.0901

to be negative. The estimated regression function for the houses near the university is

$$\widehat{PRICE} = (24500 + 27453) + (76.12 + 12.99)SQFT - 190.09AGE + 4377.16POOL$$
$$+ 1649.17FPLACE$$
$$= 51953 + 89.11SQFT - 190.09AGE + 4377.16POOL + 1649.17FPLACE$$

For houses in other areas, the estimated regression function is

$$\widehat{PRICE} = 24500 + 76.12SQFT - 190.09AGE + 4377.16POOL + 1649.17FPLACE$$

Based on these regression estimates, what do we conclude?

- We estimate the location premium, for lots near the university, to be $27,453.
- We estimate the price per square foot to be $89.11 for houses near the university, and $76.12 for houses in other areas.
- We estimate that houses depreciate $190.09 per year.
- We estimate that a pool increases the value of a home by $4377.16.
- We estimate that a fireplace increases the value of a home by $1649.17.

9.5 Common Applications of Dummy Variables

In this section we review some standard ways in which dummy variables are used. Pay close attention to the interpretation of dummy variable coefficients in each example.

9.5.1 INTERACTIONS BETWEEN QUALITATIVE FACTORS

We have seen how dummy variables can be used to represent qualitative factors in a regression model. Intercept dummy variables for qualitative factors are **additive.** That is, the effect of each qualitative factor is added to the regression intercept, and the effect of any dummy variable is independent of any other qualitative factor. Sometimes, however, we might question whether qualitative factors' effects are independent.

For example, suppose we are estimating a wage equation, in which an individual's wages are explained as a function of their experience, skill, and other factors related to productivity. It is customary to include dummy variables for race and gender in such equations. If we have modeled productivity attributes well, and if wage determination is not discriminatory, then the coefficients of the race and gender dummy variables should not be significant. Including just race and gender dummies, however, will not capture interactions between these qualitative factors. Special wage treatment for being "white" <u>and</u> "male" is not captured by separate race and gender dummies. To allow for such a possibility consider the following specification, where for simplicity we use only experience (*EXP*) as a productivity measure,

$$WAGE = \beta_1 + \beta_2 EXP + \delta_1 RACE + \delta_2 SEX + \gamma(RACE \times SEX) + e \quad (9.5.1)$$

where

$$RACE = \begin{cases} 1 & white \\ 0 & nonwhite \end{cases} \quad SEX = \begin{cases} 1 & male \\ 0 & female \end{cases}$$

When multiple dummy variables are present, and especially when there are interactions between dummies, it is important, for proper interpretation, to write out the regression function, $E(WAGE)$, for each dummy variable combination.

$$E(WAGE) = \begin{cases} (\beta_1 + \delta_1 + \delta_2 + \gamma) + \beta_2 EXP & white\text{—}male \\ (\beta_1 + \delta_1) + \beta_2 EXP & white\text{—}female \\ (\beta_1 + \delta_2) + \beta_2 EXP & nonwhite\text{—}male \\ \beta_1 + \beta_2 EXP & nonwhite\text{—}female \end{cases} \quad (9.5.2)$$

The parameter δ_1 measures the effect of race, the parameter δ_2 measures the effect of gender, and the parameter γ measures the effect of being "white" and "male."

9.5.2 QUALITATIVE VARIABLES WITH SEVERAL CATEGORIES

Many qualitative factors have more than two categories. Examples are region of the country (North, South, East, West) and level of educational attainment (less than high school, high school, college, postgraduate). For each category we create a separate binary dummy variable. However, as we will see, some care must be taken when entering these dummy variables into a regression equation.

To illustrate, let us again use a wage equation as an example, and focus only on experience and level of educational attainment (as a proxy for skill) as explanatory variables. Define dummies for educational attainment as follows:

$$E_0 = \begin{cases} 1 & \text{less than high school} \\ 0 & \text{otherwise} \end{cases} \quad E_1 = \begin{cases} 1 & \text{high school diploma} \\ 0 & \text{otherwise} \end{cases}$$

$$E_2 = \begin{cases} 1 & \text{college degree} \\ 0 & \text{otherwise} \end{cases} \quad E_3 = \begin{cases} 1 & \text{postgraduate degree} \\ 0 & \text{otherwise} \end{cases}$$

Specify the wage equation as

$$WAGE = \beta_1 + \beta_2 EXP + \delta_1 E_1 + \delta_2 E_2 + \delta_3 E_3 + e \quad (9.5.3)$$

First notice that we have not included all the dummy variables for educational attainment. Doing so would have created a model in which **exact collinearity** exists. Since the educational categories are exhaustive, the sum of the education dummies $E_0 + E_1 + E_2 + E_3 = 1$. Thus the "intercept variable" $x_1 = 1$ is an exact linear combination of the education dummies. Recall, from Chapter 8.7, that the least squares estimator is not defined in such cases. The usual solution to this problem is to omit one dummy variable, which defines a **reference group,** as we shall see by examining the regression function,

$$E(WAGE) = \begin{cases} (\beta_1 + \delta_3) + \beta_2 EXP & \text{postgraduate degree} \\ (\beta_1 + \delta_2) + \beta_2 EXP & \text{college degree} \\ (\beta_1 + \delta_1) + \beta_2 EXP & \text{high school diploma} \\ \beta_1 + \beta_2 EXP & \text{less than high school} \end{cases} \quad (9.5.4)$$

The parameter δ_1 measures the expected wage differential between workers who have a high school diploma and those who do not. The parameter δ_2 measures the expected wage differential between workers who have a college degree and those who did not graduate from high school, and so on. The omitted dummy variable, E_0, identifies those who did not graduate from high school. The coefficients of the dummy variables represent expected wage differentials <u>relative to</u> this group. The intercept parameter β_1 represents the base wage for a worker with no experience and no high school diploma.

Mathematically it does not matter which dummy variable is omitted, although the choice of E_0 is convenient in the example above. If we are estimating an equation using geographic dummy variables, N, S, E, and W, identifying regions of the country, the choice of which dummy variable to omit is more arbitrary. Recall, however, that the omitted dummy variable defines the reference group for the equation.

Failure to omit one dummy variable will lead to your computer software returning a message saying that least squares estimation fails. This error is sometimes described as falling into the **dummy variable trap**.

9.5.3 CONTROLLING FOR TIME

The earlier examples we have given apply to cross-sectional data. Dummy variables are also used in regressions using time series data, as the following examples illustrate.

9.5.3a Seasonal Dummies. Suppose we are estimating a model with dependent variable y_t = the number of 20 pound bags of Royal Oak charcoal sold in one week at a supermarket. Explanatory variables would include the price of Royal Oak, the price of competitive brands (Kingsford and the store brand), the prices of complementary goods (charcoal lighter fluid, pork ribs and sausages) and advertising (newspaper ads and coupons). While these standard demand factors are all relevant, we may also find strong seasonal effects. All other things being equal, more charcoal is sold in the summer than in other seasons. Thus we may want to include either monthly dummies (e.g., AUG = 1 if month is August, AUG = 0 otherwise) or seasonal dummies (SUMMER = 1 if month = June, July, or August; SUMMER = 0 otherwise) into the regression. In addition to these seasonal effects, holidays are special occasions for cookouts. In the United States these are Memorial Day (last Monday in May), Independence Day (July 4), and Labor Day (first Monday in September). Additional sales can be expected in the week before these holidays, meaning that dummy variables for each should be included into the regression.

9.5.3b Annual Dummies. In the same spirit as seasonal dummies, annual dummies are used to capture year effects not otherwise measured in a model. The real estate model discussed earlier in this chapter provides an example. Real estate data are available continuously, every month, every year. Suppose we have data on house prices for a certain community covering a 10-year period. In addition to house

characteristics, such as those employed in (9.4.1), local economic conditions affect house prices. If the local economy is in a recession, then we can expect house prices to fall, ceteris paribus. Measuring the economy-driven "pure" price effects is important for a number of groups. Economists creating "cost-of-living" indexes for cities must include a component for housing that takes the pure price effect into account. Another interested group is composed of homeowners, who in many places pay property taxes, which are used to fund local schools. Tax payments are usually specified to be a certain percentage of the market value of the property. Tax assessors may assess property market values annually, taking into account the price effects induced by economic conditions.

The simplest method for capturing these price effects is to include annual dummies (D99 = 1 if year = 1999; D99 = 0 otherwise) into the hedonic regression model. This important example is illustrated in Exercise 9.3.

9.5.3c Regime Effects. An economic regime is a set of structural economic conditions that exists for a certain period. The idea is that economic relations may behave one way during one regime, but they may behave differently during another. Economic regimes may be associated with political regimes (conservatives in power, liberals in power); unusual economic conditions (oil embargo, recession, hyperinflation); or changes in the legal environment (tax law changes). An example concerning an investment tax credit is suggested by Intriligator, Bodkin, and Hsiao (*Econometric Models, Techniques and Applications, 2nd Edition*, Prentice Hall, Upper Saddle River, NJ, 1996, p. 53). The investment tax credit was enacted in 1962 in an effort to stimulate additional investment. The law was suspended in 1966, reinstated in 1970, and eliminated in the Tax Reform Act of 1986. Thus we might create a dummy variable

$$ITC = \begin{cases} 1 & 1962 - 1965, 1970 - 1986 \\ 0 & otherwise \end{cases}$$

A macroeconomic investment equation might be

$$INV_t = \beta_1 + \delta ITC_t + \beta_2 GNP_t + \beta_3 GNP_{t-1} + e_t$$

If the tax credit was successful, then $\delta > 0$.

9.6 Testing for the Existence of Qualitative Effects

If the regression model assumptions hold, and the errors e are normally distributed (Assumption MR6), or if the errors are not normal but the sample is large, then the testing procedures outlined in Chapters 7.5, 8.1, and 8.2 may be used to test for the presence of qualitative effects.

9.6.1 TESTING FOR A SINGLE QUALITATIVE EFFECT

Tests for the presence of a single qualitative effect can be based on the t-distribution. For example, consider the investment equation $INV_t = \beta_1 + \delta ITC_t + \beta_2 GNP_t + \beta_3 GNP_{t-1} + e_t$ introduced in the last section. The efficacy of the investment

tax credit program is checked by testing the null hypothesis that $\delta = 0$ against the alternative that $\delta \neq 0$, or $\delta > 0$, using the appropriate two- or one-tailed t-test.

9.6.2 TESTING JOINTLY FOR THE PRESENCE OF SEVERAL QUALITATIVE EFFECTS

If a model has more than one dummy variable, representing several qualitative characteristics, the significance of each, apart from the others, can be tested using the t-test outlined in the previous section. It is often of interest, however, to test the *joint* significance of *all* the qualitative factors.

For example, consider the wage equation (9.5.1)

$$WAGE = \beta_1 + \beta_2 EXP + \delta_1 RACE + \delta_2 SEX + \gamma(RACE \times SEX) + e \qquad (9.6.1)$$

How do we test the hypothesis that neither race nor gender affects wages? We do it by testing the joint null hypothesis $H_0 : \delta_1 = 0, \delta_2 = 0, \gamma = 0$ against the alternative that at least one of the indicated parameters is not zero. If the null hypothesis is true, race and gender fall out of the regression, and thus have no effect on wages.

To test this hypothesis we use the F-test procedure that is described in Chapter 8.1. The test statistic for a joint hypothesis is

$$F = \frac{(SSE_R - SSE_U)/J}{SSE_U/(T-K)} \qquad (9.6.2)$$

where SSE_R is the sum of squared least squares residuals from the "restricted" model in which the null hypothesis is assumed to be true, SSE_U is the sum of squared residuals from the original, "unrestricted," model, J is the number of joint hypotheses, and $(T-K)$ is the number of degrees of freedom in the unrestricted model. If the null hypothesis is true, then the test statistic F has an F-distribution with J numerator degrees of freedom and $(T-K)$ denominator degrees of freedom, $F_{(J,T-K)}$. We reject the null hypothesis if $F \geq F_c$, where F_c is the critical value, illustrated in Figure 8.1, for the level of significance α.

To test the $J = 3$ joint null hypotheses $H_0 : \delta_1 = 0, \delta_2 = 0, \gamma = 0$, we obtain the unrestricted sum of squared errors SSE_U by estimating (9.6.1). The restricted sum of squares SSE_R is obtained by estimating the restricted model

$$WAGE = \beta_1 + \beta_2 EXP + e \qquad (9.6.3)$$

9.7 Testing the Equivalence of Two Regressions Using Dummy Variables

In the previous section we tested for the existence of qualitative effects. In this section we extend this idea to an entire equation. In Section 9.3 we considered the hedonic house price example, in which the price of a house was related to its size and a dummy variable representing a neighborhood effect. In (9.3.3) we assume that house location affects *both* the intercept and the slope. The resulting regression model is

$$P_t = \beta_1 + \delta D_t + \beta_2 S_t + \gamma(S_t D_t) + e_t \qquad (9.7.1)$$

The regression functions for the house prices in the two locations are

$$E(P_t) = \begin{cases} (\beta_1 + \delta) + (\beta_2 + \gamma)S_t = \alpha_1 + \alpha_2 S_t & \text{desirable neighborhood} \\ \beta_1 + \beta_2 S_t & \text{other neighborhood} \end{cases} \quad (9.7.2)$$

Note that since we have allowed the intercept and slope to differ, we have essentially assumed that the regressions in the two neighborhoods are completely different. This is made clear graphically in Figure 9.2b. In fact, we could apply least squares separately to data from the two neighborhoods to obtain estimates of α_1 and α_2, and β_1 and β_2, in (9.7.2).

9.7.1 THE CHOW TEST

An important question is "Are there differences between the hedonic regressions for the two neighborhoods or not?" If there are no differences, then the data from the two neighborhoods can be "pooled" into one sample, with no allowance made for differing slope or intercept. How can we test this? If the joint null hypothesis $H_0: \delta = 0$, $\gamma = 0$ is true, then there are no differences between the base price and price per square foot in the two neighborhoods. If we reject this null hypothesis, then the intercepts and/or slopes are different, meaning that we cannot simply pool the data and ignore neighborhood effects.

From (9.7.2), by testing $H_0: \delta = 0$, $\gamma = 0$ we are testing the equivalence of the two regressions

$$P_t = \alpha_1 + \alpha_2 S_t + e_t$$
$$P_t = \beta_1 + \beta_2 S_t + e_t \quad (9.7.3)$$

If $\delta = 0$ then $\alpha_1 = \beta_1$, and if $\gamma = 0$, then $\alpha_2 = \beta_2$. In this case we can simply estimate the "pooled" (9.2.1), $P_t = \beta_1 + \beta_2 S_t + e_t$, using data from the two neighborhoods together. If we reject either or both of these hypotheses, then the equalities $\alpha_1 = \beta_1$ and $\alpha_2 = \beta_2$ are not true, in which case pooling the data together would be equivalent to imposing constraints, or restrictions, which are not true, on the parameters of (9.7.3). From Chapter 8.5, we know that imposing constraints that are not true makes the least squares estimator biased, no matter how large our sample.

Testing the equivalence of two regressions is sometimes called a **Chow test**, after econometrician Gregory Chow, who studied some aspects of this type of testing. We carry out the test by creating an intercept and slope dummy for every variable in the model, and then jointly testing the significance of the dummy variable coefficients using an F-test.

> **REMARK:** The usual F-test of a joint hypothesis relies on the assumptions MR 1–6 of the linear regression model. Of particular relevance for testing the equivalence of two regressions is assumption 3, that the variance of the error term, $\text{var}(e_t) = \sigma^2$, is the same <u>for all</u> observations. If we are considering possibly different slopes and intercepts for parts of the data, it might also be true that the error variances are different in the two parts of the data. In such a case the usual F-test is not valid. Testing for equal variances is covered in Chapter 11, and the question of pooling in this case is covered in Chapter 17. For now, be aware that we are assuming constant error variances in the remainder of this chapter.

9.7.2 AN EMPIRICAL EXAMPLE OF THE CHOW TEST

As an empirical example, let us consider the investment behavior of two large corporations, General Electric and Westinghouse. These firms compete against each other and produce many of the same types of products. We might wonder if they have similar investment strategies. In Table 9.3 are investment data for the years 1935 to 1954 (this is a famous data set) for these two corporations. The variables, for each firm, in 1947 dollars, are

INV = gross investment in plant and equipment

V = value of the firm = value of common and preferred stock

K = stock of capital

A simple investment function is

$$INV_t = \beta_1 + \beta_2 V_t + \beta_3 K_t + e_t \qquad (9.7.4)$$

If we combine, or pool, the data for both firms we have $T = 40$ observations with which to estimate the parameters of the investment function. But pooling the two sources of data is valid only if the regression parameters *and* the variances of the error terms are the *same* for both corporations. If these parameters are not the same, and we combine the data sets anyway, it is equivalent to *restricting* the investment

Table 9.3 **Time Series Data on Real *INV*, *V* and *K***

Year	General Electric			Westinghouse		
	INV	*V*	*K*	*INV*	*V*	*K*
1	33.1	1170.6	97.8	12.93	191.5	1.8
2	45.0	2015.8	104.4	25.90	516.0	0.8
3	77.2	2803.3	118.0	35.05	729.0	7.4
4	44.6	2039.7	156.2	22.89	560.4	18.1
5	48.1	2256.2	172.6	18.84	519.9	23.5
6	74.4	2132.2	186.6	28.57	628.5	26.5
7	113.0	1834.1	220.9	48.51	537.1	36.2
8	91.9	1588.0	287.8	43.34	561.2	60.8
9	61.3	1749.4	319.9	37.02	617.2	84.4
10	56.8	1687.2	321.3	37.81	626.7	91.2
11	93.6	2007.7	319.6	39.27	737.2	92.4
12	159.9	2208.3	346.0	53.46	760.5	86.0
13	147.2	1656.7	456.4	55.56	581.4	111.1
14	146.3	1604.4	543.4	49.56	662.3	130.6
15	98.3	1431.8	618.3	32.04	583.8	141.8
16	93.5	1610.5	647.4	32.24	635.2	136.7
17	135.2	1819.4	671.3	54.38	723.8	129.7
18	157.3	2079.7	726.1	71.78	864.1	145.5
19	179.5	2371.6	800.3	90.08	1193.5	174.8
20	189.6	2759.9	888.9	68.60	1188.9	213.5

functions of the two firms to be identical when they are not, and the least squares estimators of the parameters in the restricted model (9.7.4) are biased and inconsistent. Estimating the restricted, pooled, model by least squares provides the *restricted* sum of squared errors, SSE_R, that we will use in the formation of an F-test statistic.

Using the Chow test we can test whether or not the investment functions for the two firms are identical. To do so, let D be a dummy variable that is 1 for the 20 Westinghouse observations, and 0 otherwise. We then include an intercept dummy variable and a complete set of slope dummy variables

$$INV_t = \beta_1 + \delta_1 D_t + \beta_2 V_t + \delta_2(D_t V_t) + \beta_3 K_t + \delta_3(D_t K_t) + e_t \qquad (9.7.5)$$

This is an *unrestricted* model. From the least squares estimation of this model we will obtain the unrestricted sum of squared errors, SSE_U, that we will use in the construction of an F-statistic shown in (9.6.2).

We test the equivalence of the investment regression functions for the two firms by testing the $J = 3$ joint null hypotheses $H_0 : \delta_1 = 0$, $\delta_2 = 0$, $\delta_3 = 0$ against the alternative H_1 : at least one $\delta_i \neq 0$. Let us use the data in Table 9.3 to carry out this test. The estimated restricted and unrestricted models, with t-statistics in parentheses, and their sums of squared residuals are as follows.

Restricted (one pooled relation for all observations):

$$\hat{INV} = 17.8720 + 0.0152V + 0.1436K$$
$$(2.544) \quad (2.452) \quad (7.719)$$

$$SSE_R = 16563.00$$

(9.7.6)

Unrestricted:

$$\hat{INV} = -9.9563 + 9.4469D + 0.0266V + 0.0263(D \times V) + 0.1517K - 0.0593(D \times K)$$
$$(0.421) \quad (0.328) \quad (2.265) \quad (0.767) \quad (7.837) \quad (-0.507)$$

(9.7.7)

$$SSE_U = 14989.82$$

Constructing the F-statistic,

$$F = \frac{(SSE_R - SSE_U)/J}{SSE_U/(T - K)} = \frac{(16563.00 - 14989.82)/3}{14989.82/(40 - 6)} = 1.1894 \qquad (9.7.8)$$

The $\alpha = .05$ critical value $F_c = 2.8826$ comes from the $F_{(3, 34)}$ distribution. Since $F < F_c$, we cannot reject the null hypothesis that the investment functions for General Electric and Westinghouse are identical. In this case the joint F-test and the individual t-tests of the dummy variable and slope dummy variables reach the same conclusion. *However, remember that the t- and F-tests have different purposes and their outcomes will not always match in this way.*

It is interesting that for the Chow test we can calculate SSE_U, the unrestricted sum of squared errors, another way, which is frequently used in practice. Instead of estimating the model (9.7.5) to obtain SSE_U, we can estimate the simpler model in (9.7.4) twice. Using the $T = 20$ General Electric observations, estimate (9.7.4) by

least squares; call the sum of squared residuals from this estimation SSE_1. Then, using the $T = 20$ Westinghouse observations, estimate (9.7.4) by least squares; call the sum of squared residuals from this estimation SSE_2. The unrestricted sum of squared residuals SSE_U from (9.7.5) is identical to the sum $SSE_1 + SSE_2$. You are invited to demonstrate this for this investment example in Exercise 9.5. The advantage of this approach to the Chow test is that it does not require the construction of the dummy and interaction variables.

9.8 Learning Objectives

Based on the material in this chapter you should be able to explain:

1. The difference between qualitative and quantitative economic variables.
2. How including a 0–1 dummy variable on the right-hand side of a regression affects model interpretation, and give an example.
3. How including a slope dummy variable in a regression affects model interpretation, and give an example.
4. How including a product of two dummy variables in a regression affects model interpretation, and give an example.
5. How to model qualitative factors with more than two categories (like region of the country), how to interpret the resulting model, and give an example.
6. The consequences of ignoring a structural change in parameters during part of the sample.
7. How to test for the significance of individual dummy variables.
8. How to test for the joint significance of a set of dummy variables.
9. How to test the equivalence of two regression equations using dummy variables.

9.9 Exercises

9.1 An Economics department at a large State University keeps track of its majors' starting salaries. We address the question of the value of taking econometrics, based on last year's crop of 50 majors. Let $SAL = \$$ salary, GPA = grade point average on a 4.0 scale, $METRICS = 1$ if student took econometrics, $METRICS = 0$ otherwise.
The estimated regression (estimates rounded) is

$$\hat{SAL} = 24200 + 1643GPA + 5033METRICS \quad R^2 = .74$$
$$\text{(se)} \quad (1078) \quad (352) \quad\quad (456)$$

(a) Interpret the estimated equation.
(b) How would you modify the equation to see if women had lower starting salaries than men? (Define $SEX = 1$ for females.)
(c) How would you modify the equation to see if the value of econometrics was the same for men and women.
(d) The file *metrics.dat* contains the data upon which estimation was based. Estimate the models you define in (b) and (c) and discuss the results.

9.2 In September 1998, a local TV station contacted an econometrician to analyze some data for them. They were going to do a Halloween story on the legend of full moons affecting behavior in strange ways. They collected data on the daily number of Emergency room cases for the period from Jan 1, 1998 until mid-August. There were 229 observations. During this time there were 8 full moons and 7 new moons (a related myth concerns new moons) and 3 holidays (New Year's day, Memorial Day and Easter). This question is important for hospital administrators as they attempt to staff emergency rooms with doctors and nurses, and important for local police when determining the number of officers to be on duty.

In the regression results T is a time trend ($T = 1, 2, 3, \ldots, 229$) and the rest are dummy variables. $HOLIDAY = 1$ if the day is a holiday, $= 0$ otherwise. $FRI = 1$ if the day is a Friday, $= 0$ otherwise. $SAT = 1$ if the day is a Saturday, $= 0$ otherwise. $FULLMOON = 1$ if there is a full moon, $= 0$ otherwise. $NEWMOON = 1$ if there is a new moon, $= 0$ otherwise.

The SAS regression results are shown below:

```
                         Analysis of Variance

                        Sum of          Mean
      Source      DF     Squares        Square      F Value    Prob > F

      Model        6    5693.37691    948.89615      7.771      0.0001
      Error      222   27108.82396    122.11182
      C Total    228   32802.20087

             Root MSE       11.05042      R-square    0.1736
             Dep Mean      100.56769      Adj R-sq    0.1512
             C.V.           10.98804

                         Parameter Estimates

                   Parameter      Standard      T for HO:
      Variable   DF  Estimate       Error      Parameter=0    Prob > |T|

      INTERCEP    1   93.695825    1.55915929      60.094       0.0001

      T           1    0.033800    0.01105281       3.058       0.0025

      HOLIDAY     1   13.862929    6.44517459       2.151       0.0326

      FRI         1    6.909776    2.11131827       3.273       0.0012

      SAT         1   10.589401    2.11843183       4.999       0.0001

      FULLMOON    1    2.454453    3.90892345       0.617       0.5382

      NEWMOON     1    6.405947    4.25689321       1.505       0.1338
```

(a) Interpret these regression results. When should emergency rooms expect more calls?

(b) The data are in the file *fullmoon.dat*. Replicate the results above using your software.

(c) Test the joint significance of *FULLMOON* and *NEWMOON*. State the null and alternative hypotheses and indicate the test statistic you use. What do you conclude?

9.3 In the file *stockton.dat* we have data from January 1991 to December 1996 on house prices, square footage, and other characteristics of 4682 houses that were sold in Stockton, CA. Professor John Knight, University of the Pacific,

provided these data. One of the key problems regarding housing prices in a region concerns construction of "house price indexes." After controlling for features of a house, what change in selling price is due to changes in the overall price level? The overall price level is affected by demand in the local economy, such as population change, interest rates, unemployment rate, and income growth. If we were constructing a "consumer price index" for living in an area, the house price index is one element we would incorporate. Understanding the price index is important for tax assessors, who must re-assess the market value of homes in order to compute their annual property tax. It is also important to mortgage bankers and other home lenders, who must re-evaluate the value of their portfolio of loans with changing local conditions. It is also important information for homeowners trying to sell their houses as well as potential buyers, as they attempt to agree upon a selling price.

(a) Estimate a regression model for house price, including as explanatory variables the size of the house (*SQFT*), the age of the house (*AGE*), and annual dummy variables, omitting the dummy variable for the year 1991.

$$PRICE = \beta_1 + \beta_2 SQFT + \beta_3 AGE + \delta_1 D92 + \delta_2 D93$$
$$+ \delta_3 D94 + \delta_4 D95 + \delta_5 D96 + e$$

(b) Discuss the estimated coefficients on *SQFT* and *AGE*, including their interpretation, signs, and statistical significance.

(c) Discuss the estimated coefficients on the dummy variables.

(d) What would have happened if we had included a dummy variable for 1991?

9.4 In (9.4.1) we specified a hedonic model for house price. The dependent variable was the price of the house, in dollars. Real estate economists have found that for many data sets a more appropriate model has the dependent variable ln(*PRICE*).

(a) Using the data in Table 9.1, estimate the model (9.4.1) using ln(*PRICE*) as the dependent variable.

(b) Discuss the estimated coefficients on *SQFT* and *AGE*. Refer to Chapter 6 for help with interpreting the coefficients in this *log–linear* functional form.

(c) Interpretation of dummy variables in *log–linear* models requires a bit of work. The difference between the log–price of houses with and without a pool is δ_3. That is,

$$\ln(PRICE_{pool}) - \ln(PRICE_{nopool}) = \delta_3$$

Algebraically manipulate this equation to show that the percentage change in price attributable to a pool is

$$\frac{PRICE_{pool} - PRICE_{nopool}}{PRICE_{nopool}} = e^{\delta_3} - 1$$

(d) Using the results in part (c), compute the percentage change in price due to the presence of a pool.

(e) Using the results in part (c), compute the percentage change in price due to the presence of a fireplace.

(f) Using the results in part (c), compute the percentage change in price of a 2500 square foot home near the university relative to the same house in another location.

9.5 Show that the unrestricted sum of squared residuals given in (9.7.7) can be obtained by adding together the sums of squared least squares residuals obtained by estimating (9.7.4) twice—once using the General Electric data and once using the Westinghouse data.

9.6 Data on the weekly sales of a major brand of canned tuna by a supermarket chain in a large midwestern U.S. city during a recent calendar year are contained in the file *tuna.dat*. There are 52 observations on the variables

$Sal1$ = unit sales of brand no. 1 canned tuna

$Apr1$ = price per can of brand no. 1 canned tuna

$Apr2,3$ = price per can of brands nos. 2 and 3 of canned tuna

$Disp$ = a dummy variable that takes the value 1 if there is a store display for brand no. 1 during the week but no newspaper ad; 0 otherwise

$DispAd$ = a dummy variable that takes the value 1 if there is a store display *and* a newspaper ad during the week; 0 otherwise

(a) Estimate, by least squares, the log–linear model

$$\ln(Sal1) = \beta_1 + \beta_2 Apr1 + \beta_3 Apr2 + \beta_4 Apr3 + \beta_5 Disp + \beta_6 DispAd + e$$

(b) Discuss and interpret the estimates of β_2, β_3, and β_4.

(c) Are the signs and *relative* magnitudes of the estimates of β_5 and β_6 consistent with economic logic? Interpret these estimates using the device in Exercise 9.4 (c).

(d) Test, at the $\alpha = .05$ level of significance, each of the following hypotheses:
 (i) $H_0 : \beta_5 = 0$, $H_1 : \beta_5 \neq 0$
 (ii) $H_0 : \beta_6 = 0$, $H_1 : \beta_6 \neq 0$
 (iii) $H_0 : \beta_6 = 0$, $\beta_6 = 0$; $H_1 : \beta_5$ or $\beta_6 \neq 0$
 (iv) $H_0 : \beta_6 \leq \beta_5$, $H_1 : \beta_6 > \beta_5$

Discuss the relevance of these hypothesis tests for the supermarket chain's executives.

9.7 F. G. Mixon and R. W. Ressler (forthcoming in *Review of Industrial Organization*) investigate the pricing of compact disks. They note that it is common for new releases to be priced lower than older CDs. Their explanation of this pricing scheme is differences in the price elasticity of demand. The number of substitutes for old CDs is less than for new. For example, new music can be heard on VH1, MTV, in movie and TV-program soundtracks, on radio and live. That old favorite you had on vinyl record or tape, and now want on CD, has much more limited competition. To empirically test this they obtain data on 118 CDs. The data are in the file *music.dat*. The variables are:

$Price$ = retail price of the CD ($US)

Age = age of the recording (1999 − copyright date)

Old = a dummy variable = 1 if the recording is not a new release

Net = a dummy variable = 1 for internet prices (Tower Records and Amazon web sites).

(a) Estimate the model $Price = \beta_1 + \beta_2 Age + \delta Net + e$. Interpret the estimated model.

(b) Estimate the model $Price = \beta_1 + \beta_2 Old + \delta Net + e$. Interpret the estimated model.

9.8 Henry Saffer and Frank Chaloupka ("The Demand for Illicit Drugs," *Economic Inquiry*, 37(3), July 1999, 401–411) estimate demand equations for alcohol, marijuana, cocaine, and heroin using a sample of size $n = 44889$. The estimated alcohol use equation results, after omitting a few control variables, are:

Variable	Estimate	\|t-value\|
Intercept	4.099	17.98
Alcohol price	−0.045	5.93
Income	0.000057	17.45
Gender	1.637	29.23
Marital status	−0.807	12.13
Age 12–20	−1.531	17.97
Age 21–30	0.035	0.51
Black	−0.580	8.84
Hispanic	−0.564	6.03

The variable definitions (sample means in parentheses) are:
- The dependent variable is the number of days alcohol was used in the past 31 days (3.49).
- Alcohol price—price of a liter of pure alcohol in 1983 dollars (24.78).
- Income—total personal income in 1983 dollars (12,425).
- Gender—a binary variable = 1 if male (.479).
- Marital status—a binary variable = 1 if married (.569).
- Age 12–20—a binary variable = 1 if individual is 12–20 years of age (.155).
- Age 21–30—a binary variable = 1 if individual is 21–30 years of age (.197).
- Black—a binary variable = 1 if individual is black (.116).
- Hispanic—a binary variable = 1 if individual is Hispanic (.078).

(a) Interpret the coefficient of alcohol price.

(b) Compute the price elasticity at the means of the variables.

(c) Compute the price elasticity at the means of alcohol price and income, for a married black male, age 21–30.

(d) Interpret the coefficient of income. If we measured income in $1000 units, what would be the estimated coefficient?

(e) Interpret the coefficients of the dummy variables, and their significance.

Chapter 10

Nonlinear Models

Nonlinear models can be classified into two categories. In the first category are models that are nonlinear in the variables, but still linear in terms of the unknown parameters. This category includes models which are made linear in the parameters via a transformation. For example, the Cobb–Douglas production function that relates output (Y) to labor (L) and capital (K) can be written as

$$Y = \alpha L^{\beta} K^{\gamma}$$

At first glance this function appears to be nonlinear and difficult to estimate using least squares. However, taking logarithms yields

$$\ln(Y) = \delta + \beta \ln(L) + \gamma \ln(K)$$

where $\delta = \ln(\alpha)$. This function is nonlinear in the variables Y, L, and K, but it is linear in the parameters δ, β, and γ. Other examples of models which are nonlinear in the variables, but linear in the parameters were given in Chapter 6.3. An important characteristic of models of this kind is that they can be estimated using the least squares technique that has been the focus of Chapters 3–9.

The second category of nonlinear models contains models that are nonlinear in the parameters and cannot be made linear in the parameters after a transformation. For estimating models in this category the familiar least squares technique is extended to an estimation procedure known as *nonlinear least squares*.

This chapter is concerned with some aspects of both categories of models. First we consider models which contain polynomial and interaction terms. These models are linear in the parameters and can be estimated using least squares. Then, we consider application of nonlinear least squares to models that are nonlinear in the parameters.

10.1 Polynomial and Interaction Variables

Models with polynomial and/or interaction variables are useful for describing relationships where the response to a variable changes depending on the value of that variable or the value of another variable. We have encountered some examples of this kind already. In Chapter 8.3, the response of total revenue to advertising was made dependent on the level of advertising by including the square of advertising in the model. In Chapter 9.3, an interaction variable defined as the product of house size and a dummy variable for neighborhood was used to make the response

of house price to house size dependent on the neighborhood. Further examples are considered in this section. In contrast to the dummy variable examples in Chapter 9, we model relationships in which the slope of the regression model is *continuously* changing. We consider two such cases, interaction variables that are the product of a variable by itself, producing a polynomial term; and interaction variables that are the product of two different variables.

10.1.1 POLYNOMIAL TERMS IN A REGRESSION MODEL

In microeconomics you studied "cost" curves and "product" curves that describe a firm. Total cost and total product curves are mirror images of each other, taking the standard "cubic" shapes shown in Figure 10.1.

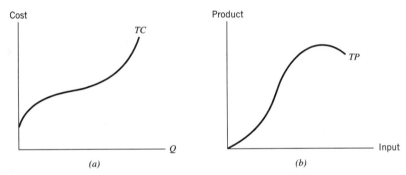

FIGURE 10.1 (*a*) Total cost curve and (*b*) total product curve.

Average and marginal cost curves, and their mirror images, average and marginal product curves, take quadratic shapes, usually represented as shown in Figure 10.2.

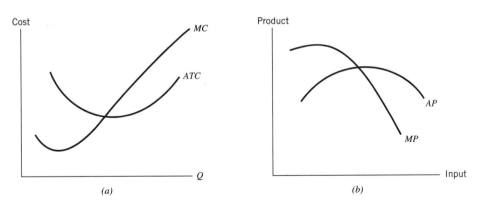

FIGURE 10.2 Average and marginal (*a*) cost curves and (*b*) product curves.

The slopes of these relationships are not constant and cannot be represented by regression models that are "linear in the variables." However, these shapes are easily represented by polynomials, that are a special case of interaction variables in which variables are multiplied by themselves. For example, if we consider the average cost

relationship in Figure 10.2*a*, a suitable regression model is

$$AC = \beta_1 + \beta_2 Q + \beta_3 Q^2 + e \tag{10.1.1}$$

This quadratic function can take the "U" shape we associate with average cost functions. For the total cost curve in Figure 10.1a a cubic polynomial is in order:

$$TC = \alpha_1 + \alpha_2 Q + \alpha_3 Q^2 + \alpha_4 Q^3 + e \tag{10.1.2}$$

These functional forms, which represent nonlinear shapes, *are still linear regression models, since the parameters enter in a linear way.* The variables Q^2 and Q^3 are explanatory variables that are treated no differently from any others. This is the same situation we encountered in Chapter 6, in which alternative functional forms for regression models were considered. The parameters in (10.1.1) and (10.1.2) can still be estimated by least squares.

A difference in these models, also true for the models discussed in Chapter 6.3, is in the interpretation of the parameters. The parameters of these models are not themselves slopes. The slope of the average cost curve (10.1.1) is

$$\frac{dE(AC)}{dQ} = \beta_2 + 2\beta_3 Q \tag{10.1.3}$$

The slope of the average cost curve changes for every value of Q and depends on the parameters β_2 and β_3. For this U-shaped curve we expect $\beta_2 < 0$ and $\beta_3 > 0$.

The slope of the total cost curve (10.1.2), which is the marginal cost, is

$$\frac{dE(TC)}{dQ} = \alpha_2 + 2\alpha_3 Q + 3\alpha_4 Q^2 \tag{10.1.4}$$

The slope is a quadratic function of Q, involving the parameters α_2, α_3, and α_4. For a U-shaped marginal cost curve $\alpha_2 > 0$, $\alpha_3 < 0$, and $\alpha_4 > 0$.

Using polynomial terms is an easy and flexible way to capture nonlinear relationships between variables. Their inclusion does not complicate least squares estimation, with one exception, which is explored in Exercise 10.1. As we have shown, however, care must be taken when interpreting the parameters of models containing polynomial terms.

10.1.2 INTERACTIONS BETWEEN TWO CONTINUOUS VARIABLES

When the product of two continuous variables is included in a regression model, the effect is to alter the relationship between each of them and the dependent variable. We will consider a "life-cycle" model to illustrate this idea. Suppose we are economists for Gutbusters Pizza, and we wish to study the effect of income and age on an individual's expenditure on pizza. For that purpose we take a random sample of forty individuals, age 18 and older, and record their annual expenditure on pizza (*PIZZA*), their income (*Y*) and age (*AGE*). The first 5 observations of these data are shown in Table 10.1. The full data set is contained in the file *table10-1.dat*.

As an initial model, let us consider

$$PIZZA = \beta_1 + \beta_2 AGE + \beta_3 Y + e \tag{10.1.5}$$

T a b l e 1 0 . 1 **Pizza Expenditure Data**

PIZZA	Y	AGE
109	15000	25
0	30000	45
0	12000	20
108	20000	28
220	15000	25

The implications of this specification are:

1. $\partial E(PIZZA)/\partial AGE = \beta_2$: For any *given level of income*, the expected expenditure on pizza changes by the amount β_2 with an additional year of age. What would you expect here? Based on our casual observation of college students, who appear to consume massive quantities of pizza, we expect the sign of β_2 to be negative. With the effects of income removed, we expect that as a person ages his or her pizza expenditure will fall.

2. $\partial E(PIZZA)/\partial Y = \beta_3$: For individuals of any *given age*, an increase in income of \$1 increases expected expenditures on pizza by β_3. Since pizza is probably a normal good, we expect the sign of β_3 to be positive. The parameter β_3 might be called the marginal propensity to spend on pizza.

These are the implications of the model in (10.1.5). However, is it reasonable to expect that, *regardless* of the age of the individual, an increase in income by \$1 should lead to an increase in pizza expenditure by β_3 dollars? Probably not. It would seem more reasonable to assume that as a person grows older, their marginal propensity to spend on pizza declines. That is, as a person ages, less of each extra dollar is expected to be spent on pizza. This is a case in which *the effect of income depends on the age of the individual*. That is, the effect of one variable is modified by another. One way of accounting for such interactions is to include an interaction variable that is the product of the two variables involved. Since *AGE* and *Y* are the variables that interact, we will add the variable $(AGE \times Y)$ to the regression model. The result is

$$PIZZA = \beta_1 + \beta_2 AGE + \beta_3 Y + \beta_4 (AGE \times Y) + e \qquad (10.1.6)$$

Just as in the cases when we interacted a continuous variable with a dummy variable, and when we interacted a continuous variable with itself, when the product of two continuous variables is included in a model, the interpretation of the parameters requires care. The effects of *Y* and *AGE* are:

1. $\partial E(PIZZA)/\partial AGE = \beta_2 + \beta_4 Y$: The effect of *AGE* now depends on income. As a person ages, pizza expenditure is expected to fall, and, because β_4 is expected to be negative, the greater the income, the greater will be the fall attributable to a change in age.

2. $\partial E(PIZZA)/\partial Y = \beta_3 + \beta_4 AGE$: The effect of a change in income on expected pizza expenditure, which is the marginal propensity to spend on pizza, now depends on *AGE*. If our logic concerning the effect of aging is correct, then

β_4 should be negative. Then, as *AGE* increases, the value of the partial derivative declines.

Estimates of (10.1.5) and (10.1.6), with *t*-statistics in parentheses, are:

$$\hat{PIZZA} = 342.8848 - 7.5756AGE + 0.0024Y \qquad\qquad (R10.1)$$
$$\phantom{\hat{PIZZA} =} (4.740) \qquad (-3.270) \qquad (3.947)$$
$$\hat{PIZZA} = 161.4654 - 2.9774AGE + 0.0091Y - 0.00016(Y \times AGE) \quad (R10.2)$$
$$\phantom{\hat{PIZZA} =} (1.338) \qquad (-0.888) \qquad (2.473) \qquad (-1.847)$$

In (R10.1) the signs of the estimated parameters are as we anticipated. Both *AGE* and income (*Y*) have significant coefficients, based on their *t*-statistics. In (R10.2) the product ($Y \times AGE$) enters the equation. Its estimated coefficient is negative and significant at the $\alpha = .05$ level using a one-tailed test. The signs of other coefficients remain the same, but *AGE*, by itself, no longer appears to be a significant explanatory factor. This suggests that *AGE* affects pizza expenditure through its interaction with income—that is, it affects the marginal propensity to spend on pizza.

Using the estimates in (R10.2) let us estimate the marginal effect of age on pizza expenditure for two individuals; one with $25,000 income and one with $90,000 income.

$$\frac{\partial E(\hat{PIZZA})}{\partial AGE} = b_2 + b_4 Y = -2.9774 - 0.00016Y$$

$$= \begin{cases} -6.9774 & \text{for } Y = \$25,000 \\ -17.3774 & \text{for } Y = \$90,000 \end{cases} \qquad (R10.3)$$

That is, we expect that an individual with $25,000 income will reduce expenditure on pizza by $6.98 per year, while the individual with $90,000 income will reduce pizza expenditures by $17.38 per year, all other factors held constant. In Exercise 10.1 you are invited to evaluate more marginal effects of income and age for this model.

10.2 A Simple Nonlinear-in-the-Parameters Model

We turn now to models that are nonlinear in the parameters and which need to be estimated by a technique called nonlinear least squares. There are a variety of models that fit into this framework, because of the functional form of the relationship being modeled, or because of the statistical properties of the variables. To explain the nonlinear least squares estimation technique, it is convenient to begin with the following artificial example:

$$y_t = \beta x_{t1} + \beta^2 x_{t2} + e_t \qquad\qquad (10.2.1)$$

where y_t is a dependent variable, x_{t1} and x_{t2} are explanatory variables, β is an unknown parameter that we wish to estimate, and the e_t are uncorrelated random errors with mean zero and variance σ^2. This example differs from the conventional linear model because the coefficient of x_{t2} is equal to the square of the coefficient of x_{t1}.

How can β be estimated? Think back to Chapter 3. What did we do when we had a simple linear regression equation with two unknown parameters β_1 and β_2? We set up a sum of squared errors function that, in the context of (10.2.1), is

$$S(\beta) = \sum_{t=1}^{T} (y_t - \beta x_{t1} - \beta^2 x_{t2})^2 \qquad (10.2.2)$$

Then we asked what values of the unknown parameters make $S(\beta)$ a minimum. We searched for the bottom of the bowl in Figure 3.8. We found that we could derive formulas for the minimizing values b_1 and b_2. We called these formulas the *least squares estimators*.

When we have a nonlinear function like (10.2.1), we *cannot* derive a formula for the parameter β that minimizes (10.2.2). However, for a given set of data, we can ask the computer to look for the parameter value that take us to the bottom of the bowl. Many software algorithms can be used to find *numerically* the value that minimizes $S(\beta)$. This value is called a **nonlinear least squares estimate.** It is also impossible to get formulas for standard errors, but it *is* possible for the computer to calculate a numerical standard error that assesses the reliability of a parameter estimate. Estimates and standard errors computed in this way have good properties in large samples.

As an example, consider the data on y_t, x_{t1}, and x_{t2} in Table 10.2. The sum of squared errors function in (10.2.2) is graphed in Figure 10.3. Because we have only one unknown parameter, we have a two-dimensional curve, not a "bowl." It is clear that the minimizing value for β lies between 1.0 and 1.5.

T a b l e 10 . 2 Data for Simple Example

y_t	x_{1t}	x_{2t}
3.284	.286	.645
3.149	.973	.585
2.877	.384	.310
−.467	.276	.058
1.211	.973	.455
1.389	.543	.779
1.145	.957	.259
2.321	.948	.202
.998	.543	.028
.379	.797	.099
1.106	.936	.142
.428	.889	.296
.011	.006	.175
1.179	.828	.180
1.858	.399	.842
.388	.617	.039
.651	.939	.103
.593	.784	.620
.046	.072	.158
1.152	.889	.704

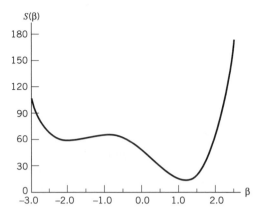

FIGURE *10.3* Sum of squares function for single-parameter example.

Using nonlinear least squares software, we find that the nonlinear least squares esti-
mate and its standard error are

$$b = 1.1612, \quad se(b) = 0.1307 \tag{R10.4}$$

Be warned that different software can yield slightly different approximate standard
errors. However, the nonlinear least squares estimate should be the same for all
packages.

10.3 A Logistic Growth Curve

A model that is popular for modeling the diffusion of technological change is the
logistic growth curve

$$y_t = \frac{\alpha}{1 + \exp(-\beta - \delta t)} + e_t \tag{10.3.1}$$

In this equation, y_t is the adoption proportion of a new technology. For example, y_t
might be the proportion of households who own a computer. Alternatively, it could
be the proportion of computer-owning households who have the latest computer.
The proportion of musical recordings sold as compact disks is another example. In
our example, y_t is the share of total U.S. crude steel production that is produced
by electric arc furnace technology.

 Before considering this example, we note some details about the relationship in
(10.3.1). There is only one explanatory variable on the right-hand side, namely,
time, $t = 1, 2, \ldots, T$. Thus, the logistic growth model is designed to capture the
rate of adoption of technological change, or, in some examples, the rate of growth
of market share. An example of a logistic curve is depicted in Figure 10.4. In this
example, the rate of growth increases at first, to a point of inflection that occurs at $t =
-\beta/\delta = 20$. Then, the rate of growth declines, leveling off to a saturation proportion
given by $\alpha = 0.8$. Since $y_0 = \alpha/(1 + \exp(-\beta))$, the parameter β determines how far
the share is below saturation level at time zero. The parameter δ controls the speed
at which the point of inflection, and the saturation level, are reached. The curve is
such that the share at the point of inflection is $\alpha/2 = 0.4$, half the saturation level.

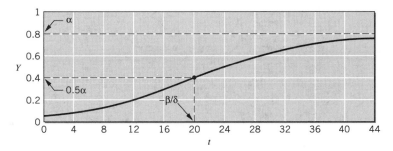

$FIGURE$ **10.4** Logistic growth curve.

The e_t are assumed to be uncorrelated random errors with zero mean and variance σ^2. Because the parameters in (10.3.1) enter the equation in a nonlinear way, it is estimated using nonlinear least squares.

Over the last three decades traditional technology for steel making, involving blast and oxygen furnaces and the use of iron ore, has been displaced by newer electric arc furnace technology that utilizes scrap steel. This displacement has implications for the suppliers of raw materials such as iron ore. Thus, prediction of the future electric arc furnace share of steel production is of vital importance to mining companies. It has been examined in some depth by Paul Crompton in a paper entitled "Modelling the Diffusion of New Steel-Making Technology," presented at the 1999 PhD Conference in Economics and Business at the University of Western Australia. To illustrate estimation of (10.3.1) we use his data on the electric arc furnace (EAF) share of steel production in the United States. These data appear in Table 10.3.

Using nonlinear least squares to estimate the logistic growth curve yields the results in Table 10.4. We find that the estimated saturation share of the EAF technology is $\hat{\alpha} = 0.46$. The point of inflection, where the rate of adoption changes from

Table **10.3** **Electric Arc Furnace Share of U.S. Steel Production**

Year	t	EAF Share	Year	t	EAF Share
1970	1	0.153	1984	15	0.339
1971	2	0.174	1985	16	0.339
1972	3	0.178	1986	17	0.372
1973	4	0.184	1987	18	0.381
1974	5	0.197	1988	19	0.369
1975	6	0.194	1989	20	0.359
1976	7	0.192	1990	21	0.373
1977	8	0.222	1991	22	0.384
1978	9	0.235	1992	23	0.380
1979	10	0.246	1993	24	0.394
1980	11	0.272	1994	25	0.393
1981	12	0.283	1995	26	0.404
1982	13	0.311	1996	27	0.426
1983	14	0.315	1997	28	0.438

Table 10.4 **Estimated Growth Curve for EAF Share of Steel Production**

Dependent Variable: Y
Sample: 1970 1997
Included observations: 28
Convergence achieved after 8 iterations
Y=C(1)/(1+EXP(-C(2)-C(3)*T))

	Coefficient	Std. Error	t-Statistic	Prob.
C(1)	0.462303	0.018174	25.43765	0.0000
C(2)	−0.911013	0.058147	−15.66745	0.0000
C(3)	0.116835	0.010960	10.65979	0.0000

Wald Test:
Null Hypothesis: -C(2)/C(3)=11

F-statistic	16.65686	Probability	0.000402
Chi-square	16.65686	Probability	0.000045

increasing to decreasing, is estimated as

$$-\frac{\hat{\beta}}{\hat{\delta}} = \frac{0.911}{0.117} = 7.8 \tag{R10.5}$$

which is approximately the year 1977. In the upper part of Table 10.4 is the phrase "convergence achieved after 8 iterations." This means that the numerical procedure used to minimize the sum of squared errors took 8 steps to find the minimizing least squares estimates. If you run a nonlinear least squares problem and your software reports that convergence has not occurred, you should not use the "estimates" from that run.

Suppose that you wanted to test the hypothesis that the point of inflection actually occurred in 1980. The corresponding null and alternative hypotheses can be written as

$$H_0: -\frac{\beta}{\delta} = 11 \qquad H_1: -\frac{\beta}{\delta} \neq 11$$

The null hypothesis is different from any that you have encountered so far because it is nonlinear in the parameters β and δ. Despite this nonlinearity, the test can be carried out using most modern software. The outcome of this test appears in the last two rows of Table 10.4 under the heading "Wald test." The nonlinearity means that this test is only approximate, requiring a large sample to be valid. Two large-sample approximations are available, an F-test and a χ^2-test. From the very small p-values associated with both the F and the χ^2-statistics, we reject H_0 and conclude that the point of inflection does not occur at 1980.

In Exercise 10.10 you are invited to use the estimated equation to predict the EAF share of steel production for the next ten years. These predictions are of considerable interest to mining companies.

10.4 Poisson Regression

About 350 miles northwest of Sydney is a man-made lake called Lake Keepit. Apart from being an irrigation source for downstream cotton growers, Lake Keepit is used for recreation. Boating, water skiing, picnicking and hiking are popular pastimes. To help decide the annual budget allocations for recreational areas, the state government collects information on the demand for recreation. It took a random sample of 250 households from households who live within a 120 mile radius of Lake Keepit. House-holds were asked a number of questions, including how many times they visited Lake Keepit during the last year. The frequency of visits appears in Table 10.5. Note the special nature of the data in this table. A large number of households did not visit the lake at all. Also large numbers had 1 visit, 2 visits, and 3 visits. Fewer households made a greater number of trips, such as 6 or 7.

Data of this kind are called *count data*. The possible values that can occur are the countable integers 0, 1, 2, Other examples of count data are the number of telephone calls that come through a switchboard in a given period, or the number of customers arriving at a bank during a given time period. Count data can be viewed as observations on a *discrete random variable*. The common assumption that we have made for many of our examples so far, that the observations are normally distributed, is not appropriate. A distribution more suitable for count data is the *Poisson distribution*. Its probability density function is given by

$$f(y) = \frac{\mu^y \exp(-\mu)}{y!} \tag{10.4.1}$$

In the context of our example, y is the number of times a household visits Lake Keepit per year and μ is the average or mean number of visits per year, for all households. Recall that $y! = y \times (y-1) \times (y-2) \times \ldots \times 2 \times 1$.

In *Poisson regression*, we improve on (10.4.1) by recognizing that the mean μ is likely to depend on various household characteristics. Households who live close to the lake are likely to visit more often than more-distant households. If recreation is a normal good, the demand for recreation will increase with income. Larger households (more family members) are likely to make more frequent visits to the lake. To accommodate these differences, we write μ_i, the mean for the ith household as

$$\mu_i = \exp(\beta_1 + \beta_2 x_{i2} + \beta_3 x_{i3} + \beta_4 x_{i4}) \tag{10.4.2}$$

where the β_j's are unknown parameters and

x_{i2} = distance of the ith household from the lake in miles,
x_{i3} = household income in tens of thousands of dollars, and
x_{i4} = number of household members.

Table 10.5 **Frequency of Visits to Keepit Dam**

Number of visits	0	1	2	3	4	5	6	7	8	9	10	13
Frequency	61	55	41	31	23	19	8	7	2	1	1	1

Writing μ_i as an exponential function of x_2, x_3, and x_4, rather than a simple linear function, ensures μ_i will be positive.

Recall that, in the simple *linear* regression model, we can write

$$y_i = \mu_i + e_i = \beta_1 + \beta_2 x_i + e_i \qquad (10.4.3)$$

The mean of y_i is $\mu_i = E(y_i) = \beta_1 + \beta_2 x_i$. Thus, μ_i can be written as a function of the explanatory variable x_i. The error term e_i is defined as $y_i - \mu_i$ and, consequently, has a zero mean. We can proceed in the same way with our Poisson regression model. We define the zero-mean error term $e_i = y_i - \mu_i$, or $y_i = \mu_i + e_i$, from which we can write

$$y_i = \exp(\beta_1 + \beta_2 x_{i2} + \beta_3 x_{i3} + \beta_4 x_{i4}) + e_i \qquad (10.4.4)$$

Equation (10.4.4) is a model which is nonlinear in the parameters. It can be estimated via nonlinear least squares. Estimating the equation tells us how the demand for recreation at Lake Keepit depends on distance traveled, income, and number of household members. It also gives us a model for predicting the number of visitors to Lake Keepit.

The 250 sampled values for (x_2, x_3, x_4, y) appear in the file *keepit.dat* in that order. The nonlinear least squares estimates of (10.4.4) appear in Table 10.6. Because of the nonlinear nature of the function, we must be careful how we interpret the magnitudes of the coefficients. However, examining their signs, we can say the greater the distance from Lake Keepit, the less will be the expected number of visits. Increasing income, or the size of the household, increases the frequency of visits.

The estimated model can also be used to compute probabilities relating to a household with particular characteristics. For example, what is the probability that a household located 50 miles from the Lake, with income of $60,000, and 3 family members, visits the park less than 3 times per year? First we compute an estimate of the mean for this household:

$$\hat{\mu} = \exp(1.39067 - 0.020865 \times 50 + 0.022814 \times 6 + 0.13356 \times 3)$$
$$= 2.423 \qquad (R10.6)$$

Table 10.6 **Estimated Model for Visits to Lake Keepit**

Dependent Variable: VISITS
Sample: 1 250
Included observations: 250
Convergence achieved after 7 iterations
VISITS=EXP(C(1)+C(2)*DIST+C(3)*INC+C(4)*MEMB)

	Coefficient	Std. Error	t-Statistic	Prob.
C(1)	1.390670	0.176244	7.890594	0.0000
C(2)	−0.020865	0.001749	−11.93031	0.0000
C(3)	0.022814	0.015833	1.440935	0.1509
C(4)	0.133560	0.030310	4.406527	0.0000

Then, using the Poisson distribution, we have

$$P(y < 3) = P(y = 0) + P(y = 1) + P(y = 2)$$

$$= \frac{(2.423)^0 \exp(-2.423)}{0!} + \frac{(2.423)^1 \exp(-2.423)}{1!} + \frac{(2.423)^2 \exp(-2.423)}{2!}$$

$$= 0.0887 + 0.2148 + 0.2602$$

$$= 0.564 \tag{R10.7}$$

Other probabilities can be computed in a similar way.

10.5 Learning Objectives

Based on the material in this chapter you should be able to:

1. Explain the difference between models which are linear in the parameters and linear in the variables.
2. Give examples of models which are (a) linear in the parameters and nonlinear in the variables and (b) nonlinear in the parameters.
3. Explain why models with polynomial terms and interaction variables are sometimes specified.
4. Explain the marginal effects in a model with polynomial terms and interaction variables.
5. Use your computer software to estimate a model which is nonlinear in the parameters.
6. Report and comment on the estimates from a nonlinear-in-the-parameters model.

10.6 Exercises

10.1 In Section 10.1.2 the effect of income on pizza expenditure was permitted to vary by the age of the individual. Before proceeding with this exercise, divide the income data series in Table 10.1 by 1000.
 (a) Estimate the regression model in which pizza expenditure depends *only* on income, Y.
 (b) Estimate the model in (10.1.5). Comment on the signs and significance of the parameters, and on the effect of scaling the income variable.
 (c) Estimate the model in (10.1.6). Comment on the signs and significance of the parameters. Is there a significant interaction effect between age and income? What is the effect of scaling income?
 (d) In (10.1.6) test the hypothesis that age does not affect pizza expenditure. That is, test the joint null hypothesis $H_0: \beta_2 = 0, \beta_4 = 0$. What do you conclude?
 (e) Construct point estimates and 95% interval estimates of the marginal propensity to spend on pizza for individuals of age 20, 30, 40, and 50. Comment on these estimates.

(f) Modify (10.1.6) to permit a "life-cycle" effect in which the marginal effect of income on pizza expenditure increases with age, up to a point, and then falls. Do so by adding the term $(AGE^2 \times Y)$ to the model. What sign do you anticipate on this term? Estimate the model and test the significance of the coefficient for this variable.

(g) Check the model used in part (f) for collinearity. Add the term $(AGE^3 \times Y)$ to the model in (f) and check the resulting model for collinearity.

10.2 A more complete version of Table 10.1 is contained in the file *pizza.dat*. It includes additional information about the 40 individuals used in the pizza expenditure example. The dummy variable $S = 1$ for females, 0 otherwise. The variables E_1, E_2, and E_3 are dummy variables indicating level of educational attainment. $E_1 = 1$ for individuals whose highest degree is a high school diploma. $E_2 = 1$ for individuals whose highest degree is a college diploma. $E_3 = 1$ if individuals have a graduate degree. If E_1, E_2, and E_3 are all 0 the individual did not complete high school.

(a) Begin with the model in (10.1.6). Include gender (S) as an explanatory variable and estimate the resulting model. What is the effect of including this dummy variable? Is gender a relevant explanatory variable?

(b) Begin with the model in (10.1.6). Include the dummy variables E_1, E_2, and E_3 as explanatory variables and estimate the resulting model. What is the effect of including these dummy variables? Is level of educational attainment a significant explanatory variable?

(c) Consider (10.1.6). Test the hypothesis that separate regression equations for males and females are identical, against the alternative that they are not. Use the 5% level of significance and discuss the consequences of your findings.

10.3 Use the data in Table 10.1 to do the following:

(a) Estimate the model (10.1.6) and compare your results to those in (R10.2).

(b) Calculate the marginal effect $\partial E(PIZZA)/\partial Y$ for an individual of average age and income and test the statistical significance of the estimate.

(c) Calculate a 95% interval estimate for the marginal effect in (b).

(d) Calculate the marginal effect $\partial E(PIZZA)/\partial AGE$ for an individual of average age and income and test the statistical significance of the estimate.

(e) Calculate a 95% interval estimate for the marginal effect in (d).

(f) Write a report to the president of Gutbusters summarizing your findings.

10.4 Table 10.7 contains the results from estimating the relationship between peanut yield Y (in pounds per acre) and the application of nitrogen fertilizer N (in hundreds of pounds per acre) and phosphorus fertilizer P (in hundreds of pounds per acre). The specified relationship is

$$Y_t = \beta_1 + \beta_2 N_t + \beta_3 P_t + \beta_4 N_t^2 + \beta_5 P_t^2 + \beta_6 N_t P_t + e_t$$

(a) Find and comment on the estimated functions describing the marginal response of yield to nitrogen when $P = 1$, $P = 2$ and $P = 3$.

(b) Find and comment on the estimated functions describing the marginal response of yield to phosphorus when $N = 1$, $N = 2$ and $N = 3$.

Table 10.7 **Results for Peanut Example in Exercise 10.4**

Dependent Variable: Y
Sample: 1 27
Included observations: 27

Variable	Coefficient	Std. Error	t-Statistic	Prob.
C	1.385185	1.263941	1.095925	0.2855
N	8.011111	0.940504	8.517889	0.0000
P	4.800000	0.940504	5.103645	0.0000
N2	−1.944444	0.219654	−8.852287	0.0000
P2	−0.777778	0.219654	−3.540915	0.0019
NP	−0.566667	0.155319	−3.648401	0.0015

R-squared	0.892179	Mean dependent var		12.03704
Adjusted R-squared	0.866508	S.D. dependent var		1.472608
S.E. of regression	0.538041	F-statistic		34.75350
Sum squared resid	6.079259	Prob (F-statistic)		0.000000

10.5* For the function estimated in Exercise 10.4, what levels of N and P give maximum yield? Are these levels the optimal fertilizer applications for the peanut producer?

10.6 For the model in Exercise 10.4, test the hypothesis that the marginal response of yield to nitrogen is zero when
(a) $P = 1$ and $N = 1$,
(b) $P = 1$ and $N = 2$, and
(c) $P = 1$ and $N = 3$.
The following information will be useful:

$$\widehat{\text{var}}(b_2 + 2b_4 + b_6) = 0.233202$$
$$\widehat{\text{var}}(b_2 + 4b_4 + b_6) = 0.040208$$
$$\widehat{\text{var}}(b_2 + 6b_4 + b_6) = 0.233202.$$

10.7 Lion Forest has been a very successful golf professional. However, at age 45 his game is not quite what it used to be. He started the pro-tour when he was only 20 and he has been looking back examining how his scores have changed as he got older. In the file *golf.dat*, the first column contains his final score (relative to par) for 150 tournaments. The second column contains his age (in units of 10 years). There are scores for 6 major tournaments in each year for the last 25 years. Denoting his score by Y and his age by A, estimate the following model and obtain the within-sample predictions.

$$Y_t = \beta_1 + \beta_2 A_t + \beta_3 A_t^2 + \beta_4 A_t^3 + e_t$$

(a) Test the null hypothesis that a quadratic function is adequate against the cubic function as an alternative. What are the characteristics of the cubic equation that might make it appropriate?

(b) Use the within-sample predictions to answer the following questions:
 (i) At what age was Lion at the peak of his career?
 (ii) When was Lion's game improving at an increasing rate?
 (iii) When was Lion's game improving at a decreasing rate?
 (iv) At what age did Lion start to play worse than he had played when he was 20 years old?
 (v) When could he no longer score less than par (on average)?
(c) When he is aged 70, will he be able to break 100? (Assume par is 72.)

10.8 (a) Use nonlinear least squares with the 20 observations on K, L, and Q in the file *cespro.dat* to directly estimate the constant elasticity of substitution (CES) production function

$$\ln(Q_t) = \beta - \frac{\eta}{\rho} \ln[\delta L_t^{-\rho} + (1 - \delta)K_t^{-\rho}] + e_t$$

Report estimates and standard errors and comment. The economic interpretations of the parameters may be useful when making your comments. The parameters are the efficiency parameter ($\alpha = \exp(\beta) > 0$), the returns to scale parameter ($\eta > 0$), the substitution parameter ($\rho > -1$), and the distribution parameter ($0 < \delta < 1$) that relates the share of output (Q) to the two inputs (K and L). It can be shown that as $\rho \rightarrow 0$, the CES production function reduces to the simpler Cobb–Douglas production function. A disadvantage of the Cobb–Douglas function is that its elasticity of substitution, which measures how capital can substitute for labor and vice versa, is always equal to 1. The elasticity of substitution for the CES production function is given by

$$ES = \frac{1}{1 + \rho}$$

(b) Test the hypothesis that the elasticity of substitution is unity by:
 (i) Testing $H_0: \rho = 0$ against $H_1: \rho \neq 0$ with a t test.
 (ii) Estimating the Cobb–Douglas function

$$\ln(Q_t) = \beta + \alpha_1 \ln(L_t) + \alpha_2 \ln(K_t) + v_t$$

 and using an F-test that compares restricted and unrestricted sums of squared errors.

10.9* Consider the following equation, where the quantity of wool demanded, q, depends on the price of wool, p, and the price of synthetics, s:

$$q_t = \beta_1 + \frac{\beta_2(p_t^\lambda - 1)}{\lambda} + \frac{\beta_3(s_t^\lambda - 1)}{\lambda} + e_t$$

where β_1, β_2, β_3, and λ are unknown parameters and e_t is an independent, identically distributed random error with mean zero and variance σ^2.
(a) Find, in terms of the unknown parameters, the elasticity of demand for wool with respect to:
 (i) Its own price.
 (ii) The price of synthetics.

(b) Show that the model is a linear function of p and s if $\lambda = 1$.

(c) Use the 45 observations given in the file *wool.dat* and nonlinear least squares to estimate the unknown parameters. Find corresponding elasticity estimates at the means of the sample data. Comment.

(d) Test the hypothesis $\lambda = 1$. What is the relevance of this test?

(e) Test the hypothesis that $\beta_2 = -\beta_3$.

10.10 Use the logistic growth curve model estimated in Section 10.3 to forecast the EAF share of U.S. steel production for the next 10 years beyond the sample period. Comment on the forecasts. How quickly is the share approaching the saturation level?

10.11 The EAF share of Japanese steel production appears in the file *eafjap.dat*. Estimate the parameters of a logistic growth curve for this EAF share. Comment on the estimates. Predict the share for the next 10 years. In what year do you think the saturation level will be reached? (Note that $t = 1$ is equivalent to 1970 and $t = 28$ is 1997.)

10.12 The agricultural scientists Vohnout and Jimenez conducted a study whose purpose was to develop methods for optimal utilization of tropical resources in livestock feeding. They investigated the relationship between Y = weight gain (in kilograms) per day per animal (heifer) and the input variables x_1 = stocking rate (total weight of animals in kilograms per hectare of available grass) and x_2 = intake of supplemental feed (in kilograms) per day per animal. They recorded 9 observations that are stored in the file *heifer.dat*. It was assumed that a nonlinear model of the form

$$Y = \theta_1 + \theta_2 \exp\left(\frac{-\theta_3}{x_1} - \theta_4 x_2\right) + e$$

would adequately represent the relationship between Y and (x_1, x_2).

(a) Estimate the model and find approximate 95% confidence intervals for each parameter. Do you have any reservations about these confidence intervals?

(b) If a stocking rate of 1000 and supplemental feed of 5 had the same cost as a stocking rate of 250 with no supplementary feed, which option would you choose?

(c) The scientists are considering a simpler model given by

$$Y = \theta_1\left[1 - \exp\left(\frac{-\theta_3}{x_1}\right)\right] + e$$

Specify a joint null hypothesis that gives this model. Test this hypothesis.

10.13 Laurie Daley is a well-known Rugby League player for the Canberra Raiders. Honest Bill the Bookie has recently opened a sports betting shop where he plans to offer odds on the number of tries (touchdowns) that Laurie scores in each rugby match. Bill has collected information on the last 40 matches played by the Canberra Raiders. For each match he has the number of tries scored by Laurie (y), the record of the opposing team, measured as proportion of games won (*record*), and whether the game was home or

away. He defines a dummy variable *home* = 1 for home games and *home* = 0 for away games. These data are stored in the file *daley.dat* in the order (*y, record, home*).

(a) Estimate a Poisson regression model with mean

$$E(y) = \mu = \exp(\beta_1 + \beta_2 record + \beta_3 home)$$

(b) Do the estimated coefficients have the expected signs?

(c) The Canberra Raiders' next match is an away game against the Melbourne Storm who have a record of 0.873. Honest Bill wants to set his odds carefully. What is the probability that Laurie Daley scores 2 tries? What is the probability that he scores 3 tries?

(d) The following match is a home game against the ailing North Sydney Bears who have a record of 0.237. In this match, what is the probability that Laurie scores 2 tries? What is the probability that he scores 3 tries?

(e) Give reasons for the differences in your answers to parts (c) and (d).

Chapter 11

Heteroskedasticity

11.1 The Nature of Heteroskedasticity

In Chapter 3 we introduced the linear model

$$y = \beta_1 + \beta_2 x \tag{11.1.1}$$

to explain household expenditure on food (y) as a function of household income (x). In this function β_1 and β_2 are unknown parameters that convey information about the expenditure function. The response parameter β_2 describes how household food expenditure changes when household income increases by one unit. The intercept parameter β_1 measures expenditure on food for a zero income level. Knowledge of these parameters aids planning by institutions such as government agencies or food retail chains.

We begin this section by asking whether a function such as $y = \beta_1 + \beta_2 x$ is better at explaining expenditure on food for low-income households than it is for high-income households. If you were to guess food expenditure for a low-income household and food expenditure for a high-income household, which guess do you think would be easier? Low-income households do not have the option of extravagant food tastes; comparatively, they have few choices, and are almost forced to spend a particular portion of their income on food. High-income households, on the other hand, could have simple food tastes or extravagant food tastes. They might dine on caviar or spaghetti, while their low-income counterparts have to take the spaghetti. Thus, income is less important as an explanatory variable for food expenditure of high-income families. It is harder to guess their food expenditure.

This type of effect can be captured by a statistical model that exhibits heteroskedasticity. To discover how, and what we mean by heteroskedasticity, let us return to the statistical model for the food expenditure-income relationship that we analyzed in Chapters 3 through 6. Given $T = 40$ cross-sectional household observations on food expenditure and income, the statistical model specified in Chapter 3 was given by

$$y_t = \beta_1 + \beta_2 x_t + e_t \tag{11.1.2}$$

where y_t represents weekly food expenditure for the t-th household, x_t represents weekly household income for the t-th household, and β_1 and β_2 are unknown parameters to estimate. We assumed the e_t were uncorrelated random error terms with mean zero and constant variance σ^2. That is,

$$E(e_t) = 0 \quad \text{var}(e_t) = \sigma^2 \quad \text{cov}(e_i, e_j) = 0 \qquad (11.1.3)$$

Using the least squares procedure and the data in Table 3.1 we found estimates b_1 = 40.768 and b_2 = 0.1283 for the unknown parameters β_1 and β_2. Including the standard errors for b_1 and b_2, the estimated mean function was

$$\hat{y}_t = 40.768 + 0.1283x_t \qquad (11.1.4)$$
$$(22.139) \ (0.0305)$$

A graph of this estimated function, along with all the observed expenditure-income points (y_t, x_t), appears in Figure 11.1. Notice that, as income (x_t) grows, the observed data points (y_t, x_t) have a tendency to deviate more and more from the estimated mean function. The points are scattered further away from the line as x_t gets larger. Another way of describing this feature is to say that the least squares residuals, defined by

$$\hat{e}_t = y_t - b_1 - b_2x_t \qquad (11.1.5)$$

increase in absolute value as income grows.

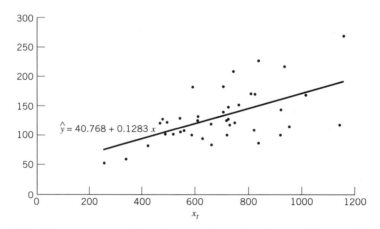

FIGURE **11.1** Least squares estimated expenditure function and observed data points.

The observable least squares residuals (\hat{e}_t) are proxies for the unobservable errors (e_t) that are given by

$$e_t = y_t - \beta_1 - \beta_2x_t \qquad (11.1.6)$$

Thus, the information in Figure 11.1 suggests that the unobservable errors also increase in absolute value as income (x_t) increases. That is, the variation of food expenditure y_t around mean food expenditure $E(y_t)$ increases as income x_t increases. This observation is consistent with the hypothesis that we posed earlier, namely, that the mean food expenditure function is better at explaining food expenditure for low-income (spaghetti-eating) households than it is for high-income households who might be spaghetti eaters or caviar eaters.

Is this type of behavior consistent with the assumptions of our model? The parameter that controls the spread of y_t around the mean function, and measures the uncertainty in the regression model, is the variance σ^2. If the scatter of y_t around the mean function increases as x_t increases, then the uncertainty about y_t increases as x_t increases, and we have evidence to suggest that the variance is not constant. Instead, we should be looking for a way to model a variance σ^2 that increases as x_t increases.

Thus, we are questioning the constant variance assumption, which we have written as

$$\text{var}(y_t) = \text{var}(e_t) = \sigma^2 \qquad (11.1.7)$$

The most general way to relax this assumption is to simply add a subscript t to σ^2, recognizing that the variance can be different for different observations. We then have

$$\text{var}(y_t) = \text{var}(e_t) = \sigma_t^2 \qquad (11.1.8)$$

In this case, when the variances for all observations are not the same, we say that **heteroskedasticity** exists. Alternatively, we say the random variable y_t and the random error e_t are *heteroskedastic*. Conversely, if (11.1.7) holds we say that **homoskedasticity** exists, and y_t and e_t are *homoskedastic*.

The heteroskedastic assumption is illustrated in Figure 11.2. At x_1, the probability density function $f(y_1|x_1)$ is such that y_1 will be close to $E(y_1)$ with high probability. When we move to x_2, the probability density function $f(y_2|x_2)$ is more spread out; we are less certain about where y_2 might fall. When homoskedasticity exists, the probability density function for the errors does not change as x changes, as we illustrated in Figure 3.3.

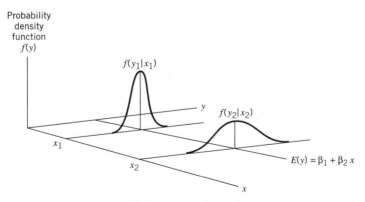

FIGURE **11.2** Heteroskedastic errors.

The existence of different variances, or heteroskedasticity, is often encountered when using **cross-sectional data.** The term *cross-sectional data* refers to having data on a number of economic units such as firms or households, *at a given point in time*. The household data on income and food expenditure fall into this cate-

gory. Other possible examples include data on costs, outputs, and inputs for a number of firms, and data on quantities purchased and prices for some commodity, or commodities, in a number of retail establishments. Cross-sectional data invariably involve observations on economic units of varying sizes. For example, data on households will involve households with varying numbers of household members and different levels of household income. With data on a number of firms, we might measure the size of the firm by the quantity of output it produces. Frequently, the larger the firm, or the larger the household, the more difficult it is to explain the variation in some outcome variable y_t by the variation in a set of explanatory variables. Larger firms and households are likely to be more diverse and flexible with respect to the way in which values for y_t are determined. What this means for the linear regression model is that, as the size of the economic unit becomes larger, there is more uncertainty associated with the outcomes y_t. For our linear regression model to describe a data-generation process with this property, the variance of the error term has to be larger, the larger the size of the economic unit.

Heteroskedasticity is not a property that is necessarily restricted to cross-sectional data. With *time-series data*, where we have data *over time on one economic unit*, such as a firm, a household, or even a whole economy, it is possible that the error variance will change. This would be true if there was an external shock or change in circumstances that created more or less uncertainty about y. An example that fits into this category is the supply response example that we consider in Section 11.5.

Given that we have a model that exhibits heteroskedasticity, we need to ask about the consequences on least squares estimation of the violation of one of our assumptions. Is there a better estimator that we can use? Also, how might we detect whether or not heteroskedasticity exists? It is to these questions that we now turn.

11.2 The Consequences of Heteroskedasticity for the Least Squares Estimator

If we have a linear regression model with heteroskedasticity (the assumption $\text{var}(e_t) = \sigma^2$ is violated), and we use the least squares estimator to estimate the unknown coefficients, then:

1. The least squares estimator is still a linear and unbiased estimator, but it is no longer the best linear unbiased estimator (B.L.U.E.).

2. The standard errors usually computed for the least squares estimator are incorrect. Confidence intervals and hypothesis tests that use these standard errors may be misleading.

We will explore these issues. We do so in the context of the simple linear regression model, with only one explanatory variable. However, the results generalize to the more general multiple regression model that was introduced in Chapter 7. If you do not wish to participate in our exciting exploration, please skip the marked text down to the kangaroo.

We consider the model

$$y_t = \beta_1 + \beta_2 x_t + e_t \tag{11.2.1}$$

where

$$E(e_t) = 0, \qquad \text{var}(e_t) = \sigma_t^2, \qquad \text{cov}(e_i, e_j) = 0, (i \neq j)$$

Note the heteroskedastic assumption $\text{var}(e_t) = \sigma_t^2$. In Chapter 4 (4.2.1), we wrote the least squares estimator for β_2 as

$$b_2 = \beta_2 + \sum w_t e_t \qquad (11.2.2)$$

where

$$w_t = \frac{x_t - \bar{x}}{\sum (x_t - \bar{x})^2} \qquad (11.2.3)$$

This expression is a useful one for exploring the properties of least squares estimation under heteroskedasticity. The first property that we establish is that of unbiasedness. This property was derived under homoskedasticity in (4.2.3) of Chapter 4. This proof still holds because the only error term assumption that it used, $E(e_t) = 0$, still holds. We reproduce it here for completeness.

$$\begin{aligned} E(b_2) &= E(\beta_2) + E(\sum w_t e_t) \\ &= \beta_2 + \sum w_t E(e_t) = \beta_2 \end{aligned} \qquad (11.2.4)$$

The next result is that the least squares estimator is no longer best. That is, although it is still unbiased, it is no longer *the* best linear unbiased estimator. The way we tackle this question is to derive an alternative estimator that *is* the best linear unbiased estimator. This new estimator is considered in Sections 11.3 and 11.5.

To show that the usual formulas for the least squares standard errors are incorrect under heteroskedasticity, we return to the derivation of $\text{var}(b_2)$ in (4.2.11). From that equation, and using (11.2.2), we have

$$\begin{aligned} \text{var}(b_2) &= \text{var}(\beta_2) + \text{var}(\sum w_t e_t) \\ &= \text{var}(\sum w_t e_t) \\ &= \sum w_t^2 \, \text{var}(e_t) + \sum_{i \neq j} \sum w_i w_j \, \text{cov}(e_i, e_j) \\ &= \sum w_t^2 \sigma_t^2 \\ &= \frac{\sum [(x_t - \bar{x})^2 \sigma_t^2]}{[\sum (x_t - \bar{x})^2]^2} \end{aligned} \qquad (11.2.5)$$

In an earlier proof, where the variances were all the same ($\sigma_t^2 = \sigma^2$), we were able to write the next-to-last line as $\sigma^2 \sum w_t^2$. Now, the situation is more complex;

the point to note from the last line in (11.2.5) is that

$$\text{var}(b_2) \neq \frac{\sigma^2}{\sum (x_t - \bar{x})^2} \qquad (11.2.6)$$

Thus, if we use the least squares estimation procedure and ignore heteroskedasticity when it is present, we will be using an estimate of (11.2.6) to obtain the standard error for b_2, when in fact we should be using an estimate of (11.2.5). Using incorrect standard errors means that interval estimates and hypothesis tests will no longer be valid. Note that standard computer software for least squares regression will compute the estimated variance for b_2 based on (11.2.6), unless told otherwise.

11.2.1 WHITE'S APPROXIMATE ESTIMATOR FOR THE VARIANCE OF THE LEAST SQUARES ESTIMATOR

Given that the conventional least squares standard errors are incorrect under heteroskedasticity, we ask whether there is a way of computing correct standard errors. Getting suitable standard errors for the least squares estimator overcomes one of its adverse consequences. Getting a better estimator, with lower variance, is considered in subsequent sections.

Halbert White, an econometrician, has suggested an estimator for the variances and covariances of the least squares coefficient estimators when heteroskedasticity exists. In the context of the simple regression model, his estimator for $\text{var}(b_2)$ is obtained by replacing σ_t^2 by the squares of the least squares residuals \hat{e}_t^2, in (11.2.5). Large variances are likely to lead to large values of the squared residuals. Because the squared residuals are used to approximate the variances, White's estimator is strictly appropriate only in large samples.

> **REMARK:** Most regression software packages include an option for calculating standard errors using White's estimator. Check out the options provided by your software.

If we apply White's estimator to the food expenditure–income data, we obtain

$$\hat{\text{var}}(b_1) = 561.89, \quad \hat{\text{var}}(b_2) = 0.0014569 \qquad (R11.1)$$

Taking the square roots of these quantities yields the standard errors, so that we could write our estimated equation as

$$\hat{y}_t = 40.768 + 0.1283x_t$$
$$\quad (23.704) \quad (0.0382) \quad \text{(White)} \qquad (R11.2)$$
$$\quad (22.139) \quad (0.0305) \quad \text{(incorrect)}$$

In this case, ignoring heteroskedasticity and using incorrect standard errors tends to overstate the precision of estimation; we tend to get confidence intervals that are narrower than they should be. Specifically, following (5.1.12) of Chapter 5, we can construct two corresponding 95% confidence intervals for β_2.

$$\text{White}: \quad b_2 \pm t_c \text{se}(b_2) = 0.1283 \pm 2.024(0.0382) = [0.051, 0.206]$$

$$\text{(R11.3)}$$

$$\text{Incorrect}: \quad b_2 \pm t_c \text{se}(b_2) = 0.1283 \pm 2.024(0.0305) = [0.067, 0.190]$$

If we ignore heteroskedasticity, we estimate that β_2 lies between 0.067 and 0.190. However, recognizing the existence of heteroskedasticity means recognizing that our information is less precise, and we estimate that β_2 lies between 0.051 and 0.206.

White's estimator for the standard errors helps overcome the problem of drawing incorrect inferences from least squares estimates in the presence of heteroskedasticity. However, if we can get a better estimator than least squares, then it makes more sense to use this better estimator and its corresponding standard errors. What *is* a "better estimator" will depend on how we model the heteroskedasticity. That is, it will depend on what further assumptions we make about the σ_t^2. In Sections 11.3 and 11.5 we consider two examples with two different heteroskedastic structures.

11.3 Proportional Heteroskedasticity

In this section we return to the example where weekly food expenditure (y_t) is related to weekly income (x_t) through the equation

$$y_t = \beta_1 + \beta_2 x_t + e_t \tag{11.3.1}$$

Following the discussion in Section 11.1, we make the following statistical assumptions:

$$E(e_t) = 0, \quad \text{var}(e_t) = \sigma_t^2, \quad \text{cov}(e_i, e_j) = 0, (i \neq j)$$

By itself, the assumption $\text{var}(e_t) = \sigma_t^2$ is not adequate for developing a better procedure for estimating β_1 and β_2. We would need to estimate T different variances (σ_1^2, σ_2^2, ... , σ_T^2) plus β_1 and β_2, with only T sample observations; it is not possible to consistently estimate T or more parameters. We overcome this problem by making a further assumption about the σ_t^2. Our earlier inspection of the least squares residuals suggested that the error variance increases as income increases. A reasonable model for such a variance relationship is

$$\text{var}(e_t) = \sigma_t^2 = \sigma^2 x_t \tag{11.3.2}$$

That is, we assume that the variance of the tth error term σ_t^2 is given by a positive unknown constant parameter σ^2 multiplied by the positive income variable x_t. As explained earlier, in economic terms this assumption implies that for low levels of income (x_t), food expenditure (y_t) will be clustered close to the mean function $E(y_t) = \beta_1 + \beta_2 x_t$. Expenditure on food for low-income households will be largely

explained by the level of income. At high levels of income, food expenditures can deviate more from the mean function. This means that there are likely to be many other factors, such as specific tastes and preferences, that reside in the error term, and that lead to a greater variation in food expenditure for high-income households. Thus, the assumption of heteroskedastic errors in (11.3.2) is a reasonable one for the expenditure model. In any given practical setting it is important to think not only about whether the residuals from the data exhibit heteroskedasticity, but also about whether such heteroskedasticity is a likely phenomenon from an economic standpoint.

Under heteroskedasticity the least squares estimator is not the best linear unbiased estimator. One way of overcoming this dilemma is *to change or transform our statistical model into one with homoskedastic errors*. Leaving the basic structure of the model intact, it is possible to turn the heteroskedastic error model into a homoskedastic error model. Once this transformation has been carried out, application of least squares to the transformed model gives a best linear unbiased estimator.

To demonstrate these facts, we begin by dividing both sides of (11.3.1) by $\sqrt{x_t}$:

$$\frac{y_t}{\sqrt{x_t}} = \beta_1\left(\frac{1}{\sqrt{x_t}}\right) + \beta_2\left(\frac{x_t}{\sqrt{x_t}}\right) + \frac{e_t}{\sqrt{x_t}} \tag{11.3.3}$$

Now, define the following *transformed variables*

$$y_t^* = \frac{y_t}{\sqrt{x_t}}, \quad x_{t1}^* = \frac{1}{\sqrt{x_t}}, \quad x_{t2}^* = \frac{x_t}{\sqrt{x_t}} = \sqrt{x_t}, \quad e_t^* = \frac{e_t}{\sqrt{x_t}} \tag{11.3.4}$$

so that (11.3.3) can be rewritten as

$$y_t^* = \beta_1 x_{t1}^* + \beta_2 x_{t2}^* + e_t^* \tag{11.3.5}$$

The beauty of this transformed model is that the new transformed error term e_t^* is homoskedastic. The proof of this result is:

$$\text{var}(e_t^*) = \text{var}\left(\frac{e_t}{\sqrt{x_t}}\right) = \frac{1}{x_t}\text{var}(e_t) = \frac{1}{x_t}\sigma^2 x_t = \sigma^2 \tag{11.3.6}$$

Also, the transformed error term will retain the properties of zero mean, $E(e_t^*) = 0$, and zero correlation between different observations, $\text{cov}(e_i^*, e_j^*) = 0$ for $i \neq j$. As a consequence, we can apply least squares to the transformed variables, y_t^*, x_{t1}^*, and x_{t2}^*, to obtain the best linear unbiased estimator for β_1 and β_2. Note that these transformed variables are all observable; it is a straightforward matter to compute "the observations" on these variables. Also, the transformed model is linear in the unknown parameters β_1 and β_2. These are the original parameters that we are interested in estimating. They have not been affected by the transformation. In short, the transformed model is a linear statistical model to which we can apply least squares estimation. The transformed model satisfies the conditions of the Gauss-Markov Theorem, and the least squares estimators defined in terms of the transformed variables are B.L.U.E.

To summarize, to obtain the best linear unbiased estimator for a model with heteroskedasticity of the type specified in (11.3.2):

1. Calculate the transformed variables given in (11.3.4).

2. Use least squares to estimate the transformed model given in (11.3.5).

The estimator obtained in this way is called a generalized least squares estimator.

One way of viewing the generalized least squares estimator is as a *weighted least squares estimator*. Recall that the least squares estimator is those values of β_1 and β_2 that minimize the sum of squared errors. In this case, we are minimizing the sum of squared transformed errors that is given by

$$\sum_{t=1}^{T} e_t^{*2} = \sum_{t=1}^{T} \frac{e_t^2}{x_t}$$

The squared errors are *weighted* by the reciprocal of x_t. When x_t is small, the data contain more information about the regression function and the observations are weighted heavily. When x_t is large, the data contain less information and the observations are weighted lightly. In this way we take advantage of the heteroskedasticity to improve parameter estimation.

> **REMARK:** In the transformed model $x_{t1}^* \neq 1$. That is, the variable associated with the intercept parameter is no longer equal to one. Since least squares software usually automatically inserts a "1" for the intercept, when dealing with transformed variables you will need to learn how to turn this option off. If you use a "weighted" or "generalized" least squares option on your software, the computer will do both the transforming and the estimating. In this case suppressing the constant will not be necessary.

Applying the generalized (weighted) least squares procedure to our household expenditure data yields the following estimates:

$$\hat{y}_t = 31.924 + 0.1410x \qquad \text{(R11.4)}$$
$$(17.986) \quad (0.0270)$$

That is, we estimate the intercept term as $\hat{\beta}_1 = 31.924$ and the slope coefficient that shows the response of food expenditure to a change in income as $\hat{\beta}_2 = 0.1410$. These estimates are somewhat different from the least squares estimates $b_1 = 40.768$ and $b_2 = 0.1283$ that did not allow for the existence of heteroskedasticity. It is important to recognize that the interpretations for β_1 and β_2 are the same in the transformed model (11.3.5) as they are in the untransformed model (11.3.1). *Transformation of the variables should be regarded as a device for converting a heteroskedastic error model into a homoskedastic error model, not as something that changes the meaning of the coefficients.*

The standard errors in (R11.4), namely $se(\hat{\beta}_1) = 17.986$ and $se(\hat{\beta}_2) = 0.0270$, are both lower than their least squares counterparts that were calculated from White's estimator, namely $se(b_1) = 23.704$ and $se(b_2) = 0.0382$. Since generalized least squares is a better estimation procedure than least squares, we do expect the generalized least squares standard errors to be lower.

> **REMARK:** Remember that standard errors are square roots of *estimated* variances; in a single sample the relative magnitudes of variances may not always be reflected by their corresponding variance estimates. Thus, lower standard errors do not *always* mean better estimation.

The smaller standard errors have the advantage of producing narrower, more informative confidence intervals. For example, using the generalized least squares results, a 95% confidence interval for β_2 is given by

$$\hat{\beta}_2 \pm t_c se(\hat{\beta}_2) = 0.1410 \pm 2.024(0.0270) = [0.086, 0.196] \qquad (R11.5)$$

The least squares confidence interval computed using White's standard errors was [0.051, 0.206].

11.4 Detecting Heteroskedasticity

In our discussion of the food expenditure equation we used the nature of the economic problem and the data to argue why heteroskedasticity of a particular form might be present. In other equations, using other types of data, there is likely to be uncertainty about whether a heteroskedastic-error assumption is warranted. A common question is: How do I know if heteroskedasticity is likely to be a problem for my model and my set of data? Is there a way of detecting heteroskedasticity so that I know whether to use generalized least squares techniques? We will consider two ways of investigating these questions. One is the use of residual plots. The second is a statistical test known as the Goldfeld–Quandt test.

11.4.1 RESIDUAL PLOTS

One way of investigating the existence of heteroskedasticity is to estimate your model using least squares and to plot the least squares residuals. If the errors are homoskedastic, there should be no patterns of any sort in the residuals. If the errors are heteroskedastic, they may tend to exhibit greater variation in some systematic way. For example, for the household expenditure data, we suspected that the variance may increase as income increased. In Figure 11.1 we plotted the estimated least squares function and the residuals and discovered that the absolute values of the residuals did indeed tend to increase as income increased. This method of investigating heteroskedasticity can be followed for any simple regression.

When we have more than one explanatory variable, the estimated least squares function is not so easily depicted on a diagram. However, what we can do is plot the

least squares residuals against each explanatory variable, against time, or against \hat{y}_t, to see if those residuals vary in a systematic way relative to the specified variable.

11.4.2 THE GOLDFELD–QUANDT TEST

While plotting the residuals does provide useful information about the likely existence of heteroskedasticity, it does not tell us, in a formal sense, whether variations in the magnitude of the residuals could be attributable to chance or whether they constitute statistical evidence against a null hypothesis of homoskedasticity. A formal test that can be used for this purpose is the Goldfeld–Quandt test. It involves the following steps:

1. Split the sample into two approximately equal subsamples. If heteroskedasticity exists, some observations will have large variances and others will have small variances. Divide the sample such that the observations with potentially high variances are in one subsample and those with potentially low variances are in the other subsample. For example, in the food expenditure equation, where we believe the variances are related to x_t, the observations should be sorted according to the magnitude of x_t; the $T/2$ observations with the largest values of x_t would form one subsample and the other $T/2$ observations, with the smallest values of x_t, would form the other.

2. Compute estimated error variances $\hat{\sigma}_1^2$ and $\hat{\sigma}_2^2$ for each of the subsamples. Let $\hat{\sigma}_1^2$ be the estimate from the subsample with potentially large variances and let $\hat{\sigma}_2^2$ be the estimate from the subsample with potentially small variances. If a null hypothesis of equal variances is not true, we expect $\hat{\sigma}_1^2/\hat{\sigma}_2^2$ to be large.

3. Compute $GQ = \hat{\sigma}_1^2/\hat{\sigma}_2^2$ and reject the null hypothesis of equal variances if $GQ > F_c$ where F_c is a critical value from the F-distribution with $(T_1 - K)$ and $(T_2 - K)$ degrees of freedom. The values T_1 and T_2 are the numbers of observations in each of the subsamples; if the sample is split exactly in half, $T_1 = T_2 = T/2$.

Applying this test procedure to the household food expenditure model, we set up the hypotheses

$$H_0 : \sigma_t^2 = \sigma^2 \qquad H_1 : \sigma_t^2 = \sigma^2 x_t \qquad (11.4.1)$$

After ordering the data according to decreasing values of x_t, and using a partition of 20 observations in each subset of data, we find $\hat{\sigma}_1^2 = 2285.9$ and $\hat{\sigma}_2^2 = 682.46$. Hence, the value of the Goldfeld–Quandt statistic is

$$GQ = \frac{2285.9}{682.46} = 3.35 \qquad (R11.6)$$

The 5% critical value for (18, 18) degrees of freedom is $F_c = 2.22$. Thus, because $GQ = 3.35 > F_c = 2.22$, we reject H_0 and conclude that heteroskedasticity does exist; the error variance does depend on the level of income.

> **REMARK:** The above test is one-sided because the alternative hypothesis suggested which sample partition will have the larger variance. If we suspect that two sample partitions could have different variances, but we do not know which variance is potentially larger, then a two-sided test with alternative hypothesis $H_1 : \sigma_1^2 \neq \sigma_2^2$ is more appropriate. To perform a two-sided test at the 5% significance level we put the larger variance estimate in the numerator and use a critical value F_c such that $P[F > F_c] = 0.025$.

11.5 A Sample with a Heteroskedastic Partition

11.5.1 ECONOMIC MODEL

Consider modeling the supply of wheat in a particular wheat-growing area in Australia. In the supply function the quantity of wheat supplied will typically depend on the production technology of the firm, on the price of wheat or expectations about the price of wheat, and on weather conditions. We can depict this supply function as

$$\text{Quantity} = f(\text{Price, Technology, Weather}) \qquad (11.5.1)$$

Information on the response of quantity supplied to price is important for government policy purposes. If the government is to pay a guaranteed price to wheat growers, or to support the price in any other way, it needs an idea of the wheat supply that a given price will bring forth; a large proportion of this wheat needs to be sold on the international market.

To estimate how the quantity supplied responds to price and other variables, we move from the economic model in (11.5.1) to an econometric model that we can estimate. If we have a sample of time-series data, aggregated over all farms, there will be price variation from year to year, variation that can be used to estimate the response of quantity to price. Also, production technology will improve over time, meaning that a greater supply can become profitable at the same level of output price. Finally, a large part of the year-to-year variation in supply could be attributable to weather conditions.

The data we have available from the Australian wheat-growing district consist of 26 years of aggregate time-series data on quantity supplied and price. Because there is no obvious index of production technology, some kind of proxy needs to be used for this variable. We use a simple linear time-trend—a variable that takes the value 1 in year 1, 2 in year 2, and so on, up to 26 in year 26. An obvious weather variable is also unavailable; thus, in our econometric model, weather effects will form part of the random error term. Using these considerations, we specify the linear supply function

$$q_t = \beta_1 + \beta_2 p_t + \beta_3 t + e_t \quad t = 1, 2, \ldots, 26 \qquad (11.5.2)$$

where

q_t is the quantity of wheat produced in year t,

p_t is the price of wheat guaranteed for year t,

t $= 1, 2, \ldots, 26$ is a trend variable introduced to capture changes in production technology, and

e_t is a random error term that includes, among other things, the influence of weather.

As before, β_1, β_2, and β_3 are unknown parameters that we wish to estimate. The data on q, p, and t are given in Table 11.1.

To complete the statistical model in (11.5.2), some assumptions for the random error term e_t are needed. One possibility is to assume the e_t are independent identically distributed random variables with zero mean and constant variance. This assumption is in line with those made in earlier chapters. In this case, however, we have additional information that makes an alternative assumption more realistic. We know that, after the thirteenth year, new wheat varieties whose yields are less susceptible to variations in weather conditions were introduced. These new varieties do not have an average yield that is higher than that of the old varieties, but the variance of their yields is lower because yield is less dependent on weather conditions. Since the weather effect is a major component of the random error term e_t, we can model the reduced weather effect of the last thirteen years by assuming the error variance in those years is different from the error variance in the first thirteen years. Thus, we assume that

$$\begin{aligned}
E(e_t) &= 0 & t &= 1, 2, \ldots, 26 \\
\text{var}(e_t) &= \sigma_1^2 & t &= 1, 2, \ldots, 13 \\
\text{var}(e_t) &= \sigma_2^2 & t &= 14, 15, \ldots, 26 \\
\text{cov}(e_i, e_j) &= 0 & i &\neq j
\end{aligned} \tag{11.5.3}$$

From the above argument, we expect that $\sigma_2^2 < \sigma_1^2$.

Table 11.1 **Data on Quantity, Price, and Trend for an Australian Wheat Growing District**

q	p	t	q	p	t
197.6	1.47	1	240.0	2.42	14
140.1	1.30	2	236.1	2.45	15
162.3	1.59	3	234.5	2.44	16
166.5	1.44	4	239.0	2.26	17
159.5	1.89	5	258.4	2.50	18
195.6	1.49	6	247.9	2.41	19
207.0	1.94	7	272.2	2.83	20
218.4	1.52	8	266.2	2.79	21
239.0	2.15	9	284.1	3.17	22
208.2	2.09	10	283.4	2.83	23
253.4	1.74	11	277.4	2.69	24
278.7	2.51	12	301.0	3.65	25
221.1	2.14	13	281.4	3.36	26

Since the error variance in (11.5.3) is not constant for all observations, this model describes another form of heteroskedasticity. It is a form that partitions the sample into two subsets, one subset where the error variance is σ_1^2 and one where the error variance is σ_2^2.

11.5.2 GENERALIZED LEAST SQUARES THROUGH MODEL TRANSFORMATION

Given the heteroskedastic error model with two variances, one for each subset of thirteen years, we consider transforming the model so that the variance of the transformed error term is constant over the whole sample. This approach was followed for the household expenditure example; it made it possible to obtain a best linear unbiased estimator by applying least squares to the transformed model.

With this idea in mind, we write the model corresponding to the two subsets of observations as

$$q_t = \beta_1 + \beta_2 p_t + \beta_3 t + e_t \quad \text{var}(e_t) = \sigma_1^2 \quad \text{for } t = 1, 2, \ldots, 13$$
$$q_t = \beta_1 + \beta_2 p_t + \beta_3 t + e_t \quad \text{var}(e_t) = \sigma_2^2 \quad \text{for } t = 14, 15, \ldots, 26 \quad (11.5.4)$$

Dividing each variable by σ_1 for the first 13 observations and by σ_2 for the last 13 observations yields

$$\frac{q_t}{\sigma_1} = \beta_1 \left(\frac{1}{\sigma_1} \right) + \beta_2 \left(\frac{p_t}{\sigma_1} \right) + \beta_3 \left(\frac{t}{\sigma_1} \right) + \frac{e_t}{\sigma_1} \quad \text{for } t = 1, 2, \ldots, 13$$

$$\frac{q_t}{\sigma_2} = \beta_1 \left(\frac{1}{\sigma_2} \right) + \beta_2 \left(\frac{p_t}{\sigma_2} \right) + \beta_3 \left(\frac{t}{\sigma_2} \right) + \frac{e_t}{\sigma_2} \quad \text{for } t = 14, 15, \ldots, 26$$

$$(11.5.5)$$

This transformation yields transformed error terms that have the same variance for all observations. Specifically, the transformed error variances are all equal to *one* because

$$\text{var}\left(\frac{e_t}{\sigma_1} \right) = \frac{1}{\sigma_1^2} \text{var}(e_t) = \frac{\sigma_1^2}{\sigma_1^2} = 1 \quad \text{for } t = 1, 2, \ldots, 13$$

$$\text{var}\left(\frac{e_t}{\sigma_2} \right) = \frac{1}{\sigma_2^2} \text{var}(e_t) = \frac{\sigma_2^2}{\sigma_2^2} = 1 \quad \text{for } t = 14, 15, \ldots, 26$$

Providing σ_1 and σ_2 are known, the transformed model in (11.5.5) provides a set of new transformed variables to which we can apply the least squares principle to

obtain the best linear unbiased estimator for $(\beta_1, \beta_2, \beta_3)$. The transformed variables are

$$\left(\frac{q_t}{\sigma_i}\right), \qquad \left(\frac{1}{\sigma_i}\right), \qquad \left(\frac{p_t}{\sigma_i}\right), \qquad \left(\frac{t}{\sigma_i}\right) \qquad\qquad (11.5.6)$$

where σ_i is either σ_1 or σ_2, depending on which half of the observations are being considered. As before, the complete process of transforming variables, then applying least squares to the transformed variables, is called *generalized least squares*.

11.5.3 IMPLEMENTING GENERALIZED LEAST SQUARES

An important difference between this generalized least squares estimator and the one we used for the earlier heteroskedastic error model is that the transformed variables in (11.5.6) depend on the unknown variance parameters σ_1^2 and σ_2^2. Thus, as they stand, the transformed variables cannot be calculated. To overcome this difficulty, we use estimates of σ_1^2 and σ_2^2 and transform the variables as if the estimates were the true variances.

What is a reasonable way to estimate σ_1^2 and σ_2^2? Since σ_1^2 is the error variance from the first half of the sample and σ_2^2 is the error variance from the second half of the sample, it makes sense to split the sample into two, applying least squares to the first half to estimate σ_1^2 and applying least squares to the second half to estimate σ_2^2. Substituting these estimates for the true values causes no difficulties in large samples.

If we follow this strategy for the wheat supply example we obtain

$$\hat{\sigma}_1^2 = 641.64, \qquad \hat{\sigma}_2^2 = 57.76 \qquad\qquad (R11.7)$$

Using these estimates to calculate observations on the transformed variables in (11.5.6), and then applying least squares to the complete sample defined in (11.5.5), yields the estimated equation:

$$\hat{q}_t = 138.1 + 21.72p_t + 3.283t \qquad\qquad (R11.8)$$
$$(12.7) \quad (8.81) \quad (0.812)$$

These estimates suggest that an increase in price of 1 unit will bring about an increase in supply of 21.72 units. The coefficient of the trend variable suggests that, each year, technological advances mean that an additional 3.283 units will be supplied, given constant prices. The standard errors are sufficiently small to make the estimated coefficients significantly different from zero. However, the 95% confidence intervals for β_2 and β_3, derived using these standard errors, are relatively wide.

$$\hat{\beta}_2 \pm t_c \text{se}(\hat{\beta}_2) = 21.72 \pm 2.069(8.81) = [3.5, 39.9]$$
$$\hat{\beta}_3 \pm t_c \text{se}(\hat{\beta}_3) = 3.283 \pm 2.069(0.812) = [1.60, 4.96] \qquad\qquad (R11.9)$$

> **REMARK:** A word of warning about calculating the standard errors is necessary. As demonstrated after (11.5.5), the transformed errors in (11.5.5) have a variance equal to one. However, when you transform your variables using $\hat{\sigma}_1$ and $\hat{\sigma}_2$, and apply least squares to the transformed variables for the complete sample, your computer program will automatically *estimate* a variance for the transformed errors. This estimate will not be *exactly* equal to one. The standard errors in (R11.8) were calculated by forcing the computer to use *one* as the variance of the transformed errors. Most software packages will have options that let you do this, but it is not a crucial flaw if your package does not; the variance estimate will usually be close to one anyway.

11.5.4 TESTING THE VARIANCE ASSUMPTION

To use a residual plot to check whether the wheat-supply error variance has decreased over time, it is sensible to plot the least-squares residuals against time. See Figure 11.3. The dramatic drop in the variation of the residuals after year 13 supports our belief that the variance has decreased.

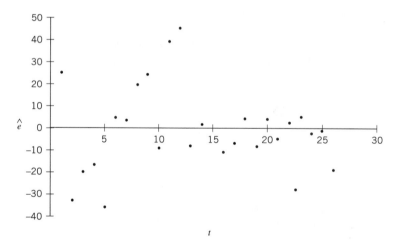

FIGURE **11.3** Least squares residuals plotted against time.

For the Goldfeld–Quandt test, the sample is already split into two natural subsamples. Thus, we set up the hypotheses

$$H_0 : \sigma_1^2 = \sigma_2^2 \qquad H_1 : \sigma_2^2 < \sigma_1^2 \tag{11.5.7}$$

The computed value of the Goldfeld–Quandt statistic is

$$GQ = \frac{\hat{\sigma}_1^2}{\hat{\sigma}_2^2} = \frac{641.64}{57.76} = 11.11 \tag{R11.10}$$

Also, $T_1 = T_2 = 13$ and $K = 3$; thus, if H_0 is true, 11.11 is an observed value from

an *F*-distribution with (10, 10) degrees of freedom. The corresponding 5% critical value is $F_c = 2.98$. Since $GQ = 11.11 > F_c = 2.98$, we reject H_0 and conclude that the observed difference between $\hat{\sigma}_1^2$ and $\hat{\sigma}_2^2$ could not reasonably be attributable to chance. There is evidence to suggest the new varieties have reduced the variance in the supply of wheat.

11.6 Learning Objectives

Based on the material in this chapter, you should be able to:

1. Define heteroskedasticity. Give examples of econometric models where heteroskedasticity is likely to exist. Give examples of heteroskedastic error assumptions.
2. Explain the consequences of heteroskedasticity for the least squares estimator.
3. Explain the purpose of White's standard errors. Use your computer software to compute White's standard errors.
4. Explain how the weighted or generalized least squares estimator works.
5. Compute generalized least squares estimates for alternative assumptions about the error variance, including one where the variances are estimated for two subsamples.
6. Examine residual plots for heteroskedasticity.
7. Test for heteroskedasticity using the Goldfeld–Quandt test.

11.7 Exercises

11.1 Reconsider the household expenditure model that appears in the text, and the data for which appear in Table 3.1. That is, we have the model

$$y_t = \beta_1 + \beta_2 x_t + e_t$$

where y_t is food expenditure for the *t*-th household and x_t is income. Find generalized least squares estimates for β_1 and β_2 under the assumptions
(a) $\text{var}(e_t) = \sigma^2\sqrt{x_t}$
(b) $\text{var}(e_t) = \sigma^2 x_t$
(c) $\text{var}(e_t) = \sigma^2 x_t^2$
(d) $\text{var}(e_t) = \sigma^2 \ln(x_t)$
Comment on the sensitivity of the estimates and their standard errors to the heteroskedastic specification. For each case, use the Goldfeld–Quandt test and the residuals from the transformed model to test to see whether heteroskedasticity has been eliminated. (Use a two-tailed test and a 10% significance level.)

11.2 In the file *pubexp.dat* there are data on public expenditure on education (*EE*), gross domestic product (*GDP*), and population (*P*) for thirty-four countries in the year 1980. These data are taken from Dougherty, C. (1992), *Introduction to Econometrics*, Oxford University Press. It is hypothesized that per capital expenditure on education is linearly related to per capita *GDP*. That is,

$$y_t = \beta_1 + \beta_2 x_t + e_t \qquad\qquad (11.7.1)$$

where $y_t = (EE_t/P_t)$ and $x_t = (GDP_t/P_t)$.

It is suspected that e_t may be heteroskedastic with a variance related to x_t.

(a) Why might the suspicion about heteroskedasticity be reasonable?

(b) Estimate (11.7.1) using least squares; plot the least squares function and the residuals. Is there any evidence of heteroskedasticity?

(c) Test for heteroskedasticity using the Goldfeld–Quandt test.

(d) Use White's formula for least squares variance estimates to find some alternative standard errors to those obtained in part (b). Use these standard errors and those obtained in part (b) to construct two alternative 95% confidence intervals for β_2. What can you say about the confidence interval that ignores the heteroskedasticity?

(e) Re-estimate the equation under the assumption that $var(e_t) = \sigma^2 x_t$. Report the results. Construct a 95% confidence interval for β_2. Comment on its width relative to those of the confidence intervals found in part (d).

11.3 In Chapter 9.7, firm investment (INV) was related to value of the firm (V) and the firm's capital stock (K) through the equation

$$INV_t = \beta_1 + \beta_2 V_t + \beta_3 K_t + e_t \qquad\qquad (11.7.2)$$

Table 9.3 contains data on these variables for two firms, General Electric and Westinghouse. You wish to examine whether the error variances for the two firms could be the same.

(a) Set up and estimate two investment equations, one for General Electric and one for Westinghouse. Test, at the 10% significance level, the null hypothesis of equal error variances against the alternative that the error variances are different.

(b) Assuming the error variances are different, but the coefficients are the same for each firm, pool the data from both firms and estimate the responses of investment to capital stock and value, using

(i) generalized least squares, and

(ii) least squares with White's variance estimator.

Compare the two sets of estimates and their standard errors.

11.4* This question is a continuation of Exercise 11.3. You wish to test whether the assumption of equal coefficients for each of the two firms is a reasonable one. One way to carry out this test is to set up the model with a dummy variable attached to each of the explanatory variables:

$$INV_t = \beta_1 + \delta_1 D_t + \beta_2 V_t + \delta_2 V_t D_t + \beta_3 K_t + \delta_3 K_t D_t + e_t$$
$$t = 1, 2, \ldots, 40 \qquad\qquad (11.7.3)$$

where $D_t = 0$ for the General Electric observations and $D_t = 1$ for the Westinghouse observations. The observations have been placed in a convenient stacked form in the file *tab9-3s.dat*. You wish to test the hypothesis $H_0: \delta_1 = \delta_2 = \delta_3 = 0$. This hypothesis was tested in Chapter 9.7, assuming the error variances for General Electric and Westinghouse were the same. If this assumption is not true, the test result from that section may be misleading.

(a) Carry out the test by estimating (11.7.3) using generalized least squares. How does your result compare with that in Section 9.7?

(b) In Chapters 8 and 9, you learned that hypotheses such as $H_0: \delta_1 = \delta_2 = \delta_3 = 0$ can be tested using an F-statistic calculated from restricted and unrestricted sums of squares; the formula is

$$F = \frac{(SSE_R - SSE_U)/J}{SSE_U/(T - K)}$$

(i) For the case where (11.7.3) is estimated using least squares, verify that $SSE_U = SSE_W + SSE_{GE}$ where SSE_W and SSE_{GE} are the sums of squared errors from separate estimation of the General Electric and Westinghouse equations.

(ii) For the case where (11.7.3) is estimated using generalized least squares, use the result in (i) to explain why

$$SSE_U = T - K = 34$$

Prove that the F-statistic becomes

$$F = (SSE_R - 34)/3 \tag{11.7.4}$$

(iii) Verify that (11.7.4) gives the same answer as that obtained by your computer in part (a).

11.5 Consider the following cost function. Assume that $\text{var}(e_{1t}) = \sigma^2 Q_{1t}$. Data are in the file *cloth.dat*. There are 28 observations.

$$C_{1t} = \beta_1 + \beta_2 Q_{1t} + \beta_3 Q_{1t}^2 + \beta_4 Q_{1t}^3 + e_{1t}$$

(a) Find generalized least squares estimates of β_1, β_2, β_3, and β_4.
(b) Test the hypothesis $\beta_1 = \beta_4 = 0$.
(c) What can you say about the nature of the average cost function if the hypothesis in (b) is true?
(d) Under what assumption about the error term would it be more appropriate to estimate the average cost function than the total cost function?

11.6* In the file *cloth.dat* there are 28 time-series observations on total cost (C) and output (Q) for two clothing manufacturing firms. It is hypothesized that both firms' cost functions are cubic and can be written as:

$$\text{firm 1}: C_{1t} = \beta_1 + \beta_2 Q_{1t} + \beta_3 Q_{1t}^2 + \beta_4 Q_{1t}^3 + e_{1t}$$
$$\text{firm 2}: C_{2t} = \gamma_1 + \gamma_2 Q_{2t} + \gamma_3 Q_{2t}^2 + \gamma_4 Q_{2t}^3 + e_{2t}$$

where

$$E(e_{1t}) = E(e_{2t}) = 0, \qquad \text{var}(e_{1t}) = \sigma_1^2, \qquad \text{var}(e_{2t}) = \sigma_2^2$$

and e_{1t} and e_{2t} are independent of each other and over time.

(a) Estimate each function using least squares. Report and comment on the results. Do the estimated coefficients have the expected signs?

(b) Test the hypothesis that $H_0: \sigma_1^2 = \sigma_2^2$ against the alternative that $H_1: \sigma_1^2 \neq \sigma_2^2$. Use a 10% significance level and note that this is a two-tailed test.

(c) Estimate both equations jointly, assuming that $\beta_1 = \gamma_1$, $\beta_2 = \gamma_2$, $\beta_3 = \gamma_3$, and $\beta_4 = \gamma_4$. Report and comment on the results.

(d) Test the hypothesis

$$H_0: \beta_1 = \gamma_1, \beta_2 = \gamma_2, \beta_3 = \gamma_3, \beta_4 = \gamma_4$$

against

$$H_1: \text{at least one of the equalities in } H_0 \text{ does not hold.}$$

Comment on the test outcome. (*Hint:* Look over Exercise 11.4(b).)

11.7 The file *foodus.dat* contains observations on food expenditure (y_t), income (x_t), and number of persons in each household (n_t) from a random sample of 38 households in a large U.S. city. Food expenditure and income are measured in terms of thousands of dollars. Consider the statistical model

$$y_t = \beta_1 + \beta_2 x_t + \beta_3 n_t + e_t \tag{11.7.5}$$

where the e_t are independent normal random errors with zero mean.

(a) Estimate (11.7.5) using least squares. Report and comment on the results.

(b) Plot the least squares residuals from (a) against (i) income x, and (ii) number of persons n. Do these plots suggest anything about the existence of heteroskedasticity?

(c) Use a Goldfeld–Quandt test to test for heteroskedasticity with the observations ordered (i) according to decreasing values of x_t and (ii) according to decreasing values of n_t. Comment on the outcomes.

(d) Based on results from using White's variance estimator, do you think the usual least squares results over- or underestimate the reliability of estimation of β_2 and β_3?

(e) Find generalized least squares estimates of (11.7.5) under the assumption that

$$\text{var}(e_t) = \sigma_t^2 = \sigma^2 \exp\{0.055x_t + 0.12n_t\}$$

Compare the estimates with those obtained using least squares. Does allowing for heteroskedasticity appear to have improved the precision of estimation?

11.8* Consider two regression models with error variances σ_1^2 and σ_2^2 and corresponding estimators $\hat{\sigma}_1^2$ and $\hat{\sigma}_2^2$. Suppose the first has T_1 observations and K_1 coefficients and the second T_2 observations and K_2 coefficients. Given that

$$V_1 = \frac{(T_1 - K_1)\hat{\sigma}_1^2}{\sigma_1^2} \sim \chi_{(T_1 - K_1)}^2, \quad V_2 = \frac{(T_2 - K_2)\hat{\sigma}_2^2}{\sigma_2^2} \sim \chi_{(T_2 - K_2)}^2$$

use the result in (8.1.4) to prove that when $\sigma_1^2 = \sigma_2^2$,

$$GQ = \frac{\hat{\sigma}_1^2}{\hat{\sigma}_2^2} \sim F_{(T_1 - K_1, T_2 - K_2)}$$

11.9 Consider the simple regression model

$$y_t = \beta_1 + \beta_2 x_t + e_t$$

where the e_t are independent errors with $E(e_t) = 0$ and $\text{var}(e_t) = \sigma^2 x_t^2$. Suppose that you have the following five observations

$$y = (4, 3, 1, 0, 2) \qquad x = (1, 2, 1, 3, 4)$$

Use a hand calculator to find generalized least squares estimates of β_1 and β_2.

11.10 A sample of 200 Chicago households was taken to investigate how far American households tend to travel when they take vacation. Measuring distance in miles per year, the following model was estimated

$$miles = \beta_1 + \beta_2 income + \beta_3 age + \beta_4 kids + e$$

The variables are self-explanatory except perhaps for *age* which is the average age of the adult members of the household. The data are in the file *vacation.dat* in the order (*miles, income, age, kids*).

(a) The equation was estimated by least squares and the residuals are plotted against age and income in Figure 11.4. What do these graphs suggest to you?

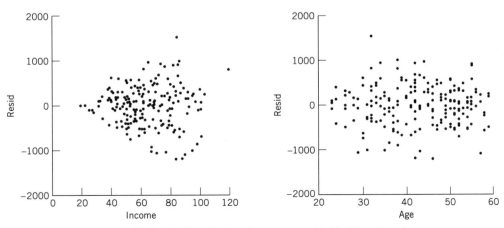

FIGURE **11.4** Residual plots for exercise 11.10: Vacation data.

(b) Ordering the observations according to descending values of *income*, and applying least squares to the first 100 observations, and again to the second 100 observations, yields the sums of squared errors

$$SSE_1 = 2.9471 \times 10^7 \qquad SSE_2 = 1.0479 \times 10^7$$

Use the Goldfeld–Quandt test to test for heteroskedastic errors. Include specifications of the null and alternative hypotheses.

(c) Table 11.2 contains three sets of estimates, those from least squares, those from least squares with White's standard errors, and those from generalized least squares under the assumption $\sigma_t^2 = \sigma^2 \times income$.

 (i) How do vacation miles traveled depend on income, age, and the number of kids in the household?

 (ii) How do White's standard errors compare with the least squares standard errors? Do they change your assessment of the precision of estimation?

 (iii) Is there evidence to suggest the generalized least squares estimates are better estimates?

11.11 In Exercise 7.8 an equation used for the valuation of homes in towns surrounding Boston was estimated. Re-estimating that equation with White's standard errors yields the output in Table 11.3.

(a) For the coefficients of CRIME, ROOMS, AGE, and TAX, compare 95% confidence intervals obtained using the standard errors from Exercise 7.8 with those from Table 11.3.

Table 11.2 **Estimates for Exercise 11.10: Vacation Model**

Least squares estimates

VARIABLE NAME	ESTIMATED COEFFICIENT	STANDARD ERROR	T-RATIO 196 DF
INCOME	14.201	1.800	7.889
AGE	15.741	3.757	4.189
KIDS	−81.826	27.13	−3.016
CONSTANT	−391.55	169.8	−2.306

Least squares estimates with White standard errors

VARIABLE NAME	ESTIMATED COEFFICIENT	STANDARD ERROR	T-RATIO 196 DF
INCOME	14.201	1.919	7.399
AGE	15.741	3.926	4.010
KIDS	−81.826	28.86	−2.835
CONSTANT	−391.55	141.2	−2.773

Generalized least squares estimates

VARIABLE NAME	ESTIMATED COEFFICIENT	STANDARD ERROR	T-RATIO 196 DF
INCOME	13.971	1.648	8.476
AGE	16.348	3.422	4.777
KIDS	−78.363	24.74	−3.168
CONSTANT	−408.37	145.7	−2.803

Table 11.3 **Boston House Value Equation for Exercise 11.11**

Dependent Variable: VALUE
Sample: 1 506
Included observations: 506
White Heteroskedasticity-Consistent Standard Errors & Covariance

Variable	Coefficient	Std. Error	t-Statistic	Prob.
C	28.40666	7.379962	3.849161	0.0001
CRIME	−0.183449	0.034722	−5.283319	0.0000
NITOX	−22.81088	4.359500	−5.232453	0.0000
ROOMS	6.371512	0.665493	9.574120	0.0000
AGE	−0.047750	0.010772	−4.432781	0.0000
DIST	−1.335269	0.190234	−7.019086	0.0000
ACCESS	0.272282	0.074714	3.644345	0.0003
TAX	−0.012592	0.002843	−4.429701	0.0000
PTRATIO	−1.176787	0.123589	−9.521782	0.0000

(b) Do you think heteroskedasticity is likely to be a problem?

(c) What misleading inferences are likely if the incorrect standard errors are used?

11.12 The observations for Exercises 7.8 and 11.11 appear in the file *ex7-8.dat*, with VALUE first and the remaining variables appearing in the same order as in Tables 7.8 and 11.3.

(a) Carry out two Goldfeld–Quandt tests, one after sorting the observations according to ROOMS and one after sorting the observations according to DIST. Specify null and alternative hypotheses in each case. Is there evidence of heteroskedasticity?

(b) Given that

$$\sigma_t^2 = \sigma^2 \exp(0.57 \times ROOMS - 0.15 \times DIST)$$

find generalized least squares estimates of the coefficients.

(c) Summarize the main differences between the generalized least squares estimates and those in Table 11.3.

Chapter *12*

Autocorrelation

12.1 The Nature of the Problem

In Chapters 3 through 9 we assumed that the errors (e_t) in the linear regression model were *uncorrelated* random variables with mean zero and a constant variance σ^2. The constant variance assumption, which implies the error variance is the same for each observation, was relaxed in Chapter 11. Now, it is time to relax the other main assumption about the error terms, the assumption that they are uncorrelated.

Cross-sectional data are often generated by way of a random sample of a number of economic units such as households or firms. The randomness of the sample implies that the error terms for different observations (households or firms) will be uncorrelated. However, when we have time-series data, where the observations follow a natural ordering through time, there is always a possibility that successive errors will be correlated with each other. To see how such correlation might arise, suppose that we have an equation that relates the aggregate demand for money in the economy to a number of explanatory variables. Any policy shock that occurs will have an impact on money demanded through the error term. Also, a shock usually takes several periods to work through the system. This means that, in any one period, the current error term contains not only the effects of current shocks but also the carryover from previous shocks. This carryover will be related to, or *correlated with*, the effects of the earlier shocks. When circumstances such as these lead to error terms that are correlated, we say that **autocorrelation** exists. The possibility of autocorrelation should always be entertained when we are dealing with time-series data. How we check for autocorrelation and how to take the appropriate course of action when it exists are the subjects of this chapter.

Before we turn to a specific example to illustrate the nature of the autocorrelation problem and how to solve it, it is useful to be more explicit about which assumption we are relaxing. Suppose we have a linear regression model with two explanatory variables. That is,

$$y_t = \beta_1 + \beta_2 x_{t2} + \beta_3 x_{t3} + e_t \tag{12.1.1}$$

The error term assumptions utilized in Chapters 3 through 9 are

$$E(e_t) = 0, \qquad \text{var}(e_t) = \sigma^2 \tag{12.1.2a}$$

$$\text{cov}(e_t, e_s) = 0 \quad \text{for } t \neq s \tag{12.1.2b}$$

Of interest now is relaxing the zero covariance assumption in (12.1.2b). When (12.1.2b) does not hold, we say that the random errors e_t are autocorrelated.

12.1.1 AREA RESPONSE MODEL FOR SUGAR CANE

One way of modeling supply response for an agricultural crop is to specify a model in which area planted (acres) depends on price. When the price of the crop's output is high, farmers plant more of that crop than when its price is low. Letting A denote area planted, and P denote output price, and assuming a log–log (constant elasticity) functional form, an area response model of this type can be written as

$$\ln(A) = \beta_1 + \beta_2 \ln(P) \tag{12.1.3}$$

As an example of a situation where autocorrelated errors exist, we use the model in (12.1.3) to explain the area of sugar cane planted in a region of Bangladesh, a country in the southern part of Asia. Information on the area elasticity β_2 is useful for government planning. It is important to know whether existing sugar processing mills are likely to be able to handle predicted output, whether there is likely to be excess milling capacity, and whether a pricing policy linking production, processing, and consumption is desirable.

Data comprising 34 annual observations on area and price are given in Table 12.1. After we specify an econometric model corresponding to (12.1.3), our task is to use these data to estimate the parameters β_1 and β_2. The econometric model is obtained by using the subscript t to describe area and price in year t, and adding a random error term e_t. Thus, we have

$$\ln(A_t) = \beta_1 + \beta_2 \ln(P_t) + e_t \tag{12.1.4}$$

In line with our earlier notation, we can write this equation as

Table 12.1 **Data for Area Response for Sugar Cane in Bangladesh**

Area	Price of Sugar Cane	Area	Price of Sugar Cane
29	0.075258	91	0.205394
71	0.114894	121	0.267396
42	0.101075	162	0.230411
90	0.110309	143	0.368771
72	0.109562	138	0.285076
57	0.132486	230	0.360332
44	0.141783	128	0.322976
61	0.209559	87	0.301266
60	0.188259	124	0.287834
70	0.195946	97	0.401437
88	0.226087	152	0.404692
80	0.145585	197	0.353188
125	0.194030	220	0.410233
232	0.270362	171	0.360418
125	0.235821	208	0.463087
99	0.220826	237	0.401582
250	0.380952	235	0.391660

$$y_t = \beta_1 + \beta_2 x_t + e_t \qquad (12.1.5)$$

where

$$y_t = \ln(A_t) \quad \text{and} \quad x_t = \ln(P_t) \qquad (12.1.6)$$

12.1.1a Least Squares Estimation

Given our previous experience with least squares estimation, our first natural strategy for estimating (12.1.5) is to apply the least squares rule. In so doing, we are assuming, initially at least, that the statistical assumptions in (12.1.2a) and (12.1.2b) hold; there is no heteroskedasticity or autocorrelation. Application of least squares yields the following estimated equation.

$$\hat{y}_t = \underset{(0.169)}{6.111} + \underset{(0.111)}{0.971} x_t \quad R^2 = 0.706$$
$$\text{(std. errors)} \qquad (R12.1)$$

The results indicate that both coefficients are significantly different from 0, and suggest that the elasticity of area response to price is approximately 1.

Suppose now that we wish to investigate whether autocorrelation might be a problem. After all, we have time-series data, and we have been warned that such a problem may exist. It is likely that farmers' decisions about area of sugar cane planted will depend on their perceptions about future prices, and about government policies on prices and the establishment of processing mills. Since variables for these perceptions are not explicitly included in the model, their effect on area planted will be felt through the error term e_t. Also, if perceptions change slowly over time, or at least not in a completely random manner, the e_t will be correlated over time.

Later in the chapter we introduce a specific test, called the Durbin–Watson test, that we can use to test for the existence of autocorrelation. For the time being, let us examine the least squares residuals (\hat{e}_t) to see if they can tell us anything about the nature of autocorrelation. The \hat{e}_t are likely to have characteristics that are similar to those of the errors (e_t) and they could give us an indication of what to expect when the assumption $\text{cov}(e_t, e_s) = 0$ is violated.

The least squares residuals appear in Table 12.2 and are plotted against time in Figure 12.1.

Table 12.2 Least Squares Residuals for the Sugar Cane Example

Time	\hat{e}_1	Time	\hat{e}_t	Time	\hat{e}_t	Time	\hat{e}_t
1	−0.233	10	−0.281	19	−0.035	27	−0.651
2	0.251	11	−0.191	20	0.401	28	−0.209
3	−0.149	12	0.141	21	−0.180	29	0.182
4	0.528	13	0.308	22	0.034	30	0.147
5	0.312	14	0.605	23	0.317	31	0.021
6	−0.106	15	0.119	24	−0.162	32	−0.027
7	−0.431	16	−0.050	25	−0.481	33	0.242
8	−0.484	17	0.347	26	−0.082	34	0.258
9	−0.396	18	−0.064				

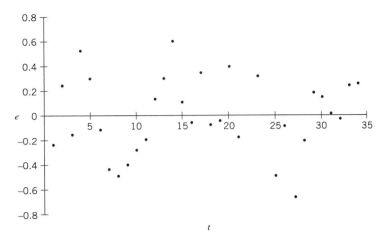

FIGURE *12.1* Least squares residuals plotted against time.

From both the table and the figure we can see that there is a tendency for negative residuals to follow negative residuals and for positive residuals to follow positive residuals. There is a long run of negative residuals from observation 6 to observation 11, followed by a run of positive residuals from observation 12 to observation 15. Similarly, the residuals from observation 24 to observation 28 are all negative, while those from observation 29 to observation 34 are all positive (except for a small negative value at observation 32). This kind of behavior is consistent with an assumption of positive correlation between successive residuals. With uncorrelated errors, we would not expect to see any particular pattern. If the errors are negatively autocorrelated, we would expect the residuals to show a tendency to oscillate in sign.

When attempting to detect autocorrelation, we can examine the least squares residuals as we have done for the sugar cane example. However, any conclusions from such an examination will be subjective, because we will need to decide "how long" a long run of residuals with the same sign needs to be before we conclude it is caused by autocorrelation. An objective assessment can be carried out using a formal hypothesis test. Two such tests, the Durbin–Watson test and a Lagrange multiplier test are considered later in this chapter. Our next task is to suggest a way to model autocorrelation.

12.2 First-Order Autoregressive Errors

Given the likely existence of correlated errors, the next question is: How should we take this correlation into account when constructing an econometric model? If the assumption $\text{cov}(e_t, e_s) = 0$ is no longer valid, what alternative assumption can we use to replace it? Is there some way to describe how the e_t are correlated? If we are going to allow for autocorrelation when estimating β_1 and β_2, then we need some way to represent it. There are a number of models that can be used to represent correlated errors. By far the most common is what is known as a first-order autoregressive model or, more simply, an AR(1) model. In this model e_t depends on its lagged value e_{t-1} plus another random component that is uncorrelated over

time and has zero mean and constant variance. That is,

$$e_t = \rho e_{t-1} + v_t \tag{12.2.1}$$

where ρ (rho) is a parameter that determines the correlation properties of e_t, and the v_t are uncorrelated random variables with a constant variance σ_v^2. Thus, v_t has the statistical properties that we assumed about e_t in the earlier chapters.

$$E(v_t) = 0, \qquad \text{var}(v_t) = \sigma_v^2, \qquad \text{cov}(v_t, v_s) = 0 \quad t \neq s \tag{12.2.2}$$

The rationale for the autoregressive model in (12.2.1) is a simple one. The random component e_t in time period t is composed of two parts: (i) ρe_{t-1} is a carryover from the random error in the previous period, due to the inertia in economic systems, with the magnitude of the parameter ρ determining how much carryover there is, and (ii) v_t is a "new" shock to the level of the economic variable. In our example, the "carry-over" might be farmers' perceptions of government policies on pricing and the establishment of mills. A new shock could be the announcement of a new policy or information on sugar cane shortages or excesses. The autoregressive model asserts that shocks to an economic variable do not work themselves out in one period. The parameter ρ in (12.2.1) is the autoregressive parameter that determines how quickly the effect of a shock dissipates. The larger the magnitude of ρ, the greater the carryover from one period to another and the more slowly the shock spreads over time.

12.2.1 PROPERTIES OF AN AR(1) ERROR

Our next task is to examine the implications of the AR(1) error model in (12.2.1) and (12.2.2) for the properties (mean, variance, and correlations) of the e_t. For the e_t to have properties that do not change from year to year, we assume that ρ is less than one in absolute value. That is,

$$-1 < \rho < 1 \tag{12.2.3}$$

If we did not make this assumption, then, through the relationship $e_t = \rho e_{t-1} + v_t$, the e_t would tend to become larger and larger through time, eventually becoming infinite, which is not consistent with our experience.

It can be shown that the mean, variance and the covariances of the e_t are:

1.
$$E(e_t) = 0 \tag{12.2.4}$$

When the equation errors follow an AR(1) model, they continue to have a zero mean.

2.
$$\text{var}(e_t) = \sigma_e^2 = \frac{\sigma_v^2}{1 - \rho^2} \tag{12.2.5}$$

This equation describes the relationship between the variance (σ_e^2) of the original equation error e_t and the variance (σ_v^2) of the uncorrelated homoskedastic error v_t. Because σ_e^2 does not change over time, the error e_t is also homoskedastic.

3. $$\text{cov}(e_t, e_{t-k}) = \sigma_e^2 \rho^k \quad k > 0 \qquad (12.2.6)$$

This equation is our replacement for the zero-correlation assumption $\text{cov}(e_t, e_s) = 0$. The symbol k is used to represent the time between errors. The expression says that the covariance between two errors that are k periods apart depends on the variance σ_e^2, and on the parameter ρ raised to the power k.

To describe the correlation behavior implied by the covariance in (12.2.6), we use (2.5.4) from Chapter 2. In terms of our quantities of interest, the correlation between two errors, k periods apart, is

$$\text{corr}(e_t, e_{t-k}) = \frac{\text{cov}(e_t, e_{t-k})}{\sqrt{\text{var}(e_t)\text{var}(e_{t-k})}}$$

$$= \frac{\sigma_e^2 \rho^k}{\sqrt{\sigma_e^2 \sigma_e^2}} = \rho^k \qquad (12.2.7)$$

An interpretation or definition of the unknown parameter ρ can be obtained by setting $k = 1$. Specifically,

$$\text{corr}(e_t, e_{t-1}) = \rho \qquad (12.2.8)$$

Thus, ρ represents the correlation between two errors that are one period apart; it is sometimes called the autocorrelation coefficient.

Also from (12.2.7), we can consider the sequence of correlations between errors as those errors become further apart in time. Considering one period apart, two periods apart, three periods apart, and so on, we obtain the sequence

$$\rho, \rho^2, \rho^3, \ldots$$

Since $-1 < \rho < 1$, the values in this sequence are declining. The greatest correlation between errors is for those that are one period apart; as the errors become further apart, the correlation between them becomes smaller and smaller. This characteristic of an AR(1) error model is one that seems reasonable for many economic phenomena.

12.3 Consequences for the Least Squares Estimator

Given the existence of autocorrelated errors, we need to ask about the consequences for least squares estimation. If we have an equation whose errors exhibit autocorrelation, but we ignore it, or are simply unaware of it, what impact does it have on the properties of least squares estimates? The consequences are essentially the same as those of heteroskedasticity.

1. The least squares estimator is still a linear unbiased estimator, but it is no longer best.
2. The formulas for the standard errors usually computed for the least squares estimator are no longer correct, and hence, confidence intervals and hypothesis tests that use these standard errors may be misleading.

We can illustrate these facts using results from Chapter 4. If you would prefer to avoid this illustration, do the kangaroo trick; skip the marked text.

In Chapter 4, for the simple regression model $y_t = \beta_1 + \beta_2 x_t + e_t$, we wrote the least squares estimator for β_2 as

$$b_2 = \beta_2 + \sum w_t e_t \qquad (12.3.1)$$

where

$$w_t = \frac{(x_t - \bar{x})}{\sum (x_t - \bar{x})^2} \qquad (12.3.2)$$

We can prove b_2 is still an unbiased estimator for β_2 under autocorrelation by showing that

$$E(b_2) = \beta_2 + \sum w_t E(e_t) = \beta_2 \qquad (12.3.3)$$

For the variance of b_2 we have

$$\text{var}(b_2) = \sum w_t^2 \, \text{var}(e_t) + \sum_{i \neq j} \sum w_i w_j \, \text{cov}(e_i, e_j)$$

$$= \sigma_e^2 \sum w_t^2 + \sigma_e^2 \sum_{i \neq j} \sum w_i w_j \rho^k \qquad \text{(where } k = |i - j|\text{)}$$

$$= \frac{\sigma_e^2}{\sum (x_t - \bar{x})^2} \left(1 + \frac{1}{\sum (x_t - \bar{x})^2} \sum_{i \neq j} \sum (x_i - \bar{x})(x_j - \bar{x})\rho^k \right)$$

$$(12.3.4)$$

When we were proving that $\text{var}(b_2) = \sigma_e^2 / \sum (x_t - \bar{x})^2$ in the absence of auto-correlation, the terms $\text{cov}(e_i, e_j)$ were all zero. This simplification no longer holds. From (12.3.4) we see that the variance of the least squares estimator for β_2 under autocorrelation is equal to the variance of the least squares estimator in the absence of autocorrelation, multiplied by another factor that depends on the explanatory variable and ρ. Thus, ignoring autocorrelation can lead to a misleading estimate of $\text{var}(b_2)$; this has consequences for interval estimates and hypothesis tests.

To give an idea of how least squares standard errors can lead to incorrect interval estimates, we return to least squares estimation of the sugar cane example. Given estimates for ρ and σ_e^2, it is possible to use a computer to calculate an estimate for $\text{var}(b_2)$ from (12.3.4). A similar estimate for $\text{var}(b_1)$ can also be obtained. How to estimate ρ and σ_e^2, in a manner that is consistent with the autocorrelation assumptions in (12.2.4) to (12.2.6) is covered later in this chapter. Suppose, for the moment, that we have such

estimates, and that we have used them to estimate $\text{var}(b_1)$ and $\text{var}(b_2)$. The square roots of these quantities we can call *correct* standard errors, while those we calculated with our least squares estimates and reported in (12.1.7) we call *incorrect*. The two sets of standard errors, along with the estimated equation, are:

$$\hat{y}_t = 6.111 + 0.971x_t$$
$$(0.169) \quad (0.111) \text{ "incorrect" se}$$
$$(0.226) \quad (0.147) \text{ "correct" se} \qquad (R12.2)$$

Note that the correct standard errors are larger than the incorrect ones. If we ignored the autocorrelation, we would tend to overstate the reliability of the least squares estimates. The confidence intervals would be narrower than they should be. For example, using $t_c = 2.037$, we find the following 95% confidence intervals for β_2:

$$(0.745, 1.197) \quad \text{(incorrect)}$$
$$(0.672, 1.269) \quad \text{(correct)} \qquad (R12.3)$$

If we are unaware of the autocorrelation, we estimate that the elasticity of area response lies between 0.745 and 1.197. In reality, the reliability of least squares estimation is such that the interval estimate should be from 0.672 to 1.269. Although autocorrelation can lead to either overstatement or understatement of the reliability of the least squares estimates, understatement of reliability, as illustrated in this example, is the most common occurrence.

12.4 Generalized Least Squares

In practice, after autocorrelation has been diagnosed, it is *not* common to stick with our least squares estimates and to simply look for better estimates of the standard errors. We did follow this strategy in the previous section. However, our purpose there was to illustrate the dangers of using least-squares standard errors, not to describe what is common practice. The more usual strategy is to employ a better estimation procedure, namely, generalized least squares. Generalized least squares tends to give us narrower, more informative, confidence intervals than the "correct" ones from least squares.

In Chapter 11 we discovered that the generalized least squares estimator for a heteroskedastic error model can be computed by transforming the model so that it has a new, uncorrelated homoskedastic error term, and by applying least squares to the transformed model. We can pursue this same kind of approach when autocorrelation exists.

12.4.1 A TRANSFORMATION

Our objective is to transform the model in (12.1.5)

$$y_t = \beta_1 + \beta_2 x_t + e_t \qquad (12.4.1)$$

so that the autocorrelated error e_t is replaced by the uncorrelated error v_t, without

altering the basic structure of the model. The relationship between e_t and v_t is given by

$$e_t = \rho e_{t-1} + v_t \tag{12.4.2}$$

and the properties of e_t and v_t were outlined in (12.2.2) through (12.2.6). Substituting (12.4.2) into (12.4.1) yields

$$y_t = \beta_1 + \beta_2 x_t + \rho e_{t-1} + v_t \tag{12.4.3}$$

We have eliminated e_t from the equation, but it still contains e_{t-1}. To substitute out e_{t-1}, we note that (12.4.1) holds for every single observation. In particular, in terms of the previous period we can write

$$e_{t-1} = y_{t-1} - \beta_1 - \beta_2 x_{t-1} \tag{12.4.4}$$

Multiplying (12.4.4) by ρ yields

$$\rho e_{t-1} = \rho y_{t-1} - \rho \beta_1 - \rho \beta_2 x_{t-1} \tag{12.4.5}$$

Substituting (12.4.5) into (12.4.3) yields

$$y_t = \beta_1 + \beta_2 x_t + \rho y_{t-1} - \rho \beta_1 - \rho \beta_2 x_{t-1} + v_t$$

or, after rearranging,

$$y_t - \rho y_{t-1} = \beta_1(1 - \rho) + \beta_2(x_t - \rho x_{t-1}) + v_t \tag{12.4.6}$$

This is the transformed equation that we seek. The transformed dependent variable is

$$y_t^* = y_t - \rho y_{t-1} \quad t = 2, 3, \ldots, T \tag{12.4.7a}$$

The transformed explanatory variable is

$$x_{t2}^* = x_t - \rho x_{t-1} \quad t = 2, 3, \ldots, T \tag{12.4.7b}$$

and the new constant term is

$$x_{t1}^* = 1 - \rho \quad t = 2, 3, \ldots, T. \tag{12.4.7c}$$

Making these substitutions we have

$$y_t^* = x_{t1}^* \beta_1 + x_{t2}^* \beta_2 + v_t \tag{12.4.8}$$

Thus, we have formed a new statistical model with transformed variables y_t^*, x_{t1}^*, and x_{t2}^* and, *importantly*, with an error term that is *not* the correlated e_t, but the uncorrelated v_t that we have assumed to be distributed $(0, \sigma_v^2)$. We would expect

application of least squares to (12.4.8) to yield a best linear unbiased estimator for β_1 and β_2. here are two additional problems that we need to solve, however:

1. Because lagged values of y_t and x_t had to be formed, only $(T-1)$ new observations were created by the transformation in (12.4.7). We have values $(y_t^*, x_{t1}^*, x_{t2}^*)$ for $t = 2, 3, \ldots, T$. But, we have no $(y_1^*, x_{11}^*, x_{12}^*)$.

2. The value of the autoregressive parameter ρ is not known. Since y_t^*, x_{t1}^* and x_{t2}^* depend on ρ, we cannot compute these transformed observations without estimating ρ.

12.4.1a Transforming the First Observation

One way of tackling the problem of having $(T-1)$ instead of T transformed observations is to ignore the problem, and to proceed with estimation on the basis of the $(T-1)$ observations. If T is large, this strategy might be a reasonable one. However, the resulting estimator is not the best linear unbiased generalized least squares estimator. To get the generalized least squares estimator we need to transform the first observation so that its transformed error has the same variance as the errors (v_2, v_3, \ldots, v_T).

The first observation in the regression model is

$$y_1 = \beta_1 + x_1\beta_2 + e_1 \tag{12.4.9}$$

with error variance $\mathrm{var}(e_1) = \sigma_e^2 = \sigma_v^2/(1 - \rho^2)$. The transformation that yields an error variance of σ_v^2 is multiplication by $\sqrt{1 - \rho^2}$. The result is

$$\sqrt{1 - \rho^2}\,y_1 = \sqrt{1 - \rho^2}\,\beta_1 + \sqrt{1 - \rho^2}\,x_1\beta_2 + \sqrt{1 - \rho^2}\,e_1 \tag{12.4.10}$$

or

$$y_1^* = x_{11}^*\beta_1 + x_{12}^*\beta_2 + e_1^* \tag{12.4.11a}$$

where

$$y_1^* = \sqrt{1 - \rho^2}\,y_1 \quad x_{11}^* = \sqrt{1 - \rho^2}$$
$$x_{12}^* = \sqrt{1 - \rho^2}\,x_1 \quad e_1^* = \sqrt{1 - \rho^2}\,e_1 \tag{12.4.11b}$$

To confirm that the variance of e_1^* is the same as that of the errors $(v_2, v_3, \ldots v_T)$, note that

$$\mathrm{var}(e_1^*) = (1 - \rho^2)\mathrm{var}(e_1) = (1 - \rho^2)\,\frac{\sigma_v^2}{1 - \rho^2} = \sigma_v^2$$

To be able to use the first transformed observation in (12.4.11*b*), we also require

that e_1^* be uncorrelated with (v_2, v_3, \ldots, v_T). This result will hold because each of the v_t does not depend on any past values for e_t.

> **REMARK:** We can summarize these results by saying that, *providing ρ is known*, we can find the best linear unbiased estimator for β_1 and β_2 by applying least squares to the transformed model
>
> $$y_t^* = \beta_1 x_{t1}^* + \beta_2 x_{t2}^* + v_t \qquad (12.4.12)$$
>
> where the transformed variables are defined by
>
> $$y_1^* = \sqrt{1 - \rho^2}\, y_1, \qquad x_{11}^* = \sqrt{1 - \rho^2}, \qquad x_{12}^* = \sqrt{1 - \rho^2}\, x_1$$
>
> for the first observation, and
>
> $$y_t^* = y_t - \rho y_{t-1}, \qquad x_{t1}^* = 1 - \rho, \qquad x_{t2}^* = x_t - \rho x_{t-1}$$
>
> for the remaining $t = 2, 3, \ldots, T$ observations.

All the procedures you have learned for testing hypotheses and constructing interval estimates hold, providing you use transformed variables rather than original variables to do your calculations. One caveat to this statement is that the interpretation of R^2 no longer holds in the usual way and its use should probably be avoided in econometric models with correlated errors. When you study econometrics at a more advanced level you will learn alternative ways of calculating summary goodness-of-fit statistics for this and similar models.

12.5 Implementing Generalized Least Squares

The remaining problem is the fact that the transformed variables y_t^*, x_{t1}^*, and x_{t2}^* cannot be calculated without knowledge of the parameter ρ. We overcome this problem by using instead an estimate of ρ. As a method for estimating ρ consider the equation

$$e_t = \rho e_{t-1} + v_t \qquad (12.5.1)$$

If the e_t values were observable, we could treat this equation as a linear regression model and estimate ρ by least squares. However, the e_t are not observable because they depend on the unknown parameters β_1 and β_2 through the equation

$$e_t = y_t - \beta_1 - \beta_2 x_t \qquad (12.5.2)$$

As an approximation to the e_t we use instead the least squares residuals

$$\hat{e}_t = y_t - b_1 - b_2 x_t \qquad (12.5.3)$$

where b_1 and b_2 are the least squares estimates from the untransformed model. Substituting the \hat{e}_t for the e_t in (12.5.1) is justified, providing that the sample size

T is large. Making this substitution yields the model

$$\hat{e}_t = \rho\hat{e}_{t-1} + \hat{v}_t \tag{12.5.4}$$

The least squares estimator of ρ from (12.5.4) is given by

$$\hat{\rho} = \frac{\displaystyle\sum_{t=2}^{T} \hat{e}_t\hat{e}_{t-1}}{\displaystyle\sum_{t=2}^{T} \hat{e}_{t-1}^2} \tag{12.5.5}$$

Thus, in practice, the transformed data that are defined below (12.4.12) are computed using the estimated value of $\hat{\rho}$ from (12.5.5). The estimator for β_1 and β_2 that uses $\hat{\rho}$ instead of the true value ρ has good properties if the sample size is large. If the sample is not large, then great care must be taken when making claims about the results of hypothesis tests and interval estimations, so as not to overstate the importance of the results obtained.

12.5.1 THE SUGAR CANE EXAMPLE REVISITED

In Sections 12.1 and 12.3 we obtained least squares estimates of the coefficients in the sugar-cane area response model. We saw how the least squares residuals tend to exhibit autocorrelation and how misleading interval estimates can arise from using incorrect least squares standard errors. We are now in a position to use the least squares residuals that were displayed in Figure 12.1 and Table 12.2 to estimate ρ and to use this estimate in a generalized least squares estimator for β_1 and β_2. Specifically, we obtain

$$\hat{\rho} = \frac{\displaystyle\sum_{t=2}^{T} \hat{e}_t\hat{e}_{t-1}}{\displaystyle\sum_{t=2}^{T} \hat{e}_{t-1}^2} = 0.342 \tag{R12.4}$$

The next step toward finding generalized least squares estimates is to transform the data as shown below (12.4.12). To illustrate, we give the first 4 observations in Table 12.3. As examples, note that

Table 12.3 **The First Four Transformed and Untransformed Observations**

	x_{t1}^*	x_t	x_{t2}^*	y_t	y_t^*
1	0.93970	−2.5868	−2.4308	3.3673	3.1642
2	0.65799	−2.1637	−1.2790	4.2627	3.1110
3	0.65799	−2.2919	−1.5519	3.7377	2.2798
4	0.65799	−2.2045	−1.4206	4.4998	3.2215

$$y_1^* = \sqrt{1 - \hat{\rho}^2}y_1$$
$$= \sqrt{1 - 0.342^2}(3.3673)$$
$$= 3.1642 \tag{R12.5}$$

and

$$x_{32}^* = x_{32} - \hat{\rho}x_{22}$$
$$= -2.2919 - (0.342)(-2.1637)$$
$$= -1.5519 \tag{R12.6}$$

You are encouraged to verify some of the other entries. Computations such as these are usually done automatically on the computer, but nevertheless, it is instructive to understand their nature.

Applying least squares to all transformed observations yields the generalized least squares estimated model

$$\ln(\hat{A}_t) = 6.164 + 1.007\ln(P_t) \tag{R12.7}$$
$$(0.213) \quad (0.137)$$

These estimates are similar, but not exactly the same as the least squares estimates ($b_1 = 6.111$, $b_2 = 0.971$). A comparison of the standard errors with those obtained in Chapter 12.3 is given in Table 12.4. Note that the GLS standard errors are less than the "correct LS" ones, reflecting the increased precision of GLS estimates. Also, an ill-informed comparison of the GLS estimates with the "incorrect LS" ones may lead to the erroneous conclusion that LS estimates are more precise.

> **REMARK:** Software packages automatically estimate ρ, transform the variables, and obtain generalized least squares estimates, without you having to do each step separately. Also, we have considered just one of a number of alternative methods for estimating ρ. Your software package is likely to have options for some of these alternative methods. One alternative is to use the generalized least squares estimated equation to get another set of residuals, use these residuals to re-estimate ρ, re-apply generalized least squares to get new estimates of β_1 and β_2, and so on until there is no change in the estimates. This estimator is often called an *iterative* generalized least squares estimator. Because different software packages often use different estimators, you might find a slight variation in the results from one package to the next.

Table 12.4 Different Standard Errors

	Standard Errors for Estimators	
	β_1	β_2
GLS	0.213	0.137
Incorrect LS	0.169	0.111
Correct LS	0.226	0.147

12.6 **Testing for Autocorrelation**

So far in this chapter we have described the nature of an autocorrelated error term, and how to estimate the parameters β_1 and β_2 in the presence of an autocorrelated error. We have not yet indicated how to detect the presence of autocorrelation. Clearly, such detection is vital. If autocorrelation does not exist, then there is no need to estimate ρ and to then proceed with estimating β_1 and β_2 using transformed data; least squares applied to the original data will be adequate. On the other hand, if autocorrelation is present, we need to implement the procedures we have described in this chapter. In Section 12.1 we illustrated how positively autocorrelated least squares residuals tend to appear in runs of positive and runs of negative values. Thus, looking for runs in the least squares residuals gives some indication of whether autocorrelation is likely to be a problem. We do, however, need a more objective procedure than "just looking." Two tests will be considered, the Durbin–Watson test and a Lagrange multiplier test.

12.6.1 THE DURBIN–WATSON TEST

This test is named after its inventors, Durbin and Watson, who derived it way back in 1950. It remains one of the most important tests for testing for autocorrelation. To introduce it, consider again the linear regression model

$$y_t = \beta_1 + \beta_2 x_t + e_t \tag{12.6.1}$$

where the errors may follow the first-order autoregressive model

$$e_t = \rho e_{t-1} + v_t \tag{12.6.2}$$

It is assumed that the v_t are independent random errors with distribution $N(0, \sigma_v^2)$. The assumption of *normally* distributed random errors is needed to derive the probability distribution of the test statistic used in the Durbin–Watson test.

Note that if $\rho = 0$, then $e_t = v_t$, and so the errors in (12.6.1) will not be autocorrelated. Thus, for a null hypothesis of no autocorrelation, we can use $H_0: \rho = 0$. For an alternative hypothesis we could use $H_1: \rho > 0$ or $H_1: \rho < 0$ or $H_1: \rho \neq 0$. We will choose $H_1: \rho > 0$; in most empirical applications in economics, positive autocorrelation is the most likely form that autocorrelation will take. Thus, we consider testing

$$H_0: \rho = 0 \text{ against } H_1: \rho > 0 \tag{12.6.3}$$

To test the null hypothesis it seems natural to compute $\hat{\rho}$ and to investigate whether this estimate is significantly greater than zero. However, derivation of the exact probability distribution of $\hat{\rho}$ is difficult. As an alternative, Durbin and Watson chose a different but closely related statistic whose probability distribution can be derived. Their statistic is

$$d = \frac{\sum\limits_{t=2}^{T} (\hat{e}_t - \hat{e}_{t-1})^2}{\sum\limits_{t=1}^{T} \hat{e}_t^2} \tag{12.6.4}$$

where the \hat{e}_t are the least squares residuals $\hat{e}_t = y_t - b_1 - b_2 x_t$. To see why d is closely related to $\hat{\rho}$, and is a reasonable statistic for testing for autocorrelation, we expand (12.6.4) as

$$d = \frac{\displaystyle\sum_{t=2}^{T} \hat{e}_t^2 + \sum_{t=2}^{T} \hat{e}_{t-1}^2 - 2 \sum_{t=2}^{T} \hat{e}_t \hat{e}_{t-1}}{\displaystyle\sum_{t=1}^{T} \hat{e}_t^2}$$

$$= \frac{\displaystyle\sum_{t=2}^{T} \hat{e}_t^2}{\displaystyle\sum_{t=1}^{T} \hat{e}_t^2} + \frac{\displaystyle\sum_{t=2}^{T} \hat{e}_{t-1}^2}{\displaystyle\sum_{t=1}^{T} \hat{e}_t^2} - 2 \frac{\displaystyle\sum_{t=2}^{T} \hat{e}_t \hat{e}_{t-1}}{\displaystyle\sum_{t=1}^{T} \hat{e}_t^2}$$

$$\approx 1 + 1 - 2\hat{\rho} \qquad\qquad\qquad (12.6.5)$$

The last line in (12.6.5) holds only approximately. The first two terms differ from the number one through the exclusion of \hat{e}_1^2 and \hat{e}_T^2 from the first and second numerator summations, respectively. The last term differs from $2\hat{\rho}$ through the inclusion of \hat{e}_T^2 in the denominator summation. Thus, we have

$$d \approx 2(1 - \hat{\rho}) \qquad\qquad\qquad (12.6.6)$$

If the estimated value of $\rho = 0$, then the Durbin–Watson statistic $d \approx 2$, which is taken as an indication that the model errors are not autocorrelated. If the estimate of ρ happened to be $\hat{\rho} = 1$ then $d \approx 0$, and thus a low value for the Durbin–Watson statistic implies that the model errors are correlated, and $\rho > 0$.

The question we need to answer is: How close to zero does the value of the test statistic have to be before we conclude that the errors are correlated? In other words, what is a critical value d_c such that we reject H_0 when $d \leq d_c$?

Following the discussion in Chapter 5.2, determination of a critical value and a rejection region for the test requires knowledge of the probability distribution of the test statistic under the assumption that the null hypothesis, H_0: $\rho = 0$, is true. If a 5% significance level is required, knowledge of the probability distribution $f(d)$ under H_0 allows us to find d_c such that $P(d \leq d_c) = 0.05$. Then, as illustrated in Figure 12.2, we reject H_0 if $d \leq d_c$ and fail to reject H_0 if $d > d_c$. Alternatively, we can state the test procedure in terms of the p-value of the test. For this one-tail test, the p-value is given by the area under $f(d)$ to the left of the calculated value of d. Thus, if the p-value is less than or equal to 0.05, it follows that $d \leq d_c$, and H_0 is rejected. If the p-value is greater than 0.05, then $d > d_c$, and H_0 is accepted. (If this use of the p-value is not clear, it would be a good idea to review Chapter 5.2.)

In any event, whether the test result is found by comparing d with d_c, or by computing the p-value, the probability distribution $f(d)$ is required. A difficulty associated with $f(d)$, and one that we have not previously encountered when using other test statistics, is that this probability distribution depends on the values of the explanatory variables. Different sets of explanatory variables lead to different distributions for d. Because $f(d)$ depends on the values of the explanatory variables,

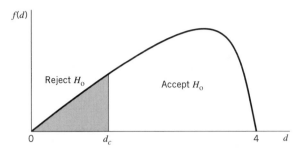

FIGURE **12.2** Testing for positive autocorrelation.

the critical value d_c for any given problem will also depend on the values of the explanatory variables. This property means that it is impossible to tabulate critical values that can be used for every possible problem. With other test statistics, such as t, F, and χ^2, the tabulated critical values are relevant for all models.

There are two ways to overcome this problem. The first way is to use software that computes the p-value for the explanatory variables in the model under consideration. (SHAZAM and SAS are examples of software that can perform this task.) Instead of comparing the calculated d value with some tabulated values of d_c, we get our computer to calculate the p-value of the test. If this p-value is less than the specified significance level, H_0: $\rho = 0$ is rejected and we conclude that autocorrelation does exist.

In the sugar cane area response model the calculated value for the Durbin–Watson statistic is $d = 1.291$. Is this value sufficiently close to zero (or sufficiently less than 2), to reject H_0 and conclude that autocorrelation exists? Using SHAZAM, we find that

$$p\text{-value} = P(d \le 1.291) = 0.0098 \tag{R12.8}$$

This value is much less than a conventional 0.05 significance level; we conclude, therefore, that the equation's error is positively autocorrelated.

12.6.1a The Bounds Test
In the absence of software that computes a p-value, a test known as the bounds test can be used to partially overcome the problem of not having general critical values. Durbin and Watson considered two other statistics, d_L and d_U, whose probability distributions do not depend on the explanatory variables and which have the property that

$$d_L < d < d_U \tag{12.6.7}$$

That is, irrespective of the explanatory variables in the model under consideration, d will be bounded by an upper bound d_U and a lower bound d_L. The relationship between the probability distributions $f(d_L)$, $f(d)$, and $f(d_U)$ is depicted in Figure 12.3. Let d_{Lc} be the 5% critical value from the probability distribution for d_L. That is, d_{Lc} is such that $P(d_L < d_{Lc}) = .05$. Similarly, let d_{Uc} be such that $P(d_U < d_{Uc}) = .05$. Since the probability distributions $f(d_L)$ and $f(d_U)$ do not depend on the explanatory variables, it is possible to tabulate the critical values d_{Lc} and d_{Uc}. These values do depend on T and K, but it is possible to tabulate them for different T and K. See Table 5 in the Statistical Tables section at the end of this book.

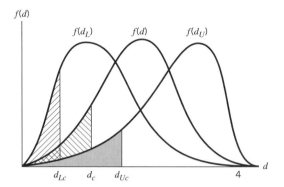

FIGURE **12.3** Upper and lower critical value bounds for the Durbin–Watson test.

Thus, in Figure 12.3 we have three critical values. The values d_{Lc} and d_{Uc} can be readily obtained from the tables. The value d_c, the one in which we are really interested for testing purposes, cannot be found without a specialized computer program. However, it is clear from the figure that if the calculated value d is such that $d < d_{Lc}$, then it must follow that $d < d_c$, and H_0 is rejected. Also, if $d > d_{Uc}$, then it follows that $d > d_c$, and H_0 is accepted. If it turns out that $d_{Lc} < d < d_{Uc}$, then, because we do not know the location of d_c, we cannot be sure whether to accept or reject. These considerations led Durbin and Watson to suggest the following decision rules, which are known collectively as the Durbin–Watson *bounds test*.

If $d < d_{Lc}$, reject H_0: $\rho = 0$ and accept H_1: $\rho > 0$

If $d > d_{Uc}$, do not reject H_0: $\rho = 0$

If $d_{Lc} < d < d_{Uc}$, the test is inconclusive

The presence of a range of values where no conclusion can be reached is an obvious disadvantage of the test. For this reason it is preferable to have software which can calculate the required p-value if such software is available.

To find the critical bounds for the sugar cane example we consult statistical Table 5 for $T = 34$ and $K = 2$. The values are

$$d_{Lc} = 1.393 \qquad d_{Uc} = 1.514$$

Since $d = 1.291 < d_{Lc}$, we conclude that $d < d_c$, and hence we reject H_0; there is evidence to suggest that autocorrelation exists.

12.6.2 A Lagrange Multiplier Test

A second test that we consider for testing for autocorrelation is derived from a general set of hypothesis testing principles known as *Lagrange multiplier* (LM) tests. In more advanced courses you will learn the origin of the term Lagrange multiplier. We will be content to study its use in a test for autocorrelation. To introduce this test, return to (12.4.3), which is written as

$$y_t = \beta_1 + \beta_2 x_1 + \rho e_{t-1} + v_t \tag{12.6.8}$$

If e_{t-1} was observable, an obvious way to test the null hypothesis H_0: $\rho = 0$ would

be to regress y_t on x_t and e_{t-1} and to use a t- or F-test to test the significance of the coefficient of e_{t-1}. Because e_{t-1} is not observable, we replace it by the lagged least squares residuals \hat{e}_{t-1}, and then perform the test in the usual way.

Proceeding in this way for the sugar cane example yields

$$t = 2.006 \qquad F = 4.022 \qquad p\text{-value} = 0.054 \qquad \text{(R12.9)}$$

Obtaining a p-value greater than 0.05 means that, at a 5% significance level, the LM test does not reject a null hypothesis of no autocorrelation. This test outcome conflicts with that obtained earlier using the Durbin–Watson test. Such conflicts are a fact of life. When a hypothesis test is performed, it is always possible to make a type I or a type II error. In this particular case, either the Durbin–Watson test has led to a type I error or the LM test has produced a type II error. The most likely scenario is a type II error from the LM test; in other words, it was not sufficiently powerful to pick up the autocorrelation.

You should note the following four points:

1. When estimating the regression in (12.6.8), using the first observation $t = 1$, requires knowledge of \hat{e}_0. Two ways of overcoming this lack of knowledge are often employed. One is to set $e_0 = 0$. The other is to omit the first observation. In our calculations we set $e_0 = 0$. The results change very little if the first observation is omitted instead.

2. The Durbin–Watson test is an exact test valid in finite samples. The LM test is an approximate large-sample test, the approximation occurring because e_{t-1} is replaced by \hat{e}_{t-1}.

3. The Durbin–Watson test is not valid if one of the explanatory variables is the lagged dependent variable y_{t-1}. The LM test can still be used in these circumstances. This fact is particularly relevant for a distributed lag model studied in Chapter 15.

4. We have only been concerned with testing for autocorrelation involving one lagged error e_{t-1}. To test for more complicated autocorrelation structures, involving higher order lags such as e_{t-2}, e_{t-3}, etc, the LM test can be used by including the additional lagged errors in (12.6.8), and using an F test to test the relevance of their inclusion.

12.7 Prediction With AR(1) Errors

In Chapters 5.3 and 8.8 we considered the problem of forecasting or predicting a future observation y_0 that we assumed is generated from the linear regression model

$$y_0 = \beta_1 + x_0\beta_2 + e_0 \qquad \text{(12.7.1)}$$

where x_0 is a given future value of an explanatory variable and e_0 is a future error term. Equation (12.7.1) can be extended to include more than one explanatory variable, as was illustrated in Chapter 8.8. We discovered that, when the errors are uncorrelated, the best linear unbiased predictor for y_0 is the least squares predictor

$$\hat{y}_0 = b_1 + b_2x_0 \qquad \text{(12.7.2)}$$

There are two important differences between this forecasting problem and the forecasting problem that involves a linear model with AR(1) errors. The first difference

relates to the best way to estimate β_1 and β_2. When the errors are autocorrelated, the generalized least squares estimators, denoted by $\hat{\beta}_1$ and $\hat{\beta}_2$, are more precise than their least squares counterparts b_1 and b_2. A better predictor is obtained, therefore, if we replace b_1 and b_2 by $\hat{\beta}_1$ and $\hat{\beta}_2$.

The second difference between the prediction problem in Chapters 5 and 8 and that for the AR(1) error model relates to the best forecast for the future error e_0. When e_0 is uncorrelated with past errors, as was assumed in Chapters 5 and 8, the best forecast of e_0 is its mean value of zero. When e_0 is correlated with past errors, as it is in the AR(1) error model, we can use information contained in the past errors to improve upon zero as a forecast for e_0. For example, if the last error e_T is positive, then it is likely that the next error e_{T+1} will also be positive.

To see how an improvement can be made, note that, when we are predicting one period into the future, the model with an AR(1) error can be written as

$$y_{T+1} = \beta_1 + \beta_2 x_{T+1} + e_{T+1}$$
$$= \beta_1 + \beta_2 x_{T+1} + \rho e_T + v_{T+1} \qquad (12.7.3)$$

where we have used $e_{T+1} = \rho e_T + v_{T+1}$. Equation (12.7.3) has three distinct components:

1. Given the explanatory variable x_{T+1}, the best linear unbiased predictor for $\beta_1 + \beta_2 x_{T+1}$ is $\hat{\beta}_1 + \hat{\beta}_2 x_{T+1}$ where $(\hat{\beta}_1, \hat{\beta}_2)$ are generalized least squares estimates.

2. To predict the component ρe_T, we need estimates for both ρ and e_T. For ρ we can use the estimator $\hat{\rho}$ specified in (12.5.5). To estimate e_T we use the generalized least squares residual, defined as

 $$\tilde{e}_T = y_T - \hat{\beta}_1 - \hat{\beta}_2 x_T \qquad (12.7.4)$$

3. The best forecast of the third component v_{T+1} is zero because this component is uncorrelated with past values v_1, v_2, \ldots, v_T.

Collecting all these results, *our predictor for y_{T+1} is given by*

$$\hat{y}_{T+1} = \hat{\beta}_1 + \hat{\beta}_2 x_{T+1} + \hat{\rho}\tilde{e}_T \qquad (12.7.5)$$

A comparison of (12.7.5) and (12.7.3) shows that we are using $\hat{\rho}\tilde{e}_T$ to predict the future error e_{T+1}. That is, we are using information on the t-th error e_T, and our knowledge that e_T and e_{T+1} are correlated, to improve on zero as a predictor for e_{T+1}.

What about predicting more than one period into the future? For h periods ahead, it can be shown that the best predictor is

$$\hat{y}_{T+h} = \hat{\beta}_1 + \hat{\beta}_2 x_{T+h} + \hat{\rho}^h \tilde{e}_T \qquad (12.7.6)$$

Assuming $|\hat{\rho}| < 1$, the influence of the term $\hat{\rho}^h \tilde{e}_T$ diminishes the further we go into the future (the larger h becomes).

In the Bangladesh sugar cane example

$$\hat{\beta}_1 = 6.1641, \qquad \hat{\beta}_2 = 1.0066, \qquad \hat{\rho} = 0.342$$

and

$$\tilde{e}_T = y_T - \hat{\beta}_1 - \hat{\beta}_2 x_T$$
$$= \ln(A_T) - \hat{\beta}_1 - \hat{\beta}_2 \ln(P_T)$$
$$= 5.4596 - 6.1641 - 1.0066(-0.9374)$$
$$= 0.239 \tag{R12.10}$$

To predict y_{T+1} and y_{T+2} for a sugar cane price of 0.4, in both periods $(T + 1)$ and $(T + 2)$, we have

$$\hat{y}_{T+1} = \hat{\beta}_1 + \hat{\beta}_2 x_{T+1} + \hat{\rho}\tilde{e}_T$$
$$= 6.1641 + 1.0066\ln(0.4) + (0.342)(0.239)$$
$$= 5.3235 \tag{R12.11}$$
$$\hat{y}_{T+2} = \hat{\beta}_1 + \hat{\beta}_2 x_{T+2} + \hat{\rho}^2\tilde{e}_T$$
$$= 6.1641 + 1.0066\ln(0.4) + (0.342)^2(0.239)$$
$$= 5.2697 \tag{R12.12}$$

Note that these predictions are for the logarithm of area; they correspond to areas of 205 and 194, respectively.

12.8 Learning Objectives

Based on the material in this chapter, you should be able to:

1. Define autocorrelation. Give examples of econometric models where autocorrelation is likely to exist.
2. Define an AR(1) error. Explain the properties of an AR(1) error.
3. Explain the consequences of an autocorrelated error for least squares estimation.
4. Test for autocorrelation using the Durbin–Watson test and the Lagrange multiplier test.
5. Use your computer software to obtain generalized least squares estimates in the presence of an AR(1) error.
6. Predict future values of a dependent variable in the presence of an AR(1) error.

12.9 Exercises

12.1 Consider the investment function

$$I_t = \beta_1 + \beta_2 Y_t + \beta_3 R_t + e_t$$

where

$$I_t = \text{investment in year } t$$
$$Y_t = \text{GNP in year } t$$
$$R_t = \text{interest rate in year } t$$

Thirty observations on I, Y, and R are given in the file *inv.dat*. Use these data to answer the following questions.

(a) Find least squares estimates of β_1, β_2 and β_3 and report the results in the usual way. Comment on the implied statistical reliability of the results. Do the estimates for β_2 and β_3 have the expected signs?

(b) Plot the least squares residuals. Do they suggest the existence of auto-correlaton?

(c) Use the Durbin–Watson test to test for positive autocorrelation.

(d) Re-estimate the model after correcting for autocorrelation. Report the results. Note any differences between these results and those obtained in part (a). Suggest how the results obtained in part (a) could be mis-leading.

(e) Predict next year's level of investment given that next year's values for Y and R are $Y = 36$ and $R = 14$. How does this forecast compare with the one that would be obtained if autocorrelation is ignored?

12.2* Consider the AR(1) error model

$$e_t = \rho e_{t-1} + v_t$$

where $E(v_t) = 0$, $\text{var}(v_t) = \sigma_v^2$ and $E(v_t v_s) = 0$ for $t \neq s$. Given that $\text{var}(e_t) = \text{var}(e_{t-1}) = \sigma_e^2$, prove that

$$\sigma_e^2 = \frac{\sigma_v^2}{1 - \rho^2}$$

Show that

$$E(e_t e_{t-1}) = \sigma_e^2 \rho \qquad \text{and} \qquad E(e_t e_{t-2}) = \sigma_e^2 \rho^2$$

12.3 To investigate the relationship between job vacancies (JV) and the unem-ployment rate (U), a researcher sets up the model

$$\ln(JV_t) = \beta_1 + \beta_2 \ln(U_t) + e_t$$

and assumes that the e_t are independent $N(0, \sigma_e^2)$ random variables.

(a) Use the 24 observations in the file *vacan.dat* to find least squares esti-mates for β_1 and β_2. Construct a 95% confidence interval for β_2.

(b) Find the value of the Durbin–Watson statistic. In light of this value, what can you say about the original assumptions for the error e_t, what can you say about the confidence interval for β_2 found in (a)?

(c) Re-estimate the model assuming the errors follow an AR(1) error model. Find a new 95% confidence interval for β_2 and comment on the results, particularly in relation to your answers for part (a).

12.4* Data for a monopolist's total revenue (tr), total cost (tc), and output (q), for 48 consecutive months, appear in the file *monop.dat*. Suppose that the mo-nopolist's economic models for total revenue and total cost are given respec-tively by

$$tr = \beta_1 q + \beta_2 q^2$$
$$tc = \alpha_1 + \alpha_2 q + \alpha_3 q^2$$

(a) Show that marginal cost and marginal revenue are given by

$$mc = \alpha_2 + 2\alpha_3 q \qquad mr = \beta_1 + 2\beta_2 q$$

(b) Show that the profit maximizing quantity which equates marginal revenue and marginal cost is

$$q^* = \frac{\alpha_2 - \beta_1}{2(\beta_2 - \alpha_3)}$$

(c) Use the least squares estimator to estimate the total revenue and total cost functions. For what statistical models are these estimates appropriate? What do the least squares estimates suggest is the profit maximizing level of output?
(d) After rounding the optimizing output to an integer, use that output to predict total revenue, total cost, and profit for the next three months. (Continue to assume the least squares statistical assumptions are appropriate.)
(e) Separately test the errors for each of the functions to see if these errors might be autocorrelated.
(f) Where autocorrelation has been suggested by the tests in part (e), find generalized least squares estimates of the relevant function(s).
(g) What is the profit-maximizing level of output suggested by the results in part (f)?
(h) Given the output level found in part (g), and the autocorrelation assumption, predict total revenue, total cost, and hence, profit for the next three months. Compare the predictions with those from part (d).

12.5 Consider the learning curve data and model given in Exercise 3.8 and file *learn.dat*. The model is

$$\ln(u_t) = \beta_1 + \beta_2 \ln(q_t) + e_t$$

(a) Test a null hypothesis of no autocorrelation in the e_t against an alternative of positive autocorrelation at a 5% level of significance.
(b) Compare 95% confidence intervals for β_2 obtained using:
 (i) least squares estimates and standard errors, and
 (ii) generalized least squares estimates and standard errors after correcting for autocorrelation.
 What does this comparison suggest?
(c) Suppose that cumulative production in year 1971 is 3800. Under the following conditions, do you expect cost per unit in 1971 to be more or less than it was in 1970?
 (i) If the errors are not autocorrelated
 (ii) If the errors are autocorrelated

12.6 The file *icecr.dat* contains 30 observations on variables potentially relevant for modeling the demand for ice cream. This example is taken from a classic

paper on autocorrelation by Hildreth and Lu. Each observation represents a four-week period during the years 1951–53. The variables are:

Q: per capita consumption of ice cream in pints
P: price per pint in dollars
I: weekly family income in dollars
F: mean temperature in Fahrenheit

(a) Use least squares to estimate the model

$$Q_t = \beta_1 + \beta_2 P_t + \beta_3 I_t + \beta_4 F_t + e_t$$

(b) Are there any coefficient estimates that are not significantly different from zero? Do you think the corresponding variable(s) is (are) not relevant for explaining ice cream demand?
(c) Is there any evidence of autocorrelated errors? Check for runs of positive and negative least squares residuals, as well as using the Durbin–Watson and Lagrange multiplier test statistics.
(d) Estimate the model after transforming the variables to correct for autocorrelation.
(e) Do your estimates from part (d) change your answer to part (b)?

12.7* Reconsider Exercise 12.6:
(a) Compute the Durbin–Watson p-value for the residuals from the transformed model estimated in 12.6(d). Does there still seem to be an autocorrelation problem?
(b) Get your computer software to estimate the equation assuming the errors follow what is called a "second order" autoregressive model. Comment on the coefficient estimates.

12.8 (a) Suppose that you run a regression where $T = 90$, $K = 5$,

$$\sum_{t=1}^{T} \hat{e}_t^2 = 63316 \qquad \sum_{t=2}^{T} \hat{e}_t \hat{e}_{t-1} = 55453$$

Find an estimate for the AR(1) parameter ρ. Compute an approximate value of the Durbin–Watson statistic. Is autocorrelation present?
(b) Repeat part (a) with $T = 90$, $K = 6$,

$$\sum_{t=1}^{T} \hat{e}_t^2 = 12292 \qquad \sum_{t=2}^{T} \hat{e}_t \hat{e}_{t-1} = 621$$

12.9 Consider the model

$$DISP = \beta_1 + \beta_2 DUR + e$$

where $DISP$ represents factory shipments of disposers and DUR is durable goods expenditures. See Exercise 6.22 for further details. Table 12.5 contains selected portions of EViews output for estimating this model. The least squares residuals are plotted in Figure 12.4.

Table 12.5 **EViews Output for Exercise 12.9**

Least Squares Estimates

Dependent Variable: DISP
Sample: 1960 1985
Included observations: 26

Variable	Coefficient	Std. Error	t-Statistic	Prob.
C	−387.9700	112.6555	−3.443863	0.0021
DUR	24.76462	0.971526	25.49044	0.0000

Durbin–Watson stat	1.124277

Breusch-Godfrey Serial Correlation LM Test:

F-statistic	4.560118	Probability	0.043598

Generalized Least Squares Estimates

Dependent Variable: DISP
Sample(adjusted): 1961 1985
Included observations: 25 after adjusting endpoints
Convergence achieved after 6 iterations

Variable	Coefficient	Std. Error	t-Statistic	Prob.
C	−343.8475	192.1654	−1.789332	0.0873
DUR	24.38816	1.574072	15.49367	0.0000
AR(1)	0.418645	0.201098	2.081797	0.0492

Durbin–Watson stat	1.746910

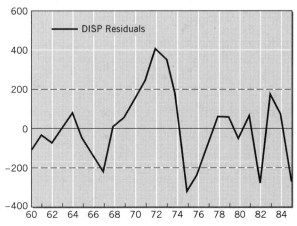

FIGURE 12.4 Least squares residuals for Exericse 12.9.

(a) What evidence is there to suggest the existence of AR(1) errors?

(b) Summarize the differences between the least squares and the generalized least squares estimates. In what way would ignoring autocorrelation lead to misleading inferences?

(c) Given that $\tilde{e}_{1985} = -277.2$, $DUR_{1986} = 190$, $DUR_{1987} = 195$, $DUR_{1988} = 192$, forecast shipments of disposers for 1986, 1987, and 1988.

12.10 In the file *mining.dat*, are seasonally adjusted quarterly observations on indices of mining production, and electric power use for mining, in the United States. The observations run from 1972, quarter 1 to 1999, quarter 3, and appear in the file in the order (year, quarter, production (*PRO*), and power use (*POW*)). Consider the model

$$\ln(POW_t) = \beta_1 + \beta_2 t + \beta_3 t^2 + \beta_4 \ln(PRO_t) + e_t$$

where t is a time trend.

(a) Estimate the model using least squares. Comment on the signs of the estimated coefficients and what they imply. Does autocorrelation appear to be a problem?

(b) Estimate the model assuming the existence of an AR(1) error. Comment on the differences between these results and those obtained in part (a).

(c) Suppose that you wish to test the hypothesis $H_0: \beta_4 = 1$. Compare the p-values of this test before and after correcting for autocorrelation.

12.11 Reconsider Exercise 12.10. Assuming the errors follow an AR(1) process, estimate the model with the restriction $\beta_4 = 1$ imposed. Use these estimates to plot a trend for (POW_t/PRO_t).

12.12 Reconsider Exercise 12.10.

(a) Estimate a model where

$$\beta_1 = \alpha_1 + \delta_1 D_t \qquad \beta_4 = \alpha_4 + \delta_4 D_t$$

and D_t is the dummy variable that takes the value 1 for the period 1985 : 1 to 1999 : 3 and is zero otherwise. If necessary, allow for autocorrelation.

(b) Test the hypothesis $H_0: \delta_1 = \delta_4 = 0$. Does the test outcome depend on whether or not autocorrelation is assumed?

(c) If the hypothesis in part (b) is rejected, what can you conclude?

Chapter 13

Random Regressors and Moment Based Estimation

13.1 Introduction

In this chapter we reconsider the linear regression model. We discuss the simple linear regression model, but our comments apply to the general model as well. The usual assumptions we make are:

SR1. $y = \beta_1 + \beta_2 x + e$

SR2. $E(e) = 0$

SR3. $\text{var}(e) = \sigma^2$

SR4. $\text{cov}(e_i, e_j) = 0$

SR5. The variable x is not random, and it must take at least two different values.

SR6. (optional) $e \sim N(0, \sigma^2)$

(*Note:* In stating the assumptions we have omitted the observation subscript, except where necessary, and will follow this practice through the chapter.)

In Chapter 11 we relaxed the assumption $\text{var}(e) = \sigma^2$, that the error variance is the same for all observations. In Chapter 12 we considered regressions with time series data in which the assumption of serially uncorrelated errors, $\text{cov}(e_i, e_j) = 0$, cannot be maintained.

In this chapter we relax the assumption that variable x is not random. You may have wondered about the validity of this assumption. In our original discussion of random variables in Chapter 2, we said that a variable is random if its value is unknown until an experiment is performed. Clearly, in an economist's nonexperimental world, the values of x and y are usually revealed at the same time, making x random, in the same manner as y.

We have considered the variable x to be nonrandom for several reasons. First, when regression is based on data from controlled experiments, or if we are conditioning our results upon the sample we have, it is a proper assumption. Second, it simplifies the algebra of least squares. Third, even if x is random, the properties of the least squares estimator still hold under slightly modified assumptions.

The purpose of this chapter is to discuss regression models in which x is random and correlated with the error term e. We will:

- Discuss the conditions under which having a random x is not a problem, and how to test whether our data satisfy these conditions.

- Present cases in which the randomness of x causes the least squares estimator to fail.

- Provide estimators that have good properties even when x is random.

13.2 Linear Regression with Random x's

Let us modify the usual simple regression assumptions as follows:

A13.1 $y = \beta_1 + \beta_2 x + e$ correctly describes the relationship between y and x in the population, where β_1 and β_2 are unknown (fixed) parameters and e is an unobservable random error term.

A13.2 The data pairs (x_t, y_t), $t = 1, \ldots, T$ are obtained by **random sampling**. That is, the data pairs are collected from the same population, by a process in which each pair is independent of every other pair. Such data are said to be independent and identically distributed.

A13.3 $E(e|x) = 0$. The expected value of the error term, **conditional** on any value of x, is zero.

A13.4 In the sample, x_t must take at least two different values.

A13.5 $\text{var}(e|x) = \sigma^2$. The variance of the error term, conditional on any x, is a constant σ^2.

A13.6 $e|x \sim N(0, \sigma^2)$. The distribution of the error term, conditional on x, is normal.

There is only one new assumption in this list. That is, assumption A13.2 states that both y and x are obtained by a sampling process, and thus are random. Also, by assuming that the pairs are independent, this implies that assumption SR4 holds as well. In the other assumptions all we have done is bring back the explicit conditioning notation introduced in Chapter 3.

Because it plays a key role in the properties of the least squares estimator, let us clearly state the interpretation of A13.3, $E(e|x) = 0$. This assumption implies that we have (1) omitted no important variables, (2) used the correct functional form, and (3) there exist no factors that cause the error term to be correlated with x.

While the first two of these implications are intuitive, the third may not be.

- If $E(e|x) = 0$, then we can show that it is also true that x and e are uncorrelated, and that $\text{cov}(x, e) = 0$.

- Conversely, if x and e are correlated, then $\text{cov}(x, e) \neq 0$ and we can show that $E(e|x) \neq 0$.

Thus in addition to the usual specification errors of omitted variables and incorrect functional form, assumption A13.3 eliminates correlation between a random explanatory variable, x, and the random error term, e. We discuss the consequences of correlation between x and e in Section 13.2.4. As we will see, correlation between x and e exists in simultaneous equations models and when explanatory variables are measured with error. In each of these cases the usual least squares estimation procedure is no longer appropriate.

13.2.1 THE FINITE (SMALL) SAMPLE PROPERTIES OF THE LEAST SQUARES ESTIMATOR

In Chapter 4 we proved the Gauss-Markov theorem. The result being that under the classical assumptions, and fixed *x*'s, the least squares estimator is the best linear unbiased estimator, is a **finite sample**, or a **small sample**, property of the least squares estimator. What this means is that the result does not depend on the size of the sample. It holds in every sample, whether $T = 20$, or $T = 50$, or $T = 10,000$.

The finite sample properties of the least squares estimator when *x* is random can be summarized as follows:

1. Under assumptions A13.1–A13.4 the least squares estimator is unbiased.
2. Under assumptions A13.1–A13.5 the least squares estimator is the best linear unbiased estimator of the regression parameters, conditional on *x*, and the usual estimator of σ^2 is unbiased.
3. Under assumptions A13.1–A13.6 the distributions of the least squares estimators, conditional upon *x*, are normal, and their variances are estimated in the usual way. Consequently the usual interval estimation and hypothesis testing procedures are valid.

What these results say is that if *x* is random, as long as the data are obtained by random sampling, and the other usual assumptions hold, no change in our regression method is required.

13.2.2 THE ASYMPTOTIC (LARGE) SAMPLE PROPERTIES OF THE LEAST SQUARES ESTIMATOR WHEN *x* IS NOT RANDOM

In this section we examine the large sample properties of the least squares estimator under the classical assumptions SR1–SR6. What happens to the probability distribution of the least squares estimator if we have a *very large* sample, or when the sample size $T \to \infty$? The answer, whether the random errors are normal or not, is found in two properties of the least squars estimator that we have already established. First, the least squares estimator is unbiased. Second, the variance of the least squares estimator, given in (4.2.10) for the simple linear regression model, *converges to zero* as $T \to \infty$. As the sample size gets increasingly large the probability distribution of the least squares estimator *collapses* about the true parameter. In Figure 13.1 this is illustrated for b_2. As $T \to \infty$ *all* the probability is concentrated about β_2. This is a very reassuring result. Its consequence is that as $T \to \infty$

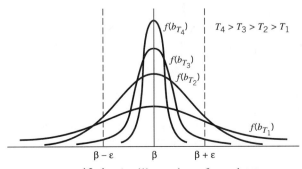

FIGURE 13.1 An illustration of consistency.

the probability approaches *one* that a least squares estimate b_2 will be *close* to β_2, no matter how narrowly you define the term "close." The same is true for b_1. Estimators with this property are called *consistent* estimators, and consistency is a nice large sample property of the least squares estimator.

REMARK: Consistency is a "large sample" or "asymptotic" property. We have stated another large sample property of the least squares estimators in Chapter 4.4. We found that even when the random errors in a regression model are not normally distributed, the least squares estimators will have approximate normal distributions if the sample size T is large enough. How large must T be for these large sample properties to be valid approximations of reality? In a simple regression, $T = 50$ might be enough. In multiple regression models the number might be much higher, depending on the quality of the data. What is important for now is that you recognize we are discussing situations in this chapter in which the samples must be large for our conclusions to be valid.

13.2.3 THE ASYMPTOTIC (LARGE) SAMPLE PROPERTIES OF THE LEAST SQUARES ESTIMATOR WHEN *x* IS RANDOM

For the purpose of a "large sample" analysis of the least squares estimator it is convenient to replace assumption A13.3 by

A13.3* $E(e) = 0$ and $\text{cov}(x, e) = 0$

We can make this replacement because, if assumption A13.3 is true, it follows that A13.3* is true. That is, $E(e|x) = 0 \Rightarrow \text{cov}(x, e) = 0$ and $E(e|x) = 0 \Rightarrow E(e) = 0$. Introducing assumption A13.3* is convenient because we want to investigate how to estimate models in which a random regressor x is correlated with the error term e, that is, when we violate the assumption that $\text{cov}(x, e) = 0$. While it does not seem like much of a change, because A13.3* is actually a weaker assumption than A13.3, under A13.3* we cannot show that the least squares estimator is unbiased, or that any of the other finite sample properties hold.

What we can say is the following:

1. Under assumption A13.3* the least squares estimators are consistent. That is, they converge to the true parameter values as $T \rightarrow \infty$.

2. Under assumptions A13.1, A13.2, A13.3*, A13.4, and A13.5, the least squares estimators have approximate normal distributions in large samples, whether the errors are normally distributed or not. Furthermore our usual interval estimators and test statistics are valid, if the sample is large.

3. If assumption A13.3* is <u>not</u> true, and in particular if $\text{cov}(x, e) \neq 0$, and consequently x and e are correlated, then the least squares estimators are inconsistent. They do not converge to the true parameter values even in very large samples. Furthermore, none of our usual hypothesis testing or interval estimation procedures are valid.

Thus when x is random, the relationship between x and e is the crucial factor when deciding whether least squares estimation is appropriate or not. If the error term is correlated with x (any x in the multiple regression model) then the least squares estimator fails. In Section 13.4 we provide a way to test whether x and e are correlated. In the next section we show that if x and e are correlated then the least squares estimator fails.

13.2.4 THE INCONSISTENCY OF THE LEAST SQUARES ESTIMATOR WHEN $\operatorname{cov}(x, e) \neq 0$

We will demonstrate that the least squares estimator is inconsistent in two ways; first, graphically and second, algebraically. You can skip the algebraic proof on the first reading.

13.2.4a A Geometric Explanation of Why the Least Squares Estimator Is Inconsistent When $\operatorname{cov}(x, e) \neq 0$

To demonstrate why the least squares estimator fails when $\operatorname{cov}(x, e) \neq 0$ we will use a tool of econometrics, the Monte Carlo simulation. A Monte Carlo simulation uses artificially created data. By creating data from a model we know, we can evaluate how alternative estimation procedures work under a variety of conditions. Specifically, let us specify a simple regression model in which the parameter values are $\beta_1 = 1$ and $\beta_2 = 1$. Thus, the systematic part of the regression model is $E(y) = \beta_1 + \beta_2 x = 1 + 1 \times x$. By adding to $E(y)$ an error term value, which will be a random number we create, we can create a sample value of y.

We want to explore the properties of the least squares estimator when x and e are correlated. Using random number generators, we create $T = 25$ correlated pairs of x and e values, such that e has mean zero and constant variance. A few of these values are given in Table 13.1. The complete table is contained in the file *table13-1.dat*.

The values of x and e are plotted in Figure 13.2. We then create an artificial sample of y values by adding e to the systematic portion of the regression,

$$y = E(y) + e = \beta_1 + \beta_2 x + e = 1 + 1 \times x + e$$

We obtain the least squares estimates and the fitted values $\hat{y} = b_1 + b_2 x$. The values of y, $E(y)$, and \hat{y} are plotted against x in Figure 13.3.

Table 13.1 **Artificially Created Values of x and e**

x	e
−0.68243	−1.26483
−0.57665	0.17476
1.00781	0.19643
−0.749	−1.05292
−1.65062	−1.79023

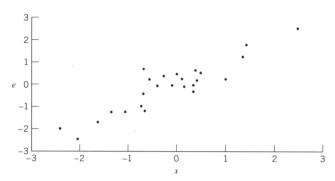

FIGURE **13.2** Plot of correlated x and e.

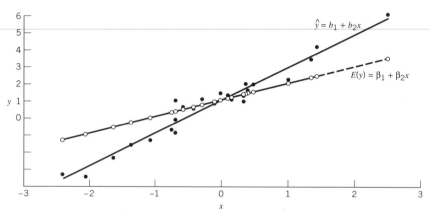

FIGURE **13.3** Plot of data, true and fitted regressions.

The line $E(y) = \beta_1 + \beta_2 x = 1 + 1 \times x$ is plotted in this figure. In the "real world" we would never know where this line falls, since we never know the values of the true parameters. Note that the data values *are not* randomly scattered around this regression function, because of the correlation we have created between x and e. The least squares principle works by fitting a line through the "center" of the data. The fitted line $\hat{y} = b_1 + b_2 x$ is an estimate of the true regression function $E(y) = \beta_1 + \beta_2 x$. When x and e are correlated, the least squares idea is not going to work. When x and e are positively correlated, the estimated slope tends to be too large and the estimated intercept tends to be too small, relative to the true parameter values. Furthermore, the systematic overestimation of the slope, and underestimation of the intercept will not go away in larger samples, and thus the least squares estimators are not correct on average even in large samples. The least squares estimators are inconsistent.

13.2.4b Algebraic Proof that the Least Squares Estimator Is Inconsistent When cov(x, e) \neq 0
While it is a bit messy, it is important for you to see the algebraic proof that the least squares estimator is not consistent when cov(x, e) \neq 0. Our regression model is $y = \beta_1 + \beta_2 x + e$. Under A13.3* $E(e) = 0$, so that $E(y) = \beta_1 + \beta_2 E(x)$.

Then,

- subtract this expectation from the original equation,

$$y - E(y) = \beta_2[x - E(x)] + e$$

- multiply both sides by $x - E(x)$

$$[x - E(x)][y - E(y)] = \beta_2[x - E(x)]^2 + [x - E(x)]e$$

- take expected values of both sides

$$E[x - E(x)][y - E(y)] = \beta_2 E[x - E(x)]^2 + E\{[x - E(x)]e\},$$

or

$$\text{cov}(x, y) = \beta_2 \text{var}(x) + \text{cov}(x, e)$$

- solve for β_2

$$\beta_2 = \frac{\text{cov}(x, y)}{\text{var}(x)} - \frac{\text{cov}(x, e)}{\text{var}(x)} \tag{13.2.1}$$

Equation (13.2.1) is the basis for showing when the least squares estimator is consistent, and when it is not.

If we can assume that that $\text{cov}(x, e) = 0$, then

$$\beta_2 = \frac{\text{cov}(x, y)}{\text{var}(x)}. \tag{13.2.2}$$

The least squares estimator can be expressed as

$$b_2 = \frac{\sum(x_t - \bar{x})(y_t - \bar{y})}{\sum(x_t - \bar{x})^2} = \frac{\sum(x_t - \bar{x})(y_t - \bar{y})/(T-1)}{\sum(x_t - \bar{x})^2/(T-1)} = \frac{\hat{\text{cov}}(x, y)}{\hat{\text{var}}(x)} \tag{13.2.3}$$

It is the sample analog of the population relationship in (13.2.2). The sample variance and covariance converge to the true variance and covariance as the sample size T increases, so that the least squares estimator converges to β_2. That is, if $\text{cov}(x, e) = 0$ then

$$b_2 = \frac{\hat{\text{cov}}(x, y)}{\hat{\text{var}}(x)} \longrightarrow \frac{\text{cov}(x, y)}{\text{var}(x)} = \beta_2$$

showing that the least squares estimator is consistent.

On the other hand, if x and e are correlated, then

$$\beta_2 = \frac{\text{cov}(x, y)}{\text{var}(x)} - \frac{\text{cov}(x, e)}{\text{var}(x)}$$

The least squares estimator now converges to

$$b_2 \rightarrow \frac{\text{cov}(x, y)}{\text{var}(x)} = \beta_2 + \frac{\text{cov}(x, e)}{\text{var}(x)} \neq \beta_2$$

In this case b_2 is an *inconsistent* estimator of β_2.

13.2.5 MEASUREMENT ERRORS IN REGRESSION EQUATIONS

There are several common situations in which the least squares estimator fails due to the presence of correlation between an explanatory variable and the error term. One is called the **errors-in-variables** problem, in which an explanatory variable is measured with error. When we measure an explanatory variable with error, then it is correlated with the error term, and the least squares estimator is inconsistent. As an illustration, consider the following important example. Let us assume that an individual's personal saving, like their consumption, is based on their "permanent" income. Let y_t = annual savings of the tth worker and let x_t^* = the permanent annual income of the tth worker. A simple regression model representing this relationship is

$$y_t = \beta_1 + \beta_2 x_t^* + v_t \tag{13.2.4}$$

We have asterisked (*) the permanent income variable because it is difficult, if not impossible, to observe. For the purposes of a regression, suppose that we attempt to measure permanent income using x_t = current income. Current income is a measure of permanent income, but it does not measure permanent income exactly. It is sometimes called a **proxy variable**. To capture this feature let us specify that

$$x_t = x_t^* + u_t \tag{13.2.5}$$

where u_t is a random disturbance, with mean 0 and variance σ_u^2. With this statement we are admitting that observed current income only approximates permanent income, and consequently that we have measured permanent income with error. Furthermore, let us assume that u_t is independent of e_t and serially uncorrelated. When we use x_t in the regression in place of x_t^*, we do so by replacement. That is, substitute $x_t^* = x_t - u_t$ into (13.2.4) to obtain

$$\begin{aligned} y_t &= \beta_1 + \beta_2 x_t^* + v_t \\ &= \beta_1 + \beta_2 (x_t - u_t) + v_t \\ &= \beta_1 + \beta_2 x_t + (v_t - \beta_2 u_t) \\ &= \beta_1 + \beta_2 x_t + e_t \end{aligned} \tag{13.2.6}$$

In (13.2.6) the explanatory variable x_t is random, from the assumption of measurement error in (13.2.5).

In order to estimate (13.2.6) by least squares we must determine whether or not x_t is uncorrelated with the random disturbance e_t. The covariance between these two random variables, using the fact that $E(e_t) = 0$, is

$$\text{cov}(x_t, e_t) = E(x_t e_t) = E[(x_t^* + u_t)(v_t - \beta_2 u_t)]$$
$$= E(-\beta_2 u_t^2) = -\beta_2 \sigma_u^2 \neq 0 \qquad (13.2.7)$$

The least squares estimator b_2 is an *inconsistent* estimator of β_2 because of the correlation between the explanatory variable and the error term. Consequently b_2 does not converge to β_2 in large samples. Furthermore, in large or small samples b_2 is <u>not</u> approximately normal with mean β_2 and variance $\text{var}(b_2) = \sigma^2 / \sum(x_t - \bar{x})^2$. When ordinary least squares fails in this way, is there another estimation approach that works? The answer is yes, as we will see in Section 13.3. First, however, we present an empirical example.

13.2.6 AN EXAMPLE OF THE CONSEQUENCES OF MEASUREMENT ERRORS

To illustrate the consequences of errors in variables, we survey 50 randomly selected individuals and record their savings in 1999 (y_t) and their income in 1999 (x_t). These data are contained in the file *table13-2.dat*. The first few observations (the data in thousands of dollars) on current savings and current income are given in Table 13.2. For the present, ignore the column labeled "z."

***Table 13.2* Representative Sample Data**

Savings	Income	z
2.412	83.830	65.917
2.473	68.147	64.553
4.594	84.205	71.658
3.893	84.016	64.584

In the complete sample, savings varies from about $1800 to $6100 with an average of $3,950. Income ranges between approximately $49,000 and $106,000 with an average value of $75,600. The estimated least squares regression results are contained in Table 13.3. The regression results in Table 13.3 are disappointing, and contrary to expectations. The sign of the estimated relationship between income and savings is negative, whereas economic theory implies that the relationship is a positive one, and the estimated slope parameter, the marginal propensity to save, is not statistically significant. The cause of these problems is measurement error. In Section 13.3 we explore alternative estimation procedures for this and similar cases in which least squares fails due to correlation between an explanatory variable and the error term.

T a b l e 1 3 . 3 **Least Squares Regression of Saving on Current Income**

Analysis of Variance

Source	DF	Sum of Squares	Mean Square	F Value	Pr > F
Model	1	0.22074	0.22074	0.22	0.6444
Error	48	49.09998	1.02292		
Corrected Total	49	49.32072			

Root MSE		1.01139	R-Square	0.0045	
Dependent Mean		3.95066	Adj R-Sq	-0.0163	
Coeff Var		25.60061			

Parameter Estimates

Variable	DF	Parameter Estimate	Standard Error	t Value	Pr > \|t\|
Intercept	1	4.34277	0.85612	5.07	<.0001
x	1	-0.00519	0.01116	-0.46	0.6444

13.3 Estimators Based on the Method of Moments

In the simple linear regression model, $y_t = \beta_1 + \beta_2 x_t + e_t$, when x_t is random, and $cov(x_t, e_t) = E(x_t e_t) \neq 0$, the least squares estimators are biased and inconsistent, with none of their usual nice properties holding. When faced with such a situation we must consider alternative estimation procedures. In this section we discuss the "method of moments" principle of estimation, which is an alternative to the least squares estimation principle. When all the usual assumptions of the linear model hold, the method of moments leads us to the least squares estimator. If x is random and correlated with the error term, the method of moments leads us to an alternative, called instrumental variables estimation, or two-stage least squares estimation, that will work in large samples.

13.3.1 METHOD OF MOMENTS ESTIMATION OF THE MEAN AND VARIANCE OF A RANDOM VARIABLE

Let us begin with a simple case. The kth moment of a random variable is the expected value of the random variable raised to the kth power. That is,

$$E(Y^k) = \mu_k = k\text{th moment of } Y \qquad (13.3.1)$$

Recall that an "expected value" is an average, over an infinite number of experimental outcomes. Consequently, the kth population moment in (13.3.1) can be estimated consistently using the sample (of size T) analog

$$\hat{E}(Y^k) = \hat{\mu}_k = k\text{th sample moment of } Y$$

$$= \sum_{t=1}^{T} y_t^k \Big/ T \qquad (13.3.2)$$

The **method of moments** estimation procedure equates m population moments to m sample moments to estimate m unknown parameters. As an example, let Y be a random variable with mean $E(Y) = \mu$ and variance

$$\text{var}(Y) = \sigma^2 = E(Y - \mu)^2 = E(Y^2) - \mu^2 \tag{13.3.3}$$

In order to estimate the two population parameters μ and σ^2, we must equate two population moments to two sample moments. The first two population and sample moments of Y are

$$E(Y) = \mu_1 = \mu, \qquad \hat{\mu} = \sum_{t=1}^{T} y_t \Big/ T$$

$$E(Y^2) = \mu_2, \qquad \hat{\mu}_2 = \sum_{t=1}^{T} y_t^2 \Big/ T \tag{13.3.4}$$

Note that for the first population moment, μ_1, it is customary to drop the subscript. With these two moments we can solve for the unknown mean and variance parameters. First, equate the first sample moment to the first population moment to obtain an estimate of the population mean,

$$\hat{\mu} = \sum_{t=1}^{T} y_t \Big/ T = \bar{y} \tag{13.3.5}$$

Then, use (13.3.3), replacing the second population moment by its sample value, and replacing first moment μ by (13.3.5), we obtain

$$\tilde{\sigma}^2 = \hat{\mu}_2 - \hat{\mu}^2 = \frac{\sum y_t^2}{T} - \bar{y}^2 = \frac{\sum y_t^2 - T\bar{y}^2}{T} = \frac{\sum (y_t - \bar{y})^2}{T} \tag{13.3.6}$$

The method of moments leads us to the sample mean as an estimator of the population mean. The method of moments estimator of the variance has T in its denominator, rather than the usual $T - 1$, so it is not exactly the sample variance we are used to. But clearly in large samples this will not make much difference. In general, method of moments estimators are consistent in large samples, but there is no guarantee that they are "best" in any sense.

13.3.2 METHOD OF MOMENTS ESTIMATION IN THE SIMPLE LINEAR REGRESSION MODEL

The definition of a "moment" can be extended to more general situations. We know that if Y is a random variable, then the function $g(Y)$ is also random. Consequently, $E[g(Y)]$ is a moment of $g(Y)$. In the linear regression model $y_t = \beta_1 + \beta_2 x_t + e_t$ we usually assume that

$$E(e_t) = 0 \Rightarrow E(y_t - \beta_1 - \beta_2 x_t) = 0 \tag{13.3.7}$$

Furthermore, if x_t is fixed, or random but not correlated with e_t, then

$$E(x_t e_t) = 0 \Rightarrow E[x_t(y_t - \beta_1 - \beta_2 x_t)] = 0 \qquad (13.3.8)$$

Equations (13.3.7–8) are moment conditions. If we replace the two population moments by the corresponding sample moments, we have two equations in two unknowns, which define the method of moments estimators for β_1 and β_2.

$$\frac{1}{T} \sum (y_t - b_1 - b_2 x_t) = 0$$

$$\frac{1}{T} \sum x_t(y_t - b_1 - b_2 x_t) = 0 \qquad (13.3.9)$$

These two equations are equivalent to the least squares "normal" equations from Chapter 3, (3.3.6), and their solution yields the least squares estimators

$$b_2 = \frac{\sum (x_t - \bar{x})(y_t - \bar{y})}{\sum (x_t - \bar{x})^2} .$$

$$b_1 = \bar{y} - b_2 \bar{x}$$

Thus under "nice" assumptions, the method of moments principle of estimation leads us to the same estimators for the simple linear regression model as the least squares principle.

13.3.3 INSTRUMENTAL VARIABLES ESTIMATION IN THE SIMPLE LINEAR REGRESSION MODEL

Problems for least squares arise when x is random and correlated with the random disturbance e, so that $E(x_t e_t) \neq 0$. This makes the moment condition in (13.3.8) invalid. Suppose, however, that there is another variable, z_t, called an **instrumental variable**, which satisfies the moment condition

$$E(z_t e_t) = 0 \Rightarrow E[z_t(y_t - \beta_1 - \beta_2 x_t)] = 0 \qquad (13.3.10)$$

Then we can use (13.3.7) and (13.3.10) to obtain estimates of β_1 and β_2. The sample moment conditions are

$$\frac{1}{T} \sum (y_t - \hat{\beta}_1 - \hat{\beta}_2 x_t) = 0$$

$$\frac{1}{T} \sum z_t(y_t - \hat{\beta}_1 - \hat{\beta}_2 x_t) = 0 \qquad (13.3.11)$$

Solving these equations leads us to method of moments estimators, which are usually called the **instrumental variable estimators**,

$$\hat{\beta}_2 = \frac{T \sum z_t y_t - \sum z_t \sum y_t}{T \sum z_t x_t - \sum z_t \sum x_t} = \frac{\sum (z_t - \bar{z})(y_t - \bar{y})}{\sum (z_t - \bar{z})(x_t - \bar{x})}$$

$$\hat{\beta}_1 = \bar{y} - \hat{\beta}_2 \bar{x} \tag{13.3.12}$$

These new estimators have the following properties:

- They are consistent, if $E(z_t e_t) = 0$
- In large samples the instrumental variable estimators have approximate normal distributions. For example,

$$\hat{\beta}_2 \sim N\left(\beta_2, \frac{\sigma^2}{\sum (x_t - \bar{x})^2 r_{zx}^2}\right) \tag{13.3.13}$$

where r_{zx}^2 is the squared sample correlation between the instrument z and the random regressor x. Clearly we want to obtain an instrument z that is highly correlated with x to improve the efficiency of the instrumental variable estimator. The larger r_{zx}^2 the smaller is the variance of the instrumental variables estimator,

$$\text{var}(\hat{\beta}_2) = \frac{\sigma^2}{\sum (x_t - \bar{x})^2 r_{zx}^2} \tag{13.3.14}$$

- The error variance is estimated using the estimator

$$\hat{\sigma}_{IV}^2 = \frac{\sum (y_t - \hat{\beta}_1 - \hat{\beta}_2 x_t)^2}{T - 2} \tag{13.3.15}$$

13.3.3a The Consistency of the Instrumental Variables Estimator
The demonstration that the instrumental variables estimator is consistent follows the logic used in Section 13.2.4b. It can be skipped on the first reading. The IV estimator can be expressed as

$$\hat{\beta}_2 = \frac{\sum (z_t - \bar{z})(y_t - \bar{y})/(T - 1)}{\sum (z_t - \bar{z})(x_t - \bar{x})/(T - 1)} = \frac{\hat{\text{cov}}(z, y)}{\hat{\text{cov}}(z, x)}. \tag{13.3.16}$$

The sample covariance converges to the true covariance in large samples, so we can say

$$\hat{\beta}_2 \rightarrow \frac{\text{cov}(z, y)}{\text{cov}(z, x)} \tag{13.3.17}$$

If the instrumental variable z_t is not correlated with x_t in both the sample data and in the population, then the instrumental variable estimator fails, since that would mean a zero in the denominator of $\hat{\beta}_2$ in (13.3.16) and (13.3.17). Thus for an instrumental variable to be valid, it must be uncorrelated with the error term e but correlated with the explanatory variable x.

Now, follow the same steps that led to (13.2.1). We obtain

$$\beta_2 = \frac{\mathrm{cov}(z, y)}{\mathrm{cov}(z, x)} - \frac{\mathrm{cov}(z, e)}{\mathrm{cov}(z, x)} \qquad (13.3.18)$$

If we can assume that $\mathrm{cov}(z, e) = 0$, a condition we imposed on the choice of the instrumental variable z, then the instrumental variables estimator in (13.3.17) converges in large samples to β_2,

$$\hat{\beta}_2 \rightarrow \frac{\mathrm{cov}(z, y)}{\mathrm{cov}(z, x)} = \beta_2. \qquad (13.3.19)$$

Thus if $\mathrm{cov}(z, e) = 0$ and $\mathrm{cov}(z, x) \neq 0$, then the instrumental variable estimator of β_2 is consistent, in a situation in which the least squares estimator is not consistent due to correlation between x and e.

13.3.4 AN EMPIRICAL EXAMPLE OF INSTRUMENTAL VARIABLES ESTIMATION

In Section 13.2.5 we estimated by least squares a regression model relating annual saving to current annual income, which was taken to be a proxy for permanent income. Now let us consider instrumental variables estimation. As part of the interview process, suppose we obtain annual income for previous years from each individual. It is reasonable to suppose that an individual views permanent income as a long-run average. Therefore, suppose we average the previous 10 years of income, not including the current year income, to obtain an "instrument" z for permanent income. This new variable is not permanent income, but it no doubt correlates with permanent income, and also current income. The file *table13-2.dat* contains data on the instrument z, and in Table 13.2 a few of the observations are shown. This measure of permanent income ranges between $56,000 and $80,900 with a mean value of $67,400.

The instrumental variables estimates are shown in Table 13.4.

Table 13.4 **Instrumental Variables Estimation of Savings Function**

Two-Stage Least Squares Estimation

		Parameter Estimates			
Variable	DF	Parameter Estimate	Standard Error	t Value	Pr > \|t\|
Intercept	1	0.988267	1.524164	0.65	0.5198
x	1	0.039176	0.020038	1.96	0.0564

The SAS statistical package was used to obtain the estimates shown in Table 13.4. In the next section we explain why SAS refers to those instrumental variables estimates as "two-stage least squares estimates." Note that the estimated slope of the saving function is now positive and statistically significant at the .05 level of significance using a one-tailed test. The estimate implies that for each additional $100 of permanent income we expect savings to increase by $3.92. Clearly these results agree more with our prior expectations than those in Table 13.3. By using the instrumental variable z, and the instrumental variable estimators in (13.3.12), we have obtained an estimate with the proper sign and a reasonable magnitude. In the next section we explore the link between instrumental variable estimation and two-stage least squares.

13.3.5 INSTRUMENTAL VARIABLES ESTIMATION WHEN SURPLUS INSTRUMENTS ARE AVAILABLE

In the simple regression model we need only one instrumental variable, yielding two moment conditions like (13.3.11), which we solve for the two unknown model parameters. Usually, however, we have more instrumental variables at our disposal than are necessary. For example, let w be a variable that is correlated with x but uncorrelated with e, so that we have three moment conditions (dropping the $1/T$):

$$E(e_t) = E(y_t - \beta_1 - \beta_2 x_t) = m_1 = 0 \Rightarrow \sum (y_t - \hat{\beta}_1 - \hat{\beta}_2 x_t) = \hat{m}_1 = 0$$

$$(13.3.20a)$$

$$E(z_t e_t) = E[z_t(y_t - \beta_1 - \beta_2 x_t)] = m_2 = 0 \Rightarrow \sum z_t(y_t - \hat{\beta}_1 - \hat{\beta}_2 x_t) = \hat{m}_2 = 0$$

$$(13.3.20b)$$

$$E(w_t e_t) = E[w_t(y_t - \beta_1 - \beta_2 x_t)] = m_3 = 0 \Rightarrow \sum w_t(y_t - \hat{\beta}_1 - \hat{\beta}_2 x_t) = \hat{m}_3 = 0$$

$$(13.3.20c)$$

In (13.3.20) we have three equations in two unknowns, $\hat{\beta}_1$ and $\hat{\beta}_2$. We could simply throw away one of the conditions and use the remaining two to solve for the unknowns. However, throwing away good information is hardly ever a good idea. An alternative that uses all of the moment conditions is to choose values for $\hat{\beta}_1$ and $\hat{\beta}_2$ satisfying (13.3.20) as closely as possible. One way to do this is to use the least squares principle, choosing $\hat{\beta}_1$ and $\hat{\beta}_2$ to minimize the sum of squares $\hat{m}_1^2 + \hat{m}_2^2 + \hat{m}_3^2$. It is best, however, to use weighted least squares, putting the greatest weight on the moments with the smaller variances. While the exact details are beyond the scope of this book, the values of $\hat{\beta}_1$ and $\hat{\beta}_2$ that minimize this weighted sum of squares can be obtained using a two-step process.

1. Regress x on a constant term, z and w, and obtain the predicted values \hat{x}.

2. Use \hat{x} as an instrumental variable for x.

This leads to the two moment conditions

$$\sum (y_t - \hat{\beta}_1 - \hat{\beta}_2 x_t) = 0$$

$$\sum \hat{x}_t (y_t - \hat{\beta}_1 - \hat{\beta}_2 x_t) = 0$$

Solving these conditions, and using the fact that $\bar{\hat{x}} = \bar{x}$, we have

$$\hat{\beta}_2 = \frac{\sum (\hat{x}_t - \bar{\hat{x}})(y_t - \bar{y})}{\sum (\hat{x}_t - \bar{\hat{x}})(x_t - \bar{x})} = \frac{\sum (\hat{x}_t - \bar{x})(y_t - \bar{y})}{\sum (\hat{x}_t - \bar{x})(x_t - \bar{x})}$$

$$\hat{\beta}_1 = \bar{y} - \hat{\beta}_2 \bar{x} \qquad (13.3.21)$$

These instrumental variables estimators, derived using the method of moments, are also called **two-stage least squares estimators**, because they can be obtained using two least squares regressions.

- Stage 1 is the regression of x on a constant term, z and w, to obtain the predicted values \hat{x}.

- Stage 2 is ordinary least squares estimation of the simple linear regression

$$y_t = \beta_1 + \beta_2 \hat{x}_t + error_t \qquad (13.3.22)$$

Least squares estimation of (13.3.22) is numerically equivalent to obtaining the instrumental variables estimates using (13.3.21).

Another useful result is that the approximate, large sample, variance of $\hat{\beta}_2$ is given by the usual formula for the variance of the least squares estimator of (13.3.22),

$$\text{var}(\hat{\beta}_2) = \frac{\sigma^2}{\sum (\hat{x}_t - \bar{x})^2} \qquad (13.3.23)$$

Unfortunately standard least squares software cannot be used to obtain appropriate standard errors and t-values, because the estimator of the error variance must be based on the residuals from the original model, $y_t = \beta_1 + \beta_2 x_t + e_t$, yielding

$$\hat{\sigma}_{IV}^2 = \frac{\sum (y_t - \hat{\beta}_1 - \hat{\beta}_2 x_t)^2}{T - 2} \qquad (13.3.24)$$

Thus the appropriate estimator of the variance of $\hat{\beta}_2$ is

$$\hat{\text{var}}(\hat{\beta}_2) = \frac{\hat{\sigma}_{IV}^2}{\sum (\hat{x}_t - \bar{x})^2} \qquad (13.3.25)$$

This estimated variance can be used as a basis for t-tests of significance and interval estimation of parameters.

13.4 Testing for Correlation Between Explanatory Variables and the Error Term

In the previous sections we discussed the fact that the ordinary least squares estimator fails if there is correlation between an explanatory variable and the error term. We also provided an estimator, the instrumental variables estimator, that can be used when the least squares estimator fails. The question we address in this section is how to test for the presence of a correlation between an explanatory variable and the error term, so that we can use the appropriate estimation procedure.

The null hypothesis is $H_0 : \operatorname{cov}(x, e) = 0$ against the alternative that $H_1 : \operatorname{cov}(x, e) \neq 0$. The idea of the test is to compare the performance of the least squares estimator to an instrumental variables estimator. Under the null and alternative hypotheses we know the following:

- If the null hypothesis is true, both the least squares estimator and the instrumental variables estimator are consistent. Thus, in large samples the difference between them converges to zero. That is, $q = (b_{ols} - \hat{\beta}_{IV}) \rightarrow 0$. Naturally if the null hypothesis is true, use the more efficient estimator, which is the least squares estimator.

- If the null hypothesis is false, the least squares estimator is not consistent, and the instrumental variables estimator is consistent. Consequently the difference between them does not converge to zero in large samples. That is, $q = (b_{ols} - \hat{\beta}_{IV}) \rightarrow c \neq 0$. If the null hypothesis is not true, use the instrumental variables estimator, which is consistent.

There are several forms of the test, usually called the "**Hausman Test**," for these null and alternative hypotheses. One form of the test directly examines the differences between the least squares and instrumental variables estimators, as we have described above. Many computer software programs implement this test, which sometimes can be computationally difficult to carry out.

An alternative form of the test is very easy to implement and is the one we suggest here. In the regression $y_t = \beta_1 + \beta_2 x_t + e_t$ we wish to know whether x is correlated with e. Let z_{t1} and z_{t2} be instrumental variables for x. At a minimum you need one instrument for each variable you think might be correlated with the error term. Then carry out the following steps:

- Estimate the model $x_t = a_0 + a_1 z_{t1} + a_2 z_{t2} + v_t$ by least squares, and obtain the residuals $\hat{v}_t = x_t - \hat{a}_0 - \hat{a}_1 z_{t1} - \hat{a}_2 z_{t2}$. If more than one explanatory variables are questionable, repeat this estimation for each one, using all available instrumental variables in each regression.

- Include the residuals computed in step 1 as an explanatory variable in the regression, $y_t = \beta_1 + \beta_2 x_t + \delta \hat{v}_t + e_t$. Estimate this "artificial regression" by least squares, and employ the usual t-test for the hypothesis of significance.

$$H_0 : \delta = 0 \qquad \text{(no correlation between } x \text{ and } e\text{)}$$
$$H_1 : \delta \neq 0 \qquad \text{(correlation between } x \text{ and } e\text{)}$$

- If more than one variable is suspect, the test will be an F-test of joint significance of the coefficients on the included residuals.

13.4.1 AN EMPIRICAL EXAMPLE OF THE HAUSMAN TEST

We illustrate the Hausman test using the savings-permanent income example. Following these steps, the estimated artificial regression $y_t = \beta_1 + \beta_2 x_t + \delta \hat{v}_t + e_t$ yields the results in Table 13.5.

Table 13.5 The Hausman Test via Artificial Regression

Variable	Label	DF	Parameter Estimate	Standard Error	t Value	Pr > \|t\|
Intercept	Intercept	1	0.98827	1.17168	0.84	0.4032
x		1	0.03918	0.01540	2.54	0.0143
vhat	Residual	1	−0.07550	0.02010	−3.76	0.0005

The estimated coefficient of \hat{v}_t has a t-value of $t = -3.757$, which is statistically significant at the .01 level of significance. Thus, at the .01 level of significance, we can reject the null hypothesis that x and e are uncorrelated, and accept the alternative that there is correlation between x and e. The outcome of this test supports the decision to use instrumental variable estimation in this problem.

In Tables 13.3 and 13.4 we have the least squares and instrumental variable (two-stage least squares) estimates of the savings-permanent income relationship. The SAS software package computes the Hausman test statistic value (often called "m") comparing the slope and intercept estimates from the two procedures. The SAS output is shown in Table 13.6. When comparing both the slope and intercept the test statistic has a chi-square distribution with 2 degrees of freedom. The value of the test statistic is $m = 7.1064$, which gives a p-value of .0286. Thus, at the .05 level of significance, we can reject the null hypothesis that x and e are uncorrelated, and accept the alternative that there is correlation between x and e. The outcome of this test supports the decision to use instrumental variable estimation in this problem.

Table 13.6 SAS's Hausman Test Output

MODEL Procedure

Hausman's Specification Test Results

Comparing To		DF	m-Stat	Prob
OLS	2SLS	2	7.11	0.0286

13.5 Learning Objectives

Based on the material in this chapter you should be able to:

1. Explain why we might sometimes consider explanatory variables in a regression model to be random.

2. Explain the difference between finite sample and large sample properties of estimators.

3. Draw a diagram illustrating the probability density functions of a consistent estimator as the sample size increases. Explain why consistency is a desirable property of an estimator, and how we know the least squares estimator (in the simple linear regression model) is consistent under the classical assumptions of Chapter 3.

4. Give an intuitive explanation of why correlation between a random x and the error term causes the least squares estimator to be inconsistent.

5. Describe the "errors-in-variables" problem in econometrics and its consequences for the least squares estimator.

6. Describe the properties of a good instrumental variable.

7. Discuss how the method of moments can be used to derive the least squares and instrumental variables estimators, paying particular attention to the assumptions upon which the derivations are based.

8. Explain why it is important for an instrumental variable to be highly correlated with the random explanatory variable for which it is an instrument.

9. Describe how instrumental variables estimation is carried out in the case of surplus instruments.

10. State the large-sample distribution of the instrumental variables estimator for the simple linear regression model, and how it can be used for the construction of interval estimates and hypothesis tests.

11. Describe a test for the existence of correlation between the error term and the explanatory variables in a model, explaining the null and alternative hypotheses, and the consequences of rejecting the null hypothesis.

13.6 **Exercises**

13.1 The 25 values of x and e in *table13-1.dat* were generated artificially. Using your computer software:
(a) Create the value of the dependent variable y from the model $y = \beta_1 + \beta_2 x + e = 1 + 1 \times x + e$, as described in Section 13.2.4a.
(b) In the same graph, plot the value of y against x, and the regression function $E(y) = 1 + 1 \times x$. Note that the data do not fall randomly about the regression function.
(c) Using the data on y created in part (a), and x, obtain the least squares estimates of the parameters β_1 and β_2. Compare the estimated values of the parameters to the true values.
(d) Plot the data and the fitted least squares regression line $\hat{y} = b_1 + b_2 x$. Compare this plot to the one in part (b).
(e) Compute the least squares residuals from the least squares regression in part (d). Find the sample correlation matrix of the variables x, e, and the least squares residuals $\hat{e} = y - b_1 - b_2 x$. Comment on the values of the correlations. Which of these correlations could you <u>not</u> compute in a real problem?

13.2 Using your computer software, and the 50 observations on savings (y), income (x) and averaged income (z) in *table13-2.dat*, verify the results in Tables 13.3, 13.4, and 13.5. That is,

(a) Estimate a least squares regression of savings on income.

(b) Estimate the relation between savings and permanent income using the instrumental variables estimator, with instrument z.

(c) Follow the steps described in Section 13.4 to carry out the Hausman test (via an artificial regression) for the existence of correlation between x and the random disturbance e. If your software has an automatic command to compute the Hausman test statistic, compute it. Does it compute the statistic as in Table 13.5 or Table 13.6?

13.3 Using your computer software, and the 50 observations on savings (y), income (x), and averaged income (z) in *table13-2.dat*, use two least squares regressions to obtain the estimates in Table 13.4. That is, estimate a first-stage regression of current income x on permanent income z, saving the predicted value \hat{x}. Estimate (13.3.22) by least squares. Compare the estimates, standard errors, and t-statistics to those in Table 13.4 and comment on the differences.

13.4 Solve (13.3.11) to obtain the instrumental variables estimators in (13.3.12).

13.5 The 500 values of x, y, z_1, and z_2 in *table13-3.dat* were generated artificially. The variable $y = \beta_1 + \beta_2 x + e = 3 + 1 \times x + e$.

(a) The explanatory variable x follows a normal distribution with mean zero and variance $\sigma_x^2 = 2$. The random error e is normally distributed with mean zero and variance $\sigma_e^2 = 1$. The covariance between x and e is 0.9. Find the correlation between x and e.

(b) Given the values of y and x, and the values of $\beta_1 = 3$ and $\beta_2 = 1$, solve for the values of the random disturbances e. Find the sample correlation between x and e and compare it to your answer in (a).

(c) In the same graph, plot the value of y against x, and the regression function $E(y) = 3 + 1 \times x$. Note that the data do not fall randomly about the regression function.

(d) Estimate the regression model $y = \beta_1 + \beta_2 x + e$ by least squares using a sample consisting of the first $T = 10$ observations on y and x. Repeat using $T = 20$, $T = 100$, and $T = 500$. What do you observe about the least squares estimates? Are they getting closer to the true values as the sample size increases, or not? If not, why not?

(e) The variables z_1 and z_2 were constructed to have normal distributions with means 0 and variances 1, and to be correlated with x but uncorrelated with e. Using the full set of 500 observations, find the sample correlations between z_1, z_2, x, and e. Will z_1 and z_2 make good instrumental variables? Why? Is one better than the other? Why?

(f) Estimate the model $y = \beta_1 + \beta_2 x + e$ by instrumental variables using a sample consisting of the first $T = 10$ observations and the instrument z_1. Repeat using $T = 20$, $T = 100$, and $T = 500$. What do you observe about the IV estimates? Are they getting closer to the true values as the sample size increases, or not? If not, why not?

(g) Estimate the model $y = \beta_1 + \beta_2 x + e$ by instrumental variables using a sample consisting of the first $T = 10$ observations and the instrument z_2. Repeat using $T = 20$, $T = 100$, and $T = 500$. What do you observe about the IV estimates? Are they getting closer to the true values as the sample size increases, or not? If not, why not? Comparing the results using z_1 alone to those here, using z_2 alone, which instrument leads to more precise estimation? Why?

(h) Estimate the model $y = \beta_1 + \beta_2 x + e$ by instrumental variables using a sample consisting of the first $T = 10$ observations and the instruments z_1 and z_2. Repeat using $T = 20$, $T = 100$, and $T = 500$. What do you observe about the IV estimates? Are they getting closer to the true values as the sample size increases, or not? If not, why not? Is estimation more precise using two instruments than one, as in parts (f) and (g)?

13.6 A consulting firm run by Mr. John Chardonnay is investigating the relative efficiency of wine production at 75 Californian wineries. John sets up the production function

$$y_t = \beta_1 + \beta_2 mgt_t + \beta_3 cap_t + \beta_4 lab_t + e_t$$

where y_t is an index of wine output for the tth winery, taking into account both quantity and quality, mgt_t is a variable that reflects the efficiency of management, cap_t is an index of capital input and lab_t is an index of labor input. Because he cannot get data on management efficiency, John collects observations on the number years of experience ($xper_t$) of each winery manager and uses that variable in place of mgt_t. The 75 observations are stored in the file *chard.dat*.

(a) Estimate the revised equation using least squares and comment on the results.

(b) Find corresponding interval estimates for wine output at wineries that have the sample average values for labor and capital and have managers with
 (i) 10 years' experience
 (ii) 20 years' experience
 (iii) 30 years' experience.

(c) John is concerned that the proxy variable $xper_t$ might be correlated with the error term. He decides to do a Hausman test, using the manager's age (age_t) as an instrument for $xper_t$, and cap_t and lab_t as instruments for themselves. Regress $xper_t$ on age_t, cap_t, and lab_t and save the residuals. Include these residuals as an extra variable in the equation you estimated in part (a), and comment on the outcome of the Hausman test.

(d) Use the instrumental variables estimator to estimate the equation

$$y_t = \beta_1 + \beta_2 xper_t + \beta_3 cap_t + \beta_4 lab_t + e_t$$

with age_t, cap_t, and lab_t as the instrumental variables. Comment on the results and compare them with those obtained in part (a).

(e) Find corresponding interval estimates for wine output at wineries that have the sample average values for labor and capital and have managers with
 (i) 10 years' experience
 (ii) 20 years' experience
 (iii) 30 years' experience.
 Compare these interval estimates with those obtained in part (b).

Chapter *14*

Simultaneous Equations Models

14.1 Introduction

For most of us, our first encounter with economic models comes through studying *supply and demand* models, in which the market price and quantity of goods sold are *jointly determined* by the equilibrium of supply and demand. In this chapter we consider econometric models for data that are *jointly determined* by two or more economic relations. These **simultaneous equations** models differ from those we have considered in previous chapters because in each model there are *two* or more dependent variables rather than just one.

Simultaneous equations models also differ from most of the econometric models we have considered so far because they consist of a *set of equations*. For example, price and quantity are determined by the interaction of two equations, one for supply and one for demand. Simultaneous equations models, which contain more than one dependent variable and more than one equation, require special statistical treatment. The least squares estimation procedure *is not* appropriate in these models and we must develop new ways to obtain reliable estimates of economic parameters.

14.2 A Supply and Demand Model

Supply and demand *jointly* determine the market price of a good and the amount of it that is sold. Graphically, you recall that market equilibrium occurs at the intersection of the supply and demand curves, as shown in Figure 14.1.

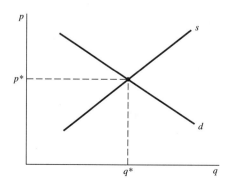

FIGURE *14.1* Supply and demand equilibrium.

An econometric model that explains market price and quantity should consist of two equations, one for supply and one for demand. It will be a simultaneous equations model since both equations working together determine price and quantity. A very simple model might look like the following:

$$\text{Demand:} \qquad q = \alpha_1 p + \alpha_2 y + e_d \qquad\qquad (14.2.1)$$

$$\text{Supply:} \qquad q = \beta_1 p + e_s \qquad\qquad\qquad\quad (14.2.2)$$

In this model we assume that the quantity demanded (q) is a function of price (p) and income (y), plus an error term e_d. Quantity supplied is taken to be only a function of price. We have omitted the intercepts to make the algebra easier. In practice we would include intercept terms in these models.

The point we wish to make very clear is that it takes *two* equations to describe the supply and demand equilibrium. The *two* equilibrium values, for price and quantity, p^* and q^*, respectively, are determined at the same time. In this model the variables p and q are called **endogenous** variables because their values are determined within the system we have created. The income variable y has a value that is given to us, and which is determined outside this system. It is called an **exogenous** variable.

Random errors are added to the supply and demand equations for the usual reasons, and we assume that they have the usual properties:

$$E(e_d) = 0, \qquad \text{var}(e_d) = \sigma_d^2$$

$$E(e_s) = 0, \qquad \text{var}(e_s) = \sigma_s^2$$

$$\text{cov}(e_d, e_s) = 0 \qquad\qquad\qquad (14.2.3)$$

Let us emphasize the difference between simultaneous equations models and regression models using influence diagrams. An "influence diagram" is a graphical representation of relationships between model components. In the previous chapters we would have modeled the supply and demand relationships as separate regressions, implying the influence diagrams in Figure 14.2. In this diagram the circles represent random variables and the squares represent fixed, exogenous, quantities. In regression analysis the direction of the influence is one-way: from the explanatory variable and the error term to the dependent variable.

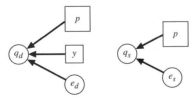

FIGURE **14.2** Influence diagrams for two regression models.

In this case there is no equilibrating mechanism that will lead quantity demanded to equal quantity supplied at a market-clearing price. For price to adjust to the market clearing equilibrium there must be an influence running from p to q and from q to p.

Recognizing that price p and quantity q are *jointly determined,* and that there is feedback between them, suggests the influence diagram in Figure 14.3.

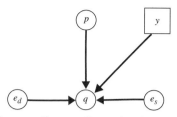

FIGURE **14.3** Influence diagram for a simultaneous equations model.

In the simultaneous equations model we see the feedback between p and q because they are jointly determined. The random error terms e_d and e_s affect both p and q, suggesting a correlation between each of the endogenous variables *and* each of the random error terms. As we will see, this leads to failure of the least squares estimator in simultaneous equations models. Income, y, is a fixed, exogenous, variable that affects the endogenous variables, but there is no feedback from p and q to y.

The fact that p is random means that on the right-hand side of the supply and demand equations we have an explanatory variable that is random. This is contrary to the assumption of "fixed explanatory variables" that we usually make in regression model analysis. Furthermore, as we have suggested, p and the random errors, e_d and e_s, are correlated, which has a devastating impact on our usual least squares estimation procedure, making the least squares estimator biased and inconsistent. For a full discussion of these issues in a general context, see Chapter 13.

14.3 **The Reduced Form Equations**

The two structural equations (14.2.1) and (14.2.2) can be solved, to express the endogenous variables p and q as functions of the exogenous variable y. This reformulation of the model is called the **reduced form** of the structural equation system. The reduced form is very important in its own right, and it also helps us understand the structural equation system. To find the reduced form we solve (14.2.1) and (14.2.2) simultaneously for p and q.

To solve for p, set q in the demand and supply equations to be equal,

$$\beta_1 p + e_s = \alpha_1 p + \alpha_2 y + e_d$$

Then solve for p,

$$p = \frac{\alpha_2}{(\beta_1 - \alpha_1)} y + \frac{e_d - e_s}{(\beta_1 - \alpha_1)}$$

$$= \pi_1 y + v_1 \tag{14.3.1}$$

To solve for q, substitute the value of p in (14.3.1) into either the demand or supply equation. The supply equation is simpler, so we will substitute p into (14.2.2) and simplify.

$$q = \beta_1 p + e_s = \beta_1 \left[\frac{\alpha_2}{(\beta_1 - \alpha_1)} y + \frac{e_d - e_s}{(\beta_1 - \alpha_1)} \right] + e_s$$

$$= \frac{\beta_1 \alpha_2}{(\beta_1 - \alpha_1)} y + \frac{\beta_1 e_d - \alpha_1 e_s}{(\beta_1 - \alpha_1)}$$

$$= \pi_2 y + v_2 \tag{14.3.2}$$

The parameters π_1 and π_2 in (14.3.1) and (14.3.2) are called *reduced form parameters*. The error terms v_1 and v_2 are called *reduced form errors*, or disturbance terms.

The reduced form equations can be estimated consistently by least squares. The explanatory variable y is exogenous and determined outside this system. It is not correlated with the disturbances v_1 and v_2, which themselves have the usual properties of zero mean, constant variances, and zero covariance. Thus the least squares estimator is BLUE for the purpose of estimating π_1 and π_2.

The reduced form equations are important for economic analysis. These equations relate the *equilibrium* values of the endogenous variables to the exogenous variables. Thus, if there is an increase in income y, π_1 is the expected increase in price, after market adjustments lead to a new equilibrium for p and q. Similarly, π_2 is the expected increase in the equilibrium value of q. (*Question:* How did we determine the directions of these changes?) Second, and using the same logic, the estimated reduced form equations can be used to *predict* values of equilibrium price and quantity for different levels of income. Clearly, CEOs and other market analysts are interested in the ability to forecast both prices and quantities sold of their products. It is the estimated reduced form equations that make such predictions possible.

14.4 The Failure of Least Squares Estimation in Simultaneous Equations Models

In this section we explain why the least squares estimator should not be used to estimate the supply equation (14.2.2) in the simultaneous equations model given by the two equations

$$\text{Demand:} \quad q = \alpha_1 p + \alpha_2 y + e_d \tag{14.2.1}$$
$$\text{Supply:} \quad q = \beta_1 p + e_s \tag{14.2.2}$$

In the supply equation (14.2.2), the random explanatory variable p on the right-hand side of the equation is *correlated* with the error term e_s. The existence of this correlation can be seen in both intuitive and algebraic ways.

14.4.1 An Intuitive Explanation of the Failure of Least Squares

Intuitively, suppose there is a small change, or blip, in the error term e_s, say Δe_s. Let us trace the effect of this change through the system.

The blip Δe_s in the error term of (14.2.2) is directly transmitted to the equilibrium value of p. This is clear from the reduced form equation (14.3.1). Every time there

is a change in the supply equation error term, e_s, it has a direct linear effect upon p. Since $\beta_1 > 0$ and $\alpha_1 < 0$, if $\Delta e_s > 0$, then $\Delta p < 0$. Thus, every time there is a change in e_s there is an associated change in p in the opposite direction. Consequently, p and e_s are negatively correlated.

The failure of least squares estimation for the supply equation can be explained as follows: least squares estimation of the relation between q and p gives "credit" to price for the effect of changes in the disturbances. This occurs because we do not observe the change in the disturbance, but only the change in p resulting from its correlation with the disturbance. The least squares estimator of β_1 will *understate* the true parameter value in this model. In large samples, the least squares estimator will tend to be negatively biased. This bias persists even when the sample size is large, and thus the least squares estimator is inconsistent. This means that the probability distribution of the least squares estimator will "collapse" about a point that is not the true parameter value as the sample size $T \to \infty$ (see Chapter 13.2.2).

The intuitive argument will now be verified algebraically. The demonstration can be skipped if you wish to move ahead quickly. The results are summarized as follows:

> The least squares estimator of parameters in a structural simultaneous equation is biased and inconsistent because of the correlation between the random error and the endogenous variables on the right-hand side of the equation.

14.4.2 AN ALGEBRAIC EXPLANATION OF THE FAILURE OF LEAST SQUARES

First, let us obtain the covariance between p and e_s.

$$\text{cov}(p, e_s) = E[p - E(p)][e_s - E(e_s)]$$

$$= E(pe_s) \qquad \text{[since } E(e_s) = 0 \text{]}$$

$$= E[\pi_1 y + v_1]e_s \qquad \text{(substitute for } p\text{)}$$

$$= E\left[\frac{e_d - e_s}{\beta_1 - \alpha_1}\right]e_s \qquad \text{(since } \pi_1 y \text{ is exogenous)}$$

$$= \frac{-E(e_s^2)}{\beta_1 - \alpha_1} \qquad \text{(since } e_d, e_s \text{ assumed uncorrelated)}$$

$$= \frac{-\sigma_s^2}{\beta_1 - \alpha_1} < 0$$

$$(14.4.1)$$

As noted in the previous section, this covariance is negative.

What impact does the negative covariance in (14.4.1) have on the least squares estimator? The least squares estimator in (14.2.2) (which does not have an intercept term) is

$$b_1 = \frac{\sum p_t q_t}{\sum p_t^2} \qquad (14.4.2)$$

Substitute for q from (14.3.2) and simplify,

$$b_1 = \frac{\sum p_t(\beta_1 p_t + e_{st})}{\sum p_t^2} = \beta_1 + \sum \left(\frac{p_t}{\sum p_t^2} \right) e_{st} = \beta_1 + \sum h_t e_{st} \qquad (14.4.3)$$

where

$$h_t = \frac{p_t}{\sum p_t^2}$$

The expected value of the least squares estimator is

$$E(b_1) = \beta_1 + \sum E(h_t e_{st}) \neq \beta_1 \qquad (14.4.4)$$

The expectation $E(h_t e_{st}) \neq 0$ because e_s and p are correlated.

In large samples there is a similar failure. Multiply through the supply equation by price, p, take expectations and solve.

$$pq = \beta_1 p^2 + p e_s$$

$$E(pq) = \beta_1 E(p^2) + E(p e_s)$$

$$\beta_1 = \frac{E(pq)}{E(p^2)} - \frac{E(p e_s)}{E(p^2)} \qquad (14.4.5)$$

In large samples, as $T \rightarrow \infty$, sample analogs of expectations, which are averages, converge to the expectations. That is, $\sum q_t p_t / T \rightarrow E(pq)$, $\sum p_t^2 / T \rightarrow E(p^2)$. Consequently, because the covariance between p and e_s is negative, from (14.4.1),

$$b_1 = \frac{\sum q_t p_t / T}{\sum p_t^2 / T} \rightarrow \frac{E(pq)}{E(p^2)} = \beta_1 + \frac{E(p e_s)}{E(p^2)} = \beta_1 - \frac{\sigma_s^2 / (\beta_1 - \alpha_1)}{E(p^2)} < \beta_1$$

$$(14.4.6)$$

The least squares estimator of the slope of the supply equation, in large samples, converges to a value less than β_1.

14.5 The Identification Problem

In the supply and demand model given by (14.2.1) and (14.2.2), the parameters of the demand equation, α_1 and α_2, cannot be consistently estimated by *any* estimation method. The slope of the supply equation, β_1, can be consistently estimated. How are we able to make such statements? The answer is quite intuitive, and it can be illustrated graphically. What happens when income y changes? The demand curve shifts and a new equilibrium price and quantity are created. In Figure 14.4 we show the demand curves d_1, d_2, and d_3 and equilibria, at points a, b, and c, for three levels of income.

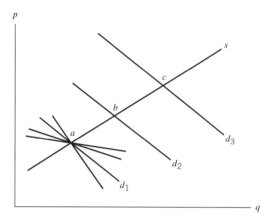

FIGURE **14.4** The effect of changing income.

As income changes, data on price and quantity will be observed around the inter-
sections of supply and demand. The random errors e_d and e_s cause small shifts in the
supply and demand curves, creating equilibrium observations on price and quantity
that are scattered about the intersections at points a, b, and c.

The data values will trace out the *supply curve*, suggesting that we can fit a line
through them to estimate the slope β_1. The data values fall along the supply curve
because income is present in the demand curve and *absent* from the supply curve.
As income changes the demand curve shifts but the supply curve remains fixed,
resulting in observations along the supply curve.

There are *no* data values falling along any of the demand curves, and there is
no way to estimate their slope. Any one of an infinite number of demand curves
passing through the equilibrium points could be correct. Given the data, there is no
way to distinguish the true demand curve from all the rest. Through the equilibrium
point a we have drawn a few demand curves, each of which could have generated
the data we observe.

The problem lies with the model that we are using. There is no variable in the
supply equation that will shift it relative to the demand curve. If we were to add
a variable to the supply curve, say w, then each time w changed the supply curve
would shift and the demand curve would stay fixed. The shifting of supply relative
to a fixed demand curve (since w is *absent* from the demand equation) would create
equilibrium observations along the demand curve, making it possible to estimate the
slope of the demand curve and the effect of income on demand.

It is the *absence* of variables from an equation that makes it possible to estimate
its parameters. A general rule, which is called a condition for *identification* of an
equation, is this:

> **A NECESSARY CONDITION FOR IDENTIFICATION:** In a system of M
> simultaneous equations, which jointly determine the values of M endogenous vari-
> ables, at least $M-1$ variables must be absent from an equation for estimation of
> its parameters to be possible. When estimation of an equation's parameters is pos-
> sible, then the equation is said to be *identified*, and its parameters can be estimated
> consistently. If less than $M-1$ variables are omitted from an equation, then it is
> said to be *unidentified* and its parameters cannot be consistently estimated.

In our supply and demand model there are $M = 2$ equations and there is a total of three variables: p, q, and y. In the demand equation none of the variables are omitted; thus it is unidentified and its parameters cannot be estimated consistently. In the supply equation $M - 1 = 1$ and one variable, income, is omitted; the supply curve is identified, and its parameter can be estimated.

The identification condition must be checked *before* trying to estimate an equation. If an equation is not identified, then changing the model must be considered, before it is estimated. However, changing the model should not be done in a haphazard way; no important variable should be omitted from an equation just to identify it. The structure of a simultaneous equations model should reflect your understanding of how equilibrium is achieved and should be consistent with economic theory. Creating a false model is not a good solution to the identification problem.

> **REMARK:** The two-stage least squares estimation procedure is developed in Chapter 13 and shown to be an instrumental variables estimator. The number of instrumental variables required for estimation of an equation within a simultaneous equations model is equal to the number of right-hand-side endogenous variables. In a typical equation within a simultaneous equations model, several exogenous variables appear on the right-hand side. Thus instruments must come from those exogenous variables omitted from the equation in question. Consequently, identification requires that the number of omitted exogenous variables in an equation be at least as large as the number of right-hand-side endogenous variables. This ensures an adequate number of instrumental variables.

14.6 Two-Stage Least Squares Estimation

In this section we briefly describe the most widely used method for estimating the parameters in an identified structural equation. The estimator is called *two-stage least squares* (which is often abbreviated as *2SLS*) because it is based on two least squares regressions. We will explain how it works by considering the supply equation in (14.2.2):

$$q = \beta_1 p + e_s \qquad (14.2.2)$$

We cannot apply least squares to estimate β_1 in this equation because the endogenous variable p on the right-hand side of the equation is random, and it is correlated with the error term e_s.

The variable p is composed of a *systematic* part, which is its expected value $E(p)$, and a *random* part, which is the reduced form random error v_1. That is,

$$p = E(p) + v_1 = \pi_1 y + v_1 \qquad (14.6.1)$$

In the supply equation (14.2.2) the portion of p that causes problems for the least squares estimator is v_1, the random part. It is v_1 that causes p to be correlated with the error term e_s. Suppose we *knew* the value of π_1. Then we could replace p in

(14.2.2) by (14.6.1) to obtain

$$q = \beta_1[E(p) + v_1] + e_s$$
$$= \beta_1 E(p) + (\beta_1 v_1 + e_s)$$
$$= \beta_1 E(p) + e_* \tag{14.6.2}$$

In (14.6.2) the explanatory variable on the right-hand side is $E(p)$. It is not a random variable, and it is not correlated with the error term e_*. We could apply least squares to (14.6.2) to consistently estimate β_1.

Of course, we cannot use the variable $E(p) = \pi_1 y$ in place of p, since we do not know the value of π_1. However, we can *estimate* π_1 using $\hat{\pi}_1$ from the reduced form equation for p. Then, a consistent estimator for $E(p)$ is

$$\hat{p} = \hat{\pi}_1 y$$

Using \hat{p} as a replacement for $E(p)$ in (14.6.2) we obtain

$$q = \beta_1 \hat{p} + \hat{e}_* \tag{14.6.3}$$

In large samples, \hat{p} and the random error \hat{e}_* are uncorrelated, and consequently the parameter β_1 can be consistently estimated by applying least squares to (14.6.3).

Estimating (14.6.3) by least squares generates the so-called **two-stage least squares** estimator of β_1, which is consistent and asymptotically normal. To summarize, the *two stages* of the estimation procedure are:

1. Least squares estimation of the reduced form equation for p and the calculation of its predicted value, \hat{p}.

2. Least squares estimation of the structural equation in which the right-hand side endogenous variable p is replaced by its predicted value \hat{p}.

> **REMARK:** The discussion above is an attempt to provide a rough, intuitive explanation of the two-stage least squares estimator. For a more complete and logically developed explanation of this estimation method, we urge you to read Chapter 13, and especially Chapter 13.3. There we derive the two-stage least squares estimator and discuss its properties.

14.6.1 THE GENERAL TWO-STAGE LEAST SQUARES ESTIMATION PROCEDURE

The two-stage least squares estimation procedure can be used to estimate the parameters of any identified equation within a simultaneous equations system. In a system of M simultaneous equations, let the endogenous variables be y_1, y_2, \ldots, y_M. Let there be K exogenous variables, x_1, x_2, \ldots, x_K. Suppose the first structural equation within this system is

$$y_1 = \alpha_2 y_2 + \alpha_3 y_3 + \beta_1 x_1 + \beta_2 x_2 + e_1 \tag{14.6.4}$$

If this equation is identified, then its parameters can be estimated in the two steps:

1. Estimate the parameters of the reduced form equations

$$y_2 = \pi_{12}x_1 + \pi_{22}x_2 + \cdots + \pi_{K2}x_K + v_2$$
$$y_3 = \pi_{13}x_1 + \pi_{23}x_2 + \cdots + \pi_{K3}x_K + v_3$$

 by least squares and obtain the predicted values

$$\hat{y}_2 = \hat{\pi}_{12}x_1 + \hat{\pi}_{22}x_2 + \cdots + \hat{\pi}_{K2}x_K$$
$$\hat{y}_3 = \hat{\pi}_{13}x_1 + \hat{\pi}_{23}x_2 + \cdots + \hat{\pi}_{K3}x_K \qquad (14.6.5)$$

2. Replace the endogenous variables, y_2 and y_3 on the right-hand side of the structural equation (14.6.4) by their predicted values from (14.6.5)

$$y_1 = \alpha_2\hat{y}_2 + \alpha_3\hat{y}_3 + \beta_1 x_1 + \beta_2 x_2 + e_1^*$$

 Estimate the parameters of this equation by least squares.

14.6.2 THE PROPERTIES OF THE TWO-STAGE LEAST SQUARES ESTIMATOR

We have described how to obtain estimates for structural equation parameters in identified equations. As for the properties of the two-stage least squares estimator, we will say the following:

- The 2*SLS* estimator is a biased estimator, but it is consistent.

- In large samples the 2*SLS* estimator is approximately normally distributed.

- The variances and covariances of the 2*SLS* estimator are unknown in small samples, but for large samples we have expressions that we can use as approximations. These formulas are built into econometric software packages, which report standard errors and *t*-values just like an ordinary least squares regression program.

- If you obtain 2*SLS* estimates by applying two least squares regressions using ordinary least squares regression software, the standard errors and *t*-values reported in the *second* regression are *not* correct for the 2*SLS* estimator. Always use specialized 2*SLS* software when obtaining estimates of structural equations.

14.7 An Example of Two-Stage Least Squares Estimation

Truffles are a gourmet delight. They are edible fungi that grow below the ground. In France they are often located by collectors who use pigs to sniff out the truffles and "point" to them. Actually, the pigs dig frantically for the truffles because pigs—as well as the French—have an insatiable taste for them, and they must be restrained

from "pigging out" on them. Let us consider a supply and demand model for truffles:

$$\text{Demand:} \qquad q_t = \alpha_1 + \alpha_2 p_t + \alpha_3 ps_t + \alpha_4 di_t + e_t^d \qquad (14.7.1)$$
$$\text{Supply:} \qquad q_t = \beta_1 + \beta_2 p_t + \beta_3 pf_t + e_t^s \qquad (14.7.2)$$

In this demand equation q is the quantity of truffles traded in a particular French market at time t, p is the market price of truffles, ps is the market price of a substitute for real truffles (another fungus much less highly prized), and di is per capita disposable income. The supply equation contains the market price and quantity supplied. Also, it includes pf, the price of a factor of production, which in this case is the hourly rental price of truffle pigs used in the search process. In this model we assume that p and q are endogenous variables. The exogenous variables are ps, di, pf, and the intercept variables.

14.7.1 IDENTIFICATION

Before thinking about estimation, let us check the identification of each equation. The rule for identifying an equation is that in a system of M equations at least $M-1$ variables must be omitted from each equation in order for it to be identified. In the demand equation the variable pf is not included and thus the necessary $M - 1 = 1$ variable is omitted. In the supply equation both ps and di are absent—more than enough to satisfy the identification condition. Note, too, that the variables that are omitted are different for each equation, ensuring that each contains at least one *shift* variable not present in the other. We conclude that each equation in this system is identified and can thus be estimated by two-stage least squares.

Why are the variables omitted from their respective equations? Because economic theory says that the price of a factor of production should affect supply but not demand—and the price of substitute goods and income should affect demand and not supply. The specifications we used are based on the microeconomic theory of supply and demand.

14.7.2 THE REDUCED FORM EQUATIONS

The reduced form equations express each endogenous variable, p and q, in terms of the exogenous variables ps, di, pf, and the intercept variable, plus an error term.

$$q_t = \pi_{11} + \pi_{21} ps_t + \pi_{31} di_t + \pi_{41} pf_t + v_{t1}$$
$$p_t = \pi_{12} + \pi_{22} ps_t + \pi_{32} di_t + \pi_{42} pf_t + v_{t2}$$

We can estimate these equations by least squares since the right-hand-side variables are exogenous and uncorrelated with the random errors v_{t1} and v_{t2}. The data file *table 14-1.dat* contains 30 observations on each of the endogenous and exogenous variables. A few of these observations are shown in Table 14.1. The price p is measured in dollars per ounce, q is measured in ounces, ps is measured in dollars per pound, di is in thousands of dollars, and pf is the hourly rental rate for a truffle-finding pig. The results of the least squares estimations of the reduced form equations for q and p are reported in Tables 14.2a and 14.2b, respectively. In Table 14.2a we see that the estimated coefficients are statistically significant, and thus, we conclude that the exogenous variables affect the quantity of truffles traded, q,

Table 14.1 **Representative Truffle Supply and Demand Data**

OBS	p	q	ps	di	pf
1	9.88	19.89	19.97	21.03	10.52
2	13.41	13.04	18.04	20.43	19.67
3	11.57	19.61	22.36	18.70	13.74
4	13.81	17.13	20.87	15.25	17.95
5	17.79	22.55	19.79	27.09	13.71

Table 14.2a **Reduced Form Equation for Quantity of Truffles (q)**

Variable	Estimate	Std. Error	t-value	p-value
INTERCEP	7.895099	3.243422	2.434	0.0221
PS	0.656402	0.142538	4.605	0.0001
DI	0.216716	0.070047	3.094	0.0047
PF	−0.506982	0.121262	−4.181	0.0003

Table 14.2b **Reduced Form Equation for Price of Truffles (p)**

Variable	Estimate	Std. Error	t-value	p-value
INTERCEP	−10.837473	2.661412	−4.072	0.0004
PS	0.569382	0.116960	4.868	0.0001
DI	0.253416	0.057478	4.409	0.0002
PF	0.451302	0.099502	4.536	0.0001

in this reduced form equation. The $R^2 = .697$ and the overall F-statistic is 19.973, which has a p-value of less than .0001. In Table 14.2b the estimated coefficients are statistically significant, indicating that the exogenous variables have an effect on market price p. The $R^2 = .889$, implying a good fit of the reduced form equation to the data. The overall F-statistic value is 69.189, which has a p-value of less than .0001, indicating that the model has statistically significant explanatory power. The reduced form equations are used to obtain \hat{p}_t, which will be used in place of p_t on the right-hand side of the supply and demand equations in the second stage of two-stage least squares.

$$\hat{p}_t = \hat{\pi}_{12} + \hat{\pi}_{22}ps_t + \hat{\pi}_{32}di_t + \hat{\pi}_{42}pf_t$$
$$= -10.837 + .569ps_t + .253di_t + .451pf_t$$

The 2*SLS* results are given in Tables 14.3a and 14.3b. The estimated demand curve results are in Table 14.3a. Note that the coefficient of price is negative, indicating that as the market price rises the quantity demanded of truffles declines, as predicted

Table 14.3a **2SLS Estimates for Truffle Demand**

Variable	Estimate	Std. Error	t-value	p-value
INTERCEP	−4.27947	5.543884	−0.772	0.4471
P	−1.12338	0.494255	−2.273	0.0315
PS	1.296033	0.355193	3.649	0.0012
DI	0.501398	0.228356	2.196	0.0372

Table 14.3b **2SLS Estimates for Truffle Supply**

Variable	Estimate	Std. Error	t-value	p-value
INTERCEP	20.0328	1.223115	16.379	0.0001
P	1.013945	0.074759	13.563	0.0001
PF	−1.00091	0.082528	−12.128	0.0001

by the law of demand. The standard errors that are reported are obtained from *2SLS* software. They and the *t*-values are valid in large samples. The *p*-value indicates that the estimated slope of the demand curve is significantly different from zero. Increases in the price of the substitute for truffles increase the demand for truffles, which is a characteristic of substitute goods. Finally, the effect of income is positive, indicating that truffles are a normal good. All of these variables have statistically significant coefficients, and thus have an effect on the quantity demanded.

The supply equation results appear in Table 14.3b. As anticipated, increases in the price of truffles increase the quantity supplied, and increases in the rental rate for truffle-seeking pigs, which is an increase in the cost of a factor of production, reduce supply. Both of these variables have statistically significant coefficient estimates.

14.8 Learning Objectives

Based on the material in this chapter you should be able to:

1. Explain why estimation of a supply and demand model requires an alternative to least squares.
2. Explain the difference between exogenous and endogenous variables.
3. Define the "identification" problem in simultaneous equations models, and give an example (different from the one in the book).
4. Define the reduced form of a simultaneous equations model and explain its usefulness.
5. Explain why it is acceptable to estimate reduced form equations by least squares.
6. Describe the similarities between the "errors-in-variables" model and the simultaneous equations model.
7. Explain why it is useful to be able to estimate supply and demand models.

8. Describe the two-stage least squares estimation procedure for estimating an equation in a simultaneous equations model, and how it resolves the estimation problem for least squares.

14.9 Exercises

14.1 Can you suggest a method for using the reduced form equations (14.3.1) and (14.3.2) to obtain an estimate of the slope of the supply function $q = \beta_1 p + e_s$? (*Hint:* look at the expressions for π_1 and π_2.)

14.2 Derive the reduced form equations from the demand and supply equations in (14.7.1) and (14.7.2) and use your computer software *for least squares regressions analysis* and the data in the file *table14-1.dat* to obtain the estimated reduced form equations in Table 14.2.

14.3 Use your computer software for simultaneous equations and the 30 observations in the file *table14-1.dat* to obtain 2SLS estimates of the system in (14.7.1) and (14.7.2). Compare your results to those in Table 14.3.

14.4 Estimate (14.7.1) and (14.7.2) by least squares regression, ignoring the fact that they form a simultaneous system. Use the data in *table14-1.dat*. Compare your results to those in Table 14.3. Do the signs of the least squares estimates agree with economic reasoning?

14.5 Assume the following simultaneous equations model for the U.S. economy:

$$c_t = \alpha_1 + \alpha_2 y_t + e_{t1}$$
$$i_t = \beta_1 + \beta_2 r_t + e_{t2}$$
$$y_t = c_t + i_t + g_t$$

where c is private consumption expenditure, i is private investment expenditure, y is gross national product, r is a weighted average of interest rates, and g is government expenditure. In this model c, i, and y are endogenous. Fifty observations for these variables are contained in the file *keynes.dat*.
(a) Briefly explain the signs you expect for the unknown parameters.
(b) Derive the reduced form equations.
(c) Estimate the reduced form equations by least squares. Use the estimated reduced form equations to predict the values of the endogenous variables if $r = 15.0$ and $g = 20.0$.
(d) Check the identification of each equation.
(e) Obtain 2SLS estimates of the unknown parameters for the identified equations and comment on their signs and statistical significance.

14.6 Assume the following simultaneous equations model for the U.S. economy:

$$c_t = \alpha_1 + \alpha_2 y_t + \alpha_3 c_{t-1} + e_{t1}$$
$$i_t = \beta_1 + \beta_2 r_t + \beta_3 y_t + e_{t2}$$
$$y_t = c_t + i_t + g_t$$

where c is private consumption expenditure, i is private investment expenditure, y is gross national product, r is a weighted average of interest rates, and g is government expenditure. In this model c, i, and y are endogenous.

The lagged endogenous variable c_{t-1} is treated as if it were exogenous. Fifty observations for these variables are contained in the file *keynes.dat*.

(a) Briefly explain the signs you expect for the unknown parameters.

(b) Derive the reduced form equations.

(c) Estimate the reduced form equations by least squares. Use the estimated reduced form equations to predict the values of the endogenous variables in the next period, given $r = 15.0$ and $g = 20.0$.

(d) Check the identification of each equation.

(e) Obtain *2SLS* estimates of the unknown parameters for the identified equations and comment on their signs and statistical significance.

Chapter 15

Distributed Lag Models

15.1 Introduction

In this chapter we focus on the dynamic nature of the economy, and the corresponding dynamic characteristics of economic data. We recognize that a change in the level of an explanatory variable may have behavioral implications beyond the time period in which it occurred. The consequences of economic decisions that result in changes in economic variables can last a long time. When the income tax is increased, consumers have less disposable income, reducing their expenditures on goods and services, which reduces profits of suppliers, which reduces the demand for productive inputs, which reduces the profits of the input suppliers, and so on. The effect of the tax increase ripples through the economy. These effects do not occur instantaneously but are spread, or *distributed*, over future time periods. As shown in Figure 15.1, economic actions or decisions taken at one point in time, t, affect the economy at time t, but also at times $t + 1$, $t + 2$, and so on.

FIGURE **15.1** The distributed lag effect.

Monetary and fiscal policy changes, for example, may take six to eight months to have a noticeable effect; then it may take twelve to eighteen months for the policy effects to work through the economy. Algebraically, we can represent this lag effect by saying that a change in a policy variable x_t has an effect on economic outcomes $y_t, y_{t+1}, y_{t+2}, \ldots$. If we turn this around slightly, then we can say that y_t is affected by the values of $x_t, x_{t-1}, x_{t-2}, \ldots$, or

$$y_t = f(x_t, x_{t-1}, x_{t-2}, \ldots) \tag{15.1.1}$$

Policymakers are, of course, aware of the lagged effects of their actions. In order to make policy changes they must be concerned with the *timing* of the changes and the length of time it takes for the major effects to take place. In order to make policy, they must know *how much* of the policy change will take place at the time of the

change, *how much* will take place one month after the change, *how much* will take place two months after the change, and so on. We are back, again, to the problem of using an economic model and economic data to learn about the workings of the economy.

In this chapter we will consider econometric models based on economic models like (15.1.1). Such models are said to be *dynamic* since they describe the evolving economy and its reactions over time. One immediate question with models like this is how far back in time we must go, or the *length* of the distributed lag. **Infinite distributed lag models** portray the effects as lasting, essentially, forever. Such models arise from economic theory and have the practical advantage of avoiding the question of how long the lag effect might be. In **finite distributed lag models** we assume that the effect of a change in a (policy) variable x_t affects economic outcomes y_t only for a certain, fixed, period of time. We begin by considering the finite lag model.

15.2 Finite Distributed Lag Models

15.2.1 AN ECONOMIC MODEL

Quarterly capital expenditures by manufacturing firms arise from appropriations decisions in prior periods. The appropriations decisions themselves are based on projections of the profitability of alternative investment projects, and comparison of the marginal efficiency of investments to the cost of capital funds. Once an investment project is decided on, funds for it are *appropriated*, or approved for expenditure. The actual expenditures arising from any appropriation decision are observed over subsequent quarters as plans are finalized, materials and labor are engaged in the project, and construction is carried out. Thus, if x_t is the amount of capital appropriations observed at a particular time, we can be sure that the effects of that decision, in the form of capital expenditures y_t, will be "distributed" over periods t, $t+1$, $t+2$, and so on until the projects are completed. Furthermore, since a certain amount of "start-up" time is required for any investment project, we would not be surprised to see the major effects of the appropriation decision delayed for several quarters. Furthermore, as the work on the investment projects draws to a close, we expect to observe the expenditures related to the appropriation x_t declining.

Since capital appropriations at time t, designated by x_t, affect capital expenditures in the current and future periods (y_t, y_{t+1}, ...), until the appropriated projects are completed, we may say equivalently that current expenditures y_t are a function of current and past appropriations x_t, x_{t-1}, Furthermore, let us assert that after n quarters, where n is the **lag length**, the effect of any appropriation decision on capital expenditure is exhasuted. We can represent this economic model as

$$y_t = f(x_t, x_{t-1}, x_{t-2}, \ldots, x_{t-n}) \qquad (15.2.1)$$

Current capital expenditures y_t depend on current capital appropriations, x_t, as well as the appropriations in the previous n periods, $x_{t-1}, x_{t-2}, \ldots, x_{t-n}$. This distributed lag model is *finite* as the duration of the effects is a finite period of time, namely n periods. We now must convert this economic model into a statistical one so that we can give it empirical content.

15.2.2 THE ECONOMETRIC MODEL

In order to convert (15.2.1) into a statistical model we must choose a functional form, add an error term, and make assumptions about the properties of the error term. As a first approximation let us assume that the functional form is linear, so that the finite lag model, with an additive error term, is

$$y_t = \alpha + \beta_0 x_t + \beta_1 x_{t-1} + \beta_2 x_{t-2} + \cdots + \beta_n x_{t-n} + e_t \quad t = n+1, \ldots, T$$

$$(15.2.2)$$

where we assume that $E(e_t) = 0$, $\text{var}(e_t) = \sigma^2$, and $\text{cov}(e_t, e_s) = 0$. Note that if we have T observations on the pairs (y_t, x_t) then only $T - n$ *complete* observations are available for estimation, since n observations are "lost" in creating $x_{t-1}, x_{t-2}, \ldots, x_{t-n}$.

In this finite distributed lag the parameter α is the intercept and the parameter β_i is called a **distributed lag weight** to reflect the fact that it measures the effect of changes in past appropriations, Δx_{t-i}, on expected current expenditures, $\Delta E(y_t)$, all other things held constant. That is,

$$\frac{\partial E(y_t)}{\partial x_{t-i}} = \beta_i \qquad (15.2.3)$$

Equation (15.2.2) can be estimated by least squares if the error term e_t has the usual desirable properties. However, collinearity is often a serious problem in such models. Recall from Chapter 8 that collinearity is a problem caused by explanatory variables that are correlated with one another. In (15.2.2) the variables x_t and x_{t-1}, and other pairs of lagged x's as well, are likely to be closely related when using time-series data. If x_t follows a pattern over time, then x_{t-1} will follow a similar pattern, thus causing x_t and x_{t-1} to be correlated. There may be serious consequences from applying least squares to these data. Some of these consequences are imprecise least squares estimation, leading to wide interval estimates, coefficients that are statistically insignificant, estimated coefficients that may have incorrect signs, and results that are very sensitive to changes in model specification or the sample period. These consequences mean that the least squares estimates may be unreliable. Since the pattern of lag weights will often be used for policy analysis, this imprecision may have adverse social consequences. Imposing a tax cut at the *wrong* time in the business cycle can do much harm.

15.2.3 AN EMPIRICAL ILLUSTRATION

Consider the problem of estimating the relationship between quarterly capital expenditures and appropriations for U.S. Manufacturing firms. The data are contained in the file *table15-1.dat*. Some of the observations are shown in Table 15.1. We assume that $n = 8$ periods are required to exhaust the expenditure effects of a capital appropriation in manufacturing. The basis for this choice is investigated in Section 15.2.5, since the lag length n is actually an unknown constant. The least squares parameter estimates for the finite lag model (15.2.2) are given in Table 15.2. The R^2 for the estimated relation is 0.99 and the overall F-test value is 1174.8. The statistical model "fits" the data well, and the F-test of the joint hypotheses that all distributed lag weights $\beta_i = 0$, $i = 0, \ldots, 8$, is rejected at the $\alpha = .01$ level of signif-

Table 15.1 Quarterly Capital Expenditures (y_t) and Appropriations (x_t) for U.S. Manufacturing Firms

t	y	x
1	2072	1767
2	2077	2061
3	2078	2289
4	2043	2047
5	2062	1856
⋮	⋮	⋮
84	8093	12199
85	9013	12865
86	9752	14985
87	10704	16378
88	11597	12680

Table 15.2 Least Squares Estimates for the Unrestricted Finite Distributed Lag Model

Variable	Estimate	Std. Error	t-value	p-value
const.	33.414	53.709	0.622	0.5359
x_t	0.038	0.035	1.107	0.2721
x_{t-1}	0.067	0.069	0.981	0.3300
x_{t-2}	0.181	0.089	2.028	0.0463
x_{t-3}	0.194	0.093	2.101	0.0392
x_{t-4}	0.170	0.093	1.824	0.0723
x_{t-5}	0.052	0.092	0.571	0.5701
x_{t-6}	0.052	0.094	0.559	0.5780
x_{t-7}	0.056	0.094	0.597	0.5526
x_{t-8}	0.127	0.060	2.124	0.0372

icance. Examining the individual parameter estimates, we notice several disquieting facts. First, only the lag weights b_2, b_3, b_4, and b_8 are statistically significantly different from zero based on individual t-tests, reflecting the fact that the estimates' standard errors are large relative to the estimated coefficients. Second, the estimated lag weights b_7 and b_8 are *larger* than the estimated lag weights for lags of five and six periods. This does not agree with our anticipation that the lag effects of appropriations should decrease with time and in the most distant periods should be small and approaching zero.

These characteristics are symptomatic of collinearity in the data. The simple correlations among the current and lagged values of capital appropriations are large. Consequently, a high level of *linear* dependence is indicated among the explanatory variables. Thus, we conclude that the least squares estimates in Table 15.2 are subject to great sampling variability and are unreliable, owing to the limited independent information provided by each explanatory variable x_{t-i}.

In Chapter 8 we noted that one way to combat the ill-effects of collinearity is to use restricted least squares. By placing restrictions on the model parameters we reduce the variances of the estimator. In the context of distributed lag models we often have an idea of the pattern of the time effects, which we can translate into parameter restrictions. In the following section we restrict the lag weights to fall on a polynomial.

15.2.4 POLYNOMIAL DISTRIBUTED LAGS

Imposing a shape on the lag distribution will reduce the effects of collinearity. Let us assume that the lag weights follow a smooth pattern that can be represented by a low-degree polynomial. Shirley Almon introduced this idea, and the resulting finite lag model is often called the **Almon distributed lag**, or a **polynomial distributed lag**.

For example, suppose we select a second-order polynomial to represent the pattern of lag weights. Then the effect of a change in x_{t-i} on $E(y_t)$ is

$$\frac{\partial E(y_t)}{\partial x_{t-i}} = \beta_i = \gamma_0 + \gamma_1 i + \gamma_2 i^2, \quad i = 0, \ldots, n \tag{15.2.4}$$

An example of this quadratic polynomial lag is depicted in Figure 15.2. The polynomial lag in Figure 15.2 depicts a situation that commonly arises when modeling the effecs of monetary and fiscal policy. At time t the effect of a change in a policy variable is

$$\frac{\partial E(y_t)}{\partial x_t} = \beta_0 = \gamma_0$$

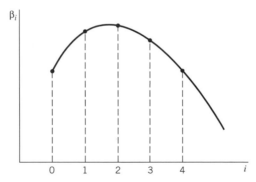

FIGURE 15.2 A polynomial distributed lag.

This immediate impact might well be less than the impact after several quarters, or months. After reaching its maximum, the policy effect diminishes for the remainder of the finite lag.

For illustrative purposes, suppose that the lag length is $n = 4$ periods. Then the finite lag model is

$$y_t = \alpha + \beta_0 x_t + \beta_1 x_{t-1} + \beta_2 x_{t-2} + \beta_3 x_{t-3} + \beta_4 x_{t-4} + e_t, \quad t = 5, \ldots, T \tag{15.2.5}$$

The relations in (15.2.4) become

$$\begin{aligned}
\beta_0 &= \gamma_0 & i &= 0\\
\beta_1 &= \gamma_0 + \gamma_1 + \gamma_2 & i &= 1\\
\beta_2 &= \gamma_0 + 2\gamma_1 + 4\gamma_2 & i &= 2\\
\beta_3 &= \gamma_0 + 3\gamma_1 + 9\gamma_2 & i &= 3\\
\beta_4 &= \gamma_0 + 4\gamma_1 + 16\gamma_2 & i &= 4
\end{aligned} \tag{15.2.6}$$

In order to estimate the parameters describing the polynomial lag, γ_0, γ_1, and γ_2, we substitute (15.2.6) into the finite lag model (15.2.5) to obtain

$$\begin{aligned}
y_t &= \alpha + \gamma_0 x_t + (\gamma_0 + \gamma_1 + \gamma_2)x_{t-1} + (\gamma_0 + 2\gamma_1 + 4\gamma_2)x_{t-2}\\
&\quad + (\gamma_0 + 3\gamma_1 + 9\gamma_2)x_{t-3} + (\gamma_0 + 4\gamma_1 + 16\gamma_2)x_{t-4} + e_t\\
&= \alpha + \gamma_0 z_{t0} + \gamma_1 z_{t1} + \gamma_2 z_{t2} + e_t
\end{aligned} \tag{15.2.7}$$

In this equation we have defined the constructed variables z_{tk} as

$$\begin{aligned}
z_{t0} &= x_t + x_{t-1} + x_{t-2} + x_{t-3} + x_{t-4}\\
z_{t1} &= x_{t-1} + 2x_{t-2} + 3x_{t-3} + 4x_{t-4}\\
z_{t2} &= x_{t-1} + 4x_{t-2} + 9x_{t-3} + 16x_{t-4}
\end{aligned}$$

Once these variables are created the polynomial coefficients are estimated by applying least squares to (15.2.7). If we denote the estimated values of γ_k by $\hat{\gamma}_k$, then we can obtain the estimated lag weights as

$$\hat{\beta}_i = \hat{\gamma}_0 + \hat{\gamma}_1 i + \hat{\gamma}_2 i^2, \quad i = 0,\ldots,n \tag{15.2.8}$$

Whatever the degree of the polynomial, the general procedure is an extension of what we have described for the quadratic polynomial.

Equation (15.2.7) is a restricted model. We have replaced $(n + 1) = 5$ distributed lag weights with three polynomial coefficients. This implies that in constraining the distributed lag weights to a polynomial of degree 2, we have imposed $J = (n + 1) - 3 = 2$ parameter restrictions. We may wish to check the compatibility of the quadratic polynomial lag model with the data by performing an F-test, comparing the sum of squared errors from the restricted model in (15.2.7) to the sum of squared errors from the unrestricted model, (15.2.5).

As an illustration, we will fit a second-order polynomial lag to the capital expenditure data in Table 15.1, with a lag length of $n = 8$ periods. In Table 15.3 are the estimated polynomial coefficients from (15.2.7).

In Table 15.4 we present the distributed lag weights calculated using (15.2.8). The reported standard errors are based on the fact that the estimated distributed lag weights are combinations of the estimates in Table 15.3. Since the estimated weights in Table 15.4 are linear combinations of the estimated polynomial coefficients in Table 15.3, as shown in (15.2.8), their estimated variances are calculated using (2.5.8), from Chapter 2. Constraining the distributed lag weights to fall on a polynomial of degree two has drastically affected their values as compared to the unconstrained values in Table 15.2. Also, note that the standard errors of the estimated coefficients are much smaller than those in the unconstrained model, indicating more precise parameter estimation.

Table 15.3 **Estimated (Almon) Polynomial Coefficients**

Parameter	Estimates	t-value	p-value
α	51.573	0.970	0.3351
γ_0	0.067	4.411	0.0001
γ_1	0.038	2.984	0.0038
γ_2	−0.005	−3.156	0.0023

Table 15.4 **Estimated (Almon) Distributed Lag Weights from Polynomial of Degree Two**

Parameter	Estimate	Std. Error	t-value	p-value
β_0	0.067	0.015	4.41	0.0001
β_1	0.100	0.005	19.60	0.0001
β_2	0.123	0.005	22.74	0.0001
β_3	0.136	0.009	14.40	0.0001
β_4	0.138	0.011	12.86	0.0001
β_5	0.130	0.009	14.31	0.0001
β_6	0.112	0.005	20.92	0.0001
β_7	0.083	0.007	11.32	0.0001
β_8	0.044	0.018	2.47	0.0156

REMARK: Recall that imposing restrictions on parameters leads to bias unless the restrictions are true. In this case we do not really believe that the distributed lag weights fall exactly on a polynomial of degree 2. However, if this assumption approximates reality, then the constrained estimator will exhibit a small amount of bias. Our objective is to trade a large reduction in sampling variance for the introduction of some bias, increasing the probability of obtaining estimates *close* to the true values.

In Figure 15.3 we plot the unrestricted estimates of lag weights and the restricted estimates. Note that the restricted estimates display the increasing-then-decreasing "humped" shape that economic reasoning led us to expect. The effect of a change in capital appropriations x_t at time t leads to an increase in capital expenditures in the current period, y_t, by a relatively small amount. However, the expenditures arising from the appropriation decision increase during the next four quarters, before the effect begins to taper off.

15.2.5 SELECTION OF THE LENGTH OF THE FINITE LAG

Numerous procedures have been suggested for selecting the length n of a finite distributed lag. None of the proposed methods is entirely satisfactory. The issue is an important one, however, because fitting a polynomial lag model in which the

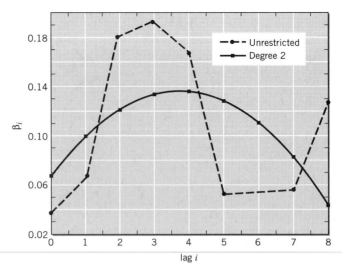

FIGURE **15.3** Restricted and unrestricted distributed lag weights.

lag length is either over- or understated may lead to biases in the estimation of the lag weights, even if an appropriate polynomial degree has been selected. We offer two suggestions that are based on "goodness-of-fit" criteria. Begin by selecting a lag length N that is the *maximum* that you are willing to consider. The unrestricted finite lag model is then

$$y_t = \alpha + \beta_0 x_t + \beta_1 x_{t-1} + \beta_2 x_{t-2} + \beta_3 x_{t-3} + \cdots + \beta_N x_{t-N} + e_t \qquad (15.2.9)$$

We wish to assess the goodness of fit for lag lengths $n \le N$. The usual measures of goodness-of-fit, R^2 and \overline{R}^2, have been found not to be useful for this task. Two goodness-of-fit measures that are more appropriate are Akaike's *AIC* criterion

$$AIC = \ln \frac{SSE_n}{T-N} + \frac{2(n+2)}{T-N} \qquad (15.2.10)$$

and Schwarz's *SC* criterion

$$SC = \ln \frac{SSE_n}{T-N} + \frac{(n+2)\ln(T-N)}{T-N} \qquad (15.2.11)$$

These values are routinely computed by some software packages. For each of these measures we seek that lag length n^* that minimizes the criterion used. Since adding more lagged variables reduces *SSE*, the second part of each of the criteria is a *penalty function* for adding additional lags. These measures weigh reductions in sum of squared errors obtained by adding additional lags against the penalty imposed by each. They are useful for comparing lag lengths of alternative models estimated using the same number of observations.

15.3 **The Geometric Lag**

An *infinite distributed lag model* in its most general form is

$$y_t = \alpha + \beta_0 x_t + \beta_1 x_{t-1} + \beta_2 x_{t-2} + \beta_3 x_{t-3} + \cdots + e_t$$

$$= \alpha + \sum_{i=0}^{\infty} \beta_i x_{t-i} + e_t \qquad (15.3.1)$$

In this model, y_t is taken to be a function of x_t and *all* its previous values. There may also be other explanatory variables on the right-hand side of the equation. The model in (15.3.1) is a general one, and as it stands it is impossible to estimate, since there are an infinite number of parameters. Consequently, models have been developed that are *parsimonious*, and that reduce the number of parameters to estimate. The cost of reducing the number of parameters is that these models must assume particular patterns for the parameters β_i, which are called *distributed lag weights*.

One popular model is the **geometric lag**, in which the lag weights are positive and decline geometrically. That is,

$$\beta_i = \beta \phi^i, \qquad |\phi| < 1 \qquad (15.3.2)$$

The parameter β is a scaling factor and the parameter ϕ is less than 1 in absolute value. The pattern of lag weights β_i is shown in Figure 15.4.

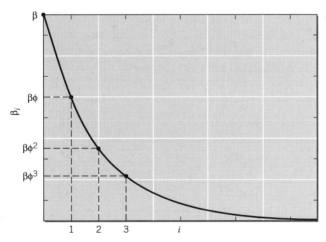

FIGURE **15.4** Geometrically declining lag weights.

The lag weights $\beta_i = \beta \phi^i$ decline toward zero as i gets larger. The most recent past is more heavily weighted than the more distant past, and, although the weights never reach zero, beyond a point they become negligible.

Substituting (15.3.2) into (15.3.1), we obtain

$$y_t = \alpha + \beta_0 x_t + \beta_1 x_{t-1} + \beta_2 x_{t-2} + \beta_3 x_{t-3} + \cdots + e_t$$

$$= \alpha + \beta(x_t + \phi x_{t-1} + \phi^2 x_{t-2} + \phi^3 x_{t-3} + \cdots) + e_t \qquad (15.3.3)$$

which is the **infinite geometric distributed lag model.** In this model there are three parameters—α, an intercept parameter; β, a scale factor; and ϕ, which controls the rate at which the weights decline.

In (15.3.3) the effect of a one-unit change in x_{t-i} on $E(y_t)$ is

$$\frac{\partial E(y_t)}{\partial x_{t-i}} = \beta_i = \beta\phi^i \qquad (15.3.4)$$

This equation says that the change in the average value of y in period t given a change in x in period $t - i$, all other factors held constant, is $\beta_i = \beta\phi^i$. The change in $E(y_t)$ given a unit change in x_t, is β; it is called an **impact multiplier,** since it measures the change in the current period. If the change in period t is sustained for another period, then the combined effect $\beta + \beta\phi$ is felt in period $t + 1$. If the change is sustained for three periods, the effect on $E(y_{t+2})$ is $\beta + \beta\phi + \beta\phi^2$. These sums are called **interim multipliers** and are the effect of sustained changes in x_t. If the change is sustained permanently, then the total effect, or the **long-run multiplier,** is

$$\beta(1 + \phi + \phi^2 + \phi^3 + \cdots) = \frac{\beta}{1 - \phi}$$

15.4 The Koyck Transformation

How shall we estimate the geometric lag model represented by (15.3.3)? As it stands, it is an impossible task, since the model has an infinite number of terms, and the parameters β and ϕ are multiplied together, making the model *nonlinear in the parameters.* One way around these difficulties is to use the **Koyck transformation,** in deference to L. M. Koyck, who developed it.

To apply the Koyck transformation, lag equation (15.3.3) one period, multiply by ϕ, and subtract that result from (15.3.3). We obtain

$$\begin{aligned}
y_t - \phi y_{t-1} &= [\alpha + \beta(x_t + \phi x_{t-1} + \phi^2 x_{t-2} + \phi^3 x_{t-3} + \cdots) + e_t] \\
&\quad - \phi[\alpha + \beta(x_{t-1} + \phi x_{t-2} + \phi^2 x_{t-3} + \phi^3 x_{t-4} + \cdots) + e_{t-1}] \\
&= \alpha(1 - \phi) + \beta x_t + (e_t - \phi e_{t-1}) \qquad (15.4.1)
\end{aligned}$$

Solving for y_t we obtain the Koyck form of the geometric lag,

$$\begin{aligned}
y_t &= \alpha(1 - \phi) + \phi y_{t-1} + \beta x_t + (e_t - \phi e_{t-1}) \\
&= \delta_1 + \delta_2 y_{t-1} + \delta_3 x_t + v_t \qquad (15.4.2)
\end{aligned}$$

where $\delta_1 = \alpha(1 - \phi)$, $\delta_2 = \phi$, $\delta_3 = \beta$ and the random error $v_t = (e_t - \phi e_{t-1})$.

15.4.1 INSTRUMENTAL VARIABLES ESTIMATION OF THE KOYCK MODEL

The last line of (15.4.2) looks like a multiple regression model, with two special characteristics. The first is that one of the explanatory variables is the *lagged dependent variable,* y_{t-1}. The second is that the error term v_t depends on e_t and on e_{t-1}.

Consequently, y_{t-1} and the error term v_t must be *correlated*, since (15.3.3) shows that y_{t-1} depends directly on e_{t-1}. In Chapter 13.2.4 we showed that such a correlation between an explanatory variable and the error term causes the least squares estimator of the parameters to be biased and *inconsistent*. Consequently, in (15.4.2) we should *not* use the least squares estimator to obtain estimates of δ_1, δ_2, and δ_3.

We can estimate the parameters in (15.4.2) consistently using the instrumental variables estimator. The "problem" variable in (15.4.2) is y_{t-1}, since it is the one correlated with the error term v_t. An appropriate instrument for y_{t-1} is x_{t-1}, which is correlated with y_{t-1} [from (15.4.2)] and which is uncorrelated with the error term v_t (since it is exogenous). Instrumental variables estimation can be carried out using two-stage least squares. Replace y_{t-1} in (15.4.2) by $\hat{y}_{t-1} = a_0 + a_1 x_{t-1}$, where the coefficients a_0 and a_1 are obtained by a simple least squares regression of y_{t-1} on x_{t-1}, to obtain

$$y_t = \delta_1 + \delta_2 \hat{y}_{t-1} + \delta_3 x_t + error \qquad (15.4.3)$$

Least squares estimation of (15.4.3) is equivalent to instrumental variables estimation, as we have shown in Chapter 13.3.5. The variable x_{t-1} is an instrument for y_{t-1}, and x_t is an instrument for itself.

Using the instrumental variables estimates of δ_1, δ_2, and δ_3, we can derive estimates of α, β, and ϕ in the geometric lag model.

Let us remind you that using least squares regression software twice to carry out 2*SLS* will yield the correct parameter estimates but it will not produce proper standard errors or *t*-values. Use a program designed for two stage least squares or instrumental variables estimation. Such programs are commonly included in econometric software packages.

15.4.2 TESTING FOR AUTOCORRELATION IN MODELS WITH LAGGED DEPENDENT VARIABLES

In the context of the lagged dependent variable model (15.4.2), obtained by the Koyck transformation, we know that the error term is correlated with the lagged dependent variable on the right-hand side of the model, and thus that the usual least squares estimator fails. Suppose, however, that we have obtained a model like (15.4.2) through other reasoning, and that we do not know whether the error term is correlated with the lagged dependent variable or not. If it is not, then we can use least squares estimation. If it is, we should not use least squares estimation.

The key question is whether the error term, v_t in (15.4.2), is serially correlated or not, since if it is, then it is also correlated with y_{t-1}. The Durbin–Watson test introduced in Chapter 12 is not applicable in this case, because in a model with an explanatory variable that is a lagged dependent variable it is biased toward finding no autocorrelation. A test that is valid in large samples is the LM test for autocorrelation introduced in Chapter 12.6.2. Estimate (15.4.2) by least squares and compute the least squares residuals, \hat{e}_t. Then estimate the artificial regression

$$y_t = a_1 + a_2 y_{t-1} + a_3 x_t + a_4 \hat{e}_{t-1} + error \qquad (15.4.4)$$

Test the significance of the coefficient on \hat{e}_{t-1} using the usual *t*-test. If the coefficient is significant, then reject the null hypothesis of no autocorrelation. This alter-

native test is also useful in other general circumstances and can be extended to include least squares residuals with more than one lag.

15.5 **Autoregressive Distributed Lags**

There are some obvious problems with the two distributed lags models we have discussed. The finite lag model requires us to choose the lag length and then deal with collinearity in the resulting model. The polynomial distributed lag addresses the collinearity by requiring the lag weights to fall on a smooth curve. While the polynomial distributed lag is flexible, it is still a very strong assumption to make about the structure of lag weights. The infinite lag model removes the problem of specifying the lag length, but requires us to impose structure on the lag weights to get around the problem that there are an infinite number of parameters. The geometric lag is one such structure, but it imposes the condition that successive lag weights decline geometrically. This model would not do in a situation in which the peak effect does not occur for several periods, such as when modeling monetary or fiscal policy. In this section we present an alternative model that may be useful when neither a polynomial distributed lag nor a geometric lag is suitable.

15.5.1 THE AUTOREGRESSIVE DISTRIBUTED LAG MODEL

The autoregressive-distributed lag (ARDL) is an infinite lag model that is both flexible and parsimonious. An example of an ARDL is

$$y_t = \mu + \beta_0 x_t + \beta_1 x_{t-1} + \gamma_1 y_{t-1} + e_t \tag{15.5.1}$$

In this model we include the explanatory variable x_t, and one or more of its lags, with one or more lagged values of the dependent variable. The model in (15.5.1) is denoted as ARDL(1, 1) as it contains one lagged value of x and one lagged value of y. A model containing p lags of x and q lags of y is denoted ARDL(p, q). If the usual error assumptions on the error term e hold, then the parameters of (15.5.1) can be estimated by least squares. Despite its simple appearance the ARDL(1, 1) model represents an infinite lag. To see this we repeatedly substitute for the lagged dependent variable on the right-hand side of (15.5.1). The lagged value y_{t-1} is given by

$$y_{t-1} = \mu + \beta_0 x_{t-1} + \beta_1 x_{t-2} + \gamma_1 y_{t-2} + e_{t-1} \tag{15.5.2}$$

Substitute into (15.5.1) and rearrange

$$
\begin{aligned}
y_t &= \mu + \beta_0 x_t + \beta_1 x_{t-1} + \gamma_1 [\mu + \beta_0 x_{t-1} + \beta_1 x_{t-2} + \gamma_1 y_{t-2} + e_{t-1}] + e_t \\
&= \mu(1 + \gamma_1) + \beta_0 x_t + (\beta_1 + \gamma_1 \beta_0) x_{t-1} + \gamma_1 \beta_1 x_{t-2} + \gamma_1^2 y_{t-2} + (\gamma_1 e_{t-1} + e_t)
\end{aligned}
\tag{15.5.3}
$$

Substitute the lagged value $y_{t-2} = \mu + \beta_0 x_{t-2} + \beta_1 x_{t-3} + \gamma_1 y_{t-3} + e_{t-2}$ into (15.5.3) to obtain

$$
\begin{aligned}
y_t &= \mu(1 + \gamma_1 + \gamma_1^2) + \beta_0 x_t + (\beta_1 + \gamma_1 \beta_0) x_{t-1} + \gamma_1(\beta_1 + \gamma_1 \beta_0) x_{t-2} + \gamma_1^2 \beta_1 x_{t-3} \\
&\quad + \gamma_1^3 y_{t-3} + (\gamma_1^2 e_{t-2} + \gamma_1 e_{t-1} + e_t)
\end{aligned}
\tag{15.5.4}
$$

Continue this process, and assuming that $|\gamma_1| < 1$, we obtain in the limit

$$y_t = \alpha + \beta_0 x_t + \sum_{i=1}^{\infty} \gamma_1^{(i-1)}(\beta_1 + \gamma_1\beta_0)x_{t-i} + u_t \tag{15.5.5}$$

where $\alpha = \mu(1 + \gamma_1 + \gamma_1^2 + \gamma_1^3 + \ldots) = \mu/(1 - \gamma_1)$ and $u_t = e_t + \gamma_1 e_{t-1} + \gamma_1^2 e_{t-2} + \gamma_1^3 e_{t-3} + \ldots$. Equation (15.5.5) is an infinite distributed lag model,

$$y_t = \alpha + \sum_{i=0}^{\infty} \alpha_i x_{t-i} + u_t \tag{15.5.6}$$

with lag weights

$$\begin{aligned} \alpha_0 &= \beta_0 \\ \alpha_1 &= (\beta_1 + \gamma_1\beta_0) \\ \alpha_2 &= \gamma_1(\beta_1 + \gamma_1\beta_0) = \gamma_1\alpha_1 \\ \alpha_3 &= \gamma_1^2\alpha_1 \\ &\vdots \\ \alpha_s &= \gamma_1^{(s-1)}\alpha_1 \end{aligned} \tag{15.5.7}$$

Estimating the ARDL(1, 1) model yields an infinite lag model with weights given by (15.5.7). Similarly, the ARDL(2, 2) model, given by

$$y_t = \mu + \beta_0 x_t + \beta_1 x_{t-1} + \beta_2 x_{t-2} + \gamma_1 y_{t-1} + \gamma_2 y_{t-2} + e_t \tag{15.5.8}$$

yields the infinite lag (15.5.6) with weights

$$\begin{aligned} \alpha_0 &= \beta_0 \\ \alpha_1 &= (\beta_1 + \gamma_1\beta_0) \\ \alpha_2 &= \alpha_0\gamma_2 + \alpha_1\gamma_1 + \beta_2 \\ \alpha_3 &= \alpha_2\gamma_1 + \alpha_1\gamma_2 \\ \alpha_4 &= \alpha_3\gamma_1 + \alpha_2\gamma_2 \\ &\vdots \\ \alpha_s &= \alpha_{s-1}\gamma_1 + \alpha_{s-2}\gamma_2 \end{aligned} \tag{15.5.9}$$

It can be shown that an infinite lag from the ARDL(p, q) model, with sufficiently large values of p and q, is flexible enough to approximate an infinite lag distribution of any shape.

15.5.2 AN ILLUSTRATION OF THE ARDL MODEL

To illustrate the estimation of an infinite ARDL, let us use the capital expenditure data in Table 15.1. Figure 15.5. shows the first eight lag weights from three alternative ARDL models.

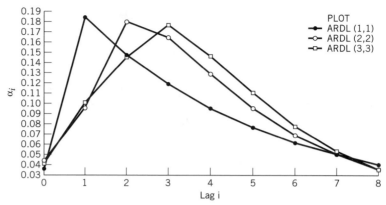

FIGURE *15.5* ARDL models.

We see that unlike a geometric lag, the lag weights implied by the ARDL models capture the delay in the peak lag effect. Furthermore, as the order of the ARDL(p, q) increases, the lag weights exhibit a more flexible shape, and the peak effect is further delayed. The ARDL(3, 3) model yields lag weights not unlike the polynomial distributed lag of order two, shown in Figure 15.3; one difference is that the maximum weight is now at lag 3 instead of lag 4, which is more in line with the unrestricted lag weights.

15.6 Learning Objectives

Based on the material in this chapter you should be able to:

1. Discuss the economic rationale for using distributed lag models in economics, and give an example of a dynamic economic model.

2. Explain why finite distributed lag models are often difficult to estimate using least squares.

3. Explain why the use of a polynomial distributed lag is equivalent to using restricted least squares estimation.

4. Discuss the Koyck transformation of the geometric lag into an estimable form, and why the resulting model should be estimated using instrumental variables and not least squares.

5. Summarize a testing procedure for the presence of autocorrelation in regression models with lagged endogenous variables on the right-hand side.

6. Compare and contrast autoregressive-distributed lag models, and the implied pattern of lag weights, to finite polynomial lags and infinite geometric lag models.

15.7 Exercises

15.1 In Section 15.2.4 we assumed that the length n of the finite lag was 8 periods. If the maximum length of the lag we are willing to consider is $N = 12$ peri-

ods, evaluate the information criteria *AIC* and *SC* for lags of lengths $n = 6, 7$, ..., 12 using the data in file *table15-1.dat*. What lag length minimizes these criteria?

15.2 The least squares estimates for the finite lag model discussed in Section 15.2.2 are contained in Table 15.2. Calculate the simple correlations among the current and lagged capital appropriations variables $x_t, x_{t-1}, \ldots, x_{t-8}$. Based on these correlations, does collinearity appear to be a severe problem in this model?

15.3 In the file *adaptive.dat* are quarterly data on U.S. real per capita consumption (c) and real per capita disposable income (y) from 1947.I to 1980.IV (1982 dollars). Assume that a finite distributed lag model has been specified such that $c_t = \alpha + \sum_{i=0}^{n} \beta_i y_{t-i} + e_t$ with $n = 12$.
 (a) Estimate the unrestricted finite distributed lag model.
 (b) Estimate the finite lag imposing a polynomial distributed lag of order 4.
 (c) Estimate the finite lag imposing a polynomial distributed lag of order 3.
 (d) Estimate the finite lag imposing a polynomial distributed lag of order 2.
 (e) Compare the distributed lag weights estimated in parts (a)–(d). Which model would you choose? Why? [*Hint:* Compare each of the restricted models in parts (b)–(d) to the unrestricted model in (a) using the *F*-test].
 (f) Update the data series to the present. Re-estimate the distributed lag models (a)–(d) and compare them to the results from the older data.

15.4 A special case of the polynomial lag is the *arithmetic lag*. For a finite distributed lag model with lag length n it is obtained by imposing the parameter restrictions

$$\beta_0 = (n+1)\gamma, \quad \beta_1 = n\gamma, \quad \beta_2 = (n-1)\gamma, \ldots, \beta_n = \gamma$$

where $\gamma > 0$ is a positive constant.
 (a) Plot the pattern of lag weights, assuming $\gamma = .05$ and $n = 6$.
 (b) Assuming $n = 4$, substitute the parameter constraints into (15.2.2) and simplify to obtain a reduced (restricted) model.
 (c) Let $\hat{\gamma}$ be the least squares estimate of γ from the model in part (b). Explain how to compute the estimated lag weights *and* their standard errors.
 (d) How does the arithmetic lag compare to a polynomial lag of degree one?

15.5 In the file *adaptive.dat* are quarterly data on real per capita consumption (c) and real per capita disposable income (y) from 1947.I to 1980.IV.
 (a) Use least squares to estimate the distributed lag model in (15.2.2) explaining consumption as a function of current and past income. Assume $n = 8$. Plot the estimated lag coefficients.
 (b) Estimate a finite polynomial distributed lag, of degree 2, relating consumption in time period t to current and lagged values of income. Assume that the lag length is $n = 8$. Create a plot of the estimated lag weights.

15.6 In the file *adaptive.dat* are quarterly data on real per capita consumption (c) and real per capita disposable income (y) from 1947.I to 1980.IV.
 (a) Specify a geometric lag relating current consumption to current and past values of income. See (15.3.1). Use the Koyck transformation to obtain an equation like (15.4.2) and estimate it by least squares. Test for the presence of autocorrelation using the LM test described in Section 15.4.2.

 (b) Estimate the Koyck model in (a) by instrumental variables, using lagged income as an instrument for lagged consumption and income as an instrument for itself. Plot the estimated lag weights.

 (c) Estimate the Koyck model in (a) by instrumental variables, using lagged income and the second lag of income as instruments for lagged consumption and income as an instrument for itself. Plot the estimated lag weights.

15.7 In the file *adaptive.dat* are quarterly data on real per capita consumption (c) and real per capita disposable income (y) from 1947.I to 1980.IV.

 (a) Estimate the relationship between current consumption and lagged income in an ARDL(2, 2) model like that in (15.5.8). Test for the presence of first and second order autocorrelation using the LM test described in Section 15.4.2.

 (b) Obtain and plot the distributed lag weights using (15.5.9).

15.8 Compare the estimated lag distributions in Exercises 15.5–15.7.

15.9 Update the data series to the present. Re-estimate the distributed lag models 15.5–15.7 and compare them to the results from the older data.

Chapter 16

Regression With Time Series Data

In this chapter we extend our analysis of dynamic modeling using time series data. The analysis of time series data is of vital interest to many groups, such as macro-economists studying the behavior of national and international economies, financial economists who study the stock market, agricultural economists who want to predict supplies and demands for agricultural products. We introduced the problem of autocorrelated errors when using time series data in Chapter 12. In Chapter 15 we considered distributed lag models. In both of these chapters we made implicit assumptions about the time series data, namely, that the time series we examined were **stationary**. In the context of the AR(1) model of autocorrelation, $e_t = \rho e_{t-1} + v_t$, we assumed that $|\rho| < 1$. In the infinite geometric lag model, $y_t = \alpha + \sum_{i=0}^{\infty} \beta_i x_{t-i} + e_t$, where $\beta_i = \beta\phi^i$, we assumed $|\phi| < 1$. These assumptions ensure that the time series variables in question are stationary time series. However, many of the variables studied in macroeconomics, monetary economics and finance are **nonstationary** time series. The econometric consequences of nonstationarity can be quite severe, leading to least squares estimators, test statistics and predictors that are unreliable. Moreover, the study of nonstationary time series is one of the fascinating recent developments in econometrics. In this chapter we examine these and related issues.

16.1 Stationary Time Series

Let y_t be an economic variable that we observe over time. Examples of such variables are interest rates, the inflation rate, the gross domestic product, disposable income, etc. The variable y_t is random, since we cannot perfectly predict it. We never know the values of these variables until they are observed. The economic model generating the time series variable y_t is called a **stochastic** or **random process**. We observe a sample of y_t values, which is called a particular **realization** of the stochastic process. It is one of many possible paths that the stochastic process could have taken.

The usual properties of the least squares estimator in a regression using time series data depend on the assumption that the time series variables involved are stationary stochastic processes. A stochastic process (time series) y_t is stationary if its mean and variance are constant over time, and the covariance between two values from the series depends only on the length of time separating the two values, and not on the actual times at which the variables are observed. That is, the time

series y_t is stationary if for all values it is true that

$$E(y_t) = \mu \qquad \text{(constant mean)} \qquad (16.1.1a)$$
$$\text{var}(y_t) = \sigma^2 \qquad \text{(constant variance)} \qquad (16.1.1b)$$
$$\text{cov}(y_t, y_{t+s}) = \text{cov}(y_t, y_{t-s}) = \gamma_s \qquad \text{(covariance depends on } s, \text{not } t)$$
$$\qquad (16.1.1c)$$

The conditions for stationarity may be difficult to grasp, but looking at some pictures may help. In Figure 16.1 (a)–(b) we plot some artificially generated, stationary time series. Note that the series vary randomly at a constant level (mean) and with constant dispersion (variance). In Figure 16.1 (c)–(d) are plots of series that are not stationary. These time series are called **random walks**, because they slowly wander upwards or downwards, but with no real pattern. In Figure 16.1 (e)–(f) are two more nonstationary series, but these show a definite trend either upwards or downwards. These are called **random walks with a drift**.

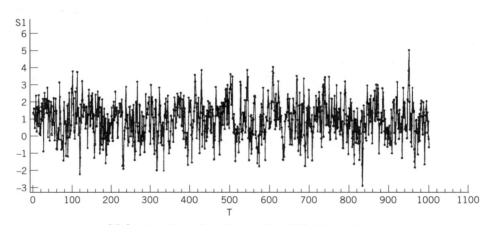

FIGURE **16.1** (a) $y(t) = .5 + .5y(t - 1) + N(0, 1)$; stationary process.

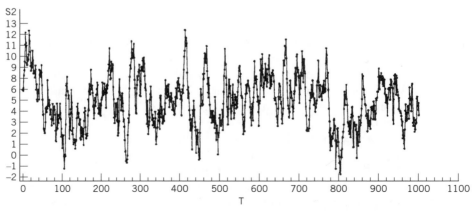

FIGURE **16.1** (b) $y(t) = .5 + .9y(t - 1) + N(0, 1)$; stationary process.

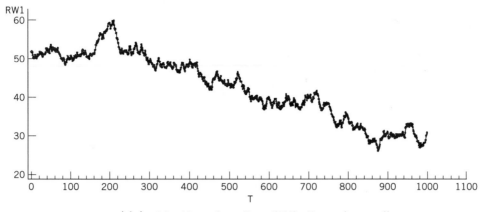

FIGURE 16.1 (c) $y(t) = y(t - 1) + .5N(0, 1)$; random walk.

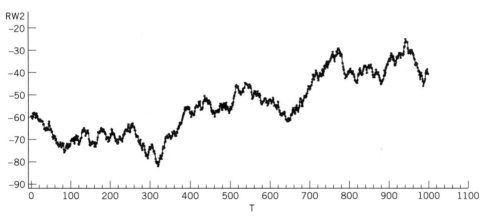

FIGURE 16.1 (d) $y(t) = y(t - 1) + N(0, 1)$; random walk.

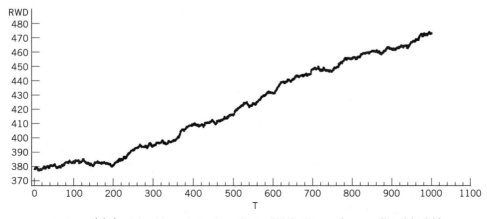

FIGURE 16.1 (e) $y(t) = .1 + y(t - 1) + .5N(0, 1)$; random walk with drift.

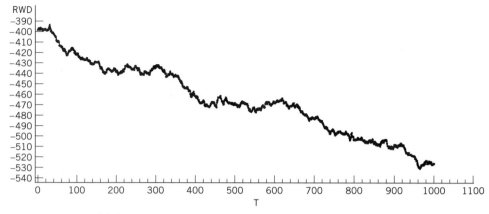

FIGURE **16.1** (f) $y(t) = -.1 + y(t-1) + N(0, 1)$; random walk with drift.

The series in Figure 16.1 are generated from an AR(1) process, much like the AR(1) error process we discussed in Chapter 12. The AR(1) process we consider is

$$\textbf{AR(1) process} \qquad y_t = \alpha + \rho y_{t-1} + v_t \qquad (16.1.2)$$

The AR(1) process is stationary if $|\rho| < 1$, as is the case in Figure 16.1 (a)–(b). If $\alpha = 0$ and $\rho = 1$ the AR(1) process reduces to a nonstationary random walk series, depicted in Figure 16.1 (c)–(d), in which the value of y_t this period is equal to the value y_{t-1} from the previous period plus a disturbance v_t.

$$\textbf{Random walk} \qquad y_t = y_{t-1} + v_t \qquad (16.1.3)$$

A random walk series shows no definite trend, and slowly turns one way or the other.

If $\alpha \neq 0$ and $\rho = 1$ the series produced is also nonstationary and is called a random walk with a drift.

$$\textbf{Random walk with drift} \qquad y_t = \alpha + y_{t-1} + v_t \qquad (16.1.4)$$

Such series do show a trend, as illustrated in Figure 16.1 (e)–(f).

Many macroeconomic and financial time series are nonstationary. In Figure 16.2 we plot time series of some important economic variables. Compare these plots to those in Figure 16.1. Which ones look stationary? The ability to distinguish stationary series from nonstationary series is important because, as we noted earlier, using nonstationary variables in regression can lead to least squares estimators, test statistics and predictors that are unreliable and misleading, as we illustrate in the next section.

16.2 Spurious Regressions

There is a danger of obtaining apparently significant regression results from unrelated data when using nonstationary series in regression analysis. Such regressions

[Note: data obtained from www.economagic.com]

(a) Real disposable personal income; billions of 1992 dollars, monthly
(b) Inflation in consumer prices: percent, monthly
(c) Bank prime loan rate, monthly
(d) Real personal consumption expenditures; billions of 1992 dollars, monthly
(e) U.S. index of leading indicators, 1987 = 100, monthly
(f) Corporate profits after tax; billions of dollars, quarterly

FIGURE **16.2** Economic time series.

are said to be **spurious**. To illustrate the problem, let us take the random walk data from Figure 16.1 (c)–(d) and estimate a regression of series one ($y = rw1$) on series two ($x = rw2$). These series were generated independently and have no relation to

one another. Yet, when we plot them, as we have done in Figure 16.3, we see an inverse relationship between them.

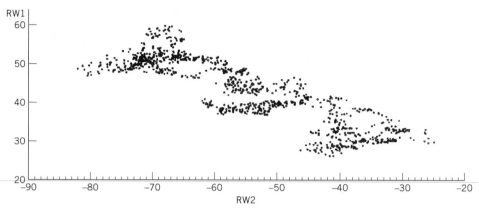

FIGURE 16.3 $y = rw1$ and $x = rw2$ scatter plot.

If we estimate the simple regression, we obtain the results in Table 16.1. These results indicate that the simple regression model fits the data well ($R^2 = .75$), and that the estimated slope is significantly different from zero ($t = -54.67$). These results are completely meaningless, or spurious. The apparent significance of the relationship is false, resulting from the fact that we have related one slowly turning series to another. Similar and more dramatic results are obtained when the random walk with drift series are used in a regression. Note that the Durbin–Watson statistic is low. Granger and Newbold (C. W. J. Granger and P. Newbold, "Spurious Regressions in Econometrics," *Journal of Econometrics*, 2, 1974, pp. 111–120) suggest the rule of thumb that when estimating regressions with time series data, if the R^2 value is greater than the Durbin–Watson statistic, then one should suspect a spurious regression. In the next section we propose some ways to test whether a time series is stationary or not; these tests can also be used to detect when a problem is likely to occur.

To summarize, when nonstationary time series are used in a regression model the results may spuriously indicate a significant relationship when there is none. In these cases the least squares estimator and least squares predictor do not have their usual properties, and t-statistics are not reliable. Since many macroeconomic time series are nonstationary, it is very important that we take care when estimating regressions with macro-variables.

Table 16.1 **Spurious Regression Results**

Reg Rsq	0.7495 Durbin-Watson 0.0305				
Variable	DF	B Value	Std Error	t Ratio	Approx Prob
Intercept	1	14.204040	0.5429	26.162	0.0001
RW2	1	-0.526263	0.00963	-54.667	0.0001

16.3 Checking Stationarity Using the Autocorrelation Function

In (16.1.1c) we defined the covariance between y_t and y_{t+s}. Using this definition we can construct the **autocorrelation function**, ρ_s, of the series as

$$\rho_s = \frac{\text{cov}(y_t, y_{t+s})}{\text{var}(y_t)} = \frac{\gamma_s}{\gamma_0} \tag{16.3.1}$$

The value of $\rho_0 = 1$, and for $s > 1$ the correlations ρ_s are pure numbers (unitless) between -1 and 1. The estimated sample correlations are

$$\hat{\rho}_s = \frac{\hat{\text{cov}}(y_t, y_{t+s})}{\hat{\text{var}}(y_t)} = \frac{\hat{\gamma}_s}{\hat{\gamma}_0} \tag{16.3.2}$$

where the sample variance and covariance are estimated from a sample of size T as

$$\hat{\gamma}_s = \frac{\sum (y_t - \bar{y})(y_{t+s} - \bar{y})}{T}$$

$$\hat{\gamma}_0 = \frac{\sum (y_t - \bar{y})^2}{T} \tag{16.3.3}$$

If we plot the sample correlations $\hat{\rho}_s$ against s we obtain what is called a **correlogram**. Econometric software will compute the sample correlations. In Tables 16.2 and 16.3 we show the first 10 correlations (AC) for the stationary series $s2$ and the nonstationary series $rw1$.

There is a dramatic difference between the correlograms for the stationary series $s2$ and the nonstationary series $rw1$. For the stationary series the autocorrelations, the column labeled AC in Table 16.2, gradually die out, indicating that values further in the past are less correlated with the current value. For the nonstationary series $rw1$, the autocorrelations in Table 16.3 do not die out rapidly at all. The cor-

Table 16.2 **Correlogram for s2**

Autocorrelation	s	AC	Q-Stat.	Prob.
.\|*******\|	1	0.900	813.42	0.000
.\|******	2	0.803	1461.0	0.000
.\|******	3	0.718	1979.1	0.000
.\|*****	4	0.629	2377.9	0.000
.\|****	5	0.545	2677.4	0.000
.\|****	6	0.470	2900.7	0.000
.\|***	7	0.408	3068.7	0.000
.\|***	8	0.348	3191.2	0.000
.\|**	9	0.299	3281.8	0.000
.\|**	10	0.266	3353.2	0.000

Table 16.3 **Correlogram for *rw*1**

Autocorrelation	s	AC	Q-Stat	Prob
.\|********	1	0.997	997.31	0.000
.\|********	2	0.993	1988.8	0.000
.\|********	3	0.990	2973.9	0.000
.\|********	4	0.986	3953.2	0.000
.\|********	5	0.983	4926.3	0.000
.\|********	6	0.979	5893.4	0.000
.\|********	7	0.975	6854.4	0.000
.\|*******\|	8	0.972	7809.4	0.000
.\|*******\|	9	0.968	8758.3	0.000
.\|*******\|	10	0.965	9701.0	0.000

relation between $rw1_t$, and $rw1_{t-10}$ is .965. Thus visual inspection of these functions can be a first indicator of nonstationarity.

Are the autocorrelations statistically different from zero? In large samples, if the autocorrelation is zero, then the estimated autocorrelations $\hat{\rho}_s$ are approximately normally distributed with mean 0 and variance $1/T$. Thus for our sample, of size $T = 1001$, the approximate standard error is $\sqrt{1/T} = 0.0316$. A 95% confidence interval is $\pm 1.96(0.0316) = \pm 0.062$. Thus, if a value of $\hat{\rho}_s$ falls outside the interval $(-0.062, 0.062)$, we conclude that it is significantly different from zero. Given our large sample, and correspondingly narrow confidence interval, the autocorrelations in Tables 16.2 and 16.3 are statistically different from zero.

When the autocorrelations are computed they are customarily accompanied by one or more test statistics for the null hypothesis that all the autocorrelations ρ_s, up to some lag m, are zero. Two commonly reported statistics are the Box-Pierce statistic

$$Q = T \sum_{s=1}^{m} \hat{\rho}_s^2 \qquad (16.3.4)$$

and a variation of it developed by Ljung and Box,

$$Q' = T(T+2) \sum_{s=1}^{m} \frac{\hat{\rho}_s^2}{T-s} \qquad (16.3.5)$$

Under the null hypothesis that all autocorrelations up to lag m are zero, the statistics Q and Q' are distributed in large samples as $\chi^2_{(m)}$ random variables. If the value of either test statistic is greater than the critical value from the appropriate chi-square distribution, then we reject the null hypothesis that all the autocorrelations are zero and accept the alternative that one or more of them are not zero. In Tables 16.2 and 16.3 the column labeled Q-Stat is the Ljung-Box statistic Q'. The reported *p*-values indicate that for both series we can reject the null hypothesis that all the autocorrelations are zero.

Testing for zero autocorrelations is, of course, not actually a test for stationarity. The series *s*2 is a stationary series, with statistically significant autocorrelations, as shown in Table 16.2. However, if we fail to reject the null hypothesis of zero

autocorrelations, then we conclude that the series is a purely random, or **white noise**, process, which is a special kind of stationary process. In the next section we provide direct tests for nonstationarity.

16.4 Unit Root Tests for Stationarity

The stationarity of a time series can be tested directly with a **unit root test**. The AR(1) model for the time series variable y_t is

$$y_t = \rho y_{t-1} + v_t \tag{16.4.1}$$

Assume that v_t is a random disturbance with zero mean and constant variance σ_v^2. In this model, if $\rho = 1$ then y_t is the nonstationary random walk, $y_t = y_{t-1} + v_t$, and is said to have a **unit root**, because the coefficient $\rho = 1$.

By computing its variance, we can show that the random walk process $y_t = y_{t-1} + v_t$ is nonstationary. Suppose that $y_0 = 0$, then, by repeated substitution,

$$y_1 = v_1$$
$$y_2 = y_1 + v_2 = v_1 + v_2$$
$$y_3 = y_2 + v_3 = v_1 + v_2 + v_3$$
$$\vdots$$
$$y_t = \sum_{j=1}^{t} v_j \tag{16.4.2}$$

Therefore,

$$\text{var}(y_t) = t\sigma_v^2 \tag{16.4.3}$$

Since the variance of y_t changes over time, it is a nonstationary series. In fact, as $t \to \infty$ the variance of y_t becomes infinitely large.

Recall that if $|\rho| < 1$, then the AR(1) process is stationary. Thus we can test for nonstationarity by testing the null hypothesis that $\rho = 1$ against the alternative that $|\rho| < 1$, or simply $\rho < 1$. The test is put into a convenient form by subtracting y_{t-1} from both sides of (16.4.1), to obtain

$$y_t - y_{t-1} = \rho y_{t-1} - y_{t-1} + v_t$$
$$\Delta y_t = (\rho - 1)y_{t-1} + v_t$$
$$= \gamma y_{t-1} + v_t \tag{16.4.4}$$

where $\Delta y_t = y_t - y_{t-1}$ and $\gamma = \rho - 1$. Then

$$H_0 : \rho = 1 \leftrightarrow H_0 : \gamma = 0$$
$$H_1 : \rho < 1 \leftrightarrow H_1 : \gamma < 0 \tag{16.4.5}$$

The variable $\Delta y_t = y_t - y_{t-1}$ is called the **first difference** of the series y_t. If y_t follows a random walk, then $\gamma = 0$ and

$$\Delta y_t = y_t - y_{t-1} = v_t \tag{16.4.6}$$

An interesting feature of the series $\Delta y_t = y_t - y_{t-1}$ is that it is stationary if, as we have assumed, the random error v_t is purely random. Series like y_t, which can be made stationary by taking the first difference, are said to be **integrated of order 1**, and denoted I(1). Stationary series are said to be integrated of order zero, I(0). In general, if a series must be differenced d times to be made stationary it is **integrated of order d**, or **I(d)**.

16.4.1 THE DICKEY–FULLER TESTS

To test the hypothesis in (16.4.5) we estimate (16.4.4) by least squares as usual, and examine the t-statistic for the hypothesis that $\gamma = 0$ as usual. Unfortunately this t-statistic no longer has a t-distribution, since, if the null hypothesis is true, y_t follows a random walk. Consequently this statistic, which is often called the τ **(tau) statistic,** must be compared to specially constructed critical values. Originally these critical values were tabulated by statisticians Dickey and Fuller (D. A. Dickey and W. A. Fuller, "Distribution of the Estimators for Autoregressive Time Series with a Unit Root," *Journal of the American Statistical Association*, 74, 1979, 427–431). The test using these critical values has become known as the **Dickey–Fuller test**.

In addition to testing if a series is a random walk, Dickey and Fuller also developed critical values for the presence of a unit root (a random walk process) in the presence of a **drift**.

$$\Delta y_t = \alpha_0 + \gamma y_{t-1} + v_t \tag{16.4.7}$$

Such series display a definite trend, as we have illustrated with simulated data in Figure 16.1 (e)–(f). This is an extremely important case, because as you can see in Figure 16.2, macroeconomic variables often exhibit a strong trend.

It is also possible to allow explicitly for a nonstochastic trend. To do so, the model is further modified to include a time trend, or time, t

$$\Delta y_t = \alpha_0 + \alpha_1 t + \gamma y_{t-1} + v_t \tag{16.4.8}$$

Critical values for the *tau* (τ) statistic, which are valid in large samples for a one-tailed test, are given in Table 16.4. Comparing these values to the standard values in the last row, you see that the τ-statistic must take larger (negative) values than usual in order for the null hypothesis $\gamma = 0$, a unit root-nonstationary process, to be rejected in favor of the alternative that $\gamma < 0$, a stationary process. To control for the possibility that the error term in one of the equations, for example (16.4.7), is autocorrelated, additional terms are included. The modified model is

$$\Delta y_t = \alpha_0 + \gamma y_{t-1} + \sum_{i=1}^{m} a_i \Delta y_{t-i} + v_t \tag{16.4.9}$$

where

$$\Delta y_{t-1} = (y_{t-1} - y_{t-2}), \qquad \Delta y_{t-2} = (y_{t-2} - y_{t-3}), \ldots$$

Table 16.4 **Critical Values for the Dickey–Fuller Test**

Model	1%	5%	10%
$\Delta y_t = \gamma y_{t-1} + v_t$	−2.56	−1.94	−1.62
$\Delta y_t = \alpha_0 + \gamma y_{t-1} + v_t$	−3.43	−2.86	−2.57
$\Delta y_t = \alpha_0 + \alpha_1 t + \gamma y_{t-1} + v_t$	−3.96	−3.41	−3.13
Standard critical values	−2.33	−1.65	−1.28

Note: These critical values are taken from R. Davidson and J. G. MacKinnon (1993) *Estimation and Inference in Econometrics*, New York: Oxford University Press, p. 708.

Testing the null hypothesis that $\gamma = 0$ in the context of this model is called the **augmented Dickey–Fuller test**. The test critical values are the same as for the Dickey–Fuller test, as shown in Table 16.4.

16.4.2 THE DICKEY–FULLER TESTS: AN EXAMPLE

As an example, consider real personal consumption expenditures (y_t) as plotted in Figure 16.2(d). This variable is strongly trended, and we suspect that it is non-stationary. Inspection of the correlogram shows very slowly declining autocorrelations, a first indicator of nonstationarity. We estimate (16.4.7) and (16.4.8) with and without additional terms to control for autocorrelation. These results are reported in (16.4.10). In each case the estimated value of γ (the coefficient of PCE_{t-1}) is positive, as are the associated *tau* statistics. Clearly we do not reject the null hypothesis that personal consumption expenditures have a unit root.

$$\Delta P\hat{C}E_t = -1.5144 + .0030 PCE_{t-1}$$
$$\text{(tau)} \quad (-0.349) \quad (2.557) \tag{16.4.10a}$$

$$\Delta P\hat{C}E_t = 2.0239 + 0.0152t + 0.0013 PCE_{t-1}$$
$$\text{(tau)} \quad (0.1068) \quad (0.1917) \quad (0.1377) \tag{16.4.10b}$$

$$\Delta P\hat{C}E_t = -2.111 + 0.00397 PCE_{t-1} - 0.2503\Delta PCE_{t-1} - 0.0412\Delta PCE_{t-2}$$
$$\text{(tau)} \quad (-0.4951) \quad (3.3068) \quad\quad (-4.6594) \quad\quad (-0.7679) \quad (16.4.10c)$$

The question then becomes: Is the first difference ($\Delta PCE_t = PCE_t - PCE_{t-1}$) of the personal consumption series stationary?

In Figure 16.4 we plot the first differences, which certainly look like the plots of stationary processes in Figure 16.1 (a)–(b). The correlogram shows small correlations at all lags, suggesting stationarity. The result of the Dickey–Fuller test for a random walk (since there is no trend) applied to the series ΔPCE_t, which we denote as D_t, is given in (16.4.11):

$$\Delta \hat{D}_t = -0.9969 D_{t-1}$$
$$\text{(tau)} \quad (-18.668) \tag{16.4.11}$$

FIGURE 16.4 First differences of PCE series.

Based on the large negative value of the *tau* statistic we reject the null hypothesis that ΔPCE_t has a unit root and accept the alternative that it is stationary. Collecting the results from the unit root tests on PCE_t and ΔPCE_t, we can say that the series *PCE* is I(1). Had the null hypothesis of a unit root not been rejected in (16.4.11), we would have concluded that *PCE* is I(2) or integrated of an order higher than 2.

16.5 Cointegration

As a general rule nonstationary time series variables should not be used in regression models, in order to avoid the problem of spurious regression. However, there is an exception to this rule. If y_t and x_t are nonstationary I(1) variables, then we would expect that their difference, or any linear combination of them, such as $e_t = y_t - \beta_1 - \beta_2 x_t$, to be I(1) as well. However, there are important cases when $e_t = y_t - \beta_1 - \beta_2 x_t$ is a stationary I(0) process. In this case y_t and x_t are said to be **cointegrated**. Cointegration implies that y_t and x_t share similar stochastic trends, and in fact, since their difference e_t is stationary, they never diverge too far from each other. The cointegrated variables y_t and x_t exhibit a *long-term equilibrium* relationship defined by $y_t = \beta_1 + \beta_2 x_t$, and e_t is the *equilibrium error*, which represents short-term deviations from the long-term relationship.

We can test whether y_t and x_t are cointegrated by testing whether the errors $e_t = y_t - \beta_1 - \beta_2 x_t$ are stationary. Since we cannot observe e_t, we instead test the stationarity of the least squares residuals, $\hat{e}_t = y_t - b_1 - b_2 x_t$, using a Dickey–Fuller test. We estimate the regression

$$\Delta \hat{e}_t = \alpha_0 + \gamma \hat{e}_{t-1} + v_t \tag{16.5.1}$$

where $\Delta \hat{e}_t = \hat{e}_t - \hat{e}_{t-1}$, and examine the t (or *tau*) statistic for the estimated slope. Because we are basing this test upon estimated values, the critical values given in Table 16.5 are somewhat different than those in Table 16.4.

Table 16.5 **Critical Values for the Co-integration Test**

Model	1%	5%	10%
$\Delta\hat{e}_t = \alpha_0 + \gamma\hat{e}_{t-1} + v_t$	−3.90	−3.34	−3.04

Note: These critical values are taken from R. Davidson and J. G. MacKinnon (1993), *Estimation and Inference in Econometrics*, New York: Oxford University Press, p. 722.

16.5.1 AN EXAMPLE OF A COINTEGRATION TEST

To illustrate, let us test whether $y_t = PCE_t$ and $x_t = PDI_t$, where PDI_t is real personal disposable income (monthly), as plotted in Figure 16.2(a), are cointegrated. You may confirm that PDI_t is nonstationary. The estimated least squares regression between these variables is

$$\hat{PCE}_t = -390.7848 + 1.0160 DPI_t$$
$$\text{(t-stats)} \ (-24.50) \quad (252.97) \tag{16.5.2}$$

Estimating (16.5.1) we obtain

$$\Delta\hat{e}_t = 0.188250 - 0.120344\hat{e}_{t-1}$$
$$\text{(tau)} \ (0.1107) \quad (-4.5642) \tag{16.5.3}$$

The *tau* statistic is less than the critical value −3.90 for the 1% level of significance, thus we reject the null hypothesis that the least squares residuals are nonstationary, and conclude that they are stationary. Thus we conclude that personal consumption expenditures and personal disposable income are cointegrated, indicating that there is a long-run, equilibrium relationship between these variables.

16.6 Summarizing Estimation Strategies When Using Time Series Data

We have mentioned in this chapter some of the complexities that arise when using time series data. In doing so we have glossed over many issues that are discussed in books devoted to the study of time series data. However, we have made some important points. Let us summarize what we have discovered so far in this chapter.

- A regression between two nonstationary variables can produce spurious results.
- Nonstationarity of variables can be assessed using the autocorrelation function, and through unit root tests.
- Spurious regressions exhibit a low value of the Durbin–Watson statistic and a high R^2.
- If two nonstationary variables are cointegrated, their long-run relationship can be estimated via a least squares regression.
- Cointegration can be assessed via a unit root test on the residuals of the regression.

There are still some unanswered questions.

1. First, if the variables are nonstationary, and not cointegrated, is there any relationship that can be estimated? In these circumstances one can investigate whether there is a relationship between the variables after they have been differenced to achieve stationarity. For example, suppose that the two variables y_t and x_t are I(1) variables, and that they are not cointegrated. Since the changes Δy_t and Δx_t are stationary, we can run regressions of the form

$$\Delta y_t = \beta_1 + \beta_2 \Delta x_t + e_t \qquad (16.6.1)$$

Estimating equations like this one gives information on any relationship between the *changes* in the variables.

2. A second case is the one in which y_t and x_t are stationary, the implicit assumption maintained for most of the text. In this case least squares or generalized least squares, whichever is more appropriate, can be used to estimate a relationship between y and x.

3. Finally, there is a third relationship that is of interest, called an **error correction model**, that can be estimated when y_t and x_t are nonstationary, but cointegrated.

For I(1) variables, the error-correction model relates changes in a variable, say Δy_t, to departures from the long-run equilibrium in the previous period $(y_{t-1} - \beta_1 - \beta_2 x_{t-1})$. It can be written as

$$\Delta y_t = \alpha_1 + \alpha_2(y_{t-1} - \beta_1 - \beta_2 x_{t-1}) + v_t \qquad (16.6.2)$$

The changes or *corrections* Δy_t depend on the departure of the system from its long-run equilibrium in the previous period. The shock v_t leads to a short-term departure from the cointegrating equilibrium path; then, there is a tendency to correct back toward the equilibrium. The coefficient α_2 governs the speed of adjustment back toward the long-run equilibrium. We usually expect the sign of α_2 to be negative, so that a positive (negative) departure from equilibrium in the previous period will be corrected by a negative (positive) amount in the current period.

One way to estimate the error correction model is to use least squares to estimate the cointegrating relationship $y_t = \beta_1 + \beta_2 x_t$, and to then use the lagged residuals $\hat{e}_{t-1} = y_{t-1} - b_1 - b_2 x_{t-1}$ as the right-hand-side variable in the error-correction model, estimating it with a second least squares regression.

16.7 Learning Objectives

Based on the material in this chapter, you should be able to explain:

1. In intuitive terms, what the difference is between stationary and nonstationary time series processes?

2. What is the general behavior of a random walk time series?

3. What is a "spurious regression."

4. The general characteristics of the correlogram for stationary and nonstationary processes.

5. What is a "unit root" test, and state implications of the null and alternative hypotheses?

6. The meaning of a series being "integrated of order 1," or I(1).

7. The Dickey–Fuller and Augmented Dickey–Fuller tests for unit roots, and carry them out using your computer software.

8. The concept of cointegration, and how to test whether two series are cointegrated.

9. The formulation of an error-correction model.

16.8 Exercises

16.1 The data for Figure 16.1 are in the file *fig16-1.dat*. There are 1001 observations on 6 series, *s1*, *s2*, *rw1*, *rw2*, *rwd1*, *rwd2*.
 (a) Plot each of these series using your computer software.
 (b) Obtain the correlogram for each series and comment.
 (c) Estimate a simple regression of *rwd1* on *rwd2*. Comment on the results.
 (d) Estimate a simple regression of *s1* on *s2*. Comment on the results.
 (e) Explain how the regressions in (c) and (d) are related to the problem of spurious regressions.

16.2 The data for Figure 16.2 (a)–(e) are in the file *fig16-2.dat*. These series are monthly from 1970.01 to 1999.08. The quarterly data for Figure 16.2 (f), covering the period 1959.I to 1999.III, are in the file *profits.dat*.
 (a) Plot each of these series using your computer software.
 (b) Obtain the correlogram for each series and comment.
 (c) Test each of these series for a unit root. (Include an intercept, and perform the test with and without a trend. Use four augmentation terms and the 10% significance level.)
 (d) For each series in (c) that is nonstationary, take the first difference. Plot this series and test it for stationarity. What do you conclude about the "order of integration" of each series?

16.3 In the file *oil.dat* are 88 annual observations on the price of oil (in 1967 constant dollars) for the period 1883–1970. These data are from Pindyck and Rubinfeld, *Econometric Models and Economic Forecasts*, 3rd Ed. (1991, p. 463).
 (a) Plot the data and obtain the correlogram. Based on this information, do oil prices appear stationary or not?
 (b) Use a unit root test to demonstrate that the series is stationary. Use the instructions in Exercise 16.2(c).

16.4 In the file *bond.dat* there are 102 monthly observations on AA railroad bond yields for the period January 1968 to June 1976. [They are taken from Cryer, J. D., *Time Series Analysis* (1986)].
 (a) Plot the data and obtain the correlogram. Based on this information, do railroad bond yields appear stationary?
 (b) Use a unit root test to demonstrate that the series is nonstationary. Use the instructions in Exercise 16.2(c).
 (c) Find the first difference of the bond yield series and check it for non-

stationarity. What do you conclude about the order of integration of this series?

16.5 Test whether the quarterly observations for nondurable consumption and disposable income (for 1947:I to 1980:IV) stored in the file *macrovar.dat* are cointegrated.

16.6 In the file *texas.dat* there are 57 quarterly observations on the real price of oil (*RPO*), Texas nonagricultural employment (*TXNAG*), and nonagricultural employment in the rest of the U.S. (*USNAG*). The data cover the period 1974:Q1 through 1988:Q1 and were used in a study by Fomby and Hirschberg (T. B. Fomby and J. G. Hirschberg, "Texas in Transition: Dependence on Oil and the National Economy," *Federal Reserve Bank of Dallas Economic Review*, January 1989, 11–28). Let $x_t = \ln(RPO_t/RPO_{t-1})$, $y_t = \ln(TXNAG_t/TXNAG_{t-1})$, and $z_t = \ln(USNAG_t/USNAG_{t-1})$.
 (a) Test *RPO*, *TXNAG*, and *USNAG* for unit roots.
 (b) Test x_t, y_t, and z_t for the existence of unit roots, using the instructions in Exercise 16.2(c).

16.7 Visit one of the web sites at which economic data can be downloaded. Several of these are listed in Chapter 19. Download time series data on five macroeconomic variables.
 (a) Plot these variables and examine them for stationarity.
 (b) Are any of these series cointegrated?

Chapter 17

Pooling Time–Series and Cross-Sectional Data

When investigating the behavior of economic units such as households, firms, or even nations, we often have observations on a number of such units for a number of time periods. For example, if we are studying the economic behavior of electric utility firms, we may observe costs, inputs, and outputs for a number of firms across the United States. These observations could be made every year for a number of years. On the aggregate level, if we are studying the international usage of oil and coal, we may observe usage and the corresponding explanatory variables for a number of countries, in each quarter or each year, for a number of years. In these examples an investigator possesses a time-series of data on a cross-section of economic units. The problem is how to specify a model that will capture individual differences in behavior so that we may combine, or **pool**, all the data (information) for estimation and inference purposes. In this chapter we consider three models for pooling time-series and cross-sectional data. They are (i) the seemingly unrelated regressions model, (ii) a dummy variable model, and (iii) an error components model. The same economic example will be carried through the chapter to illustrate all three models. Before turning to these models we introduce the economic example, and a general equation for pooling data.

17.1 An Economic Model

Investment demand is the purchase of durable goods by both households and firms. In terms of total spending, investment spending is the volatile component. Therefore, understanding what determines investment is crucial to understanding the sources of fluctuations in aggregate demand. In addition, a firm's net fixed investment, which is the flow of additions to capital stock or replacements for worn out capital, is important because it determines the future value of the capital stock and thus affects future labor productivity and aggregate supply.

There are several interesting and elaborate theories that seek to describe the determinants of the investment process for the firm. Most of these theories evolve to the conclusion that perceived profit opportunities (expected profits or present discounted value of future earnings) and desired capital stock are two important determinants of a firm's fixed business investment. Unfortunately, neither of these variables are directly observable. Therefore, in formulating our economic model, we use observable proxies for these variables instead.

In terms of expected profits, one alternative is to identify the present discounted

value of future earnings as the market value of the firms securities. The price of a firm's stock represents and contains information about these expected profits. Consequently, the stock market value of the firm at the beginning of the year, denoted by V_t, may be used as a proxy for expected profits.

In terms of desired capital stock, expectations play a definite role. To catch these expectational effects, one possibility is to use a model that recognizes that actual capital stock in any period is the sum of a large number of past desired capital stocks. Thus, we use the beginning of the year actual capital stock K_t as a proxy for permanent desired capital stock.

Focusing on these explanatory variables, an economic model for describing gross firm investment for the ith firm in the tth time period may be expressed as

$$INV_{it} = f(V_{it}, K_{it}) \qquad (17.1.1)$$

Let $y_{it} = INV_{it}$ denote values for the dependent variable and $x_{2it} = V_{it}$ and $x_{3it} = K_{it}$ denote values for the explanatory variables. A very flexible linear statistical model that corresponds to (17.1.1) is

$$y_{it} = \beta_{1it} + \beta_{2it}x_{2it} + \beta_{3it}x_{3it} + e_{it} \qquad (17.1.2)$$

In this general model the intercepts and response parameters are permitted to differ for each firm in each time period. The model cannot be estimated in its current form, as there are more unknown parameters than data points. However, there are many types of simplifying assumptions that can be made to make the model operational. One of the challenges of econometrics is to specify a statistical model that is consistent with how the data are generated. The three models that we outline in this chapter can be viewed as special cases of the general model in (17.1.2).

17.2 Seemingly Unrelated Regressions

The simplification of (17.1.2) that yields what is called the **seemingly unrelated regressions (SUR)** model is

$$\beta_{1it} = \beta_{1i} \qquad \beta_{2it} = \beta_{2i} \qquad \beta_{3it} = \beta_{3i} \qquad (17.2.1)$$

That is, the parameters of the investment function differ across firms (note that the "i" subscript remains) but are constant across time. This assumption means that the model in (17.1.2) becomes

$$y_{it} = \beta_{1i} + \beta_{2i}x_{2it} + \beta_{3i}x_{3it} + e_{it} \qquad (17.2.2)$$

The data we use to illustrate the SUR model are given in Table 9.3; they consist of 20 time-series observations on investment, stock market value, and capital stock for two firms, General Electric (G) and Westinghouse (W). Thus, in terms of the subscripts in (17.2.2), $i = G$ and W, and $t = 1, 2, \ldots, 20$. The investment functions for these two firms were considered in Chapter 9.6 and Exercises 11.3 and 11.4; further aspects of the functions are explored now, and are related to the earlier specifications.

17.2.1 ESTIMATING SEPARATE EQUATIONS

Corresponding to the model in (17.2.2), we can specify two regression models, one for General Electric and one for Westinghouse.

$$INV_{Gt} = \beta_{1G} + \beta_{2G}V_{Gt} + \beta_{3G}K_{Gt} + e_{Gt} \qquad (17.2.3a)$$

$$INV_{Wt} = \beta_{1W} + \beta_{2W}V_{Wt} + \beta_{3W}K_{Wt} + e_{Wt} \qquad (17.2.3b)$$

For the moment we make the usual least squares assumptions about the errors.

$$E(e_{Gt}) = 0 \qquad \text{var}(e_{Gt}) = \sigma_G^2 \qquad \text{cov}(e_{Gt}, e_{Gs}) = 0 \qquad (17.2.4a)$$

$$E(e_{Wt}) = 0 \qquad \text{var}(e_{Wt}) = \sigma_W^2 \qquad \text{cov}(e_{Wt}, e_{Ws}) = 0 \qquad (17.2.4b)$$

Assumption (17.2.4a) says that the errors in the first investment function (i) have zero mean, (ii) are homoskedastic with constant variance σ_G^2, and (iii) are not correlated over time; autocorrelation does not exist. A similar set of assumptions is made in (17.2.4b) for the second investment function. Note, however, that the two functions do have different error variances σ_G^2 and σ_W^2.

So far, the assumptions in (17.2.4) are precisely those for which least squares is the best linear unbiased estimator for the unknown coefficients. We are able to confidently apply least squares separately to each equation, knowing we have chosen the appropriate estimator. However, when we follow this strategy, we are saying: Given the information we have on General Electric, what is the best estimator of the General Electric equation? And, given the information on Westinghouse, what is the best estimator for the Westinghouse equation? We are treating the two equations separately. We are not asking whether we might have information on General Electric that could be utilized to obtain a better estimator of the Westinghouse equation; or vice versa. For information on one equation to improve estimation of the other, we need some kind of link between the two equations. Let us investigate some possible linkages.

One way of linking the two equations was explored in Chapter 9.7. In that chapter the two equations were combined using a dummy variable to give the model

$$INV_t = \beta_{1G} + \delta_1 D_t + \beta_{2G}V_t + \delta_2 D_t V_t + \beta_{3G}K_t + \delta_3 D_t K_t + e_t \qquad (17.2.5)$$

where D_t is a dummy variable equal to 1 for the Westinghouse observations and 0 for the General Electric observations. You should think of (17.2.5) as representing the pooled set of 40 observations. Because we have combined the 20 General Electric observations with the 20 Westinghouse observations, we have dropped the G and W subscripts from the variables.

Equation (17.2.5) is just another way of writing (17.2.3). You should satisfy yourself that this is so by seeing what happens when $D = 1$ and what happens when $D = 0$. You will find that they are identical specifications with the following relationships between the parameters:

$$\beta_{1W} = \beta_{1G} + \delta_1 \qquad \beta_{2W} = \beta_{2G} + \delta_2 \qquad \beta_{3W} = \beta_{3G} + \delta_3$$

A natural question to ask is: What happens if we apply least squares to (17.2.5), utilizing all 40 observations? How would this estimation differ from applying least

squares twice, once to the 20 observations for Westinghouse and once to the 20 observations for General Electric? The answer is that the estimates of the βs turn out to be exactly the same. The new model treats all the coefficients in exactly the same way. However, the standard errors from the two procedures will be different. If we estimate the pooled dummy variable model by least squares, we are implicitly assuming that the error variance for e_t is constant over all 40 observations. When estimating separate equations for General Electric and Westinghouse, we are recognizing that one set of 20 values of e_t has variance σ_G^2 and the other set of 20 values of e_t has variance σ_W^2; correspondingly, we get different variance *estimates* for each equation.

What happens, then, if we recognize the existence of heteroskedasticity ($\sigma_G^2 \neq \sigma_W^2$), and apply generalized least squares to the pooled dummy-variable model? In this case all the results, both coefficient estimates and standard errors, will be exactly the same as those obtained from separate least squares estimation of the two equations [see Exercise 11.4(a)]. In other words, if we recognize that $\sigma_G^2 \neq \sigma_W^2$, estimation by linking the two equations with the dummy variable model is not any more precise than separate least squares estimation. We need to look for an additional link.

17.2.2 JOINT ESTIMATION OF THE EQUATIONS

An assumption that lets us utilize a joint estimation procedure that is better than separate least squares estimation is

$$\text{cov}(e_{Gt}, e_{Wt}) = \sigma_{GW} \tag{17.2.6}$$

This assumption says that the error terms in the two equations, at the same point in time, are correlated. This kind of correlation is often called **contemporaneous correlation**. To understand why e_{Gt} and e_{Wt} might be correlated, recall that these errors contain the influence on investment of factors that have been omitted from the equations. Such factors might include capacity utilization, current and past interest rates, liquidity, and the general state of the economy. Since the two firms are similar in many respects, it is likely that the effects of the omitted factors on investment by General Electric will be similar to their effect on investment by Westinghouse. If so, then e_{Gt} and e_{Wt} will be capturing similar effects and will be correlated. Adding the contemporaneous correlation assumption (17.2.6) has the effect of introducing additional information that is not included when we carry out separate least squares estimation of the two equations.

What are the implications of (17.2.6) for the error term e_t in the pooled dummy variable model in (17.2.5)? It means that all 40 errors will not be uncorrelated. The General Electric errors are not correlated with each other, and the Westinghouse errors are not correlated with each other, but (17.2.6) implies that the first Westinghouse error will be correlated with the first General Electric error, the second Westinghouse error will be correlated with the second General Electric error, and so on. This information cannot be utilized when the equations are estimated separately. However, it can be utilized to produce better estimates when the equations are jointly estimated as they are in the dummy variable model.

To improve the precision of the dummy variable model estimates, the errors must be transformed so that they all have the same variance and are uncorrelated. In particular, we need the transformed Westinghouse errors to be uncorrelated with the transformed General Electric errors. The variables are correspondingly transformed.

This transformation is too complicated to present here, but it is automatically carried out by your computer software, usually using some kind of "seemingly unrelated regression" command. The steps that your software follows are: (i) Estimate the equations separately using least squares; (ii) Use the least squares residuals from step (i) to estimate σ_G^2, σ_W^2 and σ_{GW}; (iii) Use the estimates from step (ii) to estimate the two equations jointly within a generalized least squares framework.

Estimates of the coefficients of the two investment functions are presented in Table 17.1. Standard errors are in parentheses. Two sets of estimates are given, those obtained from separate least squares estimation of the two equations and those obtained using the joint seemingly unrelated regression (SUR) technique. Since the SUR technique utilizes the information on the correlation between the error terms, it is more precise than least squares. This fact is supported by the lower standard errors of the SUR estimates. You should be cautious, however, when making judgments about precision on the basis of standard errors. Standard errors are themselves estimates; it is possible for a standard error for SUR to be greater than a corresponding least squares standard error even when SUR is a better estimator than least squares. From an economic standpoint our estimated coefficients for the capital stock and value variables have the expected positive signs. Also, all are significantly different from zero except for the coefficient of capital stock in the Westinghouse equation. This coefficient has a low t-value, and hence, is estimated with limited precision.

Equations that exhibit contemporaneous correlation were called "seemingly unrelated" by their inventor, a famous econometrician Arnold Zellner; the equations seem to be unrelated, but the additional information provided by the correlation between the equation errors means that joint generalized least squares estimation is better than single-equation least squares.

17.2.3 SEPARATE OR JOINT ESTIMATION

Is it always better to estimate two or more equations jointly? Or are there circumstances when it is just as good to estimate each equation separately?

There are two situations where separate least squares estimation is just as good as the SUR technique. The first of these cases is where the errors are not correlated. If the errors are not correlated, there is nothing linking the two equations, and separate estimation cannot be improved upon.

The second situation is less obvious. Indeed, some advanced algebra is needed to prove that least squares and SUR give *identical* estimates when the same explana-

Table 17.1 **Least Squares and Seemingly Unrelated Regression Estimates for Two Investment Functions**

Variable	General Electric		Westinghouse	
	LS	SUR	LS	SUR
Constant	−9.956	−27.719	−0.509	−1.252
	(31.374)	(27.033)	(8.015)	(6.956)
V	0.0265	0.0383	0.0529	0.0576
	(0.0156)	(0.0133)	(0.0157)	(0.0134)
K	0.1517	0.1390	0.0924	0.0640
	(0.0257)	(0.0230)	(0.0561)	(0.0489)

tory variables appear in each equation. By the "same explanatory variables," we mean more than variables with similar definitions, like the value and capital stock variables for General Electric and Westinghouse. We mean the same variables with the same numerical values on those variables. For example, suppose we are interested in estimating demand equations for beef, chicken, and pork. Since these commodities are all substitute meats, it is reasonable to specify the quantity demanded for each of the meats as a function of the price of beef, the price of chicken, and the price of pork, as well as income. The same variables with the same observation values appear in all three equations. Even if the errors of these equations are correlated, as is quite likely, the use of SUR will not yield an improvement over separate estimation.

If the explanatory variables in each equation are different, then a test to see if the correlation between the errors is significantly different from zero is of interest. If a null hypothesis of zero correlation is not rejected, then there is no evidence to suggest that SUR will improve on separate least squares estimation. To carry out such a test we compute the squared correlation

$$r_{GW}^2 = \frac{\hat{\sigma}_{GW}^2}{\hat{\sigma}_G^2 \hat{\sigma}_W^2} = \frac{(176.45)^2}{(660.83)(88.662)} = (0.729)^2 = .53139 \qquad (R17.1)$$

The variance estimates $\hat{\sigma}_G^2$ and $\hat{\sigma}_W^2$ are the usual ones from separate least squares estimation, except that $T = 20$ rather than $T - K = 17$ has, for large-sample approximation reasons, been used as the divisor in the formulas. The estimated covariance is computed from

$$\hat{\sigma}_{GW} = \frac{1}{T} \sum_{t=1}^{20} \hat{e}_{Gt} \hat{e}_{Wt}$$

To check the statistical significance of r_{GW}^2, we test the null hypothesis $H_0: \sigma_{GW} = 0$. If $\sigma_{GW} = 0$, then $\lambda = T r_{GW}^2$ is a test statistic that is distributed as a $\chi_{(1)}^2$ random variable in large samples. The 5% critical value of a chi-square distribution with one degree of freedom is 3.84. The value of the test statistic from our data is $\lambda = 10.628$. Hence, we reject the null hypothesis of no correlation between the e_{Gt} and e_{Wt}.

If we are testing for the existence of correlated errors for more than two equations, the relevant test statistic is equal to T times the sum of squares of all the correlations; the probability distribution under H_0 is a chi-square distribution with degrees of freedom equal to the number of correlations. For example, with three equations, denoted by subscripts "1," "2," and "3," the null hypothesis is

$$H_0: \sigma_{12} = \sigma_{13} = \sigma_{23} = 0$$

and the $\chi_{(3)}^2$ test statistic is

$$\lambda = T(r_{12}^2 + r_{13}^2 + r_{23}^2)$$

There are many economic problems where we have cause to consider a system of equations. The investment function example was one; estimation of demand functions, like the meat functions we alluded to in this section, is another. Further examples are given in the exercises.

17.2.4 TESTING CROSS-EQUATION RESTRICTIONS

Suppose we are interested in whether the equations for Westinghouse and General Electric have identical coefficients. That is, we are interested in testing

$$H_0: \beta_{1G} = \beta_{1W}, \qquad \beta_{2G} = \beta_{2W}, \qquad \beta_{3G} = \beta_{3W} \qquad (17.2.7)$$

against the alternative that at least one pair of coefficients are not equal. In Chapter 9.7 this hypothesis was tested under the assumption of equal error variances and no error correlation. It was called the Chow test. In Exercise 11.4 the same assumption was tested assuming e_{Gt} and e_{Wt} had different variances, but remained uncorrelated. It is also possible to test hypotheses such as (17.2.7) when the more general error assumptions of the SUR model are relevant. Most computer software will perform an F-test and/or a χ^2-test. In the context of SUR equations both tests are large sample approximate tests. The F-statistic has J and $(MT - K)$ degrees of freedom where M is the number of equations, K is the total number of coefficients in the whole system and J is the number of restrictions. The χ^2-statistic has J degrees of freedom. For our particular example, at a 5% significance level, we find that $F = 3.01 > F_c = 2.88$ and $\chi^2 = 10.31 > \chi_c^2 = 7.81$. Thus, both tests reject the null hypothesis of equal coefficients.

The equality of coefficients is not the only cross-equation restriction that can be tested. Any linear, or indeed nonlinear, restrictions on parameters in different equations can be tested. Such restrictions are particularly relevant in estimating equations derived from demand and production theory.

17.3 A Dummy Variable Specification

To introduce the dummy variable model as a method for pooling time-series and cross-sectional data, we return to (17.1.2), which is

$$y_{it} = \beta_{1it} + \beta_{2it}x_{2it} + \beta_{3it}x_{3it} + e_{it} \qquad (17.3.1)$$

Both the dummy variable model to be described in this section and the error components model considered in the next section assume that

$$\beta_{1it} = \beta_{1i} \qquad \beta_{2it} = \beta_2 \qquad \beta_{3it} = \beta_3 \qquad (17.3.2)$$

This model of parameter variation specifies that *only the intercept parameter varies*, not the response parameters; and the intercept varies only across firms and not over time. Also, we will assume that the errors e_{it} are independent and distributed $N(0, \sigma_e^2)$ for all individuals and in all time periods. Given this assumption, and (17.3.2), it follows that *all behavioral differences between individual firms and over time are captured by the intercept.* The resulting statistical model is

$$y_{it} = \beta_{1i} + \beta_2 x_{2it} + \beta_3 x_{3it} + e_{it} \qquad (17.3.3)$$

The feature that distinguishes the dummy variable model from the error components model is the way in which the varying intercept β_{1i} is treated. The dummy

variable model treats it as a fixed, unknown parameter. We make inferences only about the firms on which we have data. The error components model views the firms on which we have data as a random sample from a larger population of firms. The intercepts are treated as random drawings from the population distribution of firm intercepts. Inferences are made about the population of firms. Sometimes the dummy variable model is called a **fixed effects model,** and the error components model bears the name **random effects model.**

The example we use for introducing the dummy variable and error components frameworks is the same investment behavior example that we used for the section on SUR. However, instead of using only two firms, we extend our data set to include ten firms. These data are given in the file *pool.dat*. They comprise $T = 20$ time-series observations on $N = 10$ firms.

17.3.1 THE MODEL

To introduce the dummy variable version of (17.3.3), we define dummy variables of the following type

$$D_{1i} = \begin{cases} 1 & i = 1 \\ 0 & \text{otherwise} \end{cases} \quad D_{2i} = \begin{cases} 1 & i = 2 \\ 0 & \text{otherwise} \end{cases} \quad D_{3i} = \begin{cases} 1 & i = 3 \\ 0 & \text{otherwise} \end{cases}, \text{etc.}$$

Under these definitions (17.3.3) becomes

$$y_{it} = \beta_{11}D_{1i} + \beta_{12}D_{2i} + \cdots + \beta_{1,10}D_{10i} + \beta_2 x_{2it} + \beta_3 x_{3it} + e_{it} \tag{17.3.4}$$

Compared to the model setups in Chapter 9 and in the SUR specification, the dummy variables in (17.3.4) are introduced in a slightly different way. In this equation there are ten dummy variables, one for each firm, and no constant term; the coefficients β_{1i} are equal to the firm intercepts. To make (17.3.4) consistent with our earlier treatments, we would need to specify a constant and nine dummy variables; each dummy variable coefficient would be equal to the difference between the intercept for its firm and the intercept for the base firm for which we did not specify a dummy variable. The specification in (17.3.4) is more convenient for our current discussion. However, you should recognize that the two alternatives are just different ways of looking at the same model.

Given that the error terms e_{it} are independent and $N(0, \sigma_e^2)$ for all observations, the best linear unbiased estimator of (17.3.4) is the least squares estimator. The results from this estimation (coefficients, standard errors, and t values) appear in Table 17.2. The response parameters for value (x_2) and capital stock (x_3) have small standard errors, implying that their influence on investment has been accurately estimated. The firm intercepts vary considerably, and some of them have large t-values, suggesting that the assumption of differing intercepts for different firms is appropriate. To confirm this fact, we can test the following hypothesis.

$$H_0: \beta_{11} = \beta_{12} = \cdots = \beta_{1N}$$
$$H_1: \text{the } \beta_{1i} \text{ are not all equal} \tag{17.3.5}$$

Table 17.2 **Dummy Variable Results**

Variable	Parameter Estimate	Standard Error	t-Statistic
D_1	−69.14	49.68	−1.39
D_2	100.86	24.91	4.05
D_3	−235.12	24.42	−9.63
D_4	−27.63	14.07	−1.96
D_5	−115.32	14.16	−8.14
D_6	−23.07	12.66	−1.82
D_7	−66.68	12.84	−5.19
D_8	−57.36	13.99	−4.10
D_9	−87.28	12.89	−6.77
D_{10}	−6.55	11.82	−0.55
x_2	0.1098	0.0119	9.26
x_3	0.3106	0.0174	17.88

These $(N-1)$ joint null hypotheses may be tested using the usual F-test statistic.

$$F = \frac{(SSE_R - SSE_U)/J}{SSE_U/(NT-K)}$$

$$= \frac{(1749127 - 522855)/9}{522855/(200-12)}$$

$$= 48.99 \tag{R17.2}$$

If the null hypothesis is true, then $F \sim F_{9,188}$. The value of the test statistic $F = 48.99$ yields a p-value of less than .0001; we reject the null hypothesis that the intercept parameters for all firms are equal.

17.4 An Error Components Model

In an error components framework, we continue to model differences in firm investment behavior by permitting each firm to have a different intercept parameter. However, we assume the intercepts are random variables; this alternative model is useful *if the individual firms (or cross-sectional units) appearing in the sample are randomly chosen and taken to be "representative" of a larger population of firms.* Returning to (17.3.3),

$$y_{it} = \beta_{1i} + \beta_2 x_{2it} + \beta_3 x_{3it} + e_{it} \tag{17.4.1}$$

we take β_{1i} to be *random* and modeled as

$$\beta_{1i} = \bar{\beta}_1 + \mu_i \qquad i = 1, \ldots, N \tag{17.4.2}$$

$\bar{\beta}_1$ is an unknown parameter that represents the **population mean intercept,** and μ_i is an unobservable random error that accounts for individual differences in firm behavior. We assume that the μ_i are independent of each other and e_{it}, and that

$$E(\mu_i) = 0 \qquad \text{var}(\mu_i) = \sigma_\mu^2$$

Consequently, $E(\beta_{1i}) = \overline{\beta}_1$ and $\text{var}(\beta_{1i}) = \sigma_\mu^2$.
Substituting (17.4.2) into (17.4.1) yields

$$
\begin{aligned}
y_{it} &= (\overline{\beta}_1 + \mu_i) + \beta_2 x_{2it} + \beta_3 x_{3it} + e_{it} \\
&= \overline{\beta}_1 + \beta_2 x_{2it} + \beta_3 x_{3it} + (e_{it} + \mu_i) \\
&= \overline{\beta}_1 + \beta_2 x_{2it} + \beta_3 x_{3it} + v_{it}
\end{aligned}
\qquad (17.4.3)
$$

where $v_{it} = e_{it} + \mu_i$. The phrase *error components* comes from the fact that the error term $v_{it} = (e_{it} + \mu_i)$ consists of two components: the overall error e_{it} and the individual specific error μ_i. The error μ_i reflects individual differences; it varies across individuals, but is constant across time.

The choice of estimation technique depends on the properties of the new error v_{it}. It can be shown that the following are true.

$$E(v_{it}) = 0 \qquad \text{(v_{it} has zero mean)} \qquad (17.4.4a)$$

$$\text{var}(v_{it}) = \sigma_\mu^2 + \sigma_e^2 \quad \text{(v_{it} is homoskedastic)} \qquad (17.4.4b)$$

$$\text{cov}(v_{it}, v_{is}) = \sigma_\mu^2 \ (t \neq s) \quad \text{(the errors from the same firm in} \qquad (17.4.4c)$$
$$\text{different time periods are correlated)}$$

$$\text{cov}(v_{it}, v_{js}) = 0 \ (i \neq j) \quad \text{(errors from different firms are always} \qquad (17.4.4d)$$
$$\text{uncorrelated)}$$

The nonzero correlation in (17.4.4c) means that least squares is not the optimal technique. The generalized least squares estimator, which uses a transformed model, with appropriately transformed error term, is a better estimator. Also, it yields standard errors that are appropriate for interval estimation and hypothesis testing.

These tasks are performed automatically using appropriate econometric software. If we do so for the investment function that utilizes the 20 time-series observations on ten firms, we obtain the following generalized least squares estimated equation

$$\hat{y}_{it} = -57.873 + 0.1095 \, x_{2it} + 0.3087 \, x_{3it} \qquad (R17.3)$$
$$(28.875) \quad (0.0105) \qquad (0.0172)$$

In this case the response parameters for the value and capital stock variables, and their standard errors, are virtually identical to those obtained from the dummy variable model. It makes little difference which model is specified. Such is not always the case, however.

17.5 Learning Objectives

Based on the material in this chapter, you should be able to:

1. Explain what is meant by seemingly unrelated regressions. What makes seemingly unrelated regressions related? Why is it useful to estimate seemingly unrelated regressions as a set of equations?

2. Use your computer software to:
 (a) Estimate a set of SUR.
 (b) Test for the existence of contemporaneous correlation.
 (c) Test cross-equation restrictions.

3. Explain the important characteristics of the dummy variable model and the error components model as alternatives for pooling data.

4. Use your computer software to estimate dummy variable and error-component models.

17.6 Exercises

17.1 Consider the following three demand equations

$$\ln q_{1t} = \beta_{11} + \beta_{12} \ln p_{1t} + \beta_{13} \ln y_t + e_{1t}$$
$$\ln q_{2t} = \beta_{21} + \beta_{22} \ln p_{2t} + \beta_{23} \ln y_t + e_{2t}$$
$$\ln q_{3t} = \beta_{31} + \beta_{32} \ln p_{3t} + \beta_{33} \ln y_t + e_{3t} \qquad (17.6.1)$$

where q_{it} is the quantity consumed of the ith commodity, $i = 1, 2, 3$, in the tth time period, $t = 1, 2, \ldots, 30$, p_{it} is the price of the ith commodity in time t, and y_t is disposable income in period t. The commodities are meat ($i = 1$), fruits and vegetables ($i = 2$), and cereals and bakery products ($i = 3$). Prices and income are in real terms, and all data are in index form. They can be found in the file *demand.dat*.
 (a) Estimate each equation by least squares and test whether the equation errors for each time period are correlated. Report the estimates and their standard errors. Do the elasticities have the expected signs?
 (b) Estimate the system jointly using the SUR estimator. Report the estimates and their standard errors. Do they differ much from your results in part (a)?
 (c) Test the null hypothesis that all income elasticity's are equal to unity. (Consult your software to see how such a test is implemented.)

17.2 This exercise uses data from Zhenjuan Liu and Thanasis Stengos, "Non-linearities in Cross Country Growth Regressions: A Semiparametric Approach," *Journal of Applied Econometrics*, Vol. 14, No. 5, 1999, pp. 527–538. There are observations on 86 countries, in three time periods, 1960, 1970, and 1980. The authors attempt to explain each country's growth rate (G) in terms of the explanatory variables:

 POP = population growth,
 INV = the share of output allocated to investment,
 $IGDP$ = initial level of GDP in 1960 in real terms,
 SEC = human capital measured as the enrollment rate in secondary schools.

We are considering three cross-sectional regressions, one for each of the years 1960, 1970, and 1980.

(a) The results from estimating a three-equation SUR system appear in Table 17.3.

Table 17.3 **EViews Output for SUR Equations in Exercise 17.2**

System: GROWTH
Estimation Method: Seemingly Unrelated Regression
Sample: 1 86
Included observations: 86
Total system (balanced) observations 258

	Coefficient	Std. Error	t-Statistic	Prob.
C(1)	0.023054	0.019475	1.183757	0.2377
C(2)	−0.243506	0.238361	−1.021585	0.3080
C(3)	0.128040	0.033314	3.843435	0.0002
C(4)	−4.09E-06	2.04E-06	−2.008929	0.0457
C(5)	0.041036	0.017216	2.383642	0.0179
C(6)	0.018522	0.031341	0.590981	0.5551
C(7)	−0.433559	0.402894	−1.076110	0.2829
C(8)	0.186990	0.039739	4.705479	0.0000
C(9)	−2.56E-06	1.79E-06	−1.432678	0.1532
C(10)	0.012653	0.018368	0.688854	0.4916
C(11)	0.042313	0.026512	1.595990	0.1118
C(12)	−0.815601	0.299663	−2.721726	0.0070
C(13)	0.115460	0.029727	3.884020	0.0001
C(14)	−6.52E-07	1.25E-06	−0.519600	0.6038
C(15)	0.002755	0.014103	0.195343	0.8453

Equation: G60 = C(1) + C(2)*POP60 + C(3)*INV60
 + C(4)IGDP60 + C(5)*SEC60
Observations: 86

R-squared	0.289138	Mean dependent var	0.029989
Adjusted R-squared	0.254033	S.D. dependent var	0.020633
S.E. of regression	0.017821	Sum squared resid	0.025724
Durbin–Watson stat	2.333417		

Equation: G70 = C(6) + C(7)*POP70 + C(8)*INV70
 + C(9)*IGDP70 + C(10)*SEC70
Observations: 86

R-squared	0.302252	Mean dependent var	0.027548
Adjusted R-squared	0.267795	S.D. dependent var	0.025098
S.E. of regression	0.021476	Sum squared resid	0.037358
Durbin–Watson stat	1.653182		

Equation: G80 = C(11) + C(12)*POP80 + C(13)*INV80
 + C(14)*IGDP80 + C(15)*SEC80
Observations: 86

R-squared	0.387397	Mean dependent var	0.008289
Adjusted R-squared	0.357145	S.D. dependent var	0.023152
S.E. of regression	0.018562	Sum squared resid	0.027910
Durbin–Watson stat	2.059211		

(i) Report each of the estimated equations with standard errors in parentheses below the estimated coefficients.

(ii) Comment on the signs of the coefficients. Can you explain these signs in terms of the expected impact of the explanatory variables on growth rate?

(iii) Does human capital appear to influence growth rate?

(b) The estimated correlations between the residuals from the three equations are

$$r_{12} = 0.1084 \qquad r_{13} = 0.1287 \qquad r_{23} = 0.3987$$

Carry out a hypothesis test to see if SUR estimation is preferred over separate least squares estimation.

(c) Table 17.4 contains the outcome of a hypothesis test. Describe the hypothesis that is being tested. What is the test outcome?

Table 17.4 **Test Results for Exercise 17.2**

Wald Test:		
System: GROWTH		
Null Hypothesis:	C(2) = C(7)	C(4) = C(9)
	C(2) = C(12)	C(4) = C(14)
	C(3) = C(8)	C(5) = C(10)
	C(3) = C(13)	C(5) = C(15)
Chi-square	12.03956	Probability 0.149448

17.3 Table 17.5 contains the results from SUR estimation of the equations in Exercise 17.2, with some restrictions imposed.

(a) What are the restrictions?

(b) Report the estimated equations, and comment on any substantial differences between these results and those in Exercise 17.2.

(c) What hypothesis is being tested by the Wald test at the bottom of the table? Is it accepted or rejected?

17.4 Another way to estimate the model in Exercise 17.3 is to pool all the observations and use dummy variables for each of the years 1960, 1970, and 1980.

(a) If you estimate the model this way, what different assumptions are you making about the error terms, relative to the assumptions made for Exercise 17.3?

(b) The results for the estimated dummy variable model appear in Table 17.6. Report the estimated equation. Comment on any differences or similarities with the estimates obtained in Exercise 17.3.

(c) Does the RESET test suggest the equation is misspecified?

17.5 The U.S. Secretary of Agriculture asks one of his economists to provide him with a basis for determining cattle inventories in the Midwest, Southwest, and West regions. Let $i = 1, 2, 3$ denote the three regions. The economist hypothesizes that in each region cattle numbers at the end of the year (c_{it}) depend on average price during the year (p_{it}), rainfall during the year (r_{it}), and cattle numbers at the end of the previous year (c_{it-1}). Because growing conditions are quite different in the three regions, he wants to try

Table 17.5 EViews Output for SUR Equations in Exercise 17.3

	Coefficient	Std. Error	*t*-Statistic	Prob.
C(1)	0.035179	0.015250	2.306806	0.0219
C(2)	−0.428557	0.188910	−2.268573	0.0241
C(3)	0.136086	0.020644	6.592178	0.0000
C(4)	−1.13E-06	1.00E-06	−1.126248	0.2611
C(5)	0.015002	0.010020	1.497161	0.1356
C(6)	0.025147	0.015952	1.576434	0.1162
C(7)	0.006838	0.016414	0.416585	0.6773

System: GROWTH
Estimation Method: Seemingly Unrelated Regression
Sample: 1 86
Included observations: 86
Total system (balanced) observations 258

Equation: G60 = C(1) + C(2)*POP60 + C(3)*INV60
 + C(4)*IGDP60 + C(5)*SEC60
Observations: 86

R-squared	0.258992	Mean dependent var	0.029989
Adjusted R-squared	0.222399	S.D. dependent var	0.020633
S.E. of regression	0.018195	Sum squared resid	0.026815
Durbin–Watson stat	2.293405		

Equation: G70 = C(6) + C(2)*POP70 + C(3)*INV70
 + C(4)*IGDP70 + C(5)*SEC70
Observations: 86

R-squared	0.256190	Mean dependent var	0.027548
Adjusted R-squared	0.219459	S.D. dependent var	0.025098
S.E. of regression	0.022173	Sum squared resid	0.039824
Durbin–Watson stat	1.556383		

Equation: G80 = C(7) + C(2)*POP80 + C(3)*INV80
 + C(4)*IGDP80 + C(5)*SEC80
Observations: 86

R-squared	0.367368	Mean dependent var	0.008289
Adjusted R-squared	0.336127	S.D. dependent var	0.023152
S.E. of regression	0.018863	Sum squared resid	0.028822
Durbin–Watson stat	2.058471		

Wald Test:
System: GROWTH

Null Hypothesis:	C(1) = C(6)		
	C(1) = C(7)		

| Chi-square | 93.09755 | Probability | 0.000000 |

Table 17.6 **Eviews Output for Dummy Variable Model in Exercise 17.4**

Dependent Variable: G Method: Least Squares Sample: 1 258 Included observations: 258				
Variable	Coefficient	Std. Error	*t*-Statistic	Prob.
D60	0.031527	0.014673	2.148656	0.0326
D70	0.020514	0.015297	1.341000	0.1811
D80	0.002896	0.015794	0.183381	0.8546
POP	−0.436464	0.182325	−2.393881	0.0174
INV	0.162829	0.020750	7.847380	0.0000
IGDP	−1.43E-06	9.42E-07	−1.516792	0.1306
SEC	0.014886	0.009759	1.525366	0.1284
R-squared	0.406119	Mean dependent var		0.021942
Adjusted R-squared	0.391923	S.D. dependent var		0.024919
S.E. of regression	0.019432			
Sum squared resid	0.094778			
Ramsey RESET Test:				
F-statistic	1.207756	Probability		0.300612

three separate equations, one for each region, that he writes as

$$c_{1t} = \beta_{11} + \beta_{12}p_{1t} + \beta_{13}r_{1t} + \beta_{14}c_{1,t-1} + e_{1t}$$
$$c_{2t} = \beta_{21} + \beta_{22}p_{2t} + \beta_{23}r_{2t} + \beta_{24}c_{2,t-1} + e_{2t}$$
$$c_{3t} = \beta_{31} + \beta_{32}p_{3t} + \beta_{33}r_{3t} + \beta_{34}c_{3,t-1} + e_{3t}$$

(a) What signs would you expect on the various coefficients? Why?
(b) Under what assumptions about the e_{it} should the three equations be estimated jointly, as a set, rather than individually?
(c) Use the 27 observations that appear in the file *cattle.dat* to find separate least squares estimates for each equation, and the corresponding standard errors.
(d) Test for the existence of contemporaneous correlation between the e_{it}.
(e) Estimate the three equations jointly using the seemingly unrelated regression technique. Compare these results with those obtained in (c) in terms of reliability and economic feasibility.

17.6* Consider the production function

$$Q_t = f(K_t, L_t)$$

where Q_t is output, K_t is capital, and L_t is labor, all for the *t*-th firm. Suppose the function $f(\cdot)$ is a CES or constant elasticity of substitution production function. The elasticity of substitution, which we denote by ω, measures the degree to which capital and labor are substituted when the factor price ratio

changes. Let P_t be the price of output, R_t be the price of capital, and W_t the price of labor. If the function $f(\cdot)$ is a CES production function, then the conditions for profit maximization, with errors attached, are

$$\ln\left(\frac{Q_t}{L_t}\right) = \gamma_1 + \omega \ln\left(\frac{W_t}{P_t}\right) + e_{1t} \qquad \text{where } e_{1t} \sim N(0, \sigma_1^2)$$

$$\ln\left(\frac{Q_t}{K_t}\right) = \gamma_2 + \omega \ln\left(\frac{R_t}{P_t}\right) + e_{2t} \qquad \text{where } e_{2t} \sim N(0, \sigma_2^2)$$

Since these equations are linear in γ_1, γ_2, and ω, some version(s) of least squares can be used to estimate these parameters. Data on twenty firms appear in the file *cespro.dat*.

(a) Find separate least squares estimates of each of the first-order conditions. Compare the two estimates of the elasticity of substitution.

(b) Test for contemporaneous correlation between e_{1t} and e_{2t}.

(c) Estimate the two equations using generalized least squares, allowing for the existence of contemporaneous correlation.

(d) Repeat part (c), but impose a restriction so that only one estimate of the elasticity of substitution is obtained. (Consult your software to see how to impose such a restriction.) Comment on the results.

(e) Compare the standard errors obtained in parts (a), (c), and (d). Do they reflect the efficiency gains that you would expect?

(f) If $\omega = 1$, the CES production function becomes a Cobb–Douglas production function. Use the results in (d) to test whether a Cobb–Douglas production function is adequate.

17.7* This exercise illustrates the transformation that is necessary to produce generalized least squares estimates for the error components model. It utilizes the data on the investment example that appears in *pool.dat*.

(a) Compute the sample means for *INV*, *V*, and *K* for each of the firms. (We can denote these means as $(\bar{y}_i, \bar{x}_{2i}, \bar{x}_{3i})$, $i = 1, 2, \ldots, 10$.)

(b) Show that the error variance estimate from regressing \bar{y}_i on \bar{x}_{2i} and \bar{x}_{3i} is

$$\hat{\sigma}_*^2 = 7218.2329$$

(c) Show that the error variance estimate from the dummy variable model is

$$\hat{\sigma}_e^2 = 2781.1445$$

(d) Show that

$$\alpha = 1 - \sqrt{\frac{\hat{\sigma}_e^2}{T\hat{\sigma}_*^2}} = 0.8612$$

(e) Show that the results in (R17.3) are obtained from least squares applied

to the regression model

$$y_{it}^* = \overline{\beta}_1 x_{1it}^* + \beta_2 x_{2it}^* + \beta_3 x_{3it}^* + v_{it}^*$$

where the transformed variables are given by

$$y_{it}^* = y_{it} - \alpha \overline{y}_i \quad x_{1it}^* = 1 - \alpha$$

$$x_{2it}^* = x_{2it} - \alpha \overline{x}_{2i} \quad x_{3it}^* = x_{3it} - \alpha \overline{x}_{3i}$$

17.8 The file *liquor.dat* contains observations on annual expenditure on liquor (L) and annual income (X), (both in thousands of dollars) for forty randomly selected households for three consecutive years. Consider the model

$$L_{it} = \beta_{1i} + \beta_2 X_{it} + e_{it}$$

where $i = 1, 2, \ldots, 40$ refers to household and $t = 1, 2, 3$ refers to year; the e_{it} are assumed to be uncorrelated with $e_{it} \sim N(0, \sigma_e^2)$.
(a) Compare the alternative estimates for β_2, and their corresponding standard errors, that are obtained under the following circumstances:
 (i) The different household intercepts are modeled using dummy variables.
 (ii) Only average data are available, averaged over the three years.
 (iii) The β_{1i} are random drawings with mean $\overline{\beta}_1$ and variance σ_μ^2.
 Comment on the estimates and their relative precision.
(b) Test the hypothesis that all household intercepts are equal.
17.9 In the model

$$\ln\left(\frac{Gas}{Car}\right) = \beta_1 + \beta_2 \ln\left(\frac{Y}{Pop}\right) + \beta_3 \ln\left(\frac{P_{MG}}{P_{GDP}}\right) + \beta_4 \ln\left(\frac{Car}{Pop}\right) + e$$

Gas/Car is motor gasoline consumption per car, *Y/Pop* is per capita real income, P_{MG}/P_{GDP} is real motor gasoline price and *Car/Pop* is the stock of cars per capita. The files *gascar1.dat, gascar2.dat, ... , gascar6.dat* each contain 19 time series observations on the above variables, for the countries, Austria, Belgium, Canada, Denmark, France, and Germany, respectively. The data are a subset of those used by Baltagi, B. H. and J. M. Griffin (1983), "Gasoline Demand in the OECD: An Application of Pooling and Testing Procedures," *European Economic Review*, 22, 117–137. Consider a set of 6 equations, one for each country.
(a) Compare least squares and SUR estimates of the coefficients of each equation. Comment on the signs.
(b) Test for contemporaneous correlation.
(c) Using the SUR-estimated equations,
 (i) Test the hypothesis that corresponding slope coefficients in different equations are equal.
 (ii) Test the hypothesis that $\ln(Car/Pop)$ should be omitted from all six equations.

Chapter *18*

Qualitative and Limited Dependent Variable Models

18.1 Introduction

In this book we focus primarily on econometric models in which the dependent variable is continuous, and fully observable; quantities, prices, and outputs are examples of such variables. However, economics is a general theory of choice, and many of the choices that individuals and firms make can not be measured by a continuous outcome variable. In this chapter we examine some fascinating models that are used to describe choice behavior, and which do not have the usual continuous dependent variable. Our descriptions will be brief, since we will not go into all the theory, but we will reveal to you a rich area of economic applications.

We also introduce a class of models with dependent variables that are *limited*. By that, we mean that they are continuous, but their range of values is constrained in some way and their values are not completely observable. Alternatives to least squares estimation must be considered for such cases, since the least squares estimator is both biased and inconsistent.

18.2 Models with Binary Dependent Variables

Many of the choices that individuals and firms make are "either-or" in nature. For example, a high school graduate decides to attend college or not. A worker decides to drive to work or to get there another way. A household decides to purchase a house or to rent. A firm decides to advertise its product on the Internet or it decides against such advertising. As economists we are interested in explaining why particular choices are made, and what factors enter into the decision process. We also want to know *how much* each factor affects the outcome. Such questions lead us to the problem of constructing a statistical model of binary, either–or, choices. Choices such as those above can be represented by a binary variable that takes the value 1 if one outcome is chosen, and takes the value 0 otherwise. The binary variable describing a choice is the *dependent* variable rather than an independent variable. This fact affects our choice of a statistical model.

The list of economic applications in which choice models may be useful is a long one. These models are useful in *any* economic setting in which an agent must choose one of two alternatives. Examples include the following:

1. An economic model explaining why some states in the United States ratified the Equal Rights Amendment and others did not.

2. An economic model explaining why some individuals take a second, or third, job and engage in "moonlighting."

3. An economic model of why some legislators in the U.S. House of Representatives vote for a particular bill and others do not.

4. An economic model of why the federal government awards development grants to some large cities and not others.

5. An economic model explaining why some loan applications are accepted and others not at a large metropolitan bank.

6. An economic model explaining why some individuals vote "yes" for increased spending in a school board election and others vote "no."

7. An economic model explaining why some female college students decide to study engineering and others do not.

This list illustrates the great variety of circumstances in which a model of binary choice may be used. In each case an economic decision maker chooses between two mutually exclusive outcomes.

For these models usual least squares estimation methods are not the best choices. Instead, **maximum likelihood estimation** is the usual method chosen. However, we begin by illustrating the least squares method and its difficulties in this context.

18.2.1 THE LINEAR PROBABILITY MODEL

We will illustrate binary choice models using an important problem from transportation economics. How can we explain an individual's choice between driving (private transportation) and taking the bus (public transportation) when commuting to work, assuming, for simplicity, that these are the only two alternatives? Represent an individual's choice by the dummy variable

$$y = \begin{cases} 1 & \text{individual drives to work} \\ 0 & \text{individual takes bus to work} \end{cases} \qquad (18.2.1)$$

If we collect a random sample of workers who commute to work, then the outcome y will be unknown to us until the sample is drawn. Thus, y is a random variable. In Chapter 2, Example 2.1, we described the probability function for such dichotomous random variables by

$$f(y) = p^y (1-p)^{1-y}, \qquad y = 0, 1 \qquad (18.2.2)$$

where p is the probability that y takes the value 1. This discrete random variable has expected value $E(y) = p$.

What factors might affect the probability that an individual chooses one transportation mode over the other? One factor will certainly be how long it takes to get either way to work. Define the explanatory variable

$$x = (\text{commuting time by bus} - \text{commuting time by car})$$

There are other factors that affect the decision, but let us focus on this single explanatory variable. A priori we expect that as x increases, and commuting time

by bus increases relative to commuting time by car, an individual would be more inclined to drive. That is, we expect a positive relationship between x and p, the probability that an individual will drive to work.

In regression analysis we break the dependent variable into fixed and random parts. If we do this for the random variable y, we have

$$y = E(y) + e = p + e \qquad (18.2.3)$$

We then relate the fixed, systematic portion of y to explanatory variables that we believe help explain its expected value. We are assuming that the probability of driving is related to the difference in driving times, x, in the transportation example. Assuming that the relationship is linear,

$$E(y) = p = \beta_1 + \beta_2 x \qquad (18.2.4)$$

The linear regression model, called the *linear probability model*, explaining the choice variable y is

$$y = E(y) + e = \beta_1 + \beta_2 x + e \qquad (18.2.5)$$

One problem with the linear probability model is that the error term is *heteroskedastic*; the variance of the error term e varies from one observation to another. Another problem with the linear probability model is more serious. If we estimate the parameters of (18.2.5) by least squares, we will obtain the fitted model explaining the systematic portion of y. This systematic portion is p, the probability that an individual chooses to drive to work; that is,

$$\hat{p} = b_1 + b_2 x \qquad (18.2.6)$$

When using this model to predict behavior, by substituting alternative values of x, we can easily obtain values of \hat{p} that are less than 0 or greater than 1. Values like these do not make sense as probabilities, and we are left in a difficult situation. The problem lies in the fact that in the linear probability model (18.2.4) we implicitly assume that increases in x have a constant effect on the probability of choosing to drive,

$$\frac{dp}{dx} = \beta_2 \qquad (18.2.7)$$

That is, as x increases the probability of driving continues to increase at a constant rate. However, since $0 \leq p \leq 1$, a constant rate of increase is impossible. To overcome this problem we consider the nonlinear *probit* model.

18.2.2 THE PROBIT MODEL

To keep the choice probability p within the interval [0, 1] a nonlinear S-shaped relationship between x and p can be used. In Figure 18.1(a) such a curve is illustrated.

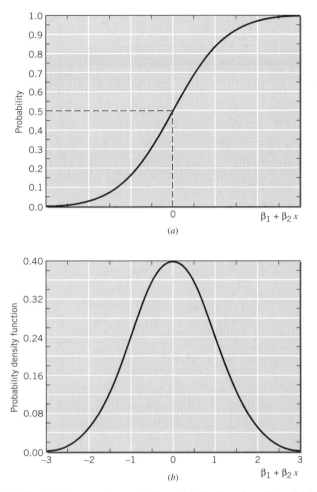

FIGURE **18.1** (*a*) Standard normal cumulative distribution function (*b*) Standard normal probability density function.

As *x* increases, the probability curve rises rapidly at first, and then begins to increase at a decreasing rate. The *slope* of this curve gives the change in probability given a unit change in *x*. The slope is not constant as in the linear probability model.

A functional relationship that is used to represent such a curve is the probit function. The probit function is related to the standard normal probability distribution. If *Z* is a standard normal random variable then its probability density function is

$$f(z) = \frac{1}{\sqrt{2\pi}} e^{-.5z^2}$$

The probit function is

$$F(z) = P[Z \le z] = \int_{-\infty}^{z} \frac{1}{\sqrt{2\pi}} e^{-.5u^2} du \qquad (18.2.8)$$

If you are not familiar with integral calculus, ignore the last expression in (18.2.8). This mathematical expression is the probability that a standard normal random vari-

able falls to the left of point z. In geometric terms it is the area under the standard normal probability density function to the left of z.

The probit statistical model expresses the probability p that y takes the value 1 to be

$$p = P[Z \le \beta_1 + \beta_2 x] = F(\beta_1 + \beta_2 x) \qquad (18.2.9)$$

where F is the probit function. The probit model is said to be *nonlinear* because (18.2.9) is a nonlinear function of β_1 and β_2. If β_1 and β_2 were known, we could use (18.2.9) to find the probability that an individual will drive to work. However, since these parameters are not known we will undertake the task of estimating them.

18.2.3 MAXIMUM LIKELIHOOD ESTIMATION OF THE PROBIT MODEL

To estimate this nonlinear model we take a slightly different approach than the least squares principle. Suppose we randomly select three individuals and observe that the first two drive to work and the third takes the bus; $y_1 = 1$, $y_2 = 1$ and $y_3 = 0$. Furthermore, suppose that the values of x, in minutes, for these individuals are $x_1 = 15$, $x_2 = 20$ and $x_3 = 5$. What is the joint probability of observing $y_1 = 1$, $y_2 = 1$ and $y_3 = 0$? The probability function for y is given by (18.2.2), which we now combine with the probit model (18.2.9) to obtain

$$f(y_i) = [F(\beta_1 + \beta_2 x_i)]^{y_i}[1 - F(\beta_1 + \beta_2 x_i)]^{1-y_i}, \qquad y_i = 0, 1 \qquad (18.2.10)$$

If the three individuals are independently drawn, then the joint probability density function for y_1, y_2, and y_3 is the product of the marginal density functions:

$$f(y_1, y_2, y_3) = f(y_1)f(y_2)f(y_3)$$

Consequently, the probability of observing $y_1 = 1$, $y_2 = 1$, and $y_3 = 0$ is

$$P[y_1 = 1, y_2 = 1, y_3 = 0] = f(1, 1, 0) = f(1)f(1)f(0)$$

Substituting in (18.2.10), and the values of x_i, we have

$$P[y_1 = 1, y_2 = 1, y_3 = 0] = F[\beta_1 + \beta_2(15)] \cdot F[\beta_1 + \beta_2(20)] \cdot \{1 - F[\beta_1 + \beta_2(5)]\}$$

$$(18.2.11)$$

In statistics, the function (18.2.11), which gives us the probability of observing the sample data, is called the *likelihood function*. Intuitively it makes sense to choose as estimates for β_1 and β_2 the values b_1 and b_2 that *maximize the probability, or likelihood*, of observing the sample. Unfortunately there are no formulas that give us the values for b_1 and b_2 as there are in least squares estimation of the linear regression model. Consequently, we must use the computer and techniques from numerical analysis to obtain b_1 and b_2. On the surface, this appears to be a daunting task, because $F(z)$ from (18.2.8) is such a complicated function. As it turns out, however, using a computer to maximize (18.2.11) is a relatively easy process.

What is most interesting about this *maximum likelihood* estimation procedure is that while its properties in small samples are not known, we can show that in *large*

samples the maximum likelihood estimator is normally distributed, consistent, and *best*, in the sense that no competing estimator has smaller variances.

Econometric software packages have the maximum likelihood estimation procedure built in for the probit model, and thus it is not difficult to estimate the parameters β_1 and β_2 in practice. However, in order for the maximum likelihood estimation procedure to be reliable, large samples are required. Our expression in (18.2.11) was limited to three observations for illustration only, and maximum likelihood estimation should not be carried out with such a small amount of data. In Section 18.2.5 we give an empirical example based on a larger sample.

18.2.4 INTERPRETATION OF THE PROBIT MODEL

The probit model is represented by (18.2.9). In this model we can examine the effect of a one unit change in x on the probability that $y = 1$ by considering the derivative

$$\frac{dp}{dx} = \frac{dF(t)}{dt} \cdot \frac{dt}{dx} = f(\beta_1 + \beta_2 x)\beta_2 \qquad (18.2.12)$$

where $t = \beta_1 + \beta_2 x$ and $f(\beta_1 + \beta_2 x)$ is the standard normal probability density function evaluated at $\beta_1 + \beta_2 x$. To obtain this result we have used the *chain rule* of differentiation. We estimate this effect by replacing the unknown parameters by their estimates b_1 and b_2.

In Figure 18.1 we show the probit function $F(z)$ and the standard normal probability density function $f(z)$ just below it.

The expression in (18.2.12) shows the effect of an increase in x on p. The effect depends on the slope of the probit function, which is given by $f(\beta_1 + \beta_2 x)$ and the magnitude of the parameter β_2. Equation (18.2.12) has the following implications:

1. Since $f(\beta_1 + \beta_2 x)$ is a probability density function its value is always *positive*. Consequently the sign of dp/dx is determined by the sign of β_2. In the transportation problem we expect β_2 to be positive so that $dp/dx > 0$; as x increases we expect p to increase.

2. As x changes, the value of the function $f(\beta_1 + \beta_2 x)$ changes. The standard normal probability density function reaches its maximum when $z = 0$, or when $\beta_1 + \beta_2 x = 0$. In this case $p = F(0) = 0.5$ and an individual is equally likely to choose car or bus transportation. It makes sense that in this case the effect of a change in x has its greatest effect, since the individual is "on the borderline" between car and bus transportation. The slope of the probit function $p = F(z)$ is at its maximum when $z = 0$, the borderline case.

3. On the other hand, if $\beta_1 + \beta_2 x$ is large, say near 3, then the probability that the individual chooses to drive is very large and close to 1. In this case a change in x will have relatively little effect since $f(\beta_1 + \beta_2 x)$ will be nearly 0. The same is true if $\beta_1 + \beta_2 x$ is a large negative value, say near -3. These results are consistent with the notion that if an individual is "set" in their ways, with p near 0 or 1, the effect of a small change in commuting time will be negligible.

The results of a probit model can also be used to predict an individual's choice. The ability to predict discrete outcomes is very important in many applications. For

example, banks prior to approving loans predict the probability that an applicant will default. If the probability of default is high, then the loan is either not approved, or additional conditions, such as extra collateral or a higher interest rate, will be imposed.

In order to predict the probability that an individual chooses the alternative $y = 1$ we can use the probability model $p = F(\beta_1 + \beta_2 x)$. If we obtain estimates b_1 and b_2 of the unknown parameters, then we estimate the probability p to be

$$\hat{p} = F(b_1 + b_2 x) \tag{18.2.13}$$

By comparing to a threshold value, like 0.5, we can predict choice using the rule

$$\hat{y} = \begin{cases} 1 & \hat{p} > 0.5 \\ 0 & \hat{p} \le 0.5 \end{cases}$$

18.2.5 AN EXAMPLE

As a basis for bringing these models and methods to life, data from Ben-Akiva and Lerman [1985, *Discrete Choice Analysis*, Cambridge, MA: MIT Press] on automobile and public transportation travel times and the alternative chosen for $T = 21$ individuals are given in Table 18.1. In this table the variable $x_i =$ (bus time − auto time) and the dependent variable $y_i = 1$ if automobile transportation is chosen. Using the data in Table 18.1, and a numerical optimization program for the probit model (such programs as available in most econometric packages), we can obtain

Table 18.1 **Data for Transportation Example**

Auto Time	Bus Time	x	y
52.9	4.4	−48.5	0
4.1	28.5	24.4	0
4.1	86.9	82.8	1
56.2	31.6	−24.6	0
51.8	20.2	−31.6	0
0.2	91.2	91.0	1
27.6	79.7	52.1	1
89.9	2.2	−87.7	0
41.5	24.5	−17.0	0
95.0	43.5	−51.5	0
99.1	8.4	−90.7	0
18.5	84.0	65.5	1
82.0	38.0	−44.0	1
8.6	1.6	−7.0	0
22.5	74.1	51.6	1
51.4	83.8	32.4	1
81.0	19.2	−61.8	0
51.0	85.0	34.0	1
62.2	90.1	27.9	1
95.1	22.2	−72.9	0
41.6	91.5	49.9	1

the maximum likelihood estimates of the parameters. For example, the estimation results using EViews are given in Table 18.2. We are provided with quite a bit of information, most of which we will not address. The critical results are the estimated coefficients and their "t" statistics, given in (R18.1).

$$b_1 + b_2 x_i = -0.0644 + 0.0299 \, x_i$$
$$t\text{-values} \quad (-.161) \quad (2.916)$$
(R18.1)

The values in parentheses below the parameter estimates are t-values, which are based on estimated standard errors that are valid in large samples. Note that EViews refers to the "t" statistics by the name "z-Statistics," since they are valid only for large samples, and in large samples the differences between the t and standard normal distributions are negligible. The negative sign of b_1 implies that individuals, given that commuting times via bus and auto are equal so $x = 0$, have a bias against driving to work, relative to public transportation, though the estimated coefficient is not statistically significant. The positive sign of b_2 indicates that an increase in public transportation travel time increases the probability that an individual will choose to drive to work, and this coefficient is statistically significant.

Based on the positive sign on the estimated coefficient b_2, we infer that an increase in public transportation time relative to auto travel increases the probability of auto travel. Suppose that we wish to make a judgment about the magnitude of the effect of increased public transportation time given that travel via public transportation currently takes 20 minutes longer than auto travel. Using (18.2.12),

$$\frac{d\hat{p}}{dx} = f(b_1 + b_2 x)b_2 = f(-0.0644 + 0.0299 \times 20)(0.0299)$$

$$= f(.5355)(0.0299) = 0.3456 \times 0.0299 = 0.0104$$
(R18.2)

For the probit probability model, an incremental (1-minute) increase in the travel time via public transportation increases the probability of travel via auto by approximately 0.01, given that taking the bus already requires 20 minutes more travel time than driving.

The estimated parameters of the probit model can also be used to "predict" the behavior of an individual who must choose between auto and public transportation to travel to work. If an individual is faced with the situation that it takes 30 minutes longer to take public transportation than to drive to work, then the estimated probability that auto transportation will be selected is calculated using (18.2.13):

Table 18.2 **EViews Probit Output**

Variable	Coefficient	Std. Error	z-Statistic	Prob.
C	−0.064434	0.399239	−0.161391	0.8718
X	0.029999	0.010286	2.916350	0.0035

Notes: Dependent Variable: Y
Method: ML-binary probit
Included observations: 21
Convergence achieved after four iterations
Covariance matrix computed using second derivatives

$$\hat{p} = F(b_1 + b_2 x) = F(-0.0644 + 0.0299 \times 30) = .798 \qquad (R18.3)$$

Since the estimated probability that the individual will choose to drive to work is 0.798, which is greater than 0.5, we "predict" that when public transportation takes 30 minutes longer than driving to work, the individual will choose to drive.

18.3 The Logit Model for Binary Choice

Probit model estimation is numerically complicated because it is based on the normal distribution. A frequently used alternative to the probit model for binary choice situations is the logit model. These models differ only in the particular S-shaped curve used to constrain probabilities to the [0, 1] interval. If L is a logistic random variable, then its probability density function is

$$f(l) = \frac{e^{-l}}{(1 + e^{-l})^2}, \qquad -\infty < l < \infty \qquad (18.3.1)$$

The corresponding cumulative distribution function, unlike the normal distribution, has a closed form expression, which makes analysis somewhat easier. The cumulative distribution function for a logistic random variable is

$$F(l) = p[L \leq l] = \frac{1}{1 + e^{-l}} \qquad (18.3.2)$$

In the logit model the probability p that the observed value y takes the value 1 is

$$p = P[L \leq \beta_1 + \beta_2 x] = F(\beta_1 + \beta_2 x) = \frac{1}{1 + e^{-(\beta_1 + \beta_2 x)}} \qquad (18.3.3)$$

In maximum likelihood estimation of the logit model, (18.3.3) is used to form the likelihood function (18.2.11). To interpret the logit estimates, the derivative in (18.2.12) is still valid, using (18.3.1) instead of the normal probability density function.

The shapes of the logistic and normal probability density functions are somewhat different, and maximum likelihood estimates themselves will be slightly different. However, the marginal probabilities in (18.2.12) and the predicted probabilities in (18.2.13) usually differ only slightly. The choice is really a matter of convenience.

18.4 Other Models With Qualitative Dependent Variables

Applied microeconomics is filled with examples of probit and logit model estimation. However, a 0–1 dependent variable is insufficient to describe outcomes in many situations. In this section we illustrate some of these situations.

18.4.1 MULTINOMIAL CHOICE MODELS

In probit and logit models the decision maker chooses between two alternatives. Clearly we are faced with choices involving more than two alternatives. These are called **multinomial choice** situations. Examples include the following:

- If you are shopping for a laundry detergent, which one do you choose—Tide, Cheer, Arm & Hammer, Wisk, etc? The consumer is faced with a wide array of alternatives. Marketing researchers relate these choices to prices of the alternatives, advertising, consumer income, and product characteristics.
- If you enroll in the business school, will you major in economics, marketing, management, finance, or accounting?
- If you are going to a mall on a shopping spree, which mall will you go to, and why?
- When you graduated from high school, you had to choose between not going to college, or going to a private four-year college, a public four-year college, or a 2-year college. What factors led to your decision among these alternatives?

It would not take you a long time to come up with other illustrations. In each case, researchers wish to relate the observed choice to a set of explanatory variables. More specifically, as in probit and logit models, they wish to explain and predict the probability that an individual with a certain set of characteristics chooses one of the alternatives. The estimation and interpretation of such models are, in principle, similar to that in logit and probit models. The models themselves go under the names **multinomial logit**, **conditional logit**, and **multinomial** or **multivariate probit**.

18.4.2 ORDERED CHOICE MODELS

In the multinomial choice models just described, the alternatives facing the decision maker were "unordered." That is, if you were going to shop for laundry detergents, there is no natural ordering among Tide, Cheer, Arm & Hammer, and Wisk. If the alternatives facing the decision maker are ordered in some fashion, we should take that into account. Examples include the following:

- Survey questionnaires provide alternatives like "strongly disagree, disagree, neutral, agree, strongly agree."
- Teachers must assign the alternative grades A, B, C, D, F to students.
- Financial services, like Standard & Poors, assign ratings to bonds, AAA, AA, etc.

In these models the alternatives can be assigned **ranks**, with 1 being the lowest, 2 the next lowest, up to J, if there are J ordered alternatives. The important characteristic of the ranks themselves is that the numbers assigned, 1, 2, 3, . . . , are **ordinal** rather than **cardinal**. Ordinal numbers indicate the ranking, but the actual values assigned are arbitrary. All that matters is that one alternative is ranked higher than another.

As economists we are interested in studying the factors determining and predicting the probability that a particular bond, for example, is ranked AAA. Because we are working with probabilities the problem of keeping the predicted probabilities

in the [0, 1] interval must be addressed. Once again the normal and logistic distributions are the most commonly used, resulting in the **ordered probit** and **ordered logit** models. These models are estimated by maximum likelihood.

18.4.3 COUNT DATA MODELS AND POISSON REGRESSION

Count data models focus on the "number of occurrences" of an event. Here the outcome variable is $y = 0, 1, 2, 3, \ldots$. These numbers are actual counts, and thus different from the ordinal numbers of the previous section. Examples include:

- The number of trips to a physician a person makes during a year.
- The number of fishing trips taken by a person during the previous year.
- The number of children in a household.
- The number of automobile accidents at a particular intersection during a month.
- The number of televisions in a household.
- The number of alcoholic drinks a college student takes in a week.

While we are again interested in explaining and predicting *probabilities*, such as the probability that an individual will take two or more trips to the doctor during a year, the probability distribution we use as a foundation is the Poisson, not the normal or the logistic.

You may recall from your statistics course working on problems in which you used the Poisson distribution to compute the probability of five or more phone calls coming into a switchboard in a one-minute interval. If Y is a Poisson random variable, then its probability function is

$$\Pr(Y = y) = \frac{e^{-\lambda}\lambda^y}{y!}, \qquad y = 0, 1, 2, \ldots$$

This probability function has one parameter λ, which is the mean (and variance) of Y. That is, $E(Y) = \lambda$. In a regression model we try to explain the behavior of $E(Y)$ as a function of some explanatory variables. We do the same here, keeping the value of $E(Y) \geq 0$ by defining

$$E(Y) = \lambda = e^{\beta_1 + \beta_2 x}$$

This choice defines the **Poisson regression model** for count data. The parameters can be estimated by maximum likelihood, or by **nonlinear least squares**, which is described in Chapter 10. The **negative binomial model** is a generalization that is often used when the Poisson regression assumption that $E(Y) = \lambda = \text{var}(Y)$ is unacceptable.

18.5 Limited Dependent Variable Models

18.5.1 THE TOBIT MODEL

The models we have discussed so far in this chapter all have **qualitative** dependent variables. A related class of models has **limited dependent variables**. In these

models the outcome variable we observe is continuous, but cut-off, or **censored**, at some particular value. As an example, suppose we randomly select individuals and ask them, "How much did you give to charity last year?" The answers will vary, of course, and will depend on many factors. We would expect wealthy individuals to contribute more than poor individuals. However, there are going to be many responses of $0, and none will be less than $0. This is an example of a dependent variable that is limited in its range. The usual least squares estimator fails in this case, being biased even in large samples, whether you (a) leave the $0 in the data and treat them like all other observations, or (b) throw out all the $0 observations.

The **Tobit** estimation procedure (in honor of Nobel prize winning economist James Tobin, who first considered this type of problem) is a maximum likelihood based estimation procedure that treats the $0 observations differently than the rest. Most econometric packages include Tobit as an estimation option.

18.5.2 SAMPLE SELECTION

If you consult an econometrician concerning an estimation problem, the first question you will usually hear is, "How were the data obtained?" If the data are obtained by random sampling, then classic regression methods, such as least squares, work well. However, if the data are obtained by a sampling procedure that is not random, then standard procedures do not work well. Economists regularly face such data problems. The most famous illustration comes from labor economics. If we wish to study the determinants of the wages of married women, we face a **sample selection** problem. If we collect data on married women, and ask them what wage rate they earn, many will respond that the question is not relevant since they are homemakers. We only observe data on market wages when the woman chooses to enter the workforce. One strategy is to ignore the women who are homemakers, omit them from the sample, then use least squares to estimate a wage equation for those who work. This strategy fails, the reason for the failure being that our sample is not a random sample. The data we observe are "selected" by a systematic process for which we do not account.

A solution to this problem is a technique called "Heckit" (named after its developer, econometrician James Heckman). This simple procedure uses two estimation steps. In the context of the problem of estimating the wage equation for married women, a probit model is first estimated explaining why a woman is in the labor force or not. In the second stage, a least squares regression is estimated relating the wage of a working woman to education, experience, etc., and a variable called the "Inverse Mills Ratio," or IMR. The IMR is created from the first-step probit estimation, and accounts for the fact that the observed sample of working women is not random. Further details of this procedure are beyond the scope of this book.

18.6 Learning Objectives

Based on the material in this chapter you should be able to:

1. Give some examples of economic decisions in which the outcome is a binary variable.

2. Explain why probit, or logit, is usually preferred to least squares when estimating a model in which the dependent variable is binary.

3. Give some examples of multinomial choice situations.

4. Give some examples of ordered choice situations.

5. Give some examples of count data variables.

6. Give some examples in which "tobit" is a correct estimation technique.

7. Explain the phrase "sample selection."

18.7 Exercises

18.1 Use the data in Table 18.1, and your computer software, to obtain maximum likelihood estimates of the probit model for the auto/public transportation example.

18.2 Use the data in Table 18.1, and your computer software, to obtain maximum likelihood estimates of the logit model for the auto/public transportation example.

(a) Compute the marginal effect of an increase in public transportation time, given that public transportation currently takes 20 minutes longer than auto travel. Compare your result to that in (R18.2).

(b) Predict the probability that an individual will drive to work if public transportation takes 30 minutes longer than driving to work. Compare your result to that in (R18.3).

18.3 Within the context of the auto/public transportation example, and the probit model, what is the probability of choosing to drive to work, and what is the effect of an incremental increase in public transportation travel time on the probability of auto travel, if it currently takes:

(a) Exactly the same amount of time to travel to work via car and public transportation?

(b) If the auto takes 15 minutes less?

(c) If the auto takes 60 minutes less?

18.4 Data from William Greene's *Econometric Analysis, 2nd Edition* (1990, p. 672) on the voting outcome, by state (51 observations), in the 1976 U.S. presidential election are contained in the file *vote.dat*. The outcome variable y takes the value of 1 if the popular vote favored the Democratic candidate (Jimmy Carter) and 0 if the vote favored the Republican candidate (Gerry Ford). The other variables are:

Income = 1975 median income

School = median number of years of school completed by persons 18 years of age or older

Urban = percentage of population living in an urban area

Region = 1 for Northeast, 2 for Southeast, 3 for Midwest and Middle South, 4 for West and Mountain regions.

(a) Estimate a probit model for the vote outcome using the explanatory variables *Income, School, Urban*, and dummy variables for the Midwest and West. Discuss the fitted model.

(b) Calculate the effect on the probability of the state voting Democratic, given an increase in income of $1000, in the states of Louisiana, Oklahoma, and California.

(c) What is the estimated probability that Oregon would favor the Democratic candidate?

18.5 Dhillon, Shilling, and Sirmans, "Choosing Between Fixed and Adjustable Rate Mortgages," *Journal of Money, Credit and Banking*, 19(1), 1987, 260–267, estimate a probit model designed to explain the choice by home-buyers of fixed versus adjustable rate mortgages. They use 78 observations from a bank in Baton Rouge, Louisiana, taken over the period January 1983 to February 1984. These data are contained in the file *sirmans.dat*. In this data set 46 fixed-rate and 32 adjustable-rate mortgages were chosen. Dhillon et al. used both financial measures and personal characteristics as explanatory variables in their model, and did not reject a hypothesis that the personal characteristics have no impact on the choice probability. We focus on the financial measures.

The dependent variable $y = 1$ if an adjustable rate mortgage is chosen. The explanatory variables, and the expected direction of their effects, are:

x_{2i} = fixed interest rate (+);

x_{3i} = margin = the variable rate less the fixed rate (−);

x_{4i} = yield = the 10-year treasury rate less the one year treasury rate (−);

x_{5i} = points = ratio of points paid on adjustable rates to those paid on fixed rates (−);

x_{6i} = maturity = ratio of maturities on adjustable to fixed rates (−);

x_{7i} = net worth of borrower (+).

(a) Estimate the model explaining the choice of mortgage type by least squares and obtain the predicted values from this estimation. Are the signs consistent with expectations? Are the predicted values between zero and one?

(b) Estimate the model of mortgage choice using probit. Are the signs consistent with expectations?

18.6 The choice of what type of college to attend is important to high school graduates. The National Education Longitudinal Study of 1988 (NELS : 88) was the first nationally representative longitudinal study of eighth grade students in public and private schools. It was sponsored by the National Center for Education Statistics. In the data file *commcoll.dat* are 7071 observations on the choices made by high school seniors. The variables included are:

- commcoll = 1 if a community college is chosen, 0 if some other type of secondary education institution is chosen

- gpa = numerical value of student's grade point average, on a 4 point scale, with 4.0 being the highest

- parcol = 1 if a parent has some college training, 0 otherwise

- fem = 1 if student is female, 0 for male

- blk = 1 if student is black, 0 otherwise

- oth = 1 if student is not black or white, but of another race; 0 otherwise

- mid = 1 if household income is $20,000–$49,999; 0 otherwise

- upmid = 1 if household income is $50,000–$74,999; 0 otherwise

- high = 1 if household income is $75,000 or more

- sou = 1 if household lives in a southern state

(a) Estimate the probit model explaining the choice of attending a community college as a function of the remaining variables. Discuss the signs of the estimated coefficients (do they make sense?) and their significance.

(b) Estimate the probability that a southern, white, female, C student (gpa = 2.0), whose parents did not attend college, with low income, attends a community college.

(c) Estimate the marginal effect of an increase in a student's gpa by 1/2 point, for a southern, white, female, C student (gpa = 2.0), whose parents did not attend college, with low income.

Chapter *19*

Writing an Empirical Research Report, and Sources of Economic Data

In the preceding chapters, we emphasized (*i*) the formulation of an econometric model from an economic model; (*ii*) estimation of the econometric model by an appropriate procedure; (*iii*) interpretation of the estimates; and (*iv*) inferences, in the form of interval estimates, hypothesis tests, and predictions. In this chapter, we recognize that specifying the model, selecting an estimation method, and obtaining the data are all part of an econometric research project. In particular, we discuss the selection of a suitable topic for a research project, the essential components of a research report, and sources of economic data.

19.1 Selecting a Topic for an Economics Project

Economics research is an adventure and can be *fun*! A research project is an opportunity to investigate a topic of importance in which you are interested. However, before you begin the actual research and writing of a report, it is a good idea to give some quality thinking time to the selection of your topic. Then, once you have an idea formulated, it is wise to write an abstract of the project, summarizing what you know and what you hope to learn. These two steps are the focus of this section.

19.1.1 CHOOSING A TOPIC

Choosing a good research topic is essential if you are to successfully complete a class project. A starting point is the question, "What am I interested in?" If you are interested in a particular topic, then that will add to the pleasure of research effort. If you begin working on a topic other questions usually will occur to you. These new questions may put a new light on the original topic, or they may represent new paths to follow that are even more interesting to you.

By the time you have completed several semesters of economics classes, you will find yourself enjoying some areas more than others. For each of us, specialized areas such as industrial organization, public finance, resource economics, monetary economics, environmental economics, and international trade hold a different appeal. If you are generally interested in one of these areas, but do not have a specific idea of where to start in the selection of a topic, speak with your instructor. He or she will be able to suggest some ideas that will give you a start, and can cite some

published research for you to read, or can suggest specific professional journals that carry applied research articles on a general area. If you find an area or topic in which you are interested, consult the *Journal of Economic Literature* for a list of related journal articles. The *JEL* has a classification scheme that makes it easy to isolate particular areas of study.

Once you have tentatively identified a problem that you wish to work on, the next issues are pragmatic ones. During one semester you will not be able to collect your own data to use in a project. Thus you must find out whether suitable data are available for the problem you have identified. Once again your instructor may be of help.

We have so far identified two aspects of a good research topic—the topic should be of interest to you, and data that are relevant to the topic should be readily available. The third aspect of a good project is again pragmatic: you should be able to finish in the time remaining in your semester. This requires not only the availability of the data, but also implies that you are familiar with the econometric procedures that are appropriate for analyzing the data, and that you can implement them on the computer, or learn the procedure in a reasonable amount of time.

19.1.2 WRITING AN ABSTRACT

After you have selected a specific topic, it is a good idea to write up a brief abstract. Writing the abstract will help you focus your thoughts about what you really want to do, and you can show it to your instructor for preliminary approval and comments. The abstract should be short, usually no more than 500 words, and should include:

1. A concise statement of the problem;
2. Comments on the information that is available with one or two key references;
3. A description of the research design that includes:
 (a) The economic model,
 (b) The econometric estimation and inference methods,
 (c) Data sources,
 (d) Estimation, hypothesis testing, and prediction procedures; and

4. The contribution of the work.

19.2 A Format for Writing a Research Report

Economics research reports have a standard format in which the various steps of the research project are discussed and the results interpreted. The following outline is typical:

1. *Statement of the problem:* The place to start your report is with a summary of the questions you have investigated, why they are important, and who should be interested in the results. Identify the contents of each section of the report. This section should be nontechnical and it should motivate the reader to continue reading the paper.
2. *Review of the literature:* Briefly summarize the relevant literature in the research area you have chosen, so that you may make clear how your work

extends our knowledge. By all means, cite the works of others that have motivated your research, but keep it brief. You do not have to survey everything that has been written on the topic.

3. *The economic model:* Specify the economic model that you use, and define the economic variables. State the model's assumptions and identify hypotheses you wish to test. Economic models can get complicated. Your task is to explain the model as clearly, but as briefly and simply, as possible. Don't use unnecessary technical jargon. Use simple terms instead of complicated ones when possible. Your objective is to display the quality of your thinking, not the extent of your vocabulary.

4. *The econometric model:* Discuss the econometric model that corresponds to the economic model. Make sure you include a discussion of the variables in the model, the functional form, the error assumptions, and any other assumptions that you make. Use notation that is as simple as possible, and do not clutter the body of the paper with long proofs or derivations. These can go in a technical appendix.

5. *The data:* Describe the data you used, the source of the data, and any reservations you have about their appropriateness.

6. *The estimation and inference procedures:* Describe the estimation methods you used and why they were chosen. Explain hypothesis testing procedures and their use.

7. *The empirical results and conclusions:* Report the parameter estimates, their interpretation, and values of test statistics. Comment on their statistical significance, their relation to previous estimates, and their economic implications.

8. *Possible extensions and limitations of the study:* Your research will raise questions about the economic model, data and estimation techniques. What future research is suggested by your findings and how might you go about it?

9. *Acknowledgements:* It is appropriate to recognize those who have commented on and contributed to your research. This may include your instructor, a librarian who helped you find data, a fellow student who read and commented on your paper.

10. *References:* An alphabetical list of the literature you cite in your study, as well as references to the data sources you used.

By all means, once you've written the first draft, use your computer software's "spell-checker" to check for errors. The spell-checker may identify economic terms you've used as misspelled, and these you can enter into the software's database. Have a friend read the paper, make suggestions for clarifying the prose, and check your logic and conclusions. Before you turn in the paper you want to eliminate as many errors as possible. Typos, missing references, and incorrect formulas can spell doom for an otherwise excellent paper. Some do's and don'ts are summarized nicely, and with good humor, by Diedre N. McClosky in *Economical Writing, 2nd Edition* (Prospect Heights, IL: Waveland Press, Inc., 2000).

The paper should have clearly defined sections and subsections. The equations, tables, and figures should be numbered. References and footnotes should be formatted in an acceptable fashion. A style guide is a good investment. Two classic ones are *The Chicago Manual of Style: The Essential Guide for Writers, Editors, and*

Publishers (14th Edition) (September 1993, University of Chicago Press; ISBN: 0226103897) and *A Manual for Writers of Term Papers, Theses, and Dissertations (Chicago Guides to Writing, Editing, and Publishing)* by Kate L. Turabian, John Grossman, and Alice Bennett (March 1996, University of Chicago Press; ISBN: 0226816265).

On the web, *The Economist Style Guide* can be found at http://www.economist.com/editorial/freeforall/library/styleguide/

19.3 Sources of Economic Data

Economic data are much easier to obtain since the World Wide Web has developed. In this section we direct you to some places on the Internet where economic data are accessible. We also describe data resources that you may find in your university's library.

19.3.1 LINKS TO ECONOMIC DATA ON THE INTERNET

There are a number of fantastic sites on the World Wide Web for obtaining economic data. The following three sources provide links to many specific sources of data.

Resources for Economists (RFE) [http://www.rfe.org] is a primary gateway to resources for economists on the Internet. This excellent site is the work of Bill Goffe. There you will find links to sites for economic data, and to sites of general interest to economists. For data we recommend you go to the index [http://www.rfe.org/Data/index.html]. The broad data categories listed are

- *U.S. Macro and Regional Data* Here you will find links to various data sources such as the Bureau of Economic Analysis, Bureau of Labor Statistics, *Economic Reports of the President*, and the Federal Reserve Banks.

- *Other U.S. Data* Here you will find links to the U.S. Census Bureau, as well as links to many panel and survey data sources. The gateway to U.S. Government agencies is FedStats [http://www.fedstats.gov/]. Once there, click on *Agencies* to see a complete list of U.S. Government agencies and links to their homepages.

- *World and Non-U.S. Data* Links to world data, such as the CIA Factbook, and the Penn World Tables. International organizations such as the Asian Development Bank, the International Monetary Fund, the World Bank, etc. Also links to sites with data on specific countries and sectors of the world.

- *Finance and Financial Markets* Links to sources of U.S. and world financial data.

- *Journal Data and Program Archives* Some economic journals post data used in articles. Links to these journals are provided here. Many of the articles in these journals will be beyond the scope of undergraduate economics majors.

B&E Datalinks [http://www.econ-datalinks.org/] is a site maintained by the Business and Economics Statistics Section of the American Statistical Association. It provides links to economics and financial data sources of interest to economists and business statisticians along with an assessment of the quality of each site.

Econ Data & Links [http://www.csufresno.edu/Economics/econ_EDL.htm]
Contains current values of economic variables and links to sites that generate them.

19.3.2 ECONOMIC DATA ON THE INTERNET

Some web sites make extracting data relatively easy. Examples are the following.

Economagic [http://www.Economagic.com/] is an excellent and easy to use
source of macro time series (some 100,000 series available). The data series are
easily viewed in a copy and paste format, or graphed. Users can carry out least
squares regressions online.

Economic Information Systems [http://www.econ-line.com/] provides long-
time series, formatted in such a way that copying and pasting into a spreadsheet is
easy.

The Dismal Scientist [http://www.dismal.com/] is a general interest site with
current and recent historical data on many economic series. The site also includes
data definitions and analyses.

19.3.3 TRADITIONAL SOURCES OF ECONOMIC DATA

Your library contains a wealth of business and economic data. To locate it you can
take several approaches. First, your school's web page may contain a link to the
library, and there you may find links describing available resources. Second, you
might search using your library's computerized database. Third, you might ask a
librarian. Some well-known data sources are the following.

At the international level, macro data are published by agencies such as the Inter-
national Monetary Fund (IMF), the European Economic Community (OECD), the
United Nations (UN), and the Food and Agricultural Organization (FAO). Some
examples of publications of these agencies that include a wide array of data include:

International Financial Statistics (IMF, monthly)

Basic Statistics of the Community (OECD, annual)

Consumer Price Indices in the European Community (OECD, annual)

World Statistics (UN, annual)

Yearbook of National Accounts Statistics (UN, annual)

FAO Trade Yearbook (annual)

The major sources of United States economic data are the Bureau of Economic
Analysis (BEA), the Bureau of the Census (BC), the Bureau of Labor Statis-
tics (BLS), the Federal Reserve (FR), and the Statistical Reporting Service of the
Department of Agriculture (USDA). Some examples of publications of these U.S.
agencies that include a wide array of macroeconomic data include:

Survey of Current Business (BEA, monthly)

Handbook of Basic Economic Statistics (Bureau of Economic Statistics, Inc.,
monthly)

Monthly Labor Review (BLS, monthly)

Federal Reserve Bulletin (FR, monthly)

Statistical Abstract of the US (BC, annual)

Economic Report of the President (annual)

Agricultural Statistics (USDA, annual)

Agricultural Situation Reports (USDA, monthly)

Economic Indicators (Council of Economic Advisors, monthly)

19.3.4 INTERPRETING ECONOMIC DATA

In many cases it is easier to obtain economic data than it is to understand the meaning of the data. It is essential when using macroeconomic or financial data that you understand the variable definitions. Just what is the index of leading economic indicators? What is included in personal consumption expenditures? You may find the answers to some questions like these in your textbooks. Other resources you might find useful are: (1) *The Black Book of Economic Information: A Guide to Sources and Interpretation* [David B. Johnson (1996) Sun Lakes, AZ: Thomas Horton and Daughters]. This fine book spells out in great detail, with numerical examples, the construction of many economic aggregates and discusses their uses in economic analysis. (2) *A Guide to Everyday Economic Statistics, 4th Edition* [Gary E. Clayton and Martin Gerhard Giesbrecht (1997) Boston: Irwin/McGraw-HIll]. This slender volume examines how economic statistics are constructed and how they can be used.

19.4 Exercises

19.1 Check out in your library the latest *Economic Report of the President*. Become acquainted with the aggregate income, employment, and production data and their sources that are reported therein. Note how these data are used in the narrative portion of the report.

19.2 Locate the *Survey of Current Business* in your library and describe its contents.

19.3 Visit, on the Internet, the Economagic web site. Download data on the prime interest rate and graph it against time.

19.4 Choose two economic articles containing empirical work that uses some of the techniques we have discussed in this book. Critique their format and the clarity of their writing.

Statistical Tables

Table 1 Area Under the Standard Normal Distribution

z	0.00	0.01	0.02	0.03	0.04	0.05	0.06	0.07	0.08	0.09
0.0	0.0000	0.0040	0.0080	0.0120	0.0160	0.0199	0.0239	0.0279	0.0319	0.0359
0.1	0.0398	0.0438	0.0478	0.0517	0.0557	0.0596	0.0636	0.0675	0.0714	0.0753
0.2	0.0793	0.0832	0.0871	0.0910	0.0948	0.0987	0.1026	0.1064	0.1103	0.1141
0.3	0.1179	0.1217	0.1255	0.1293	0.1331	0.1368	0.1406	0.1443	0.1480	0.1517
0.4	0.1554	0.1591	0.1628	0.1664	0.1700	0.1736	0.1772	0.1808	0.1844	0.1879
0.5	0.1915	0.1950	0.1985	0.2019	0.2054	0.2088	0.2123	0.2157	0.2190	0.2224
0.6	0.2257	0.2291	0.2324	0.2357	0.2389	0.2422	0.2454	0.2486	0.2517	0.2549
0.7	0.2580	0.2611	0.2642	0.2673	0.2704	0.2734	0.2764	0.2794	0.2823	0.2852
0.8	0.2881	0.2910	0.2939	0.2967	0.2995	0.3023	0.3051	0.3079	0.3106	0.3133
0.9	0.3159	0.3186	0.3212	0.3238	0.3264	0.3289	0.3315	0.3340	0.3365	0.3389
1.0	0.3413	0.3438	0.3461	0.3485	0.3508	0.3531	0.3554	0.3577	0.3599	0.3621
1.1	0.3643	0.3665	0.3686	0.3708	0.3729	0.3749	0.3770	0.3790	0.3810	0.3830
1.2	0.3849	0.3869	0.3888	0.3907	0.3925	0.3944	0.3962	0.3980	0.3997	0.4015
1.3	0.4032	0.4049	0.4066	0.4082	0.4099	0.4115	0.4131	0.4147	0.4162	0.4177
1.4	0.4192	0.4207	0.4222	0.4236	0.4251	0.4265	0.4279	0.4292	0.4306	0.4319
1.5	0.4332	0.4345	0.4357	0.4370	0.4382	0.4394	0.4406	0.4418	0.4429	0.4441
1.6	0.4452	0.4463	0.4474	0.4484	0.4495	0.4505	0.4515	0.4525	0.4535	0.4545
1.7	0.4554	0.4564	0.4573	0.4582	0.4591	0.4599	0.4608	0.4616	0.4625	0.4633
1.8	0.4641	0.4649	0.4656	0.4664	0.4671	0.4678	0.4686	0.4693	0.4699	0.4706
1.9	0.4713	0.4719	0.4726	0.4732	0.4738	0.4744	0.4750	0.4756	0.4761	0.4767
2.0	0.4773	0.4778	0.4783	0.4788	0.4793	0.4798	0.4803	0.4808	0.4812	0.4817
2.1	0.4821	0.4826	0.4830	0.4834	0.4838	0.4842	0.4846	0.4850	0.4854	0.4857
2.2	0.4861	0.4864	0.4868	0.4871	0.4875	0.4878	0.4881	0.4884	0.4887	0.4890
2.3	0.4893	0.4896	0.4898	0.4901	0.4904	0.4906	0.4909	0.4911	0.4913	0.4916
2.4	0.4918	0.4920	0.4922	0.4925	0.4927	0.4929	0.4931	0.4932	0.4934	0.4936
2.5	0.4938	0.4940	0.4941	0.4943	0.4945	0.4946	0.4948	0.4949	0.4951	0.4952
2.6	0.4953	0.4955	0.4956	0.4957	0.4959	0.4960	0.4961	0.4962	0.4963	0.4964
2.7	0.4965	0.4966	0.4967	0.4968	0.4969	0.4970	0.4971	0.4972	0.4973	0.4974
2.8	0.4974	0.4975	0.4976	0.4977	0.4977	0.4978	0.4979	0.4979	0.4980	0.4981
2.9	0.4981	0.4982	0.4983	0.4983	0.4984	0.4984	0.4985	0.4985	0.4986	0.4986
3.0	0.4987	0.4987	0.4987	0.4988	0.4988	0.4989	0.4989	0.4989	0.4990	0.4990

Source: This table was generated using the SAS® function PROBNORM.

Table 2 **Right–Tail Critical Values for the *t*-distribution**

DF	α = .10	α = .05	α = .025	α = .01	α = .005
1	3.078	6.314	12.706	31.821	63.657
2	1.886	2.920	4.303	6.965	9.925
3	1.638	2.353	3.182	4.541	5.841
4	1.533	2.132	2.776	3.747	4.604
5	1.476	2.015	2.571	3.365	4.032
6	1.440	1.943	2.447	3.143	3.707
7	1.415	1.895	2.365	2.998	3.499
8	1.397	1.860	2.306	2.896	3.355
9	1.383	1.833	2.262	2.821	3.250
10	1.372	1.812	2.228	2.764	3.169
11	1.363	1.796	2.201	2.718	3.106
12	1.356	1.782	2.179	2.681	3.055
13	1.350	1.771	2.160	2.650	3.012
14	1.345	1.761	2.145	2.624	2.977
15	1.341	1.753	2.131	2.602	2.947
16	1.337	1.746	2.120	2.583	2.921
17	1.333	1.740	2.110	2.567	2.898
18	1.330	1.734	2.101	2.552	2.878
19	1.328	1.729	2.093	2.539	2.861
20	1.325	1.725	2.086	2.528	2.845
21	1.323	1.721	2.080	2.518	2.831
22	1.321	1.717	2.074	2.508	2.819
23	1.319	1.714	2.069	2.500	2.807
24	1.318	1.711	2.064	2.492	2.797
25	1.316	1.708	2.060	2.485	2.787
26	1.315	1.706	2.056	2.479	2.779
27	1.314	1.703	2.052	2.473	2.771
28	1.313	1.701	2.048	2.467	2.763
29	1.311	1.699	2.045	2.462	2.756
30	1.310	1.697	2.042	2.457	2.750
31	1.309	1.696	2.040	2.453	2.744
32	1.309	1.694	2.037	2.449	2.738
33	1.308	1.692	2.035	2.445	2.733
34	1.307	1.691	2.032	2.441	2.728
35	1.306	1.690	2.030	2.438	2.724
36	1.306	1.688	2.028	2.434	2.719
37	1.305	1.687	2.026	2.431	2.715
38	1.304	1.686	2.024	2.429	2.712
39	1.304	1.685	2.023	2.426	2.708
40	1.303	1.684	2.021	2.423	2.704
50	1.299	1.676	2.009	2.403	2.678
60	1.296	1.671	2.000	2.390	2.660
70	1.294	1.667	1.994	2.381	2.648
80	1.292	1.664	1.990	2.374	2.639
90	1.291	1.662	1.987	2.368	2.632
100	1.290	1.660	1.984	2.364	2.626
110	1.289	1.659	1.982	2.361	2.621
120	1.289	1.658	1.980	2.358	2.617
∞	1.282	1.645	1.960	2.326	2.576

Source: This table was generated using the SAS® function TINV.

Table 3 **Right-Tail Critical Values for the *F*-Distribution**

Upper 5% Points

$v_2 \backslash v_1$	1	2	3	4	5	6	7	8	9	10	12	15	20	24	30	40	60	120	∞
1	161.45	199.50	215.71	224.58	230.16	233.99	236.77	238.88	240.54	241.88	243.91	245.95	248.01	249.05	250.1	251.14	252.2	253.25	254.31
2	18.51	19.00	19.16	19.25	19.30	19.33	19.35	19.37	19.38	19.40	19.41	19.43	19.45	19.45	19.46	19.47	19.48	19.49	19.50
3	10.13	9.55	9.28	9.12	9.01	8.94	8.89	8.85	8.81	8.79	8.74	8.70	8.66	8.64	8.62	8.59	8.57	8.55	8.53
4	7.71	6.94	6.59	6.39	6.26	6.16	6.09	6.04	6.00	5.96	5.91	5.86	5.80	5.77	5.75	5.72	5.69	5.66	5.63
5	6.61	5.79	5.41	5.19	5.05	4.95	4.88	4.82	4.77	4.74	4.68	4.62	4.56	4.53	4.50	4.46	4.43	4.40	4.37
6	5.99	5.14	4.76	4.53	4.39	4.28	4.21	4.15	4.10	4.06	4.00	3.94	3.87	3.84	3.81	3.77	3.74	3.70	3.67
7	5.59	4.74	4.35	4.12	3.97	3.87	3.79	3.73	3.68	3.64	3.57	3.51	3.44	3.41	3.38	3.34	3.30	3.27	3.23
8	5.32	4.46	4.07	3.84	3.69	3.58	3.50	3.44	3.39	3.35	3.28	3.22	3.15	3.12	3.08	3.04	3.01	2.97	2.93
9	5.12	4.26	3.86	3.63	3.48	3.37	3.29	3.23	3.18	3.14	3.07	3.01	2.94	2.90	2.86	2.83	2.79	2.75	2.71
10	4.96	4.10	3.71	3.48	3.33	3.22	3.14	3.07	3.02	2.98	2.91	2.85	2.77	2.74	2.70	2.66	2.62	2.58	2.54
11	4.84	3.98	3.59	3.36	3.20	3.09	3.01	2.95	2.90	2.85	2.79	2.72	2.65	2.61	2.57	2.53	2.49	2.45	2.40
12	4.75	3.89	3.49	3.26	3.11	3.00	2.91	2.85	2.80	2.75	2.69	2.62	2.54	2.51	2.47	2.43	2.38	2.34	2.30
13	4.67	3.81	3.41	3.18	3.03	2.92	2.83	2.77	2.71	2.67	2.60	2.53	2.46	2.42	2.38	2.34	2.30	2.25	2.21
14	4.60	3.74	3.34	3.11	2.96	2.85	2.76	2.70	2.65	2.60	2.53	2.46	2.39	2.35	2.31	2.27	2.22	2.18	2.13
15	4.54	3.68	3.29	3.06	2.90	2.79	2.71	2.64	2.59	2.54	2.48	2.40	2.33	2.29	2.25	2.20	2.16	2.11	2.07
16	4.49	3.63	3.24	301	2.85	2.74	2.66	2.59	2.54	2.49	2.42	2.35	2.28	2.24	2.19	2.15	2.11	2.06	2.01
17	4.45	3.59	3.20	2.96	2.81	2.70	2.61	2.55	2.49	2.45	2.38	2.31	2.23	2.19	2.15	2.10	2.06	2.01	1.96
18	4.41	3.55	3.16	2.93	2.77	2.66	2.58	2.51	2.46	2.41	2.34	2.27	2.19	2.15	2.11	2.06	2.02	1.97	1.92
19	4.38	3.52	3.13	2.90	2.74	2.63	2.54	2.48	2.42	2.38	2.31	2.23	2.16	2.11	2.07	2.03	1.98	1.93	1.88
20	4.35	3.49	3.10	2.87	2.71	2.60	2.51	2.45	2.39	2.35	2.28	2.20	2.12	2.08	2.04	1.99	1.95	1.90	1.84
21	4.32	3.47	3.07	2.84	2.68	2.57	2.49	2.42	2.37	2.32	2.25	2.18	2.10	2.05	2.01	1.96	1.92	1.87	1.81
22	4.30	3.44	3.05	2.82	2.66	2.55	2.46	2.40	2.34	2.30	2.23	2.15	2.07	2.03	1.98	1.94	1.89	1.84	1.78
23	4.28	3.42	3.03	2.80	2.64	2.53	2.44	2.37	2.32	2.27	2.20	2.13	2.05	2.01	1.96	1.91	1.86	1.81	1.76
24	4.26	3.40	3.01	2.78	2.62	2.51	2.42	2.36	2.30	2.25	2.18	2.11	2.03	1.98	1.94	1.89	1.84	1.79	1.73
25	4.24	3.39	2.99	2.76	2.60	2.49	2.40	2.34	2.28	2.24	2.16	2.09	2.01	1.96	1.92	1.87	1.82	1.77	1.71
26	4.23	3.37	2.98	2.74	2.59	2.47	2.39	2.32	2.27	2.22	2.15	2.07	1.99	1.95	1.90	1.85	1.80	1.75	1.69
27	4.21	3.35	2.96	2.73	2.57	2.46	2.37	2.31	2.25	2.20	2.13	2.06	1.97	1.93	1.88	1.84	1.79	1.73	1.67
28	4.20	3.34	2.95	2.71	2.56	2.45	2.36	2.29	2.24	2.19	2.12	2.04	1.96	1.91	1.87	1.82	1.77	1.71	1.65
29	4.18	3.33	2.93	2.70	2.55	2.43	2.35	2.28	2.22	2.18	2.10	2.03	1.94	1.90	1.85	1.81	1.75	1.70	1.64
30	4.17	3.32	2.92	2.69	2.53	2.42	2.33	2.27	2.21	2.16	2.09	2.01	1.93	1.89	1.84	1.79	1.74	1.68	1.62
40	4.08	3.23	2.84	2.61	2.45	2.34	2.25	2.18	2.12	2.08	2.00	1.92	1.84	1.79	1.74	1.69	1.64	1.58	1.51
60	4.00	3.15	2.76	2.53	2.37	2.25	2.17	2.10	2.04	1.99	1.92	1.84	1.75	1.70	1.65	1.59	1.53	1.47	1.39
120	3.92	3.07	2.68	2.45	2.29	2.18	2.09	2.02	1.95	1.91	1.83	1.75	1.66	1.61	1.55	1.50	1.43	1.35	1.25
∞	3.84	3.00	2.60	2.37	2.21	2.10	2.01	1.94	1.88	1.83	1.75	1.67	1.57	1.52	1.46	1.39	1.32	1.22	1.00

Source: This table was generated using the SAS® function FINV. v_1 = numerator degrees of freedom; v_2 = denominator degrees of freedom.

Table 4 **Right-Tail Critical Values for the *F*-Distribution**

Upper 1% Points

$v_2\backslash v_1$	1	2	3	4	5	6	7	8	9	10	12	15	20	24	30	40	60	120	∞
1	4052.18	4999.50	5403.35	5624.58	5763.65	5858.99	5928.36	5981.07	6022.47	6055.85	6106.32	6157.28	6208.73	6234.63	6260.65	6286.78	6313.03	6339.39	6365.86
2	98.50	99.00	99.17	99.25	99.30	99.33	99.36	99.37	99.39	99.40	99.42	99.43	99.45	99.46	99.47	99.47	99.48	99.49	99.50
3	34.12	30.83	29.46	28.71	28.24	27.91	27.67	27.49	27.35	27.23	27.05	26.87	26.69	26.60	26.50	26.41	26.32	26.22	26.13
4	21.20	18.00	16.69	15.98	15.52	15.21	14.98	14.80	14.66	14.55	14.37	14.20	14.02	13.93	13.84	13.75	13.65	13.56	13.46
5	16.26	13.27	12.06	11.39	10.97	10.67	10.46	10.29	10.16	10.05	9.89	9.72	9.55	9.47	9.38	9.29	9.20	9.11	9.02
6	13.75	10.92	9.78	9.15	8.75	8.47	8.26	8.10	7.98	7.87	7.72	7.56	7.40	7.31	7.23	7.14	7.06	6.97	6.88
7	12.25	9.55	8.45	7.85	7.46	7.19	6.99	6.84	6.72	6.62	6.47	6.31	6.16	6.07	5.99	5.91	5.82	5.74	5.65
8	11.26	8.65	7.59	7.01	6.63	6.37	6.18	6.03	5.91	5.81	5.67	5.52	5.36	5.28	5.20	5.12	5.03	4.95	4.86
9	10.56	8.02	6.99	6.42	6.06	5.80	5.61	5.47	5.35	5.26	5.11	4.96	4.81	4.73	4.65	4.57	4.48	4.40	4.31
10	10.04	7.56	6.55	5.99	5.64	5.39	5.20	5.06	4.94	4.85	4.71	4.56	4.41	4.33	4.25	4.17	4.08	4.00	3.91
11	9.65	7.21	6.22	5.67	5.32	5.07	4.89	4.74	4.63	4.54	4.40	4.25	4.10	4.02	3.94	3.86	3.78	3.69	3.60
12	9.33	6.93	5.95	5.41	5.06	4.82	4.64	4.50	4.39	4.30	4.16	4.01	3.86	3.78	3.70	3.62	3.54	3.45	3.36
13	9.07	6.70	5.74	5.21	4.86	4.62	4.44	4.30	4.19	4.10	3.96	3.82	3.66	3.59	3.51	3.43	3.34	3.25	3.17
14	8.86	6.51	5.56	5.04	4.70	4.46	4.28	4.14	4.03	3.94	3.80	3.66	3.51	3.43	3.35	3.27	3.18	3.09	3.00
15	8.68	6.36	5.42	4.89	4.56	4.32	4.14	4.00	3.89	3.80	3.67	3.52	3.37	3.29	3.21	3.13	3.05	2.96	2.87
16	8.53	6.23	5.29	4.77	4.44	4.20	4.03	3.89	3.78	3.69	3.55	3.41	3.26	3.18	3.10	3.02	2.93	2.84	2.75
17	8.40	6.11	5.19	4.67	4.34	4.10	3.93	3.79	3.68	3.59	3.46	3.31	3.16	3.08	3.00	2.92	2.83	2.75	2.65
18	8.29	6.01	5.09	4.58	4.25	4.01	3.84	3.71	3.60	3.51	3.37	3.23	3.08	3.00	2.92	2.84	2.75	2.66	2.57
19	8.18	5.93	5.01	4.50	4.17	3.94	3.77	3.63	3.52	3.43	3.30	3.15	3.00	2.92	2.84	2.76	2.67	2.58	2.49
20	8.10	5.85	4.94	4.43	4.10	3.87	3.70	3.56	3.46	3.37	3.23	3.09	2.94	2.86	2.78	2.69	2.61	2.52	2.42
21	8.02	5.78	4.87	4.37	4.04	3.81	3.64	3.51	3.40	3.31	3.17	3.03	2.88	2.80	2.72	2.64	2.55	2.46	2.36
22	7.95	5.72	4.82	4.31	3.99	3.76	3.59	3.45	3.35	3.26	3.12	2.98	2.83	2.75	2.67	2.58	2.50	2.40	2.31
23	7.88	5.66	4.76	4.26	3.94	3.71	3.54	3.41	3.30	3.21	3.07	2.93	2.78	2.70	2.62	2.54	2.45	2.35	2.26
24	7.82	5.61	4.72	4.22	3.90	3.67	3.50	3.36	3.26	3.17	3.03	2.89	2.74	2.66	2.58	2.49	2.40	2.31	2.21
25	7.77	5.57	4.68	4.18	3.86	3.63	3.46	3.32	3.22	3.13	2.99	2.85	2.70	2.62	2.54	2.45	2.36	2.27	2.17
26	7.72	5.53	4.64	4.14	3.82	3.59	3.42	3.29	3.18	3.09	2.96	2.82	2.66	2.58	2.50	2.42	2.33	2.23	2.13
27	7.68	5.49	4.60	4.11	3.78	3.56	3.39	3.26	3.15	3.06	2.93	2.78	2.63	2.55	2.47	2.38	2.29	2.20	2.10
28	7.64	5.45	4.57	4.07	3.75	3.53	3.36	3.23	3.12	3.03	2.90	2.75	2.60	2.52	2.44	2.35	2.26	2.17	2.06
29	7.60	5.42	4.54	4.04	3.73	3.50	3.33	3.20	3.09	3.00	2.87	2.73	2.57	2.49	2.41	2.33	2.23	2.14	2.03
30	7.56	5.39	4.51	4.02	3.70	3.47	3.30	3.17	3.07	2.98	2.84	2.70	2.55	2.47	2.39	2.30	2.21	2.11	2.01
40	7.31	5.18	4.31	3.83	3.51	3.29	3.12	2.99	2.89	2.80	2.66	2.52	2.37	2.29	2.20	2.11	2.02	1.92	1.80
60	7.08	4.98	4.13	3.65	3.34	3.12	2.95	2.82	2.72	2.63	2.50	2.35	2.20	2.12	2.03	1.94	1.84	1.73	1.60
120	6.85	4.79	3.95	3.48	3.17	2.96	2.79	2.66	2.56	2.47	2.34	2.19	2.03	1.95	1.86	1.76	1.66	1.53	1.38
∞	6.63	4.61	3.78	3.32	3.02	2.80	2.64	2.51	2.41	2.32	2.18	2.04	1.88	1.79	1.70	1.59	1.47	1.32	1.00

Source: This table was generated using the SAS® function FINV. v_1 = numerator degrees of freedom; v_2 = denominator degrees of freedom.

Table 5 Critical Values for the Durbin–Watson Test: 5% Significance Level[a]

T	K=2 d_L^*	K=2 d_U^*	K=3 d_L^*	K=3 d_U^*	K=4 d_L^*	K=4 d_U^*	K=5 d_L^*	K=5 d_U^*	K=6 d_L^*	K=6 d_U^*	K=7 d_L^*	K=7 d_U^*	K=8 d_L^*	K=8 d_U^*	K=9 d_L^*	K=9 d_U^*	K=10 d_L^*	K=10 d_U^*	K=11 d_L^*	K=11 d_U^*
6	0.510	1.400																		
7	0.700	1.356	0.467	1.896																
8	0.763	1.332	0.559	1.777	0.368	2.287														
9	0.824	1.320	0.629	1.699	0.455	2.128	0.296	2.588												
10	0.879	1.320	0.697	1.641	0.525	2.016	0.376	2.414	0.243	2.822										
11	0.927	1.324	0.758	1.604	0.595	1.928	0.444	2.283	0.316	2.645	0.203	3.005								
12	0.971	1.331	0.812	1.579	0.658	1.864	0.512	2.177	0.379	2.506	0.268	2.832	0.171	3.149						
13	1.010	1.340	0.861	1.562	0.715	1.816	0.574	2.094	0.445	2.390	0.328	2.692	0.230	2.985	0.147	3.266				
14	1.045	1.350	0.905	1.551	0.767	1.779	0.632	2.030	0.505	2.296	0.389	2.572	0.286	2.848	0.200	3.111	0.127	3.360		
15	1.077	1.361	0.946	1.543	0.814	1.750	0.685	1.977	0.562	2.220	0.447	2.472	0.343	2.727	0.251	2.979	0.175	3.216	0.111	3.438
16	1.106	1.371	0.982	1.539	0.857	1.728	0.734	1.935	0.615	2.157	0.502	2.388	0.398	2.624	0.304	2.860	0.222	3.090	0.155	3.304
17	1.133	1.381	1.015	1.536	0.897	1.710	0.779	1.900	0.664	2.104	0.554	2.318	0.451	2.537	0.356	2.757	0.272	2.975	0.198	3.184
18	1.158	1.391	1.046	1.5635	0.933	1.696	0.820	1.872	0.710	2.060	0.503	2.257	0.502	2.461	0.407	2.667	0.321	2.873	0.244	3.073
19	1.180	1.401	1.074	1.536	0.967	1.685	0.859	1.848	0.752	2.023	0.649	2.206	0.549	2.396	0.456	2.589	0.369	2.783	0.290	2.974
20	1.201	1.411	1.100	1.537	0.998	1.676	0.894	1.828	0.792	1.991	0.692	2.162	0.595	2.339	0.502	2.521	0.416	2.704	0.336	2.885
21	1.221	1.420	1.125	1.538	1.026	1.669	0.927	1.812	0.829	1.964	0.732	2.124	0.637	2.290	0.547	2.460	0.461	2.633	0.380	2.806
22	1.239	1.429	1.147	1.541	1.053	1.664	0.958	1.797	0.863	1.940	0.769	2.090	0.677	2.246	0.588	2.407	0.504	2.571	0.424	2.734
23	1.257	1.437	1.168	1.543	1.078	1.660	0.986	1.785	0.895	1.920	0.804	2.061	0.715	2.208	0.628	2.360	0.545	2.514	0.465	2.670
24	1.273	1.446	1.188	1.546	1.101	1.656	1.013	1.775	0.925	1.902	0.837	2.035	0.751	2.174	0.666	2.318	0.584	2.464	0.506	2.613
25	1.288	1.454	1.206	1.550	1.123	1.654	1.038	1.767	0.953	1.886	0.868	2.012	0.784	2.144	0.702	2.280	0.621	2.419	0.544	2.560
26	1.302	1.461	1.224	1.553	1.143	1.652	1.062	1.759	0.979	1.873	0.897	1.992	0.816	2.117	0.735	2.246	0.657	2.379	0.581	2.513
27	1.316	1.469	1.240	1.556	1.162	1.651	1.084	1.753	1.004	1.861	0.925	1.974	0.845	2.093	0.767	2.216	0.691	2.342	0.616	2.470
28	1.328	1.476	1.255	1.560	1.181	1.650	1.104	1.747	1.028	1.850	0.951	1.958	0.874	2.071	0.798	2.188	0.723	2.309	0.650	2.431
29	1.341	1.483	1.270	1.563	1.198	1.650	1.124	1.743	1.050	1.841	0.975	19.44	0.900	2.052	0.826	2.164	0.753	2.278	0.682	2.396
30	1.352	1.489	1.284	1.567	1.214	1.650	1.143	1.739	1.071	1.833	0.998	1.931	0.926	2.034	0.854	2.141	0.782	2.251	0.712	2.363
31	1.363	1.496	1.297	1.570	1.229	1.650	1.160	1.735	1.090	1.825	1.020	1.920	0.950	2.018	0.879	2.120	0.810	2.226	0.741	2.333

[a] K refers to the number of columns in X, including the constant term.

Table 5 (continued)

T	K=2 d*_L	K=2 d*_U	K=3 d*_L	K=3 d*_U	K=4 d*_L	K=4 d*_U	K=5 d*_L	K=5 d*_U	K=6 d*_L	K=6 d*_U	K=7 d*_L	K=7 d*_U	K=8 d*_L	K=8 d*_U	K=9 d*_L	K=9 d*_U	K=10 d*_L	K=10 d*_U	K=11 d*_L	K=11 d*_U
32	1.373	1.502	1.309	1.574	1.244	1.650	1.177	1.732	1.109	1.819	1.041	1.909	0.972	2.004	0.904	2.102	0.836	2.203	0.769	2.306
33	1.383	1.508	1.321	1.577	1.258	1.651	1.193	1.730	1.127	1.813	1.061	1.900	0.994	1.991	0.927	2.085	0.861	2.181	0.795	2.281
34	1.393	1.514	1.333	1.580	1.271	1.652	1.208	1.728	1.144	1.808	1.080	1.891	1.015	1.979	0.950	2.069	0.885	2.162	0.821	2.257
35	1.402	1.519	1.343	1.584	1.283	1.653	1.222	1.726	1.160	1.803	1.097	1.884	1.034	1.967	0.971	2.054	0.908	2.144	0.845	2.236
36	1.411	1.525	1.354	1.587	1.295	1.654	1.236	1.724	1.175	1.799	1.114	1.877	1.053	1.957	0.991	2.041	0.930	2.127	0.868	2.216
37	1.419	1.530	1.364	1.590	1.307	1.655	1.249	1.723	1.190	1.795	1.313	1.870	1.071	1.948	1.011	2.029	0.951	2.112	0.891	2.198
38	1.427	1.535	1.373	1.594	1.318	1.656	1.261	1.722	1.204	1.792	1.146	1.864	1.088	1.939	1.029	2.017	0.970	2.098	0.912	2.180
39	1.435	1.540	1.382	1.597	1.328	1.658	1.273	1.722	1.218	1.789	1.161	1.859	1.104	1.932	1.047	2.007	0.990	2.085	0.932	2.164
40	1.442	1.544	1.391	1.600	1.338	1.659	1.285	1.721	1.230	1.786	1.175	1.854	1.120	1.924	1.064	1.997	1.008	2.072	0.945	2.149
45	1.475	1.566	1.430	1.615	1.383	1.666	1.336	1.720	1.287	1.776	1.238	1.835	1.189	1.895	1.139	1.958	1.089	2.022	1.038	2.088
50	1.503	1.585	1.462	1.628	1.421	1.674	1.378	1.721	1.335	1.771	1.291	1.822	1.246	1.875	1.201	1.930	1.156	1.986	1.110	2.044
55	1.528	1.601	1.490	1.641	1.452	1.681	1.414	1.724	1.374	1.768	1.334	1.814	1.294	1.861	1.253	1.909	1.212	1.959	1.170	2.010
60	1.549	1.616	1.514	1.642	1.480	1.689	1.444	1.727	1.408	1.767	1.372	1.808	1.335	1.850	1.298	1.894	1.260	1.939	1.222	1.984
65	1.567	1.629	1.536	1.662	1.503	1.696	1.471	1.731	1.438	1.767	1.404	1.805	1.370	1.843	1.336	1.882	1.301	1.923	1.266	1.964
70	1.583	1.641	1.554	1.672	1.525	1.703	1.494	1.735	1.464	1.768	1.433	1.802	1.401	1.837	1.369	1.873	1.337	1.910	1.305	1.948
75	1.598	1.652	1.571	1.680	1.543	1.709	1.515	1.739	1.487	1.770	1.458	1.801	1.428	1.834	1.399	1.867	1.369	1.901	1.339	1.935
80	1.611	1.662	1.586	1.688	1.560	1.715	1.534	1.743	1.507	1.772	1.480	1.801	1.453	1.831	1.425	1.861	1.397	1.893	1.369	1.925
85	1.624	1.671	1.600	1.696	1.575	1.721	1.550	1.747	1.525	1.774	1.500	1.801	1.474	1.829	1.448	1.857	1.422	1.886	1.396	1.925
90	1.635	1.679	1.612	1.703	1.589	1.726	1.566	1.751	1.542	1.776	1.518	1.801	1.494	1.827	1.469	1.854	1.445	1.881	1.420	1.909
95	1.645	1.687	1.623	1.709	1.602	1.732	1.579	1.755	1.557	1.778	1.535	1.802	1.512	1.827	1.489	1.852	1.465	1.877	1.442	1.903
100	1.654	1.694	1.634	1.715	1.613	1.736	1.592	1.758	1.571	1.780	1.550	1.803	1.528	1.826	1.506	1.850	1.484	1.874	1.462	1.898
150	1.720	1.746	1.706	1.760	1.693	1.774	1.679	1.788	1.665	1.802	1.651	1.817	1.637	1.832	1.622	1.847	1.608	1.862	1.594	1.877
200	1.758	1.778	1.748	1.789	1.738	1.799	1.728	1.810	1.718	1.820	1.707	1.831	1.697	1.841	1.686	1.852	1.675	1.863	1.65	1.874

Table 5 (continued)

T	K=12 d_L^*	K=12 d_U^*	K=13 d_L^*	K=13 d_U^*	K=14 d_L^*	K=14 d_U^*	K=15 d_L^*	K=15 d_U^*	K=16 d_L^*	K=16 d_U^*	K=17 d_L^*	K=17 d_U^*	K=18 d_L^*	K=18 d_U^*	K=19 d_L^*	K=19 d_U^*	K=20 d_L^*	K=20 d_U^*	K=21 d_L^*	K=21 d_U^*
16	0.098	3.503																		
17	0.138	3.378	0.087	3.557																
18	0.177	3.265	0.123	3.441	0.078	3.603														
19	0.220	3.159	0.160	3.335	0.111	3.496	0.070	3.642												
20	0.263	3.063	0.200	3.234	0.145	3.395	0.100	3.542	0.063	3.676										
21	0.307	2.976	0.240	3.141	0.182	3.300	0.132	3.448	0.091	3.583	0.058	3.705								
22	0.349	2.897	0.281	3.057	0.220	3.211	0.166	3.358	0.120	3.495	0.083	3.619	0.052	3.731						
23	0.391	2.826	0.322	2.979	0.259	3.128	0.202	3.272	0.153	3.409	0.110	3.535	0.076	3.650	0.048	3.753				
24	0.431	2.761	0.352	2.908	0.297	3.053	0.239	3.193	0.186	3.327	0.141	3.454	0.101	3.572	0.070	3.678	0.044	3.773		
25	0.470	2.702	0.400	2.844	0.335	2.983	0.275	3.119	0.221	3.251	0.172	3.376	0.130	3.494	0.094	3.604	0.065	3.702	0.041	3.790
26	0.508	2.649	0.438	2.784	0.373	2.919	0.312	3.051	0.256	3.179	0.205	3.303	0.160	3.420	0.120	3.531	0.087	3.632	0.060	3.724
27	0.544	2.600	0.475	2.730	0.409	2.859	0.348	2.987	0.291	3.112	0.238	3.233	0.191	3.349	0.149	3.460	0.112	3.563	0.081	3.658
28	0.578	2.555	0.510	2.680	0.445	2.805	0.383	2.928	0.325	3.050	0.271	3.168	0.222	3.283	0.178	3.392	0.138	3.495	0.104	3.592
29	0.612	2.515	0.544	2.634	0.479	2.755	0.418	2.874	0.359	2.992	0.305	3.107	0.254	3.219	0.208	3.327	0.166	3.431	0.129	3.528
30	0.643	2.477	0.577	2.592	0.512	2.708	0.451	2.823	0.392	2.937	0.337	3.050	0.286	3.160	0.238	3.266	0.195	3.368	0.156	3.465
31	0.674	2.443	0.608	2.553	0.545	2.665	0.484	2.776	0.425	2.887	0.370	2.996	0.317	3.103	0.269	3.208	0.224	3.309	0.183	3.406
32	0.703	2.411	0.638	2.517	0.576	2.625	0.515	2.733	0.457	2.840	0.401	2.946	0.349	3.050	0.299	3.153	0.253	3.252	0.211	3.348
33	0.731	2.382	0.668	2.484	0.606	2.588	0.546	2.692	0.488	2.796	0.432	2.899	0.379	3.000	0.329	3.100	0.283	3.198	0.239	3.293
34	0.758	2.355	0.695	2.454	0.634	2.554	0.575	2.654	0.518	2.754	0.462	2.854	0.409	2.954	0.359	3.051	0.312	3.147	0.267	3.240
35	0.783	2.330	0.722	2.425	0.662	2.521	0.604	2.619	0.547	2.716	0.492	2.813	0.439	2.910	0.388	3.005	0.340	3.099	0.295	3.190
36	0.808	2.306	0.748	2.398	0.689	2.492	0.631	2.586	0.575	2.680	0.520	2.774	0.467	2.868	0.417	2.961	0.369	3.053	0.323	3.142
37	0.831	2.285	0.772	2.374	0.714	2.464	0.657	2.555	0.602	2.646	0.548	2.738	0.495	2.829	0.445	2.920	0.397	3.009	0.351	3.097
38	0.854	2.265	0.796	2.351	0.739	2.438	0.683	2.526	0.628	2.614	0.575	2.703	0.522	2.792	0.472	2.880	0.424	2.968	0.378	3.054

Table 5 (continued)

T	K = 12 d^*_L	K = 12 d^*_U	K = 13 d^*_L	K = 13 d^*_U	K = 14 d^*_L	K = 14 d^*_U	K = 15 d^*_L	K = 15 d^*_U	K = 16 d^*_L	K = 16 d^*_U	K = 17 d^*_L	K = 17 d^*_U	K = 18 d^*_L	K = 18 d^*_U	K = 19 d^*_L	K = 19 d^*_U	K = 20 d^*_L	K = 20 d^*_U	K = 21 d^*_L	K = 21 d^*_U
39	0.875	2.246	0.819	2.329	0.763	2.413	0.707	2.499	0.653	2.585	0.600	2.671	0.549	2.757	0.499	2.843	0.451	2.929	0.404	3.013
40	0.896	2.228	0.840	2.309	0.785	2.391	0.731	2.473	0.678	2.557	0.626	2.641	0.575	2.724	0.525	2.808	0.477	2.892	0.430	2.974
45	0.988	2.156	0.938	2.225	0.887	2.296	0.838	2.367	0.788	2.439	0.740	2.512	0.692	2.586	0.644	2.659	0.598	2.733	0.553	2.807
50	1.064	2.103	1.019	2.163	0.973	2.225	0.927	2.287	0.882	2.350	0.836	2.414	0.792	2.479	0.747	2.544	0.703	2.610	0.660	2.675
55	1.129	2.062	1.087	2.116	1.045	2.170	1.003	2.225	0.961	2.281	0.919	2.338	0.877	2.396	0.836	2.454	0.795	2.512	0.754	2.571
60	1.184	2.031	1.145	2.079	1.106	2.127	1.068	2.177	1.029	2.227	0.990	2.278	0.951	2.330	0.913	2.382	0.874	2.434	0.836	2.487
65	1.231	2.006	1.195	2.049	1.160	2.093	1.124	2.138	1.088	2.183	1.052	2.229	1.016	2.276	0.980	2.323	0.944	2.371	0.908	2.419
70	1.272	1.986	1.239	2.026	1.206	2.066	1.172	2.106	1.139	2.148	1.105	2.189	1.072	2.232	1.038	2.275	1.005	2.318	0.971	2.362
75	1.308	1.970	1.277	2.006	1.247	2.043	1.215	2.080	1.184	2.118	1.153	2.156	1.121	2.195	1.090	2.235	1.058	2.275	1.027	2.315
80	1.340	1.957	1.311	1.991	1.283	2.024	1.253	2.059	1.224	2.093	1.195	2.129	1.165	2.165	1.136	2.201	1.106	2.238	1.076	2.275
85	1.369	1.946	1.342	1.977	1.315	2.009	1.287	2.040	1.260	2.073	1.232	2.105	1.205	2.139	1.177	2.172	1.149	2.206	1.121	2.241
90	1.395	1.937	1.369	1.966	1.344	1.995	1.318	2.025	1.292	2.055	1.266	2.085	1.240	2.116	1.213	2.148	1.187	2.179	1.160	2.211
95	1.418	1.929	1.394	1.956	1.370	1.984	1.345	2.012	1.321	2.040	1.296	2.068	1.271	2.097	1.247	2.126	1.222	2.156	1.197	2.186
100	1.439	1.923	1.416	1.948	1.393	1.974	1.371	2.000	1.347	2.026	1.324	2.053	1.301	2.080	1.277	2.108	1.253	2.135	1.229	2.164
150	1.579	1.892	1.564	1.908	1.550	1.924	1.535	1.940	1.519	1.956	1.504	1.972	1.489	1.989	1.474	2.006	1.468	2.023	1.443	2.040
200	1.654	1.885	1.643	1.896	1.632	1.908	1.621	1.919	1.610	1.931	1.599	1.943	1.588	1.955	1.576	1.967	1.565	1.979	1.554	1.991

Source: This table is reproduced from N. E. Savin, and K. J. White, "The Durbin–Watson Test for Serial Correlation with Extreme Sample Sizes or Many Regressors." Econometrica, 45; 1989–1996, 1977. With permission from The Econometric Society.

Index

The Normal Equations

$$Tb_1 + \sum x_t b_2 = \sum y_t \qquad (3.3.7a)$$

$$\sum x_t b_1 + \sum x_t^2 b_2 = \sum x_t y_t \qquad (3.3.7b)$$

Least Squares Estimators

$$b_2 = \frac{T \sum x_t y_t - \sum x_t \sum y_t}{T \sum x_t^2 - (\sum x_t)^2} \qquad (3.3.8a)$$

$$b_1 = \bar{y} - b_2 \bar{x} \qquad (3.3.8b)$$

Elasticity

$$\bullet \ \eta = \frac{\text{percentage change in } y}{\text{percentage change in } x} = \frac{\Delta y / y}{\Delta x / x} = \frac{\Delta y}{\Delta x} \cdot \frac{x}{y} \quad (3.3.11)$$

$$\bullet \ \eta = \frac{\Delta E(y)/E(y)}{\Delta x/x} = \frac{\Delta E(y)}{\Delta x} \cdot \frac{x}{E(y)} = \beta_2 \cdot \frac{x}{E(y)} \quad (3.3.13)$$

Least Squares Expressions Useful for Theory

$$\bullet \ b_2 = \beta_2 + \sum w_t e_t \qquad (4.2.1)$$

$$\bullet \ w_t = \frac{x_t - \bar{x}}{\sum (x_t - \bar{x})^2} \qquad (4.2.2)$$

$$\bullet \ E(b_2) = E(\beta_2 + \sum w_t e_t) = E(\beta_2) + \sum E(w_t e_t)$$

$$= \beta_2 + \sum w_t E(e_t) = \beta_2 \qquad (4.2.3)$$

$$\bullet \ b_2 = \frac{\sum (x_t - \bar{x})(y_t - \bar{y})}{\sum (x_t - \bar{x})^2} \qquad (4.2.6)$$

Properties of the Least Squares Estimators

$$\text{var}(b_1) = \sigma^2 \left[\frac{\sum x_t^2}{T \sum (x_t - \bar{x})^2} \right]$$

$$\text{var}(b_2) = \frac{\sigma^2}{\sum (x_t - \bar{x})^2}$$

$$\text{cov}(b_1, b_2) = \sigma^2 \left[\frac{-\bar{x}}{\sum (x_t - \bar{x})^2} \right] \qquad (4.2.10)$$

- **Gauss-Markov Theorem:** Under the assumptions SR1–SR5 of the linear regression model the estimators b_1 and b_2 have the *smallest variance of all linear and unbiased estimators* of β_1 and β_2. They are the <u>B</u>est <u>L</u>inear <u>U</u>nbiased <u>E</u>stimators (BLUE) of β_1 and β_2.

- *If* we make the normality assumption, assumption SR6 about the error term, then the least squares estimators are normally distributed.

$$b_1 \sim N\left(\beta_1, \ \frac{\sigma^2 \sum x_t^2}{T \sum (x_t - \bar{x})^2} \right)$$

$$b_2 \sim N\left(\beta_2, \ \frac{\sigma^2}{\sum (x_t - \bar{x})^2} \right) \qquad (4.4.1)$$

Estimated Error Variance

$$\hat{\sigma}^2 = \frac{\sum \hat{e}_t^2}{T - 2} \qquad (4.6.4)$$

Estimator Standard Errors

$$se(b_1) = \sqrt{\hat{\text{var}}(b_1)},$$
$$se(b_2) = \sqrt{\hat{\text{var}}(b_2)} \qquad (4.5.6)$$

t-distribution

- If assumptions SR1–SR6 of the simple linear regression model hold, then

$$t = \frac{b_k - \beta_k}{se(b_k)} \sim t_{(T-2)}, \quad k = 1, 2 \qquad (5.1.9)$$

Interval Estimates

$$P[b_2 - t_c \, se(b_2) \le \beta_2 \le b_2 + t_c \, se(b_2)] = 1 - \alpha \qquad (5.1.13)$$

Hypothesis Testing

- Components of Hypothesis Tests
 1. A *null* hypothesis, H_0
 2. An *alternative* hypothesis, H_1
 3. A test *statistic*
 4. A *rejection* region

- *If* the null hypothesis H_0: $\beta_2 = c$ is **true**, then

$$t = \frac{b_2 - c}{se(b_2)} \sim t_{(T-2)} \qquad (5.2.2)$$

- **Rejection rule for a two-tailed test:** If the value of the test statistic falls in the rejection region, either tail of the t-distribution, then we reject the null hypothesis and accept the alternative.

- Type I error—The null hypothesis is *true* and we decide to *reject* it

- Type II error—The null hypothesis is *false* and we decide *not* to reject it

- **Rejection rule for a two-tailed test:** When the **p-value** of a hypothesis test is *smaller* than the chosen value of α, then the test procedure leads to *rejection* of the null hypothesis.

Prediction

- $y_0 = \beta_1 + \beta_2 x_0 + e_0$ \qquad (5.3.1)
- $\hat{y}_0 = b_1 + b_2 x_0$ \qquad (5.3.2)
- $f = \hat{y}_0 - y_0$
- $\hat{\text{var}}(f) = \hat{\sigma}^2 \left[1 + \frac{1}{T} + \frac{(x_0 - \bar{x})^2}{\sum (x_t - \bar{x})^2} \right]$ \qquad (5.3.6)

- $se(f) = \sqrt{\hat{\text{var}}(f)}$ \qquad (5.3.7)
- A $(1-\alpha) \times 100\%$ confidence interval, or prediction interval, for y_0 is $\hat{y}_0 \pm t_c \, se(f)$ \qquad (5.3.12)

Goodness of Fit

- $\sum (y_t - \bar{y})^2 = \sum (\hat{y}_t - \bar{y})^2 + \sum \hat{e}_t^2$ \qquad (6.1.5)
- $SST = SSR + SSE$ \qquad (6.1.6)
- $R^2 = \dfrac{SSR}{SST} = 1 - \dfrac{SSE}{SST}$ \qquad (6.1.7)